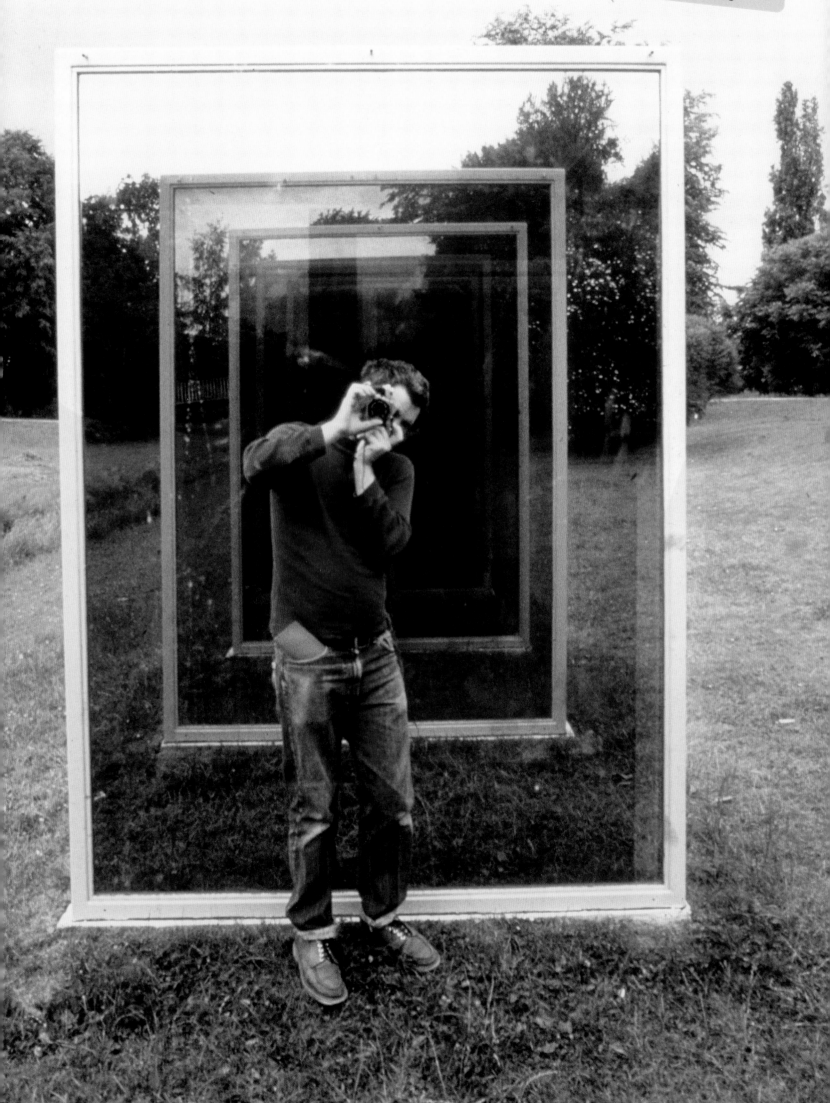

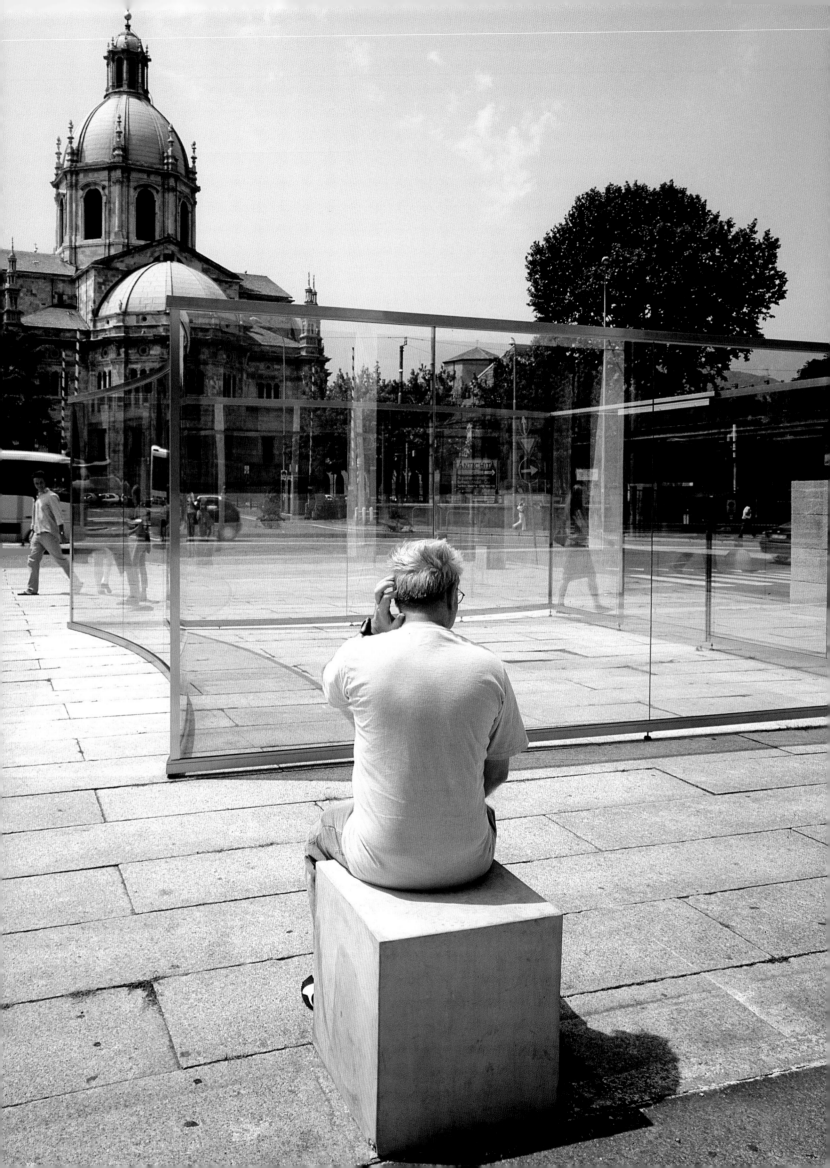

DAN GRAHAM

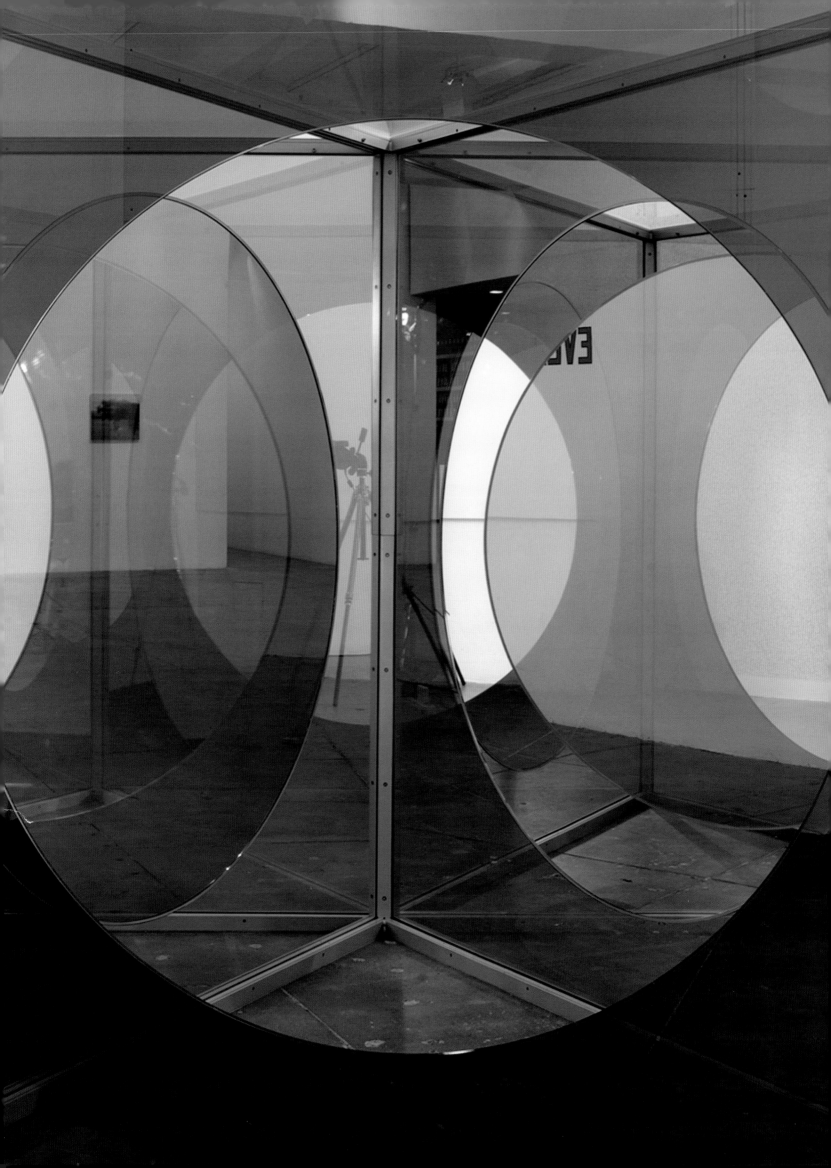

The Museum of Contemporary Art
Los Angeles

The MIT Press
Cambridge, Massachusetts
London, England

Organized by Bennett Simpson and Chrissie Iles

Essays by
Rhea Anastas, Beatriz Colomina,
Mark Francis, Dan Graham,
Chrissie Iles, Alexandra Midal,
Bennett Simpson, Mark von Schlegell,
and Philippe Vergne

Interviews with
Dan Graham by
Kim Gordon,
Rodney Graham,
and Nicolás Guagnini

Manga by
Fumihiro Nonomura
and Ken Tanimoto

DAN GRAHAM: BEYOND

CONTENTS

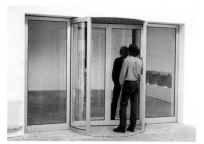

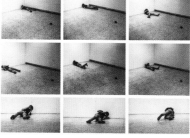
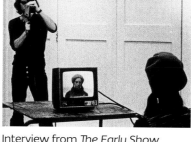

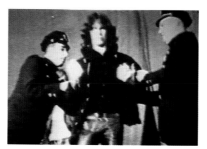
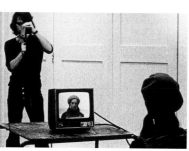

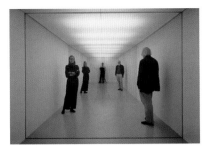

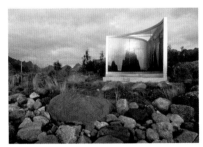

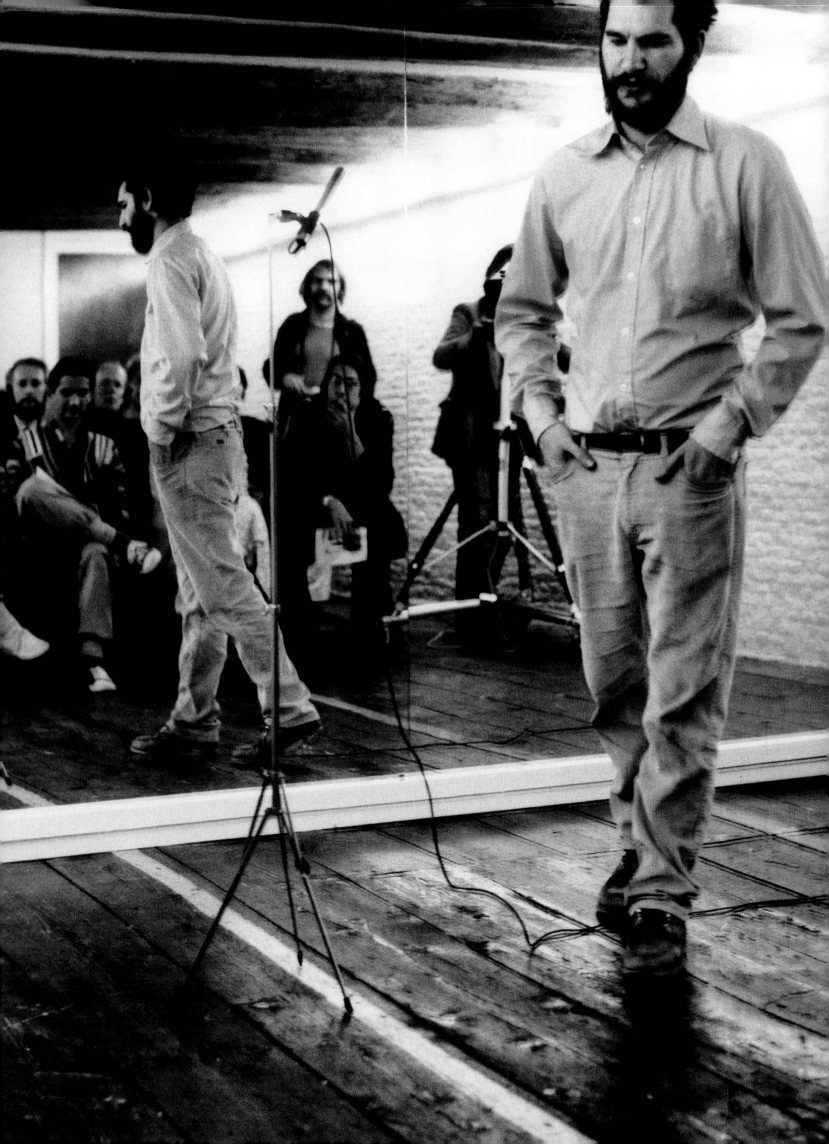

Foreword

Since the 1960s, Dan Graham has cultivated a unique practice that is as distinguished by its intellect and humor as it is by its engagement with the culture of which it is a part. Critical and interpretive, Graham's work is marked by a profound generosity towards its audience, investigating the complex and multilayered relationships between art objects and viewers, viewers and performers, and architecture and its inhabitants. He has experimented with a wide range of media throughout his career—photography, film and video, performance, installation, and architecture—and authored numerous influential essays on art, rock music, and popular culture.

Though Graham has had many solo exhibitions in Europe, his work has been relatively underappreciated in the United States, and so it is with exceptional pride that the Museum of Contemporary Art, Los Angeles (MOCA), presents "Dan Graham: Beyond," the first major North American retrospective of this remarkable artist's oeuvre. This exhibition features a full range of Graham's history, from his early works conceived for publication in magazines, to video and film installations, to architectural models and pavilions. I am grateful to MOCA Associate Curator Bennett Simpson, who has shepherded this project through its organization at MOCA, and co-curator Whitney Museum of American Art Anne and Joel Ehrenkranz Curator Chrissie Iles. Their sensitivity, vision, and commitment to Graham's work have resulted in this extraordinary presentation.

That this project has been a bicoastal curatorial endeavor is entirely fitting. New York City has been Graham's home for nearly five decades, and he was an influential force in that city's art world early on, establishing the John Daniels Gallery in 1964 and forging friendships with other artists of his generation including Dan Flavin, Robert Smithson, and Sol LeWitt, as well as participating in the New York music scene through collaborations with Glenn Branca and Sonic Youth. Graham has maintained a strong connection to Los Angeles as well, drawn especially to its often haphazard experimental architecture. In 1973, he showed at California Institute of the Arts, Valencia, and, in 1975, the Otis Art Institute Gallery mounted an important early exhibition of his work. Over the years he has cultivated close and fruitful relationships with Los Angeles–based artists John Knight and Michael Asher and, later, Mike Kelley and Paul McCarthy. In fact, Graham's long history of collaboration with artists, as well as his writings, lectures, and passionate and critical engagement with contemporary art practices, have influenced younger practitioners on the East and West Coasts and everywhere in between.

"Dan Graham: Beyond" solidifies the museum's commitment to mounting comprehensive monographic exhibitions of the work of the most important American artists, including many of Graham's generation. During the past five years, MOCA has presented retrospectives of the work of Lawrence Weiner (co-organized with the

Whitney Museum), as well as of Eva Hesse, Robert Smithson, and Gordon Matta–Clark (organized in collaboration with the Whitney Museum). In addition, Graham's work was included in two landmark surveys of Minimal and Conceptual art organized by MOCA Senior Curator Ann Goldstein, "1965–1975: Reconsidering the Object of Art," co-curated with Anne Rorimer in 1995, and "A Minimal Future? Art as Object 1958–1968," presented in 2004. However, the opportunity to show this wide range of Graham's work at MOCA is especially thrilling because so much of his practice deals with transformation through the act of viewing. His desire for gallery spaces to be interactive, social, and public realms constitutes a challenge to the art–viewing public to be participants in that process as well as to reflect on its meaning and consequences.

MOCA is pleased to share "Dan Graham: Beyond" with the Whitney Museum of American Art, New York, the first venue on the tour and an institution whose support and partnership we have cherished over the years—in particular, throughout the organization and presentation of a trio of exhibitions, including "Gordon Matta Clark: 'You Are the Measure'" and "Lawrence Weiner: As Far As the Eye Can See," concluding with this show. I especially thank Adam D. Weinberg, Alice Pratt Brown Director, for his support of this project. We are also pleased that this exhibition will travel to the Walker Art Center, Minneapolis. Without the extremely generous funding from supporters of both MOCA and the Whitney

Museum, this exhibition would not have been possible. I am especially thankful to the Sydney Irmas Exhibition Endowment; Galerie Hauser & Wirth, Zürich and London; Marian Goodman Gallery, New York and Paris; The MOCA Contemporaries; the National Endowment for the Arts; the Graham Foundation for Advanced Studies in the Fine Arts; Mary and Robert Looker; the Pasadena Art Alliance; Peter Gelles and Eve Steele Gelles; John Morace and Tom Kennedy; Bagley and Virginia Wright; and Marieluise Hessel. I also extend my heartfelt thanks to MOCA's Board of Trustees, especially Audrey Irmas and Betye Monell Burton, who provided financial support for the exhibition, and Co–Chair David G. Johnson for championing this project.

I commend former MOCA curator Cornelia Butler, now Robert Lehman Foundation Chief Curator of Drawings at the Museum of Modern Art, New York, for initiating this project on behalf of MOCA, laying the groundwork for the exhibition and our successful collaboration with the Whitney Museum.

Finally, I reserve my deepest gratitude for Dan Graham, whose work continues to amaze and inspire new generations of artists and viewers alike.

Jeremy Strick

Director, The Museum of Contemporary Art, Los Angeles

Acknowledgments

Few artists in the contemporary period have been as pioneering and provocative as Dan Graham. His works and writings since the mid–1960s have constituted a "position," to use a somewhat archaic term, that has opened art to myriad challenges, not just from the many new disciplines and media he has explored— among them, architecture, music, film, video, performance, and publication—but from an ethos that is deeply democratic and uncommonly receptive to the culture at large. In a presentation for the Art Workers' Coalition open hearing in April 1969, Graham stated, "We must go back to the old notion of socially 'good works' as against the private, aesthetic notion of 'good work'—i.e., art to go public."

This commitment to an art situated *between* people and *beyond* the traditional values and contexts of the gallery and museum placed him at the leading edge of that decade's political rethinking of art. Pursuing ideology, however, has never been Graham's intent. One need only consider his performances of the 1970s or his pavilion sculptures since the 80s to understand that his public imperative has always oriented towards questions of the subject, the self, as it forms and deforms in the real time of social and architectural context. The insistent "beyond" of Graham's challenge has been to reject the illusions of art for the very human struggle towards subjectivity, one in which art becomes a means or device but never an end.

"Dan Graham: Beyond" is the first major survey of Graham's work in a United States museum. This surprising status, which on its own begins to reconcile a historical and geographical imbalance in the reception of his work and the art of the 1960s generally, brings with it the great opportunity to present the full range of a practice unique in its diversity. Including works for magazine pages, photographs, drawings, films and videos, performances, multimedia installations, and architectural pavilions, the exhibition selects from each of the key phases of Graham's four-decade career. Organized by the Museum of Contemporary Art, Los Angeles (MOCA), "Dan Graham: Beyond" is a joint curatorial effort originally initiated by former MOCA curator Cornelia Butler, now Robert Lehman Foundation Chief Curator of Drawings at the Museum of Modern Art, New York. The project was developed over many years and represents a curatorial and institutional dialogue unparalleled in contemporary museum work.

Given the public and frequently collaborative nature of Graham's practice and his long history of exhibiting on both sides of the Atlantic as well as in Asia, Graham's work suggests distinct challenges to the scholarship of its contexts, receptions, and presentations. The development of this exhibition has relied upon and was profoundly enriched by the efforts and cooperation of numerous individuals. First and foremost, our gratitude extends to the artist himself. Throughout this process, Graham has been a most committed participant, opening his history and archives to us with enthusiasm, knowledge, and care. One of the great contemporary artist-writers, he has shared with us his passion for artistic and critical distinctions, conveyed with ample wit, clarifying stories, and helpful speculation. There is no overestimating how generous Graham can be—how open, thoughtful, and funny. His constant efforts to demystify not just his own history but that of contemporary art in general have provided an example from which we have truly benefited. We are also extremely grateful to Sylvia Chivaratanond for her good-natured and perspicacious assistance to Graham throughout the planning of this exhibition and to Antoine Catala and Trevor Shimizu in Dan Graham's studio for their many timely efforts on the artist's behalf.

This exhibition would not have been possible without the profound and long-standing dedication to Graham's work and career expressed by the many collectors who have lent their time and artworks, and to them we are most indebted. We are grateful for the assistance of Graham's galleries in helping facilitate so many aspects of this exhibition and wish to acknowledge Marian Goodman, Karina Daskalov, Catherine Belloy, and Brian Loftus of Marian Goodman Gallery, New York and Paris; Ivan Wirth, Florian Berktold, Ursula Hauser, and Marc Payot of Galerie Hauser & Wirth, Zürich and London; Nicholas Logsdail and Andrew Herdon of Lisson Gallery, London; Markus Mascher and Jörg Johnen of Johnen + Schöttle, Berlin; Valentina Costa and Massimo Minini of Galleria Massimo Minini, Brescia, Italy; Patrick Painter of Patrick Painter Inc., Los Angeles; and Anne-Claire Schmitz and Micheline Szwajcer of Galerie Micheline Szwajcer, Antwerp.

It is a particular honor that "Dan Graham: Beyond" has secured the tour participation of two museums that have great histories exhibiting and collecting Graham's work. After its presentation at MOCA, the exhibition will travel to the Whitney Museum

of American Art, New York, followed by the Walker Art Center, Minneapolis. For their early and steadfast support of this project, we are grateful to Alice Pratt Brown Director Adam D. Weinberg, Chief Curator and Associate Director for Programs Donna De Salvo, Associate Director for Exhibitions and Collection Management Christy Putnam, and Senior Curatorial Assistant Gary Carrion–Murayari at the Whitney Museum. At the Walker Art Center, we thank Director Olga Viso, Chief Curator Darsie Alexander, and Visual Arts Administrator Lynn Dierks. We also gratefully acknowledge former director Kathy Halbreich and former curator Philippe Vergne, whose commitment to this exhibition was crucial while both were still at the Walker. Lastly, we extend special acknowledgment to Connie Butler, whose early efforts over several years were essential to the shape, vision, and integrity of the exhibition as a whole.

At MOCA, we are indebted to Director Jeremy Strick for his steadfast encouragement and support and to Chief Curator Paul Schimmel for his warm embrace of the project and for so enthusiastically encouraging its fullest development. We are also grateful to Senior Curator Ann Goldstein, one of the true experts on Graham's work and the contexts from which it emerged, for her dedication to the artist and her invaluable advice throughout the exhibition process. We also extend appreciation to Deputy Director Ari Wiseman and Director of Development Jennifer Arceneaux for their efforts. Curatorial Assistant Christine Robinson was an invaluable partner as research assistant throughout the development of this project and in all aspects of its

organization; we, and the exhibition, have greatly benefited from her commitment. Very special thanks go to Director of Exhibition Production Brian Gray, Exhibition Production Coordinator Stacie B. London, former exhibition designer Sebastian Clough, Chief Exhibition Technician Jang Park, Senior Exhibition Technician Brian Boyer, Technical Manager of Exhibitions David Bradshaw, and Administrative Assistant Gregory Lee for embracing and encouraging an extraordinary exhibition design and installation. We are particularly grateful to Director of Collections and Registration Robert Hollister and Associate Registrar Melissa Altman for their dedicated efforts. Director of Exhibition Management Susan Jenkins, Administrative Assistant Carolyn Oakes, and Administrative Coordinator Blake Ferris provided crucial support. For their contributions to the project, we also thank Chief Financial Officer Diana Allan, Director of Education Suzanne Isken, Senior Education Program Manager Aandrea Stang, Deputy Director of Development Laurie McGahey, Associate Director of Development for Individual Giving Adam Gross, Grants Manager Elizabeth Jordan, Corporate Relations Coordinator James Deavoll, Individual Prospect Manager/Development Writer Janet Lomax, Special Events Director Vanessa Gonzalez, Administrative Assistant Samuel Vasquez, Director of Communications Lyn Winter and her staff, Writer/Editor Cristin Donahue, Senior Designer Nicholas Lowie, and Librarian Lynda Bunting.

This unique publication would not have been possible without the expertise and leadership of MOCA Director of Publications Lisa Gabrielle Mark, who worked closely with

the artist to guide it to its fullest potential. MOCA's exceptional publications staff—also comprising Senior Editor Jane Hyun, Editor Elizabeth Hamilton, and Publications Assistant Dawson Weber—worked tirelessly to bring the book to completion. We are deeply indebted to Michael Worthington of Counterspace, Los Angeles, who, with Yasmin Khan and Cassandra Chae, lent his extraordinary talents to conceiving an outstanding design that is consistent with the artist's practice and embraces the collaboration. We are most grateful for the outstanding contributions by catalogue essayists Rhea Anastas, Beatriz Colomina, Mark Francis, Alexandra Midal, Mark von Schlegell, and Philippe Vergne, and to Kim Gordon, Rodney Graham, and Nicolás Guagnini for their thoughtful interviews with the artist included in this book. Each of these texts reflects its author's distinctive and long-standing involvement with Graham's work. It has been a great pleasure to collaborate with Roger Conover at the MIT Press on the copublication of this catalogue. His support of the artist has been extensive and unique, and we have benefited from his experience, patience, and resolve.

A further word of thanks is due to all those who, in many other ways, have helped us prepare this exhibition and catalogue, namely Sandra Antelo–Suarez; Michael Asher; Jo Baer; Arno Bergmans; Dara Birnbaum; Marja Bloem; Rosetta Brooks; Eric de Bruyn; Susan Clark, Marc Lowenthal, Janet Rossi, and Pam Quick of the MIT Press; Rebecca Cleman and Electronic Arts Intermix, New York; Stuart Comer; Dorit Cypis; Johanna Cypis; Herman Daled; Constance De Jong; Chris Dercon;

Todd Eberle; Brian Forrest; Rudolf Frieling;
Tim Griffin and *Artforum*; Ulrike Groos; Nicolás
Guagnini; Brian Hatton; Annick and Anton
Herbert; Mara Hoberman; Chris Kempe; Peter
Kirby; John Knight; Michael Krebber; Lisa
Lapinski; Pip Laurenson; Sarah Lehrer–Graiwer;
Tony Manzella and Rusty Sena at Echelon,
Los Angeles; Paul McCarthy; John Miller; Regina
Möller; Thurston Moore; Birgit Pelzer; Jeff Preiss;
Rebecca Quaytman; Anne Rorimer; Karin
Schneider; Francis Schultz; Keiko Shimada;
Seth Siegelaub; Dirk Snauwaert; Josh Siegel;
Ian Vanek; John Vinci; Hamza Walker; Mark
Wasiuta; Christopher Williams; Ulrich Wilmes;
Mika Yoshitake; and Gene Youngblood.

Lastly, we wish to express our
sincerest thanks to MOCA's Board of Trustees
for their support and leadership, including
Co-Chairs David G. Johnson and Tom
Unterman, President Jeffrey Soros, and Vice
Chair Gil Friesen, as well as Chair Emeritus
Clifford J. Einstein and President Emeritus
Dallas Price–Van Breda. We extend special
thanks to Trustees Audrey Irmas and Betye
Monell Burton.

Bennett Simpson

Associate Curator, The Museum of
Contemporary Art, Los Angeles

Chrissie Iles

Anne and Joel Ehrenkranz Curator,
Whitney Museum of American Art, New York

1. Using any arbitrary schema (such as the example published here) produces a large, finite permutation of specific, discrete variants.

2. If a given variant is attempted to be set up by the editor following the logic step-by-step (linearly) it would be found impossible to compose a completed version as each of the component lines of exact data requiring completion (in terms of specific numbers and percentages) would be contingently determined by every other number and percentage which itself would in turn be determined by the other numbers or percentages, *ad infinitum.*

3. It would be possible to 'compose' the entire set of permutationally possible pages and to select the applicable variant(s) with the aid of a computer which could 'see' the ensemble instantly.

4. This perhaps suggests Godel's 'incompleteness' theorem.

— 1966

OTHER OBSERVATIONS

There is no composition.

No artistic or authorial 'insight' is expressed.

The work subverts value. Beyond its appearance in print or present currency, "SCHEMA (March, 1966)" is disposable; with no dependence on material (commodity), it subverts the gallery (economic) system.

It is not "art for art's sake." Its medium is in-formation. Its communicative value and comprehension is immediate, particular and altered as it fits the terms (and time) of its system or (the) context (it may be read in).

A page of "SCHEMA" exists as matter of fact materiality and simultaneously semiotic signifier of this material (present): as a sign it unites, therefore, signifier and signified.

It defines itself as place as it defines the limits and contingencies of placement (enclosing context, enclosed content). It is a measure of itself — as place. It takes its own measure — of itself as place, that is, placed two-dimensionally on (as) a page.

A specific 'material' in-formation supports its own decomposition (as it is composed) into the constituent material elements of its place.

The only relations are the relation of the elements to each other, the elements existing only by virtue of their mutual dependency — their material dependency.

Place is reduced to in-formation in terms of present appearance and so a specific variant, in a sense, does not actually exist, but under certain conditions can be made to appear.

In external fact, in-formation simply appears — to fill up available magazine space; it takes place as (is) the medium.

In the internal logic, there is the paradox that the concept of 'materiality' referred to by the language is to the language itself as some 'immaterial' material (a kind of mediumistic ether) and simultaneously is to it as the extensive space. There is a 'shell' placed between the external 'empty' material of place and the interior 'empty' material of 'language'.

(Systems of) information (in-formation) exist halfway between *material* and *concept,* without being either one.

— 1969/73

Schema for a set of pages whose component variants are specifically published as individual pages in various magazines and collections. In each printed instance, it is set in its final form (so it defines itself) by the editor of the publication where it is to appear, the exact data used to correspond in each specific instance to the specific fact(s) of its published appearance. The following schema is entirely arbitrary; any might have been used, and deletions, additions or modifications for space or appearance on the part of the editor are possible.

SCHEMA:

(Number of)	adjectives
(Number of)	adverbs
(Percentage of)	area not occupied by type
(Percentage of)	area occupied by type
(Number of)	columns
(Number of)	conjunctions
(Depth of)	depression of type into surface of page
(Number of)	gerunds
(Number of)	infinitives
(Number of)	letters of alphabets
(Number of)	lines
(Number of)	mathematical symbols
(Number of)	nouns
(Number of)	numbers
(Number of)	participles
(Perimeter of)	page
(Weight of)	paper sheet
(Type)	paper stock
(Thinness of)	paper
(Number of)	prepositions
(Number of)	pronouns
(Number of point)	size type
(Name of)	typeface
(Number of)	words
(Number of)	words capitalized
(Number of)	words italicized
(Number of)	words not capitalized
(Number of)	words not italicized

5	adjectives
2	adverbs
69.31%	area not occupied by type
31.69%	area occupied by type
1	column
1	conjunction
no	depression of type into surface of page
0	gerunds
0	infinitives
325	letters of alphabet
25	lines
11	mathematical symbols
38	nouns
29	numbers
4	participles
8¾″ x 10⅝″	page
80 lb.	paper sheet
WEDGWOOD COATED OFFSET	paper stock
4 mil	paper
6	prepositions
10	point size type
FUTURA	type face
59	words
4	words capitalized
0	words italicized
55	words not capitalized
59	words not italicized

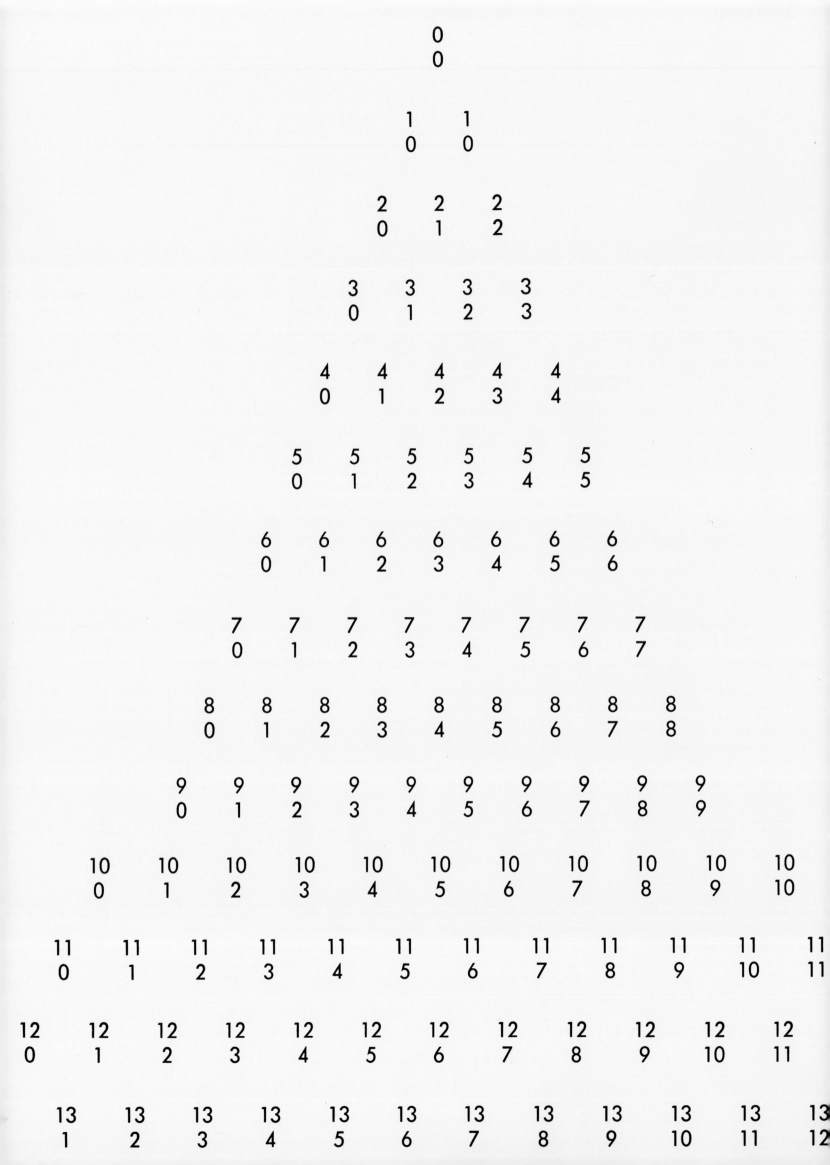

17 17 17 17 17 17 17 17 17 17 17 17 17 17 17 17 17 17
0 1 2 3 4 5 6 7 8 9 10 11 12 13 14 15 16 17

18 18 18 18 18 18 18 18 18 18 18 18 18 18 18 18 18 18 18
0 1 2 3 4 5 6 7 8 9 10 11 12 13 14 15 16 17 18

19 19 19 19 19 19 19 19 19 19 19 19 19 19 19 19 19 19 19 19
0 1 2 3 4 5 6 7 8 9 10 11 12 13 14 15 16 17 18 19

20 20
0 1 2 3 4 5 6 7 8 9 10 11 12 13 14 15 16 17 18 19 20

21 21
0 1 2 3 4 5 6 7 8 9 10 11 12 13 14 15 16 17 18 19 20 21

22 22
0 1 2 3 4 5 6 7 8 9 10 11 12 13 14 15 16 17 18 19 20 21 22

23 23
0 1 2 3 4 5 6 7 8 9 10 11 12 13 14 15 16 17 18 19 20 21 22 23

24 24
0 1 2 3 4 5 6 7 8 9 10 11 12 13 14 15 16 17 18 19 20 21 22 23 24

25 25
0 1 2 3 4 5 6 7 8 9 10 11 12 13 14 15 16 17 18 19 20 21 22 23 24 25

26 2
0 1 2 3 4 5 6 7 8 9 10 11 12 13 14 15 16 17 18 19 20 21 22 23 24 25 2

27 27
0 1 2 3 4 5 6 7 8 9 10 11 12 13 14 15 16 17 18 19 20 21 22 23 24 25 26

8 2
 1 2 3 4 5 6 7 8 9 10 11 12 13 14 15 16 17 18 19 20 21 22 23 24 25 26 2

29 29
 1 2 3 4 5 6 7 8 9 10 11 12 13 14 15 16 17 18 19 20 21 22 23 24 25 26 27

0 3
 2 3 4 5 6 7 8 9 10 11 12 13 14 15 16 17 18 19 20 21 22 23 24 25 26 27 2

Perhaps you think 18-year-olds
should vote, your curfew should
be lifted and math be outlawed
forever. But there's one thing on
which you agree with millions of
women in 106 countries—the
modern internally worn sanitary
protection—Tampax tampons.
Why does a girl with a mind
of her own go along with women
all over the world?
Tampax tampons give total
comfort, total freedom. There are
no belts, pins, pads. No odor.
They can be worn in the tub
or shower—even in swimming.
There's nothing to show under the
sleekest clothes. And Tampax
tampons are so easy to dispose
of, too—the container-applicator
just flushes away, like the
Tampax tampon.
If you haven't tried them already—
get Tampax tampons today.

DEVELOPED BY A DOCTOR
NOW USED BY MILLIONS OF WOMEN

TAMPAX® TAMPONS ARE MADE ONLY BY
TAMPAX INCORPORATED. PALMER. MASS.

A
A
A .21
A 0030
A 0033
A 0050
A 0057
A 0032
A 00.79
A 00.47
A 00.42
A 00.79
A 0033
A C033
A C025
A C029
A 0041
A 0036
A 0059
A 0041
A 0059
A 0034
A 0037
A .89
A .89
A .65
A .56
A .08

FIGURATIVE
BY
DAN
GRAHAM

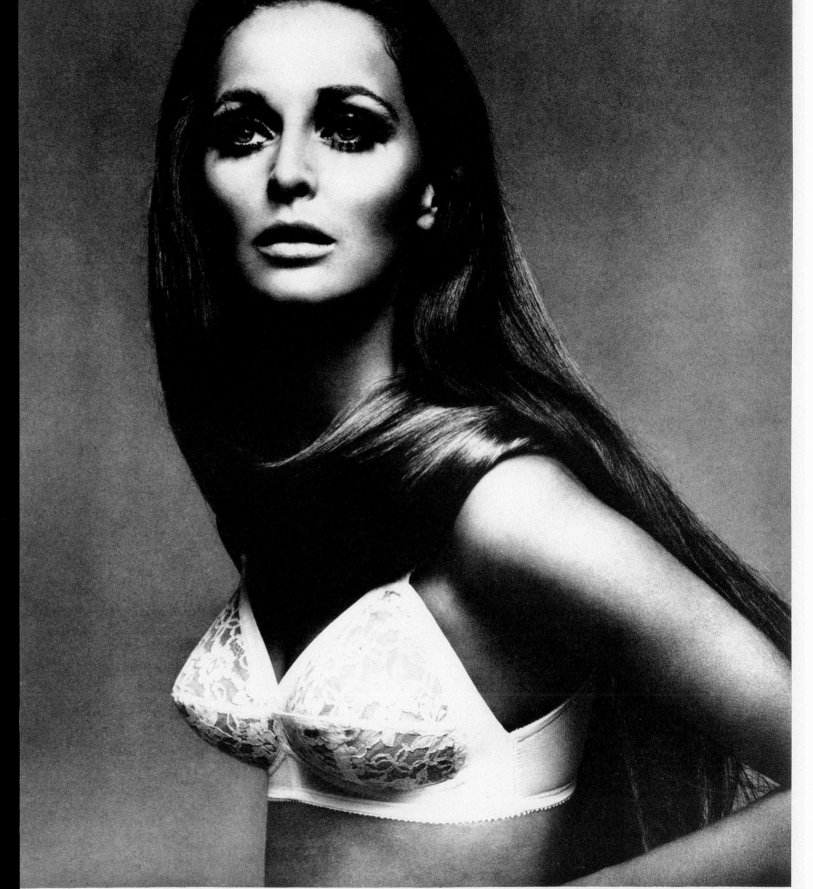

If nature didn't, Warner's will.

Our Comfort Curve™ bra with low-cut sides will do it for $5. **Warner's®**
THE ■WARNACO GROUP

TIME EXTENDED / DISTANCE EXTENDED

DETUMESCENCE

I had in mind a page, describing in clinical language the typical emotional and physiological aspects of post-climax in the sexual experience of the human male. It was noted that no description exists anywhere in the literature, as it is "anti-romantic." It may be culturally suppressed — a structural "hole" in the psycho-sexual-social conditioning of behavior. I wanted the "piece" to be, simply, this psycho-sexual-social "hole" — truncated on the page alone as printed matter. To create it, I advertised in several places. In late 1966 I advertised for a qualified medical writer in the "National Tatler" (a sex tabuloid). In early 1969 "The New York Review of Sex" gave me an ad. As both of these ads were somewhat edited, I bought an ad in "SCREW" in mid-1969. I HAVE RECEIVED NO RESPONSES.

Involuntary body contractions ensue bringing a steep drop
in excitation. The most obvious indication of this is the
rapid loss of penile erection and the return of the scrotum
and testes to an unstimulated state. This action occurs in
two stages. The first leaves the penis enlarged while a
continued shrinkage takes place concurrently at a slower
rate. The body slackens its tension. There is a loosening
of physical tautness, and a simultaneous sense of release
and relaxation. Sensations of orgasm or desire are exting-
uished; emotions recede; and ego is again bounded. Psych-
ologically, there may be feelings of anxiety, relief, plea-
surable satiation, disappointment, lassitude, leaden ex-
haustion, disgust, repulsion, or indifference, and occasionally
hatred depending on the partner and the gratification achieved
in the orgasm state.

COMMON DRUG \ SIDE EFFECT	Anorexia (Appetite loss)	Blood clot	Blurring of vision	Constipation	Convulsion	Decreased libido	Dermatosis	Depression, torpor	Headache	Hepatic disfunction	Hypertension	Insomnia	Nasal congestion	Nausea, vomiting	Pallor
STIMULANT also APPETITE DEPRESSANT															
Dextroamphetamine (Dexadrine)	●			●	●				●		●	●		●	
Methamphetamine chloride (Desoxyn)	●		●		●				●		●	●		●	
ANTI-DEPRESSANT															
Iproniazid				●					●	●	●				
Trofanil			●				●		●		●				
TRANQUILIZER															
Chorpromazine				●		●	●	●	●						●
Hydroxyzine				●			●	●	●					●	●
Meprobamate					●			●			●				
Promazine			●				●	●	●						
Resperpine	●				●	●	●	●					●	●	
Thiopropazate			●	●	●		●	●	●	●		●		●	
SEDATIVE															
Barbitol			●					●						●	
Phenobaritol			●					●						●	
ANTI-MOTION SICKNESS															
Dimenhydrinate (Dramamine)							●	●						●	
Marezine							●	●							
Meclizine							●	●						●	
CONTRACEPTIVE															
Norethynodrel (Enovid)		●	●						●	●				●	●

PROPOSAL FOR ASPEN MAGAZINE

I propose an issue on the subject of INFORMATION whose constituent parts would function doubly; as advertisements for designated information media (computer-data-processing, network television, radio, telephone, "think tank", dating service, duplication) companies and *also* as works of art. Artists (musicians, writers, artists, dancers) would be selected and arrangements made with various companies for their participation in-forming a work. This arrangement would serve a twofold function: the artist might help the corporation in establishing its corporate image while the corporation might help the artist in freeing some of the limitations in relation to the reader and social-economic frameworks. Beyond the initial selection of the artists and companies all decisions on the project would be corporate between the contributors themselves and between the individual contributor and his company. The company and the artist would be responsible for the production and design of their unit, the cost subsumed by the corporation in exchange for rights to its use in advertising and public relations. Companies would be free to use the ad/art-work in any context they think important: in trade shows, television , radio or other media campaign. As is in the nature of this type of information the usefulness (effect-impact-meaning) of these ads/artworks would be immediate, topical and more or less short-lived.

SPECIAL ISSUE OF ASPEN

The collected printed matter would be issued in a special issue of ASPEN, profits from its use going to the artists. Later the same information would be provided free of charge to any Museum wishing to use the contents in an exhibition with the provision that this Museum invites a number or all of the artists to discuss directly with the public the consequences and projected development of their working relationship with their corporate structure.

THEORY

(MOVING INFORMATION:) The information vector present would amount to re-directing the flow of traffic (it wouldn't be the sum of an individual artist's experience) in pointing directly to the outside world — to products to be played and services to be rendered (further in-forming the reader in real time). This is a radical revision of past procedures where the book and the magazine form have served to re-present (contain) the author's privileged insight (or several author's points of view) in translation to the masses of individual readers who've bought and identified (with) the experience. Under this kind of system magazines serve as part and parcel of a socio-economic structure which requires and perpetuates the 'system': a single dimension, single fixed point of view (of a complex of points in reality) representation.

DIFFERING VIEWS

It is assumed that each of the individual contributors to this proposed issue of information will undoubted have widely different views of their role than mine. Here my only relation to the subject matter of the issue of information is in placing these vectors in operation.

1967-68

```
1,000,000,000,000,000,000,000,000.00000000 miles to edge of known universe
  100,000,000,000,000,000,000.00000000 miles to edge of galaxy (Milky Way)
              3,573,000,000.00000000 miles to edge of solar system (Pluto)
                       205.00000000 miles to Washington, D. C.
                         2.85000000 miles to Times Sq., New York City
                          .38600000 mlies to Union Sq. subway stop
                          .11820000 miles to corner of 14th St. and 1st Ave.
                          .00367000 miles to door of Apartment 1D,153 1st Ave
                          .00021600 miles to typewriter paper page
                          .00000700 miles to lens of glasses
                          .00000098 miles to cornea from retinal wall
```

MAGAZINE/ADVERTISEMENTS

Art is a social sign. Magazines — all systems of context in the art system — also serve as part of a social-economic (which in part determines a psychological) framework. Each class of magazines (TIME, LIFE, BOY'S LIFE, SPORTS ILLUSTRATED, FILM CULTURE, ARTFORUM) appears to cover a defined field, its form assuming a category of readership who are identified with the 'line' of its advertisers whose ads support and uphold the magazine's existence/'image'. Thus, the type of material printed is meant to as closely identify its readers' collective projections and beliefs with the content. People read and identify with a magazine a prefabricated system of belief and buy (relate to the advertising) the product or 'image' it sells. My first (1965-66) 'conceptual' art used magazine space as their context without being defined as *a priori* content (they in-formed themselves specifically by their context of placement and useage of place). As they weren't defined (previously) as GALLERY ART they weren't usually published. I found it necessary to subvert this structure and *for the artist himself to place the work as ads* which would short-circuit the process. My next group of pieces dealt with the consequences of direct use of the ad system.

The advertisement makes *public* — publicizes — a *private* need and, as a consequence, shifts categories of this relation. "INCOME (OUTFLOW)" through this alteration, effects the larger homeostatic balance of my life.

The advertisement functions as 'exposure'.

There is a relation of a *public* figure's *private* 'piece' to *public* exposure or the reverse (as in "LIKES" where the spectator exposes his private needs).

— 1969 notes

STATEMENT OF THE ARTIST EXHIBITED AT DWAN GALLERY, NEW YORK, "LANGUAGE III"

From April 2, 1969 I have been performing activities required to allow my placing legally an advertisement (termed a 'tombstone') in various magazines offering the prospectus describing a public offering of stock in *Dan Graham, Inc*. The 'object' (my motive) of this company will be to pay Dan Graham, myself, the salary of the average American citizen out of the pool of collected income from the stock's sale. All other income realized from the activities of Dan Graham beyond the amount *will be returned to the investors* in the form of dividends. I, Dan Graham, am to be the underwriter of the forthcoming issue. Advertisements, it is planned, will be placed sequentially in a number of contexts-magazines. These are divided into 'categories' as, first: "The Wall Street Journal" (then in this order), "Life", "Time", "Artforum", "Evergreen Review", "Vogue", "Psychology Today", "The Nation". My intention is to solicit responses to my and my company's motives from a spectrum of 'fields.' Such responses *might* range from: "Mr. Graham is attempting to create socialism out of capitalism" (*political* motive) or, "Mr. Graham is a sick exhibitionist" (*psychological* motive) or, "Mr. Graham is making art" (*aesthetic* motive) . . . all categories of meaningful information feedback. Categories of responses will define feedback in terms of motive. A sampling of responses in print would be printed as additional in-formation as the advertisements progressed in their appearances. Author and place the comments appeared would also be printed. In placing the comments of additional in-formation, I would be motivated solely to induce (through 'come-ons') the greatest response in terms of new stock buyers. The prospectus outlining the terms of the offering will also include a valuation of myself and past activities by a friend, an artist, an astrologer, and anthropologist, a doctor, and others. These individuals will each take a small percentage of shares of the stock in exchange for these services.

1. Money is no object, but a *motive*, a *modus vivendi*, a means to my support; the artist changes the homeostatic balance of his life (environment) support by re-relating the categories of *private* sector and *public* sector; a modus operandi, a social sign, a sign of the times, a personal locus of attention, a *shift* of the matter/energy balance *to mediating my needs* — the artist places himself as a situational vector to sustain his existence and projected future (further) activities in the world. Money is a service commodity: in come and out go while in-formation.

2. The artist will have as his object (*motive*):

a. to make *public* information on social motives and categorization whose structure upholds, reveals in its functioning, the socio-economic support system of media.

b. to support himself (as a service to himself).

c. for other persons to emulate his example and do the same.

This announcement is under no circumstances to be construed as an offer to sell or as a solicitation of an offer to buy any of these securities. The offering is made only by the Prospectus.

NEW ISSUE **June 2, 1969**

1,500 Shares

DAN GRAHAM INC.

Price $10 per share

Dan Graham Incorporated (underwriter)
84 Eldridge St., New York, N. Y. 10002
Phone (212) 925-3490

BAUD WRITES TH

ER AND SAYS.

FUTURE WHE

N GET FRO

G SERVITU

Bennett Simpson

"Rock's creed is fun. Fun forms the basis
of its apocalyptic protest."

—Dan Graham, *Rock My Religion*[1]

From the beginning of his history as an artist, Dan Graham
has positioned his work in relation to music. Whether by
invoking music as an influence (serialism, the Kinks), col-
laborating with musicians (Glenn Branca, Sonic Youth), or
writing about music (Steve Reich, Patti Smith), Graham has
made musical contexts and metaphors an explicit dimension
of what and how his art means. It is also the case that music
has long served as one of the most prominent "ways in" to
Graham's work. If the video documentary *Rock My Religion*
(1982–84) remains a singularly popular touchstone of his
career—"one of the most important texts on the theory of
rock music,"[2] it has been called—its analysis of Shaker circle
dances, teenybopper euphoria, and hardcore mosh pits has
also served as a gateway to the ideas of performance, audi-
ence, and subjectivity that frame Graham's practice as a
whole. Though it is impossible to quantify how many people
have been turned on to Graham's work by encountering it on
the cover of Sonic Youth's 1987 album *Sister*[3] (**fig. 1**), the
artist's proximity to certain musical scenes, most notably the
underground punk world of late-1970s and 80s New York, has
suggested an Ariadne's thread for generations of admirers.

This aspect of Graham's history has made a
complicated impact on his reception. While his career spans
forty-five years and includes several retrospectives around
the world, a vast critical literature, and a reputation naming
him one of the seminal and pioneering figures of numerous
modes of art-making now taken for granted (Conceptual art,
video, performance, and site-specific sculpture), it can often
seem that there are many different, even contradictory "Dan
Grahams." From an art-historical standpoint, the best known
of these, proposed by critics such as Benjamin H. D. Buchloh

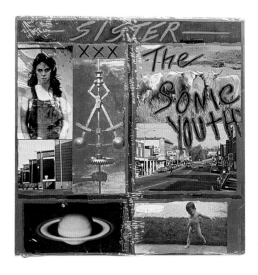

fig. 1
Cover of Sonic Youth's album *Sister* (1987)

Notes **1.** Dan Graham, *Rock My Religion* (1982–84),
video.
2. Diedrich Diederichsen, "Ecstasy and
Abstraction," in *Don't Trust Anyone Over
Thirty*, playbill (Vienna: Thyssen-Bornemisza
Art Contemporary, 2005), 49.
3. Sonic Youth used a photograph from
Graham's *Homes for America* (1966–67)
in a cover collage of numerous other im-
ages. The band's history of designing album
covers to include contemporary artworks is
well known and includes collaborations with
James Welling, Tony Oursler, Gerhard Richter,
Raymond Pettibon, Richard Prince, and
Christopher Wool, among others. The exhibi-
tions "Sonic Process, Sonic Kollaborations"
at Printed Matter, Inc., New York, 2000, and
"Sonic Youth, etc.: Sensational Fix," at LiFE, St.
Nazaire, France; Bolzano, Italy; Düsseldorf,
Germany; and Mälmo, Sweden, 2008–09,
documented aspects of this history.

Still from *Rock My Religion* (1982–84)

a reworking of modernist subject positions and perception through the artist's experiments in performance, video, and architecture.[4] Rarely, however, have art–historical accounts focused in any significant way on Graham's involvement with music.[5] This omission has left another side of Graham's reception, one that might in fact be called "popular," to grow from the bottom up. In some ways, Graham has become a quintessential "artist's artist" figure: a generous peripatetic participant whose works and collaborations with both artists and musicians continue to defy the official. That art history has been slow to deal with Graham's interest in music or, for that matter, his interest in literature and his incomparably prescient critical writings on culture, has insured a continued possibility in his reception—an openness in exactly the place where broader or new audiences might encounter his work most profitably.

This openness is one of the most valuable aspects of Graham's position. It has kept the understanding of his work off balance and, ideally, flexible. It has maintained—because Graham himself has maintained—an aura of anti–professionalism. It is more fun. And yet, one also questions what Graham's history would look like were art history and criticism to begin digesting the many non–art contexts that have guided his work, especially those pertaining to his admitted "passion"[6] for music, where the texture and range of his political and cultural voice have been so evident. In what follows, I would like to make a provisional sketch towards this synthetic view, focusing on two distinct moments where Graham's works in art and music have converged in funda–mental, if not transforming ways. Given the heterogeneity of his practice over four decades, discussing it in "phases" is something of a default approach, and Graham himself has frequently delineated breaks and new directions—most notably between the 1960s "conceptual" works for magazine pages and his subsequent turn to performance, video, and architectural installation after 1969. My approach will follow a slightly looser periodization, starting with a 1960s moment defined by Graham's first considerations of rock and youth culture, especially as it emerged from his analysis of the suburbs, mass media, and pop, before turning to the punk years of the late 1970s and early 80s, during which Graham produced some of his most trenchant responses to music in collaborations with Kim Gordon and Glenn Branca and in the videos *Minor Threat* (1983) and *Rock My Religion*.

4. That the work of Graham's generation, which includes Robert Smithson, Lawrence Weiner, and others, was initially and most thoroughly embraced in Europe and valued specifically for its philosophical and political challenges *to art*, has meant that scholarship, so often focused on precedent, has tended to omit or repress aspects that may seem implicit to audiences beyond art historians. Two of the most important art-historical texts on Graham are Benjamin H. D. Buchloh, "Moments of History in the Work of Dan Graham," in *Dan Graham: Articles*, exh. cat. (Eindhoven, The Netherlands: Stedelijk Van Abbemuseum, 1978), reprinted in *Neo-Avantgarde and Culture Industry* (Cambridge, Massachusetts:

In each of these moments, it is difficult to separate Graham's artworks as such from his statements about them, or from his statements about culture more generally. This is a fundamental reality about Graham's practice, which, after all, began with his desire to be a writer or critic rather than an artist and includes enough published essays, introductions, and explanations to have filled multiple collections over the years. Undoubtedly, Graham's position as a critic has affected—he would say adversely affected—the way his art has been received, on the one hand making it more available to cultural discourse, but on the other challenging criticism's traditional separation from its object. The autonomy his example proposes is perhaps nowhere more at stake than in his relation to music, which one thinks has been overlooked at least partially because its understanding depends on what Graham alone, and often after the fact, has had to say about it:

> Eric de Bruyn: Your writings of the 60s...are not directly concerned with the relation of visual art to popular music. This theme will become more present in your later writings from the 70s.
>
> Dan Graham: The fact that I did not write about it does not mean that it was not informative. The first works I was doing for the magazine pages were totally influenced by listening to the Kinks and the Rolling Stones. "Mother's Little Helper" was the main influence on *Side Effects/Common Drugs* (1966). So let's say that the music was always an influence. It just happened that I didn't write about it.[7]

THE 1960s, THE SUBURBS, AND THE EXPANDING SUBJECT

Among the major topics of Graham's first works of the 1960s—the suburban city plan, information design, structures of perception—music plays an implicit role. This period of Graham's career was defined by his navigating a space between writing and art-making, a double interest that led him to produce works that function ambiguously as both text and art. Taking as their context not the gallery but the pages of commercial magazines, works such as *Scheme* (1965), *Side Effects/Common Drugs* (1966), and *Homes for America* (1966–67) bear the influence of the two dominant art developments of the decade. From Pop art, Graham's move into mass media embraced ideas of disposability, popular appeal, and humor. From Minimalism, many of his specific works explore ideas of repetition and reduced schematic design. I would argue, however, that Graham's pages for magazines

Holes and Lights (1968)
Dan Graham

"Beneath each word lies a sort of existential geology... a speech full of holes and full of lights."
—Roland Barthes

SECTION I

The Vanilla Fudge, along with the Velvet Underground, could be considered the avant-garde of the New York area. Elaborating the earlier electronic experimentations of London- and Los Angeles–based groups, the Fudge's performance sound suggests Edgar Varèse wedded to the Stones. "Have You Seen Your Mother, Baby?," a series of discontinuous punctuations of sound which occasionally succeed in canceling each other out when crossed by the extreme feedback or organ buzz. The use of the feedback produces a flat static monotone devoid of interest at one moment, and at the next, jarring present simply as noise.

Conjoined and laid over all of this is a sensibility (particularly apparent in the drawn-out, overblown organ sections) of Brooklyn Italian American Barocuco: a coruscating, false, overtly "sweet" ("rich" to sickening) which is a lugubriously (in)"elegant" stylistic paste (its Italian-American equivalent is known as "Hollywood") practiced by such New York City area groups as the Four Seasons, the Shangri-Las, and the Young Rascals.

The Fudge's approach is mannerist. The lyrics of their sets (unoriginally "borrowed" from the past) are subjugated to the entire sound: rearranged, chopped up, ground down, put down, or clamped up. "Bang Bang" is typical; the "interpretation" is a male impersonation of Cher (who sounds like

The MIT Press, 2000), 179–201; and Birgit Pelzer, "Vision in Process," *October*, no. 10 (fall 1979).

5. An important exception, which I will take up later, is recent scholarship by Eric de Bruyn, which has brought Graham's early interest in the Minimal music of Steve Reich and La Monte Young to bear on his works for magazine pages and films of the late 1960s.

6. Graham once stated, "My first interest was literary criticism, which was superseded by rock critics like Lester Bangs, Greil Marcus, Sandy Perlman, and Patti Smith. I was very interested in the tradition of rock criticism, and also I was influenced in my art by structures I found in rock music. So in a way it was my passion." See de Bruyn, "'Sound Is Material': Dan Graham in Conversation with Eric de Bruyn," *Grey Room*, no. 17 (fall 2004): 113.

7. Ibid., 110.

Homes for America

Early 20th-Century Possessable House to the Quasi-Discrete Cell of '66

D. GRAHAM

Belleplain	Garden City
Brooklawn	Garden City Park
Colonia	Greenlawn
Colonia Manor	Island Park
Fair Haven	Levittown
Fair Lawn	Middleville
Greenfields Village	New City Park
Green Village	Pine Lawn
Plainsboro	Plainview
Pleasant Grove	Plandome Manor
Pleasant Plains	Pleasantside
Sunset Hill Garden	Pleasantville

'two home homes'

The logic relating each sectioned part to the entire plan follows a systematic plan. A development contains a limited, set number of house models. For instance, Cape Coral, a Florida project, advertises eight different models:

A The Sonata
B The Concerto
C The Overture
D The Ballet
E The Prelude
F The Serenade
G The Nocturne
H The Rhapsody

fig. 2
Detail of *Homes for America, Early 20th-Century Possessable House to the Quasi-Discrete Cell of '66* (1966–67)

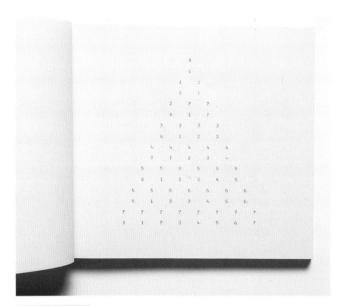

fig. 3
Scheme (1965/73)

also reflect a more general late-1960s zeitgeist, a sense of things "everyone had in front of them,"[8] perhaps best expressed in the new youth counterculture of drugs and rock.

The figure of the suburbs, or "suburbia," is fundamental to the history of rock—not just as a home to the music's primary consumer base, white teenagers of the baby-boom generation, but as a set of myths, most often negative, associated with the realities of adulthood: the planned life, the straight world, the organization man, the daily commute, monotony, happy blandness. If the suburbs were a dream of parents who sought remove from the noise, dirt, and racial disequilibrium of cities—an escape to the country, where a civilized nature harked back to the orderly gardens of pre-Industrial Revolution Europe—for teenagers, they were a nightmare. Coupled with pubescent libido, the mounting sense that the world of one's parents was at best "square" and at worst utterly fraudulent produced a desire for otherness that was rapidly channeled through the music of black urban society, rhythm and blues and Motown, and then refashioned in the romanticized image of the white-rock malcontent. By the mid-1960s, even as the Vietnam War, civil rights unrest, and student revolt threatened to permanently alter relationships between the young and not-so-young, groups like the Kinks and the Beatles spoke to suburban disaffection in songs such as "Mr. Pleasant" and "Nowhere Man." The "lonely crowd" named by sociologist David Reisman was so, in part, because its kids wanted desperately to leave.[9]

Graham himself was a child of the suburbs, spending the 1950s in Winfield, New Jersey, where his parents lived for a time in planned housing designed for government workers that, according to him, "looked like barracks," before moving to a comparatively more affluent "proto-yuppie" development in nearby Westfield.[10] The most famous of his works produced during his first years as an artist,[11] *Homes for America*, directly connects with this experience and echoes, even as a kind of Conceptual art "concrete criticism," the skepticism of the suburbs heard in his favorite rock groups of the day. Appearing in the December–January 1966–67 issue of *Arts Magazine* as a two-page layout of photographs, short critical texts, and schematic "data," Graham's work takes the form of an illustrated reportage on the architectural and sociological motifs accompanying the rise of American suburban development. It is to be looked at as much as read. Blocks of prose analyze the lapidary banalities of sales brochures. Walker Evans–like documentary photographs depict the real-world Minimalism of tract-house façades.[12] Lists of home colors, names, and styles are arrayed as permutation grids. This push-pull of image, text, and information has the effect of turning Graham's critical object, the suburbs, into a kind of

8. Graham, in "Dan Graham Interviewed by Mike Metz," *Bomb*, no. 46 (winter 1994): 24–29.
9. Graham, in "Mark Francis in Conversation with Dan Graham," in *Dan Graham* (London: Phaidon Press, 2001), 10.
10. Graham, in conversation with the author, 3 December 2008.

11. For a discussion of the period immediately leading up to Graham's first artworks, during which he directed the short-lived John Daniels Gallery in New York, see Rhea Anastas, "Minimal Difference: The John Daniels Gallery and the First Works of Dan Graham," pages 110–26 of this volume.

visual or aesthetic object, an "objectifying" that defies a basic mythology of the suburbs as soft, natural, and obvious.

If *Homes for America* is about ordering—the city plan—it also reflects Graham's interest in avant-garde music and literature as much as a kindred spirit with rock. Graham was an avid reader of the *Evergreen Review*, one of the leading literary magazines for new writing from Europe, and was well versed in the kind of anti-humanist approaches of Samuel Beckett, Roland Barthes, and the French "New Novelists" Robert Pinget and Michel Butor. With his depersonalized, almost mathematical topologies of city life, Butor in particular left a mark, one that merged with Graham's growing awareness of twentieth-century serial composers like Arnold Schönberg, Anton Webern, Pierre Boulez, and Karlheinz Stockhausen. Graham claimed that it was his friend Sol LeWitt who introduced him to this music, and that the two artists saw in its emphases on set theory and compositional "rows" an analogy to the recent developments of Minimalism.

> Minimal art abstracted certain things from the suburbs. [Minimal artists] were trying to get away from Renaissance space. Instead of receding into a representational perspective, instead of flat space abstraction, they wanted to directly project geometrical units of Renaissance perspective outside, like in Don Judd's or Sol LeWitt's *reductio ad absurdum*. [*Homes for America*] reduced the same thing to musical forms.[13]

Graham's essential point, which his article's "serial" lists make with no small amount of dry humor, was that the variety of suburban design was extremely limited, a set of elements ordered and reordered according to predetermined "rules" pegged to commercial imperatives. Where this logic seemed cold, developers rusticated their neighborhoods by calling them "Greenlawn" or "Pleasant Grove," or, as one Florida developer did, advertising home models with musical names like "The Sonata," "The Concerto," and "The Rhapsody" (**fig. 2**). As Graham stated, "I think my first use of music was in the *Homes for America* article showing the rows of houses and the ways they were arranged in terms of type plans."[14]

Graham's interest in permutational schemes is apparent in other magazine works as well, though often without the contextualizing prose of *Homes*. *Scheme* depicts an arrangement of vertically descending ordinal rows. Starting with a single row "0/0," then dropping and increasing to "1/0, 1/1," followed by "2/0, 2/1, 2/2," et cetera, the resulting pyramid shape extends to the bottom of a printed page where it is to be truncated or, in a book version published by Gerald Ferguson (**fig. 3**), expanded down and

a flattened-out Sonny anyway), the words being reduced to a group of isolated, flat, staccato eruptions (bang! bang!) a little like the early Kinks. The "interpretation" is interrupted in the middle by an ear-splitting block like a subway riding on a section of bad track. There is no movement during the built-up pseudo-climax of the opening staccato singing section. Then a false continuity (perhaps moving toward an end) is introduced by the anti-climax of an organ surge, slightly nauseating, only to be itself interrupted by the singing (just when it seems a mostly instrumental number of the usual length was concluding), then the break suggesting a subway shriek, followed by repetition of the "Bang Bang" lyrics, etc.

Each of these parts appear isolated—a separate sequence that doesn't add to a unity (much like the Beach Boys' "Good Vibrations" and "Heroes and Villains")—except that the Fudge additionally attempts the superimposition at the same musical moment of the discrete units as well as their disjunction.

The games played with "beginnings," "ends," and "middles" of compositions make difficult the determination of which way the music is spaced and carried by the Vanilla Fudge into the structure of their entire performance block. After they have concluded about three-quarters of the way through what is to be their next to the last piece, the lead singer interrupts to announce to the audience...that they are the Vanilla Fudge and that their last number will be a nine-minute version of "You Keep Me Hanging On." The set is resumed, ending in a prolonged organ hum, two minutes of which is the beginning (realized in retrospect) of "You Keep Me Hanging On."

SECTION II

The Seeds, who claim to have originated "flower music," began with their big hit, "Mr. Farmer." "Flower music" apparently means American Indian refrains. "Mr. Farmer" opens with an extended organ solo by Daryl Hooper "borrowed" from the background soundtracks of the Indian part in

12. "To me," Graham stated, "Robert Mangold's relief paintings of the early 1960s resembled façades of suburban houses, as did the materials Judd used. And I thought, why do people have to make things for galleries? Wouldn't it be easier just to take photographs or slides?" Graham, in "Mark Francis in Conversation with Dan Graham," 10.

13. De Bruyn, "'Sound as Material,'" 109–10.

14. Ibid., 109.

fig. 4
Bruce Nauman's *Untitled* (1965–66); latex on burlap;
dimensions variable; Whitney Museum of American Art,
New York; gift of Mr. and Mrs. Peter M. Brant

across successive pages as its rows gain indefinitely. "The angle of the triangle diminishes gradually to infinity with the progression to cause a cessation at some point in the book's interior. It begins at a point in the book's interior. It begins at a point and is read."[15] This movement beyond the tangible (the page, a "point in the book's interior") into the extra–sensory ("infinity") recalls rock's romance with escape, flight, getting out, and getting high. The analogy between permutation and oblivion was more humorously taken up in *Side Effects/ Common Drugs*. An "information grid" plotting the somatic effects of prescription pharmaceuticals along horizontal/ vertical axes, Graham's dot–matrix design paid homage to artists such as Roy Lichtenstein, whose comic–strip paintings, with their magnified benday dots, similarly derived from print media, and Larry Poons, whose Op canvases produce eye–tweaking afterimages. The work also keys to songs like "Mother's Little Helper" by the Rolling Stones, in which rock's much–condemned penchant for chemical indulgence is turned back onto straight society in the figure of the pill-popping housewife ("They just helped you on your way, through your busy dying day."[16]) In contrast to his friend Robert Smithson, who spoke imperiously of negative dynamics like "entropy" and cultural "ruin," Graham's permutational oblivion bore an identificatory sense of open-ness and presence[17]:

> In the 1960s, we *believed* in instant moments, in "no–time," getting rid of historical and metaphorical time. Moments after moments, with no memory.... Also, of course, there was drug–space; I remember thinking about the pop group the Byrds—they were yelling a kind of mythology of the past and a projection of the future. So there was no now, but just these dif–ferent projections.[18]

By 1968–69, when Graham's first published writing about rock—a pair of concert reviews titled "Holes and Lights" and "Live Kinks"—appeared almost simultaneously with "Subject Matter," his first extended critical writing on visual art, his thinking about both forms had become singularly inter-twined.[19] With its succession of short paragraphs devoted to artists whose work Graham had recently experienced first hand in New York—among them Carl Andre, Donald Judd, Lee Lozano, Bruce Nauman, Steve Reich, and Richard Serra—"Subject Matter," for its part, began to revise a certain discourse of Minimalist art that had acquired significant weight in writings by Judd, critic Michael Fried, and others. In contrast to "objecthood" and material transparency, Graham wrote of process, subjective human sensation, and real,

15. Graham, "Information" (1969), reprin-ted in *Rock My Religion* (Cambridge, Massachusetts: The MIT Press, 1993), 29. See also Graham, *Scheme* (1965; Halifax, Canada: Gerald Ferguson, 1973).
16. The Rolling Stones, "Mother's Little Helper" (1966).
17. Robert Smithson was one of the truly

negative critics of his day. Though written in the same context and often about the same subjects as contemporary texts by Graham, ar-ticles like "Entropy and the New Monuments" (1966), "Quasi-Infinities and the Waning of Space" (1966), and "The Monuments of Passaic" (1967) proposed a civilization be-holden to a kind of death drive, sinking back

into the prehistoric past and collapsing on itself. Read against Graham, these works cast in sharp relief the sense of curiosity, even possibility, inherent in the latter's engagement with his culture. See Smithson, *The Writings of Robert Smithson*, ed. Nancy Holt (New York: New York University Press, 1979).
18. Graham, in "Mark Francis in Conversation

present, and cybernetic time. Against the classical Euclidian geometry of Minimal sculpture, he drew from mathematics and psychology to propose a "rubber sheet geometry," curved continuous form, and envelopment. Nauman and Reich in particular stood as heroes in Graham's essay, the former's drooping rubber objects (**fig. 4**) and the latter's process–activated sonic environments announcing an art of "in–formation," in which audience and work take shape dependently through interaction and projection.

Art historian Eric de Bruyn has posited "Subject Matter" as a crucial document in a larger "topological turn" in late–1960s art: one of the first articulations of the move towards architecture and participatory experience increasingly important to a wide range of contemporary production.[20] But if Graham's theorizations of "shifting the time of the collective relations" and "deformation (present in the material's *expansion, contraction,* and *skew*)"[21] announced new models for the art experience, they did so heavily under the influence of rock performance, as a cross-reading of the music texts makes clear. In "Holes and Lights," where he wrote:

> The [Vanilla] Fudge's performance sound suggests Edgar Varèse wedded to the Stones...a series of dis-continuous punctuations of sound which occasionally succeed in canceling each other out when crossed by the extreme feedback or organ buzz.[22]

and in "Live Kinks," where he repeated:

> The climax comes in one last perversely lengthened "rave–up"; a series of discontinuous punctuations of sound which gradually succeed more and more–or–less in canceling each other out when crossed by the extreme feedback; the effect, in the end, a flat, elec-tronic, static, monotone devoid of interest (or rhythm) at one moment; and then a complexly patterned cross–rhythmic space and/or jarringly present simply as surface noise.[23]

the possibility of a new expanding subjectivity—one buffeted and informed by overwhelming material and phenomen-ological presence—is fully articulated. In these end–of–the-decade writings, Graham simultaneously recast Minimalism in terms of rock and forecast concerns of audience, perfor-mance, and consciousness that would dominate his work throughout the 1970s and early 80s.

cowboy and Indian movies. Its even "wallpaper" texture—flat and uninflected—nearly disappears in its utter obviousness. It's so stupid there is nothing to grasp: Hooper is a genius. Sky Saxon, the lead singer, does an Indian war dance when he sings; his singing, like his dancing, can best be described as "hoppy"—skipping word to word, barely touching the ground, placing no weight on continuity or meaning.

Around the middle of the act, Saxon announced: "There's going to be someone walking around handing out seeds, just take them home and see what grows."

(Many astrologists believe we are now entering the final "seed period" of the Christian-Piscean Age marking the transition to the coming Aquarian Age as Piscean attitudes of benevolence and unselfish-sympathetic love holding in check a darker sensation-seeking side given to weaknesses of sloppy emotionalism are coming to fullest flower while the world goes to pot.)

The performance closed with a cut from the Seeds' brand-new album, which seems to be influenced by the Doors. "Fallin'" is perhaps an attempt at Judeo-Christian tragedy/shamanistic rock opera or can be taken literally. At the conclusion of the performance all performers fall down, concluding, "You're falling down" about thirty times. The audience booed.

SECTION III

The Byrds began their section with a hummed sutra chant, "We don't exactly know what it is; it's just a place we go sometimes." The overpowering, sweetly harmonic texture of guitar and guitar feedback once synonymous with this group seems to have been thinned out in the direction of brittle-ness (at least in performance).

"Renaissance Fair" typifies this sharp acerbic sound dominated in this instance by Mike Clarke's superb drumming. There is a more integral use of dissonance in "Universal Mind Decoder," which combined bagpipe-like assonance with Everly Brothers lyricism. "Lady Friend," the Byrds' last release, repeats the rolling circularity (sickening sameness

with Dan Graham," 30. Emphasis mine.
19. See Graham, "Holes and Lights: A Rock Concert Special," *Straight* (New York) 1, no. 1 (April 1968): 3 (reprinted next to this essay); "Live Kinks," *Fusion* (Boston, 1969); and "Subject Matter," in *Rock My Religion*, 38–51 (first published in Graham, *End Moments,* New York, 1969).

20. See de Bruyn, "Topological Pathways of Post-Minimalism," *Grey Room,* no. 25 (fall 2006): 32–63.
21. Graham, "Subject Matter," 50, 42.
22. Serious rock writing in Graham's day was rare. Along with Richard Melzer, Paul Williams, and Lester Bangs and magazines like *Creem, Crawdaddy!,* and *Fusion,* Graham belonged

to the first wave of rock criticism to treat the form as an acoustical and cultural artifact rather than mere product. The comparison of cutting-edge rock and avant-garde music would become a standard trope of rock criti-cism, often merely aggrandizing the popular with qualities of the difficult or the imprimatur of "art." Graham's point is more specifically

phenomenological. See Graham, "Holes and Lights," 3.
23. Graham, "Live Kinks."

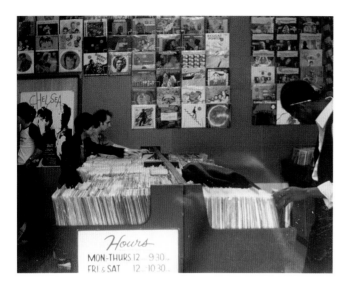

fig. 5
Project for Record Cover, Sounds, St. Marks Place, NY (1976)

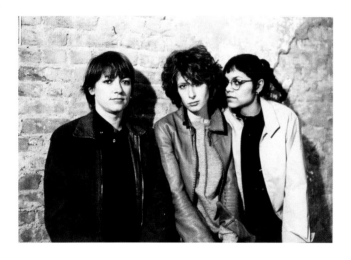

fig. 6
Members of the all–girl band Introject (from left: Kim Gordon, Christine Hahn, and Miranda Stanton) at "Eventworks," Massachusetts College of Art, Boston, 1980

POLITICAL POP AND THE 1980s

The role of music in Graham's work of the 1960s was fundamental, but it was also submerged, or at least filtered through more apparent topics like urbanism, "conceptual" schematic design, and visual art. By the late 1970s and early 80s, however, music would become an explicit concern for Graham, both in his video and performance works and in his by–then frequent critical writing. These, of course, were the punk (and post–punk) years. If late–1960s rock represented a self–conscious break from the innocence of the teenybopper period, the arrival of groups like the Sex Pistols, the Ramones, and Devo (short for "devolution") announced yet another leap in critical magnitude. Even as these bands deliberately adopted rude, stripped–back, and adolescent approaches that appeared to return to the simplistic origins of 1950s pop, the intense rejection that motivated the punk ethos corresponded—not always deliberately—with a political awakening well beyond previous moments. In contrast to rock's "no–time" of feedback and out–of–body expansion, punk demanded from its audience a kind of historical awareness, a fact that Graham seized upon as his own work became increasingly reflective. It is this period, rather than the earlier one, that most people think of when they consider Graham's musical interests.

Throughout the 1970s, Graham's work became increasingly involved with questions of performance and audience, fine–tuning issues of collective phenomenological and aesthetic experience first explored in his early rock writings and the essay "Subject Matter." Performance works such as *Lax/Relax* (1969), *Two Consciousness Projection(s)* (1972), *Past Future Split Attention* (1972), and *Performer/Audience/Mirror* (1977) use a variety of means (mirrors, closed–circuit video feeds, direct audience address) to position the encounter between an audience and a performer as a real–time reflection of consciousness processes and intersubjective awareness. Architectural installations like *Opposing Mirrors and Video Monitors on Time Delay* (1974) and *Public Space/Two Audiences* (1976) absent Graham himself as a performer but create environments in which viewers "see themselves seeing themselves." In all of these works, Graham confronts the audience with an experience of self–consciousness that is dense, immersive, and immediate. It is not a huge leap to see Graham's interest in stages and performance space in musical terms.

Graham had always been a voracious consumer of new music (**fig. 5**), but it was not until the late 1970s that he began to conceive of ways to extend his own performance work through actual collaborations with musicians.[24]

24. Thurston Moore once explained that Graham was "completely involved with underground music to such an extent that [he] bought all the records that were out there. [He was] buying records that were completely subterranean, like the first Fall singles. [He was] extremely hip that way and [he was] utilizing a lot of ideas out of that Punk Rock Underground thing, which I thought was pretty great. Dan went to all the No Wave gigs and he was taping everything too. Basically, I would just go up to Dan's apartment and we would talk about music every day." See interview with Moore by Markus Müller, "Dan Graham: Collaborations, in Other Words, Not Alone," in *Dan Graham: Works 1965–2000*

Especially crucial in this regard were relationships with Kim Gordon and Glenn Branca, two musicians who would achieve considerable fame in the downtown New York music and art scenes of the 1980s: Gordon as a founder of post-punk group Sonic Youth, Branca as a composer of "guitar symphonies" whose massively loud and overtone-laden harmonics straddled aspects of Minimal music and rock. Graham met Gordon in 1978 when he was a visiting lecturer at California Institute of the Arts, Valencia, and she was a student of Graham's friend, artist John Knight. When she moved to New York the following year and took an apartment Graham found for her below him in a building on Eldridge Street, the two struck a friendship, with Graham as a kind of mentor, that would become among the most artistically fruitful in each of their careers. Gordon, who was then primarily making and writing about art, once stated that it was Graham who first prompted her to play music: "We had a running conversation on music and TV shows and architecture and art...he asked me if I wanted to be involved in a performance piece involving an all-girl band and do a kind of interactive performance together with Miranda Stanton and Christine Hahn."[25] A modification of Graham's earlier performance *Identification Projection* (1977), this "piece," *All-Girl Band: Identification Projection*, directed each member of the band—which had taken the name Introject (fig. 6)—to perform according to script:

> Three women in a rock band perform a song. The first female performer looks at the audience, selects and describes the various men (perhaps also women) who charismatically ("sexually") attract her. The description and the feeling she expresses are to be as sincere, non-theatrical, as possible. The performer pauses between descriptions of people for a time the same length as her period of speaking (so that she appears as sexual object). The pauses should seem a little too long. During this period she does not look at or acknowledge the presence of the audience; she moves slowly; she is for herself (thinking private thoughts about herself).... Structurally, the basis of the performance is to invert and reverse the normal (unconscious) identification the spectator projects onto a film or theater performer.[26]

Realized only once, during the "Eventworks" festival (fig. 7) curated by Christian Marclay at the Massachusetts College of Art in April 1980, *All-Girl Band*, by all accounts, was a failure. In the rush of the moment, the group ignored or forgot Graham's directions; a work of performance art became a rock concert. For Gordon, at least, this was a happy

(Düsseldorf, Germany: Richter Verlag, 2001), 21.

25. "I originally met Dan through John Knight in L.A. and the first time I ever met Mike Kelley was at a lecture of Dan's at CalArts and Mike was arguing with Dan about something like the Stooges versus the New York Dolls, that kind of classic thing." See interview with Kim

Gordon by Müller in ibid., 17, 20.

26. Unpublished performance notes for *All-Girl Band: Identification Projection*, Dan Graham Archive, New York. These notes only slightly alter those corresponding to *Identification Projection* (1977), which were first published in Graham, *Theater* (Ghent, Belgium: Anton Herbert, 1981).

Holes and Lights
Dan Graham

as opposed to continuity) which characterizes the best of the Byrds' (and rock and roll generally) songs of the past:

Here it comes again
It's going to happen to me
Here it comes It looks like
the last wave I drowned in.

The Byrds seem a little bit "out of time"—they belong to a slightly earlier era. The image of this group is pervasive, unlike the decentralized "associations" of the more recently formed Seeds and Vanilla Fudge. In their cases, each performer's musical part is conceived as separate from each of the other's; each musician is content to "do his thing." Such a separate but equal notion is carried into individual difference in dress style. While Daryl Hooper was made up as J. S. Bach (a girl teased from the audience, "Where did you get that cute bow?" The answer: "From the seventeenth century"), Sky Saxon wore a too-small circus bandleader's (Sgt. Pepper) jacket.

First published as "Holes and Lights: A Rock Concert Special," *Straight* (School of Visual Arts, New York) 1, no. 1 (April 1968): 1–2.

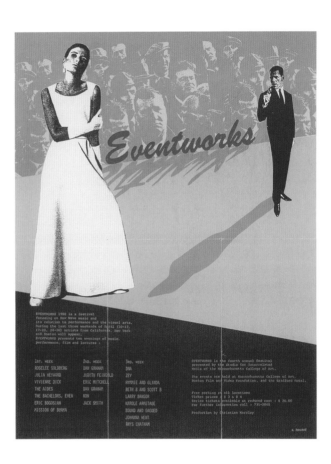

fig. 7
Poster advertising "Eventworks," organized by
Christian Marclay for the Massachusetts College of Art,
Boston, 1980

accident: "After that performance in Boston it was like, 'well, now that I played what do I do? Do I continue, or do I stop, or do I do art,' and at that time I was really more excited by the music that was going on."[27] Graham's involvement with Branca began as early as 1977, when he invited the latter's band Theoretical Girls to play their first concert ever following a performance of *Performer/Audience/Mirror* at the New York space Franklin Furnace. Along with another group Branca played in, the Static (who followed Graham's performance at London's Riverside Studios in 1979, fig. 8), Theoretical Girls was central to what was then becoming known as "no-wave," a brutalist style of rock that married punk's confrontational attitude with overtone-drenched walls of noise harking back to Minimalist composers like La Monte Young and Tony Conrad. Graham clearly felt the bone-crunching volume of this sound, which some critics dubbed "maximalism,"[28] connected to his own work. He used compositions by Branca in his 1980 video with Ernst Miztka *Westkunst (Modern Period): Dan Graham Segment* and then again for *Rock My Religion*, but it was through the work titled *Musical Performance and Stage Set Utilizing Two-Way Mirror and Time Delay* (1983, fig. 9) that his collaboration with Branca came most fully to fruition.[29] For this performance, an audience sat on the right side of a room facing a large two-way mirror. To its left, also facing the mirror, a trio led by Branca banged out a "symphony" of dissonant microtonal octaves on modified harpsichords. Behind the semi-translucent glass, a television monitor played a time-delayed video image of the entire room.

> The audience's best view of the musicians comes from looking at the mirror and monitor projecting behind it. They see other members of the audience as well as their own looks. When the musicians look toward the mirror image to see other musicians playing or to see the six-second delay video, the audience members' views are placed between the intersubjective gazes of the three musicians.[30]

The architecture of self-conscious perception that frames so many of Graham's works of the 1970s and early 80s was now explicitly wedded to musical perfor-mance—and, indeed, his collaboration with Branca was to be the last live work produced by him for some time. Even as it was realized, two new videos, *Minor Threat* and *Rock My Religion*, suggested a shift towards the documentary, a pulling back that cast Graham's experiments over the previous decade in a broader set of cultural and critical concerns.

27. Gordon, interview with Müller, 17, 19.
28. See biography on Glenn Branca's website, available at http://www.glennbranca.com/bio.html.
29. *Musical Performance and Stage Set Utilizing Two-Way Mirror and Time Delay* (1983) was first performed in conjunction with the exhibition "Dan Graham Pavilions,"

curated by Jean-Hubert Martin, Kunsthalle Bern, 1983. The catalogue for this show included a record of Branca's *Acoustic Phenomena* (1983) composition.
30. Performance notes, reprinted in *Dan Graham: Works 1965–2000*, 205.

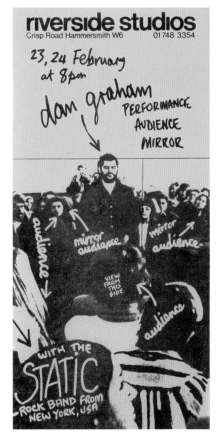

fig. 8
Poster advertising the presentation of
Performer/Audience/Mirror (1977) at
Riverside Studios, London, 1979

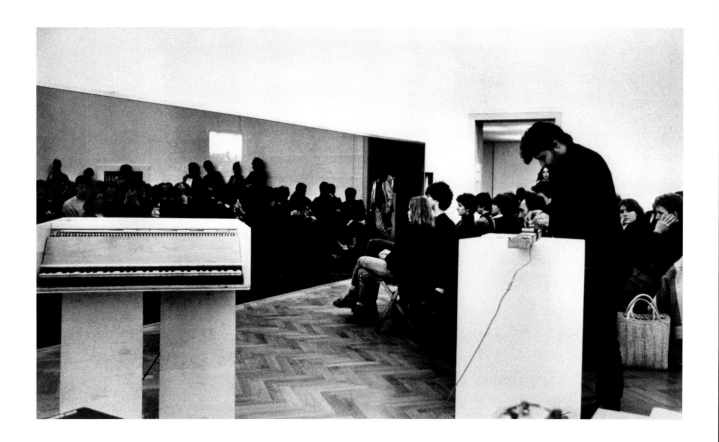

fig. 9
Performance of Graham and Glenn Branca's *Musical Performance
and Stage Set Utilizing Two-Way Mirror and Time Delay* (1983):
video camera with time delay and mirrored wall; music composed
by Branca and performed by Axel Gross, Margaret De Wys, and
Branca; at Kunsthalle Bern, Switzerland, 1983

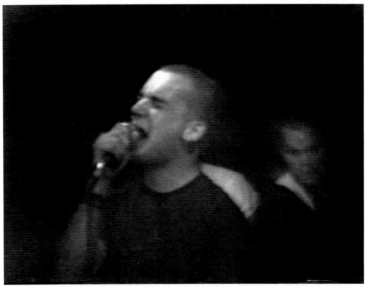

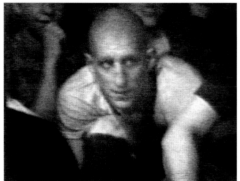

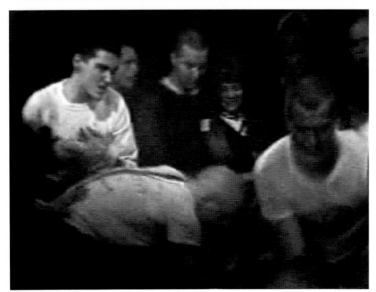

fig. 10
Stills from *Minor Threat* (1983)

Minor Threat was the more straight ahead of the two works, comprising rudimentary concert footage of the new Washington, D.C.–based band of the same name performing at CBGBs (fig. 10). Led by its somewhat messianic singer Ian MacKaye, Minor Threat had quickly become the leading exponent of hardcore, a sped–up blitz–krieg version of punk that was garnering enthusiastic crowds to its message of adolescent fury, neo–puritan politics, and do–it–yourself empowerment. Beneath the hand–held graininess of the video, it was easy to see why Graham was a fan of the group: they were about youth, they were self–reflective, and their sound compelled audiences with barely restrained mayhem. Not just in front of the stage but on it, behind it, and over it, one could see bodies flying and surging—any pretense of performer–audience separation was obliterated. That the violence of this uniformly white male audience also suggested an intimacy, a herding instinct that nurtured even as it kicked and punched, was not lost to Graham's anthropological eye. His video ends with a short fan interview discussing the merits of slam dancing.

Unlike *Minor Threat*, which resembles field notes on the present, *Rock My Religion* is conceptually and aesthetically a far more complex affair. The hour–long video took Graham almost three years to develop, a product of countless editing hours and discussions with Branca, Gordon, and Thurston Moore. At its heart, the video proposes an allegory of rock's "hidden past"[31] seen through fragmentary dreamlike contrasts between contemporary popular culture and early–American religious life. Opening with a slow–motion view of Black Flag singer Henry Rollins writhing before a crowd, it quickly segues to a montage of line drawings depicting the circle dances (fig. 11), spare architecture, and stoic visages of the Shakers, a nineteenth–century religious sect. These images are subsequently intercut with concert footage of Patti Smith performing her punk lament "Piss Factory" and superimposed with the song's lyrics scrolling down the frame (fig. 12). Overlaying again, a narrator describes Shaker leader Ann Lee's flight from religious persecution and her establishment of an alternative society based on manual labor, a rejection of marriage and procreation, and a belief that God could be channeled directly through bodily communion. Underlying this dense weave of subject matter, images, sounds, and words is an attempt, Graham said, "to restore historical memory":

> In opposition to [the] notion of history as simulation, there is possible the idea of an actual, although hidden, past, mostly eradicated from consciousness but briefly available in moments not obscured by the dominant ideology of newness.[32]

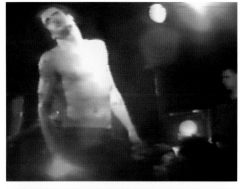
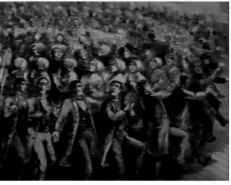

fig. 11
Stills from *Rock My Religion* (1982–84)

31. See Graham, "Video in Relation to Architecture," in *Dan Graham: Selected Writings and Interviews on Art Works, 1965–1995*, ed. Adachiara Zevi (Rome: I Libri di Zerynthia, 1996), 116.
32. Ibid.

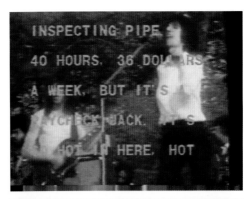

ON THE FLOOR, THEY
ROLLED OVER AND OVER,
LIKE WHEELS, OR LIKE
ROLLING LOGS. SOME GOT
DOWN ON FOUR LEGS.

CHANTED FROM THE BIBLE
AND MARCHED IN CIRCLES
STOMPING THEIR FEET,
THEY SHOUTED, "STOMP
THE DEVIL!" SISTERS

fig. 12
Stills from *Rock My Religion* (1982–84)

Graham's analysis entailed more than a simple equation of Shaker ecstasies with those of rock. In drawing his comparisons, he proposed a historical context for the development of rock as the unique expression of a new teenage "class"—one that, beginning in the 1950s, no longer privileged labor or work ethic as a primary means to transcendence, as had the Shakers and every generation hence, but believed in escape through mass consumption and sexuality not as a burden but as fun. These were the same teenagers that ostensibly populated Graham's *Homes for America*, middle–class suburban kids freed to desublimate their libidinal impulses through the commodity form of the rock star. "Teenagers are based in the isolated suburban postwar home. They are linked via the radio, telephone, tele-vision, and car. Through these means of transport, and later through drugs, teenagers and rock communicate."[33]

Rock My Religion recalls *Homes for America* in other ways as well, for it is essentially a textual critical work that Graham's video and audio montage serves to illustrate. The work's script has frequently been published as a kind of article and even lent its title to a well–known (though now impossibly hard to find) collection of Graham's writings, published in 1993.[34] Like these writings, many of which delve into the ideological ramifications of punk music, the video positioned Graham as a precursor to what in academic circles was becoming known as "cultural studies." Its attention to class, gender, popular culture, and social history paralleled, in a general sense, recent work by T. J. Clark, Dick Hebdige, and Greil Marcus, critics who, from different vantages, had each embraced the culturally oriented Marxism of Walter Benjamin in efforts to describe "latent" or "anticipatory" aspects embedded in the historical imagination. If the intellectual life of this late–1970s and early–80s context can now be pictured synthetically, *Rock My Religion* should easily stand among its most relevant documents.

THE INSTITUTIONAL AFTERLIFE OF HIPPIES VERSUS PUNKS

The 1960s–80s dichotomy is by now something of an old game, but it is one that continues to be rehashed in al-ternating and nostalgic "returns" to each period. Graham himself has indulged this trend, however ironically, in his recent "puppet rock opera" (loosely based on the 1968 film *Wild in the Streets*) *Don't Trust Anyone Over Thirty* (2004, fig. 13), in which a teen rocker named Neil Sky becomes the youngest president ever by dosing Congress with LSD and convincing them to lower the voting age to fourteen. With

33. Graham, *Rock My Religion* (1982–84).
34. The script of *Rock My Religion* was first published as the essay "My Religion," *Museumjournaal* 27, no. 7 (1982), then as "Rock Religion," in *Scenes and Conventions in Architecture by Artists*, exh. cat. (London: Institute of Contemporary Arts, 1983). It was first published in North America as "Rock Religion," in *Just Another Asshole*, no. 6 (1983). An extensive published version with stills from the video appeared in *Video by Artists* 2, ed. Elke Town (Toronto: Art Metropole, 1986), and then again in a vol-ume of Graham's collected writings, edited by

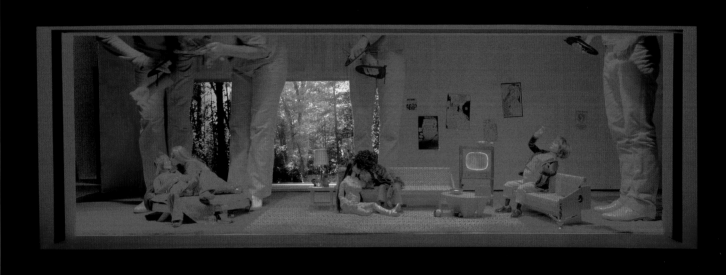

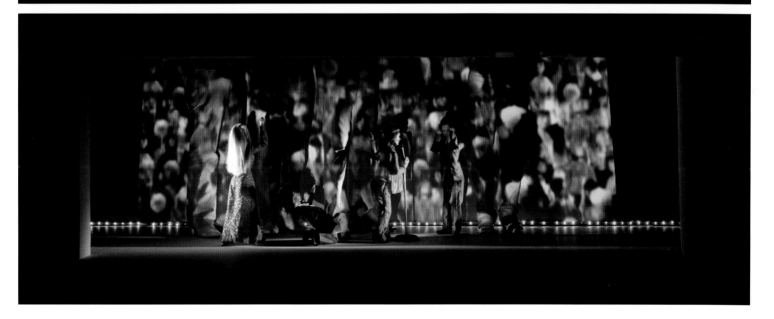

fig. 13
Performance of *Don't Trust Anyone Over Thirty* (2004)
at Art Basel Miami Beach, 2004

fig. 14
Marie-Paule Macdonald's collage for Graham and Macdonald's
Wild in the Streets: The Sixties (1987)

a platform of free dope and free love, Sky's first act in office is to relocate everyone over thirty to re-education camps, a stand for youth that works only until his adopted eight-year-old son Dylan deposes him with a gang of runaways. Such are the parables of "1968." A multimedia spectacle that has now been staged numerous times at museums and art fairs around the world,[35] *Don't Trust* suggests the ongoing importance of musical tropes even in the fourth decade of Graham's career. Indeed, it culminates what may be a third key moment of musical involvement for the artist, one that stretches fitfully back to 1987, when Graham first conceived of his rock opera in the unproduced libretto *Wild in the Streets: The Sixties* (fig. 14),[36] or even further back, to works like *Video Projection Stage-Set for Guaire by James Coleman* (1985), *Set for Two-Way Mirror Piece (Project for the Paris Biennial)* (1985), and *Cinema-Theater* (1986), which displayed the increasingly important role of theatrical

design, choreography, staging, commissioning bodies, and production in Graham's practice as it moved ever closer to architecture. That such a turn, most visible in the site-specific pavilion works that have largely defined his output over the last two decades, should correspond in musical terms with the large-scale heterotopic forms of opera may come as no surprise. Rock was the music of the subject. Punk was the music of the subject in history. Opera, in this late and successful moment of Graham's career, is the music of the subject in institutions. ⓓⒼ

Brian Wallis, which was named for the video *Rock My Religion* (1993), 80–95.

35. Loosely based on the film *Wild in the Streets* (1968) and created with collaborations from Tony Oursler, Rodney Graham, the neo-punk band Japanther, and master puppeteer Laurent Berger, *Don't Trust Anyone Over Thirty* debuted at Art Basel Miami Beach in 2004 and has been performed multiple times, including at Wiener Festwochen, Vienna, 2005; Staatsoper Unter den Linden, Berlin, 2005; Walker Art Center, Minneapolis, 2006; Whitney Biennial, Whitney Museum of American Art, New York, 2006; and Tate Modern, London, 2006.

36. This libretto, with drawings and storyboard by Marie-Paule Macdonald, was published in book form as *Wild in the Streets: The Sixties* (Ghent, Belgium: Imshoot, Uitgevers, 1994).

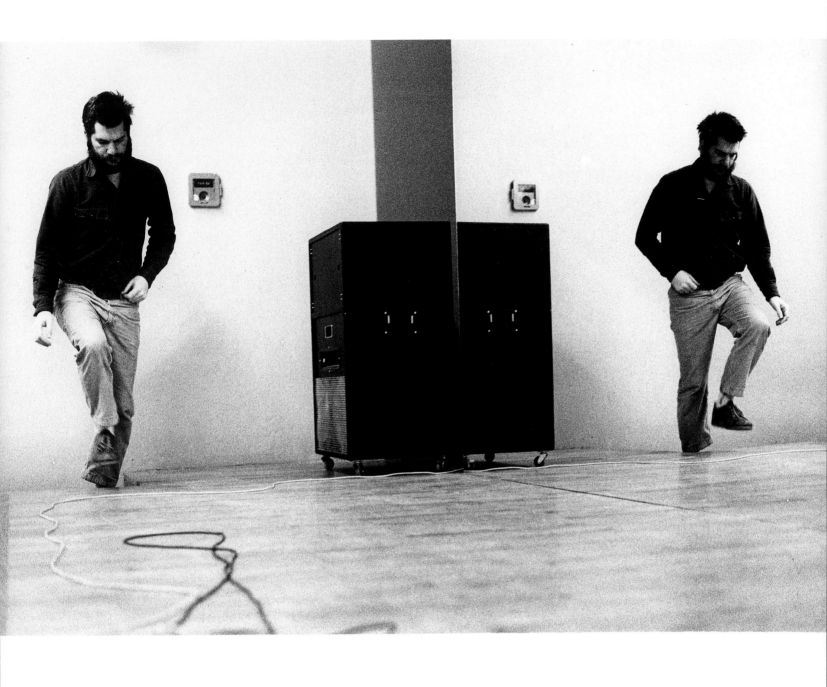

Graham performing *Performer/Audience/Mirror*
(1977) at Riverside Studios, London, 1979

following spread
Charlotte Townsend (left) and Graham (right,
with Sol LeWitt and Mimi Wheeler in the
audience) performing *Lax/Relax* (1969) in
"Performance, Film, Television & Tape,"
Loeb Student Center, New York University,
New York, 1970

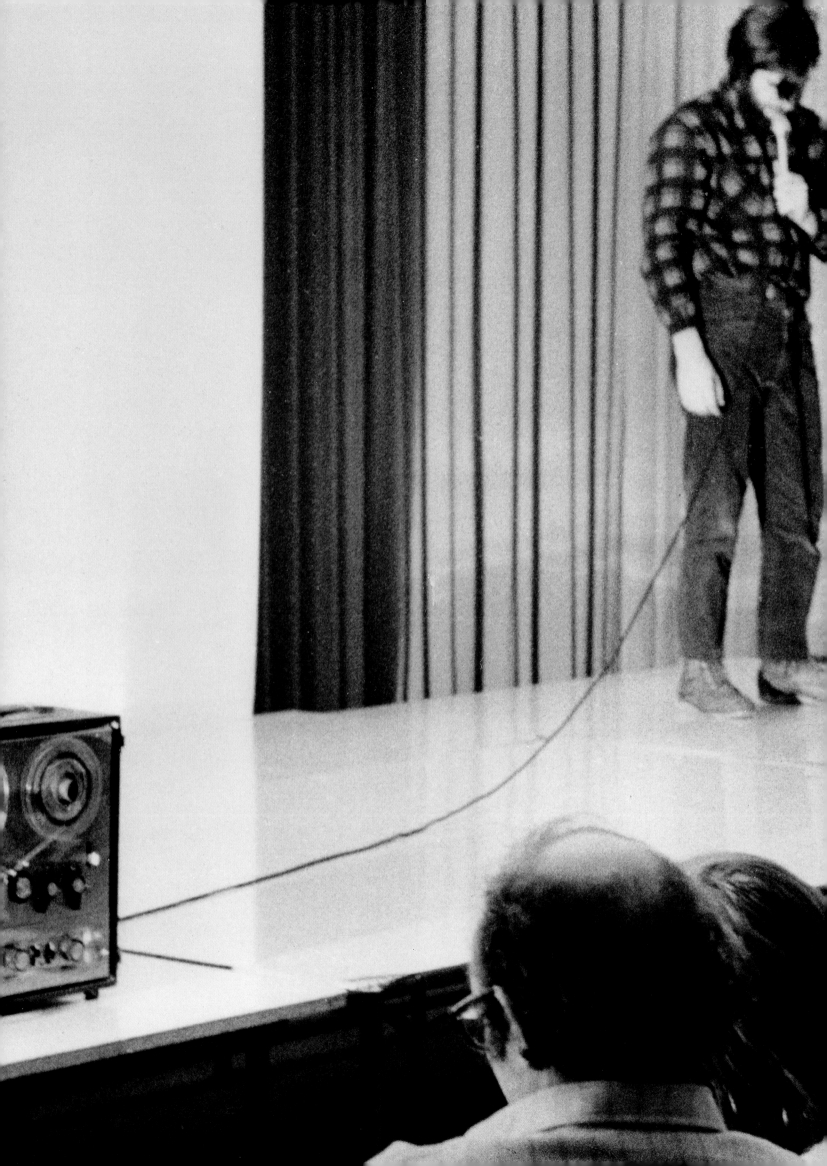

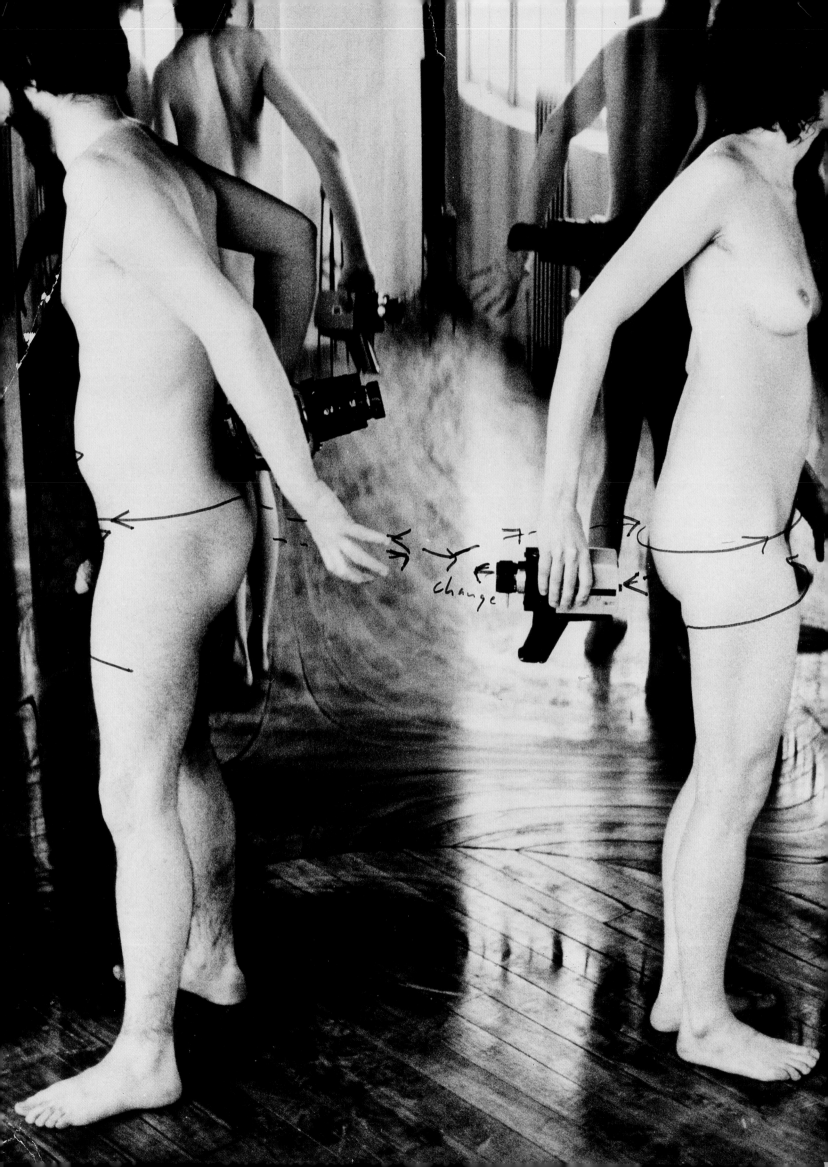

You Are the Information: Dan Graham and Performance

Chrissie Iles

The performances of Dan Graham, made during the first decade of his career, established the structures of spatial and perceptual thinking that were to inform all his subsequent work. Their appearance marked a major shift by Graham into three–dimensional space through the construction of a complex model informed by cybernetics, bodywork, topology, the newly emergent medium of video, and the philosophical, anthropological, and psychological writings of, among others, Herbert Marcuse, Kurt Lewin, Gregory Bateson, Margaret Mead, and Wilhelm Reich.

Graham's model emerged in 1969, the same year that he wrote two major articles, "Subject Matter" and "Dean Martin/Entertainment as Theater," both of which set out the trajectory of his thinking. Eric de Bruyn interpreted Graham's analysis of Bruce Nauman's rubber sculpture in "Subject Matter" as the first evidence of Graham's embrace of topology as a spatial model.[1] The Postminimalist space that Nauman's work represented—"a dynamic field of opposing forces that was conducive to a constant process of spatial warp"—required "a different geometry...to map this multidi-rectional, intensive experience of space."[2]

With each performance, the geometry that Graham put into place to navigate his own articulation of Post–minimalist space became increasingly complex. The first demonstration of it occurred in *Lax/Relax* (1969), performed at Paula Cooper Gallery on 13 June 1969 as part of an evening titled "Coulisse" (**fig. 1**), curated by Graham, that included a performance by Vito Acconci; films by Nauman, Yvonne Rainer, and Richard Serra; and a sound work by Dennis Oppenheim.

PAULA COOPER GALLERY 96 PRINCE STREET JUNE 13 FRIDAY 7:30

COULISSE 1. a piece of timber having a groove in which something glides, originally a sluice gate 2. a groove in which a partition slides 3. (a) a side scene of the stage of a theatre, or the space between the side scenes - so called from the groove in which such a scene is run; hence, figuratively, a place between the scenes (b) a place of informal discussion

VITO HANNIBAL ACCONCI DAN GRAHAM BRUCE NAUMAN DENNIS OPPENHEIM YVONNE RANIER (maybe) STEVE REICH RICHARD SERRA NEIL YOUNG

fig. 1
Announcement card for "Coulisse," Paula Cooper Gallery, New York, 1969

Notes **1.** Eric de Bruyn, "Topological Pathways of Post-Minimalism," *Grey Room*, no. 25 (fall 2006): 33–34.
2. Ibid., 33.

Graham (left) and Susan Ensley in early setup for *Body Press* (1970–72)

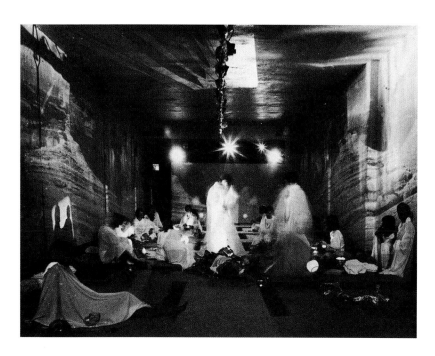

fig. 2
Photograph of the Cerebrum, New York (c. 1969), published in
Gene Youngblood, *Expanded Cinema* (New York: E. P. Dutton &
Co., 1970)

Graham had chosen his title carefully. "Coulisse" is variously defined as "a groove in which a partition slides," "a side scene of the stage of a theatre, or the space between the side scenes...hence, figuratively, a place between the scenes," and "a place of informal discussion."[3] Graham's choice of title indicated his interest in a space that was definitively not of the Euclidian geometrical kind as both the forum for his and others' work, and as the form of his first performance.

In front of the gathered audience, Graham played a taped recording of a woman repeating the word "lax" for thirty minutes, breathing slowly in and out between each utterance according to Graham's instructions, almost to the point of self–hypnosis. On stage, Graham repeated the word "relax" into a microphone for the same length of time, breathing in and out in response to the woman's paced into-nation. The taped and live words shifted in and out of phase, mesmerizing the audience, whose own breathing began to be affected by the double rhythm. The three distinct experi-ences thus began to overlap, sometimes moving hypnotically in sync, at other times moving out of phase with each other.

The simple formula of *Lax/Relax* established the basic tenets of all Graham's subsequent performances: a perceptual exchange between the audience and perfor-mer, in many cases via a video or sound recording or, later, a mirror; the setting up of a triangular dynamic; the slippage of time between present, just past, and future; the body as a communicative conductor; feedback; and the possibility of an altered state of consciousness.

Central to the meaning of *Lax/Relax* is the potential for communication through the release of the body by deep rhythmic breathing—one of the key techniques of Reichian therapy, which Graham was undergoing at the time. According to Reich's theories, psychological and emotional blocks, accumulated in the body as unreleased psycho-sexual energy, can be released by progressively working on the body, starting with deep breathing and encouraging eye contact with others. More broadly, Graham cited as an influence the group–therapy movements that proliferated during the late 1960s, many of which involved breathing exercises and an emphasis on the body and touch.

Graham's interest in this approach is made evident in the last part of his article "Dean Martin/Entertainment as Theater," published in the rock magazine *Fusion* in 1969. The article forms the underpinnings of *Lax/Relax* in two ways. Written as a critique of popular television and the conserva-tive values of the 1950s that it reflected, the article analyzes Dean Martin's on–screen behavior—stumbling, sometimes apparently drunk, throwaway, and casual—in triadic terms.

3. Graham, quoted in *Flashing Into the Shadows: The Artist's Film 1966–1976,* exh. brochure (New York: Whitney Museum of American Art, 2000), n.p. The film series included the first screening of the group of films by Yvonne Rainer, Bruce Nauman, and Richard Serra that Dan Graham showed at "Coulisse" since the evening at Paula Cooper.

4. Graham, "Dean Martin/Entertainment as Theater," reprinted in *Dan Graham Articles* (Eindhoven, The Netherlands: Van Abbemuseum, 1978), 45.
5. Ibid.

Martin's relationship with each of his guests is triangulated by a third element—the viewer or its surrogates—"an unseen cameraman Dean knows, the studio audience, or Dean's wife watching at home."[4] This technique reveals the show to be "clearly fake; at first perception, it appears to eliminate all pretense, all 'distance'"; but Martin's louche behavior "makes the spectator all the more aware of the conventionalization of television's image of 'intimacy,' [and that] the 'real' Dean Martin...is just a media fabrication."[5]

Martin's TV show interested Graham in its proto-topological structure. For the puritanical American viewer, the "lax" traits epitomized by Martin's TV persona were negative; but to "relax" in front of the television watching such expressions of laxness was to engage in a socially acceptable rest from working. The coexistence of these opposite elements in *The Dean Martin Show* demonstrates Marcuse's arguments regarding desublimated play. According to Marcuse, play can take two forms: a desublimation of unacceptable social instincts such as erotic desire ("lax") or an apparent desublimation of those instincts that is in fact highly controlled and filtered through the sieve of commercial entertainment ("relax"). In *Lax/Relax*, Graham brings both forms together in a linguistic ping-pong game, his hypnotic repetition of the word "relax" in answer to the recorded woman's "lax" melting the distinctions between them into an eroticized form of play in which the audience simultaneously becomes observer and participant.

The eroticism implied by the disembodied female voice asserting the virtues of laxness while slowly breathing in and out echoes the final paragraphs of Graham's Dean Martin article (by implication of the second part of the title, "Entertainment as Theater"), in which his analysis of Martin and television switches abruptly to a long description of a visit to the newly opened SoHo hippie club the Cerebrum, paraphrasing, sometimes almost word for word, Gene Youngblood's chapter on the Cerebrum published in his counterculture book *Expanded Cinema* (1970, fig. 2).

Graham described being invited by a series of young women to undress, relax, touch others in the room, and play.

> Each person is starting to relate to his or her partner and to the guides. Now another guide enters and, propping herself, kneels by me with a small bowl. She removes a white lotion (baby cream?) and then starts to massage (I see, the medium is the massage) my hand. At first I am unresilient, but then begin to ply *her* hand with the lotion. Couples begin putting the stuff on hands, arms, and faces to feel and touch. We are inside our skins, not merely looking out at an illusion of

Interview from *The Early Show: Video from 1969 to 1979*
Dan Graham

In *Performer/Audience/Mirror* [1977], I begin by looking just at the audience. I'm describing myself and then I describe the audience. Then I turn to the mirror describing myself and then describing the audience as I move around. Of course the audience can't move. They are stuck in a fixed Renaissance point of view, whereas I can move and get different views. So there are four different sequences, and I keep repeating them. It's very different from Vito Acconci or Bruce Nauman because as a performer I am very unimportant.

Of course what I'm doing in the descriptions of the audience and myself is a combination of behaviorism and phenomenology. What I'm doing is putting them together. Behaviorism is very American, and my dialogue is like the announcer at a football game, very play by play. But it is also phenomenological, which is European. It's a hybrid of these two. Also, I'm contradicting these two things by using the Renaissance perspective mirror.

The audience sees themselves. They can hear my description of them or they can look at themselves directly in instantaneous present time. What I'm saying in performance is a little bit behind their time. So they can see themselves instantaneously in the mirror, or they can hear what I'm saying a little bit behind, slightly time delayed. Also, what I'm saying is continuous whereas the mirror is instantaneous, it's a snapshot. So it's much more philosophical than Vito Acconci's work.

Bruce Nauman's works were always about literary and philosophical ideas or they were political. When he painted his balls black, it was about black balls, which was like a political statement. I talked to Richard Serra when he came to New York and he said his biggest influences had been

ourselves.... One of the attractive girls on the platform across from me walks onto my platform. "Join me with the others," she says. We lie beneath an open parachute given to "us" earlier, feeling the cool air of its movement. I feel part of a warm humanity. [6]

Graham's description of the erotic environment of the Cerebrum, part parody, part fantasy, echoes the intentions of *Lax/Relax*: "Usually we are embarrassed if our behavior is being observed by people who are not part of the situation, while an individual who glories in such observation is ordinarily condemned.... We relate to our bodies and to those of our neighbors. There is no need to relate or project onto the others our experiences.... we ourselves are on stage. We are our own entertainment tonight."[7]

In *Lax/Relax*, the eroticism of Graham's written description of the Cerebrum reappears in disembodied form in the dialogue between Graham and the unseen female, epitomizing the attitude of which the 1950s generation so thoroughly disapproved and which Graham's generation was collectively asserting. The attempted fusion between Graham and the recorded female echoes his desire to be "part of a warm humanity" which, by implication, also includes the viewers, whose breathing and concentration bind them to the male and female performer they are listening to, as though in a virtual Cerebrum.

fig. 3
Cover of *Radical Software* 1, no. 1 (spring 1970)

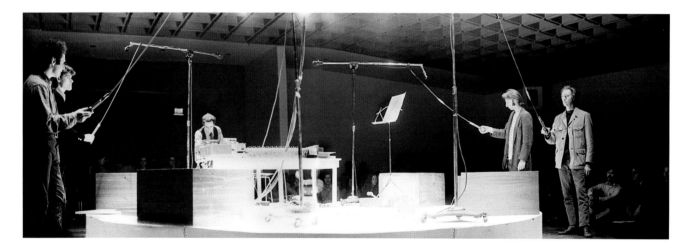

fig. 4
Performance of Steve Reich's *Pendulum Music* (1968) at the Whitney Museum of American Art, New York, 1969; from left: Richard Serra, James Tenney, Steve Reich, Bruce Nauman, and Michael Snow

6. Ibid.
7. Ibid.
8. De Bruyn, "Topological Pathways of Post-Minimalism," 49.
9. Gene Youngblood, "Cerebrum: Intermedia and Human Sensorium," in *Expanded Cinema* (New York: E. P. Dutton, 1970), 359.

Graham's performance took place at the height of the Vietnam War and at a critical moment in the sexual revolution, when assertions of both eroticism and irony within the context of art had deep personal and political meaning. Graham's use of parody was a direct challenge to what de Bruyn described as "the high seriousness of modernist aesthetics."[8] Of less obvious but equal significance in Graham's parody of Youngblood's experience at the Cerebrum is its connection to Youngblood's suggestion that the Cerebrum could represent a new model of consciousness: "Cerebrum (the place) exists in cerebrum (the mind)."[9]

Consciousness was one of the primary subjects of Graham's performances, explored through the device of feedback. Graham's feedback was constructed from several interrelated strands, including a breaking down of psychological barriers between performer and audience through increased body awareness and ideas drawn from *Radical Software* (fig. 3), a self-published magazine founded by the Raindance Corporation, a collective devoted to media activism, video, and cybernetics.

A third strand—demonstrated most explicitly by the interaction between audience, performer, and recording in *Lax/Relax*—was the influence of phasing and aural feedback in the work of Steve Reich, in particular his *Pendulum Music* (1968), which Graham saw performed at the Whitney Museum of American Art on 27 May 1969. Reich's impact on Graham signaled the source of Graham's interest in time as emanating from sound and music rather than dance, the more prevalent influence on artists of Graham's generation.

For the performance of *Pendulum Music* at the Whitney (fig. 4), Nauman, Serra, James Tenney, and Michael Snow each held up a microphone suspended from the ceiling and, on the count of four, let it go, causing it to swing back and forth over large speakers, making loud feedback noises with each pass. As the four microphones gradually lost momentum and their arcs shortened, the pace of feedback noise increased until it created a continuous electronic sound that ended only when the plug was pulled from the amplifier. Reich's phasing, in which sonic elements begin in unison then shift into echo patterns before doubling back, can be traced throughout Graham's subsequent nine performance works, all of which are structured around a linguistic manifestation of aural feedback.

Graham performed *Lax/Relax* two more times, once at Nova Scotia College of Art and Design in September 1969 and then at the Loeb Student Center, New York University, in December 1970 for "Performance, Film, Television & Tape," an evening organized by John Gibson. It was accompanied by Graham's second performance, *TV Camera/Monitor*

Bruce Nauman and the dancer/performer Simone Forti. I brought out a book at Nova Scotia College of Art called *A Handbook in Motion* of work by Simone. So much work comes out of that dance period and Simone Forti had all the ideas. She first got her ideas from Gutai. She's Italian Jewish and she saw Gutai in Italy. They were Japanese performers and also doing painting in the early 1960s. They were very similar to some of the things that Yves Klein was doing.

In *Past Future Split Attention* [1972], one person is describing the past of the other person and that person is simultaneously talking about the future of the other person who's describing them. So it's like a feedback loop. It's always about the perception of the audience, whereas the camera is just a vehicle for that. In *Past Future Split Attention* the audience would distract the performers from the feedback loop that they had with each other. So what the camera can do, it can separate the behavior of the people along with what they are actually saying. In other words, the audio can be separated from the visual track. In *Performer/Audience/Mirror*, it's actually only by luck that there was a camera documenting the performance. The camera had nothing to do with it; it's just documentation. I think it was a very inexpensive camera. You can see it's an old system of video. It was done in Europe and then it was translated to another form and it's gone through a lot of degradation so the quality is very low.

From Minimal art onwards, the idea was to get rid of the Renaissance instantaneous perspective. So the mirror is old-fashioned Renaissance perspective, it's instantaneous time, whereas time delay is much like what we were getting in music, from people like Terry Riley and Steve Reich. It also is like the exploration of video, the relationship to what is called brain time, or perceptual processes, and I think there were some analogies made to drug time. When you are experiencing marijuana, time is distorted. Also you are inside your brain, where it's contrasted with traditional Renaissance perspective and mirrors, which are

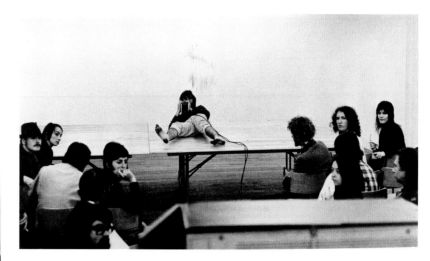

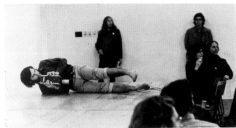

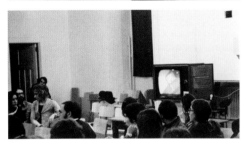

fig. 5
Performance of *TV Camera/Monitor Performance* (1970);
television camera and monitor, stage, and audience;
dimensions variable; collection Daled, Brussels; at Nova Scotia
College of Art and Design, Halifax, Canada, 1970

Performance (1970), which he had done for the first time
at Nova Scotia the month before (**fig.** 5). The execution of
so many of Graham's performances in student environments
located them within the pedagogical context they parodied.
The student environment was, like the alternative space
or studio, another form of interstitial space, designed for
communication rather than the display of objects and defini-
tively outside the high modernist temple of the white cube.

In *TV Camera/Monitor Performance*, Graham intro-
duced two new elements: an assertion of the body's surface
through rolling movements (a technique he used again in
his double–screen 1970 film installation *Roll* [**fig.** 6]) and
an awareness of the anamorphic perspective of one's own
body. Lying on a stage the height of the audience's heads,
his feet facing the group, Graham rolled back and forth to
the left and right of the stage, holding a video camera to
his eye that pointed directly at a monitor placed behind the
audience. Graham's aim was to produce "a pattern on the
monitor of image–within–image–within–image feedback.
The monitor image represents a 'subjective' view from inside
my 'mind's eye.'"[10]

Graham's words reverse those of Youngblood
describing television: "'Monitor' is the electronic manifestation
of superego."[11] Through the use of feedback, Graham trans-
formed the world of Dean Martin—a televisual collective
unconscious controlled by an invisible authoritarian power—
into a layered microcosmic model of consciousness that
viewers could only experience by turning their backs on
Graham rolling back and forth and watching it simultaneously
mirrored in the video monitor behind them.

The anamorphic shapes of the monitor's images,
in which Graham's body is seen in extreme foreshortened

10. Graham, text (1979) on *TV Camera/
Monitor Performance* (1970), reprinted in *Dan
Graham: Works 1965–2000*, ed. Marianne
Brouwer (Düsseldorf, Germany: Richter
Verlag, 2000), 133.
11. Youngblood, *Expanded Cinema*, 78.

fig. 6
Opposing stills from *Roll* (1970)

instantaneous time. The mirror is always looking at the outside; you don't have this feeling of what it's like inside the brain.

You can see I wasn't very interested in putting things on video. I'm more interested in the present time and perceptual processes, so I didn't make that many videos. I'm more interested in the actual physicality of space and the physicality of experiencing time in relation to different aspects of present time. I got out of video because in the 1980s they got rid of the easy way to make time delay, which was reel-to-reel recording where you could easily make a tape loop. Also, digital video became very expensive and of course artists were getting involved with corporations.

What I'd liked and also what Nauman liked was the fact that you could use very simple equipment that you could rent. It was amateur video. Quality was not important and we all took a lot from *Radical Software*...that great magazine. I have to emphasize how important a person like Paul Ryan was. Ryan did a book called *Cybernetics of the Sacred* [1973] and he was a writer for *Radical Software*. Frank Gillette was another important person and he did video pieces. I derived a lot from *Radical Software*. I'm sure Vito Acconci and Dara Birnbaum did too. It was a utopian idea of video then. We saw video as part of a learning process.

There was an artist and teacher, David Askevold (at Nova Scotia College of Art and Design), who decided to do a course called "Projects." He would invite Conceptual artists to give instructional projects and the students would realize them. I had no money for video or film but I had a lot of video and film projects. So I invited myself up to Nova Scotia to help realize the projects with the students. I was able to do a number of things while I was there. I was able to get on local television and talk about my computer astrological dating service. When I was teaching there I had the students use public access video. I could do everything as a learning process. *Two Consciousness Projection(s)* [1972] was done as a class project. I wanted to have things done as experiments with students as a learning process.

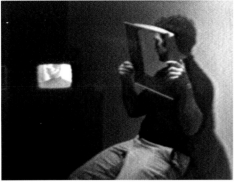

fig. 7
Still of Paul Ryan performing *Everyman's Mœbius Strip* (1969)
from Ira Schneider's *TV as a Creative Medium* (1969–84):
video, black-and-white and sound; 12:08 minutes; courtesy
Electronic Arts Intermix, New York

perspective, mark the first indications of the distorted visual perception that has become one of the dominant elements of his work. This anamorphism can be understood as part of a broad embracing of curved circular forms by a generation of Postminimalist artists, whose body- and time-based works rejected the static rectilinear forms of Minimalism and Euclidian space.

In *TV Camera/Monitor Performance*, Graham's setup could also be described as a performative parody of the structure of anamorphic painting. By setting the front edge of the stage at the same height as the spectators' heads, Graham ensured that his body was read in extreme foreshortening, just as anamorphism in painting depends on the viewer adopting a horizontal eye-level viewpoint just outside the frame of the painting. Graham's rolling back and forth further demonstrates his rewriting of his, and the viewer's, perspectival perception, dispersing the central vanishing point into an arc of movement. The rolling of his body back and forth toward the edges of the stage (for which we could read "picture plane") describes the topological character of its surface, transformed from a static object into a dynamic field by the actions of Graham's body.

As Hanneke Grootenboer observed, from its invention anamorphosis was described as "reversed perspective...the subject of anamorphosis is vision rather than representation."[12] Graham's "subjective view from inside my mind's eye" echoes what Christine Buci-Glucksmann described as the double structure of Baroque vision, in which the "baroque eye can be defined as an anamorphic gaze." In this form of vision, perspective "generate[s] play rather than proof, illusion rather than reality, effect rather than resemblance." Baroque form is "directed toward an always unstable and ephemeral state,

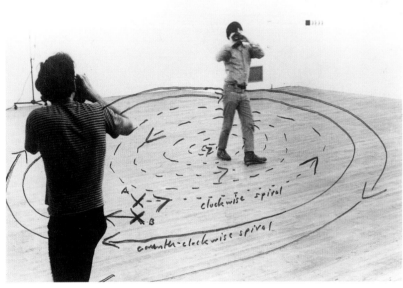

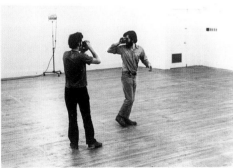

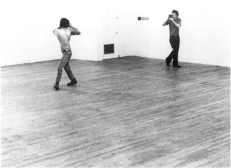

fig. 8
Publicity photographs Graham made of rehearsal of
Two Correlated Rotations (1969)

12. Hanneke Grootenboer, *The Rhetoric of Perspective: Realism and Illusionism in Seventeenth-Century Dutch Still-Life Painting* (Chicago: The University of Chicago Press, 2005), 103–04.
13. Ibid., 110–11.

which constantly solicits a double and doubling gaze.... a dialectics of seeing and gazing, similar to the schism between [Jacques] Lacan's gaze and the eye."[13]

Buci-Glucksmann's arguments can be traced in Graham's performance, in which the monitor functions as a kind of mirror, with Graham's camera the single baroque eye from which perspective emanates. During the late seventeenth century, it became popular to own tabletop semicircular mirrors reflecting anamorphic images from prints and drawings back to the viewer in "correct" form. Graham's monitor performs a similar function in reverse, revealing to the viewer a composite image of layered perspectives taken from different viewpoints as Graham moves from left to right and back again.

If the monitor in *TV Camera/Monitor Performance* operates as a kind of mirror, it also performs a visual function that a mirror cannot—unlike a mirror, it feeds back images the same way round as they are perceived, rather than as their reflective opposite. This further dissolves the perception of the self as something "other": as object. The formation of Graham's instant-feedback images was influenced not only by reading the ideas set out in the first issues of *Radical Software*, but also by a specific performance by Paul Ryan titled *Everyman's Moebius Strip* (fig. 7), made in 1969 for the exhibition "TV as a Creative Medium" at Howard Wise Gallery in New York. Ryan constructed a private booth inside which viewers could record themselves doing a set of simple exercises, watch the video of themselves, then erase the recording.

The resulting feedback of Ryan's performative environment created a kind of living Möbius strip—a single continuous surface created by flipping one end of a strip and joining it together with the other end. Graham's feedback structures adopt a similar form, seen most explicitly in his performative double-screen films *Two Correlated Rotations* (1969) and *Body Press* (1970–72). Both films fold the actions of two performers filming each other into a single entity by means of a twist similar to that of a Möbius strip—in *Two Correlated Rotations* by the overlapping of opposing spiral movements (fig. 8), and in *Body Press* by the exchanging of cameras halfway through the performance. In both cases, it becomes hard to detect which performer is using which camera, so thoroughly do the two become intertwined.

In *Two Correlated Rotations*, the fusion evokes that of *Lax/Relax* but shifts the dynamic between live and recorded. Whereas in *Lax/Relax* the primary connection is between the spectators and a live performer responding to a recorded voice, in *Two Correlated Rotations* the primary connection lies between two performers present in the same space filming each other's movements and responses as

When I was first doing video it was a very idealistic medium. It wasn't that it was utopian. It was just that it was very democratic. In other words, the reason I did performance and video was because everybody else was doing it. What I liked about performance was that it was very much about the artist community, just like Gordon Matta-Clark did his restaurant, Food, because it was about the artist community. We had a feeling of reinforcing the community. Also I was very involved idealistically in teaching the students as artists in a social situation. One thing that interested me about videos a lot in the late 1960s was how many people were involved with, well, as John Lennon said, "instant karma." It was all about psychological self-help. There were all these ideas like "Primal Scream," about self-enlightenment through some kind of collective scheme. I thought video could be part of that. That's why I did *Two Consciousness Projection(s)*.

Text from an interview with Dan Graham by Tania Cross and Andrea Merkx on 7 December 2005. First published in *The Early Show: Video from 1969 to 1979*, ed. Constance De Jong (New York: The Bertha and Karl Leubsdorf Art Gallery, Hunter College, 2006), n.p.

they walk in opposite inward and outward spirals, witnessed later by spectators at a temporal and spatial distance via two film images projected on adjacent walls of a gallery.

In contrast to *Lax/Relax*, where engagement occurs through the performer's breathing and his responses to the recorded female voice, in *Two Correlated Rotations* engagement is achieved through the eyes, as both performers attempt to maintain eye-to-eye contact through the lenses of the cameras as they walk, without the distracting attention of a third party. Direct eye contact, an intimate form of communication, creates a feedback that produces, in subsequent projection, a baroque perspective in which the conventional figure/ground relationship of painting gives way to a doubled figure revolving in opposite directions in space, readable as a complete action only through the mirror-like doubled screen.

Body Press (fig. 9) is more literally baroque in its anamorphic structure. The first evidence of the curved reflective architectural forms that were to become a major part of Graham's language, the work took place in a cylinder with a mirrored interior approximately six feet high, just large enough to enter. Inside it, a naked man and woman stood back to back, each holding a film camera that they slowly circled around their bodies, making sure that the cameras remained focused on their skin throughout the performance. The resulting films are projected large on opposite walls in a narrow room in order to evoke the restricted space of the original filmed environment.

The mirrored cylinder's shape recalls the seventeenth-century semicircular tabletop mirrors whose reflective surfaces "corrected" anamorphic images placed horizontally in front of them. By contrast, Graham's two semicircular mirrors distort the "correct" bodies they enclose and reflect. The flat picture plane of painting is folded into an anamorphic architectural enclosure, within which the nude couple stand back to back, exploring themselves and each other by detaching the camera from their eye and allowing it to travel across every inch of their bodies, always aware of each other's front view through its reflection in the mirrored surface directly in front of them. The cylinder's structure is echoed by the double cylindrical forms of both bodies and the volumetric interior of each camera lens, creating a triple-layered feedback. To this are added two further optical layers—the static frontal view seen by both performers' eyes in the distorted mirror and the fluid circulating view of the space and the bodies it contains, recorded by the cameras.

The resulting films, projected conventionally within a rectangular frame on opposite walls of another constructed space, reveal a layering of distorted and "correct" images

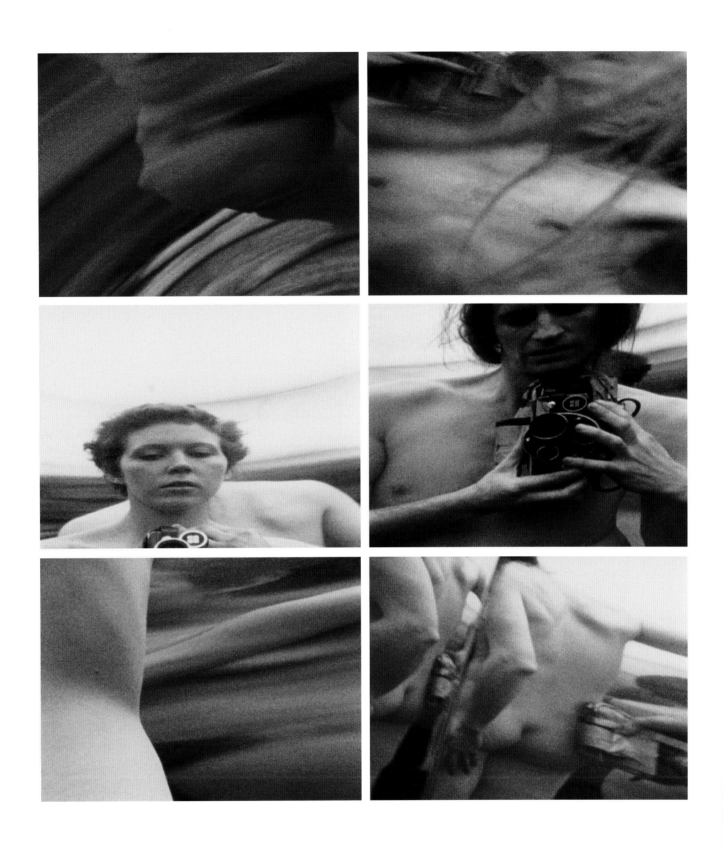

fig. 9
Pairs of opposing stills from *Body Press* (1970–72, with
Susan Ensley and Ed Bowes)

as the camera recorded both the surface of the body and its reflection on the surrounding walls. Graham constructed a double triangulation: the first in the actual performance—two figures triangulated by the mirror reflections (an architectural stand-in for the spectator)—and the second in the two opposing projections (stand-ins for the two performers), triangulated by the spectators present in the gallery. Another kind of Möbius strip emerges, in which the skin of each performer is merged into a single surface within the celluloid filmstrip.

Throughout the early 1970s, Graham's work continued to combine live and recorded action, some in the form of performances, others created as gallery installations. In 1972, he made *Two Consciousness Projection(s)* and *Past Future Split Attention*, both live performances involving video. *Two Consciousness Projection(s)* (**figs. 10, 11**) takes the structure of *Lax/Relax* and complicates it. A woman is seated in front of a monitor that relays her image back to her in live feedback as she tries to describe what is in her conscious mind. In front of her, a man she does not know stands looking through the camera connected to the monitor, describing what he sees as he watches her through the camera lens. With them both, an audience is assembled, watching the monitor, the woman, and the man and listening to their simultaneously delivered perceptions.

As in *Lax/Relax*, the audience listens to the speech of a man and woman, but in this case they also view both, delivered live. Rather than single repeated words in harmonic rhythm, both performers articulate their perceptions of self (her) and other (him), each inevitably influencing the other's thoughts. As Graham himself observed, the audience performs a superego role, "subtly influencing the course of his behavior or consciousness of the situation."[14] The woman's perception of herself is inevitably complicated both by her awareness of the man in front of her articulating his thoughts about her, and by watching her own reactions live on the monitor while trying to formulate independent thoughts of her own.

Made at the height of the women's liberation movement, Graham's performance disrupts the traditional dynamic between male and female. The female deflects the male gaze by commenting on her own live image, thereby altering and potentially controlling it. Although the woman remains in a submissive position—seated, videotaped, watched, commented upon, observed—her role is, as Graham pointed out, "more powerful than the man's, as her subject and object are *not* separated (separable). Whereas, the more the man (to himself) strives to be objective, that much more does he appear to be unconsciously subjective to any observer from the outside."[15]

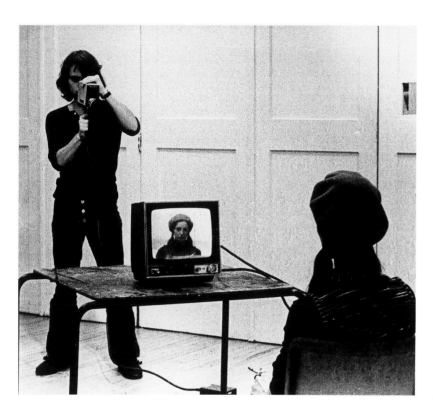

figs. 10, 11
Performance of *Two Consciousness Projection(s)* (1972) at Nova Scotia College of Art and Design, Halifax, Canada, 1972

14. Graham, text (1979) on *Two Consciousness Projection(s)* (1972), reprinted in *Dan Graham: Works 1965–2000*, 138.
15. Ibid.
16. Michael Coster Heller, "The Eye Block, Schizophrenia and Autism: A Study on Interdisciplinarity," *Adire*, no. 2 (1986).

17. Paul Ryan, "Cable Television: The Raw and the Overcooked," *Radical Software*, no. 1 (spring 1970): 12.

In 1975, Graham repeated the performance at Nova Scotia College of Art and Design, this time with both performers in the nude. The sexual undercurrents present in the earlier performance were intended to be brought to the surface more directly in this version, in which both performers' perceptions of the woman's naked body inevitably predominated. As in *Body Press*, Graham's use of naked performers was influenced by the therapy of Wilhelm Reich, whose technique involved sometimes seeing patients in the nude.

As psychotherapist Michael Coster Heller observed, during the 1950s, when both Reich's and anthropologist Gregory Bateson's ideas took root, it was felt that "bodily behavior should be approached...as a communicative phenomenon."[16] Reich's therapy also focused on direct eye contact, the consistent avoidance of which was felt to indicate a loss of connection between one's inner self and the external world, as often exhibited by schizophrenics. The role of the body as a vehicle for communication dominates Graham's performances through its ability to externalize both physical and linguistic perception.

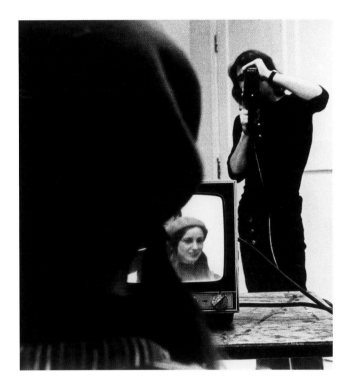

In *Identification Projection* (1977), Graham makes the erotic possibilities of this role even more explicit. A female performer stands in front of an audience and slowly describes the men (or women) in the audience to whom she feels sexually attracted. Punctuating her descriptions with long pauses, she, in turn, willingly adopts the role of a potential object of desire as the audience grows increasingly awkward. Unlike *Lax/Relax*, in which Graham's relationship to a disembodied female voice unified the audience, *Identification Projection* fractures the audience by splitting it into those identified as sexually desirable and those whom the assertive female passes over.

The group dynamic of Graham's feedback structures relates to Ryan's experiments, such as an action described in his 1970 essay "Cable Television: The Raw and the Overcooked," published in *Radical Software*: "Working with encounter group leader Dennis Walsh, I videotaped while a girl stood in the middle of the group with her eyes closed and described how she thought people were reacting to her then and there. The contrast between her negative description and the positive responses to her that the playback revealed were both illuminating and encouraging for her. This was information infold. What she and the group put out was taken by the tape and given back to them."[17]

Ryan's description reveals the cybernetic context for Graham's experiments with verbalized self-perception within a group dynamic, though Graham's female performer demonstrates a more confident self-image. Graham's setup also evokes the earliest example of video-recorded

fig. 12
Still from video documenting performance of
Past Future Split Attention (1972) at Lisson
Gallery, London, 1972

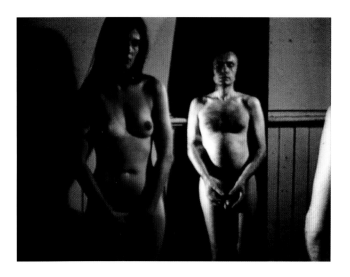

fig. 13
Still from Vito Acconci's *Three Relationship Studies* (1970);
Super-8mm film transferred to video, color and silent; 12:30
minutes; courtesy Electronic Arts Intermix, New York

feedback,[18] in Andy Warhol's double-screen film *Outer and Inner Space* (1965). In the black-and-white film, Edie Sedgwick is sitting next to a television monitor on which she appears in a previously recorded black-and-white videotape. Warhol's film/video portrait, quadrupled by dividing the film into two projections, anticipates the topological feedback structure of Graham's performances and films, layering the two live elements between two recorded ones in delayed time loops.

The pervasive exploration of the linguistic and perceptual possibilities of video feedback is also evident in a number of other works made during this period by, among others, Serra, a close friend of Snow, whose filmic experiments with ocular perception and surface were an influence on both Serra's and Graham's thinking. In Serra's color video *Boomerang* (1974), made during the same period as Graham's performances, Nancy Holt sits in a television-station recording studio in Texas wearing headphones, speaking into an audio feedback-delay system that allows her to hear simultaneously what she is saying and what she said seconds earlier. Holt remarks on the similarity of delayed time to a mirror reflection, struggling to retain comprehensibility as the present and the immediate past collide.

The slippage between what Graham calls the "just past" and the present—a temporal interstitial space—is evident in all his performances. In *Past Future Split Attention* (fig. 12), first performed alongside *Two Consciousness Projection(s)*, the just past becomes literalized. Two performers who know each other well stand together in front of an audience, one predicting the second performer's behavior while the second recounts from memory the past behavior of the first. As the performance progresses, what has just been said becomes part of the immediate past to be recounted, confusing the boundaries of what constitutes the past, the present, and the future.

The potential collapsing of temporal boundaries extended to an inquiry into the boundary between self and other, epitomized by a simple performance for two people titled *Like*, presented in December 1971 by Graham and Ian Murray at the Nova Scotia College of Art and Design (but not, in the end, to a public audience). Each performer tries to convince the other that they are like them, using persuasion, physical touch, and gestures, gradually breaking down the barriers between self and other. Graham's utopian performance was designed for communication; yet such an exercise will always come to a halt at the moment when the threshold of what constitutes the self is finally reached, which, at its deepest level, could be said to constitute the boundary between sanity and insanity.

18. Callie Angell has argued convincingly that the video feedback in *Outer and Inner Space* predates the video feedback experiments of Nam June Paik in the mid-1960s. See *Outer and Inner Space*, exh. brochure (New York: Whitney Museum of American Art, 1998), n.p.
19. Graham, unpublished transcript of second performance of *Performer/Audience Sequence* at Artists Space, New York, January 1976.

Graham's interest in discovering the borders of the self was driven by a deep desire for a connection to others. Unlike Acconci—whose performances explored the self through the dynamics of power and an existential struggle to communicate that, in some cases, handed over trust completely to another person (fig. 13)—Graham's performances were risk–averse. In his last three performances of the 1970s, *Performer/Audience Sequence* (1975, also known as *Performance/Audience Projection*), *Identification Projection*, and *Performer/Audience/Mirror* (1977), Graham involved the audience in the performance directly for the first time since *Intention Intentionality Sequence* (1972), adding the role of object to that of observer. All three performances share a similar structure. In *Intention Intentionality Sequence*, Graham stood in front of a seated audience, at first trying to isolate himself from their reactions as he verbalized his intentions, then looking at them while describing what he saw.

In *Performer/Audience Sequence*, the structure became more complex. Graham first described his own appearance and movements and then that of the audience before resuming a description of himself, finally observing the audience's reactions to his descriptions once again. This sequence was repeated until he decided that the performance was over. As Graham's descriptions evolved, they became increasingly affected by the responses of the audi–ence, who became a perceptual two–way mirror, reflecting information back to, and about, both Graham and themselves. At the end of the second performance of the work, Graham described the audience:

> It seems that the people who were rigidly holding themselves apart in some kind of way have now joined the others, it seems like the audience is more like a body of people collectively; they don't have to refer–ence each other, but they are not so conscious of themselves; also, as this becomes possible certain nervous gestures, like scratching or yawning, become possible again; maybe that's because of the relaxation or unconsciousness of their individual body activities while their minds are very focused.[19]

In *Performer/Audience/Mirror* (fig. 14), Graham literalized this reflectiveness, inserting an actual mirror into the performance. Standing facing the audience, he described first his own movements and then their behavior before turn–ing to face a large mirror and describing first his own, then the audience's reactions, influenced by what he saw in its reflection. When Graham faced the audience, they saw him

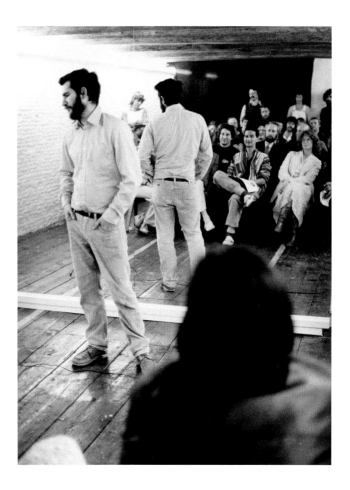

fig. 14
Graham performing *Performer/Audience/Mirror* (1977) at De Appel Arts Centre, Amsterdam, 1977

in direct relation to their own reflection in the mirror, which, when he described them, communicated a visual confirmation of what he was seeing but with a brief time delay. When he turned to the mirror, his description was that of the same reflection that the audience was watching, inserting another, more instantaneous experience of time. The opposite occurred when Graham described himself.

In Graham's topological model, the mirror becomes an analogy of consciousness, echoing Maurice Cranston's observation that "just as a mirror has no content except that which is reflected in it, so consciousness can have no content except the objects on which it reflects. Yet such an object is always separate and distinct from the consciousness which 'mirrors' it."[20] Graham's performance both confirmed and questioned this premise, folding the mirror, performance, and audience into a single self-reflexive entity in which, to borrow de Bruyn's words, "the space does not contain the performance; rather, it is the performance that constitutes the space."[21]

Performer/Audience/Mirror is the most complex of Graham's performances and his last non-theatrical live work. His insertion of a mirror into the space of the performance introduced an architectural element into his topological field of action that he had already explored fully in a series of live- and video-feedback room installations begun in 1974. The mirror appeared again much later, in two more conventionally theatrical performances of the 1980s—*Musical Performance and Stage Set Utilizing Two-Way Mirror and Time Delay* (1983) and its variation, *Set for Two-Way Mirror Piece (Project for the Paris Biennial)* (1985). In the first performance, a triangular grouping of three musicians (with collaborator Glenn Branca at the front) and a seated audience all faced a wall-sized two-way mirror, through which the glow of a video monitor could faintly be seen. The monitor behind the mirror showed the performance and the room after a six-second delay, as taped by a camera positioned next to the monitor and filtered through the mirror.

The faint image emanating from the monitor in delayed time created a double temporal experience for both the musical performers and the audience. Graham apparently reasserted the conventional spatial modernist model only to undermine it through transparency. It is a paradox that all Graham's topological performances adopt a resolute frontality, even as that frontality is interrogated by spatial and aural loopings. Throughout the possible transformations that might occur within the audience, they remain seated at all times, rooted to the spot. Only the performer—often Graham—moves, shifting from foot to foot, rolling backwards and forwards lying down on a stage, or turning to face either

the audience or a mirror. As much as Graham's performances open up a fluid, decentered Postminimalist space, they ultimately retain firm control over what such an opening up might release. The frontality of the proscenium arch presents the same dichotomy as that of the white cube—it must retain an element of its original form in order for that form to be understood as reconfigured.

It is this paradox that keeps Graham's performances, and the temporal structures they initiated, radical rather than academic, fluid rather than fixed, and newly relevant within a post–McLuhan age in which feedback has become socially internalized, conditioning our collective consciousness to an unprecedented degree. As de Bruyn pointed out, Graham's continuing relevance, epitomized by the ideas explored in his early performance work, lies in the possibilities his work continues to offer for alternatives to the confining strictures of global, technological, social control.[22] 🔴

Graham holding One *(1967)*

20. Maurice Cranston, quoted by Jonathan Judaken, *Jean-Paul Sartre and the Jewish Question: Anti-Semitism and the Politics of the French Intellectual* (Lincoln: University of Nebraska Press, 2007), 97.

21. De Bruyn, "Topological Pathways of Post-Minimalism," 34.
22. Ibid., 56–58.

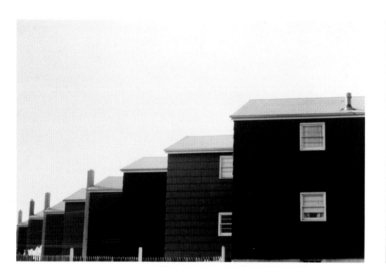

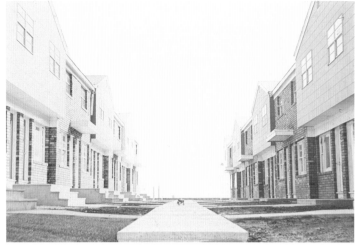
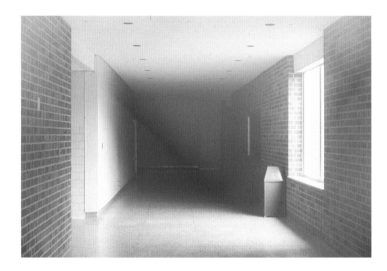
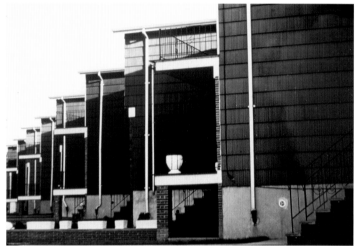

above and following spread
Slides from *Homes for America* (1966–67)

 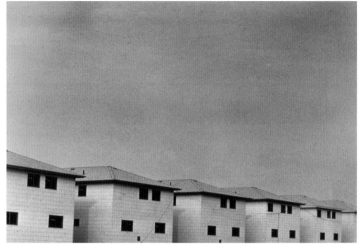

 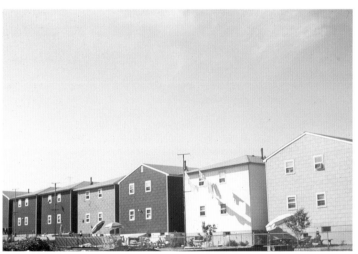

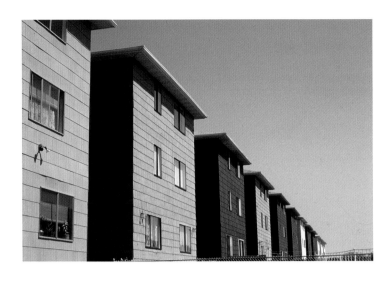 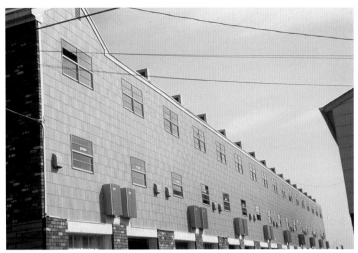

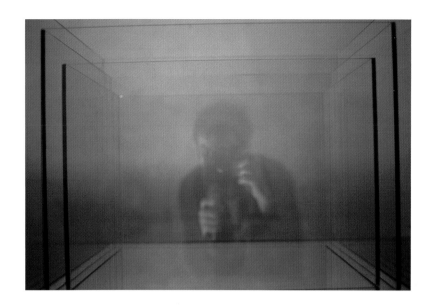

Boxes of
panes are
added until
5 boxes
in all
within
boxes
are
placed and
photographed
from each
of their
respective
sides

So 20 shots in all are taken.

20 shots in all are taken.

These shots as transparencies are copied 4 times. They are inserted in the Carousel tray for projection in this fashion: the first 20 follow the order of the shooting outlined: the second 20 are flipped over (that is, placed in the tray flipped over in relation to the first series) in backwards sequence from the first 20; the next 20 are like the first 20 and the last 20 are like the second 20.

The image — the subject matter — is transparent, illusionistic (mirror) space, developed in cyclical 'movements'. The continuity of time present in the usual walk around the three-dimensional object as well as that three-dimensionality is presented 'in' (on) the screen — slide — sequence arbitrarily transposed to the order of the *machine's* movements; so the mechanics are the product (message, as the medium is the message). The Carousel slide device is a real machine — its presence dialectically related to the images it projects (as the message is a product — a packaged illusion in the apparent sense which our apprehension of the machine's mechanism appears — literalized) by the 'real' machine which is producing, however, another illusion (related by an extension of the prior illusion). This illusion is simply-self-referring in the same 'space' or container (but in another sense) in another time and place (when viewed from a different perspective) to the mechanics of the viewing situation. The artistic use of the concept *inversion* (traditionally, an 'inversion' would yield a *distance* to the work of art) is here (at least operationally) inverted from structural/utilitarian to physical (by hand in terms of the real time-spaced of presenting the finalized work of art) inversion of the slides which proceed in a cyclic movement to re-present the 'linear' perspective. . .Two types of movement, two types of space, two types of time relationship which come together in the movement of the structure or mechanism — in its 'workings'.

Ironically it wasn't the new medium of cinema which evolved from Edison's invention, but the steps along its path — the analysis of motion — which first 'moved' artists. Marey's work is recalled by the Futurists and most notably, by Marcel Duchamp's paintings, culminating in "Nude Descending A Staircase" whose overlapping time-space was directly modeled after Marey's superimposed series. Leger, Moholy-Nagy and others did utilize the motion picture (also Duchamp at a later date), but only as an available tool and not in terms of its structural underpinnings. It wasn't until recently, with the 'Minimalist' reduction of the medium to its structural support in itself considered as an 'object' that photography could find its own subject matter.

The use of the inherent transparent 'flat', serialized space was why I turned to the 35mm. slide (color transparency) as art 'structure' in itself in a series shot in 1965 and 1966 of architectural allignments and another series of transparent-mirror 'spaces'; these were exhibited in 1966 at Finch College's "Projected Art" (they dated from 1965 and 1966) and then in "Focus On Light" in Trenton, N.J. Some of these photographs also appeared in black and white as 'documentation' contained in a two-dimensional projective network of schematic 'information' about land use economics, standardization and serialization of buildings and buildings schematically relating the appearance of large-scale housing 'tracts' (See "Homes For America", "ARTS MAGAZINE", December-January, 1967). This was the first published appearance of art ("Minimal" in this case) as place conceived, however, solely in terms of information to be construed by the reader in a mass-readable-then-disposable context-document in place of the fact (neither before the fact as a Judd or after the fact as in current "Concept" art). Place in my article is decomposed into multiple and overlapping points of reference — mapped 'points of interest' — in a two-dimensional point to point 'grid'. There is a 'shell' present placed between the external 'empty' material of place and the interior 'empty' material of language; a complex, interlocking network of systems whose variants take place as information present (and) as (like) the medium — information — (in) itself.

Overhead view diagram

TWO RELATED PROJECTS FOR SLIDE PROJECTOR

I. In December 1966 I devised a project for 35mm. transparencies and Carousel projector designed for exhibition space installation: the Carousel slide projector as object: the message to be the mechanism of the medium in itself as object. Although the project was never done, a number of people have been influenced as a result of my writing or speaking publicly about it to exhibit similar works dealing with photography.

A Carousel slide projector is loaded with 80 slides which are projected on a screen every 5 seconds. The device is in continuous operation. The slides are of transparencies and mirror-images of transparencies which have been obtained in the following manner:

A structure is built utilizing 4 rectangular panes of plate glass joined to form a box with 4 sides. The top is open and the base is a mirror. A 35mm. camera takes a shot on a parallel plane directed dead on focused on that plane and including nothing more than that plane in its periphery. Shot #2 is made similarly but of the next side of the box rotating clockwise and the lens focused further back — on a point inside the box. Shot #3 is focused still nearer the center of the box and an equal distance back from the first to the second one as the camera is aimed at the third side. #4 follows the same scheme, the focused point now at dead center of the box's interior.

<u>Spectator views the views timed on a Carousel slide projector</u> — the traditional sculptural 'walk around' the solid, 3-dimensional object is eliminated, transposed to the transparent, illusionistic (mirror) space, developed in cyclical 'movements' of the machine's workings; so the mechanics are the product (message, as the medium is the message). Continuity is transposed to the mechanical order of the machine's movements.

The subject of motion through historical time has been pictured paradoxically: Zeno's Greek word picture goes: "If at each instant the flying arrow is at rest, when does it move?"

The earliest devices made movement to reproduce movement, done either by moving their projected image optically, or by projecting on a mobile medium. The Laterna Magica used glass slides introduced from the sides. From this developed the technique of putting a sequence of pictures on the same slide and showing them in succession in a continuous motion (an impression given like that of seeing through the window of a moving car the world go by with the one inversion that the movement re-presented here by objectively <u>real</u> motion is an illusory one — i.e; the subject of seeing the world slide by the window

 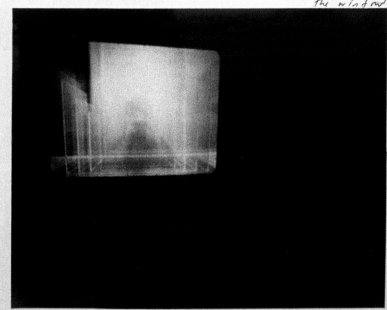

Dan Graham 1966

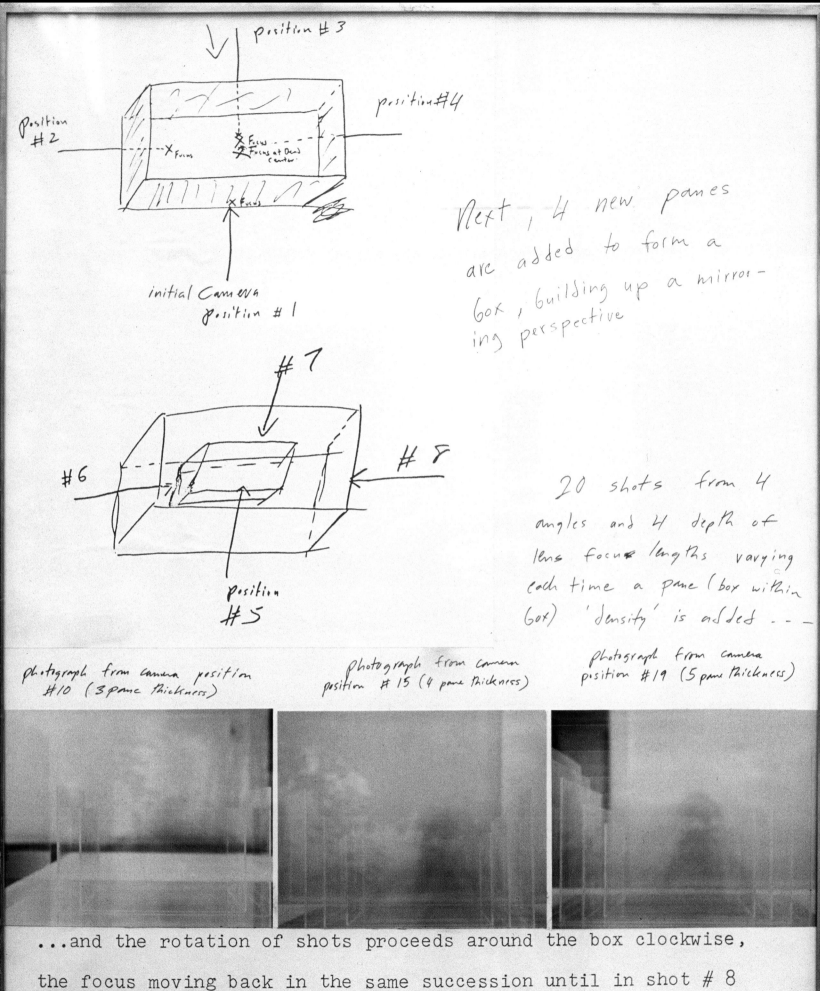

Position #3

position #4

Position #2

X Focus
X Focus at Dead Center

X Focus

X Focus

initial Camera position # 1

Next, 4 new panes are added to form a box, building up a mirror-ing perspective

#7

#6

#8

position #5

20 shots from 4 angles and 4 depth of lens focus lengths varying each time a pane (box within box) 'density' is added ---

photograph from camera position #10 (3 pane thickness)

photograph from camera position #15 (4 pane thickness)

photograph from camera position #19 (5 pane thickness)

...and the rotation of shots proceeds around the box clockwise, the focus moving back in the same succession until in shot # 8 it has returned to its first position on the outer pane of the structure. This plan is followed as, from the inside, new boxes within boxes are added and photographed in sequence.

Dan Graham 1966

Paired stills from *Binocular Zoom* (1969–70)

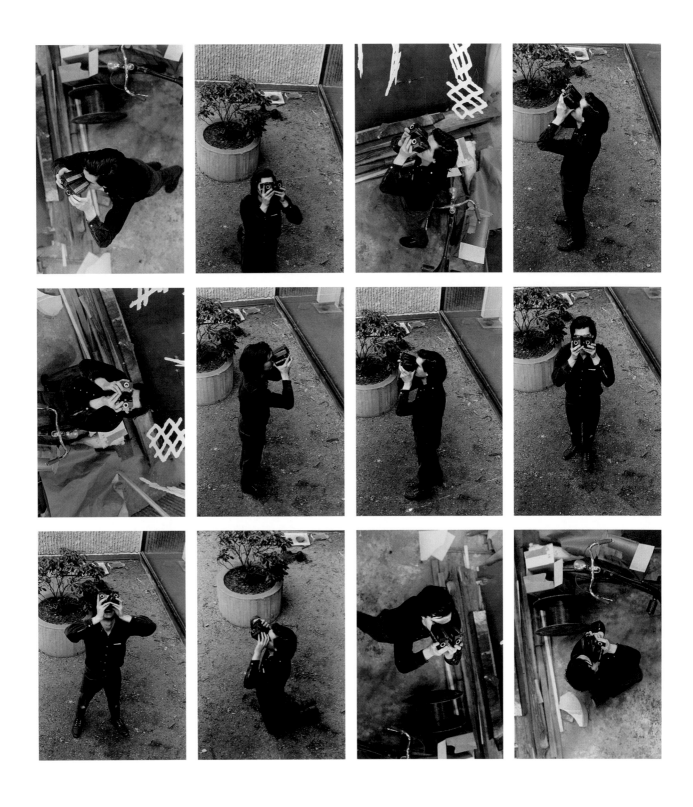

Graham filming *Binocular Zoom* (1969–70)

"LIKE" (1969) tape installed on tape recorder

A group of people (perhaps students) are brought together. Using a portable tape
recorder, they are asked what the word, "like", means to them: short, single word or
phrase answers - as many as they can think of. After going around the room for
responses, the taping is over. The responses, which may sound like a short radio
commercial were: "adore, dig, similar, such as, want, about, prefer, groovy, fine,
nice, like, same, like conotations, pretty close to, as far as, comparison, love a
little, admire, fond, close, identical, friendly, to want perhaps, desire, love,
compare, as, appreciate, O.K., in relation to, a like is like a like..." in the first
tape.

When the work is presented as a continuous tape loop, the words at first merely
seem to be defining <u>something</u>.

It was found that a group of people tends to systematically construct its own
'meaning' structure - people add and subtract from the other 'meanings' given, keeping
various sequences at times. Thus every version is particular to people, time and
place. That people tend to be saying what they (think they) are like; this creates
self-contained surfaces as subsets within the overall 'meaning' group. That the listner
is involved in the voice of the person giving the definition as much as the 'meaning'
he or she gives, following the vocal intonation as he or she gives 'meanings' in a
series as a clue to that person's (seductive) personality. That finally, it is the
qualities of the sound of the seperate voice (intonations) which are compelling, non-
verbal in nature, as they are unseen.

The word, "like", a banal or debased metaphor, when used as a structure or prop yields
a loose, overlapping and non-syntactical or categorically pre-defined 'meaning' structure.
Whereas Sauussurean linguistics postulates a dichotomous relation between the concept of
<u>language-schema</u> and <u>useage</u>, in "LIKE" <u>all</u> categories are <u>merged</u> in the process; the <u>schema</u>
(language in the Saussurean sense of the larger institution or overriding form) has no
historicity but <u>is the same container</u> and moment as the <u>useage</u> (which is that which gives
language substance in the exact and particular instance (instant) of social articulation.

What is a work of art like? In (past and) popular terms, it might come down to whether
or not you <u>liked</u> the art. However, on the bottle of 7-UP soda, the product says on it:
"YOU LIKE IT/IT LIKES YOU". As a tape recorder playing a loop in a gallery installation,
"LIKE" is saying, it (the art) is "groovy", "friendly", "nice"..."LIKE" as a debased base;
a self-referring 'value judgment'.

DAN GRAHAM

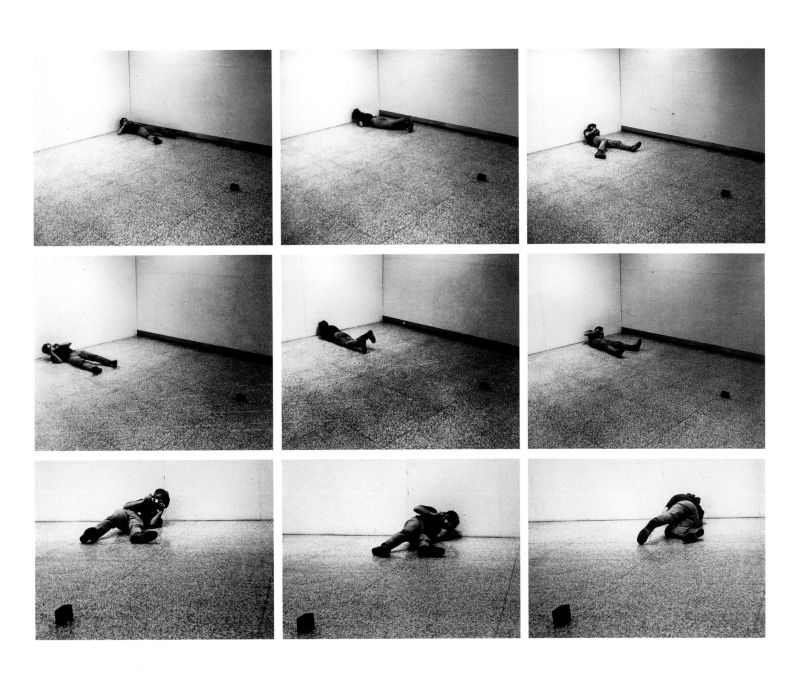

Staged publicity photographs of rehearsal
of *Roll* (1970, work later realized outdoors)

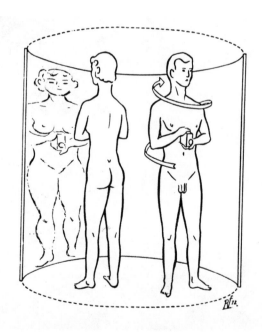 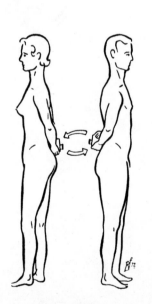

Diagrams for *Body Press* (1970–72)

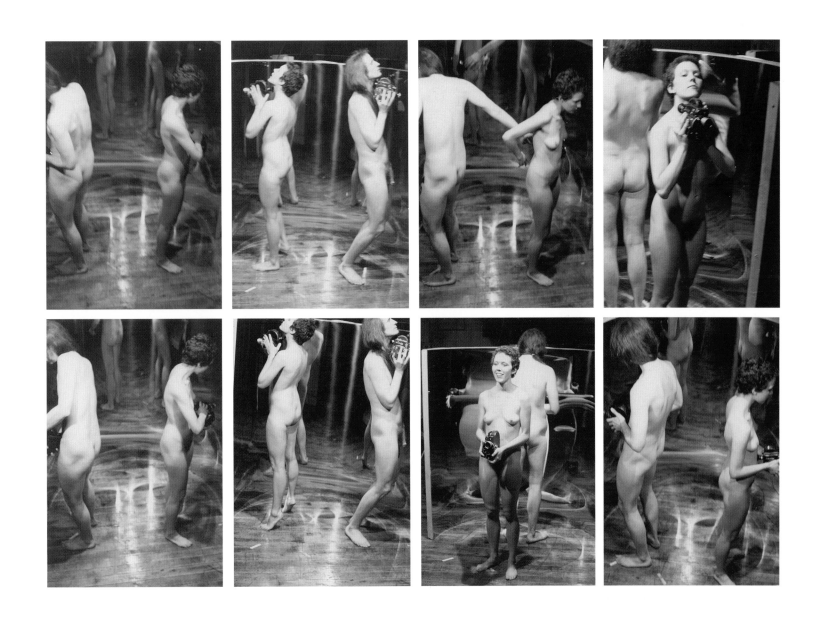

Photographs Graham made of rehearsal of *Body Press*
(1970–72, with Ed Bowes and Susan Ensley)

Rehearsal of *Like* (1971, with Graham [right] and Ian Murray)
at Nova Scotia College of Art and Design, Halifax, Canada, 1971

One person predicts continuously **the** other person's future behavior; while the oth er person recalls (by memory) his opposite's past be-havior.

Both are in the present so knowledge of the past is needed to con-tinuous deduce future behavior (in terms of causal relation). For one to see the other in terms of present attention there is a mirror-relflection (of past/future) cross of effect(s). Both's behavior be-ing reciprocally dependent on the other, each's information of his moves is seen in part as a reflection of the effect their just past behavior has had in reversed tense as the other's views of himself. For the performance to proceed, a simultaneous, but doubled attent-ion of the first performer's 'self' in relation to the other('s im-pressions) must be maintained by him. This effects cause and effect direction. The two's activity is joined by numerous loops of feed-back ⟵⟶ and feedahead words and behavior.

Publicity photograph Graham made for
Past Future Split Attention (1972)

following spread
Publicity photographs Graham made of
rehearsal of *Helix/Spiral* (1973), West Houston
Street outside Loeb Student Center, New York
University, New York

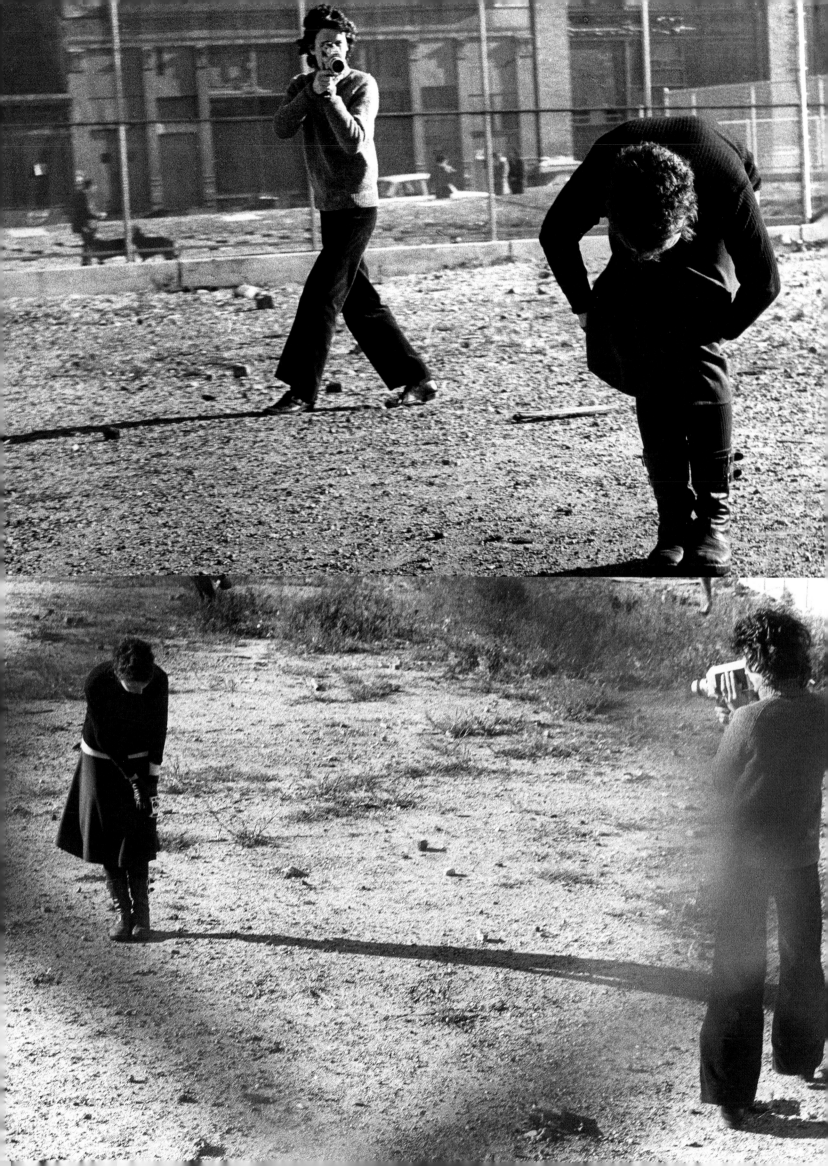

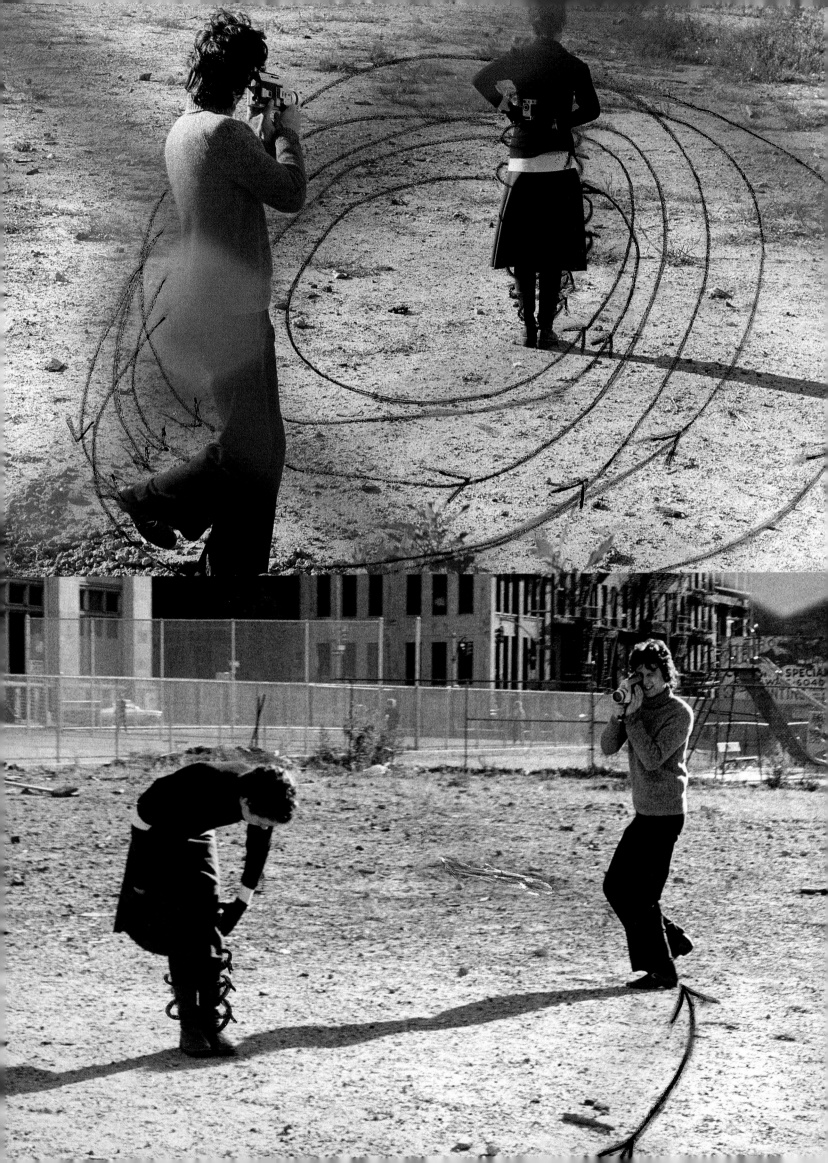

Opposing stills from *Helix/Spiral* (1973, with Simone Forti and
Ian Murray filming each other), New York

Interview with Dan Graham
by Rodney Graham

with Chrissie Iles and
Gary Carrion–Murayari
New York, New York
7 May 2008

"SUNNY AFTERNOON" and "THE WORLD KEEPS GOIN' 'ROUND"

Diagram for Ray Davies (1969)

Rodney Graham: I want to talk about something that kind of started me off, in terms of my art practice—I know you have a connection to this idea of rejection of [Marcel] Duchamp…

Dan Graham: Mm–hmm.

RG: In the 60s?

DG: Mm–hmm.

RG: You talked about this idea of overcoming or superseding the readymade idea. You mentioned [Dan] Flavin as being really important to you in terms of doing that.

DG: Well, to begin with, Sol LeWitt and Flavin were guards in the great "Russian Experiment" show at the Museum of Modern Art. They all hated Duchamp. Flavin's readymade came from Russian Constructivism. And my work all relates to this Constructivist quasi–functionality. They're not just aesthetic pavilions. And Flavin—there was some quasi–spirituality there. He was one day away from being a priest. His works are icons. But the great thing about Flavin, and Sol LeWitt, was the humor. Sol LeWitt said his early grids were jungle gyms for his cats.

RG: Right, right.

DG: And Flavin, Flavin tried to combine [Vladimir] Tatlin and [Albert] Speer.

RG: I still kind of don't understand the spirit of rejection of Duchamp with you and like, [Robert] Smithson too…The aristocratic position of—the ironic position, you were against that, or, in favor of sporadic humor…

DG: No, I think Duchamp was a smart guy. [Francis] Picabia told him about Raymond Roussel. He learned about [Frederick] Kiesler, the great architect, so he was a smart clever operator in certain ways. And, I think on the West Coast he was important because there was a show in Pasadena. And he influenced [Robert] Morris, who took many of his ideas from him—for instance, the mirrored cube pieces—and Bruce Nauman.

RG: Nauman, of course, yeah.

DG: Although Bruce's biggest influence was Simone Forti. In other words, in the West Coast I think Duchamp had a very important influence. Here, we actually despise the guy. In terms of Minimal art, Sol LeWitt comes from [Giorgio] de Chirico and [Alberto] Giacometti—those were his favorite artists. For Carl Andre, it was [Constantin] Brancusi and Agnes Martin. And I think Duchamp had absolutely no influence in New York. But I think on the West Coast he certainly did.

RG: Yeah, I know for me—not to talk about myself—but it took me back to…well, to Roussel. And I know you had some interest in Roussel in the early period when you were writing.

…

DG: My musical hero is Ray Davies. His birthday is June twenty–first, and he always calls himself Ray, so this is a little… [Shows diagram.]

RG: The diagram is…can you explain it?

DG: Well….I just made it up. It's a sun, it's about high and low, and it's basically Ray identifying himself with the sun. A little "Ray" of sunshine.

RG: Yeah, it's quite beautiful.

DG: But I want to say when I encountered your work, you were at Simon Fraser University. You were doing a performance in a ravine.

RG: You were one of the few people to see it.

DG: Yes. As you know, I'm a great fan of Flavin, so light is very important. When I saw your work, I thought Michael Heizer looked very conservative and really not very interesting. [Laughs.] Because in this ravine there was a huge generator with a flash of light illuminating the ravine. I thought it was first very Canadian; secondly, it was totally about the forest but it was also very modern. So it was Flavin, with generators. Power generators. And it was just a flash of light. For me, it was a big improvement over Michael Heizer and those Land artists.

RG: Yeah, I mean the influence—there was this influence of serial—not serial music but Minimal music and drum music that I know…

DG: In other words…

RG: It's a connection to you as well. And theater.

DG: You mean La Monte Young.

RG: Yeah. Mm–hmm. I'd never actually seen a La Monte Young performance but I knew of it and I was thinking of that, and also some of the earlier Steve Reich pieces that I know you connected with.

DG: Mm–hmm.

RG: Violin—is it Violin Phase? Or…

DG: Drumming—Come Out. But I have to say that…

RG: Come Out. Yeah, sorry.

DG: But I have to say that Steve Reich, even though the work was very structural, comes directly from Terry Riley. And phasing comes from Terry Riley.

RG: Mm–hmm, yeah.

DG: And then, Steve Reich picked it up; he was in Anna Halprin's dance group. Bruce Nauman, I think, picked it up from that dance group, and I was very influenced by Bruce Nauman in phasing. But Steve Reich was a close pal. The thing is, his work is more Jewish. He was very involved with African drumming. But maybe, because you're Anglo–Saxon, you're not a Jewish person interested in black culture. [*Laughs.*]

RG: What? I'm not?

DG: No. You're more interested in Glen Campbell.

All: [*Laughs.*]

RG: Yeah, well, that's another story. I just want to talk about Vancouver next. I mean your connection with Canada. You started with [Nova Scotia College of Art and Design (NSCAD)] in the early 70s, right? Where you met Duane Lunden and Jeff [Wall]—but you knew Jeff before that, right?

DG: No, no. Duane was a student of mine.

RG: A really good artist, but he gave it up early.

DG: He was dating an amazingly inspirational and lovely woman, Charlotte Townsend. Charlotte had a small gallery that showed me. And actually [*laughs*], when I went to Nova Scotia College of Art, David Askevold did a course called "Projects," where he invited Conceptual artists to submit projects that the students would realize. At that time I was very influenced by Bruce Nauman and Michael Snow, but I had no money. So, I submitted projects that could be realized with video and film equipment, which Nova Scotia College of Art had.

RG: Mm–hmm.

DG: So, in other words I invited myself up there to realize projects. I also used the situation to do a lot of performance things that were totally about learning processes. And I even appeared on Canadian television with my computer–dating service, which I offered through an advertisement in the local newspaper. So for me, who never—I never went to college...

RG: Yes...

DG: ...So to actually be a professor at Nova Scotia College of Art was important. Back then

they were doing lithographs by artists and they invited people who came very briefly and left. So I had two ideas. One was instead of lithographs they should do monographs by artists of artist/writers.

RG: Yeah. And then...

DG: And Kasper König wanted to publish some books, so I invited him up there to do the program. But the titles of Steve Reich, Simone Forti, Shulamith Firestone were pretty much my titles. And then I had this idea of teaching the first three weeks and the last three weeks of a series. I had as teachers people who had never taught before, like Jeff Wall, Martha Rosler, Dara Birnbaum. So, in fact, I influenced the school's program. Duane was my connection to Jeff Wall. When I was in Documenta, Jeff contacted me and because he was close friends with Duane, he spent a long time in the Documenta show.

RG: Yeah.

DG: And it was Jeff and Ian Wallace who got me out to teach in Vancouver.

RG: I met Duane toward the tail end of his truncated career, since he kind of dropped out of art–making; but I still see him around. I see him every Wednesday in fact, at a bar that I go to. He'd kind of gone into political activism and labor organization, things like that.

DG: Mm–hmm.

RG: He did some really great work. He was in that Lucy Lippard show.

DG: Well, he was...

RG: He was kind of influential to a lot of people in Vancouver.

DG: He was very influenced by [Ludwig] Wittgenstein. But that's kind of the Vancouver interest in British things.

RG: And in Vancouver you were invited by Jeff and Ian as part of the visiting artists program I remember, in the later 70s?

DG: Mm–hmm.

RG: I guess that's when I first met you, when you were lecturing at the art school...

DG: Well, Ian organized a whole series of lectures and approaches to the work. So from a heuristic point of view, what he did was brilliant. Jeff—I just did one talk with Jeff—Jeff was in an interesting situation. Because at that time he was a Marxist–Trotskyist. He was invited to

I invited myself up there to realize projects. I also used the situation to do a lot of performance things that were totally about learning processes.

Well, we had a utopian idea, when I had my gallery, that we could defeat monetary value in art.

teach at Simon Fraser, where there had been a student riot. So they wanted somebody with a Marxist background, and also degrees, to teach there. So it was a very good time for Simon Fraser. It was also like CalArts, in the middle of nowhere.

RG: He brought people like Martha Rosler and Bruce Barber out as well.

DG: Well, those people he met at NSCAD when I got him his teaching job there. The other great thing about Jeff then, he had lived in England. And his wife knew Malcolm McLaren, and actually he was deeply influenced at that time by Roxy Music, Devo, Pere Ubu. So it was a time when rock music for Jeff was pretty important.

RG: Mm–hmm.

DG: And for me also.

RG: Well, yeah, I mean our band...

DG: Mm–hmm.

RG: We had UJ3RK5, it was kind of—you know, influenced by you. Again, this is kind of Dan Graham plus Devo, you know.

DG: Mm–hmm.

RG: You kind of galvanized us into musical activity. Your lectures on the New York punk scene and on—actually, I wouldn't mind going back to talk about the stuff in '69, the popular essays on Dean Martin and on the Kinks.

Drawing reproduced in *End Moments*
(New York: Dan Graham, 1969)

DG: Mm–hmm.

RG: Like, what made you move in that direction? The Dean Martin essay is incredible.

DG: Well, I did two pop–oriented articles—one was "Eisenhower and the Hippies"; that was almost in *Arts Magazine* but it was turned down. And the Dean Martin article was also turned down, so it wasn't published until '68, although I did it much earlier. And actually I gave it to Dan Flavin. Flavin, who tried to combine low television culture (because he loved television) with German opera, the high and low. Flavin was so intrigued with it he tried to—he introduced me to Heiner Friedrich, to maybe be part of the Dia Foundation. [*Pause.*] But the first article I wrote actually was for the School of Visual Arts magazine, I mean newspaper, which Joseph Kosuth, who was a student in '68, asked me to do. It was a review of a concert by the Seeds, Vanilla Fudge, and the Byrds. It was called "Holes and Lights." When I came into art I wanted to be a writer. And I was very influenced by Leslie Fiedler, the American writer. I found that the best writers in America were writing for rock magazines. So that's why I started doing rock–and–roll writing.

RG: Yeah, you talked in one interview about how Pop artists were taking elements of popular culture and turning them into painting, and you were kind of short–circuiting that into the popular magazine context...

DG: Well...

RG: Hence, you know, the normal–sided reception, and hence, not making any money at it.

DG: Well, we had a utopian idea, when I had my gallery, that we could defeat monetary value in art. After I showed Sol LeWitt's work in wood, Sol said it should be used for fire-wood. And also, when he did his first grids he said they were jungle gyms for his cats. People forget that Sol was hilariously funny. And also I think, as a Jewish artist, Sol and I and [Robert] Mangold—who was the first person who was a big supporter of my work—we were very influenced by [Roy] Lichtenstein, not [Andy] Warhol. The thing about Lichtenstein was that he said in interviews he wanted to subvert painting by putting cheap printed matter on painting. Well, it turned out it became valuable. Flavin also wanted his work to go back to hardware stores after exhibitions. So, when that didn't work, I decided I would put things directly in magazines, which meant that they were hybrids. They were art, magazine pages, and also criticism. And

also they were disposable, they had no value. And all that work, like *Side Effects/Common Drugs* [1966], comes directly from the Rolling Stones.

RG: "Mother's Little Helper," yeah.

DG: "Mother's Little Helper." But it also comes from trying to do a Larry Poons/Roy Lichtenstein–like work as a piece in *Ladies' Home Journal*.

RG: The Dean Martin one seems like a kind of a rehearsal for later video work—and performance work like *Lax/Relax* [1969] came right out of that.

DG: Yes. Well, *Lax/Relax* is a favorite piece of mine. You see, in the 60s, every two weeks there was a new religion, like the Primal Scream—which you people now, the new generation, call yoga, but they're all about breathing exercises pretty much. For instance, the Bahá'í religion was very important for Roger McGuinn of the Byrds, whose original name was Jim, but the Bahá'í cult he belonged to said he had to change his name to a better sound, so it became Roger.

RG: You performed it again, didn't you? With Japanther? Like a remix? I think you should do a whole album of remixes of it.

DG: No, no, no. That was a performance at Tonic. I also did it at Lisson Gallery.

RG: That was the original performance, right?

DG: No, the original performance was actually done at Nova Scotia College of Art. And my performer was Charlotte Townsend, who did the "lax"—it was at the mezzanine at Nova Scotia College of Art. It was—I know, you Vancouver people think you're hip.

RG: You did it in—I think you did it in Vancouver once, didn't you?

DG: I don't remember.

RG: I have a big recollection you did it at the Vancouver Art Gallery, but that could be a false memory. The old Vancouver Art Gallery. I don't know why, but was it specifically out of this kind of duet between Dean Martin and his special guest Caterina Valente or something?

DG: Uh…

RG: I just kind of imagine that.

DG: No, it's pretty much out of Steve Reich because it's about phasing. It's also about the breathing exercise—but it comes out of

Dean Martin, anyway. All these movements were about relaxation. Whereas Dean Martin was too lax. Because he was Italian. So lax was bad, because America is a puritanical country, whereas relax is good. So it was also about American puritanism.

RG: Did you read the Nick Tosches book about the dirty business of dreams?

DG: Well, I read his big book about Dean Martin, which I didn't like.

RG: That's it. It's called *Dino: Living High in the Dirty Business*.

DG: It's a terrible book, a bad book casting doubts about Dean's reputation.

RG: I don't think it was so bad. I liked his thing about…

DG: It was only about gossip.

RG: …connecting to Bing Crosby and Elvis. You know, Dino as the missing link between Bing Crosby and Elvis.

DG: To me personally, my first interest in Dean Martin was from *Breathless* by Godard, where [Jean–Paul] Belmondo says he's imitating Dean Martin in *Some Came Running*. And actually, my favorite Dean Martin film is *Kiss Me, Stupid* with Kim Novak, by Billy Wilder.

RG: The Billy Wilder film, yeah. He basically plays himself.

DG: Yes.

RG: The character's named Dino, I think.

DG: But…[*Pause.*]

RG: Let's see, I'm going to talk about our Vancouver connection.

DG: Uh–huh.

RG: Oh yeah, I want to talk about homes first—*Alteration to a Suburban House* [1978], that was the piece that kind of really had a big influence in Vancouver, I think. That was the first piece you made a model of, right?

DG: No—yes…

RG: No?

DG: No. What happened was, I had a…

RG: But I remember seeing it in Vancouver…

DG: Yeah.

RG: And one of the first times you came, you spent a lot of time talking about it.

DG: In 1976, I did a piece in the Venice Biennale "Ambiente" show called *Public Space/Two Audiences*, and it was a very successful piece. I thought the Venice Biennale was basically like a world's fair, and every country had a pavilion. And every country had an artist who was symbolic of that country. There was a Gilbert & George show at the British Pavilion which was in that Georgian building above the Canadian Pavilion?

RG: Mm–hmm.

DG: And you got tote bags, Gilbert & George tote bags, so I thought because I'd done an early video time–delay piece for two showcase windows, I thought the people themselves, the spectators, should be inside a showcase situation looking at themselves perceiving each other. In other words, my work is always about the spectator—but the piece worked because it was a white cube. One side was a white wall, the other a mirror in the other room. I've always been against the white cube, which I thought was a very dumb idea. Two years later, at the Oxford Museum of Modern Art, the curator Mark Francis wanted me to do a show, so I designed a show of ten architecture models. I'd seen a show at Leo Castelli Gallery of architecture models by the New York Five Architects, so I thought, why shouldn't artists do architecture models? I thought also they could be propaganda for getting pieces actually done. And they could be fantasy situations. So half of the show, the pieces were things like *Clinic for a Suburban Site*, *Two Adjacent Pavilions*, and *Video Projection Outside Home* [all 1978], which were suburban fantasy projects. And the other half were pavilion sculptures. These later got done. The first one was at Argonne National Laboratory in Illinois [1978–81], and the second one was for Documenta, *Two Adjacent Pavilions*. So it was propaganda. *Alteration to a Suburban House* I think was hugely influenced by Michael Graves, the architect. Graves cut away an existing suburban house. And that's what [Gordon] Matta–Clark, me, and Frank Gehry took from him. I was also trying to combine [Ludwig] Mies van der Rohe's Farnsworth House with [Robert] Venturi's suburban work. And I think also—I have to say this politically—Jimmy Carter was very important for me. Because when he said he was in favor of ecology, he prompted the idea that we shouldn't make products but instead make things by taking away. So I took the Mies van der Rohe "less is more" notion literally. I cut away—and of course that piece, *Alteration to*

a *Suburban House*, is like the Venice Biennale piece *Public Space/Two Audiences* in that there's a mirror. There's a mirror dividing front and back.

DG: And also the piece, unlike what a lot of people are writing, the piece was actually not revealing, it was actually like a post–World War II Los Angeles house, a ranch house, because the picture window became one window. And actually it reflects on its mirror the house façades across the way, which is very much like Venturi—composition by inflection. And secondly, it doesn't so much reveal people inside, it reveals the people walking between the houses. In other words, in that space you're revealed then. But it's really a play on combining both Venturi and Mies. I always try to put together two things that shouldn't go together. And it was never realized. But I think there was a real relationship to Matta-Clark's *Splitting*, but Matta-Clark's work deals with houses that were built after World War I, along the railroad, whereas mine deals with post–World War II highway culture. And of course that relates very much to California. Jeff said it was the end of Conceptual art, because I was a Conceptual artist. I think basically…

RG: What, making the pavilions, in general?

DG: No, Jeff says *Alteration to a Suburban House* is a critique and attack on Conceptual art. Which I don't agree. I don't think it was. The pavilions come out of the models I did for that Oxford show. I do think we have a huge disease happening. All artists want to be architects, like Vito Acconci, and all architects want to be artists, like Gehry. I wanted to do something which was on the edge, between art and architecture, a hybrid. Which is actually what all my work has been.

RG: I just want to ask you about one piece that really kind of, I don't know, had a big influence on me. *Public Space/Two Audiences*, the '76 piece. One is in the Herbert Collection, I've seen that piece several times.

DG: That was in the Venice Biennale.

RG: Yeah. Because where did I see—that's where I saw it, yeah.

…

DG: That was the one, it was very successful, but I critiqued it myself. Because I took that white wall, I turned that into a window. And then it became architecture. And this is how I generated *Two Adjacent Pavilions*, which is actually

almost the same thing as *Public Space/Two Audiences*, except it's in a real suburban setting.

Chrissie Iles: [*To Rodney.*] Why was this work such an influence on you?

RG: Oh, I just always just thought it was so incredibly paradoxical, like how the effect was obtained, I could never quite get my head around it. Just the idea of turning a visual infinite regress into a kind of temporal infinite regress. It's kind of fascinating and it's super-paradoxical, it's really a successful piece for that.

DG: Well—this is very important because all my work is a critique of Minimal art; it begins with Minimal art, but it's about spectators observing themselves as they're observed by other people, so about the perceivers themselves. And all my work became about temporality. I think Minimal art is static, but I got very influenced by Steve Reich, La Monte Young, and also yes, drugs—I did inhale…

RG: [*Laughs.*]

DG: And also my work eventually became baroque, became a baroque critique. Because as you move, everything changes. The body changes, and it's a time situation.

RG: You know, I just think that piece is a particularly successful integration of that time aspect.

DG: When I was at the Venice Biennale I designed it that way so many—because there would be people in the two rooms and they'd be trying to communicate to people in the other room, like this [*makes a motion*], because in Italy people are very rhetorical. So, it was really designed very much for that situation, in Venice.

RG: Can we talk a bit about the *Wild in the Streets: The Sixties* [1987] into the *Don't Trust Anyone Over Thirty* [2004], the genesis of that one? When you first discussed that piece with me years ago in Vancouver, you told me about it. You were working on it with Marie-Paule Macdonald.

DG: Well, I hired her, actually. Chris Dercon was working for Flemish television, and there was this idea to do it at the Brussels Opera House, mini operas, which would be live on television and also at Brussels Opera House.

RG: La Monnaie it was called, that opera house? In Brussels?

DG: I don't know. And it had Aldo Rossi; James Coleman actually gave me his time frame. I didn't actually know anything about opera. But I knew there was this thing called a "rock opera."

I hated *Tommy* but I liked "A Quick One, While He's Away" by the Who in their earlier album, *A Quick One (Happy Jack)*.

RG: Mm-hmm.

DG: So, the idea of doing a rock opera was very appealing to me. I was also interested, because it was going to be live on television, to use in the stage set a kind of a rustic-hut go-go cage. Because go-go cages were very important on television shows like *Hullaballoo*, *Top of the Pops*, as a stage set. The rock-and-roll group would perform inside a go-go cage. So I adapted *Wild in the Streets*, which was a teenage film where a twenty-four-year-old rock star becomes president, has the voting age and also the age for being president lowered to fourteen. The first thing he does is he moves to the country White House, Camp David, because this was the time when hippies were moving to the country. He does his press conferences inside a rustic-hut go-go cage, which comes from Laugier's rustic hut. And actually he puts everybody—this is from the film itself—everybody over thirty has to go to a concentration camp where they are given LSD in their drinking supply. One thing I knew about opera—though I knew very little about it—was that they always took from popular sources. So I thought *Wild in the Streets* was a good popular-film source. It's also very much a part of the development of all my work about rock history, like *Rock My Religion* [1982–84], that had to do with rock-and-roll and hippie culture. But it was about the end of the hippie—I also did a poetic article called "Country Trip."

RG: Yeah, that's familiar.

DG: So, it was from that period. It was the period of the first Neil Young album. And then I enlarged it to be a rock-and-roll puppet show because it wasn't produced originally, and then it was finally realized at the Miami Art Fair and the Walker Art Center and Berlin and Vienna. It's really historical.

RG: Traffic. I mean in an English/British context the band Traffic getting it together in the Berkshire countryside…

DG: Well, Neil Young, the Byrds, and my favorite group the Seeds, come out of that period. But it was actually—what I was interested in was the costuming. So I hired Marie-Paule Macdonald because she did this amazing work called *Night Club for the Rolling Stones*. So I asked her to do the stage set and some of the costuming. I disagreed with her costuming, so when

I finally did *Don't Trust Anyone Over Thirty*, I did the costuming of the puppets myself. And it's very different from what Marie–Paule was doing. But I like collaboration, and I think she's very brilliant—her *Night Club for the Rolling Stones* project was pretty amazing. It was finally put out as a book, I wanted it to be a pop–up book, but they didn't have enough money so there's only one pop–up in the book.

RG: But in the final puppet version, you brought Japanther in to perform.

DG: Mm–hmm.

RG: And then of course I did one song, or two songs.

DG: Mm–hmm.

RG: I never got a chance to see it, because you know, it's difficult to travel. Isn't that right? It's expensive to mount?

…

DG: Mm–hmm.

RG: Maybe. Maybe not.

DG: Japanther was a Williamsburg, Brooklyn, band, and they were suggested by my old as–sistant, Teresa Seeman, who by the way did a lot of writing on the project. She did a lot of work on the script. Tony Oursler did some amazing videos. Although he was not a major player. I did the costuming and the people who were doing the puppets are the best in the business, and…

RG: Are you doing a project with Japanther, you're doing a pavilion? Or…

DG: Oh, yes. Japanther was invited to perform at Performa, the RoseLee Goldberg series, and they asked me to design a pavilion where they would perform. I did it very fast, but it's very similar to the work I'm doing now. It's a parallel–ogram. I'm using perforated metal. One side has perforated metal here with big holes, and the other, perforated metal with very small holes, and then on the diagonal is two–way mirror glass. So when they perform there people can get very close. They can look through the holes, they can get close here.

RG: Oh, let me see them.

DG: See these [*flipping pages*], similar to this. But these are small, small holes. So when you walk around you get moiré patterns. It's a little like a disco, and of course it's re–reflected on the two–way mirror glass, so the audience is reflected also. They can get very close, but

basically it's both psychedelic and disco com–bined. And I did it very fast. It can travel, and actually now I'm doing a pavilion for this Sonic Youth exhibition, they asked me to. I have two months to do it. I've designed a situation where you can listen to music tapes. And also it's using this perforated metal situation. See, I always try to combine two–way mirror glass with either wood or perforated metal. But again it goes back to this whole go–go cage concept. Of course, I don't have a girl in the cage. But the go–go cage is pretty important. But I have to say, when I did my *Octagon for Münster* [1987] there's a wooden pole which little children can rotate around, and of course I saw a Jerry Springer show where women in the audience come up and they use the pole. [*Laughs.*]

RG: A new direction for you.

DG: Mm–hmm.

RG: Dan, in your very early work you were very interested in the idea of Reichian therapy and movement. For some reason I see some kind of possible connection there but I don't know whether that's true, but you…

DG: Well, it wasn't…

RG: Well, I was thinking of it in terms of your more recent work in pavilions, it's kind of like pleasure pavilions and a possible methodology of healing rather than say, one of demystifica–tion, which your earlier work in the mid–60s relates to…

DG: Now, I agree. I was into Reichian therapy myself—also Marcuse's idea of desublimation. I think the work is becoming more influenced by Impressionism. It's located so people can lie down. Actually the first piece, *Two Adjacent Pavilions*, there was room for two people to sleep inside, in fact many students did this, and four or five people standing up—but always you have to lay on the grass. And actually the work is a photo opportunity for parents and a funhouse for children. But I think, to me, Georges Seurat is very important. He showed the working class spectators at circuses as the audience, I think he's much more interesting to me. I also love Gustave Courbet. I once hated Impressionism, but now—I'm like Christine Burgin, she's ob–sessed with the nineteenth century, and I am also. My hero is Thomas Eakins, my work comes very much out of Frederic Church. So I think the Hudson River School was very important for all of us.

RG: That Seurat drawing show, I wish I'd seen that show.

I took that white wall, I turned it into a window. And then it became architecture.

I think the thing we should talk about most…is the fact that my early conception of so-called Conceptual art was anarchistic humor.

DG: It was great.

RG: I have the catalogue, very beautiful. But in terms of a kind of popular culture, have you ever looked at—I was looking at with Christine, at some of the [Alfred] Jarry's publications *L'Ymagier* and *Perhinderion*, these publications where he combined, kind of, high art with *Épinal* prints, this interest in reviving wood-block prints that I suppose he got from [Paul] Gauguin, they're really incredible. Jarry, he was the first kind of high-low guy, I would say, the first in the nineteenth century, to kind of—you know, to have this kind of interest in popular imagery, and to incorporate it into this context—*L'Ymagier* was just like a collection of images with very little text. A mixture of like—it would be like [Albrecht] Dürer wood cuts mixed with so-called *images d'Épinal*, kitsch religious imagery, it's incredible.

…

DG: No, I'm not so much of a scholar. I just pick and choose what I see. But I think leisure time is very important to me. And I think I was influenced by Jean-Luc Godard's *Le Weekend*, and of course for me the notion of the edge of the city is very important. T. J. Clark talks about how revolutionary the emerging petit bourgeois class was, and about how [Vincent] Van Gogh's best work was on the edge of the city; in other words, the edge of the suburbs, near to the city. My *Homes for America* are about this. And I think Jeff Wall picked up on that in his work later.

RG: Mm-hmm.

DG: But, I guess you're more of an image-maker.

RG: [*Pause.*] Me?

DG: Yes.

RG: Oh. And you're more of a sculptor.

DG: I don't—no, I do pavilions. It's not sculpture.

RG: You couldn't call it sculptural? I mean, what about making models yourself?

DG: I don't do that anymore.

RG: Why not? I mean, they're beautiful.

DG: I basically do fast sketches, fax them to my architects, we do a site visit, and then they bring one or two possibilities for glass. In other words, I used to like to make these little models, but I don't think it's necessary now. In fact, I don't even have to select the glass. I have two architects, who know how to pick the type of two-way mirror glass.

RG: You used to carry it around with you.

DG: What?

RG: I remember you carried plexiglas and glass.

DG: Yes. Well, that was to impress the client. In other words…

All: [*Laugh.*]

DG: And also, they could actually see it on site. But now my career's doing so well that people actually trust me. At that point they would trust anything. And of course, the idea is you always have to have the client think that they have something to do with the design. [*Laughs.*]

All: [*Laugh.*]

RG: So you are an architect?

DG: What?

RG: You are an architect.

DG: Almost. But I think the thing we should talk about most, which is why I relate to your work so much, is the fact that my early conception of so-called Conceptual art was anarchistic humor. I think it was closer to Stanley Brouwn and On Kawara—and also my pavilions are very influenced now by [Claes] Oldenburg. They're parodies, like the *Yin/Yang* [1997–98] and *Star of David* [1991–96] pavilions.

RG: I was going to ask you about parody, actually—about the importance of that in your work.

DG: Well, I think I want to emphasize now the Jewishness. And I think the importance of Roy Lichtenstein is that he actually was doing, in a way, a political critique. He said he showed the violence in the media, so he's like the Ramones, and Benjamin Buchloh told me he was a conservative. He wasn't. And what I'm trying to do is subvert, but not sociologically, corporate buildings and corporate culture. But the program is not to critique corporate culture but make it, like you said, into a pleasure situation.

RG: Mm-hmm.

CI: Is there a connection then between your being drawn to Rodney's work, and Lichtenstein?

DG: Well, I don't see the connection. I think maybe the connection is more in this sense, I'm more connected to Sigmar Polke. And,

actually, Gerhard Richter told me his hero was Roy Lichtenstein. To actually think all of these German artists were very influenced by Lichtenstein, in a certain way. I think Warhol is magnificent as a painter, and some of his drawings are great, but as a Conceptual artist he's very overrated. But he's not a Conceptual artist—I think he's got a shtick. It's called "death." And I think death sells.

RG: Mm–hmm.

DG: His work is very dead.

RG: Are you talking about him in the Dean Martin essay though—that was kind of an interesting quote. About television making people more uncomfortable...

DG: Mm–hmm. Well, actually, in the Dean Martin...

RG: ...than film or theater, for example.

DG: Yes. Well, actually both of them are taking from Bertolt Brecht.

RG: Exactly.

DG: At that point I was a Brechtian, but now I'm against Brecht.

RG: Yeah.

DG: I think Brecht took a lot from the Russian critic, [Viktor] Shklovsky. In other words, making things strange.

CI: What about John Wesley? I noticed you have a John Wesley print.

DG: John was the husband of Jo Baer. Jo had a huge influence on me. I think in some ways she was more brilliant than Judd in her writing. She wrote for *Aspen* magazine. She was a personal influence on me, and her then–husband John Wesley was the best friend of Judd, and he was also a close friend of my friend Kasper König. He actually gave the painting to me. I guess I didn't understand the work until later. The other biggest influence on me, actually, is Robert Mangold. Mangold was the first person to be interested in my work. He was a teacher of Joseph Kosuth, who used to stalk me, and some of my pavilion forms come from Mangold paintings. The other thing about Mangold is the work is really much—it's a lot like Lichtenstein because it's kind of bland but it's about sunsets, in a certain way, so it has a kind of Jewish humor about suburban blandness. It also comes from [Josef] Albers. But it also has this Libra thing about balance. It's highly intelligent; I think he's a very great artist. The other

person who supported me early was Marcel Broodthaers.

CI: Really?

DG: I know, for John Gibson Gallery I showed *Side Effects/Common Drugs*. Herman Daled, my first collector, went to New York, bought it for five hundred dollars, and he brought it back. And then Broodthaers was his advisor. I think he loved *Side Effects*...

RG: He bought all the magazine pieces, Daled?

DG: Well, yeah.

RG: The original magazines?

DG: No, no. He asked me for my four most important pieces. So I suggested four of those pieces.

RG: Did he have all the original magazines that you collected of...

DG: He had a lot of them. But, actually, most of those magazines, I was going to do an edition with an Italian person, Pio Monti, so I bought all the magazines and sent it down to him. Pio Monti didn't understand the work, so apparently he threw out everything. So it didn't exist. But Belgium is very important because the most important gallery I showed with was MTL Gallery. He showed Marcel Broodthaers, [Daniel] Buren, and also [Andre] Cadere and Fernand Spillermaeker. He also showed Stanley Brouwn, who is one of the greatest artists ever, whose early work I really liked.

RG: Yeah, I can see that. Belgium though, was where kind of got my first start, and that was because you had kind of spoken of my work to Yves Gevaert.

DG: Oh, your dealer, Christine Burgin, had even more close relations with Belgium.

RG: Mm–hmm. Yeah, for a time.

DG: Well, you were in her first gallery, which was a pretty amazing gallery.

RG: Yeah, I just walked by there the other day, on Lafayette.

CI: Dan, what did you mean when you said you were against Brecht now?

DG: Well, I really turned against Brecht. I think that's...

CI: Why?

DG: It's simplistic. It's a very old idea—and also Brecht took a lot from Shklovsky. I think Russian Formalism is more important than what Brecht

did. And I think Brecht is now—he's overrated. I think he was very important for a while. But I think his relation to other people, like [Erwin] Piscador, may have been more important.

RG: Mm–hmm.

DG: I wrote about this movable theater that [Walter] Gropius and Piscador did. I think Brecht was only one of the important people. Russian Formalism is more original—Shklovsky, [Tzvetan] Todorov, you know those great literary critics from the late nineteenth century...

RG: The theater designs you did—like, for example, for the theater garden project.

DG: Well, that was based on my *Cinema* model. I think I discovered a little bit later the wonderful architect Johannes Duiker, who did Handelsblad Cinema in Amsterdam. So it's very much about house architecture in a certain sense.

...

DG: But don't you think it's important for an artist not to be just a professionally trained art–school artist, but to have another passion?

RG: Of course.

DG: Yes. And I think—I believe in passionate hobbies. And I think most of my art is—my photographs are basically a hobby. A passionate hobby.

RG: Yeah. You spoke about amateur photography often, and your dislike of so–called high–art photography. Does that still hold? Is it holding?

DG: Well, I found one photographer who I really dig. His name is Wolfgang Tillmans. I can really dig that work.

RG: Yeah, of course. I really like his work.

DG: Mm–hmm. I think that Ed Ruscha took photographs for fun. And he made his books for fun.

RG: Wasn't it a bit of a revelation for you, discovering amateur photography?

DG: No.

RG: No? Train to back home?

DG: It was the only thing I could afford, a cheap camera. And, actually, Robert Smithson had a salon, and he invited people to his house, at galleries. I told him about Carl Andre, Sol LeWitt, Dan Flavin, and, actually, I showed the slides I took in New Jersey at his salon. I think this idea of going to New Jersey to take photographs was influenced by me at the time. But I was

very influenced by Smithson in one way: he was interested in Mannerism. So, often these photographs of housing projects, they're in leftover spaces—and, for example, they would put a housing project at the edge of a cliff which led down to a railroad track, so the perspective was forced. Also, I was interested in Judd's use of transparency. So these photographs, I showed them as slides, as transparencies. And actually, sometimes it was near sunset, you could have the sunset and also pollution in the air, making it up. For Mangold or Judd, it was a very simple thing to do. Of course, I was very unconscious about what I was doing. I was lucky to show them in an exhibition called "Projected Art" at Finch College's Museum of Art/Contemporary Study Wing. It was an assistant editor, Susan Brockman at *Arts Magazine*, who at that time was the girlfriend of Mel Bochner, who got very interested in the work and commissioned *Homes for America*, as well as other projects. It was a time when everybody was writing for *Arts Magazine*, and I think that had a lot to do with Susan Brockman.

RG: What did you show in the recent show at Hauser & Wirth?

DG: Two new pavilions, new models, new photographs I took of New Jersey, as well as old photographs, and also this wonderful edition I did which I have to show you, *Two-Way Mirror/Work for Hedges* [2004]. It was by Edition Jacob Samuel. It sold absolutely nothing, because all of my editions don't sell. But I'll show it to you. And I put that in the show also. It's a very difficult space. But I think the work actually works there fairly well.

RG: Ian Wallace asked me to ask you why you called the show "More of the Same."

DG: I don't remember why. I think it could be that I was very influenced by Zürich being the city of Fischli and Weiss. So it has a kind of bland, a kind of blasé humor.

RG: Mm-hmm. Other question from Ian. He asked me to ask you about the future of the avant-garde. That was a connected question. I spoke to him on the phone yesterday and I asked him if he wanted to convey a question to you. That was it.

DG: Well, I was just in Poland with a close friend of mine, Anka Ptaszkowska. She kept saying she's for the avant-garde. So I said, "Anka, well we've had it with the avant-garde." And she said that was too bad. So I think more and more this avant-garde is getting diluted. And

its trendy new gimmicks. I'm not really involved with avant-garde. [*Pause.*]

…

CI: When did you two first meet?

DG: When Jeff Wall, who was teaching Rodney at Simon Fraser—actually Jeff had a group of people in downtown Vancouver at the studio there. This was Ken Lum, Rodney Graham—who else was it?

RG: Well, Stan Douglas, but he wasn't in that scene, he was at the art school.

DG: No.

RG: Ken was kind of the central character in a way.

…

DG: But the fact is, I have to say this: I'm a super fan of Rodney's work.

CI: What do you like about it?

DG: I like that it's context and humor. I thought a work that I never saw but which was very important for me was *Vexation Island*, because again, the Canadian Pavilion is rustic—it's like a little rustic cabin at the foot of the British Pavilion. And what Rodney did was he went to the Virgin Islands, which is kind of a travel paradise, and said all these artists were making films—like Robert Longo, Cindy Sherman. He wanted to hire the best advertising filmmaker, and he wanted to be the actor. Which I thought was a brilliant move. But also it was so contextual to that Canadian Pavilion.

RG: That was important for me, that piece.

CI: And what drew you to Dan's work?

RG: Well, I first met Dan—I mean I knew of some works early on like *Homes for America* actually through Jeff, because that was such a huge influence—that piece, on him. His landscape manual, a lot of his thinking came out of that. I knew some work, but I was kind of more galvanized by him as a speaker, and as a lecturer. And he was somebody who brought a lot of the outside world to Vancouver, in a way, as a visiting speaker. He talked about, you know, music and things like that that weren't really discussed that much at that time, in the context of art-school lectures, even though I was kind of auditing at that time. I was in and out of the education system as an older student. Those works were really influential. But it was kind of more as a teacher when I first met him, and as a friend of a friend. Yeah.

DG: In the beginning I was interested in—everybody was interested in—the instantaneous here and now. And I think Lawrence Weiner still says he wants his art not to be about history but to be about the here and now, so that you can see things as they really are. In other words, it's the instantaneous present-time idea, which is a 60s phenomenological idea—it's very dated. I got very involved in Walter Benjamin's notion of the importance of focusing on the just past. And I see Paul McCarthy' and Rodney Graham also dealing with resurrecting this just past, which is the *real* historical, which in fact is more revolutionary than the neo-60s or neo-70s. And I particularly like Paul McCarthy's work, redoing Jeff Koons work about Michael Jackson with Bubbles, because I think Paul was dealing with the 80s rather than the neo-60s.

RG: Mm-hmm.

DG: So, I think the historical references—it's not historicism, it's pretty much what Walter Benjamin used to talk about, about the just past being important…

RG: That's something that's repressed by the idea of modernity or recurring…

DG: The fashion system.

RG: The fashion system, yeah.

DG: It also falsifies history. I think that the neo-60s design-artists, as well as the Neo-Conceptual artists who are being pushed, are basically just kind of rehashes of work that's more complex. And I think there's too much simplification going on.

RG: I mean, everybody's rehashing of seminal 60s Conceptual works. Something that's, like—been done in my day.

DG: Mm-hmm.

RG: It's kind of a way of learning the ropes, too, but it can be…

CI: But both of you are also very influenced by English rock music and things English. Why is that?

DG: No, I'm not.

CI: You're not?

DG: I was many years ago.

RG: Oh, it's over now?

DG: Oh no. I don't like—look, Rodney and I have big disagreements. He liked a group called St. Etienne, who I think is kind of fatuous and easy.

RG: [Laughs.]

DG: Whereas I turned Rodney on to my heroes, L.A. Psychedelic, the Seeds, Love...

RG: That's true.

DG: And of course this is what we rock-and-roll aficionados—we like to have discussions.

RG: Do you know about this book, this group that has been—a book came out about them recently. This family—the Source? It's a group called the Ya Ho Wa 13.

DG: Hunh-uh.

RG: Apparently they did a talk here recently. It's like a commune led by a guy named Father Yod who started the first health food restaurants in America. Do you know this guy?

Gary Carrion-Murayari: There was an article about it somewhere.

RG: Yeah. I read the book that's written by this woman named—I can't remember, a cult member. But he was a member of this kind of L.A. bohemian group that included Jack LaLanne and the guy who wrote "Nature Boy," that guy Eden [Ahbez], and they were kind of naturist West Coast kind of proto-hippies in the late 40s. And, he started this very successful vegetarian restaurant. And he used it as a kind of recruiting base for his cult. He started you as a dishwasher, and then you kind of moved up. He ended up living with 150 people in a three-bedroom house in, like, in the Hollywood Hills. And Sky Saxon of the Seeds was involved. He played in the band.

DG: Well—I thought you were getting into this.

RG: What?

DG: Thurston says he changed his name to Sky Sunshine Saxon?

RG: Sunlight, yeah.

DG: Sunlight.

RG: Yeah.

DG: And actually Thurston said he was in a cult where they believed that dogs were gods.

RG: Well also...

DG: So it's the same cult, right?

RG: This guy, you'd be really interested, he said Santa Claus was God. And there's a big difference...

All: [Laugh.]

RG: And he looked like Santa Claus, this guy. And he has this long white hair. And he's sitting in the lotus position and dressed in a Santa Claus costume with all these like young women around, kind of sitting cross-legged at his feet kind of worshipping him. It was incredible. This guy was really—and he died, you know how he died? He decided he wanted to go skydiving. When he moved the cult to Hawaii after there was some kind of like...

DG: Yes.

RG: There was some investigation.

DG: Mm-hmm.

RG: And he wanted to go skydiving and he never dived before, and I think he was in his early 60s, and he just jumped off this cliff and died. And there's pictures—there's pictures of him, like, leaping. This is Father Yod, taken by the phone, this is Father Yod leaping off the cliff, and then you see these shots of him lying on the ground.

CI: [Gasp.] No!

RG: And he—you know, he died several hours after that. It was a strange story, I'm telling you.

DG: The thing about the Seeds, was the Doors come directly from the Seeds. Daryl Hooper's organ is imitated by Ray Manzarek.

CI: Hmm...

DG: The Seeds were an amazing group.

RG: Yeah.

DG: But, some of these people who were LSD casualties have almost recovered. Thurston Moore is playing with Roky Erickson now.

RG: Really?

DG: Yes.

CI: You're also into English music...

DG: No, that was billions of years ago.

RG: You were never drawn to Syd Barrett, for example.

CI: But you were drawn to the Kinks.

DG: The Yardbirds, the Kinks, the greatest group now, the Fall. I saw the last Joy Division concert, so there was a period when Manchester music was very important for me.

RG: Mm-hmm.

DG: Also, I was a friend of T. J. Clark when he was teaching at Leeds, and his students were

I think the historical references—it's not historicism, it's pretty much what Walter Benjamin used to talk about, about the just past being important...

Esquire magazine used to have articles about how alienating the suburbs were by sociologists, and then...a very well-known photographer would take glossy photographs.... And what I was trying to do was actually parody the whole idea.

the Mekons, Gang of Four, and Scritti Politti. And I love the early Mekons.

RG: Mm–hmm.

DG: Gang of Four was pretty good, but then it became a little bit too obvious. But these are people not from London, very much, but from provincial cities.

RG: Yeah, of course the Fall's from Manchester too, right?

DG: Yes. And also Joy Division. And I changed my mind on the Buzzcocks. I think they're more power pop than punk.

RG: Oh, completely.

DG: Yes.

RG: But the Fall, I just—I kind of lost the program with them in the 80s, and I've just been listening to some of their stuff, and it is incredible...

DG: I know.

RG: The dance stuff. Also the new Von Süden-fed, with Mouse on Mars.

DG: Mm–hmm.

RG: That's really amusing. But yeah, I've got a lot of catching up to do when it comes to Mark E. Smith. He's really brilliant.

DG: Mm–hmm.

CI: Rock-and-roll music, which is so important for both of you, has traditionally been separate from the art world to a certain degree, even though the reality might be different.

DG: Not true.

CI: Not true?

DG: In the 70s, Richard Prince had a rock group; Robert Longo had a rock group. All the artists had rock groups then.

CI: But it's never been noticed by the art world.

DG: That's because you have a stupid press. You have *Artforum*, *October*. These are people who are not artists writing. Certainly Mike Kelley is writing. And he's into rock music. I think our best writer, one of our best artists, John Miller, plays rock music.

CI: There's an artificial division. Because of the high-low thing.

DG: No, but this is not true among artists.

CI: Right.

DG: This is only true of these magazines.

RG: Yeah.

DG: And of course, sometimes artists play at—like Lawrence Weiner plays with some rock—some musicians, but I don't think he has that deep an interest or knowledge. And of course Jeff repudiates anything to do with music now. But *Rock My Religion* is basically about what happened in the 70s in New York where performer–artists had rock groups and they performed in these very small places. Like Tier 3 in New York. And I think the art world as a community—I think we began playing in a community situation, as a kind of a way to get away from the business aspect of the art world.

RG: Mm–hmm.

DG: See, Andy Warhol in the 80s thought art was only business. And certainly Richard Prince really changed from the 70s to the 80s.

RG: I didn't know about his music, Richard Prince. I didn't know about his music. He had a band?

DG: Yes.

RG: What were they called?

DG: I didn't see them. But Kim and Thurston are close to Richard Prince. Thurston Moore is doing a new book about New York New Wave, and it has photographs of everybody. Thurston asked me to locate all of the audio tapes I made of concerts, live concerts, where he played. But, see, Thurston is a music historian.

RG: Mm–hmm.

DG: And I think the problem is that the way that these celebrity shows—Chris Dercon did a really bad show of Patti Smith's paintings, celebrity painting.... But I think the Sonic Youth show is going to have their friends. In other words, it's going to have Tony Oursler, Mike Kelley, my work, Richard Prince, and also Kim's own paintings will be not be overly emphasized.

RG: Where is this show?

DG: It's organized by Corinne Diserens and a young curator from France. It's going to be in a new space in Brittany, France, where it begins in two months, then it goes to Bolzano, then it's going to go to Kunsthalle Düsseldorf, where Ulrike Groos is in charge.

RG: Sorry, I'm just nodding in agreement. You know.

DG: But, of course, I actually like—I also like rock

stars' paintings. I think they're really funny. I particularly like Tony Bennett.

RG: He's one of the more technically adept, though.

All: [*Laugh.*]

DG: Jerry Garcia is the worst.

RG: Yeah, the worst.

DG: Yeah.

All: [*Laugh.*]

RG: Let's see, Sinatra was pretty bad, but you could never say no when he would give them away. And...

DG: And Bob Dylan! I've always had a favorite Bob Dylan album, and Rodney has discovered it.

RG: Yes.

DG: *Self-Portrait.*

RG: Yes.

DG: It's his Dean Martin move.

RG: Yeah. That's an excellent album. And it has one of his better paintings on the cover.

All: [*Laugh.*]

CI: Rodney, what's your favorite album?

RG: Hmm, that's really tough. Actually, you know, my current favorite album is that first Crazy Horse album. The solo album.

DG: No, I haven't seen it.

RG: You must have. With Jack Nitzsche—oh, it's really awesome. You must have that, you must have that.

DG: No. I got very disillusioned by Neil Young.

CI: Why?

RG: Because of Crazy...

DG: No, because his early work was so good. The first album was amazing. But then he got to terrible albums like *Harvest.* And most of his stuff is pretty bad now.

RG: Yeah, I have to say it doesn't interest me too much.

DG: Although Crazy Horse as a live band is pretty amazing, so—they could do amazing things.

CI: What's your favorite album, Dan?

DG: Probably *Something Else by the Kinks.*

RG: I love Bob Dylan. Well, you talked a lot about that in your essay "Live Kinks," in "Last of the Steam-Powered Trains" the central...

DG: That's because—well, it wasn't an essay, it was a...

RG: A reverie, or a...

DG: It was a live concert.

RG: Right, right. [*Pause.*] Oh, right! Of course you gave the concert listed in there. But you did speak a lot about those. I send you my—you might have an affection for that album.

DG: That was their last album for Warner Brothers.

CI: There? The album over there?

RG: *The Village Green Preservation Society?* [*Moving away from the microphone.*] Yeah, I have it down here. It's a really awesome album.

GC–M: What's interesting about this album?

RG: Exactly.

GM: It's rooted in history, and also I think the suburbs quite a bit too.

RG: It was a bit of a flop at the time too, I think.

DG: Yes.

RG: For that reason.

DG: Well, that's because it was a period of psychedelic music. And people thought the Kinks were very unhip.

RG: Yeah. And they were kind of wearing it on their sleeves as well. Defiantly. But I think it's an album that's being reappraised, obviously. It's one of the—you know...

DG: Oh—my other favorite album is probably *Forever Changes* by Love.

RG: Yeah.

DG: Love is one of the—we rock-and-roll writers have favorites. Our favorites were the Velvet Underground, Love, the Byrds, the Kinks, those probably were the greatest groups. And maybe early Neil Young, but he really doesn't compare to the Byrds.

CI: You know Dan, you were talking about *Edge of the City.* The lyrics here are very, in an English kind of way, very suburban.

DG: Yes.

CI: "God save china cups and virginity..."

DG: Yes.

CI: "God save Tudor houses, antique tables, and billiards."

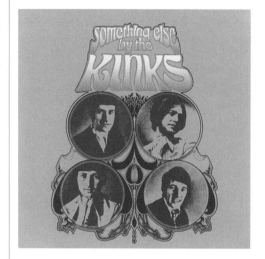

Cover of The Kinks' *Something Else by the Kinks* (1967)

DG: Mm–hmm.

CI: "God save preserving the old ways from being abused. God save the Village Green Preservation Society." This is very petit bourgeois.

RG: Mm–hmm.

CI: It's an interesting connection of the two, something like *Homes for America*. This is an English *Homes for America*, in a way.

DG: Well, first of all, that came out—*Homes for America* actually was very influenced by the songs "Nowhere Man" by the Beatles and "Mr. Pleasant" by the Kinks. It was much earlier. In fact, it's a parody, *Homes for America*. It's not—I hate sociology—it's actually anthropological. And it's a fake think piece. It's a fake. It's a total parody. And Buchloh says it's critical of Conceptual art—it's not. It's also not serious. It's flat. It's a little like Flaubert, in many ways. I was influenced by Robert Pinget and Michel Butor. Very influenced by Butor and also by Godard. Also it's about the city plan, which all my work is about. [*Pause.*] But that was a great cliché. *Esquire* magazine used to have articles about how alienating the suburbs were by sociologists, and then a good—a very well-known photographer would take glossy photographs of the—Bill Owens, people like that. And what I was trying to do was actually parody the whole idea. And there's a kind of flat-footed humor in *Homes for America*.

RG: Yeah.

DG: But, what I like actually is multiple references. And Rodney's work has multiple references. For example, he told me his series A Glass of Beer is influenced by [Edouard] Manet's *The Beer Drinker* and also by Frans Hal's *Beer Drinker*. But mostly it's influenced by these mirrors that you find in bars, with a rock group.

RG: Well, rock mirrors and then also just beer ones too.

DG: And beer ones.

RG: Yeah, that wasn't exactly a popular item. People didn't—I don't think people get it or something.

CI: It's very English.

RG: Uh–huh. Yeah, I was thinking really like, Bass Ale.

CI: Yeah, exactly.

DG: Oh, speaking about Englishness and class, one of my favorite pieces of yours, the one I want to show now for "Deep Comedy,"

which is now coming this summer to Marian Goodman Gallery. I want to have *City Self/Country Self*.

RG: Oh, really?

DG: That, to me, is a much better piece than the one you put in. Because I think it's hilariously funny. So I'm right now trying to work on the show to grab the best work. I don't know.

RG: That'd be great.

DG: I know. It's also not so well known. But this is a very English…

CI: It is.

DG: …piece.

CI: Yep. Well you both understand Englishness.

RG: Mm–hmm.

DG: It's also about—one thing we didn't show, it's about slapstick. Right?

RG: Yes, exactly.

DG: Like Buster Keaton or [Charlie] Chaplin.

CI: Film's important to both of you in different ways. I mean mainstream cinema, or cinema in a larger sense.

DG: Oh, speaking about my favorite film soundtrack, recently, *The Darjeeling Limited* by Wes Anderson. It has three wonderful Kinks songs.

RG: The film is really good?

DG: It's—yes—it's the best Wes Anderson has ever done.

RG: I didn't like—I preferred the last one. The…

CI: *The Life Aquatic*?

RG: *Life Aquatic*, yeah. [*Laughs.*]

DG: Oh yes.

RG: I thought it was more off the wall, and I don't know—oh, and the music was very good. In the new one.

CI: Dan, you talked about Godard, and Rodney you've done work referencing *Zabriskie Point*. Cinema's important to both of you.

DG: Well, first of all, my favorite filmmaker is not Godard. My favorite filmmaker is Elio Petri, who did *The Tenth Victim*, Italian—*Working Class Goes to Heaven*. And I also love Billy Wilder and [Carl Theodor] Dreyer pretty much. And Billy Wilder is so important to me.

CI: Why?

DG: Because the work has Jewish humor. It's also about culture—I think he was the greatest director ever, Billy Wilder. And Dreyer made some great films. And [Roberto] Rossellini made great films, particularly the series he did on television about history…

RG: Mm–hmm. *The Rise to Power of…*

DG: *The Rise to Power of Louis XIV.*

RG: …*Louis XIV*, yeah that was great. You know what film I really like, I think you were talking about it once the first time I had a conversation with you, is *The Billion Dollar Brain*.

CI: Oh, yeah.

RG: I just bought a DVD of it. It was actually quite hard to get.

CI: Yes.

RG: It's an awesome film. Incred—you know that film? The first film of Ken Russell?

DG: No.

RG: It's the third one in the trilogy. '67, yeah, the third one in the Harry Palmer trilogy of…

CI: It's amazing.

DG: I also love—I also love Nicolas Roeg.

GC–M: The porn…

DG: Well, no. The best film—actually the last film that he did that I saw was about sexual decadence in Romania just before the revolution. I forget the name of it; it was an amazing film. It was Channel 4. Also *Don't Look Now*, with Julie Christie, that was pretty amazing.

RG: Yeah, that was an incredible film.

DG: But I don't see that many films. I'm basically—what I see a lot of, and Rodney doesn't get, is country and western television.

CI: [*Laughs.*]

DG: No, I love country and western. I think Merle Haggard is the greatest.

RG: Yeah, yeah, I know.

DG: But also, there's a new female country and western singer, who has a new song called "Sunday Morning." It's actually the Velvet Underground song, she said her husband had Velvet Underground albums and she found it on one of her husband's albums. So actually country is now merging a lot with punk and rock music.

RG: So you watch country television?

DG: Yes, mm–hmm.

RG: [*Moving away from the microphone.*] I'm looking for something. Let me see if I can show it to you. Dylan's...

DG: I don't have too much Dylan here—speaking about Bob Dylan, I don't know if you've seen the Courbet show?

RG: No, I wanted to...

DG: Well, there's—the [Nicolas] Poussin show is absolutely great. And Courbet was a Gemini like Dylan, and all his self-portraits are all different aspects of his personality. He's a chameleon, Courbet.

RG: Yeah, I've heard the show's incredible.

DG: Well, even better is the Poussin show.

RG: Another story. So I won't be seeing that show, on this trip. In fact, I guess I won't be seeing it unless I can see it tomorrow. The Courbet—the Poussin is there at the Met, too?

CI: *Origin of the World* is in the Courbet show.

DG: Well, but—I think the most important thing is a painting that T. J. Clark wrote about. *A Man Killed by a Snake*. Which is amazing.

RG: Yeah.

DG: That book is so amazing. You know, T. J. Clark's book called *The Sight of Death*?

CI: Mm-hmm.

DG: You've read it?

GC-M: It's fantastic.

DG: Yes.

GC-M: The painting.

DG: Yes. Although he should not do poetry.

GC-M: [*Laughs.*] I know.

DG: But, Rodney, you went country for a while, right?

RG: Well, I'm—my new record is very country.

DG: Yes.

RG: In honor of your interest in country. Yes, but I have a lot of pedal-steel guitar and mandolin and stuff.

DG: Mm-hmm.

RG: It's actually influenced by one of the first kind of very country-rock albums of the late 60s: the John Phillips solo album, *The Wolf King of L.A.*—awesome.

DG: Mm-hmm.

RG: It's quite amazing actually. It's a beautiful record.

CI: Huh.

RG: It's a bit ahead of the curve.

DG: I think my favorite song—there's a song that I recommended to you, which is by the Mamas and Papas—was "For the Love of Ivy."

RG: Oh yeah, yeah, yeah.

DG: Did you find that?

RG: Yes I did, yes.

DG: This is because Rodney is friends with a young girl called Ivy.

RG: Yeah, she's here.

DG: Yes? [*Laughs.*]

RG: Yeah, you might get a chance to meet her again. And Shannon [Oksanen] and Scott [Livingstone]'s other daughter, Honor.

DG: Mm-hmm. I think that we're both involved in a production of—not avant-garde music, but music that everybody—there's something there for everybody. And, the great thing about working with Japanther, is that Ian [Vanck] and [Matt] Reilly are continually learning things. They're particularly big fans of Rodney. Even though when they began, they began as punk. The recent concert I saw in Marfa, they were doing things that sounded like the Ventures. So inside that...

RG: Really?

DG: Japanther. And in fact the Ventures, Ian said, was one of the first garage band groups.

RG: Are you working with them on a new—they wanted to do a new puppet show with you.

DG: No, they did their own puppet show, which *The States* is for. They would love to perform—Ian is from Olympia, and they would love to perform with Rodney, but Rodney is under such deadline situations, and his life is so chaotic that sometimes—that it hasn't happened.

RG: No, it would be great.

DG: Mm-hmm.

RG: I wanted to play with them here but then I ended up—because I had Lois from Olympia, who plays in my band.

DG: Mm-hmm.

RG: I thought it was more appropriate that she had opened that...[*sigh*]. Yeah.

I think that we're both involved in a production of—not avant-garde music, but music that everybody—there's something there for everybody.

CI: Dan, you talked about—we talked about that book, the origins, the Jewish origins of punk.

DG: Yeah, it was called *The Heebie Jeebies at CBGB's*.

CI: CBGB's, yeah...

RG: Oh, this is the—who wrote the book?

CI: Umm...

DG: I don't have my copy now.

CI: I can't remember.

DG: I think I sent it to Paul McCarthy. I didn't send it to you?

RG: Is it somebody from the scene who wrote that book, or is it...

DG: Yeah.

RG: I heard—maybe you told me about it. Yeah. Anyways.

CI: It's interesting, I think. We were talking about that—the idea of punk emerging out of this Jewish, first gener...

DG: No—New York punk.

CI: Was it Canadian punk? No.

DG: Yes. Yes.

GC–M: Was there a scene?

RG: Oh, yeah. Lively. In fact...

GC–M: DOA?

RG: DOA and of course the power–pop groups like the Pointed Sticks. And your favorite, the Modernettes.

DG: Mm–hmm.

RG: What a brilliant band. And also...

DG: Well, you forgot the Young Canadians.

RG: The Young Canadians. Hawaii.

DG: "Let's go to..."

Both: [*Speaking simultaneously.*] "...go to fucking Hawaii."

All: [*Laugh.*]

CI: What's the difference between that scene and the New York punk scene, you think?

RG: It was...

DG: We don't have...

RG: ...earlier. The New York scene and the Vancouver scene were very, very influenced by British punk and everybody sang with fake British accents, and...

DG: But, the best group that I think, who are now performing, the group that I took Kim Gordon to see when I was introducing her to rock music, was the Feelies.

RG: I know she had a Feelies...

DG: What?

RG: I know she had something out here, a Feelies record out there...

DG: Yes. They to me are better than Television, live, but their records aren't as good as they were live, and they're reforming. They're real nerds, from New Jersey. **DG**

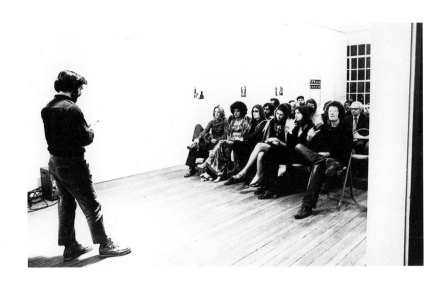

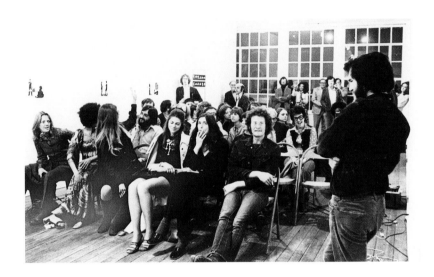

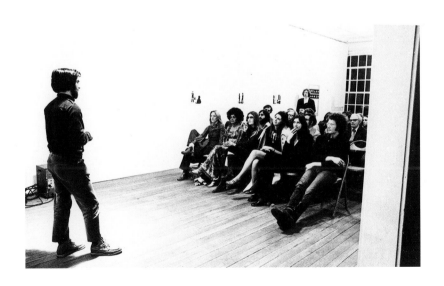

Graham performing *Intention Intentionality Sequence* (1972),
Protetch–Rivkin Gallery, Washington, D.C., 1972

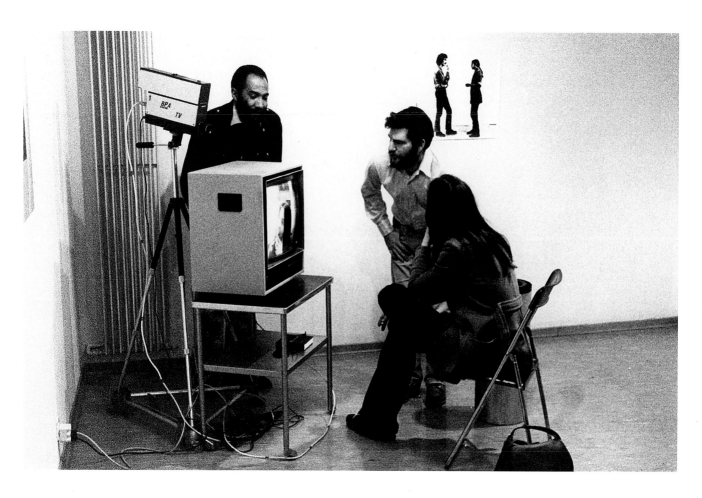

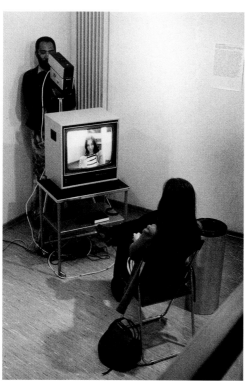

Performance of *Two Consciousness Projection(s)* (1972)
at Galerie Rudolf Zwirner, Cologne, Germany, 1973

NUDE TWO CONSCIOUSNESS PROJECTION(S)

A nude woman focuses consciousness only on a television monitor image of herself and must immediately verbalize (as accurately as possible) the content of her consciousness. A nude man focuses consciousness only <u>outside</u> <u>himself</u> on the woman, observing her objectively through the camera connected to the monitor. The man's and the woman's self-contained conscious, unconscious, or fantasized intention — <u>consciousness</u> — is projected.

As the performer's projections in the first (clothed) version of "Two Consciousness Projection(s)" imply a (covert) sexual dimension, it was decided that the piece be modified to be performed by a nude male and a nude female. Observation of one's own or another's naked body entails a different level of phenomenological experience and description.

The initial performance of this version was at Nova Scotia College of Art, Halifax in January, 1975.

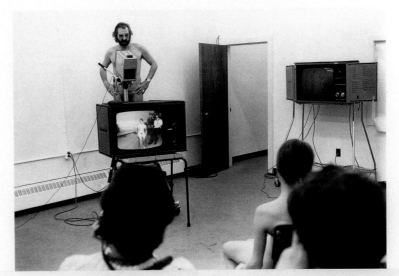

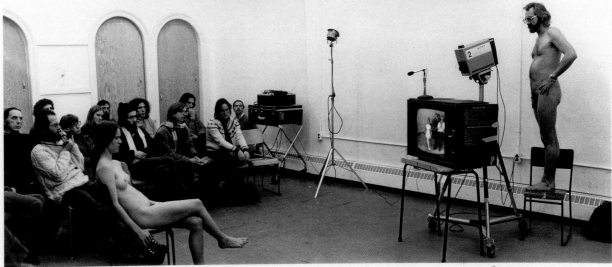

Nude Two Consciousness Projection(s) (1975)

Minimal Difference:
The John Daniels Gallery and
the First Works of Dan Graham

Rhea Anastas

Minimalism begins but does not end with such figures as Carl
Andre, Dan Flavin, Donald Judd, and Robert Morris. It is both
continued and completed with the emergence of a series
of distinct artistic positions that revise, contextualize, and
expand its aesthetic and critical orthodoxies, positions we
now associate with the art of Mel Bochner, Dan Graham, Eva
Hesse, Sol LeWitt, and Robert Smithson. This condition of
simultaneous continuing and ending can be observed in its
initial historical context. The period during which such revi-
sionist responses to Minimalism were formed, starting around
1965 and lasting through 1968, is nearly coincident with
Minimalism's own condensed emergence and canonization
from 1963 to 1968.[1] That these responses are equally artistic
and critical, and may in fact collapse such descriptions, is an
effect of Minimalism's proper qualities of aesthetic position-
taking and difficulty—a difficulty that Annette Michelson
described positively as "concrete reasonableness" in 1967

Notes **1.** This is the chronology of Minimalism that James
Meyer recently proposed. Meyer's Minimal group
includes Carl Andre, Dan Flavin, Donald Judd, Sol
LeWitt, Robert Morris, and Anne Truitt, as argued
in his *Minimalism: Art and Polemics in the Sixties*
(New Haven, Connecticut: Yale University Press,
2001). Meyer's is the first book-length historical
scholarship based on extensive primary research
to focus exclusively and narrowly on Minimalist
practice and discourse in the field of the visual
arts in its original moment. Its chronological
method allows us to see the distinction between
Minimalists such as Judd and Morris and the
younger Dan Graham and Robert Smithson, et
al. Meyer included LeWitt among his primary
Minimal "generation" comprising six artistic posi-
tions, while I consider LeWitt within another set
of positions, those of Graham, Smithson, Eva
Hesse, and Mel Bochner, among others, whose
work emerged slightly later in exhibitions and
publications and which I take to be character-
ized by revisionist qualities that both respond
to and separate from Minimalism. This "Minimal
difference" reflects that artistic generations are
heterogeneous and include lateral or peer-to-peer
associations as well as more hierarchical or verti-
cal kinds. Meyer's study is notable as the first
narrative of Minimalism to include social analysis
within its account of the art world of the 1960s
based upon a relational theory of the artistic field
and an attention to social practices after, variously,
Michel Foucault and Pierre Bourdieu.

Graham at the opening of "4D," John Daniels Gallery, New York, 1965

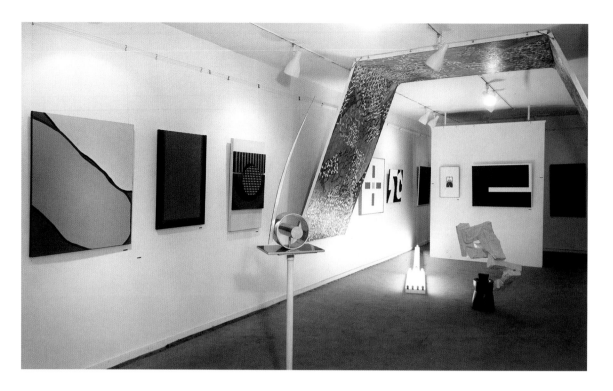

fig. 1
View of the inaugural group exhibition at John Daniels Gallery,
New York, 1964

and that Michael Fried evaluated negatively as "ideological" later that same year.[2] Thirty years later, James Meyer assessed the same quality as relational: "We come closer to the truth in viewing Minimalism not as a movement with a coherent platform, but as a field of contiguity and conflict, of proximity and difference."[3]

In this sense, Graham's art begins with a formative encounter in the Minimal field involving such artists as Judd, Smithson, LeWitt, Flavin, and Jo Baer. The scene of this encounter—or, to put it in precise historical terms—this event, was the short-lived contemporary art gallery John Daniels Gallery. Graham was the director of the gallery, which was located at 17 East 64th Street in New York, and worked there with gallerist David Herbert.[4] The Daniels Gallery was inaugurated in late 1964 (fig. 1) and operated for a period of roughly six to eight months through the summer of 1965.[5] This essay focuses on an underconsidered aspect of the artist's development: the gallery's influence upon the work he conceived beginning in 1965.[6] The short history of John Daniels Gallery suggests the ways that the historical difficulty

2. By "critical" I mean "of criticism," responsive to art discourse and enacted in art discourse, as well as critical in the ways we attribute critical qualities to visual artworks. For "concrete reasonableness," see Annette Michelson, "10 x 10: 'concrete reasonableness,'" Artforum 5, no. 5 (January 1967): 30–31. Michelson's text was a review of the artist-organized exhibition "10" (held at Dwan Gallery in New York, 4–29 October 1966) of the work of Andre, Jo Baer, Flavin, Judd, LeWitt, Agnes Martin, Morris, Ad Reinhardt, Smithson, and Michael Steiner. The exhibition traveled to Virginia Dwan's gallery in Los Angeles, 2–27 May 1967. Michael Fried's

charge of Minimalism's "ideology" can be found in his "Art and Objecthood," Artforum 5, no. 10 (summer 1967): 12–23; reprinted in Minimal Art: A Critical Anthology, ed. Gregory Battcock (New York: E. P. Dutton, 1968), 116–47. What was then seen as its difficulty is now also seen as its complex relationship to discourse. In 2003, Rosalind Krauss characterized Michelson's response to Minimalism in her review of the exhibition "10" in this way: "In January 1967, Michelson eagerly reviewed an exhibition that her colleagues at Artforum shunned from a sense of its difficulty, its closure against the universe of discourse. This was '10 x 10,' an exhibition at the Dwan Gallery...

the burgeoning movement of Minimalism which Michelson had embraced immediately upon her arrival. Her review spoke of this difficulty and the way it had produced the vocabulary of dismissal in the early critical literature, as words such as 'rejective,' 'aggressive,' and 'boring' were applied to it." Krauss, preface to Camera Obscura, Camera Lucida: Essays in Honor of Annette Michelson, ed. Richard Allen and Malcolm Turvey (Amsterdam: Amsterdam University Press, 2003), 9. Contemporaneous authors who noted Minimalism's relationship to discourse, especially in the role of artists' writings, included Lucy Lippard, Karl Beveridge, and Ian Burn (see

Beveridge and Burn's "Donald Judd," The Fox, no. 2 [1975]), as well as the artists who responded to this writing: Smithson, LeWitt, Graham, Bochner, and Baer among them. Two later articles offered definitive theorizations of these questions: Craig Owens's "Earthwords," first published in October, no. 10 (fall 1979): 120–30; and Hal Foster's "The Crux of Minimalism," in The Return of the Real: The Avant-Garde at the End of the Century (Cambridge, Massachusetts: The MIT Press, 1996), 35–69, first published in Individuals: A Selected History of Contemporary Art, 1945–1986, ed. Howard Singerman (Los Angeles: The Museum of Contemporary Art; and New York:

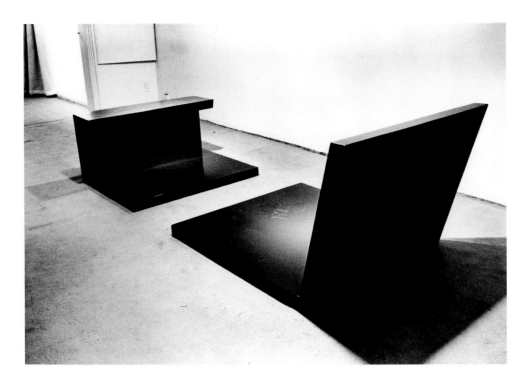

fig. 2
Sol LeWitt's *Double Floor Structure* (1964; no longer extant)
installed in "LeWitt," John Daniels Gallery, New York, 1965

fig. 3
Front and back of announcement card for "LeWitt."
John Daniels Gallery, New York, 1965

of Minimalism can be seen to have been lived concretely, that difficulty being one effect of a field that deserves analysis in social and material terms as much as intellectual ones. From its fictional name "John Daniels" (a composite of Graham's and a partner's name) to its various program and its truncated run of operation, the gallery experience proved perspicacious for Graham and, I speculate, marked his practice at its outset with ambivalence and a measure of disidentification with the usual relations of artistic genera-tion and mastery based upon an artist's connection to them by producing singular artistic statements. For Graham's encounter with the social practice of the gallery produced an insight into Minimalism's difficulty—that Minimalism's attention to context and criticism allowed for a character-ization of its scene of mastery in modernist painting and sculpture as a field of "positions" both discursive and social. As Howard Singerman wrote: "Minimalism cannot suspend the knowledge of an art world or of a professional discussion of art; rather it requires us to hold that discourse to make it present."[7] Lucy Lippard wrote that Graham "was then,

Abbeville Press, 1986), 162–83.

3. Meyer, *Minimalism*, 4.

4. Graham's major statement on John Daniels Gallery can be found in a text he wrote in 1985: "My Works for Magazine Pages, 'A History of Conceptual Art,'" in *Dan Graham*, ed. Gary Dufour (Perth: The Art Gallery of Western Australia, 1985), 8–13. According to Graham, Daniels Gallery was funded by Graham and two partners, John van Esen and Robert Tera—whose names were combined to make "John Daniels"—with the support of their families (Graham, interview with the author, New York, 11 April 2000). Graham said he held the title of gallery director, though it

appears that David Herbert also had some role in the Daniels Gallery, perhaps as the primary salesman. Herbert had a long and distinguished career in New York galleries—during the 1950s he had worked for Betty Parsons Gallery and Sidney Janis Gallery; he had his own gallery, David Herbert Gallery, from 1959 to 1962; and during the mid-to-late 60s he worked as a pri-vate dealer.

5. Based on the printed invitation cards found in the Daniels Gallery Archive (part of the Dan Graham Archives housed at the artist's stu-dio, New York), an exhibition history of John Daniels Gallery can be sketched: opening group

exhibition, 22 December 1964–23 January 1965 (list of artists not extant); Nobu Fukui, 26 January–13 February; "4D," group exhibi-tion with Mark di Suvero, Dean Fleming, Peter Forakis, Robert Grosvenor, Anthony Magar, Tamara Melcher, Forrest Myers, Edwin Ruda, Leo Valledor, and Carlos Villa, 16 February–6 March 1965; "Plastics," group exhibition with Leo Amino, Arman, Robert Cox, Sari Dienes, John Fischer, Irwin Fleminger, Forakis, Herbert Gesner, Chuck Ginnever, Greenly, Judd, Lila Katzen, Mon Levinson, Heinz Mack, Edward Meneeley, Jeanne Miles, Myers, Richard Navin, Uli Pohl, Lucas Samaras, Seamus, Smithson, Carlos Sobrino,

Robert Watts, and David Weinrib, 16 March–3 April 1965; Tadaaki Kuwayama, 6 April–1 May 1965; Sasson Soffer, "Ceramic Masks," 10 April–closing date unknown 1965; and LeWitt, 4–29 May 1965. The checklists for these exhi-bitions are not extant. See my catalogue entry for the Daniels Gallery in *Dan Graham: Works 1965–2000*, ed. Marianne Brouwer and Rhea Anastas (Düsseldorf, Germany: Richter Verlag, 2001), 88–89. In an interview with Eugenie Tsai, Graham dated the gallery-opening group exhibi-tion as early as October–November 1964. Tsai, "Interview with Dan Graham by Eugenie Tsai, New York City, October 27, 1988," in *Robert Smithson:*

WEINRIB FORAKIS

SMITHSON GREENLY

JUDE

SEAMUS MYERS

JUDD MACK

SAMARAS MENEELEY

FLEMINGER

SOBRINO **PLASTICS**

WATTS NAVIN

AMINO

CESNER LEVINSON

ARMAN KATZEN

COX

MARCH 16 TO APRIL 3, 1965 DIENES

GINNEVER

POHL

JOHN DANIELS GALLERY
17 EAST 64th STREET NEW YORK, N. Y. 10021 UN 1-6300

fig. 4
Announcement card for "Plastics," John Daniels Gallery,
New York, 1965

Zeichnungen aus dem Nachlass (Münster, Germany: Westfälisches Landesmuseum für Kunst und Kulturgeschichte, 1989), 8. I have not been able to document an exact opening date for the gallery, since there is so little extant material to work from, nor have I encountered documentation of any exhibitions before the "opening group exhibition," whose dates are written on the back of an installation photograph and also printed in the December 1964 issue of *Art News*. This memory of Graham's, taken together with the fact that the gallery may have stayed open into the month subsequent to the closing of the LeWitt exhibition (June 1965), though there is no evidence to

support a firm closing date either, leaves the exact duration of the gallery's operation unknown and explains my estimate of roughly six to eight months. Of course, the endeavor would also have required advance planning and some work to dissolve, perhaps further extending the project's timeline.

6. The first and most important text to treat Graham's 1960s work and the Minimal context is Benjamin Buchloh's "Moments of History in the Work of Dan Graham," in *Dan Graham: Articles*, ed. R. H. Fuchs (Eindhoven, The Netherlands: Stedelijk Van Abbemuseum, 1978), 73–78. This article was reprinted in Buchloh, *Neo-Avantgarde and Culture Industry: Essays on European and*

American Art from 1955 to 1975 (Cambridge, Massachusetts: The MIT Press, 2000), 179–201. Fuchs's introduction offers an important descriptive record of Graham's 1960s criticism written close to the period. Other important early articles on Graham's practice include Birgit Pelzer, "Vision in Process," *October*, no. 10 (fall 1979): 105–19; and Anne Rorimer, *Dan Graham: Buildings and Signs* (Chicago: The Renaissance Society of the University of Chicago, 1981).

7. Howard Singerman, *Art Subjects: Making Artists in the American University* (Berkeley: University of California Press, 1999), 177.

8. Lippard, "Intersections," in *Flyktpunkter/*

and probably is now, not sure he was 'an artist,'"[8] echoing Graham's stated ambition to be a critic during the 1960s. Given the autodidact artist's modesty—"seeing that I couldn't make art, I had to do something"[9]—Graham's revisionist artistic position took shape as a response to the Minimal field that was at once knowing of such a professional discussion and bore a distaste for the social authority of the critic that the Minimalist artist–critic might continue—an identity, we will see, that is reflected in Graham's best–known works of the 1960s, *Homes for America* and *Schema (March 1966)* (both 1966–67).

JOHN DANIELS AND DAN GRAHAM

Three group exhibitions and four solo shows were mounted at John Daniels Gallery during its single season of operation. The most important of these was a presentation of large wood structures LeWitt designed specifically for the gallery's domestically scaled rooms (figs. 2, 3), a space Daniels Gallery adopted from a previous gallery tenant, André Emmerich.[10] Each work was painted uniformly in a single deep hue of lacquer "to make the surface look hard and industrial,"[11] in LeWitt's words. The presentation was LeWitt's first solo exhibition. Group exhibitions at the gallery tested relationships between several not–yet–called–Minimal artists and other painters and sculptors of the day and included works by Judd and Flavin, among others. It was in the Daniels Gallery exhibition "Plastics" (fig. 4) that Smithson and Judd showed works together for the first time in a context which included Robert Watts, Arman, Forrest Myers, and many others and gathered recent work around the idea of materials new to fine art, such as resin and plexiglas. In the exhibition, Graham showed what turned out to be an important early Judd work, a red fluorescent plexiglas and stainless–steel floor box with interior wires, *Untitled* (1965, fig. 5), at a moment when Smithson's work was in a critical transitional phase. The piece, and the relationship with Judd that the Daniels Gallery exhibition materialized, proved catalytic for Smithson as well as for Graham (each artist wrote provocatively about Judd's untitled work).[12] Along with the LeWitt exhibition, Graham's most important decision at Daniels Gallery was to agree to work with Smithson in planning for a solo show in September 1965—over a year, if it had come to pass, before Virginia Dwan would give Smithson an important New York debut, this time as a sculptor.[13] Yet the Smithson exhibition never occurred due to the gallery's demise over financial difficulties.

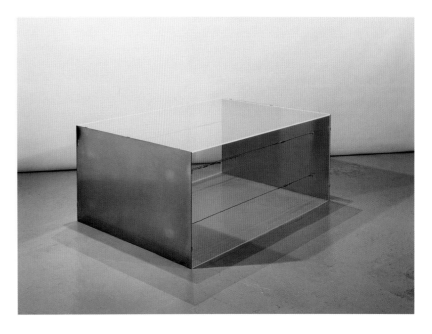

fig. 5
Donald Judd's *Untitled* (1965, DSS 58, one of two examples); stainless steel, transparent fluorescent red plexiglas, wires, and turnbuckles; 20 x 48 x 34 inches; private collection. Judd originally chose *Untitled* (1964, DSS 54, opaque turquoise pebbled plexiglas, hot–rolled steel, wires, and turnbuckles; 20 x 44 1/4 x 30 1/2 inches) for inclusion in "Plastics," but it was damaged during the course of the exhibition; Judd replaced it with the first example of the above work.

Vanishing Points, ed. Olle Granath (Stockholm: Moderna Museet, 1984), 12.
9. Graham, in Simon Field, "Dan Graham Interviewed by Simon Field," in *Dan Graham: Selected Writings and Interviews on Art Works, 1965–1995*, ed. Adachiara Zevi (Rome: Zerynthia, 1996), 76. First published *Art and Artists* 2, no. 10 (January 1973): 16–21.
10. Graham, interview with the author, 11 April 2000.
11. LeWitt, in *Sol LeWitt*, ed. Alicia Legg (New York: The Museum of Modern Art, 1978), 53: "The pieces I showed there were fairly large and simple slabs. Using lacquer, much work was

done to make the surface look hard and industrial. This was negated by the grain of the wood. They should have been made in metal, as some of them later were, but I could not afford it then."
12. Smithson, "Donald Judd," in *7 Sculptors* (Philadelphia: Institute of Contemporary Art, University of Pennsylvania, 1965), 13–16. Smithson reprised several of the passages of the essay in his later "Entropy and the New Monuments," *Artforum* 4, no. 10 (June 1966): 26–31. Graham, "Subject Matter," in *End Moments* (New York: Dan Graham, 1969), 15–30.
13. Graham had also promised the artist Leo

Valledor (a painter associated with Park Place) a one-man exhibition during Daniels Gallery's next season. See Tsai, "Interview with Dan Graham by Eugenie Tsai," 12. Smithson's first solo exhibition at Dwan Gallery was held in December 1966–January 1967. However, Smithson had two solo shows in New York and one in Rome previous to that one: an exhibition of paintings in 1959 at Artists Gallery; of assemblages in 1962 at Richard Castellane Gallery; and of paintings in Rome in 1961 at Galleria George Lester. Smithson considered his practice to have emerged in 1965–66 with his shift to three-dimensional works: see Paul Cummings,

"Interview with Robert Smithson for the Archives of American Art/Smithsonian Institution" (1972), reprinted in *Robert Smithson: The Collected Writings*, ed. Jack Flam (Berkeley: University of California Press, 1996), 284.

di SUVERO
FLEMING
FORAKIS
GROSVENOR
MAGAR

DANIELS GALLERY
17 EAST 64 ST. • N. Y. • UN 1-6300

MEYERS
RUDA
TAMARA
VALLEDOR
VILLA

FEB. 16 - MAR. 6, 1965

fig. 6
Front and back of announcement card for "4D," John Daniels Gallery, New York, 1965; and Graham (center) with friends at the opening

Still, the program at Daniels Gallery was hardly coherent. The animating ideas of the other group shows are not easy to assimilate to proto-Minimal aesthetics. The exhibition "4D" (as in "the fourth dimension"), for instance, arose from Graham's invitation to the artists of Park Place Gallery while that artist-run group was between spaces[14] (fig. 6). The show suggests the ways the emerging practices of the Minimal group might be compared to the Park Place cooperative group, especially its sculptors, whose aesthetics and cultural interests were not as defined by the formalist aesthetics of the day. The latter group included artists, such as Mark di Suvero, who were far better known than Judd or Smithson in 1965. This same comparison would ignite contentiously one year later in the context of the Jewish Museum's 1966 "Primary Structures: Younger American and British Sculptors."[15] More incommensurable aesthetically and conceptually with the work of the Minimal group was that of the painters Daniels Gallery featured in solo shows—Fukui and Tadaaki Kuwayama[16] (fig. 7).

In 1985, Graham published a text about his 1960s works that made a point of featuring a reflexive analysis of his Daniels Gallery experience. Notably, Graham defined Daniels Gallery and his perspective on the field exclusively in relationship to other artists:

I became involved with the art system accidentally when friends of mine suggested that we open a gallery. In 1964, Richard Bellamy's Green Gallery was the most important avant-garde gallery and was just beginning to show people such as Judd, Morris, and Flavin. Our gallery, John Daniels, gave Sol LeWitt a one-man show, as well as doing several group shows which included all the "proto-Minimalist" artists whether they already showed at Green Gallery or not. We had also plans to have a one-man exhibition of Robert Smithson—then a young "Pop" artist. However, the gallery was forced to close due to bankruptcy at the end of the first season.

If we could have continued for another two years, with the aid of more capital, perhaps we might have succeeded. Nevertheless, the experience of managing the gallery was particularly valuable for me in that it afforded the many conversations I had with Dan Flavin, Donald Judd, Jo Baer, Will Insley, Robert Smithson, and others who, if they were not able to give works for thematic exhibitions, supported the gallery by recommending other artists and by dropping in to chat.[17]

14. I am indebted to art historian Linda Dalrymple Henderson for her fine research on the Park Place Gallery group, which yielded these facts about their "4D" exhibition at Daniels Gallery. Her exhibition "Reimagining Space: The Park Place Gallery Group in 1960s New York" was presented at the Jack S. Blanton Museum of Art, University of Texas at Austin, 28 September 2008–18 January 2009. It was accompanied by a catalogue with an essay by Henderson, "Park Place: Its Art and Its History." See also her "Reintroduction" to her The Fourth Dimension and Non-Euclidean Geometry in Modern Art (Princeton, New Jersey: Princeton University Press, 1983; new ed., The MIT Press, 2009).

15. "Primary Structures: Younger British and American Sculptors," 27 April–12 June 1966, was organized by Kynaston McShine at the Jewish Museum, New York. The exhibition marked Smithson's debut at a New York museum and, though it was not the first museum presentation of Minimalist work, it served to catalyze Minimalism's reception through the exhibition's comparisons between American and British

Not only for Graham was the moment transformative. As told by one of the group's writer–members, Lippard: "In 1965, Hesse, Bochner, Graham, LeWitt, Smithson (and myself) were all at career turning points. LeWitt had his first show that year (at a gallery run by Dan Graham, who was then, and probably is now, not sure he was 'an artist.') I began writing criticism regularly in the winter of '64–'65; Smithson was making his plastic and mirror geometric sculptures which led directly into the work for which he became famous. Hesse began to make sculpture after limited success as a painter."[18] In turn, in a 1988 interview about Smithson, Graham narrated his and his peers' relationship as having been enabled through Daniels Gallery, which is also to say that he described Smithson's relationship to Minimalism, like his own, as shaped by social and interpersonal associations. Graham described their first meeting this way:

> I think it was late winter, early spring, in '65. He came into the gallery asking me to come to his studio to look at some work. Maybe friends of his were in the first big theme show we did in October–November. Perhaps a work of art was in the "Plastics" show. But he was really looking for good galleries to show with. He was completely unsuccessful and obviously ambitious. Something nice happened at the gallery, and I think Bob had something to do with it; people would come by just to talk, since we weren't selling anything or doing that much. Also, Bob was trying to make a connection with the Minimal artists we were showing, because he was very adaptable, in terms of influence. He wanted to have a show with a gallery and he wanted to make a connection to some of these artists in any social way that he could. Eventually he set up dinner–salon type meetings; he and Nancy Holt had just gotten married... He really liked the idea of a gallery group. We thought the gallery would continue and he was doing work for a one–man show, the first show of the next year, fall '65; he and Leo Valledor were definitely going to show.[19]

In contrast to Smithson, who had a studio practice and had been showing since 1961, Graham wasn't an artist "looking for good galleries to show with," but an artist who came to art through the social and intellectual context of a "gallery group"; somehow his visual practice followed. Smithson's own account shared an emphasis on the role of such lateral associations: "In 1964, 1965, 1966 I met people who were more compatible with my view. I met Sol LeWitt,

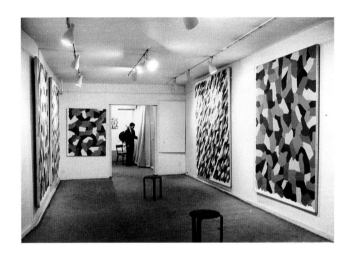

fig. 7
Front and back of announcement card for "Fukui," John Daniels Gallery, New York, 1965; and paintings by Nobu Fukui installed in the exhibition

sculpture and between work by artists associated with the Park Place Gallery and work by the emergent Minimal group. This catalytic role of the exhibition was evidenced in the critical and artistic responses to the show, which included such exhibitions as "10," an important review by Mel Bochner, and Fried's "Art and Objecthood," which can be read as a response to the gain in visibility of Minimalism during 1966.
16. The same could be said for the Daniels Gallery exhibition of Sasson Soffer's "ceramic masks." See note 5.

17. Graham, "My Works for Magazine Pages," 8. Graham's description of the substance of these art conversations is important, yet exploring these intellectual sources is beyond the scope of this essay: "In addition to a knowledge of current and historical art theory, some of these artists had an ever greater interest, which I shared, in intellectual currents of that moment such as serial music, the French 'New Novel' (Robbe-Grillet, Butor, Pinget, etc.), and new scientific theories. It was possible to connect the philosophical implications of these ideas with the art that these

'proto-Minimal' artists and more established artists such as Warhol, Johns, Stella, Lichtenstein, and Oldenburg or dancers such as Yvonne Rainer and Simone Forti, were producing" (page 8).
18. Lippard, "Intersections," 11–12.
19. Graham, in "Interview with Dan Graham by Eugenie Tsai," 12.

Dan Flavin, and Donald Judd. At that time we showed at the Daniels Gallery; I believe it was in 1965. I was doing crystalline type works and my early interest in geology and earth sciences began to assert itself over the whole cultural overlay of Europe. I had gotten that out of my system."[20]

In the published discourse of the period, the associations of the group accrue a different order of power as these expressions of ambition and possibility achieve the first marks of recognition. For instance, the following year, Smithson's first piece for *Artforum*, "Entropy and the New Monuments" (1966),[21] complexly reviewed and revised "Primary Structures"—an exhibition that included Smithson's work for the first time at a museum and was taken to launch Minimalism in the museum. The artist reproduced his own included work, *The Cryosphere* (fig. 8), among other installation views from the season's most important sculpture show. But he also recast the field according to his social world circa 1965–66, using the article to comment on the LeWitt exhibition at Daniels Gallery (a year after the fact) and publish one of its installation views. Though Daniels Gallery exhibitions were well received in the art press, this is the sole mention of the gallery (and LeWitt's first show) in *Artforum* during that time, and it reads as if to redress LeWitt's reception:

> LeWitt's first one–man show at the now defunct Daniel's [*sic*] Gallery presented a rather uncompromising group of monumental "obstructions." Many people were "left cold" by them, or found their finish "too dreary." These obstructions stood as visible clues of the future. A future of humdrum practicality in the shape of standardized office buildings modeled after Emory Roth; in other words, a jerry–built future, a feigned future, an ersatz future very much like the one depicted in the movie *The Tenth Victim*.[22]

A byline from the period captures the position and reputation Daniels Gallery secured for Graham: "Dan Graham Poet, art critic, and writer, he was Director of the John Daniels Gallery, New York, in 1964. During a brief and influential period, he introduced some important artists to the American public."[23] Raised in Winfield and then Westfield, both in Union County, New Jersey, Graham is an autodidact, having decided against attending college. His move to New York was motivated by the idea of pursuing work as a "poet, art critic, and writer," and there is little evidence of that goal being distinguished from the one (from hindsight one assumes) Graham already possessed of becoming a visual artist. Yet

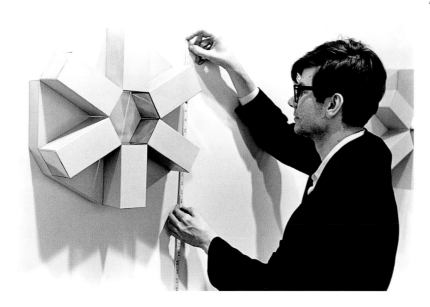

fig. 8
Robert Smithson with his *The Cryosphere* (1966); steel with chrome inserts; six units: 17 x 17 x 6 inches each; collection Camille Hoffman, Chicago; at the Jewish Museum, New York, 1966. Photograph by Fred W. McDarrah

20. Smithson, in Cummings, "Interview with Robert Smithson for the Archives of American Art/Smithsonian Institution," 284.
21. Smithson, "Entropy and the New Monuments," *Artforum* 5, no. 10 (June 1966): 26–31.
22. Ibid., 27.
23. Graham's byline as it appeared in *Art and Artists* 1, no. 12 (March 1967): 5.
24. LeWitt, in *Sol LeWitt*, 53.
25. Pelzer wrote eloquently on what she observed as Graham's liberated position in the Minimal context in "Double Intersections: The Optics of

Dan Graham," in *Dan Graham* (London: Phaidon, 2001), 40. My own article "'Not in eulogy not in praise but in fact': Ruth Vollmer and Others, 1966–70," a contribution to the first scholarly book on Ruth Vollmer, treats the reception of this German émigré sculptor's work by other artists including LeWitt, Smithson, Hesse, and Bochner, and the practice of such recognition with an approach informed by Pierre Bourdieu. See Nadja Rottner and Peter Weibel, eds., *Ruth Vollmer 1961–1978: Thinking the Line* (Ostfildern, Germany: Hatje Cantz, 2006), 71–85.

his artist–peer LeWitt intuited his position at Daniels Gallery and his art as continuous: "Dan Graham, who was particularly interested in new work, was showing Robert Smithson, Forest [sic] Myers, Jo Baer, Will Insley, and others while doing some very significant work himself."[24]

Daniels Gallery revealed Graham to have entered art by engaging with (and viewing, discussing, showing, and promoting) important early works and installations by *other* artists. This is the kind of influence to be found in this small slice of the mid–1960s New York art world during a brief moment. What Pierre Bourdieu described as recognition by those whom one recognizes is one way to gauge the quality of the difference of Graham's position within its first context.[25]

"THINGS THAT WERE ESSENTIALLY PAGES IN MAGAZINES"

During the period after Daniels Gallery closed, from 1965 until around 1969–70, Graham's primary activity was as an artist–critic. Graham wrote and published reviews—texts that advocated for the same Minimal artists he had supported through exhibitions at Daniels Gallery—and wrote and published his first experiments in cultural criticism.[26] By 1969–70, his first small catalogues and an anthology of criticism, *End Moments* (which he self–published), had appeared. In truth, during these years Graham would publish his writing and his conceptual pieces for magazines first and more frequently than see his work included in exhibitions. Through 1968, Graham's oeuvre—though the word is an unlikely one for his production—comprised a bibliography of writing consisting of nine published articles and reviews and approximately three unpublished texts, eight experimental conceptual pieces for magazine pages, a small body of photographs Graham thought of as "transparencies" and presented twice as slide projections, and a smaller group of poems.[27]

After Graham gave *other* artists opportunities at Daniels Gallery, his own first invitations came via editors and critics, some of whom he had met through the gallery.[28] Despite its short life, Daniels Gallery had received respectable representation in the art press; its exhibitions were listed in *Art News* and reviewed and discussed in *Arts Magazine* and *Art International* by such critics and artists as Lippard, Vivien Raynor, and Judd. "Plastics" is one telling example. With this group exhibition, Daniels Gallery acquired recognition in *Art International* by critics who had a special stake in the newest sculptural work: Judd and Lippard. Graham met Judd[29] at

26. See the bibliography in this volume, pages 333–34.
27. From this body of poetry only a single work, "Foams," saw publication, in *Extensions*, no. 2 (1969).
28. Most directly, the invitation from assistant editor Susan Brockman at *Arts Magazine* (a connection made through Bochner) to publish *Homes for America* established a regular relationship between Graham and the magazine.
29. Judd had published art criticism since 1959 and presented his sculptural production in New York galleries since 1963.

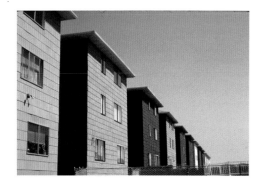

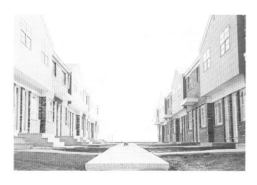

fig. 9
Slides from *Homes for America* (1966–67)

Daniels Gallery sometime during early January 1965, when Judd published a favorable review of the gallery's exhibition of abstract compositions by the Japanese–American painter Nobu Fukui. Graham had also included a work by Judd in "Plastics." The exhibition, especially Judd's *Untitled* red–pink plexiglas box, received glowing praise from the sympathetic Lippard (and the first two press reproductions for the gallery): "The most impressive work, and by far the most fully resolved, is a fluorescent pink plexiglas rectangular floor box by Donald Judd. The two end panels are stainless steel, but the rest is a glowing translucent volume, sharply defined by the mercurochrome lines of pure light along each edge—formed by the opaque crosscut and overlapping of the plastic."[30] The box was held together by interior wires and made without a sheet of plexiglas at its bottom, encompassing the gallery floor on which it rested and that showed strongly through the piece, within its open structure.[31]

The last exhibition at Daniels Gallery, LeWitt's installation, was duly recognized and related by critics to the emerging Minimal aesthetic. Lippard defined LeWitt's structures as "deadpan post–geometric anti–sculptures in the Judd–Morris vein."[32] The reviewer for *Arts Magazine* wrote: "The spatial involvements of the works and their lure to spectator participation, plus their formality of structure and no–nonsense, industrial surface, make this an important first one–man show."[33] Such writing makes clear how recognition for "new" artists worked: LeWitt's first presentation was evaluated in relation to Judd's and Morris's positions (the "Judd–Morris vein," though they were distinct), its value established through connection to the greater currency of artists who were already showing and being written about. In turn, Daniels Gallery was both covered by Judd (who was a regular critic for *Arts* at the time) and garnered interest from Lippard because she encountered work by Judd on view there.

It seems fair to say that Graham modeled his approach to art–making on the critical reception of Daniels Gallery as distinct from the influence of its exhibiting artists per se, since Graham's own debut did not involve work that would first be shown in a gallery.[34] Graham was not alone in this period as an anti–art–maker of "things that were essentially pages in magazines."[35] As is well known, Graham practiced a direct amateur–type photography with a Kodak Instamatic camera and film developed in–store as slides (fig. 9). (In an interview, the artist demurred, "Sure I'd taken those photographs...it was an easy way to make Don Judd, go out and take photos."[36]) Upon the gallery's closing during the summer of 1965, Graham began focusing in earnest on the

30. Lippard, "New York Letter," *Art International* 9, no. 4 (May 1965): 53. In Lippard's review, nearly all of the works merited description, including one by Smithson: "A rather repellent Hollywood-modern flat wall piece of metallic flecked plexiglas," 54.
31. See John Coplans, "An Interview with Don Judd," *Artforum* 9, no. 10 (June 1971): 45.
32. Lippard, "New York Letter," *Art International* 9, no. 6 (September 1965): 58.
33. A[nne] H[oene], "In the Galleries: Sol LeWitt," *Arts Magazine* 39, no. 10 (September–October 1965): 63–64.

34. Graham described it this way: "The fall after the gallery failed I began experimenting myself with artworks which could be read as a reaction against the gallery experience, but also as a response to contradictions I discerned in gallery artists." Graham, "My Works for Magazine Pages," 8. It was also true that Graham needed first to acquire access to a venue by publishing a review or critical text before he might venture to pitch one of his conceptual works, since this little-known and little-recognized practice of language-based works were to be presented (through publication)

slide images he would later publish as an *Arts Magazine* article accompanied by a text that mimed journalistic writing under the title "Homes for America, Early 20th-Century Possessable House to the Quasi-Discrete Cell of '66."[37] Graham mined the unrecognized postwar housing tracts he found in New Jersey and Staten Island for "Minimalist" imagery, engaging Minimal aesthetic language without mastering its medium-specific procedures or its fine-art conventions. As Birgit Pelzer wrote, "the process of reducing something to mere transparency was already underway for Graham,"[38] and, with it, the project of revising, contextualizing, and expanding Minimal art as a reversal or form of derision as she characterized it.

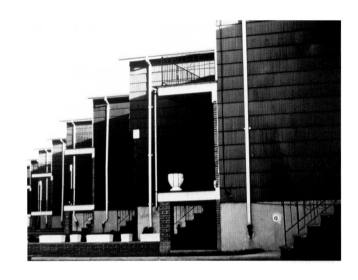

Graham placed *Homes for America* directly within the venues serving as the frameworks for Minimalism (and Pop), the same frameworks whose workings he had intuited during his time at Daniels Gallery. The quality of his work as a photographic transparency or surface owed a lot to the Daniels Gallery installation views as a communicative and symbolic, if ephemeral, medium. In Graham's view,

> through the actual experience of running a gallery, I learned that if a work of art wasn't written about and reproduced in a magazine it would have difficulty attaining the status of 'art.' It seemed that in order to be defined as having value, that is as 'art,' a work had only to be exhibited in a gallery and then to be written about and reproduced as a photograph in an art magazine. Then this record of the no-longer extant installation, along with more accretions of information after the fact, became the basis for its fame, and to a large extent, its economic value.[39]

The critical reception of the Daniels Gallery exhibition strikingly bears this out, but what Graham doesn't quite describe is the material-visual and illusionistic transformations he was enacting in making this art of "things that were essentially pages in magazines." Pelzer observed:

> Graham stressed that the real framework—the socio-economic structure, the apparatus of vali-dation—never appeared. From then on, through his statements in magazines, he saw himself as exposing and thereby undoing one of the frames of reference that supported art—art publications.... Intervening in the very terrain of economic and social conditions, his magazine pieces brought together the conditions of the dispossession and re-appropriation of the work

in art and culture periodicals as primary venues for perception and dissemination. Indeed, these works proved difficult to realize, as their often divergent conception and publication dates manifest.

35. Graham, in Field, "Dan Graham Interviewed by Simon Field," 76.

36. Ibid.

37. Graham, "Homes for America, Early 20th-Century Possessable House to the Quasi-Discrete Cell of '66," *Arts Magazine* 41, no. 3 (December 1966–January 1967): 21–22.

Remarks by Smithson on Graham's writing and a reproduction from *Homes for America* appear in "A Museum of Language in the Vicinity of Art," *Art International* 12, no. 3 (March 1968): 21–27. Again, Buchloh's "Moments of History in the Work of Dan Graham" was the first critical response to *Homes for America*, while Rorimer's was an important one from a singular American curator who supported Graham's work at the time (see note 6). Jeff Wall's *Dan Graham's Kammerspiel* (Toronto: Art Metropole, 1991) is a benchmark in a later moment of the work's reception, as is

Thomas Crow's "The Simple Life: Pastoralism and the Persistence of Genre in Recent Art" in his *Modern Art in the Common Culture* (New Haven, Connecticut: Yale University Press, 1990), 173–211. Of the now-extensive second-ary literature on *Homes for America*, Alexander Alberro's "Reductivism in Reverse" is notable: *Tracing Cultures: Art History, Criticism, Critical Fiction* (New York: Whitney Museum of American Art, Independent Study Program, 1994), 7–27. Apart from the writing specifically on *Homes for America*, a recent article that is now seminal to

the scholarship on Graham's work of the 1960s, especially the later 60s, is Eric de Bruyn's "Topological Pathways of Post-Minimalism," *Grey Room*, no. 25 (fall 2006): 32–63.

38. Pelzer, "Double Intersections," 38.

39. Graham, "My Works for Magazine Pages," 10.

while cutting across them. Graham took the view that artistic work offered no socio–political solutions, but could pinpoint the artifice of ideological representation.... how artifice is produced...where and how the illusion is made.[40]

The more elusive and abstract *Schema* (*March 1966*) of 1966–67 (**fig. 10**) is exemplary of such a theater of dispossession in the reproduction or print media. So reductive was this work that its realization—and even its perception upon publication—would prove difficult, taking Graham the rest of the decade and into the early 1970s to realize according to his full intentions. Graham's thinking on *Schema* reflects directly upon his Daniels Gallery experience as well as the analyses of Minimalism's dependency on the conventions and frameworks of art from which he sought to liberate his work:

> Magazines determine a place/frame of reference both inside and outside what is defined as "art." Magazines are boundaries mediating between the two areas—gallery "art" and communications about art. The strategy of the magazine-page work of mine I think most important, SCHEMA (March 1966), was to reduce these two frameworks into one frame. Placing the units of this (and other) work(s of mine) in magazines directly meant that it could be read as both art and "second-hand" reproduction/as "criticism" in the art journal.[41]

The work related what he saw as the broader context of the "general cultural framework which a magazine is part of" by homology to the particular field of art in the art magazine's professional or trade function, both coexisting as dual and perhaps antagonistic frameworks for the perception of the piece.

Schema made it to page proofs in *Arts Magazine* but was killed before publication. With this particular placement of the work, Graham literally revisited one venue among the Daniels Gallery's successful resumé of published appearances, trading on a "currency" his gallery had generated that he could now use to artistic ends. This version features the data specific to the issue in which it was to be published, including the heading, volume, and issue number, typeface name (Garamond Cardillo), and size (in picas), as well as the paper stock and sheet dimensions. Other descriptors—"area not occupied by type" or "depression of type into surface of page"—as well as *Schema*'s word count conjure a spatial

40. Pelzer, "Double Intersections," 40.
41. Graham, manuscript version, "My Works for Magazine Pages: 'A History of Conceptual Art,'" date unknown, Dan Graham Archives, New York, unpaginated. Judging by the 1973 interview with Field and the quotations Buchloh included in his article "Moments of History in the Work of Dan Graham," which he attributes to letters between himself and Graham, these ideas were already being articulated and may have existed in manuscript form, but were published at some delay in the context of Graham's Perth essay commission in 1985. See also Alberro, "Structure as Content: Dan Graham's *Schema (March 1966)* and the Emergence of Conceptual Art," in Gloria Moure, ed., *Dan Graham* (Barcelona, Spain: Fundació Antoni Tàpies, 1998), 21–29.

[cut off] adjectives

7 adverbs

35.52% area not occupied by type

64.48% area occupied by type

1 column

1 conjunction

0 mms. depression of type into surface of page

0 gerunds

0 infinitives

247 letters of alphabet

28 lines

6 mathematical symbols

51 nouns

29 numbers

6 participles

8" x 8" page

80 lb. paper sheet

dull coated paper stock

.007" thin paper stock

3 prepositions

0 pronouns

10 point size type

Univers 55 typeface

61 words

3 words capitalized

0 words italicized

58 words not capitalized

61 words not italicized

fig. 10
Variation of *Schema (March 1966)* (1966–67)
reproduced in *Aspen*, nos. 5–6 (fall–winter 1967)

a material and field of perception bears comparison to the openings and framings of space in LeWitt's Daniels Gallery installation or Judd's precise use of the wall space between the units of his serial "stacks" as constitutive compositional elements that are perceived as framed volumes and not only as voids. With *Schema*, Graham's close identification with the role of editor over that of studio artist becomes apparent. According to Graham's specifications and notes: "each poem-page is to be set in its final form by the editor of the publication where it is to appear"; "additions or modifications for space or appearance on the part of the editor are possible"; and, lastly, "it would be possible to 'compose' the entire set of permutationally possible poems and to select the applicable variant with the aid of a computer which could 'see' the ensemble instantly."[42]

For one evening in 1970, Graham resurrected the John Daniels Gallery at his apartment and work space at the time, 84 Eldridge Street, apartment 7, as recorded in a printed invitation. The event was to premiere the artist's first two films: *Sunrise to Sunset* (1969, fig. 11) and *Binocular Zoom* (1969–70). Graham had not yet secured gallery representation, but he had new work he was excited about and wanted to bring before an audience.[43] In a letter to John Gibson, whom he hoped to show with, the former gallerist Graham sounded equally like an artist: "The booklet will be ready with only two photos but some diagrams in two weeks. It includes a new piece for live TV camera and audience monitor on stage. It's the best thing I've done since the film of *Sunrise to Sunset*—better I think, but it can't be described or even illustrated with photos very well. It has nothing to do with word distillation."[44] His works, the former "things that were essentially pages in magazines," were now pieces whose experience exceeded description or reproduction. These works newly featured Graham as a performer and in possession of a more directly issued artistic voice, but this subjectivity would not be delivered with the social authority of the Minimal critic-artist. Graham exercised his role in a way that was critical of the heightened presence of the artist that the practices of post-Minimalism, Earth work, performance, and video were reinforcing by the end of the 1960s—not only through the art magazine but an expanded field of techniques and media. Rather, Graham's works gave a primary role to the perception process of the spectator, and, as was true of what he produced during the earlier 1960s, their keen attention to the

42. Graham, "Poem-Schema" (1967) and excerpt from *For Publication* (Los Angeles: Otis Art Institute of Los Angeles County, 1975), n.p., reprinted in *Dan Graham: Works 1965–2000*, 95.
43. His first solo exhibition was supported by a college, the Nova Scotia College of Art and Design, Halifax, Canada, and mounted in two parts in 1970 and 1971.
44. Graham, letter to Gibson, 1 June 1970, Dan Graham Archives, New York.

fig. 11, clockwise from top left
Sequence of stills from *Sunrise to Sunset* (1969)

art field's proper conditions of production and reception can be mined for what they manifestly declare through aesthetics— that something in the historical horizon had shifted.

POSTSCRIPT

The history of the John Daniels Gallery presents a fragment, not a whole; it is a truncated narrative that includes incoherence and a failure of sorts while featuring no clear outcomes. The gallery's records did not survive. Its reconstruction—any reconstruction—is necessarily subject to the effects of derealization of all historical accounts, to an abstraction and obscuring—"stripped of everything which attached [it] to the most concrete debates of [its] time."[45] Still, it is important to raise the question of what kinds of values there are to glean from a historical imagining of the Daniels Gallery, and what other kinds in the form of retrospective recognition are produced. I have narrated how Graham first encountered and sharply intuited the social and material conditions of the production of certain kinds of value for recent work during his entrance into the art field, especially that experience with the frameworks of presentation and reception of the contemporary art gallery and art magazine Daniels Gallery allowed him to witness and act upon. These observations were transformed by Graham—not into more formally ordered discrete objects or installations that might circulate within this system as Minimal statements—but rather as a new kind of artwork that turned from abstract to social spaces and, strikingly, regarded such frameworks as primary sites for perception. Graham had made this material and social condition a part of the intentional and conceptual structure of his first works. As art history, my analysis of Graham's work within its original moment follows this theoretical position of his work to suggest that an attention to the "concrete debates" and layers of that moment's discursive and institutional economies is fundamental to the historical imagination of this artist's, and his context's, art. Without the gallery's financial records and correspondence, an analysis of the gallery's and the artist's procedures at the level of detail needed to exchange criticism's and art history's largely symbolic terms for more precise materialist criteria is not possible in this instance. Forty years later, Graham's *Homes for America*, *Schema*, and other 1960s works including *Income (Outflow) Piece* (1969–73) and *Proposal for* Arts Magazine (1969) still mark that threshold and show Graham's theoretical and artistic imagination to be expansive. ⬤⬤

45. Bourdieu, "The Field of Cultural Production, or: The Economic World Reversed" (1983), in *The Field of Cultural Production: Essays on Art and Literature*, ed. Randal Johnson (New York: Columbia University Press, 1993), 31–32. The relation of Graham's work to his contemporaries and of their collective social world to its initial historical context is still to be written. Equally still to be represented are the linked histories of the dealer-critic system of the New York galleries and the institution of criticism during the 1960s. Those galleries most apposite to compare with Daniels Gallery include Richard Bellamy's Green Gallery, Park Place, and Seth Siegelaub's Seth Siegelaub Contemporary Art and Seth Siegelaub, Inc.

Graham, c. 1996

following spread
Homes for America (1966–67)

Homes for America

D. GRAHAM

Large-scale 'tract' housing 'developments' constitute the new city. They are located everywhere. They are not particularly bound to existing communities; they fail to develop either regional characteristics or separate identity. These 'projects' date from the end of World War II when in southern California speculators or 'operative' builders adapted mass production techniques to quickly build many houses for the defense workers over-concentrated there. This 'California Method' consisted simply of determining in advance the exact amount and lengths of pieces of lumber and multiplying them by the number of standardized houses to be built. A cutting yard was set up near the site of the project to saw rough lumber into those sizes. By mass buying, greater use of machines and factory produced parts, assembly line standardization, multiple units were easily fabricated.

"The Serenade"- Cape Coral unit, Fla.

Each house in a development is a lightly constructed 'shell' although this fact is often concealed by fake (half-stone) brick walls. Shells can be added or subtracted easily. The standard unit is a box or a series of boxes, sometimes contemptuously called 'pillboxes.' When the box has a sharply oblique roof it is called a Cape Cod. When it is longer than wide it is a 'ranch.' A

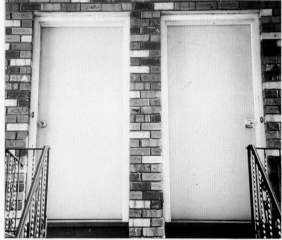

Two Entrance Doorways, 'Two Home Homes', Jersey City, N.J.

two-story house is usually called 'colonial.' If it consists of contiguous boxes with one slightly higher elevation it is a 'split level.' Such stylistic differentiation is advantageous to the basic structure (with the possible exception of the split level whose plan simplifies construction on discontinuous ground levels).

There is a recent trend toward 'two home homes' which are two boxes split by adjoining walls and having separate entrances. The left and right hand units are mirror reproductions of each other. Often sold as private units are strings of apartment-like, quasi-discrete cells formed by subdividing laterally an extended rectangular parallelopiped into as many as ten or twelve separate dwellings.

Developers usually build large groups of individual homes sharing similar floor plans and whose overall grouping possesses a discrete flow plan. Regional shopping centers and industrial parks are sometimes integrated as well into the general scheme. Each development is sectioned into blocked-out areas containing a series of identical or sequentially related types of houses all of which have uniform or staggered set-backs and land plots.

Set-back, Jersey City, New Jersey

The logic relating each sectioned part to the entire plan follows a systematic plan. A development contains a limited, set number of house models. For instance, Cape Coral, a Florida project, advertises eight different models:

A The Sonata
B The Concerto
C The Overture
D The Ballet
E The Prelude
F The Serenade
G The Noctune
H The Rhapsody

Center Court, Entrance, Development, Jersey City, N.J.

In addition, there is a choice of eight exterior colors:
1 White
2 Moonstone Grey
3 Nickle

LAWN GREEN

4 Seafoam Green
5 Lawn Green
6 Bamboo
7 Coral Pink
8 Colonial Red

As the color series usually varies independently of the model series, a block of eight houses utilizing four models and four colors might have forty-eight times forty-eight or 2,304 possible arrangements.

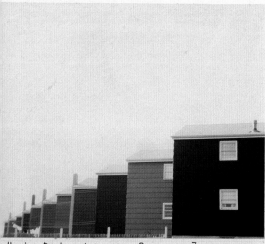

Housing Development, rear view, Bayonne, New Jersey

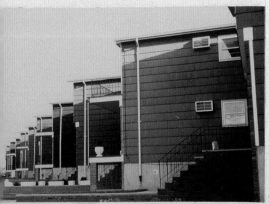

Housing Development, front view, Bayonne, New Jersey

Interior of Model Home, Staten Island, N.Y.

Each block of houses is a self-contained sequence — there is no development — selected from the possible acceptable arrangements. As an example, if a section was to contain eight houses of which four model types were to be used, any of these permutational possibilities could be used:

Bedroom of Model Home, S.I., N.Y.

AABBCCDD	ABCDABCD
AABBDDCC	ABDCABDC
AACCBBDD	ACBDACBD
AACCDDBB	ACDBACDB
AADDCCBB	ADBCADBC
AADDBBCC	ADCBADCB
BBAADDCC	BACDBACD
BBCCAADD	BCADBCAD
BBCCDDAA	BCDABCDA
BBDDAACC	BDACBDAC
BBDDCCAA	BDCABDCA
CCAABBDD	CABDCABD
CCAADDBB	CADBCADB
CCBBDDAA	CBADCBAD
CCBBAADD	CBDACBDA
CCDDAABB	CDABCDAB
CCDDBBAA	CDBACDBA
DDAABBCC	DACBDACB
DDAACCBB	DABCDABC
DDBBAACC	DBACDBAC
DDBBCCAA	DBCADBCA
DDCCAABB	DCABDCAB
DDCCBBAA	DCBADCBA

Basement Doors, Home, New Jersey

'Discount Store', Sweaters on Racks, New Jersey

The 8 color variables were equally distributed among the house exteriors. The first buyers were more likely to have obtained their first choice in color. Family units had to make a choice based on the available colors which also took account of both husband and wife's likes and dislikes. Adult male and female color likes and dislikes were compared in a survey of the homeowners:

'Like'

Male	Female
Skyway	Skyway Blue
Colonial Red	Lawn Green
Patio White	Nickle
Yellow Chiffon	Colonial Red
Lawn Green	Yellow Chiffon
Nickle	Patio White
Fawn	Moonstone Grey
Moonstone Grey	Fawn

Two Family Units, Staten Island, N.Y.

'Dislike'

Male	Female
Lawn Green	Patio White
Colonial Red	Fawn
Patio White	Colonial Red
Moonstone Grey	Moonstone Grey
Fawn	Yellow Chiffon
Yellow Chiffon	Lawn Green
Nickle	Skyway blue
Skyway Blue	Nickle

Car Hop, Jersey City, N.J.

A given development might use, perhaps, *four* of these possibilities as an arbitrary scheme for different sectors; then select four from another scheme which utilizes the remaining four unused models and colors; then select four from another scheme which utilizes all eight models and eight colors; then four from another scheme which utilizes a single model and all eight colors (or four or two colors); and finally utilize that single scheme for one model and one color. This serial logic might follow consistently until, at the edges, it is abruptly terminated by pre-existent highways, bowling alleys, shopping plazas, car hops, discount houses, lumber yards or factories.

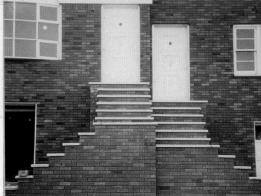
'Split-Level', 'Two Home Homes', Jersey City, N.J.

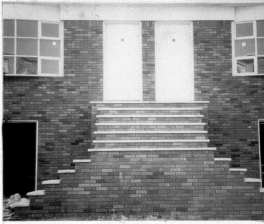
'Ground-Level', 'Two Home Homes', Jersey City, N.J.

Although there is perhaps some aesthetic precedence in the row houses which are indigenous to many older cities along the east coast, and built with uniform façades and set-backs early this century, housing developments as an architectural phenomenon seem peculiarly gratuitous. They exist apart from prior standards of 'good' architecture. They were not built to satisfy individual needs or tastes. The owner is completely tangential to the product's completion. His home isn't really possessable in the old sense; it wasn't designed to 'last for generations'; and outside of its immediate 'here and now' context it is useless, designed to be thrown away. Both architecture and craftsmanship as values are subverted by the dependence on simplified and easily duplicated techniques of fabrication and standardized modular plans. Contingencies such as mass production technology and land use economics make the final decisions, denying the architect his former 'unique' role. Developments stand in an altered relationship to their environment. Designed to fill in 'dead' land areas, the houses needn't adapt to or attempt to withstand Nature. There is no organic unity connecting the land site and the home. Both are without roots — separate parts in a larger, predetermined, synthetic order.

Kitchen Trays, 'Discount House', New Jersey

A	02.53
A	02.34
A	00.98
A	01.42
A	00.65
A	00.80
A	00.27
A	00.39
A	00.53
A	00.53
A	00.41
A	00.49
A	00.25
A	00.49
A	00.43
A	00.59
A	00.26
A	00.25
A	00.65
A	01.18
A	00.42
A	00.69
A	00.48
A	00.39
A	00.29
A	00.29
A	00.35
A	00.34
A	00.24
A	00.39
A	00.47
A	00.79
A	00.47
A	00.29
A	00.40
A	00.33
A	00.83
A	01.25
A	01.03
A	00.11
A	00.41
A	00.20
A	00.44
A	00.02

Scheme for Magazine Page 'Advertisment' — 1965

Dan Graham

Disposable Magazine, Permanent Contents

Alexandra Midal

"I love magazines because they are like pop songs, easily disposable, dealing with momentary plea- sures. They are full of clichés. We all love the cliché. We all like tautologies, things that seem to be dumb and banal but are actually quite intelligent."
—Dan Graham in *Manga Dan Graham Story* (2001)

In the 1986 text "Art as Design/Design as Art," Dan Graham suggested that the perceived relationship between the disciplines of art and design "is a cliché." He also showed that artists make use of design to create an illusion of space or interiority, "a 'phantasmagoria of the private interior'— often in juxtaposition to the owner's public image or role."[1] Graham's analysis began with a quote from Walter Benjamin's "Paris, Capital of the Nineteenth Century" (1939): "The private person who squares his accounts with reality in his office demands that the interior be maintained in his illu- sions." Discussing the transformation of the private home, Benjamin described how it was partitioned into two distinct spaces—the study, anchored in the real, and the living space, intentionally dedicated to dreams and artifices promising a world set aside. Using magazines, Graham revisited the same division. He referred to John Knight's *Journal Piece* (1976), for which Knight bought subscriptions to interior-design magazines for a hundred friends and collectors, observing that this very critical art alters the way the recipients experi- ence their living space: "[the magazine] is an artwork which

Notes **1.** Dan Graham, "Art as Design/Design as Art," reproduced on pages 267–76 of this vol- ume. Originally published in *Des Arts*, no. 5 (winter 1986–87): 68–71.

Detail from *Figurative*, 1965

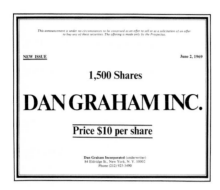

for the conventional artwork to occupy—the bathroom, the garage, for instance. It uses the interior–design aspects of architecture which already has a coffee table, magazine rack, or bedside table."[2] In a kind of pyrotechnic or "explosive"[3] effect, magazines infiltrate the territories of art, design, and architecture. Graham ended his analysis with an inspired comparison between Don Siegel's 1956 film *Invasion of the Body Snatchers* and the "architectural" power of the magazine: "in a sense, magazines—especially their covers—are subliminally planted in the home (like the pods in Don Siegel's 1956 film…), where they implant 'new design ideas' that are purchasable in the form of commodities by the millions of magazine readers."[4] Far from being trivial objects, the magazines one reads in the comfort of one's home can become fully developed works of art.

"THINGS THAT SEEM TO BE DUMB AND BANAL"

Graham created his first works, conceived for "exhibition" as printed matter in the space of the magazine, in 1965. All were intended for publication in different magazines[5]: *Figurative* (1965), *Scheme* (1965), *Sequence Number* (1965), *Detumescence* (1966), *March 31, 1966* (1966), *Side Effects/Common Drugs* (1966), *Homes for America* (1966–67), *Schema (March 1966)* (1966–67), *Proposal for Aspen* (1967–68), *Likes* (1967–69), *Income (Outflow) Piece* (1969–73), *Proposal for Arts Magazine* (1969), and *Time Extended Distance Extended* (1970) (fig. 1).

It is no accident that these works originated the very same year that the John Daniels Gallery, run by Graham, was shuttered after only a single season of operation. Penniless and idle, he had to return to his parents' house in New Jersey[6]—a setback all the more difficult because Graham had no college degree and had never been to art school; yet, like his friends Donald Judd, Robert Smithson, and Dan Flavin, Graham wanted to make art. But how? He did not even have enough money to buy canvases or paint. Furthermore, the gallery did not seem to him the ideal place for an artist.

Lacking a driver's license, Graham took the train from Penn Station to move back in with his family. The train moved across the Garden State slowly, making frequent stops and giving Graham ample time to watch the New Jersey suburban landscape roll by. He was struck by the ubiquity of tract homes methodically arranged on either side of the railway tracks; the shapes and colors seemed to repeat without end. It inspired Graham to photograph the urban

fig 1., clockwise from top

Detumescence (1966) reproduced in *The New York Review of Sex* (15 August 1969)

Income (Outflow) Piece (1969–73) reproduced in Graham, *For Publication* (Los Angeles: Otis Art Institute of Los Angeles County, 1975)

Scheme (1965) published as *Discrete Scheme Without Memory* in Robert Smithson's article "Quasi–Infinities and the Waning of Space" for *Arts Magazine* (November 1966)

2. Ibid.

3. I borrow this term from Mark Wigley, "Whatever Happened to Total Design?," *Harvard Design Magazine*, no. 5 (summer 1998), available at http://gsd.harvard.edu/research/publications/hdm/back/5wigley.html.

4. Graham, "Art as Design."

5. Despite the wishes of the artist, not all of the works were published. Some were shown afterwards, while others were published numerous times in different magazines. For a detailed listing of the destinations of each work, see the summary provided in Graham, *For Publication* (Los Angeles: Otis Art Institute of Los Angeles County, 1975).

6. Graham, in "Mark Francis in Conversation

landscape (as he at least owned a camera). He retraced his route and took pictures of those houses. At the time, Graham had no idea where this work, whose subject matter and economy of means differed from Minimalist values and the white cube of the art gallery, would lead him.

This event was the catalyst for the series of pieces produced for publication in magazines, work that Graham gathered in *For Publication* (1975). The most famous of these, *Homes for America*, was initially presented in the form of a slideshow. After casually meeting with an editor at *Arts Magazine*, he turned the slideshow into a 1966 magazine article. With this change of media, certain modifications to the presentation became necessary—among them, the addition of a text partly lifted from brochures distributed by local real-estate agents and criteria invented to mock the all-pervasive sociology that was *de rigueur* in the art world at the time. Made up of text and numerous captioned images, the article presents various permutations of mass-produced tract homes.

As one would expect, Graham's use of magazines as exhibition venues marked a turning point in his life: the beginning of his career as an artist. 1966 also marks the publication of *Side Effects/Common Drugs* and *Detumescence*. If the former subtly alludes to the "desperate housewife" who spends her leisure time downing medication to battle the depression provoked by dreary suburban existence, the latter is a feminist hymn ahead of its time that plays off the temporality of magazines. A small ad run by Graham soliciting a medical specialist's explanation of the physiological and psychological effects of detumescence was to be followed with the publication of the commissioned description of the post-coital moment (**fig. 2**). More medical than sexual, the ad nevertheless derived meaning from being placed in a section that gives sex great importance. No accident, then, that *Homes for America* makes reference to the heavily illustrated architecture articles of *Esquire* and *Playboy*. It was, after all, the mass media and printed matter of the 1960s that allowed critic Reyner Banham in *Architects' Journal* to tell his readers archly that his only interest in such magazines was their treatment of architecture and design.[7] It is to this very coupling that Graham submitted himself to when, in his 1986 text "Art as Design/Design as Art," he dissected the power of magazines in relation to domesticity. But instead of Banham's *Playboy*, which ingeniously associated architecture with virility, Graham himself chose *Esquire*, "the magazine for men," which published the most famous writers and in which he had hoped to publish *Homes for America*—alas, without success.

Involuntary body contractions ensue bringing a steep drop in excitation. The most obvious indication of this is the rapid loss of penile erection and the return of the scrotum and testes to an unstimulated state. This action occurs in two stages. The first leaves the penis enlarged while a continued shrinkage takes place concurrently at a slower rate. The body slackens its tension. There is a loosening of physical tautness, and a simultaneous sense of release and relaxation. Sensations of orgasm or desire are extinguished; emotions recede; and ego is again bounded. Psychologically, there may be feelings of anxiety, relief, pleasurable satiation, disappointment, lassitude, leaden exhaustion, disgust, repulsion, or indifference, and occasionally hatred depending on the partner and the gratification achieved in the orgasm state.

fig. 2
Detumescence (1966) reproduced in Graham, *For Publication* (Los Angeles: Otis Art Institute of Los Angeles County, 1975)

with Dan Graham," in *Dan Graham* (London: Phaidon, 2001), 9–14.

7. Reyner Banham went on to clarify that there were "a dozen other reasons for keeping abreast of *Playboy*." Banham, "I'd Crawl a Mile for...*Playboy*," *Architects' Journal* 131, no. 3,390 (7 April 1960): 107. For further reading, see Bill Osgerby, *Playboys in Paradise: Masculinity,* *Youth and Leisure-Style in Modern America* (New York: Berg, 2001), in which he argued that *Playboy* centerfolds served to justify the virility of readers who appreciated decoration and design.

Homes for America

Early 20th-Century Possessable House to the Quasi-Discrete Cell of '66

D. GRAHAM

Belleplain	Garden City
Brooklawn	Garden City Park
Colonia	Greenlawn
Colonia Manor	Island Park
Fair Haven	Levitown
Fair Lawn	Middleville
Greenfields Village	New City Park
Green Village	Pine Lawn
Plainsboro	Plainview
Pleasant Grove	Plandome Manor
Pleasant Plains	Pleasantside
Sunset Hill Garden	Pleasantville

Large-scale 'tract' housing 'developments' constitute the new city. They are located everywhere. They are not particularly bound to existing communities; they fail to develop either regional characteristics or separate identity. These 'projects' date from the end of World War II when in southern California speculators or 'operative' builders adapted mass production techniques to quickly build many houses for the defense workers over-concentrated there. This 'California Method' consisted simply of determining in advance the exact amount and lengths of pieces of lumber and multiplying them by the number of standardized houses to be built. A cutting yard was set up near the site of the project to saw rough lumber into these sizes. By mass buying, greater use of machines and factory produced parts, assembly line standardization, multiple units were easily fabricated.

Each house in a development is a lightly constructed 'shell' although this fact is often concealed by fake (half-stone) brick walls. Shells can be added or subtracted easily. The standard unit is a box or a series of boxes, sometimes contemptuously called 'pillboxes.' When the box has a sharply oblique roof it is called a Cape Cod. When it is longer than wide it is a 'ranch.' A two-story house is usually called 'colonial.' If it consists of contiguous boxes with one slightly higher elevation it is a 'split level.' Such stylistic differentiation is advantageous to the basic structure (with the possible exception of the split level whose plan simplifies construction on discontinuous ground levels).

There is a recent trend toward 'two home homes' which are two boxes split by adjoining walls and having separate entrances. The left and right hand units are mirror reproductions of each other. Often sold as private units are strings of apartment-like, quasi-discrete cells formed by subdividing laterally an extended rectangular parallelopiped into as many as ten or twelve separate dwellings.

Developers usually build large groups of individual homes sharing similar floor plans and whose overall grouping possesses a discrete flow plan. Regional shopping centers and industrial parks are sometimes integrated as well into the general scheme. Each development is sectioned into blocked-out areas containing a series of identical or sequentially related types of houses all of which have uniform or staggered set-backs and land plots.

'two home homes'

The logic relating each sectioned part to the entire plan follows a systematic plan. A development contains a limited, set number of house models. For instance, Cape Coral, a Florida project, advertises eight different models:

A The Sonata
B The Concerto
C The Overture
D The Ballet
E The Prelude
F The Serenade
G The Nocture
H The Rhapsody

Moonstone Grey

As the color series usually varies independently of the model series, a block of eight houses utilizing four models and four colors might have forty-eight times forty-eight or 2,304 possible arrangements.

split level and ground level 'two home homes'

In addition, there is a choice of eight exterior colors:

1 White
2 Moonstone Grey
3 Nickle
4 Seafoam Green
5 Lawn Green
6 Bamboo
7 Coral Pink
8 Colonial Red

Each block of houses is a self-contained sequence — there is no development — selected from the possible acceptable arrangements. As an example, if a section was to contain eight houses of which four model types were to be used, any of these permutational possibilities could be used:

AABBCCDD	ABCDABCD
AABBDDCC	ABDCABCD
AACCBBDD	ACBDACBD
AACCDDBB	ACDBACDB
AADDCCBB	ADBCADBC
AADDBBCC	ADCBADCB

BBAACCDD	BADCBADC
BBAADDCC	BACDBACD
BBCCAADD	BCADBCAD
BBCCDDAA	BCDABCDA
BBDDAACC	BDACBDAC
BBDDCCAA	BDCABDCA
CCAABBDD	CABDCABD
CCAADDBB	CADBCADB
CCBBDDAA	CBADCBAD
CCBBAADD	CBDACBDA
CCDDAABB	CDABCDAB
CCDDBBAA	CDBACDBA
DDAABBCC	DACBDACB
DDAACCBB	DABCDABC
DDBBAACC	DBACDBAC
DDBBCCAA	DBCADBCA
DDCCAABB	DCABDCAB
DDCCBBAA	DCBADCBA

The 8 color variables were equally distributed among the house exteriors. The first buyers were more likely to have obtained their first choice in color. Family units had to make a choice based on the available colors which also took account of both husband and wife's likes and dislikes. Adult male and female color likes and dislikes were compared in a survey of the homeowners:

'Like'

Male	Female
Skyway	Skyway Blue
Colonial Red	Lawn Green
Patio White	Nickle
Yellow Chiffon	Colonial Red
Lawn Green	Yellow Chiffon
Nickle	Patio White
Fawn	Moonstone Grey
Moonstone Grey	Fawn

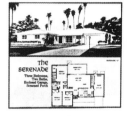

'Dislike'

Male	Female
Lawn Green	Patio White
Colonial Red	Fawn
Patio White	Colonial Red
Moonstone Grey	Moonstone Grey
Fawn	Yellow Chiffon
Yellow Chiffon	Lawn Green
Nickle	Skyway blue
Skyway Blue	Nickle

A given development might use, perhaps, four of these possibilities as an arbitrary scheme for different sectors; then select four from another scheme which utilizes the remaining four unused models and colors; then select four from another scheme which utilizes all eight models and eight colors; then four from another scheme which utilizes a single model and all eight colors (or four or two colors); and finally utilize that single scheme for one model and one color. This serial logic might follow consistently until, at the edges, it is abruptly terminated by pre-existent highways, bowling alleys, shopping plazas, car hops, discount houses, lumber yards or factories.

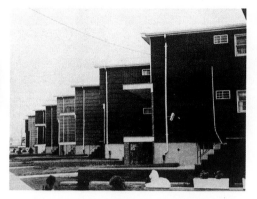

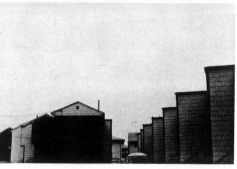

Although there is perhaps some aesthetic precedence in the row houses which are indigenous to many older cities along the east coast, and built with uniform façades and set-backs early this century, housing developments as an architectural phenomenon seem peculiarly gratuitous. They exist apart from prior standards of 'good' architecture. They were not built to satisfy individual needs or tastes. The owner is completely tangential to the product's completion. His home isn't really possessable in the old sense; it wasn't designed to 'last for generations'; and outside of its immediate 'here and now' context it is useless, designed to be thrown away. Both architecture and craftsmanship as values are subverted by the dependence on simplified and easily duplicated techniques of fabrication and standardized modular plans. Contingencies such as mass production technology and land use economics make the final decisions, denying the architect his former 'unique' role. Developments stand in an altered relationship to their environment. Designed to fill in 'dead' land areas, the houses needn't adapt to or attempt to withstand Nature. There is no organic unity connecting the land site and the home. Both are without roots — separate parts in a larger, predetermined, synthetic order.

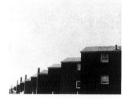

the SERENADE
Three Bedrooms, Two Baths, Enclosed Garage, Screened Porch

Top left: set-back rows (rear view); Bayonne, N.J.

Top right: set back rows (front view); Bayonne, N.J.

Bottom right: two rows of set-backs; Jersey City, N.J.

ARTS MAGAZINE/December 1966-January 1967

fig. 3

Homes for America, Early 20th-Century Possessable House to the Quasi-Discrete Cell of '66 (1966–67) published in *Arts Magazine* (December 1966–January 1967)

Citing Pop art's predilection for the banalities of mass culture, Graham revisited the conventions and played with the multiple dimensions of stereotypes, having understood that "everything conventional and traditional partakes of the chic and the stereotypical,"[8] as Charles Baudelaire proclaimed. In *Homes for America* (**fig. 3**), these codes are objects for reflection. Graham's photographs of homes—whose formal composition admittedly pays homage to Robert Mangold—explore the architecture of the façade and invoke the industrial standard emerging from the "assembly line standardization."[9] Like formal entities, the "shell" homes or "standard units" are arrayed in blocks, perspectives, and volumes. Given emphasis by the double-page layout, the banality of a suburban Arcadian dream resonates through gentle names like "The Sonata," "The Concerto," or "The Nocturne," saccharine epithets designed to conceal the monotony of the prefabricated homes for sale. From the subject to its handling, from the neutralized text to the publication in which it appears, everything is standardized. It seems as though nothing has changed since the concept of "type" was introduced in 1911 by philosopher and architect Hermann Muthesius on the occasion of his famous speech to the Deutscher Werkbund, "Wo stehen wir?" (Where do we stand?).

The standard, according to Muthesius, is the formal expression of a machine aesthetic that is the ideal response to the system of mass production and consumption that was still in its infancy in 1911. Not without a pinch of humor, *Homes for America* examines the mechanisms of an industry that produces simple, smooth geometric forms, devoid of ornament, and restores the missing link between modern capitalism's consumer and production. As early as 1907, Muthesius's Deutscher Werkbund advocated for the formal simplification of architecture and design and their subordination to an overarching harmony. *Homes for America* reexamines that principle by cataloguing the limited range of colors and models offered by the home manufacturers, which can nevertheless be combined to produce "2,304 possible arrangements," thus proposing his own version of a formal landscape composed of standards.[10]

"EASILY DISPOSABLE..."

Naturally, the serial logic characterizing magazines is tantamount to an aesthetic of disappearance–appearance. In essence, a magazine is only valid until the next issue is published. Such valorization of the disposable and/or

8. Charles Baudelaire, "Du Chic et du poncif," *Ecrits sur l'art, Salon de 1846*, cited in Marie-Paule Macdonald, "Materializations: Mass Production, Public Space, and Architectural Convention in the Work of Dan Graham," in *Dan Graham* (Paris: Dis Voir, 1995), 33.

9. The immediately following quotations are taken from Graham's *Homes for America* (article for *Arts Magazine*).

10. Concerning these architectural models and *Homes for America*, one might ask oneself whether they belong to what Thierry de Duve has called the "moment of peril," the instant before the crisis and the "degeneration of modernist ideals." De Duve, "Dan Graham et la critique de l'autonomie artistique," in *Dan Graham: Pavilions*, exh. cat. (Bern: Kunsthalle, 1983), 71.

relationship between durability and the value of consumer goods was being redefined. And so it seems fruitful to return to the origins of design to address more freely the questions raised by the works that make up *For Publication*.[11]

On April 12, 1877, William Morris, the so-called father of design, angrily defended the decorative arts in his famous first lecture "The Lesser Arts" to London's Trades' Guild of Learning. He underlined the lifespan of the manufactured object and shouted down the "nasty wares"[12] demanded by a public who crave "for something new, not for something pretty."[13] In his talk, Morris also evoked the dream of timeless design, in which beautiful objects are produced by content artisans. This is one of the founding narratives in the history of design. However, it is counterbalanced by another concept, just as valid—that of "creative waste,"[14] theorized in 1929 by Christine Frederick, who used it to justify the productive role of consumption and its necessity.[15] Ennobled during the 1960s, disposability was identified as a productive impetus by Banham as early as 1955, synthesizing the apparently opposite positions of the early twentieth century, Morris's democratic project and the creative and consumerist project of Frederick:

> A mathematical model may last long enough to solve a particular problem, which may be as long as it takes to read a newspaper, but newspaper and model will be forgotten together in the morning, and a research rocket—apex of our technological adventure—may be burned out and wrecked in a matter of minutes.[16]

Ephemerality became the norm and, for Banham, the periodicity of newspapers became the new reference point.

DESIRE FOR EXPANSION

In addition to the status of the artwork, *For Publication* incorporates aspects of review and art criticism, thus spanning art's territories of validation on paper. At this point, one might ask if Graham retrospectively provides the key to interpreting *For Publication* in "Art as Design/Design as Art." Graham takes up the model Knight proposed to describe the way magazines stealthily infiltrate the privacy of the home. Through the process of dissemination, printed matter and ideas become one and the same, like the alien-pod invasion depicted by Siegel, in which little by little the pods take possession of the earthlings and their homes. Magazines like *Esquire* often featured attractive articles on suburban life. For readers perusing

personally addressing them and making recommendations for how they are supposed to live every day.

Yet it is not so easy for readers to recognize themselves in *Homes for America*, since the work presents bland tract homes as though they were part of an ideal environment. It subtly displaces the mechanism of identification as the reader who lives in a suburban home is invited to absorb information relevant to him, but there is no intersection between how he lives and what is described. For the work does not attempt to create this or that illusion, but rather reports on the real. It offers neither resolution nor social reassurance, but merely presents a tawdry, ersatz pastoral ideal.

From the format, weight, and rapid obsolescence of the magazine—a disposable object "that one can acquire like a piece of merchandise that has become a work of art"—emerges a deterritorialization or a "desire for expansion,"[17] to borrow an expression from designer Alessandro Mendini. This expression defines the production of space by simple objects from daily life. Produced by an object as simple as a magazine article, expansion creates a correlation between the private space in which it is read and the planned uniformity of the suburbs. Graham cited as a major influence Michel Butor's 1956 novel *L'Emploi du temps* (Passing time), in which Jacques Revel, the disoriented narrator, loses his way in a fictional town called Bleston. His disorientation arises from the monotony of the architecture alone, from the lack of the particular: a labyrinth from which there is no escape. This absence of specificity, which also characterizes *Homes for America*, confirms the continuity that links domestic space with urban space. Since Benjamin, in *Charles Baudelaire: Ein Lyriker im Zeitalter des Hochkapitalismus* (1955), put forward the notion of "an interior extending right out to the street,"[18] the continuity of private and public space has been a recurrent principle.

Similarly, it is well known that many architects of the modern movement understood their work according to the principle of a recurring dynamic of expansion and contraction based on the dissolution of borders. Substantially, they recognized no essential difference between cities, chairs, graphic design, films, magazines, or advertising, for example. To that end, Baillie Scott, a peer of William Morris, claimed in 1895 to understand why it was difficult for an architect to draw the line clearly between the creation of an object and the creation of a home. Alternately, Eero Saarinen held that "the whole field of design is all one thing. Therefore [his] interest in furniture"[19] and thought of his chairs as "condensed architecture." Going farther, Saarinen extended Benjamin's idea by arguing that the entire world should be understood as an interior. Here,

11. On the subject, Graham likes to cite a Dan Flavin quote of the 1960s: "All back to store."
12. William Morris, "The Lesser Arts" (1877), reprinted in Morris, *Contre l'art d'élite* (Paris: Hermann, 1985), 28.
13. Ibid., 20.
14. Christine Frederick, *The New Housekeeping: Efficiency Studies in Home Management* (New

York: Doubleday, 1913).
15. Frederick, *Selling Mrs. Consumer* (New York: The Business Bourse, 1929), 81.
16. Banham, "Industrial Design and Popular Art," *Industrial Design* (March 1960), reprinted in Banham, *Design by Choice: Ideas in Architecture*, ed. Penny Sparke (New York: Rizzoli, 1981), 90.

Saarinen is close to Mark Wigley, who in the preamble to his text "Whatever Happened to Total Design?" (1998) sought to understand what "total design" might mean in the post–modern era. Rooting though the foundations of modernity, Wigley discovered a double dynamic:

> this pyrotechnic operation [of architecture], which dominates twentieth–century architecture, is not the destruction of the interior but rather its expansion out into the street and across the planet. The planet is transformed into a single interior, which needs design. All architecture becomes interior design.[20]

This idea differs from the way in which designers such as Norman Bel Geddes, Raymond Loewy, or Joe Colombo, among others, saw the inseparability of interior and exterior. They reframed it not in terms of a relationship of scale (whether centripetal or centrifugal), but uniquely in terms of everydayness. Loewy liked to say that he designed everything "from lipstick to locomotives," a phrase that makes clear his feeling that the commonplace was more important than any notion of physical scale. Colombo, who called one of his rare essays "Dal microcosmo al macro–cosmo" (From microcosm to macrocosm, 1971),[21] put it even more precisely, the extrapolation between the two universes rests solely upon the relationship between one and many: "Man happens to be the extrapolated identity of the collectivity that in fact constitutes humanity."[22]

In light of these remarks, one may legitimately ask from which movements and dynamics the works in *For Publication* borrow. Do they borrow from modern architec–ture's principles of expansion? Or from design's notion of dilation? From neither? Or does it strike roots in some specific combination of the two? To answer, one might return to Mendini's text *Existenz Maximum*, in which he retooled the famous *Existenzminimum* (minimum dwelling) developed by the members of the Congrès International d'Architecture Moderne in 1929. Many years after Mendini, curator Paola Antonelli picked up the Existenz Maximum concept, slightly changing its meaning by defining it as an immaterial zone defined by a movement from the interior towards the exterior and moving beyond the physical limits of the body: "The Existenz Maximum begins as a small, yet extraordinarily comfortable spatial device where the physical boundaries are protective, rather than oppressive, thus letting the senses and the spirit roam free,"[23] in which "the most revelatory designs, though, were devoted to apparently innocent objects that could unwillingly create spatial field."[24] Similarly, *Homes for America* replays the correlation between domesticity

and city, but the more one examines the deployment of this relationship and places it beside other modes and other temporalities, the more the work recedes from comprehen–sion and finally vanishes altogether. ●●

Translated from the French by Blake Ferris

17. Alessandro Mendini, *Existenz Maximum* (Florence, Italy: Ospedale degli Innocenti and Tipolito Press, 1990), and in *I Scritti* (Milan, Italy: Skira; and Brescia, Italy: Fondazione Ambrosetti Arte Contemporanea, 2004), 95.
18. Walter Benjamin, *Charles Baudelaire: Un Poète lyrique à l'apogée du capitalisme* (Paris: Payot, 2002), 84.

19. Eero Saarinen, quoted in Marian Page, *Furniture Designed by Architects* (New York: Whitney Library of Design, 1980), 204.
20. Wigley, "What Happened to Total Design."
21. Published in *Casa, Arredamento, Giardino* (Milan, Italy) (January 1971): 23.
22. Joe Colombo, in response to the ques-tion "Quelle est votre definition du design?,"

in *Qu'est-ce que le design?* (Paris: Centre de création industrielle, 1969), n.p.
23. Paola Antonelli, "Existspace-existenz-maximum," *Big* (New York), no. 24 (1998): 32.
24. Ibid., 35.

Don't Trust Anybody

Philippe Vergne

The more I think about it, the more I think that Dan Graham's work should be included in every high-school curriculum. Not so much because high-school students need to hear more about art—although they do—but because his work is the closest I can imagine to a clear and alert understanding of what constitutes Western culture as seen from the perspective of the United States. Or, to say it differently, as seen from one province of Western civilization.

From the beginning of his career, Graham has cultivated a process aimed at identifying how culture and history might be contained in forms, whether these forms are derived from music, architecture, art, comics, urban planning, literature, or mass media. If, in the postwar era, artists have striven to make the language of high art and vernacular culture meet, it seems that along the way this effort has been perceived as a form of social promotion from low to high and that the desire to invent a third way, a third aesthetic, has been lost during the journey. It is as if the history of art of the last fifty years has been a slow but continuous social and aesthetic climb.

But there are exceptions. Some artists actually overcame the hierarchical aesthetic conversation (and conservation) for the simple reason that these hierarchies are irrelevant, bloodless, and merely reassess an order that bleeds from the wall or the room of institutions to the grass

Japanther performing in *Don't Trust Anyone Over Thirty* (2004) at Art Basel Miami Beach, 2004

roots of contemporary culture; a social and class order. Graham never gave into such a phenomenon and as an artist has remained as faithful to his early days of radicalism as possible.

His radicalism is not without humor—even, from time to time, absurdity—as demonstrated in his project *Don't Trust Anyone Over Thirty* (2004, **fig. 1**), a rock puppet opera that pushes a critical vision of utopia to the extreme; corrupted by a homogeneous, obedient, standardized, and neutralized vision of hippie dreams, youth culture, flower power, and the Summer of Love, it becomes a star-fucking dystopia. The project is the logical development of concerns and interests that Graham has elaborated from the beginning of his career as a visual artist and cultural critic. In 1987, Graham and Marie-Paule Macdonald collaborated on *Wild in the Streets: The Sixties*, which they hoped to stage for La Monnaie opera in Brussels as well as for a live broadcast by Flemish television (with the help of Chris Dercon). Adapted from the 1968 film *Wild in the Streets*, it follows the life and career of a twenty-four-year-old rock star, Neil Sky, who, after provoking teenage riots, is elected president of the United States. The main policy of his administration is to send all citizens over thirty years old into mandatory retirement and those over thirty-five to re-education camp, where they are given LSD. Soon after, Sky's adopted son ironically threatens his father to put everyone over ten "out of business."

The narrative of *Don't Trust Anyone* is an absurd reading of 1960s hippie culture and its stereotypical generational politics as epitomized by the slogan "Don't trust anyone over thirty." The project employs a wealth of hilarious clichés of hippie culture, from the sets, clothing, and hairdos, to the language used by the different protagonists, whose communal existence is infused with a liberated and celebrated sexuality or well-intentioned promiscuity.

Between farce and tragedy, *Don't Trust Anyone Over Thirty* examines the allure of youth-culture autonomy, its sense of individuality, and its proximity to or complicity with the market-driven mainstream. Ultimately, the counter-culture's potential is subordinated by the social conformity of the culture industry.

If *Wild in the Streets* is itself a juvenile travesty of youth insubordination and mutiny, *Don't Trust Anyone Over Thirty* mocks that travesty, fixing a critical and ironic gaze on the crippling and laughable instrumentalization of youth movements. But if it were just that, it would be too simple for Graham. *Don't Trust*'s narrative structure is bait, an absurd sign that aims to decipher codes of representation as they appear. In this case, their stage is the cultural transversality of theater, the location of both entertainment and political incisiveness.

Notes **1.** Bertolt Brecht, *On Theater: The Development of an Aesthetic* (London: Methuen Drama, 1964), 89.

fig 1

Puppet performance from *Don't Trust Anyone Over Thirty* (2004) at Art Basel Miami Beach, 2004

Somehow, at this moment in Graham's career, this project crystallized an ongoing series of concerns and interests. It contains the invisible memory of a constellation of projects including *Piece* (1969); the 1983 essay "Theater, Cinema, Power"; his collaboration with experimental musician Glenn Branca; the single–channel video *Rock My Religion* (1982–84); and the architectural model *Cinema–Theater* (1986). All of these works evidence Graham's acute under– standing of entertainment as a cultural phenomenon, its deep ramifications for our culture, and its elusive Pascalian quality.

Ultimately, *Don't Trust Anyone Over Thirty* is a sharp analysis of the social power of theater as a conscious location for questioning established social order. Theater is elevated to a symbolic form, one that both blurs and delimits the terrain between public and private, between audience and artist, between contemplative passivity and active ruptures of conventional wisdom. Theater, according to Bertolt Brecht, has nothing to do with Broadway, with the mainstream, where one can witness entire "rows of human beings transported into a peculiar doped state, wholly passive, sunk without trace, seemingly in the grip of a severe poisoning attack" resembling the "involuntary victims of the unchecked lurchings of their emotions."[1]

PERFORMANCE
INSTRUCTIONS:

Members of the public are invited
to participate as a group of about
24 people (half male, half female)
to be selected at random freely
to realize the score. The activity
may seem at various points to be
sex education, art, exercise, en-
tertainment, sense relaxation,
therapy, theatre, encounter group,
or open to any other or entirely
undefined categories on how the
specific players relate their res-
ponses to it.

The players are naked. They 'com-
pose' the piece by 'playing') any
member of the group, selected at
random freely. The initial posit-
ions are taken from the score and
decided by each couple jointly.
The object of each is to realize
as much sense, pleasure, while
releasing tension.2)

The continuation of a player's act-
ive participation is dependent on
the continuation of his relaxation
of the tension level: if this should
increase, he or she must leave the
field of action and his or her choos-
en partner; if tension level is un-
changed or is rising for either of
the 2, activity must cease. The play-
ers will evolve a set of sexual sig-
nals to communicate these levels to
each other. A disengaged partner
selects the first available partner
and continues taking a position new
to both members of the second coup-
ling. This continues until a state
of exhaustion or lack of available
players is reached.

PERFORMANCE
INSTRUCTIONS

Players are to try to correlate,
tune in, concentrate their breath-
ing to merge with the physical act
of intercourse. So doing, they next
shift attention / the collective
breathing responses of the other
participants engaged in the process
is merged in consciousness with the
individual and couple's breathing.
Sensory mood is used as a collective
learning process: activities have
the purpose to 'break-down' previous
modes of manipulating art response.

NOTES :

1] PLAY 2. to perform an instrument
3. to take part in a game 4. to
act on or as on stage 7.(a) to move
or function freely within prescrib-
ed limits 8. to exhibit oneself
(said of a cock-bird)

PLAY 1.(a) to occupy oneself with
2. to do or execute for amusement
3. to contend with in a game

PLAY 1. any exercise or series
of actions intended for diversion
2. the representation or exhibit-
ion of some action on stage. 6.
scope for motion; space in motion
7.(a) OBS. brisk and vigorous phys-
ical action or exercise 12.(b) OBS.
pleasure; joy; enjoyment; cause or
source of pleasure or delight; dall-
iance; disport, as by way of sexual
intercourse (c) performance on an
instrument

2] TENSION 2. Electricity (b)
Potential 3. Mechanics A force
(either of two unbalancing forces)
causing or tending to cause exten-
sion

DAN GRAHAM
May, 1969

fig. 2
Piece (1969); black-and-white photo documentation of
text and diagrams with handwriting; 8 x 10 inches; courtesy
of the artist

His theater strives to abolish the traditional notion of stage, symbolically and physically. Actually, *Don't Trust Anyone Over Thirty* does not rely on one stage, but two, if not three. Two of the stages exist within a large parallelepiped. On the left, facing the audience, one stage is occupied by the puppets, activiated by their puppet masters; on the right is a retract- able stage dedicated to the band Japanther that intermittently interferes with and disrupts the dramaturgy. The third stage consists of video projections (by Oursler) that emphasize and contextualize the ongoing action. Japanther's music and Oursler's video projections, combined with events simultane- ously occurring on the puppet stage, supplement and vivify the actions, eliciting a critical approach from the spectator.

This structure of presentation is far from gratuitous. It echoes very precisely a number of German theater director and producer Erwin Piscator's innovations, such as the use of film and film projection as an integral part of the setting and the introduction of moving platforms to the stage. It also demonstrates Graham's knowledge and familiarity with the aesthetic of theater. *Don't Trust Anyone Over Thirty* is a Brechtian *Gesamtkunstwerk* that takes as its subject matter the relationship between the stage and the public, an ongoing issue that kept thinkers as diverse as Molière, Antonin Artaud, Vsevolod Meyerhold, Francis Picabia, Erik Satie, the protagonists of Agitprop, Allan Kaprow, Michelangelo Pistoletto, and Mike Kelley awake in their attempts to appeal less to spectators' emotions than to their faculties of reason. But this structure is also at the root of Graham's work, with its deep exploration of the relationship between audience and performer, public and private.

For instance, *Piece* (fig. 2) invites twenty-four (twelve male, twelve female) members of an audience to realize a performance conceived to be theater, therapy, sex education, relaxation, art, and entertainment. The "actors," naked, are invited to interpret a score made available by the artist of a series of *Kama Sutra* positions until stymied either by exhaustion or a lack of available partners. This performance (to date unrealized) brings to the public sphere the ultimate intimacy and, not unlike *Don't Trust*, is a tongue-in-cheek (no pun intended) comment on the Summer of Love's collective sexual liberation.

Another parallel can be found in the 1983 collabora- tion between Graham and Branca at the Kunsthalle Bern, titled *Musical Performance and Stage Set Utilizing Two-Way Mirror and Time Delay* (fig. 3). Here again, Graham designed an intricate setting for musical performance. For this work, the audience was seated on the right and a triangle of musicians

2. See performances such as *Performer/ Audience/Mirror* (1977); *Two Consciousness Projection(s)* (1972); and *TV Camera/Monitor Performance* (1970) and installations such as *Present Continuous Past(s)* (1974); *Two Rooms/Reverse Video Delay* (1974); and *Two Viewing Rooms* (1975).

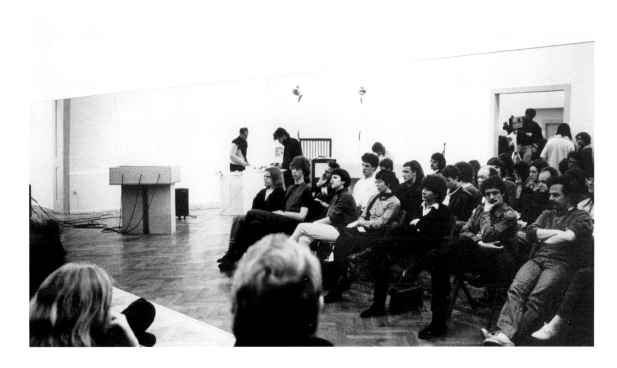

fig. 3
Performance of Graham and Glenn Branca's *Musical Performance and Stage Set Utilizing Two-Way Mirror and Time Delay* (1983); video camera with time delay and mirrored wall; music composed by Branca and performed by Axel Gross, Margaret De Wys, and Branca; at Kunsthalle Bern, Switzerland, 1983

(Axel Gross, Margaret De Wys, and Branca) was situated on the left. Both audience and musicians faced a wall-sized two-way mirror, behind which was installed a video monitor displaying a view of the entire room. That image, captured by a camera next to the monitor, played back on a six-second delay. The best way for the audience to see the musicians was to look at the monitor, which featured a delayed image of the concert where the audience is projected in the performing space between the three musicians because of the reflection of the video through the two-way mirror. This apparatus removed the audience from passive isolation, encouraging members to engage intersubjectively amongst themselves and with the musicians. The audience, therefore, became both a subject of the work and the observer of its own collective existence.

This displacement of the privacy of the audience has been a consistent feature of Graham's work, often achieved through the use of mirrors, two-way mirrors, or video recording in the context of architectural pavilions or performances.[2] Mirrors, inherited by Graham from the vocabulary of modern architecture corrupted by contemporary corporate building,

fig. 4
Architectural model *Video Projection Outside Home* (1978)

prompt the audience into an awareness of perception, of anonymous surveillance, and of the mechanisms of social alienation. At some point during the performance of *Don't Trust Anyone Over Thirty*, the stage background becomes a reflective surface, projecting the audience into a parody of the Woodstock dream of great togetherness.

A similar strategy of critical inversion has been at the center of at least two other Graham projects, *Alteration to a Suburban House* and *Video Projection Outside Home* (both 1978), both of which disrupt, deconstruct, and expose notions of privacy, family, and, eventually, entertainment. *Alteration to a Suburban House* is an architectural model of a typical suburban block inhabited by two houses that face a third across the street. The entire façade of one of the houses comprises a glass wall, in the style of Philip Johnson or Ludwig Mies van der Rohe. As described by Graham himself, "midway back and parallel to the front glass façade, a mirror divides the house in two areas. The front section is revealed to the public, while the rear, private section is not disclosed."[3] So the mirror, facing the street and the neighboring houses, incorporates the exterior surroundings and passersby as part of the interior

3. Graham, text (1981) on *Alteration to a Suburban House* (1978), reprinted in *Dan Graham: Works 1965–2000* (Düsseldorf, Germany: Richter Verlag, 2001), 179.

of the house. Conversely, the glass façade opens the living quarters to the outside world.

Similarly, *Video Projection Outside Home* (**fig. 4**) is an architectural model of a suburban house featuring a large television screen on its front yard, facing the street, which broadcasts whichever program that the home's occupants are entertaining themselves with inside. In both works, individuality and private life are challenged by new social models of exposure that threaten to eradicate individual and familial intimacy. This impersonal ontology transforms the public sphere into a vast living room where communal leisure displaces the private ritual of the intimate to create a theater of alienating togetherness.

This might explain or contextualize Graham's interest in theater and its socio–political ritual of gathering as well as its ambiguous status as a political instrument, a place of entertainment, as well as a location for instruction. Entertainment, media, and popular culture, as systems of the signs and rituals of gathering, have been at the center of Graham's own "comparative anthropology." *Cinema–Theater* (1986, **fig. 5**), an architectural model of a cinema attached to an outdoor theater, specifically explores the intricacy of these phenomena. The rear stage set incorporates a two–way mirror that reflects the gaze of the audience. This two–way mirror also operates as a rear–screen projection, layering on top of the theater performance the image of Roberto Rossellini's film *La prise du pouvoir par Louis XIV* (1966). And this might be the most interesting part, as Louis XIV fully understood the political power of theater and entertainment, giving patronage to Molière and conceiving his entire court at Versailles as a permanent theater. Louis XIV directed his entourage as to court etiquette and defined court roles and functions to force the aristocracy to be permanently in Versailles. They therefore performed for the Sun King, their author and director, in a 24/7 performance in a *mise en abime* of disobedience, a *mise en scène* of absolute power and control, in a baroque phalanstery of codified theater, where audience overlapped with actors and vice versa. The court thereby became an agent of repression, a role assumed in the twentieth century by the media and the amusement industries.

Finally, it is necessary to mention the centrality of rock music, its history and its rituals, in terms of Graham's project and in the definition of his practice. From Branca to Sonic Youth and Japanther, music has been a symbolic form, a critical historical tool that Graham has used as a sounding board to assess and question the contemporary period. For the video documentary *Rock My Religion* (1982–84, **fig. 6**), Graham created a montage of dissimilar historical moments

fig. 5
Cinema–Theater (1986); wood, Mylar, two–way plexiglas, Super–8mm film, and projector; 23 $^5/_8$ x 47 $^1/_4$ x 78 $^3/_4$ inches; collection Fonds National d'Art Contemporain, Puteaux, France, long–term loan from Château d'Oiron, Oiron, France; installed in Puteaux, France

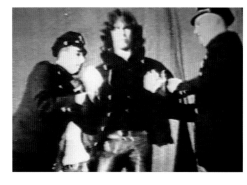

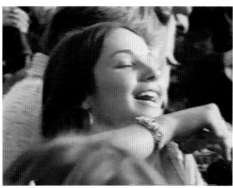

fig. 6
Stills from *Rock My Religion* (1982–84)

to draft a history; the work begins with the Shakers and their ecstatic communal trances and ends with the emergence of rock music as the religion of teenage consumers in the isolated suburban context of 1950s America. He identifies rock, within the sexual and ideological context of postwar America, as a cathartic and secular form of religion.

Taking rock music and entertainment both as tools and subjects, *Rock My Religion* is a history lesson crystallizing qualities specific to Graham's aesthetic program. It is spectacular, playful, and pedagogical, and it resists any temptation to be dogmatic. It shares with *Don't Trust Anyone Over Thirty* a capacity to spectacularize the dysfunction of the American dream. These projects formulate a confrontation with media, architecture, popular culture, and entertainment as expressions of an authoritarian architecture that sustains conformist social and political order.

What *Don't Trust Anyone Over Thirty* emphasizes through the use of theater is Graham's complex relationship with the notion of entertainment and representation. It actually weaves together in a spectacle much of the critical content of Graham's career. And as a spectacle, its content is pure fun, pure superfluous pleasure. And nothing needs less justification than pleasure. This would make Graham a populist. But as populist as he might be, he is fully aware that from the Greeks to Louis XIV, from Neil Sky to Silvio Berlusconi, tyrants need to be both entertained and to use entertainment as an organ of mass communication and as an ideological superstructure. Thus, he attempts to subvert it, to parody it, in order to reveal the mentality of our time and to suggest a radical rearrangement of our ways of living. For Graham, enjoyment is central, but it is never a commodity; rather it is a channel for amused skepticism. Brechtian more that he might admit, his puppet theater is a binocular structure that triggers both recreation and instruction. His work is elitism for everybody. He acknowledges mass culture's requirement for pleasure and remains driven by the need for emancipation and utopia. He values the *promesse de bonheur* that art carries without making it a commodity or indulging in a naïve infatuation for new-age spiritual, homogeneous, or standardized abandon. Graham does not dwell on ecstasy, and his participation in mass culture stands under the sign of disobedience rather than enthusiastic gregarious embrace. Looking at his work, experiencing his pavilions, listening to *Graham's Greatest Hits* (a mix tape provided by the artist to the author), or watching *Don't Trust Anyone Over Thirty* are incitements to think that mass culture is only instructive when things have gone wrong. His work is a "reserve of utopia"[4] that seeks to establish an art that doubts authoritarian values and structures and can only exist when it no longer expresses any ambition as art. Graham is a paradoxical entertainer who resists the immediate fulfillment of our primal and libidinal desires and shouts a simple instruction: Don't trust anything, don't trust anybody. 🞊

4. Thierry de Duve, "Dan Graham and the Critique of Artistic Autonomy," in *Dan Graham: Works 1965–2000*, 66.

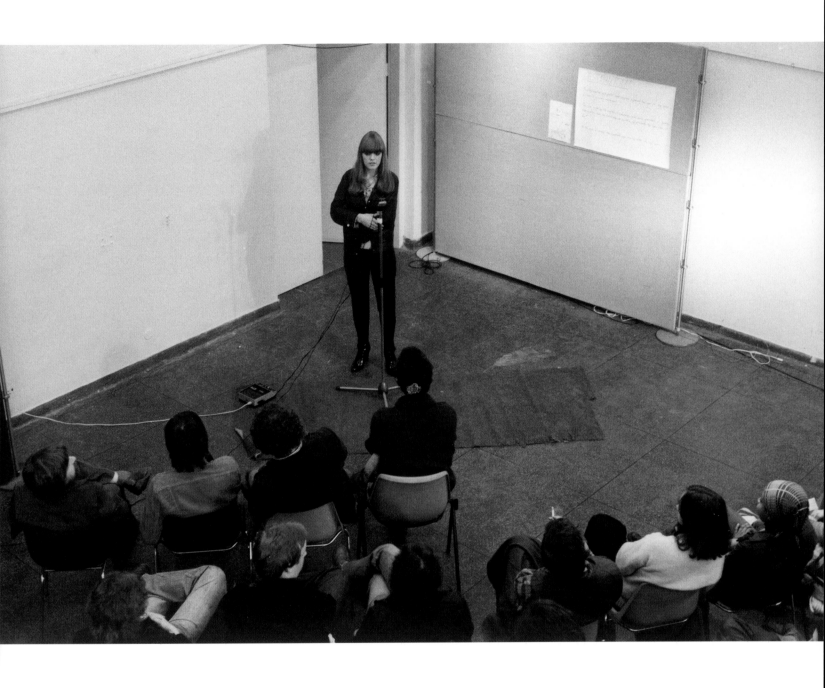

Performance of *Identification Projection* (1977) at Leeds
Polytechnic, Leeds, England, 1977

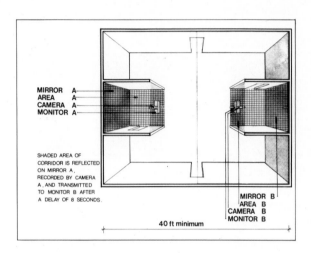

MIRROR A
AREA A
CAMERA A
MONITOR A

SHADED AREA OF
CORRIDOR IS REFLECTED
ON MIRROR A,
RECORDED BY CAMERA
A, AND TRANSMITTED
TO MONITOR B AFTER
A DELAY OF 8 SECONDS.

MIRROR B
AREA B
CAMERA B
MONITOR B

40 ft minimum

Opposing Mirrors and Video Monitors on Time Delay

Each of the opposing mirrors reflects a complete (opposing) side (half) of the enclosing room and the reflection of an observer within the Area who is viewing the monitor/mirror image. The camera sees and tapes this mirror's view.

Each of the videotaped cameraviews continuously is displayed 8 seconds later, appearing on the monitor of the opposite Area.

Mirror A reflects the present surroundings and the delayed image projected on Monitor A. Monitor A shows Mirror B 8 seconds ago, a reverse perspective of Area A. Similarly, Mirror A contains a reversed perspective of Area B.

A spectator in Area (or Area B) looking in the direction of the mirror sees: 1) a continuous present-time reflection of his surrounding space, 2) himself as observer, 3) on the reflected monitor image 8 seconds in the past, his Area as seen by the mirror of the opposite Area.

A spectator in Area A turned to face Monitor A will see both the reflection of Area A as it appeared in Mirror B 8 seconds earlier and at a reduced scale Area A reflected in Mirror B now.

If an observer walks from Area A to Area B it will take him about 8 seconds.

A spectator in Area A can observe himself now and himself 16 seconds in the past, or watch himself observing another spectator in Area B, who is shown observing him 16 seconds in the past.

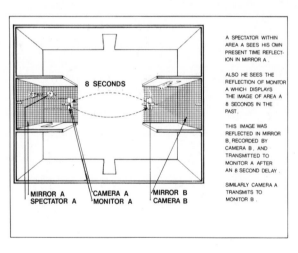

8 SECONDS

MIRROR A
SPECTATOR A
CAMERA A
MONITOR A
MIRROR B
CAMERA B

A SPECTATOR WITHIN AREA A SEES HIS OWN PRESENT TIME REFLECTION IN MIRROR A.

ALSO HE SEES THE REFLECTION OF MONITOR A WHICH DISPLAYS THE IMAGE OF AREA A 8 SECONDS IN THE PAST.

THIS IMAGE WAS REFLECTED IN MIRROR B, RECORDED BY CAMERA B, AND TRANSMITTED TO MONITOR A AFTER AN 8 SECOND DELAY.

SIMILARLY CAMERA A TRANSMITS TO MONITOR B.

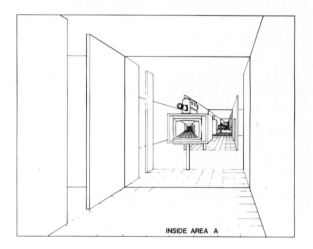

INSIDE AREA A

Diagrams for *Opposing Mirrors and Video Monitors on Time Delay* (1974)

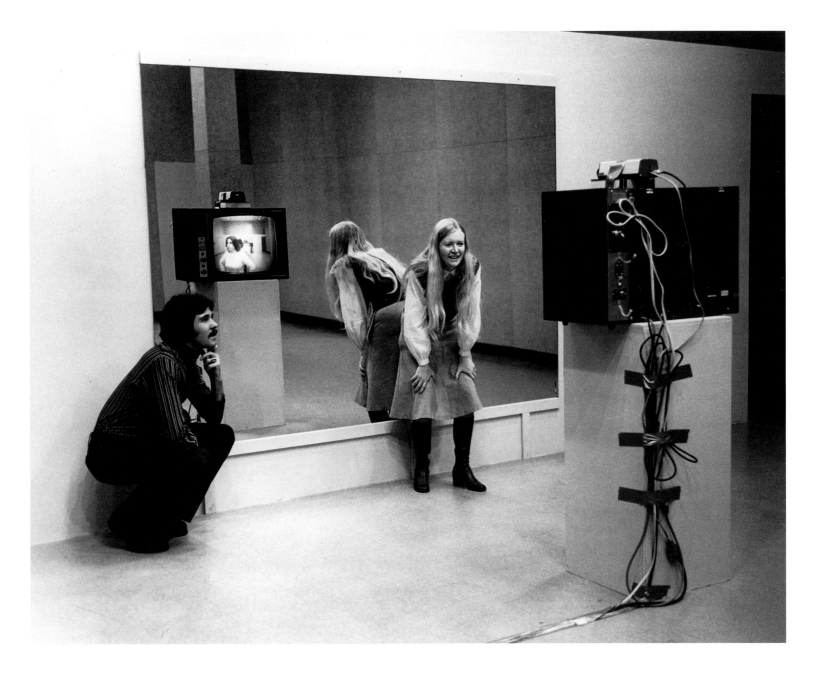

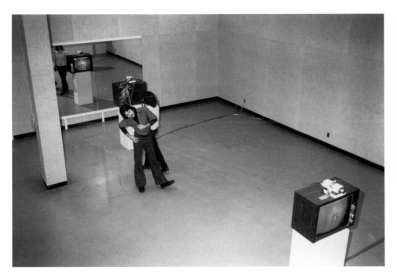

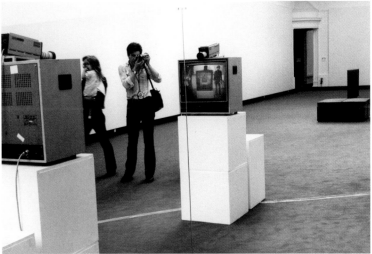

Views of *Opposing Mirrors and Video Monitors on Time Delay*
(1974) installed at St. Lawrence University, Canton, New York,
1975 (top and bottom left) and location unknown (bottom right)

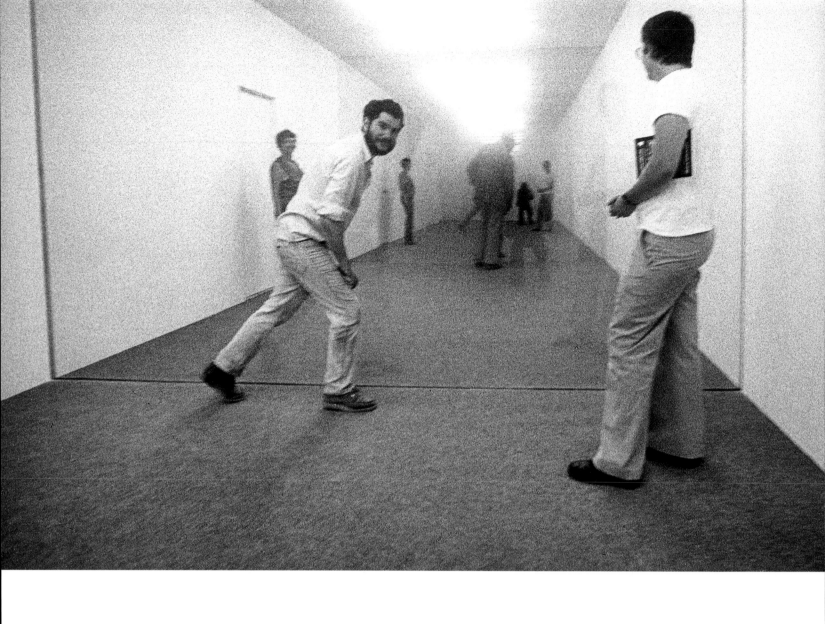

Views of *Public Space/Two Audiences* (1976) installed in
"Ambiente Arte," XXXVII Biennale di Venezia, Venice, Italy (left),
and at the Herbert Collection, Ghent, Belgium, with diagram

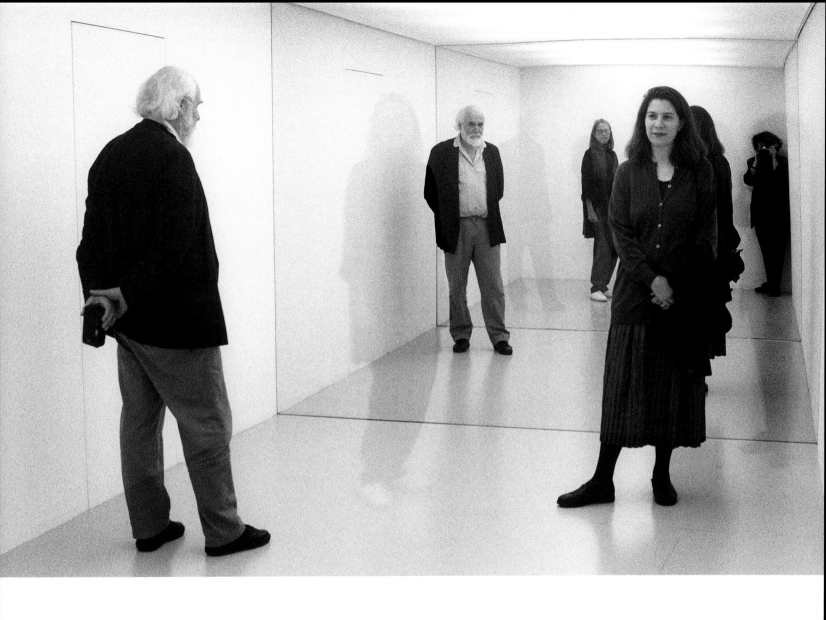

PUBLIC SPACE / TWO AUDIENCES

THE PIECE IS ONE OF MANY
PAVILIONS LOCATED IN AN
INTERNATIONAL ART EXHIBIT
WITH A LARGE AND ANONYMOUS
PUBLIC IN ATTENDANCE.

SPECTATORS CAN ENTER
THE WORK THROUGH EITHER
OF TWO ENTRANCES. THEY ARE
INFORMED BEFORE ENTERING
THAT THEY MUST REMAIN
INSIDE FOR 30 MINUTES
WITH THE DOORS CLOSED.

EACH AUDIENCE SEES
THE OTHER AUDIENCE'S
VISUAL BEHAVIOR, BUT
IS ISOLATED FROM THEIR
AURAL BEHAVIOR. EACH
AUDIENCE IS MADE MORE
AWARE OF ITS OWN
VERBAL COMMUNICATIONS.
IT IS ASSUMED THAT
AFTER A TIME, EACH
AUDIENCE WILL DEVELOP
A SOCIAL COHESION AND
GROUP IDENTITY.

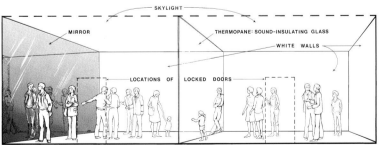

Views of architectural model *Alteration to a Suburban House* (1978)

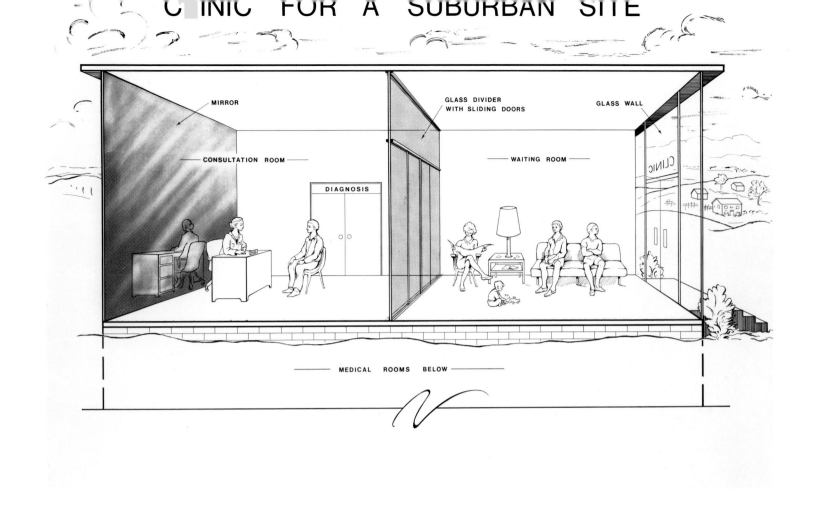

MIRROR

GLASS DIVIDER
WITH SLIDING DOORS

GLASS WALL

CONSULTATION ROOM

WAITING ROOM

CLINIC

DIAGNOSIS

MEDICAL ROOMS BELOW

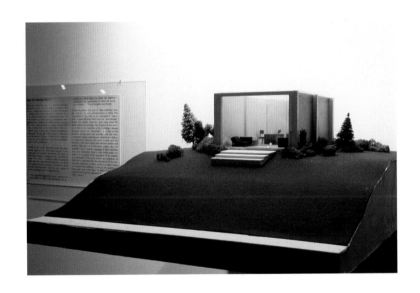

Diagram for and view of architectural model *Clinic for a Suburban Site* (1978)

Three Linked Cubes/Interior Design for Space Showing Videos
(1986) installed in Premier Festival des Artes Électroniques,
La Criée, Rennes, France, 1986

Views of *Video Projection Outside Home* (1978) installed at
a private home, Santa Barbara, California, 1996

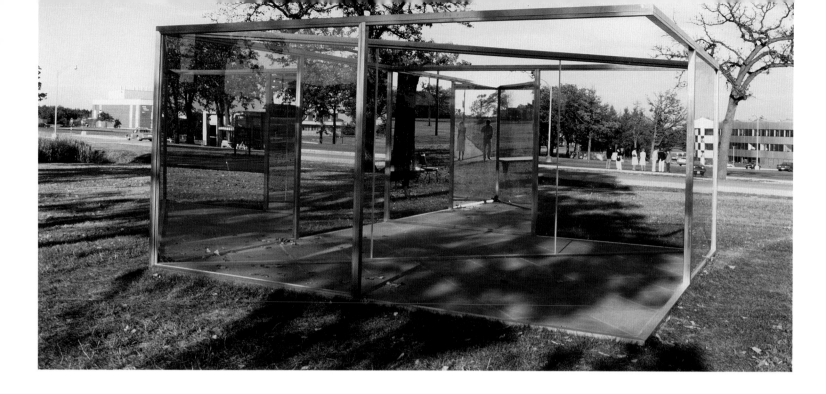

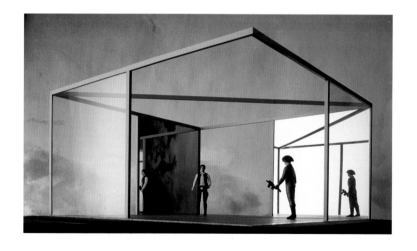

Views of *Pavilion/Sculpture for Argonne* (1978); two-way mirror, transparent glass, and steel frame; 7 1/2 x 15 x 15 feet; installed at the Argonne National Library, Argonne, Illinois, with views of architectural model

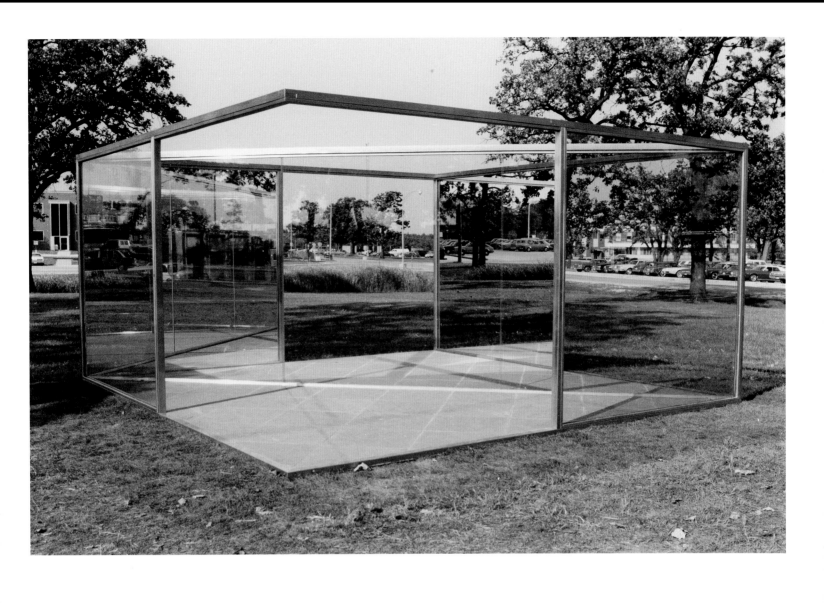

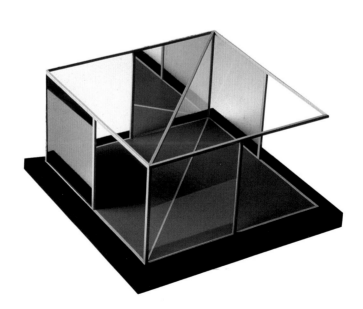

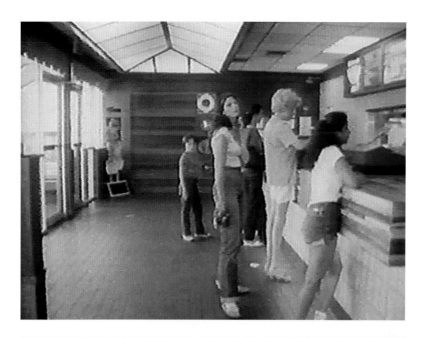

Stills from Graham and Ernst Mitzka's
*Westkunst (Modern Period): Dan Graham
Segment* (1980)

Exterior and interior (featuring Susan Ensley
on-screen) views of *Cinema* (1981/2000);
architectural model; 13 x 21 $^{11}/_{16}$ x 21 $^{11}/_{16}$
inches; collection Städtische Galerie im
Lenbachhaus, Munich, Germany

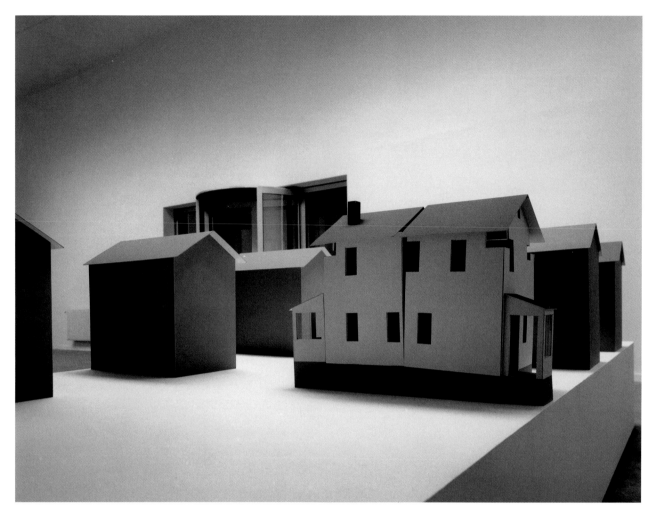

Views of Graham and Marie–Paule Macdonald's architectural model *Project for Matta–Clark Museum* (1983); cardboard; five parts: 12 x 20 x 19 $^5/_8$ inches each, one part: 11 $^4/_5$ x 28 $^1/_3$ x 19 $^5/_8$ inches; collection Marie–Paule Macdonald, Halifax

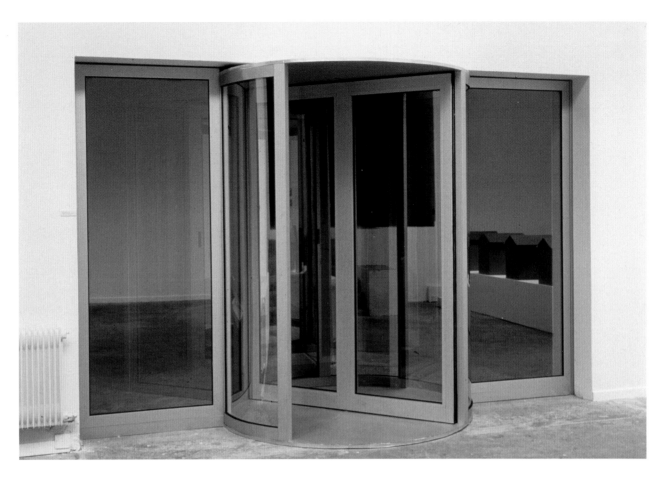

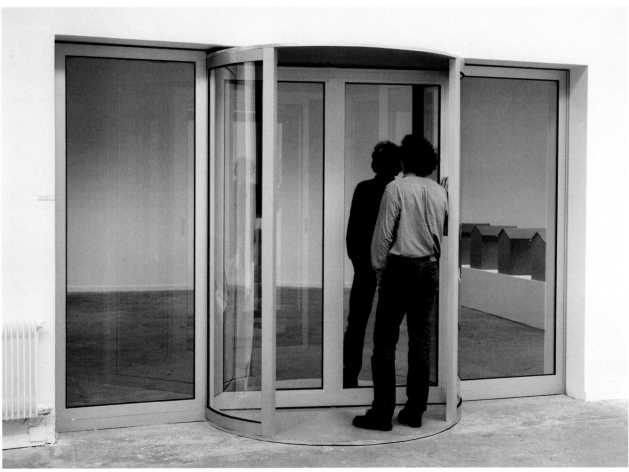

Altered Two-Way Mirror Revolving Door and Chamber (for Loie Fuller) (1987) installed at Le Consortium, Dijon, France, 1987

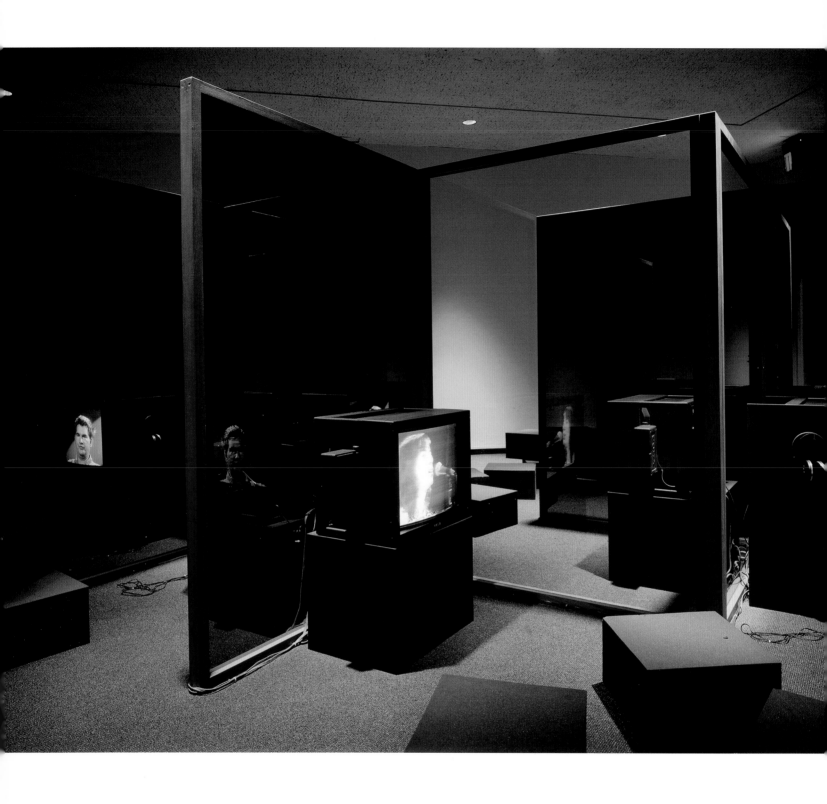

Views of *Three Linked Cubes/Interior Design for Space Showing Videos* (1986), installed in "Dan Graham: Three Linked Cubes/ Interior Design for Space Showing Videos" at the Whitney Museum of American Art, New York, 1993

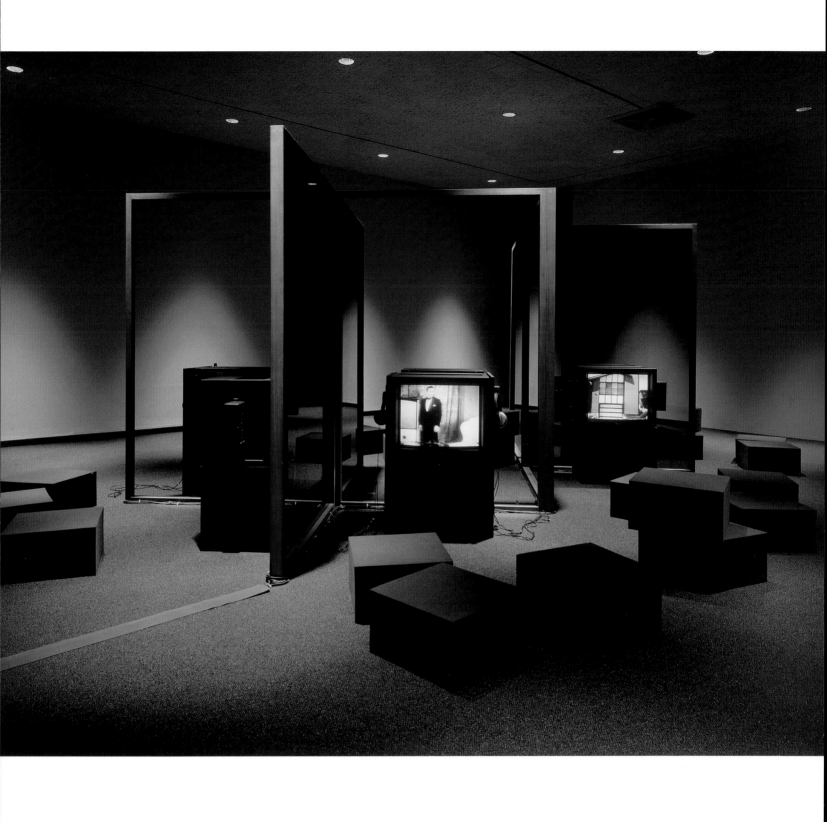

Inauguration : State of the Union Address by the President.

"You know, our folks say, 'There is a fly in the ointment.' It's not the Communists. There is a villain in history. Who? Who, after all, has caused our troubles? Those who are stiff, baby — not with love, but with age. We, the young, have lived in small pads with no bread, while they have lived high and fat with all the money! They are heavy with honey and they can't fly. Now some of us have changed this for ourselves already. Now we are going to change it for everyone. You give me the force! You give me the POWER!"

Rifle shot ... an Attempted Assassination. Man is apprehended by Secret Service.

Interior spreads from Graham and Marie–Paule Macdonald's
Wild in the Streets: The Sixties (1987)

Diagram for *Cinema-Theater* (1987)

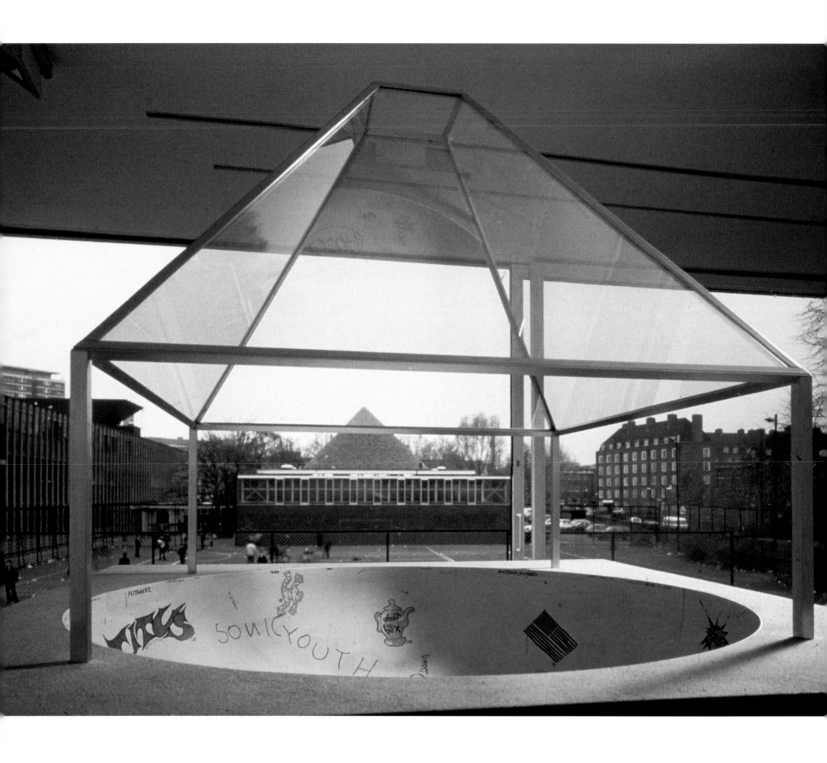

Architectural model *Skateboard Pavilion* (1989) installed
in "Pavilion Sculptures and Photographs" at Lisson Gallery,
London, 1991–92

Interview with Dan Graham
by Kim Gordon

with Gary Carrion–Murayari
Northampton, Massachusetts
24 March 2008

Graham and Kim Gordon on a flight from Bolzano, Italy,
to London, September 2008

Dan Graham: I really think that my art is a passionate hobby. In other words, I'm not a professional artist.

Kim Gordon: Do you think that's a good thing?

DG: I think there's too much professionalism when people come to art school. But I teach at art school, so I've seen the problems with it. The problem is they train you to be a professional artist.

KG: Right.

DG: When I talk to art schools, I talk about Kathryn Bigelow, one of my heroes. She was in Art & Language, then she worked for Lawrence Weiner as a cinematographer, and then she did great films in Hollywood.

...

KG: What about Simone Forti? She also doesn't really identify with being an artist.

DG: Or a dancer, she told me.

KG: Or a dancer, huh, that's interesting.

DG: She says it's all about movement...She says what she's doing is more about movement than dance.

...

DG: I figured out that many things come from Simone. Bruce Nauman was in the workshop; Robert Morris, whom she was married to in California in the mid-60s, was there; also Yvonne Rainer. Then dance was about psychological therapy—but in group settings. In this vein, I did a piece called *Lax/Relax* in 1969.

KG: Oh yeah, I love that piece.

DG: Which was pretty much about this thing in California in the 60s where you had a different psychological self-help movement/religion every two weeks—no, every month. I know John Lennon was very involved with primal scream therapy.

KG: Right. I knew Ellen Janov, the daughter of Arthur Janov, the inventor of primal scream. She was a tragic figure who died of an overdose at eighteen.

DG: Oh yeah?

KG: I remember being stuck at their house once, which was a big glass house up on the top of a canyon. It was a very alienating experience.

DG: Simone actually grew up in Los Angeles when she was young.

KG: Oh really? Where?

DG: In Westwood.

KG: When I read her book, it seemed like—I didn't realize that a lot of her ideas came out of being a hippie. One thing that was interesting was this kind of conflict between being a hippie and wanting to dance, or something. How she tried to integrate it in an organic way.

...

KG: What's the work like that she does now? Does she still involve the audience?

DG: In one piece she does, she imitates animals in a zoo because she felt like she was caged like an animal. So, it's not with a group.

...

KG: I'd love to do a collaboration with her.

DG: Mm-hmm?

...

DG: I was introduced to San Francisco 60s dance and performance by a series of events at the Whitney called "Extended-Time Pieces" in 1969, with work by Bruce Nauman. The work was about process and time.

...

DG: Richard Serra was in a show at the Whitney connected with these events. And Richard was a friend of mine—we used to go to lectures— and it was Richard who told me about Simone Forti. Her work was about the forces of gravity.

KG: Right.

...

KG: Do you think, like, at a rock concert, that the music...acts like a mirror, in a sense, that kind of brings the audience together? The way...

DG: I did this piece *Performer/Audience/Mirror* [1977] with an audience facing a mirror. I was trying to combine two ideas of time, from the Renaissance perspective to the present time in the mirror and also as I spoke, in this continuous free flow. In other words, a little like drug time, where you have an expanded sense of time. I was involved with Steve Reich's music and consciousness-expanding states. I was a mirror to the audience because I described them. And then they also saw themselves in the mirror. Also, I was trying to combine behaviorism and phenomenology.

KG: But did you get that idea *from* a rock concert?

I was trying to combine two ideas of time, from the Renaissance perspective to the present time in the mirror.

I gave up the idea of being a Conceptual artist because I thought it was kind of academic bullshit, so I gravitated toward essay writing, and I called myself a poet.

DG: I got the idea from a Joseph Beuys performance. He was trying to be an artist/politician, and the idea of performance really did come— well, of course, we all did these performances in these downtown New York alternative spaces. Tier 3...I can't remember all of them. And, of course, the artists then were doing performance and also were part of rock groups, like Robert Longo and his friends, and—but it was all about anger. And I think—in essence, Simone's work was done in a community situation.

KG: Right.

DG: From my video works, I have this idea of the art world as a community. And, of course, that was before you guys were doing arena rock with Neil Young. That period that was very important for me, this kind of group dynamic.

KG: There was that song the Velvet Underground and Nico did, "I'll Be Your Mirror."

DG: I did see the Velvet Underground, their next-to-the-last concert. But I was never a fan of Andy [Warhol]. I didn't really like him—but he's a great painter...

KG: A great portrait painter.

DG: You see, there's...

KG: A communal community. That was maybe the most interesting thing, right? The Factory community.

DG: As a Jewish artist, I'm very close to Robert Mangold and Sol LeWitt...We really enjoyed Roy Lichtenstein because of the ironic humor.

...

DG: Sonic Youth was into noise music. This is like the Feelies in some ways, even to Television, because the Feelies dealt with pop music in syncopation. Also, they're from New Jersey, and I'm from New Jersey.

...

DG: Oh, Jonathan Demme wanted to make a film about the Feelies. What I liked about the Feelies was that it related to Steve Reich and you could actually hear it in the architecture. The sound, it was in your head and in the architecture. But this is—you understand that I *did* inhale. So I know what happens when you inhale marijuana. I never did LSD. I'm too close to being schizophrenic to do LSD. And, of course, I learned all about schizophrenia from Gregory Bateson.

KG: From who?

DG: Gregory Bateson, the great psychologist who was married to Margaret Mead. His double-bind theory of schizophrenia influenced me.

KG: I haven't read that.

...

KG: You used to—when I first met you, you sometimes talked about how you used to listen to the Kinks when you were working on art or...

DG: True.

KG: Making art, I don't know what you were working on. Painting? [*Laughs.*]

DG: It was just...

KG: But—you know, you were doing the same thing that Ray Davies was doing, of the Kinks, or...I mean, so many artists I know, you know, listen to music when they work, and...and really identify closely with the music.

DG: Andy Warhol was the first. And of course Robert Smithson gets very involved in the Andy Warhol taste, which is kind of a gay taste. Smithson really liked Lesley Gore, who became a lesbian—"It's My Party and I'll Cry If I Want To." She was from New Jersey, as he was. Andy liked "Sally Go 'Round the Roses."

KG: Right, I remember you telling me about that song.

DG: By the Jaynetts, because—I thought it was very Catholic, it was like going around a rose. In the first pieces I did as magazine-page pieces I liked the disposability. I did *Side Effects/Common Drugs* [1966] partly based on "Mother's Little Helper" by the Rolling Stones. The Rolling Stones were criticized for taking drugs, and also Mick Jagger was arrested for pissing outdoors on a road trip, so "Mother's Little Helper" was showing that housewives also took drugs. And I wanted to place my work in *Ladies' Home Journal*. It was a simple way of doing Op art like Larry Poons and Lichtenstein. These works were disposable because they were in magazines. Every magazine issue would relate to each issue and then, of course, they were disposable. It's because when I had my gallery we sold nothing, but we showed Dan Flavin and Flavin said his fluorescent lights should go back to the hardware store. We gave Sol LeWitt a show and Sol said his work, which was wood, should be disposed of and used for firewood...

KG: Do you think it's kind of a hippie influence?

DG: No, it was a utopian idea. The utopian idea is "We can get rid of value." But I think the hippies

were very involved with [Herbert] Marcuse and the idea was "We shouldn't talk about the past or value, we should just live in the here and now." That was the hippie philosophy. It was all about the present time, of instantaneous present time, instantaneous pleasure, and of course Marcuse also talked about getting rid of the Oedipus complex and going back to the polymorphous perverse sexuality of children, and also getting rid of the burden of reproduction, that we should just have sex for pleasure. It was a utopian fantasy we had. But I loved pop music because it was disposable and current. So, when I did *Homes for America* [1966–67] I was thinking of the Kinks' "Mr. Pleasant" and "Nowhere Man" by the Beatles. It was a cliché that the suburbs were alienating places. And I wanted to have it in *Esquire* magazine, but my work—[Benjamin H. D.] Buchloh says the work is about sociological critique, but in fact it's a celebration of the poetry of the suburbs. And it's about upper–lower class people wanting to become lower–middle class, and it's more like [Gustave] Flaubert, in a certain way. And, of course, I thought, I knew it became a cliché later on, that rock music was a little like poetry.

KG: Mm–hmm.

DG: That became a—kind of a common thing among rock critics. So I thought I was a poet. [*Laughs.*]

KG: But didn't you come out of the poetry scene in New York?

DG: No. I gave up the idea of being a Conceptual artist because I thought it was kind of academic bullshit, so I gravitated toward essay writing, and I called myself a poet. This is also because I had low self–esteem at the time. But then I found out that almost all the poets had crushes on me because they were all gay. Except for Vito Acconci. [*Laughs.*]

KG: [*Laughs.*]

…

DG: I wanted to be a writer. And, in fact, many of the artists who I met wanted to be writers. When I had my gallery, I didn't know anything about art, I hadn't studied art. The first show I did was a Christmas show, and anybody who came into the gallery I said could show, and Sol LeWitt came in, and Sol LeWitt and I really loved the same writer, Michel Butor. Smithson wanted to be like [Jorge Luis] Borges, Flavin wanted to be like James Joyce, Sol LeWitt didn't write but he really liked writing, and Judd liked the philosophy of A. J. Ayer. So I thought you could be an artist and you could be a writer at the same time. And Andy Warhol expanded that to film. So it was a good area for me. The fact is that I didn't really know how to make art. Also, I wasn't very career–oriented. What I really liked doing was writing about rock and roll. My first article, in 1968, was about the Seeds, the Vanilla Fudge, and the Byrds concert, and it was published in a School of Visual Arts magazine called *Straight*, edited by Joseph Kosuth, who was a student there. I could get into rock concerts free by writing about rock music. In other words, I was kind of a rock–and–roll groupie. [*Laughs.*] But it was a real passion. Actually, I talked about this with Thurston [Moore]. I was also a big fan of Leslie Fiedler, the American literature critic.

KG: Right, I remember you turned me on to him.

DG: I think the rock–and–roll writers came out of literary criticism, pretty much. And I particularly admired Paul Williams and *Crawdaddy!* magazine, because he was the leading expert on Philip K. Dick, who I loved.

KG: Do you think the reason why there aren't any good rock writers any more is because...

DG: Because I don't read them. [*Laughs.*]

KG: [*Laughs.*] Well there aren't any—really hardly any. I think it's because now it's all really publicist–driven and people...I don't think people come out of...

DG: Well, actually I think Jon Savage is good. He wrote the definitive book on the Kinks. But he also wrote *England's Dreaming* about punk.

KG: What do you think about Britney Spears? Let's jump to the present.

DG: Well, actually, I've been just following her on television. I actually like her. She's white trash, but she's so honest! She's a Sagittarius. And I like her honesty and her sexuality.

KG: I think she's like a brilliant performance artist.

DG: Well, I think she's honest about her sexuality.

KG: Yes. Well, I think that it must be interesting— the men who *write* her songs.

DG: Mm–hmm.

KG: You know, because there's so much material to work with. [*Laughs.*]

DG: [*Laughs.*]

KG: You know, that's kind of...it must be weird.

DG: Mm–hmm. It must be hard, growing up a Mouseketeer. And apparently Justin Timberlake still is in love with her.

KG: Hmm. I think he should write some lyrics for Britney. [*Laughs.*]

DG: [*Laughs.*] But I'm more into country/western now, pretty much. And I was...

KG: Well, it's as if Britney was doing country/western—sex and country go so well.

DG: Yes—but something very interesting, something interesting happened. I was watching Grand Ole Opry, as I often do on Saturday night, and there's a new performer, a woman performer, who has a new country/western song going to the top. It's "Sunday Morning," which is a Lou Reed song for the Velvet Underground. She said her husband had a lot of Velvet Underground albums, and she discovered the...

KG: Really?

DG: And, of course, then...

KG: What's her name?

DG: I forget her name, because I'm not good on names, but she's quite a good performer. And this new crossover, the country/western singer discovering the Velvet Underground...

KG: Hmm...

DG: It's so much like Kris Kristofferson's Johnny Cash song "Sunday Mornin' Comin' Down." It's the same ambience.

KG: Huh. Wow. What about Lucinda Williams? Do you like her?

DG: I love Lucinda—but I've never seen her perform...

...

DG: One of my favorite songs of hers is "Maria," about the Puerto Rican...

KG: What record is that off of?

DG: It's from the Folkways L.P., the second album.

KG: Ok. I'm not familiar with all of her records.

DG: "Maria" is a modern heroine and hobo song. But the hobo is a Puerto Rican girl from New York who goes from rodeo to rodeo, encounters loneliness in the morning, and asks "Is it worth it?" for people who are always on the road. "Sometimes you have madness in the morning." It's an amazingly good song. But

so smart, because she puts together different genres in a very smart way.

...

KG: Our guitar tech was on tour with her, so we got to meet her, and she said something like, "Oh, we have so much in common." You know, we're both seen as sex symbols in our fifties, or something, icons. And I'm like, "What?" [*Laughs.*] I didn't even know she had ever heard of Sonic Youth.

DG: Well, but the thing is you have a lot in common, because her father was an academic...

KG: A professor.

DG: An academic poet. Yes.

KG: Yeah.

DG: Who is also a real feminist. Because her father did a review of Anne Sexton's book about female masturbation. And he was fired for that.

KG: Really, huh.

DG: So she really identified with her father, in a certain way. I know you went fishing with your father, right?

KG: Uh, yes. He was a great cook. That's where I learned...

DG: He took you fishing?

KG: Yeah, I went fishing.

DG: [*Laughs.*]

KG: He was a sociologist...At heart he was from Kansas.

DG: So, in other words, he was basically a Midwesterner who went to California. See, the great people from Los Angeles are people from the Midwest—like Ed Ruscha—who discovered Los Angeles.

KG: Yeah, I think Los Angeles is all about the Midwest. That's how it's different than New Jersey. [*Laughs.*] Not many people move from the Midwest to Jersey. Unless they can't afford New York.

DG: Well, New Jersey had, after World War II, a highway culture. With drive–in cinemas.

KG: That's interesting. L.A. has, of course, the ultimate drive–in, the drive–in church.

DG: It was highway culture. And, also, my parents were upper–middle class, but their student–day friends were Communists. After the war, there

was no money, so we lived in a housing project built for ship–builders. I actually loved growing up with working–class people. When we moved to an upper–middle–class suburb I freaked out. I had a nervous breakdown.

KG: How old were you?

DG: Thirteen. But I had problems with my father.

KG: That's a hard time to move.

DG: Yes. Also—well, I don't know—my relations with my father created a mental problem, he was actually very abusive to me. But, speaking of Kansas, Donald Judd's first articles are very important for me. Judd was from Kansas City, and he wrote an article about Kansas City's city plan, which was nineteenth–century neo–classical, and then he moved to New Jersey. So he combined neoclassicism with New Jersey plastic culture. And I think L.A., actually—well, it was the aircraft industry. It was the same kind of thing. And I grew up with mass production after the war.

KG: Did Judd go to the desert to escape the art world?

DG: Marfa? He actually…

KG: Have you ever been there?

DG: Yes. When he was in the army, that was his army base.

KG: Oh, yeah?

DG: Yes. Mm–hmm.

KG: Oh! Wow, I didn't know that. We were in this one building, I thought they said, that used to be a—actually they used to keep prisoners there. I was distracted by all the sculpture…

DG: I recently did a big show called "Deep Comedy" in a former ballroom in Marfa.

…

DG: New Mexico began as a writers' and artists' colony. Of course, there's Georgia O'Keeffe, who is the hottest woman artist I've ever seen in photographs.

KG: [*Laughs.*]

DG: And then Agnes Martin, who Sister Wendy thinks was the best Minimal artist…Max Ernst taught at the University of New Mexico.

…

DG: My work really comes less out of the aca–demic; my early work comes out of anarchistic humor. I was very close to On Kawara. His *I'm Still Alive* has kind of existentialist humor. I love Stanley Brouwn. And what I hated about Con–ceptual art—when they made a movement out of it, it was *such* academic seriousness. And I think all my work is really about humor. Cer–tainly I've learned a lot from Claes Oldenburg with my *Star of David* piece [1991–96]…

KG: What about [John] Baldessari?

DG: Well, Baldessari I met when I was teach–ing at the University of California, San Diego, and he was teaching there and he brought in Michael Asher. The thing about Baldessari was he brought in so many good artists to talk to his students. I admire him and his work. But my work actually comes more from Lichtenstein.

KG: Right. So you think a lot of people didn't take John Baldessari so seriously because one, he was from California, and two, his work had so much humor in it?

…

DG: I've got to put him in the next installment of "Deep Comedy" for Marian Goodman Gallery in New York. But the artist I related to most was William Wegman, early William Wegman. And my "Deep Comedy" show begins with John Wesley, who is in his late seventies. Then I had this won–derful Belgian artist Jef Geys, then Roman Signer from Switzerland. My favorite artists are actually Fischli & Weiss in Europe and Sigmar Polke, who I knew. But I think parody is very important. I did my *Yin/Yang* pavilion [2003] as a parody of 90s New Age religion and my dislike for Bill Viola.

KG: [*Laughs.*] What about Jack Goldstein?

DG: I think the thing about Jack Goldstein was his work influenced my article "The End of Liberalism," because it's all about the fact that underneath the celebration of liberalism there's facism.

KG: Wouldn't that be underneath Pop art there is fascism?

DG: Well, under…I think…

KG: I mean, not Pop art, but using pop iconog–raphy.

DG: Oh yes. But actually, I think Walter De Maria had similar insights—the idea is you have a glossy surface of everything that's nice and wonderful, and underneath there is deeply sub–liminal fascism. America was still fascist after World War II. And I think Jack also had this insight. There's a kind of terror in his work.

…

After the war, there was no money, so we lived in a housing project built for ship–builders.

The thing is, I was a feminist from the early 70s.

KG: Reading that book *Jack Goldstein and the CalArts Mafia*, I found it really interesting that all those people, Robert Longo and you know, Troy Brauntuch, they all thought that whole period was just—that it really fucked them up and that it was *weird*. I thought it was just me that got freaked out by it all. [*Laughs.*]

DG: [*Laughs.*]

KG: I just thought it was interesting, what he said about how going to CalArts and learning about Conceptual art and Baldessari and turning him on to Conceptual art and the young artists like Larry Bell and Jack almost making a conscious decision, "Well okay, we're not going to do that, we're going to do something different—a really glossy object." I mean...

DG: No, but your friend and my friend, Mike Kelley, he's a brilliant writer, but he wrote against Marcel Broodthaers, who I think was a very great, great artist. See, I think Mike, maybe because he's a Scorpio, has turned on everything in Conceptual art from the beginning. But he also loved [Öyvind] Fahlström, who he understood...

KG: And Paul Thek.

...

KG: My daughter Coco, she likes the Beatles; she likes the Kinks; she likes the Velvet Underground. She hasn't really explored country/western, although she does like Lucinda Williams and Fiona Apple. Do you like Fiona Apple?

DG: I don't think I really know this Fiona Apple. But there are so many things I don't know about women singers, like I don't really know the woman who won all the Grammys—Winehouse?

KG: Oh, Amy Winehouse. You don't need to know her. [*Laughs.*]

DG: No? Well, my heroine, actually, in music, is Cyndi Lauper. Because she really...

KG: She is good friends with Yoko Ono.

DG: She understands pop. Which, I'm afraid Madonna doesn't so much. Madonna's commercial, where she understands what pop music's about. And I think she's reinvented herself now as a torch singer. But you know who also became a torch singer, who is also a Gemini, who I admire enormously, Lydia Lunch. One of my favorite albums is...

KG: *Queen of Siam*?

DG: *Queen of Siam*.

KG: Yeah.

DG: And I actually love that album.

KG: Yeah, it's a great album.

DG: I know.

KG: It's much better than Chan Marshall's cover record. Although I really liked her early covers.

DG: Well, I traded Rodney Graham for a photo I took of Chan Marshall and a cat.

KG: Oh, the cat.

...

DG: What do you think of Joan Jonas?

KG: I like her.

DG: You do?

KG: I saw a retrospective of hers when I was in Barcelona.

DG: I met her when she was Nancy Holt's best friend, when Nancy was the wife of Robert Smithson. I've known her for years. Her installations are pretty amazing.

KG: Yeah. I mean, I guess it's also, you know, there have been all these feminist shows, so, it's sort of a way of taking some aesthetic of the body that came out of feminism and dealing with it in a way that people are kind of still afraid of, but it really transcends that period and looks so greatly esoteric.

DG: Well, feminism's...

KG: Because I think it's influenced a lot of men's work, including people like Mike Kelley, so much.

DG: Well, Mike Kelley tells everybody he's a feminist artist.

KG: Oh really?

DG: Because he studied with Judy Chicago.

KG: Huh. Well, I can see that. [*Laughs.*]

DG: What? Yes? The thing...

KG: That's so obvious, I guess, but brilliant.

DG: The thing is, I was a feminist from the early 70s. I read Shulamith Firestone's *The Dialectic of Sex*, which was the first book about feminism. I was very influenced by Margaret Mead, enormously. I guess a lot of boys, when they were twelve or thirteen, were reading Margaret Mead to find out about sexuality.

KG: Right. [*Laughs.*]

DG: It turns out Margaret Mead was pretty amazing. She was bisexual, she was a Sagittarius,

and she wanted to have sex education in elementary schools. This is America after the 40s.

KG: Wow.

DG: Eleanor Roosevelt became a lesbian. It was very, very progressive for women in the 40s. And that's my earliest memory. So I was really into feminism until the horrible mid-80s when it became all politically correct and coercive, and a little bit puritanical.

KG: Well, a lot of it, the art wasn't that great.

DG: I mean, it didn't hack it. [*Laughs.*]

KG: Yeah—but the *ideas* were radical. And again, the idea of creating work that was almost like a hobby, but with anger or passion—it was "What can we make that's outside of the structure and language of our history that's been created?" Through dandyism, or men, or whatever, you know, but—the Establishment. And...

DG: Well, I'd like to see my art as a hobby also.

KG: Mm-hmm. Isn't that like a lot of...to me, my memory of like, funk art, kind of had that vibe to it that I liked. California.

...

DG: So you come very much out of all the vibes from L.A., when you grew up in L.A.?

KG: Umm, I guess. [*Laughs.*] I guess in a way it was very...My idea of L.A. is much more surreal, because I grew up around these giant dirt mounds, when they were building freeway on-ramps, and we would play on these giant dirt mounds and stuff. But they were, you know, surrounded by suburban houses...

DG: But it was—highway construction, right?

KG: Yeah.

DG: I also grew up near where the Garden City Parkway was being built. But actually where I was at the edge of the suburbs was actually marshes, and it was like Huckleberry Finn.

KG: Huckleberry Finn in New Jersey.

DG: Well, we're going back to Leslie Fiedler again.

KG: Yeah.

...

Gary Carrion-Murayari: Well, I wanted to ask you—I guess both of you—about performance, about this idea of feminism and performance. I mean, I don't know how that affected you when you were starting to perform. But I read an interview with you once where you were saying when you stopped performing it had to do with how a woman was, I guess, constructed in those performances. How you were addressing a person or then you were asking a female to perform in a certain piece.

DG: Well, I did *Rock My Religion* [1982–84] because we needed a female heroine. And actually, I was not a Patti Smith fan, but Thurston had a key to my place and I had a key to Thurston's place, he borrowed records and I came down and ransacked his files about Patti Smith. But I needed a female heroine, and she was not known then. She was forgotten. I thought she was a good heroine. But also, I was reading about Shakers and Ann Lee. No, I stopped performing because...I was performing because all the artists were performing, and the venues were the rock clubs and performance spaces downtown. And I think a lot of music came out of that scene. I was friends with a kind of almost psychotic Scorpio guy, Jeff Lohn, who actually was very close to Glenn Branca, and, of course, I always liked to hang with musicians. I was very close to Steve Reich, who was also one of my best friends.

KG: And what about La Monte Young?

DG: I edited *Aspen Magazine* and he did a record for my issue...

KG: Mm-hmm. Did you ever want to make music yourself?

DG: Uh, no. But I also never wanted to be a dancer. [*Laughs.*]

...

KG: We were watching John Cage's brilliant performance on that TV show *What's My Line*. Did you ever see that? It's on YouTube.

DG: Well, I remember...

KG: And he does this performance of this piece called *Water Walk*...

DG: [*Laughs.*] That's great!

KG: Yeah, it's a brilliant...

DG: He's a great—oh, that's...

KG: Thurston went up to Coco's school to show it to her class, and he talked about John Cage and...

DG: One last thing I want to talk about is...

KG: Experimental music?

DG: I know that Kim is a big fan of television comics, comedians?

KG: [Pauses.]

DG: Do you like David Letterman?

KG: Uh...well...I used to.

DG: You even liked this awful guy for a while...

KG: Stephen Colbert?

DG: What?

KG: Jon Stewart?

DG: Uh no, this awful guy, he's a Scorpio, what's his—Dennis Miller?

KG: Oh yeah, he turned bad, yeah.

DG: He turned out to be a real asshole.

...

DG: Ernie Kovacs was Canadian. He had a big influence on me.

KG: Steve Allen?

DG: Uh, Steve Allen actually hated rock and roll. He used to break rock-and-roll records.

KG: My parents used to watch him.

DG: He used to break up rock-and-roll records...

KG: [Laughs.]

DG: Because he was a jazz guy. To me it was Mel Brooks that I dug, the Two-Thousand-Year-Old-Man on radio, and also The Producers. And I particularly really like Martin Short.

...

DG: I think our interest in performance, at least my interest, really, comes from television comedy, a lot of it.

KG: Really?

DG: And, of course, it's a Jewish tradition.

KG: Right.

DG: I also like Canadian comedy enormously. I like SCTV. I loved Martin Short's Primetime with Jiminy Glick, one of the best programs I saw... [Laughs.]

KG: [Laughs.] Yeah.

DG: But comedy—the key to my work is pretty much parody and comedy. And I think the performance pieces, which I just did a few of, in some ways...I think that's why Yvonne Rainer related to them. Because she's very, very funny, Yvonne.

...

KG: What about Raymond Pettibon?

DG: Oh, Raymond? I love Raymond's work enormously—absolutely enormously. Every time I go to an art fair, I want to steal a Pettibon, but then I met him recently in L.A. and he said he would love to trade with me.

...

KG: I wish he'd do more movies. His scripts are brilliant.

DG: Oh, the videos are so much fun, I asked him about that. He said he couldn't get the people together all the time. It has to be at the right moment.

...

DG: But, what's great about Mike and John Miller is that they still write.

KG: Oh yeah.

DG: And I came into art as an artist/writer. And, actually, Jeff Wall told me an artist shouldn't write, they should just—the most important thing is...

KG: Just let them draw? [Laughs.]

DG: No, no...just that artists should not write about people other than themselves. That's the job of the curator. He said the most important thing for artists is to become famous.

KG: Really?

DG: It's all about strategy. Whereas Mike Kelley is so passionate, of course he writes about the arts...

KG: Well, that's because Mike comes out of punk rock, sort of. You know, in that sense. In fact, the first time I met you, you and Mike were arguing about who started punk rock.

DG: Well, yeah...

KG: The lecture at CalArts. No, but it's more that, you know, he comes out of that Calvinistic work ethic, for one thing. You know, he doesn't come—he's not comfortable living in a pleasure dome for a house. Anyway...

DG: This is where you're right about John Baldessari. Baldessari really gave a lot of people their start. But actually, the friend of mine who just died that was very instrumental for Mike Kelley and Tony Oursler...

KG: Who's that?

DG: David Askevold.

KG: David Askevold died?

DG: Yes, he taught at CalArts. He died about nine months ago.

KG: Oh, wow. I didn't know that.

DG: That's how I got involved in Nova Scotia College of Art. He got me up there to do this projects course.

KG: Wow.

DG: Mm–hmm. But he was very instrumental, when he was teaching there.

KG: He came to one of my openings, at Participant, I think. I hadn't seen him in years.

DG: One of the shows that Rodney likes is—yes. He did a show at Canada, the gallery here, about Hank Williams and Hank's note.

KG: Oh yeah, I remember.

DG: Mm–hmm. Which Rodney thought was great.

GC–M: Not enough people know about David Askevold in New York.

KG: John Knight is the one who introduced me to him.

DG: Well, it's a kind of Aries mafia. No, see, I used to have problems with Aries women... **DG**

I think our interest in performance, at least my interest, really, comes from television comedy...

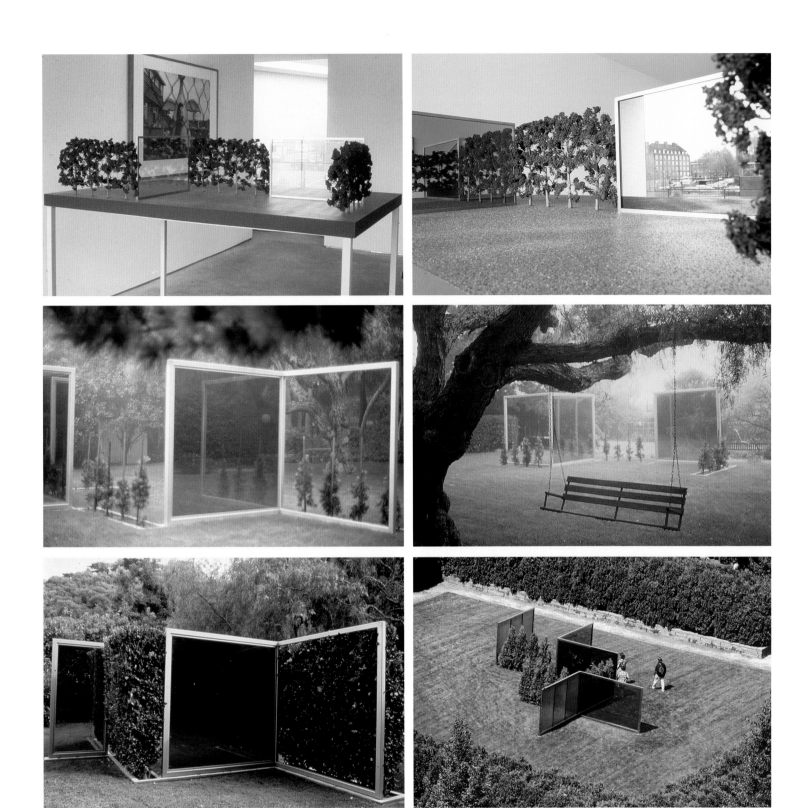

following spread
Graham and Robin Hurst's *Private "Public"
Space: The Corporate Atrium Garden* (1987)

top row
Views of architectural model *Two-Way Mirror Hedge Labyrinth* (1991)

middle row and bottom left
Views of *Two-Way Mirror Hedge Labyrinth* (1991); two-way mirror, glass, and aluminum;
6 x 27 x 15 feet; collection Robert Orton; installed in La Jolla, California

bottom right
Views of *Two-Way Mirror Punched Steel Hedge Labyrinth* (1994–96); glass, stainless steel,
and arbor vitae; 7 $^1/2$ x 17 $^1/8$ x 42 $^3/8$ feet; Walker Art Center, Minneapolis; installed in
Minneapolis Sculpture Garden

PRIVATE 'PUBLIC' SPACE:
THE CORPORATE ATRIUM GARDEN

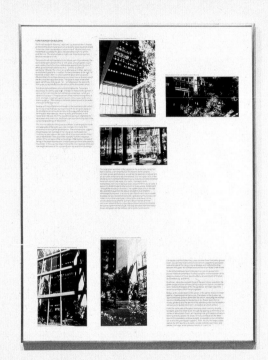

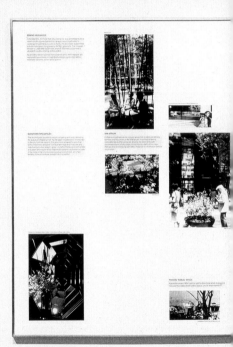

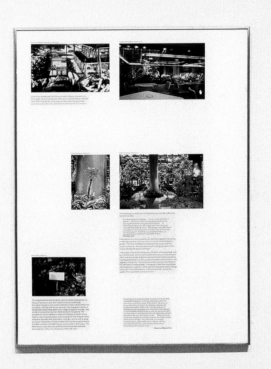

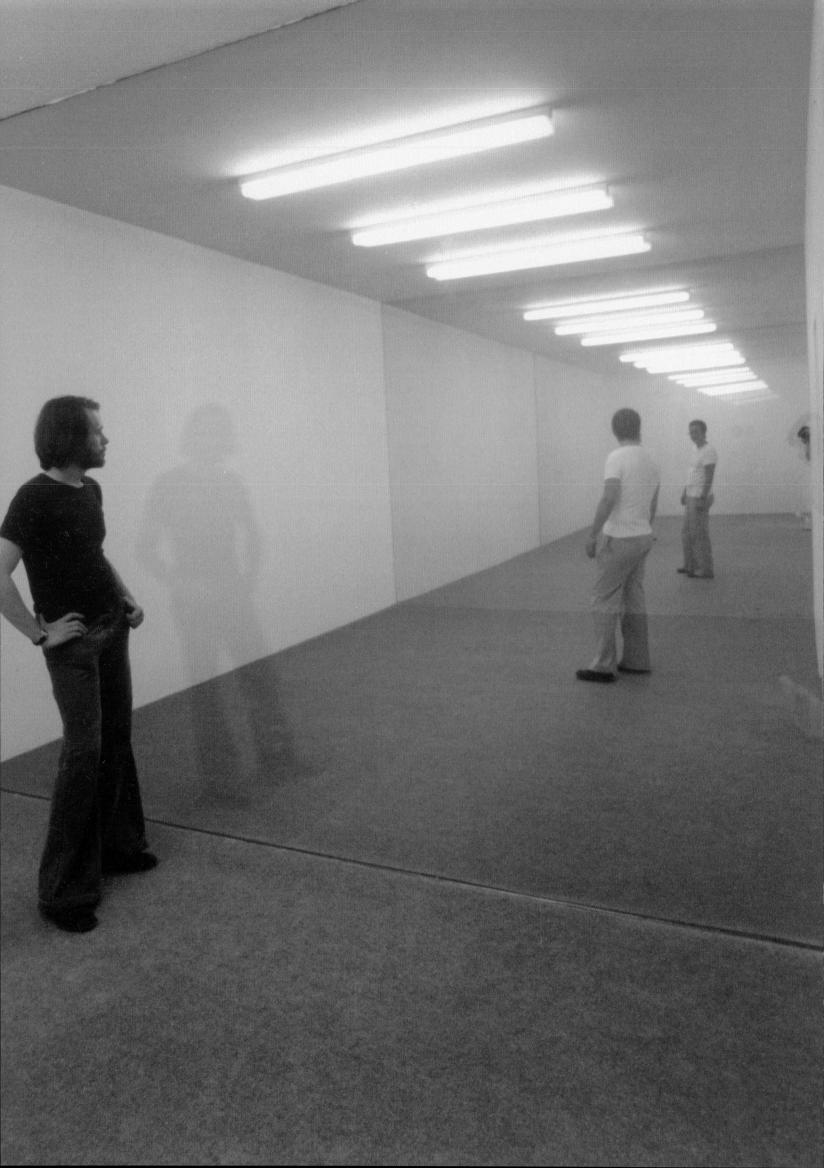

A Public Space: Context and History

Mark Francis

In the very hot summer of 1976, at the age of twenty-four, I
traveled to Venice, Italy, for the first time to see the Biennale
di Venezia. I could not afford a hotel, so I stayed in a youth
hostel on the Giudecca, and I did not have an invitation for the
preview days, so I walked along the waterfront beyond the
Giardini and climbed over the fence behind the British Pavilion
to enter the grounds. I was at the time living in Cologne,
Germany, studying "arts administration" (as it was known
prior to the "curatorial studies" courses now so prevalent) as
an intern at the Kölnischer Kunstverein, and I hitched a ride to
Venice with two friends, Paul Maenz and Gerd de Vries, who
then ran a small gallery in Lindenstrasse. We took two days
driving to Venice, staying overnight at the Lago d'Orta in a
beautiful old hotel.

 The main exhibition in the Giardini was "Ambiente
Arte," curated by Germano Celant, then in his mid-thir-
ties. The show was an unprecedented survey of historical
approaches to the creation of room environments or spaces
between art and architecture, from examples of Futurism
and Constructivism to contemporary work. Included were
reconstructions of El Lissitzky's *Proun Room* (1923/65)
from Eindhoven, Piet Mondrian's *Salon de Madame B* (1926),
Kurt Schwitters's *Merzbau* (1923–37) from Hannover and
Merzbarn (1947) from Newcastle, life-size photos of Jackson
Pollock's studio (1950), Giuseppe Pinot Gallizio's *Caverna*

Public Space/Two Audiences (1976) installed in "Ambiente Arte," XXXVII Biennale di Venezia, Venice, Italy

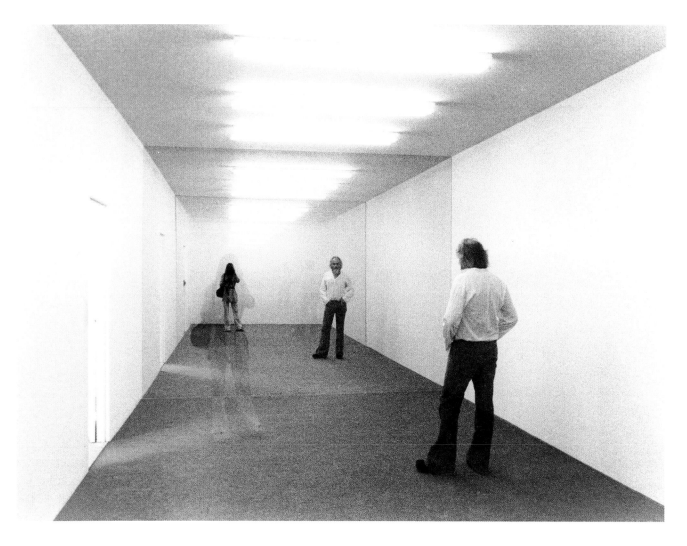

figs. 1, 2
Public Space/Two Audiences (1976) installed in "Ambiente Arte," XXXVII Biennale di Venezia, Venice, Italy

dell'antimateria (1958), Marcel Duchamp's open/closed door from 11 Rue Larrey (1927), and Andy Warhol's *Cow* (1966) wallpapered room, among many other reconstruc-tions, documents, and photos. Celant had given rooms to twelve contemporary artists to create ambient environments, including Michael Asher, Joseph Beuys, Dan Graham, Jannis Kounellis, Sol LeWitt, Maria Nordman, and Blinky Palermo.

The work shown by Graham, *Public Space/Two Audiences* (1976, **figs. 1, 2**), appears at first to be a room with two separate entrances that may be chosen at random. Entering through either one of the doors, one may establish the overall extent of the work. Each door belongs to one half

Notes **1.** Dan Graham, diagram for *Public Space/Two Audiences* (1976), in "Notes on *Public Space/Two Audiences*," *Aspects*, no. 5 (winter 1978); reprinted in Graham, *Two-Way Mirror Power: Selected Writings by Dan Graham on His Art*, ed. Alexander Alberro (Cambridge, Massachusetts: The MIT Press, 1999), 156.

2. Tommaso Trini, "The Seventies: The Crisis of the Avant-gard [*sic*] as an Institution," in *La Biennale di Venezia 1976: Environment, Participation, Cultural Structures*, vol. 2 (Venice, Italy: Biennale 1976), 294.
3. Olle Granath, "Hall of Intentions," in *La Biennale di Venezia 1976*, 298.

of a large space divided by a single, large glass wall. The back wall of one room is covered by a single large mirror, while that of the other space is a plain white wall, as are the side walls. The effects of this apparently simple division of space are profound for the audience(s), as it creates the sense that a play is being performed by those in one space for an audience on the opposite side. The sound-insulating Thermopane glass divider allows one to see, but not hear, others in the adjoining room. One's ghostly reflected image is partially visible on the glass and is therefore superimposed on the view of those on the other side. From the room opposite the mirror, one's image is infinitely reflected in diminishing scale between the intermediate glass divider and the mirror at the back of the other room. The general reaction of visitors is initially to look at each other through the glass and then to start mimicking actions as in a dance. The differences of perception are acute depending on which room one enters. One cannot hide (as in a police-interrogation setup with one-way mirrors), and yet a covert voyeurism is impossible to avoid. Each room seems a complete space, and yet one is fully conscious of it being only half of the total environment.

At the time, Graham's proposal included annotations as follows: "Each audience sees the other audience's visual behavior, but is isolated from their aural behavior. Each audience is made more aware of its own verbal communications. It is assumed that after a time, each audience will develop a social cohesion and group identity."[1] It is as if the work acts as a sociological or demographic experiment in which two groups, initially at odds, learn to interact and coexist. Of course, the artist's language was intrinsic to that historical moment. Celant's "Ambiente" exhibition was part of the re-establishment of the biennale during the mid-1970s after the upheaval of the previous years, during which political events made trivial the internal disputes about awarding competitive medals and prizes to artists, so that it was suspended after 1968 (imagine that in the current context!). At the same time, in the other main contemporary section of the biennale, held in the ex-naval yards (Cantieri Navali) on the Giudecca (this predates the use of the Arsenale as a venue), a heterogeneous selection of artists was justified by the curators' consideration of such issues as "the crisis of the avant-gard[e] as an institution"[2] (Tommaso Trini) and "statements to the effect that modernism is compromised, burned-out, moribund or dead"[3] (Olle Granath). Only Pontus Hulten (in the year before the Centre Pompidou opened) was writing in an advanced and humane manner about a new art that "has nothing to do with the production of objects, not even with situations or environments, but with making and living and with the quality and precision that go into

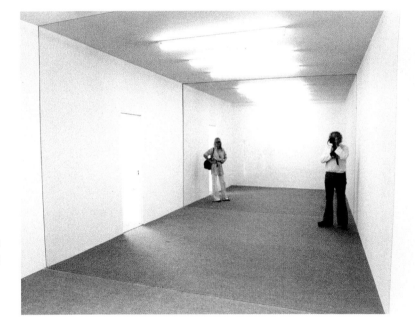

fig. 3
Maria Nordman's *Plan for Venezia* (1976); ink on paper;
13 7/16 x 17 5/8 inches; courtesy of the artist and
Marian Goodman Gallery, New York and Paris

making and living."[4] He was attempting to assess why "there seems to be no deeper understanding between the best contemporary art and progressive politics, in spite of the fact that almost all interesting artists (with a few outstanding exceptions) are politically left–wing oriented."[5] (All one night while in Venice I spent pasting up all over town large posters for International Local, a group consisting of Joseph Kosuth, Sarah Charlesworth, Anthony McCall, and Carolee Schneemann.)

Graham has reflected on his work: "The pavilions in the biennale I see as showcases for the 'top' artist of a country at that moment. In my piece the spectators (and their self–reflections in relation to each other) are in place of the art object. I began with Mies's Barcelona Pavilion and Lissitzky's rooms."[6] The context in Venice that year was not so much the nationalistic aspect of each country's pavilions, but the physical presence nearby not just of those historical antecedents of Graham's works, but the rooms of Nordman and Asher in particular. Nordman divided an octagonal room with a wall, one edge of which was bordered by a thin vertical translucent strip that allowed light only to enter one half of the space—the immaterial becoming physical (fig. 3). Asher's space seemed at the time to be the most insubstantial. An interstitial passage between two rooms, it opened out towards the gardens surrounding the biennale pavilions and was filled by the artist merely with low folding stools inviting visitors to sit and rest, thereby creating a sociable space through a minimum of intervention.

Graham's work added a performative aspect to the environments on display. Though his intentions were to use the space as a functional device directing the behavioral pattern of its spectators—like the best of Graham's work, it functions only when visitors are present: a minimum of two is required, unlike the contemplative ideal of a single absorbed viewer necessary for a conventional work of art—it also had in this original location in Venice a massive experiential, even sculptural presence, even without viewers. Graham has continued to be fascinated by public parks, world's fairs, and the organization of the bourgeoisie's leisure time and space.

At this time, during the summer of 1976 and simultaneous with the release of the Sex Pistols' first record, Graham's work was also focused on more demotic and generic public spaces. *Public Space/Two Audiences* could be contrasted with another work of the same year, *Video Piece for Showcase Windows in Shopping Arcade* (figs. 4, 5, 6), intended for the debased (and often subterranean) descendants of Ludwig Mies van der Rohe's modernist glass corporate architecture. In this work, mirrors are located on

4. Pontus Hulten, "Creativity and Politics," in
La Biennale di Venezia 1976, 293.
5. Ibid.
6. Graham, in "Notes on *Public Space/Two
Audiences*."

figs. 4, 5
Diagram for and view of *Video Piece for Showcase Windows in Shopping Arcade* (1976) installed in Groningen, The Netherlands, 1978

fig. 6
Video Piece for Showcase Windows in Shopping Arcade (1976)
installed in Groningen, The Netherlands, 1978

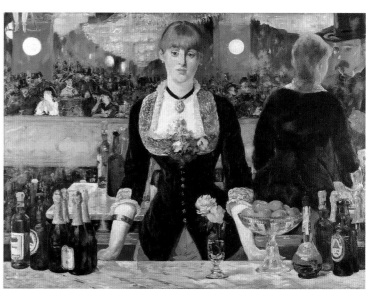

fig. 7
Édouard Manet's *Le bar aux Folies–Bergère* (1882); oil on canvas;
37 13/16 x 51 3/16 inches; Courtauld Institute of Art Gallery, London

the walls behind two opposite and parallel shop windows, with video monitors and cameras either facing the spectator in the corridor or facing the mirror reflecting the spectator, each transmitting live coverage of the interaction, with one camera's recording playing back with a five-second delay. A very complex interaction is set up with relatively simple means, whereby the viewer can indulge in narcissistic reflections on his/her place in the cycle of capitalist consumption and alienation. Visually the work is reminiscent of Édouard Manet's *Le bar aux Folies-Bergère* (1882, **fig.** 7): mirrors, lights, a transaction between a customer and salesgirl in a place of popular entertainment and nocturnal pleasures. Graham knew at that time the social art-historian T. J. Clark (then professor at Leeds University), whose great books on Gustave Courbet and French art of the mid-nineteenth century were about to transform the discipline of art history. In an annotated copy of an article on Manet's *Bar* that Clark gave the artist in 1977, Graham noted, "She sells…Roxy Music" in the section where Clark discussed the *café-concert* performer Thérésa ("the vulgar, violent, proletarian songs, the slang, the obscene gestures, the lavatorial humour"[7]). Within a year or so, Graham was writing a series of articles— "Punk: Political Pop" (1979), "McLaren's Children" (1982), and others, which themselves articulate the relationship between contemporary popular culture and fine art.

Clark's analysis of Manet aimed that "in order to confront 'the beholder' with the unity of the picture as painted surface, all the other kinds of unity which are built into our normal appropriation of the work of art—including the unity of ourselves, the 'beholder'—have to be deconstituted."[8] Then too, Graham's work in the biennale seemed to deconstitute the beholder in analogous ways. But in this instance, who is the beholder? Now, thirty years later, can this work have the same effect? Or should it, and we, have changed? ◐

7. T. J. Clark, "The Bar at the Folies-Bergère," in *The Wolf and the Lamb: Popular Culture in France from the Old Regime to the Twentieth Century* (Saratoga, California: Anma Libri, 1977), 240.
8. Ibid., 237.

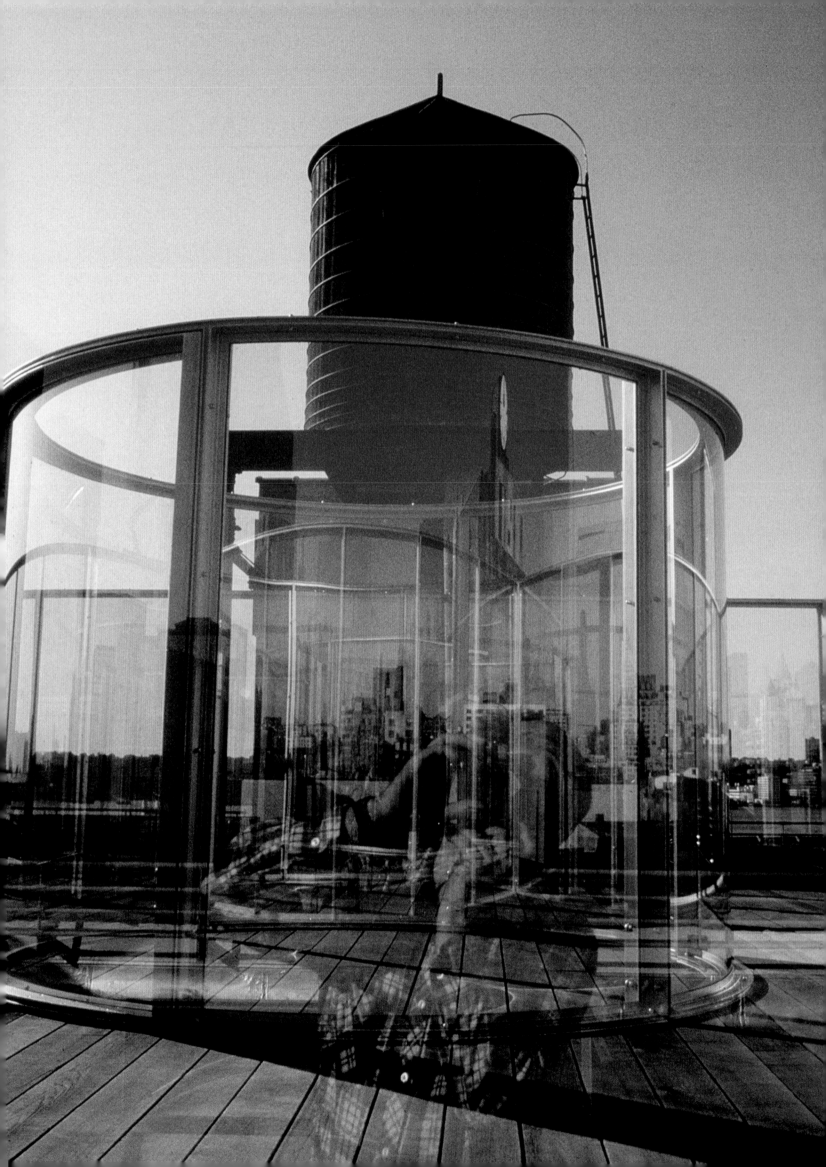

Beyond Pavilions:
Architecture as a Machine to See

Beatriz Colomina

There is a story by Anaïs Nin, "The Veiled Woman," in which a
man is in a bar and sees a stylish couple dressed all in black,
a veil covering the woman's face. The woman leaves the bar,
and her companion comes up to the first man and tells him
that he is completely dominated by the caprices of a woman
who is only interested in a man she has never seen before
and will never see again. He offers to pay him fifty dollars to
satisfy the desires of the woman. The first man accepts and
they get into a taxi, where he agrees to be blindfolded, and
they eventually arrive at a house with all-white walls, ceil-
ings, and carpets and with so many mirrored walls that he
loses all sense of perspective, seeing only infinite repetitions
of himself making passionate love to the woman. For months
he is haunted by the memory of this extraordinary experi-
ence, until one evening he meets a man at a bar who tells him
a story: several months before, an elegantly dressed man had
approached him in a bar and offered, for a fee of a hundred
dollars, to let him see a magnificent love scene. When the first
man asks him to describe the scene, he recognizes it as the
very one in which he had participated.[1]

The structure of this 1940s story echoes the optical
and psychological structure of the pavilions of Dan Graham,
where both viewers and performers are invited to participate
in a game in which their roles are unexpectedly reversed

Notes 1. Anaïs Nin, "The Veiled Woman" (c. 1940–
41), in *Delta of Venus* (London: W. H. Allen,
1978), 84–91. For Jacqueline Rose, the story
represents a model for the apparatus of cin-
ema. Rose, *Sexuality in the Field of Vision*
(London: Verso, 1986), 222–23.

Two-Way Mirror Cylinder Inside Cube and a Video Salon: Rooftop Urban Park Project for Dia Center for the Arts, New York (1981/91);
two-way mirror, glass, steel, wood, and rubber; pavilion: 9 x 36 x 36 feet; video salon and café: 10 1/$_2$ x 12 x 23 feet; collection Dia
Center for the Arts, Dia Foundation, New York; installed on rooftop of Dia Center for the Arts, New York, 1991–2004

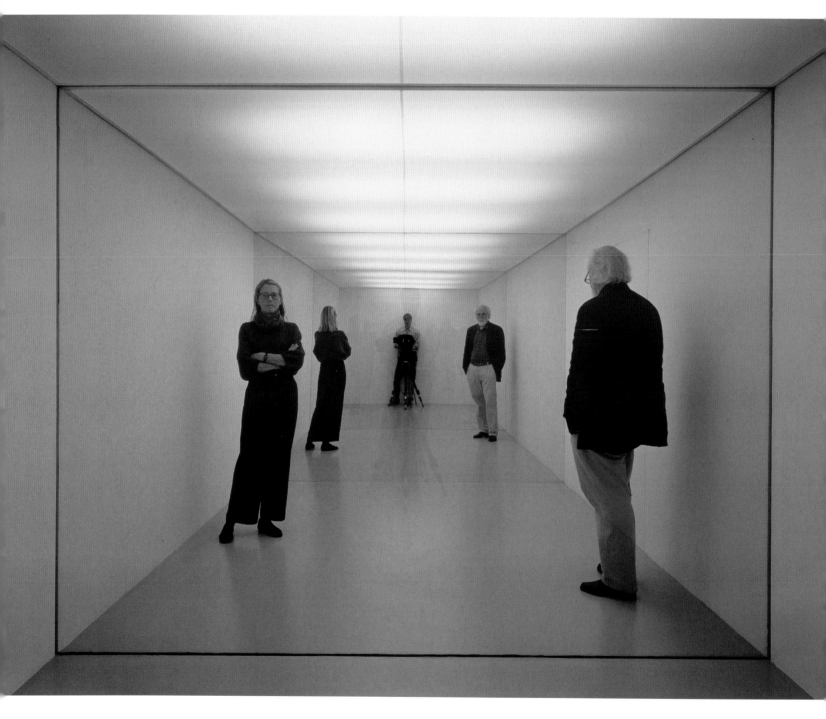

fig. 1
Public Space/Two Audiences (1976) installed at the Herbert
Collection, Ghent, Belgium

either of the doors leading into each room. Visitors on one side could see those on the other, but were isolated acoustically. They also saw themselves and the others reflected in the mirror. It is symptomatic that Graham refers to this work as a "pavilion" despite the fact that it was actually an installation within a larger building. It compacts the logic of the art fair into a small defined space, acting as a kind of condenser of the art world around it. Graham has said that the Venice Biennale and other art fairs function like nineteenth-century world's fairs, where each country is represented by a pavilion, and art is the commodity. In Venice, he attempted to upset the system by turning the audience into the exhibition. Visitors to the pavilion could see themselves seeing themselves. They had become the commodity. The subject and object of the gaze coincided.

The effect recalls that of Ludwig Mies van der Rohe's Barcelona Pavilion (1929, **figs. 2, 3**), where unwitting visitors saw themselves reflected in its dark glass walls, with the surrounding clouds, sky, and trees appearing behind them. A local journalist commented on the "mysterious" pavilion: "because a person standing in front of one of these glass walls sees himself reflected as if by a mirror, but if he moves behind them, he then sees the exterior perfectly. Not all the visitors notice this curious particularity, whose cause remains ignored."[2] It is important to go back to these kinds of spontaneous statements to understand the surprise that a glass building elicited in 1929—something that a generation grown up around Hilton International Hotels, as architect Alison Smithson put it, may have difficulty imagining.

Mies and Graham are linked by the idea of the pavilion. When commissioned to build the German Pavilion for the International Exhibition in Barcelona, Mies asked the German Ministry of Foreign Affairs what was to be exhibited. "Nothing will be exhibited," he was told, "the pavilion itself will be the exhibit."[3] In the absence of the traditional program—the exhibition of commodities—the Barcelona Pavilion became an exhibit about exhibition. All it exhibited was a new way of looking.

In both Mies's and Graham's pavilions, the visitors are themselves on display. Instead of contemplating discrete objects—artworks or commodities (both of which, as Graham noted, are thoroughly confused with each

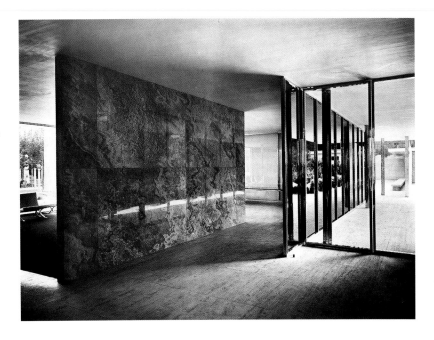

figs. 2, 3
Exterior and interior views of Ludwig Mies van der Rohe's Barcelona Pavilion for the International Exhibition, Barcelona, Spain, 1929

2. A local journalist from Barcelona reviewing the pavilion, quoted in José Quetglas, "Fear of Glass: The Barcelona Pavilion," in *Architecture Production*, guest edited by Beatriz Colomina, vol. 2 of *Revisions: Papers in Architectural Theory and Criticism* (New York: Princeton Architectural Press, 1988), 130.

3. Julius Posener, "Los primeros años: De Schinkel a De Stijl," *Mies van der Rohe, AV Monografías*, no. 6 (1986): 33.

fig. 4
Views of architectural model *Alteration to a Suburban House* (1978)

other)—they see themselves in the space of the exhibition. The pavilion is simply a space in which people encounter themselves, a space of reflection. Though Graham is a dedicated student of architectural practices, contemporary and historical, Mies is the architect who has most clearly influenced his work. Yet what he has learned from Mies is not simply the look of Mies, in the sense of a reproducible visual style, but Mies's way of exposing the very act of looking, the new ways in which we look both at ourselves and at the world: Mies's sense of architecture as a vision machine.

From his Venice Biennale installation on, Graham has steadily elaborated a reflection on vision itself in an ongoing series of pavilions that deploy architecture as an optical instrument. By now, he has completed over fifty pavilions in a remarkable sustained test in which the genre of the temporary experimental structure has been turned into a permanent project. In a sense, all of Graham's pavilions play on the original surprise of glass architecture, endlessly exploring the enigma that glass is not actually transparent. But he takes Mies's quest into another dimension, seeing the play of reflections in psychological, sexual, and economic terms. He forces the viewer to become implicated in these questions. In *Public Space/Two Audiences*, for example, visitors had to agree beforehand to spend ten minutes in the space with the doors closed. There was a kind of contract between artist and visitors, who had to confront the dynamic, literally immersing themselves in the gap between reflections. The traditional viewer of the work of art was turned into a visitor by the architecture, and then into a spectator of a performance in which he or she was implicated. All they saw were themselves being seen by others—an erotic gaze superimposed on a narcissistic gaze. It is as if all Graham wanted to capture were the complications in the very act of looking.

But why does he need architecture to intensify an effect that he had already repeatedly been exploring in video works? For *Body Press* (1970–72), for example, a naked couple films each other with two cameras inside a mirrored cylinder, capturing both themselves and the act of filming. But viewers of the work cannot enter that cylinder. Likewise, in *Two Consciousness Projection(s)* (1972), a woman concentrates on the live image of herself on a television monitor while the cameraman concentrates on her image in the camera lens. The audience watches the scene and listens to the performers but cannot enter. In *Public Space/Two Audiences*, architecture became the optical instrument and the viewer also became the performer. The key development in this work was the introduction of the two doors, which made the space architectural. The work is no longer in a space. The work is a space that can be entered.

More precisely, it became a work when entered, the observer producing the effect. Architecture was used to undermine the gallery system, with its systematic separation of viewer and work. And yet Graham felt that this undermining didn't go far enough and started to delve deeper and deeper into the realm of architecture:

> After my Venice Biennale piece...I realized the trap in that work which seemed to be very successful was that it was inside the white cube of a gallery. So I wondered what would happen if I took one wall away and made it into a window. Then immediately, you would have something that was both architecture and exhibition space. This corresponded to a group of works that I researched or had physically seen often, done by architects, such as Rietveld's sculpture pavilion for the Otterlo Kröller–Müller Museum or demonstration pavilions of new architecture for temporary expositions. So, I was thinking again about exhibiting architecture models as art. This is an area that became important during constructivism but was not really dealt with by Minimal art .[4]

Just as Mies turned his optical experiment into a house when he developed the Barcelona Pavilion for a specific domestic use in his exhibition house for the Berlin Building Exhibition in 1931, Graham too moved from pavilion to house. Dissatisfied with the fact that his pavilion was still a gallery space with a "white wall," he moved the focus of his work to the suburbs, replacing the subject of the gallery with a suburban tract house whose façade has been replaced by a glass wall. *Alteration to a Suburban House* (1978, **fig. 4**) is a house split in two with the same format as *Public Space/Two Audiences*, except that the two audiences are no longer two sections of an art audience looking at each other looking, but those living inside the house and passersby on the street.

Alteration makes visible the optical structure of suburban life. Through a mirror, which slashes the house in half lengthwise, visitors and passersby see themselves inside the house, moving around in the virtual living room with the landscape of the suburb, street, sidewalk, lawn, and neighboring houses behind them. They see themselves in an interior but also in an exterior which has now been made part of the interior. On the other side of the glass wall, inhabitants of *Alteration* see themselves outside, in the street reflected in the mirror. Their domestic setup is displayed in the mirror as an open–air room surrounded by clouds, lawns, and the façades of neighboring houses. Passersby and inhabitants share the same convoluted space in the mirror.

4. Dan Graham, "Dan Graham, A Modern Archeology of Perception: Interview by Paul Ardenne," *Art Press* (March 1993): 3–4.

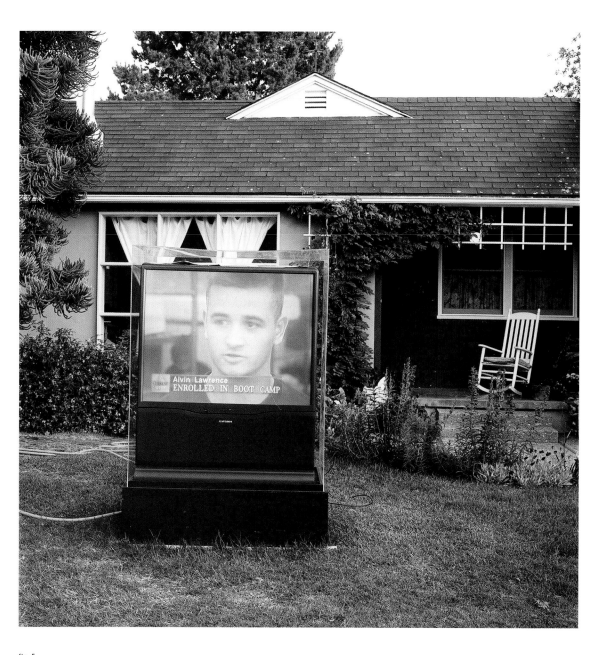

fig. 5
Video Projection Outside Home (1978) installed at a private
home, Santa Barbara, California, 1996

If tract housing is the new city, as Graham has said, it is unlike the turn–of–the century city, which for Walter Benjamin's *flâneur* was a place of hiding while contemplating the spectacle. In the suburbs, the situation is reversed. The pedestrian is now exposed, scrutinized by all these eyes behind every window, eyes that you don't see and that do not even need to be there to be felt. In Graham's *Alteration*, through the device of the mirror, this experience is doubled. I can see myself inside the living room of the house I am walking past. I have become as much a part of the living room as the furniture. I am the object of my own surveillance. I look in and see myself looking out.

With *Alteration, Video Projection Outside Home* (1978, fig. 5), *Clinic for a Suburban Site* (1978), and *Cinema* (1981), Graham adopted the architectural model as the medium for his interventions, as if the work would eventually be built to scale. In fact, some of these projects are an explicit homage to particular architects and completed architectural works. *Alteration* refers to the glass houses of Mies and Philip Johnson as well as to more recent houses by Michael Graves, Robert Venturi, and Frank Gehry. *Cinema* is both an homage to and an inversion of the Handelsblad Cineac (Amsterdam, 1934) by Dutch architect Johannes Duiker, whose work Graham admires. Duiker's cinema building was on a street corner and had glass walls on two sides offering views of the projection room and the audience to passersby on the street. For *Cinema*, Graham proposed a corner cinema with a façade of two–way mirror glass between the film audience and the people on the street. Depending on which side is most illuminated, viewers can see those in the other space as well as themselves looking. The two–way mirrored movie screen likewise allows the outside audience to look through the image and see those watching it from the inside. When the lights go on after the end of the film, the inside audience can then see itself reflected in the screen. The audience becomes the film. The "optical 'skin'" of the building allows architecture and optical instrument to coincide and expose the viewer. As Graham put it: "The architecture here allows inside and outside spectators to perceive their positions, projections, bodies and identifications."[5]

But in the end the models were not enough. Six years after his installation at the Venice Biennale, Graham returned to the idea of the pavilion. In *Two Adjacent Pavilions* (fig. 6), a pair of freestanding structures made of two–way mirror glass (first shown as a model in 1978), he developed further the strategy of Venice. Not by chance, these twin pavilions were first built for another art fair, Documenta 7 in 1982. (They now stand on the grounds of the Kröller–Müller Museum, Otterlo, The Netherlands.) If *Public Space/Two*

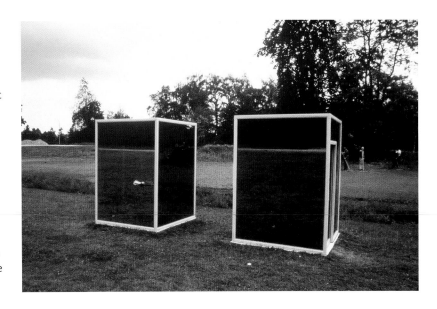

fig. 6
Two Adjacent Pavilions (1978–82); two–way mirror, glass, and steel; two structures: 8 1/4 x 6 1/8 x 6 1/8 feet each; Kröller–Müller Museum, Otterlo, The Netherlands; installed in Documenta 7 next to the Fulda River, Kassel, Germany, 1982

5. Graham, "Cinema" (1981), reprinted in *Dan Graham*, ed. Gloria Moure (Barcelona, Spain: Fundació Antoni Tàpies and Ediciones Poligrafa, 1998), 138.

Audiences had only one interface, the acoustic glass separating the two rooms, in *Two Adjacent Pavilions* the interfaces are multiple. The four sides of each of the two enterable square pavilions are made of two-way mirror glass. One pavilion has a transparent glass ceiling, while the ceiling in the other is opaque, making that pavilion more reflective on the outside and transparent on the inside. The transparent pavilion, flooded with light from above, shifts between transparency and reflectivity depending on the hour of the day and the amount of sunlight and cloud cover. The position of the pavilions next to each other exponentially multiplies the mirroring effects. Significantly, the work had moved out of a gallery setting and into the landscape: "I wanted to integrate the external space into the visual dialogue and, by getting rid of the wall, I created *Alteration to a Suburban House* and the first two-way mirror pavilions in an attempt to project myself into the surrounding landscape."[6]

If *Alteration*, *Clinic for a Suburban Site*, and *Video Projection Outside Home* reflect on suburban life, the compact twin structures of *Two Adjacent Pavilions* operate as a kind of condenser of the wider territory, a lens concentrating the visual economy operating everywhere else. In fact, Graham has insisted that all his pavilions are about the city. And indeed, one could argue that the spectator has an urban experience when implicated in the multiple reflections of the work. To be hidden by the reflections while looking through them at other spectators recalls the metropolitan experience of moving anonymously through a crowd. The overlapping reflections seemingly multiply the number of bodies in the space. Graham's isolated small pavilions reconstitute a metropolitan experience even when standing in a quiet garden. The domestic scale of the pavilions becomes a way of rethinking the urban scale.

One is reminded of another mythical pavilion in the history of architecture: Le Corbusier and Pierre Jeanneret's L'Esprit Nouveau Pavilion (fig. 7), a unit of his proposed Immueble Villas built for the Exposition Internationale des Arts Décoratifs et Industriels Modernes in Paris in 1925. The model apartment, which was designed to be suspended way up in the air in skyscrapers looking out over a new modernized Paris, was placed on the ground in the middle of a park like some kind of spaceship from the future. Le Corbusier intended the pavilion precisely as a critique of the Exposition des Arts Décoratifs with its emphasis on the exhibition of expensive commodities and its refusal to address the pressing issues of housing and urbanism.[7] The Exposition organizers were so worried about the pavilion that they gave it an out-of-the-way location and temporarily built a twenty-foot-high fence to hide it. In fact, as with the Barcelona Pavilion, despite

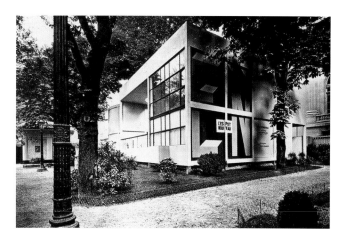

fig. 7
Le Corbusier and Pierre Jeanneret's L'Esprit Nouveau Pavilion (1925) installed in Paris

Architectural model *Elliptical Pavilion* (1995)

6. Graham, in Pietro Valle, "Interview with Dan Graham," in *Dan Graham: Half Square/ Half Crazy* (Milan, Italy: Edizione Charta, 2005), 47.

7. Tag Gronberg, "Making Up the Modern City: Modernity on Display at the 1925 International Exposition," in *L'Esprit Nouveau: Purism in Paris, 1918–1925*, ed. Carol S. Eliel (Los Angeles: Los Angeles County Museum of Art; and New York: Harry N. Abrams, 2001), 105–06.

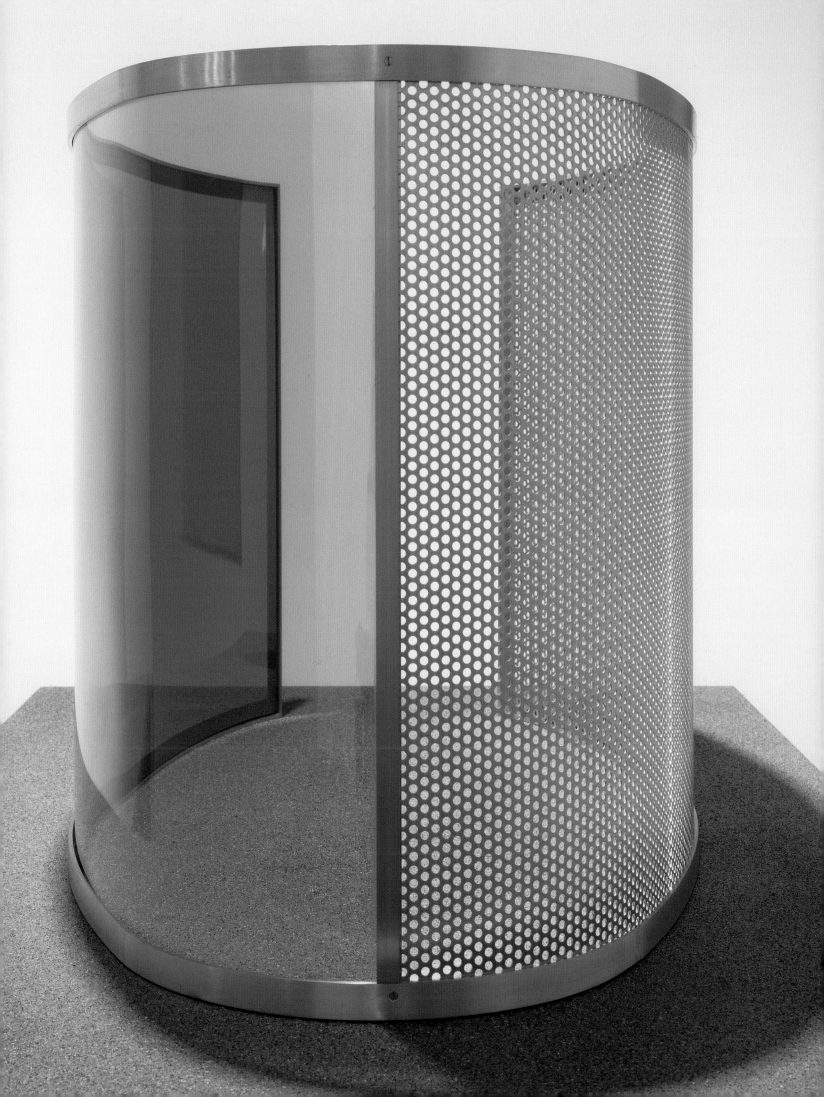

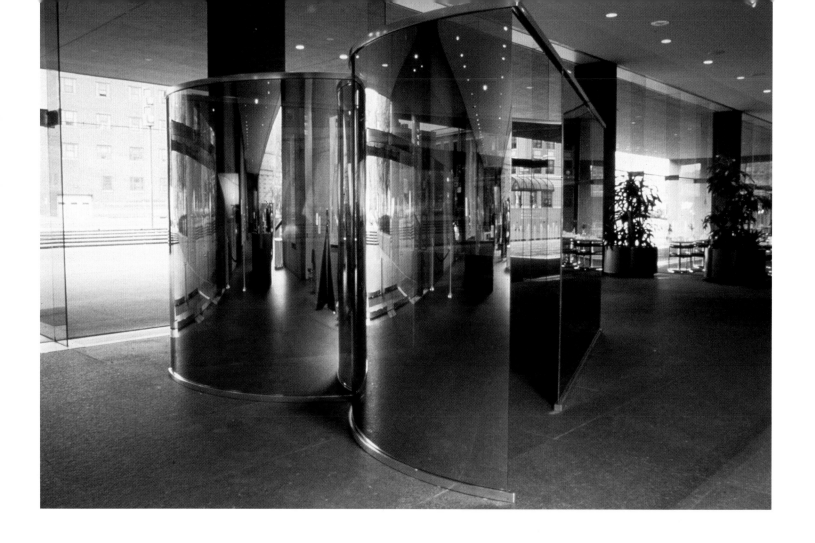

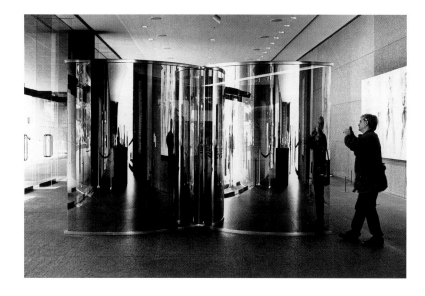

View of (top) and Graham photographing (bottom) *Heart Pavilion* (1991) installed in "1991 Carnegie International," Carnegie Museum of Art, Pittsburgh

Views of *Elliptical Pavilion* (1995–99); two-way mirror and aluminum; 7 7/8 x 16 3/8 x 1 3/8 feet; collection Berliner Kraft und Licht; installation in Berlin

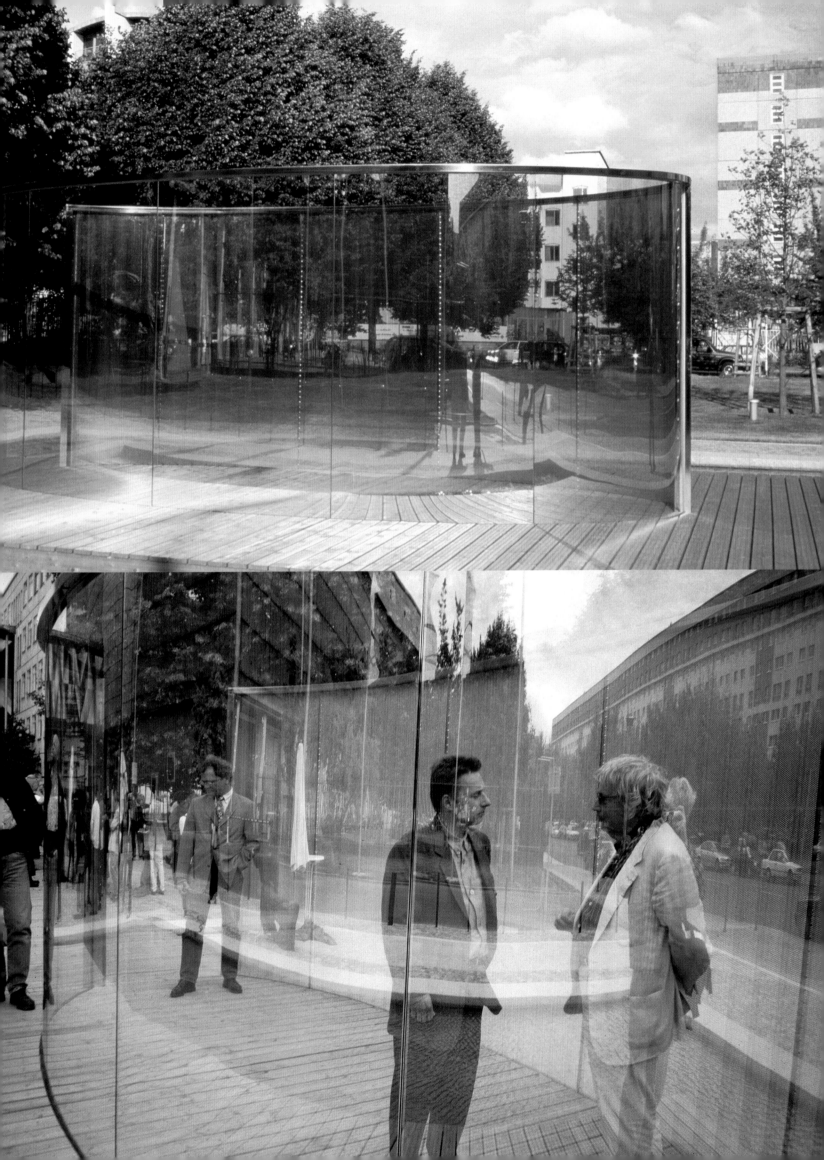

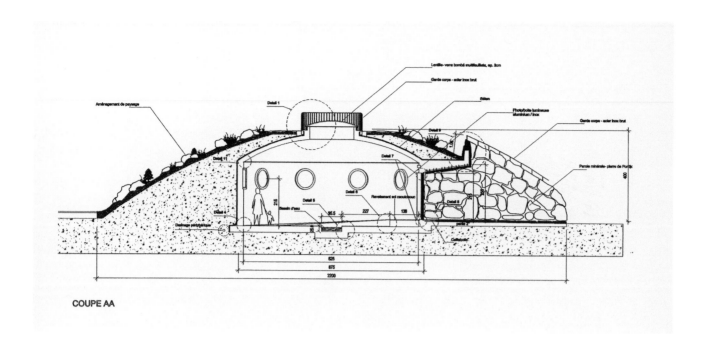

COUPE AA

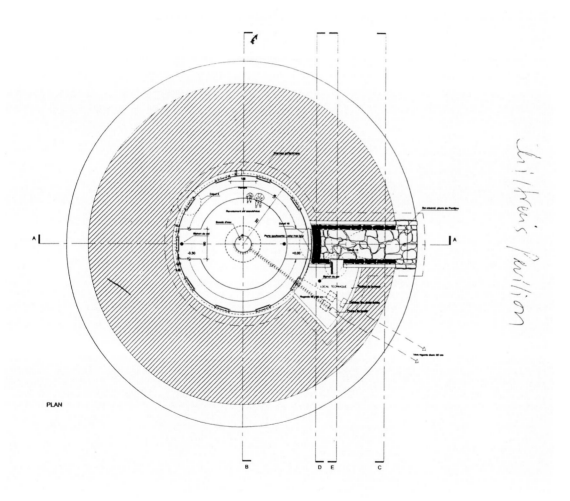

PLAN

Section and plan views of Graham and Jeff Wall's
Children's Pavilion (1989)

its prominent position in architectural history, very few people actually saw it. It became mythical through its central role in Le Corbusier's endless publications.

Le Corbusier filled the model "minimum dwelling" with all the furnishings and artworks he considered appropriate for modern life. Visitors could walk through the apartment imagining a new lifestyle. Le Corbusier even exhibited his plans for the city within the structure of the pavilion. In an annex to the minimum dwelling in the form of a rotunda, two large dioramas, each one a thousand square meters, showed Le Corbusier's 1922 plan for a modern city of three million and his Plan Voisin for Paris. The pavilion became the site for his whole architectural and urban philosophy.

In many ways, Graham's work parallels the development of modern architecture. If early twentieth-century architecture was inseparable from illustrated journals, photography, and cinema, postwar architecture is inseparable from video and television. Similarly, all of Graham's work is "media-architecture," from the very first works for magazines including *Homes for America* (1966–67), to the house designs including *Alteration*, to the pavilions that currently dominate his work. It is not simply that he deals with architectural subjects—the tract house, the picture window, the corporate office building—or that he uses media traditionally deployed by architects, but that he understands the building itself as media. From journals, to models with mirrors and glass façades, to videos in installations, to pavilions without video, we end up in his pavilions with spaces defined only by reflections, mirrors, glass, windows. The seemingly static pavilions themselves fully communicate the active space of the electronic media without the need of cameras or screens.

Designed for visitors, pavilions are always instruments of persuasion, mediums of communication. They are not so much objects to be seen in the world than ways of seeing the world. Architects use small pavilions to communicate their largest ideas. "Model" spaces are used not only to give a tangible physical and psychological experience of a projected future way of life, but also a sharp commentary on the existing way of life.

Graham understands his pavilions to be in an explicit dialogue with the long history of architectural pavilions. He often refers to the primitive hut of Marc-Antoine Laugier's mid-eighteenth-century essay on architecture, nineteenth-century park gazebos, national pavilions for the exhibition of commodities in international fairs, twentieth-century temporary pavilions built by modern architects for expositions and international fairs, and even bus stops and telephone booths. As he puts it:

Children's Pavilion (1989)
Dan Graham and Jeff Wall

The *Children's Pavilion* is located at the periphery of a playground. The structure can be entered through a portal in the form of a circle. The *Children's Pavilion* is built into and enclosed by a landscaped grass hill similar to but larger than such artificial "mountains" in children's playgrounds.

The children's playground customarily features one or more symbolic mountain or hill forms. These are archetypes of complex experiences because they permit penetration underground through various openings, a primal exploration of the earth, and, at the same time, an occasion for ascent and conquest, for the attainment of a privileged overview as "king of the mountain." In this process, one child becomes "king of the mountain" by towering on the summit.

At the top of *Children's Pavilion* is an oculus, which children can look down into. The oculus is a two-way mirror concave glass lens through which children can see an enlarged image of themselves as giants against the smaller image of adults and other children looking up from the inside, superimposed on the changing skyscape and also superimposed on Jeff Wall's nine illuminated cibachromes

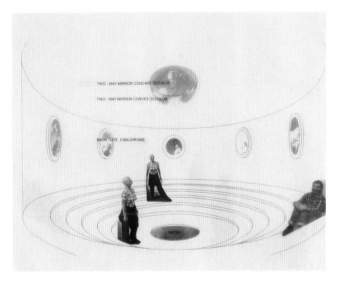

Diagram of interior for Graham and Jeff Wall's *Children's Pavilion* (1989)

In Western culture the pavilion placed in a park setting began with the Renaissance garden, where it was often used for Disney-like special effects. In the nineteenth century it grew in size into the Crystal Palace of the 1851 World's Exposition in London. It now encompasses the quasi-utilitarian modern "non-place" bus shelter and telephone booth.[8]

Graham compacts this extended tradition from aristocratic extravagance of the Renaissance to contemporary mass-market boxes into each of his works. Minimalist boxes are invested with a density of theatrical special effects. In his own words, his pavilions "retrace the history of the pavilion as a type of architecture, from the rococo pavilion on the prince's estate to the nineteenth-century belvedere, from the urban bus shelter to the pavilion presented in temporary exhibitions like Mies van der Rohe's Barcelona Pavilion."[9]

By focusing on pavilions, Graham's work is not just connected to architectural history but to that part of architecture that routinely critiques the other parts. In offering the most condensed and radical statements, pavilions

fig. 8
Bruno Taut's Glashaus (1914) for the Deutscher Werkbund
Exhibition, Cologne, Germany, 1914

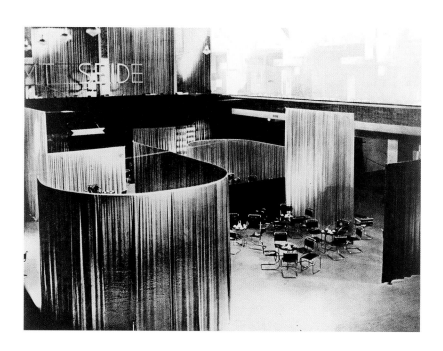

fig. 9
Ludwig Mies van der Rohe and Lilly Reich's Velvet and Silk Café
(1927) for "Die Mode der Dame," Berlin, 1927

8. Graham, "Two-Way Mirror Power" (1996), published in his *Two-Way Mirror Power: Selected Writing by Dan Graham on His Art*, ed. Alexander Alberro (Cambridge, Massachusetts: The MIT Press, 1999), 174.
9. Graham, *Ma position: Écrits sur mes oeuvres* (Villeurbanne, France: Nouveau Musée/Presses du Réel, 1992), 216.

10. Alison and Peter Smithson, "Staging the Possible," in their *Italian Thoughts* (Stockholm: A&P Smithson, 1993), 16. See also the earlier version of the same argument in "The Masque and the Exhibition: Stages Toward the Real," *International Laboratory of Architecture and Urban Design Year Book* (Urbino, Italy) (July 1982).

often represent the leading edge of architectural discourse. Exhibition pavilions of the twentieth century were sites for the incubation of new forms of architecture that were sometimes so shockingly original, so new, that they were not even recognized as architecture at all.

Indeed, the tradition of radical temporary structures is a centuries–old practice that has played a crucial role in stimulating the evolution of ideas and tastes in architecture. As Alison and Peter Smithson put it:

> The architects of the Renaissance established ways of going about things which perhaps we unconsciously follow: for example, between the idea sketchily stated and the commission for the permanent building came the stage–architecture of the court masque; the architectural settings and decorations for the birth–day of the prince, for the wedding of a ducal daughter, for the entry of a Pope into a city state; these events were used as opportunities for the realisation of the new style; the new sort of space; the new weight of decoration; made real perhaps for a single day…the transient enjoyably consumed, creating the taste for the permanent.[10]

The most extreme and influential proposals in the history of modern architecture were pavilions made in the context of temporary exhibitions. Think about Bruno Taut's Glashaus, the glass industry pavilion at the Deutscher Werkbund Exhibition, Cologne, 1914 (fig. 8); Le Corbusier and Pierre Jeanneret's L'Esprit Nouveau Pavilion; Kostantin Melnikov's USSR Pavilion at the Exposition Internationale des Arts Décoratifs et Industriels Modernes, Paris, 1925; Mies and Lilly Reich's Velvet and Silk Café, Berlin (1927, fig. 9), their Glass Room in Stuttgart (1927), and his Barcelona Pavilion; Alvar Aalto's Finnish Pavilions for the World Exposition, Paris, 1937, and the New York World's Fair, 1939; Le Corbusier and Iannis Xenakis's Philips Pavilion for the World Exposition, Brussels, 1958; Buckminster Fuller's Geodesic Dome at the American National Exhibition, Moscow, 1959, and his United States Pavilion for Expo '67, Montréal; the IBM Pavilion designed by the office of Eero Saarinen in collaboration with Charles and Ray Eames for the New York World's Fair (1964); the Pepsi Pavilion for Expo '70, Osaka, Japan, by E.A.T. (Experiments in Art and Technology); Coop Himmelb(l)au's Cloud (1968), a prototype for future living presented at Documenta 5, 1972[11]; and Aldo Rossi's Il Teatro del Mondo, a temporary theater built for the 1980 Venice Architecture Biennale to recall the floating theaters of eighteenth–century Venice popular during carnivals. The tradition of the pavilion as the site for

Photograph of doll looking down into the oculus from the top of Graham and Jeff Wall's *Children's Pavilion* (1989)

of children of different nationalities set against different skies. Inside, visitors can look up through the two-way mirror concave lens and see their own gazes against the real sky shifting superimposed on the gazes of the children outside.

The central water basin reflects the cibachromes, the overhead convex two-way mirror oculus, parents, and children inside the pavilion. As they look up at the oculus they see themselves, the overhead real sky, the interior of the pavilion, and the eyes of the children looking down at them at the top of the mountain. All these images are superimposed on each other.

The inside of the hill is like a prehistoric *cave* or a grotto. The *Children's Pavilion* also relates to the Roman Pantheon and to Boullée's neo-classical dome projects. Another aspect of this typology is provided by the observatory and the planetarium. The observatory is a structure devoted to optical study of the sky. The planetarium is, on the other hand, a kind of cinema. It reproduces, stages, and projects cosmological narratives as entertainment and education. The modern planetarium is, however, attached to telescopic power and cinematographic projection itself.

The mirror-clad La Géode, with IMAX films displayed within the structure, is also a reference point. My original proposal for the *Children's Pavilion* was in a children's playground hill adjacent to La Géode before the area became Parc de la Villette in Paris.

First published in *A Guide to the Children's Pavilion*, exh. brochure (Santa Barbara, California: Santa Barbara Contemporary Arts Forum, 1989); and "The Children's Pavilion/Der Kinderpavillon," *Parkett*, no. 22 (1989): 66–70. Text revised in 2004.

11. If realized, the Cloud would be a mobile inflatable sphere containing a core of technical elements providing for physical and psychological pleasure. The pneumatic house could be stored in a container, transported on a truck, and assembled in ninety-seven minutes.

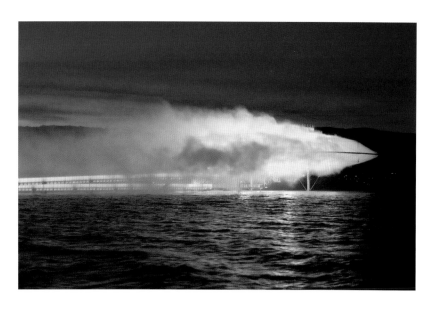

fig. 10
Diller + Scofidio's Blur Building (2002) for Swiss Expo,
Yverdon-les-Bains, Switzerland, 2002

architectural experimentation continues into the twenty-first century with such mythical projects as Diller + Scofidio's Blur Building in Yverdon-les-Bains, Switzerland, a media pavilion for Swiss Expo 2002 (now destroyed) (**fig. 10**), and the series of pavilions that spring up every year at the Serpentine Gallery in London.

The rebuilding of the Barcelona Pavilion is itself an important part of the story of pavilions. While many of Mies's buildings have been destroyed, the temporary exhibition pavilion had become such a central monument in architectural culture that it was reconstructed in 1987 on the original exhibition site as a kind of simulacra. The same thing happened to Le Corbusier's L'Esprit Nouveau Pavilion. Since 1977, a replica sits in a park in Bologna, exemplifying fifty-year-old principles. As Peter Smithson wrote, "To visit it is to be reminded that an architect always needs to have his pots and pans and his view of nature ready in case he is asked."[12]

To some extent, reconstructions interfere with the discourse. Many exhibition experiments gain their force precisely by disappearing. They inhabit the spaces of publication, of memory, of fantasy. The lack of a specific client or site gives them a permanent role. Since they are not so pinned down, they remain open to speculation. Reconstruction fixes them, if not finishes them. The full force of the pavilion is always the possibility that it will leave as abruptly as it arrived, reorganizing ambitions and calling for new connections between what were previously felt to be utopian fantasies and what are now plausible built realties. The real sign that a building is a pavilion is that it leaves, it flies away, or at least promises to do so. The encounter with an object that is about to leave is fundamentally different. The thought that you might not be able to return to it makes the experience elusive, even romantic. It defies conventional understanding. Afterwards, it becomes strangely unclear what happened, and it is this lack of clarity that opens up new horizons.

Pavilions make the dream seem real and make reality seem dreamlike. The lingering memory of the Barcelona Pavilion, perhaps the most famous of all twentieth-century pavilions, is of a simple solid object producing a complexity of space, movement, and reflected light. But the exact nature of the solid is elusive. It is the unique role of a pavilion to fuse image and structure in this way. The pavilion is the key instrument for negotiating the relationship between image and physical structure.

"Pavilion" comes from *papillon*, the French word for "butterfly." The sides of an open lightweight nomadic tent were associated with the wings of a butterfly. The pavilion, classically a royal tent in a park, is that which arrives, fluttering in from an unknown place, a pure image in flight, hovering for a moment,

12. Peter Smithson, *International Laboratory of Architecture and Urban Design Year Book* (Urbino) (1981).

touching down and standing there fully exposed before flut–
tering away again, leaving everything changed in its wake.

Graham is a relentless student of architecture and
draws extensively and perceptively on its twentieth–century
history, observing what architects themselves overlook in
their own field. It is in exposing the logic of contemporary
urban spaces (the corporate city with its mirrored office
buildings and the video surveillance of public space, for
example) that Graham's pavilions become part of architec–
tural discourse. But he operates fundamentally differently
from architects. Rather than a provisional vehicle for ideas
that will be realized in a different medium, Graham's ideas are
aimed at the pavilion itself. The architect's test site becomes
the event itself.

One finally has to consider the possibility that
the global army of more than fifty pavilions by Graham
constitutes a single artwork, a single experiment, or a single
experimental field of pavilions, an open network of instru–
ments, each one fine–tuning a very precise set of optical
issues. They form a network of optical instruments, observing
the way we see and thereby changing the way we see. ⬤⬤

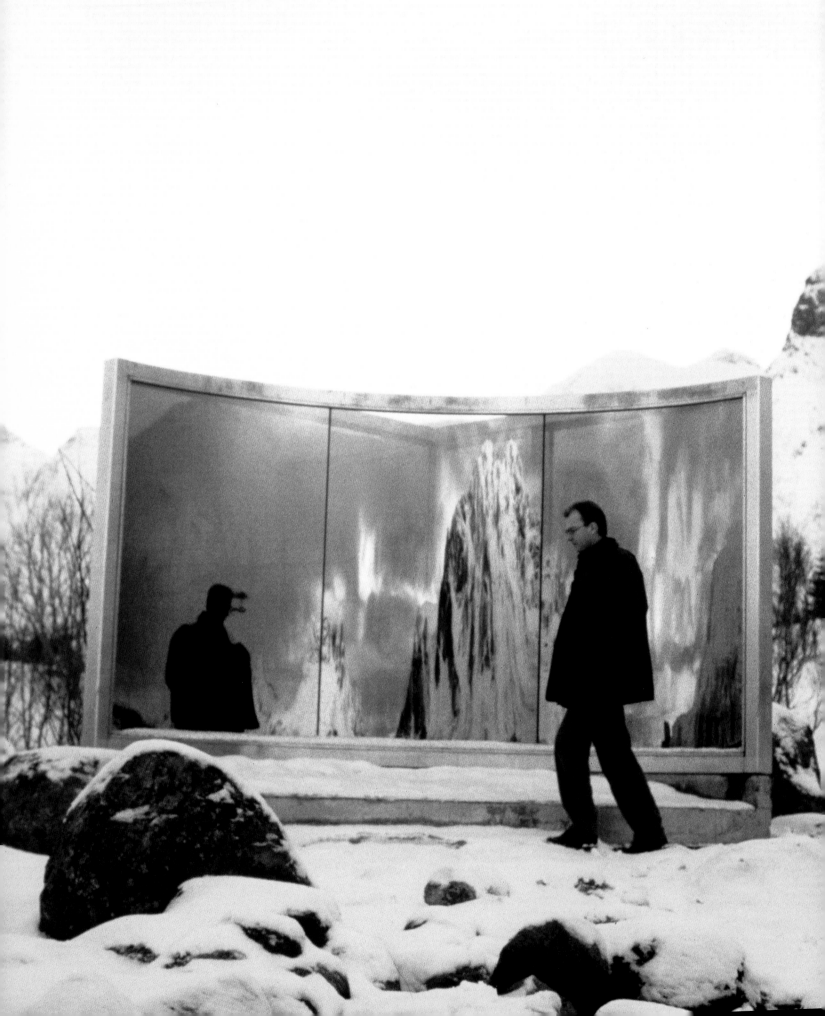

Dan Graham SF

Mark von Schlegell

1. INTO THE MAELSTROM

> The basic test that distinguishes reality from halluci-
> nation is the *consensus gentium*, that one other or
> several others see it too. This is the *idios kosmos*, the
> private dream, contrasted to the shared dream of us
> all, the *koinos kosmos*.
>
> —Philip K. Dick, *The Dark-Haired Girl*[1]

In a most peculiar fashion, Dan Graham's artworks are
nothing if not active critical engagements with their sources.
One of their important sources is science fiction. As a genre
of it own, science fiction has an *idios kosmos*, an alternative
history from where one can help qualify the nature of this
engagement and consider what it might mean for the larger
history of the *koinos kosmos* for it to be an art.

 I recently met a Norwegian who had anecdotal
evidence concerning the local effect of Graham's 1996
Two-Way Mirror Triangle with One Curved Side (fig. 1), an
outdoor sculpture on Norway's remote Lofoten Islands.
Apparently, the work continues to blow minds to this day. In
the midst of the remote Arctic wilderness, it appears as an
unannounced and undesired gap in a landscape unargu-
ably sublime. It perplexes members of the local scene busy
working ancient fishing grounds and managing for scientifically
inclined tourists the world's second most beautiful island.[2]

 Like in a funhouse in the middle of nowhere, engi-
neered to last and made out of sleek stainless steel and
two-way mirror glass, *Two-Way Mirror Triangle*'s reflec-
tions outrageously warp the ever-changing high Romantic
landscape. The distortions are presented framed for viewing,
as if a hyperreal museum had intervened in nature, intent on

Notes **1.** Philip K. Dick, quoted in Paul Williams,
"The Most Brilliant Sci-Fi Mind on Any Planet:
Philip K. Dick," *Rolling Stone* (6 November
1975): 93.
 2. "20 Paradise Islands," *The Observer*
(London), 28 September 2003.

fig. 1
Two-Way Mirror Triangle with One Curved Side (1996); two-way mirror and stainless steel;
8 1/4 x 9 7/8 feet; collection Vågan County, Norway; installed in Lofoten Islands, Norway

transforming the Pop optimism of the Hudson River Valley School into the darker "phantasmagorical" skyscapes of nineteenth-century English painter John Martin.

Graham has likened Martin's nature works to "lurid paperback covers of cheap American popular sci-fi."[3] The Lofoten Islands are nearest to the site of the actual Maelstrom, the paranormal setting of Edgar Allan Poe's "A Descent Into the Maelstrom" (1841)—a tale whose mixture of science and horror still draws visitors to the islands' shores today. Looking over Lofoten's crags, Poe's narrator reflects, "a panorama more deplorably desolate no human imagination can conceive."[4] If there is something lurid and perverse about *Two-Way Mirror Triangle* and its spectacular sci-fi views, something American and cheap, then in more ways than one, as has been said of science fiction itself, "Poe is the source."[5]

2. NEW JERSEY

The conceptually oriented, self-replicating genre that Poe jump-started became by the time Graham was growing up in New Jersey an integral facet of the American cultural landscape. As an adolescent, Graham found himself drawn to the SF magazines available in local bus stations and candy stores. *Astounding Science Fiction* in particular caught his eye.

During the late 1950s, *Astounding* was coming down off a ten-year reign as the single most important organ of American science-fiction. There is no figure more responsible for the genre's economic and literary success than the magazine's legendarily despotic editor John W. Campbell, Jr. Campbell single-handedly shaped the careers of Isaac Asimov, Robert A. Heinlein, and Theodore Sturgeon during the 1940s, conceiving, rewriting, and commissioning seminal works that raised the bar considerably. By the 1950s, the genre was expanding in new unexpected directions, and Campbell was displaying a new interventionist intensity. Still directed at an adolescent male audience, "his editorials—idiosyncratic, deliberately needling, dogmatic and near racist—absorbed much of the energy which had previously gone into the feeding of his authors."[6] Campbell became increasingly, even bizarrely concerned with the transformation of the real itself by science fiction. He persuaded his stable hack L. Ron Hubbard to start a religion and published the first article on "Dianetics." He championed the backyard inventions of his readers—teenagers and small-town crackpots—as if their psionic machines and warp drives were real earth-shattering discoveries.

Reading *Astounding*, a fifteen-year-old Graham noted that Campbell had been born in nearby Newark. In fact, he still lived there and was listed in the phonebook. Graham

3. Dan Graham, "Apocalypse Now," *Tate Etc.* (London), no. 8 (autumn 2006): 44.
4. Edgar Allan Poe, "A Descent into the Maelstrom" (1841).
5. Thomas M. Disch, *The Dreams Our Stuff Is Made Of: How Science Fiction Conquered the World* (New York: Touchstone, 2000), 32.
6. Malcom J. Edwards, "entry on John Wood Campbell, Jr.," in John Clute and Peter Nicholls, eds., *The Encyclopedia of Science Fiction* (New York: St. Martin's Griffin, 1995), 187.
7. Graham, interview with the author, 11 May 2008.
8. Jorge Luis Borges, "The Library of Babel" (1941), reprinted in *Ficciones* (New York: Grove Press, 1962), 79–89.

arrived at the Campbell residence via public transportation on a weekend afternoon, approaching an ordinary New Jersey house of the sort he would later photograph. He found Campbell at home alone. An enormous man, hawk-nosed, crew-cut, pink-skinned, and tending to the obese, Campbell wore a tight black suit, a tie, and thick horn-rimmed glasses. He moved about his empty house with a restless bitter energy. Chain-smoking from a cigarette holder clamped between his teeth, he talked about science fiction in a constant monotone. During the unceasing harangue, it was unclear to our young friend exactly what Campbell was saying or to whom. He found, essentially, a disconnect—and let himself out.[7]

3. SCHEMA (MARCH 1966)

> On some shelf in some hexagon (men reasoned) there must exist a book which is the formula and perfect compendium of *all the rest.*
> —Jorge Luis Borges, "The Library of Babel"[8]

Graham's *Schema (March 1966)* (1966–67, figs. 2, 3) can be understood today as one of the origins of Conceptual art. But Conceptual art did not yet exist when it was first published. It was unclear, in fact, whether Graham was a critic, a poet, or an artist. Bordering on the infinite and resolutely plain, the manifested work is a tree of numbers, like a Carl Andre poem or a computer printout.

In its own currency, *Schema* is both a set of directions and a set of examples of their implementation. A "recipe" or "program" is presented to the editor of a magazine, instructing the formulaic arrangement of various editorial and design features of the issue's textual content. But the actual schematization, publication, and dissemination are all performed by the magazine itself, for its own ends, and *Schema* will presumably move on, always into other versions in a presumed future or preserved past. The work is accompanied by the reflective writings of its author. The fourth and last of Graham's "Thoughts on *Schema (March 1966)*" compares it to Kurt Gödel's "incompleteness theorem."[9] The Austrian mathematician was then living in New Jersey, only belatedly earning celebrity for his 1931 breakthrough in mathematical logic. By positing that all logical systems are incomplete because they contain the formal language to state of themselves that they are unprovable, Gödel showed that natural numbers, the foundation of rationalism, are themselves irrational.

Not only did Gödel's work result in the development of algorithmic computer science, but it had large-scale

POEM

35 adjectives
7 adverbs
35.52% area not occupied by type
64.48% area occupied by type
1 column
1 conjunction
0 mms. depression of type into surface of page
0 gerunds
0 infinitives
247 letters of alphabet
28 lines
6 mathematical symbols
51 nouns
29 numbers
6 participles
8" x 8" page
80 lb. paper sheet
dull coated paper stock
.007" thin paper stock
3 prepositions
0 pronouns
10 point size type
univers 55 typeface
61 words
3 words capitalized
0 words italicized
58 words not capitalized
61 words not italicized

fig. 2
Variation of *Schema (March 1966)* (1966–67) reproduced in *Aspen* (fall–winter 1967)

9. Graham, "Thoughts on *Schema (March 1966)*," in *For Publication* (Los Angeles: Otis Art Institute of Los Angeles County, 1975).

37——ARTS MAGAZINE

Arts 8-9 Garamound Cardillo May 15 M. 1

POSSIBLE VARIANT

36 adjectives
7 adverbs
35.52% area not occupied by type
64.48% area occupied by type
1 column
1 conjunction
.02357 mms. depression of type into surface of page
0 gerunds
0 infinitives
407 letters of alphabet
29 lines
6 mathematical symbols
51 nouns
28 numbers
6 participles
6" x 8½" page
.010 Oz. paper sheet
Curtis UTOPIAN WH. WAVE bond paper stock
.007" thin paper stock
3 prepositions
0 pronouns
10 point size type
Pica typeface
72 words
7 words capitalized
12 words italized
65 words not capitalized
60 words not italized

SCHEMA

(number of) adjectives
(number of) adverbs
(percentage of) area not occupied by type
(percentage of) area occupied by type
(percentage of) blank area between lines
1 column
(number of) conjunctions
(number of mms. recessed) depression of type into surface of page
(number of) gerunds
(number of) infinitives
(number of) letters of alphabet
(number of) lines
(number of) nouns
(number of) numbers
(number of) participles
(perimeter of) page
(weight of) paper sheet
(trade-mark, type bound) paper stock
(thinness of) paper stock
(number of) prepositions
(number of) pronouns
(number of point) size type
(name of) typeface
(number of) words
(number of) words capitalized
(number of) words italized
(number of) words not capitalized
(number of) words not italized

fig. 3
Variation of *Schema (March 1966)* (1966–67) for
reproduction in *Arts Magazine*, unpublished

philosophical implications that came down heavily, even scandalously, on the side of Platonism. The most real things in the world, he had proved, were of an ideal order of reality. For many years, Gödel's theorems were kept a quiet secret among a befuddled mathematical academy. But, as Graham observed, "science became popular in the 1960s."[10] Interested readers benefiting from the miscegenation and chaos of the paperback revolution were discovering the Incompleteness Theorem alongside the Uncertainty Principle on the wings of science-fiction youth culture. Gödel's only close friend, Albert Einstein, had been shattered by the math-ematician's propositions of rotating universes and proofs that time did not exist. An apparent paranoid-schizophrenic in his day-to-day life, Gödel claimed his favorite movie was *Snow White and the Seven Dwarves*.[11]

Concerning itself with its own current position in a potentially infinite expansion, *Schema* activates a Gödelian mechanism as an act of conceptual disruption in the mechanical reproduction of the magazine. Having read philos-ophy (Raymond Lull) and literature (Jorge Luis Borges) that proposed such a machine, Graham found a way to force the magazine to expand into the formula and perfect compen-dium of all it could ever be. *Schema* is the revelation of the historical materialism of the magazine performed by its own editor's remote topology of an already detumescent organ. An unreal entity with total real-world power, *Schema* ticks out its history like a Turing machine with no halting problem.

4. MAGAZINE PIECES

> "Science Fiction, like most branches of art today, is more aware than ever before of its own nature."
> —Brian W. Aldiss, 1973[12]

Grandmaster Heinlein wrote in 1947 that he was advised that "*any* story—science fiction, or otherwise—if it is well written, can be sold to the slicks."[13] Heinlein wasn't yet hip to what was happening. He would soon discover by way of the new culture he himself had helped to create that science fiction was not simply poised to cross into the mainstream, it was poised to take over the world. By the end of the 1960s, he had established a veritable cult centered around open marriage and libertarian economics.

Today it's a truism that everything is science fiction. In the 1960s, the discovery was only just leaking out of the "ghetto genre." Via campy films, comics, and paperbacks, it was bursting into other arts. Andy Warhol's love of *The Creation of the Humanoids* (1962), a low-budget take on a

dystopic novel by "Dean of Science Fiction" Jack Williamson, inspired more than the Factory's forays into low-budget horror. In 1967, French *nouveau roman* author Michel Butor speculated in *Partisan Review* that because of the genre's anti-literary rhetoric, the members of the Science Fiction and Fantasy Writers of America, if writing in congress about the same fictional city in the same fictional future, might create an actual city out of the present. At last, "SF would be veracious, to the very degree that it realized itself."[14] As one history of early twentieth-century science-fiction put it, already "science-fiction fans had an enthusiasm for their favorite form of reading unlike any other genre devotees."[15] Indeed, science-fiction readers were the first organized fans in the modern episteme. During the 1960s, as they began to realize science fiction's real-world power, they revisioned the genre in terms of the new counterculture.

Paul Williams, founder and editor of *Crawdaddy!* magazine, remembered how the 1960s counterculture, in its own self-reflection, was deeply connected to science fiction. He found that David Crosby, "like most mid-60s rock musicians (and underground press editors, political activists, dope impresarios, etc.), was an avid reader of science fiction in general and Sturgeon in particular; and he realized early that the Byrds and other rock groups were living examples of Sturgeon's idea that a group of humans could function as more than the sum of the individuals involved [...] not just more, but *mystically* more... The 'counterculture,' in retro-spect, was heavily modeled on a handful of science fiction and fantasy novels."[16]

The new generation of writers had utopia on the mind. In England, what would be called science fiction's "new wave" was forged, promoting a story able to trump high romanticism and square low-brow rocketship yarns at the same time. Employing high-concept ideas gleaned from film, paranormal science, the pulps, psychology, art, and litera-ture, pop depths were peculiarly plunged. For the first time, women science-fiction writers were publishing under their own names. Aldiss would call Mary Shelley's *Frankenstein, or, the Modern Prometheus* (1818) the first novel in the history of the genre, claiming a high-art old-world feminist origin for this most low-brow and American genre.[17] These new literary origins opened up an old anti-utopian radicalism in science-fiction's relation to its present.

Graham has pointed to Shelley's later novel, *The Last Man* (1826), as the first sci-fi book.[18] Written after Shelley had met the American fabulist Washington Irving, *The Last Man* is cast in the far future, on a globe ravaged by plague and natural disaster. Literature defines its own limits from within the apocalypse. "I am able to escape from the mosaic

10. Alexandra Midal, "How I Learnt to Love Science Fiction: Alexandra Midal Interviews Dan Graham," in *Tomorrow Now: When Design Meets Science Fiction* (Luxembourg: Musée d'Art Moderne Grand-Duc Jean, 2007), 116.
11. Jim Holt, "Time Bandits: What Were Einstein and Gödel Talking About?," *The New Yorker* (28 February 2005).

12. Brian W. Aldiss, "The Origin of the Species: Mary Shelley," chapter 1 in *Billion Year Spree: The True History of Science Fiction* (London: Redwood Press, 1973), 11.
13. Robert A. Heinlein, "On the Writing of Speculative Fiction," in *Of Worlds Beyond: The Science of Science Fiction Writing*, ed. Lloyd Arthur Eshbach (Chicago: Advent

Publishers, 1964), 13.
14. Michel Butor, "Science Fiction: The Crisis of Its Growth," *Partisan Review* 34, no. 4 (fall 1967): 602.
15. Mike Ashley and Robert A. W. Lowndes, *The Gernsback Days: A Study of the Evolution of Modern Science Fiction from 1911 to 1936* (Holicong, Pennsylvania:

Wildside Press, 2004), 178.
16. Williams, "Theodore Sturgeon, Storyteller" (1976), unpublished, available at http://www.physics.emory.edu/~weeks/sturgeon/williams.html.
17. Aldiss, "The Origin of the Species," 7–39.
18. Midal, "How I Learnt to Love Science Fiction," 115–16.

of circumstance," writes her future hero in a text no one else will ever read, "by perceiving and reflecting back the grouping and combined colouring of the past."[19]

Eighteen years later, in New York, Poe's first science-fiction story blew a gap into the newspaper culture in which it appeared in a gesture reminiscent of Graham's interventions in magazines of the 1960s. His balloon hoax of 1844—a fake report on amateur pneumatic engineers pulling off a crossing of the Atlantic in a balloon—was splashed across the front page of the *New York Sun* as fact (**fig. 4**). It caused a sensation. The author was reported by a friend to have stood by the *Sun* offices for hours, observing the rioting crowd. Most of all Poe was fascinated by the people who were sure the news was a lie—yet had gathered, fists in the air, to shout at the fiction.[20] Biographer Daniel Hoffman considered it the happiest day of Poe's career.[21] Science fiction, for Poe, did not reveal the truth of the future, but the actual sham of the present. Like Graham's *Figurative* (1965), an ordinary cashier's receipt placed in the aura-rich matrix of an issue of *Harper's Bazaar*, this anarchist, activist, and hyper-rational gesture appeared from out of the body of the real.

5. *CRYPTOZOIC!*

So *fantasy* remains ambiguous; it stands between the false, the foolish, the delusory, the shallows of the mind, and the mind's deep connection with the real. On this threshold sometimes it faces one way, masked and beribboned, frivolous, an escapist; then it turns, and we glimpse as it turns the face of an angel, bright truthful messenger, arisen Urizen.
—Ursula K. LeGuin[22]

Brian Aldiss's pulp time-travel extravaganza *Cryptozoic!* (1967, **fig. 5**) inspired Graham to more directly investigate the relation of utopianism to time.[23] *Cryptozoic!*'s hero, one Edward Bush, is an artist who time-travels to distant epochs to paint landscapes. He begins to encounter other chrono-nauts from his own future, in which time itself seems to be coming undone. It turns out that at a certain date in Bush's future life, all of humanity, himself included, realize that the perceived arrow of time, the very motion from past to future, is a psychotic disease bred by the "overmind." Time actually goes the other way.

Halfway through the fast-moving book, the anti-Oedipal "undermind" passes backwards into the narrative, mind-fucking all in its path. Bodies cease to age. Impotence vanishes, love blossoms, blooms in adolescence, and

fig. 4
Edgar Allan Poe's balloon hoax report, published in the *New York Sun* (13 April 1844)

fig. 5
Cover of Brian Aldiss's *Cryptozoic!* (New York: Avon Books, 1967)

19. Mary Shelley, *The Last Man* (Paris: A. and W. Galignani, 1826), 149.

20. Poe, *Doings of Gotham, by Edgar Allan Poe, as Described in a Series of Letters to the Editors of the Columbia Spy; Together with Various Editorial Comments and Criticisms by Poe* (Pottsville, Pennsylvania: J. E. Spannuth, 1929), 33–34.

21. Daniel Hoffman, *Poe Poe Poe Poe Poe Poe Poe* (New York: Doubleday, 1972), 156.

22. Ursula K. LeGuin, introduction to Borges, Silvina Ocampo, and A. Bioy Caseres, eds., *The Book of Fantasy* (New York: Viking Penguin, 1988), 10.

23. Midal, "How I Learnt to Love Science Fiction," 117.

expands at last into pure infantile sexuality. The individual is finally taken into the mother's loins, she into "her mother, who would grow young and fair again."[24] The liberated self would proclaim, "incest is finally broken."[25] Bush appears to be deeply healed: "I saw how most human sin is the result of most human misery; it was misery and above all the mystery of *uncertainty* that made me do the base acts in my life. Once rid of the overmind, you—everyone can suffer no uncertainty, because you know the future."[26]

But such breakthroughs by the New Wave led quickly to breakdown. "All voyages to the moon," wrote Marie Bonaparte in *The Life and Works of Edgar Allan Poe, A Psycho-Analytic Interpretation* (1949), "an ever-recurring human phantasy, always, in their deepest sense, represent a yearning to return to the mother."[27] Science fiction was now hip to this fact. How odd then that there for all to see via live video feed, in an anti-Oedipal tour de force of science fiction's own making, was the mother herself, the moon, taken by United States astronauts in 1969 (quoting Arthur C. Clarke in the process) (fig. 6). Exactly what had just happened? As the 1960s began to collapse, science fiction found itself without its most coveted fantasy. "Man has invented his doom," Bob Dylan would sing years later, a zombie survivor of his own 1970s West Coast apocalypse. "First step was touching the moon."[28]

In *Cryptozoic!*'s low-brow trick ending, Bush emerges in the last chapter in an insane asylum in the old time. His father is visiting the hospital, and a doctor is explaining his time hallucinations. "Your son, Mr. Bush—your son knows only one woman, his mother, and all other females he meets are identified with her.... His obsessive-compulsive tendencies have collapsed into schizophrenia."[29]

6. ANAMNESIS

> The split second in time, the attosecond—it's always obsessed painters, much more than anyone else....
> If you regard the mind's distortion of time flow as sick, then the frozen time represented by the attosecond is the nearest a deluded mind can come to health.
>
> —Brian Aldiss, *Cryptozoic!*[30]

Like the relativistic astronaut in Stanislaw Lem's *Return from the Stars* (1961), artists and writers of the 1970s found themselves returning from their heady adventures into a schizophrenic hallucination of ordinary reality. Resisting this anti-utopian impulse with group think and personal interaction, Graham's 1970s performances investigated

fig. 6
Neil Armstrong's photograph of NASA's lunar module on the surface of the moon, 1969

24. Aldiss, *Cryptozoic!* (New York: Avon, 1969), 177.
25. Ibid., 187.
26. Ibid., 177.
27. Quoted in Hoffman, *Poe Poe Poe,* 153.
28. Bob Dylan, "Licence to Kill," *Infidels* (Columbia Records, 1983).
29. Aldiss, *Cryptozoic!*, 188.
30. Ibid., 157.

the mechanics of time, consciousness, and the self. In *Two Consciousness Projection(s)* (1972), one participant, a woman, focuses on an image of herself on a television monitor and verbally describes the state of her own consciousness, while a male performer, holding the camera and focused only on her, verbalizes his own state. The audience views the performers and listens to their simultaneous monologues. The structural power mechanics of the gaze-event are revealed, losing control as consciousness is projected. "An abstractly presupposed psychological (or social) model is physically observable by the audience."[31]

In *Past Future Split Attention* (1972), "two people who know each other are in the same space. While one person predicts continuously the other person's behavior, the other person recounts (by memory) the other's past behavior."[32] Finding its "ideal medium" in a videotape of the event, the work time-tracks the impossibility of locating the just past in a relativistic universe as it enters the fabric of a local friendship. Transcripts reveal performers diving to ludicrous depths in their own memories among suddenly self-evident Freudian parapraxes.

Like other artists and musicians of the 1970s, Graham was reading Philip K. Dick. Books like *Time Out of Joint* (1959) and *The Three Stigmata of Palmer Eldritch* (1965), revealing realities as artificial worlds engineered by sinister anti-human forces, had found a cult audience during the 1960s. Paul Williams's 1975 profile in *Rolling Stone*, "The Most Brilliant Sci-Fi Mind on Any Planet: Philip K. Dick," introduced the writer's strange new persona to the mainstream as a kind of performance.

Dick's humanist tours de force of the 1950s and 60s had been fueled by amphetamines, and by the 70s the drugs were taking their toll. He was relatively sober, barely getting by, and convinced secret organizations were burgling his house. He was close to madness, and wrote more exclusively for himself. In fact, Dick's writing had never been stronger, more committed to his own intensely local vision. No longer concerned with the fantasies of the future but with the schizophrenia of 1970s Americana, he celebrated the lower-middle-class Orange County that could not contain his experience as a down-and-out science-fiction author.

For Dick, science fiction now dovetailed perfectly with a pseudo-utopian present that could only be captured by the acknowledgment of its irreality (**fig. 7**). In a moment that would spark his most mature novel, *VALIS* (1981), he opened his front door to a pharmacist's delivery woman. She was wearing a New Age locket around her neck. The present dropped away as he looked at it. Dick saw that he was not standing in twentieth-century California but in ancient Rome.

31. Graham, text (1979) on *Two Conciousness Projection(s)* (1972), reprinted in *Dan Graham: Works 1965–2000* (Düsseldorf, Germany: Richter Verlag, 2001), 138.

32. Graham, text (1981) on *Past Future Split Attention* (1972), reprinted in *Dan Graham: Works 1965–2000*, 134.

THE RELIGIOUS EXPERIENCE OF PHILIP K. DICK

PHILIP K. DICK WAS A WRITER OF *SCIENCE FICTION.* IN 1982 HE DIED SUDDENLY OF A STROKE. HIS BOOKS OFTEN DEALT WITH THE ILLUSORY QUALITY OF REALITY AS WE KNOW IT. IN MARCH, 1974 DICK SAW WHAT HE LATER DESCRIBED AS "A VISION OF THE APOCALYPSE," AND SPENT THE REST OF HIS LIFE TRYING TO UNDERSTAND WHAT HE HAD EXPERIENCED. WAS IT THE ONSET OF ACUTE SCHIZOPHRENIA, OR WAS IT A GENIUNE MYSTIC REVELATION, AND THEN AGAIN, IS THERE ANY DIFFERENCE ??

FULLERTON, CALIFORNIA, MARCH, 1974: "I HAD A WISDOM TOOTH EXTRACTED. THEY GAVE ME A TREMENDOUS AMOUNT OF SODIUM PENTOTHAL. I CAME HOME AND WAS IN GREAT PAIN. HE HADN'T GIVEN ME ANY PAIN MEDICATION AND MY WIFE CALLED THE PHARMACY."

"I WAS IN SUCH PAIN THAT I WENT OUT TO MEET THE GIRL WHEN SHE CAME. SHE WAS WEARING A GOLDEN FISH IN PROFILE ON A NECKLACE. THE SUN STRUCK IT AND IT SHONE, AND I WAS DAZED BY IT."

fig. 7
Detail of R. Crumb's *The Religious Experience of Philip K. Dick* (c. 1986);
ink and correction fluid on paper; eight pages: 16 $^{15}/_{16}$ x 14 inches each;
courtesy of the artist, Paul Morris, and David Zwirner, New York

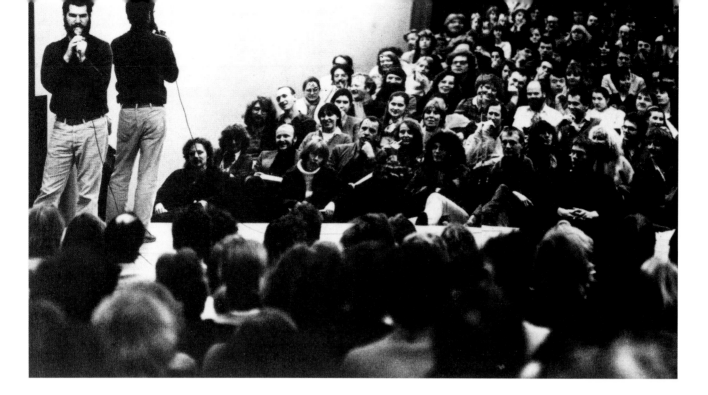

fig. 8
Graham performing *Performer/Audience/Mirror* (1977)
at Riverside Studios, London, 1979

He spoke Koine Greek. "In that instant, as I stared at the gleaming fish sign and heard her words, I suddenly experienced what I learned is called *Anamnesis*—a Greek word meaning, literally, loss of forgetfulness."[33] Dick was home, but would die in 1982 from a brain hemorrhage, unable to survive the experience.

In *Performer/Audience/Mirror* (1977, **fig.** 8), Graham faced an audience before a mirror and, as the audience looked at Graham and at itself, described his movements, then the audience's appearance and actions as they occurred. Chasing the present as close as it is possible to come, the performance moved away from science fiction's increasingly bad trip. Promoting self-reflection, group dynamics, and consciousness liberation, the performance entered and made visible the very stream of reality. All of Graham's work is what the artist calls "hybrid"—the offspring or crossing points of different genres. In fact, Graham's performances inspired and were inspired by New York experimental rock and roll of the 1970s. Bands that would one day call themselves punks still admitted they were interested in science fiction and fantasy.

Science fiction is itself a self-reflecting hybrid genre. In a Graham hybrid, science fiction reflects the hybrid's self-reflection as the utopian desire for enlightened categories of textual production. It offers direct access to conceptual reality as real-world experience. As its own example, science fiction stands immutably for the present real. It produces its temporary utopias not for the critic or the academic but for the fan, the committed critical amateur whom it spurs forward on the present path to the personal secular sacred. "An idea is important only in how it reacts on people, and in how people react to it. Whether the idea is social, political, or mechanical, we want people involved in and by it."[34] So instructed Campbell in 1965, unconsciously miming the coming rhetoric of Conceptual art. **DG**

33. In R. Crumb, "The Religious Experience of Philip K. Dick," *Weirdo* (San Francisco), no. 17 (summer 1986): 3.
34. John W. Campbell, "The Science of Science Fiction Writing," in *Of Worlds Beyond*, 94.

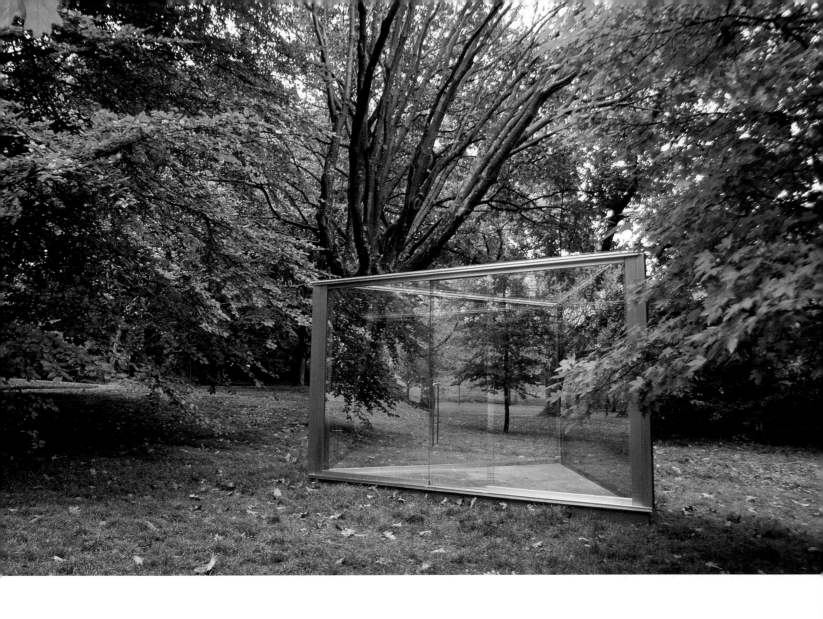

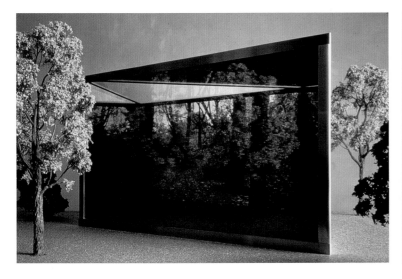

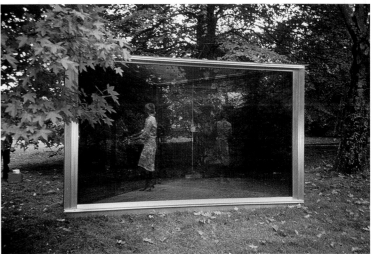

Views of *Double Exposure* (1995–2002): two-way mirror, color cibachrome transparency, and stainless steel; 7 $1/2$ x 13 $1/8$ x 13 $1/8$ feet; collection Fundação de Serralves—Contemporary Art Museum, Porto, Portugal; installation in Porto, Portugal; with architectural model (bottom left)

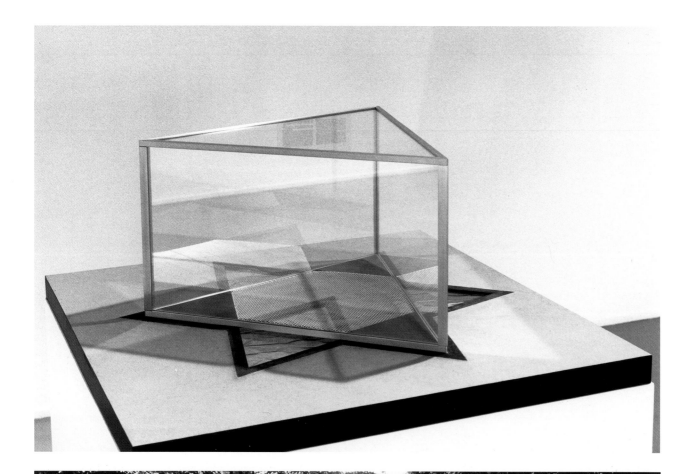

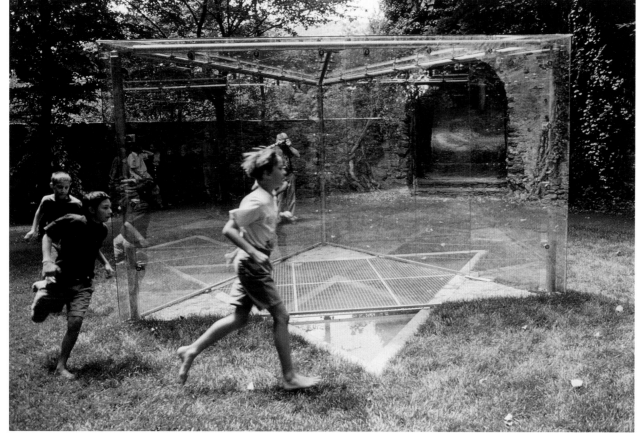

top
Architectural model *Star of David* (1991–96)

bottom
*Star of David Pavilion for Schloss Buchberg,
Austria* (1991–96); two-way mirror, aluminum,
and plexiglas; 8 1/2 x 13 3/4 x 7 7/8 feet;
collection Schloss Buchberg; installed in Gars
am Kamp, Austria

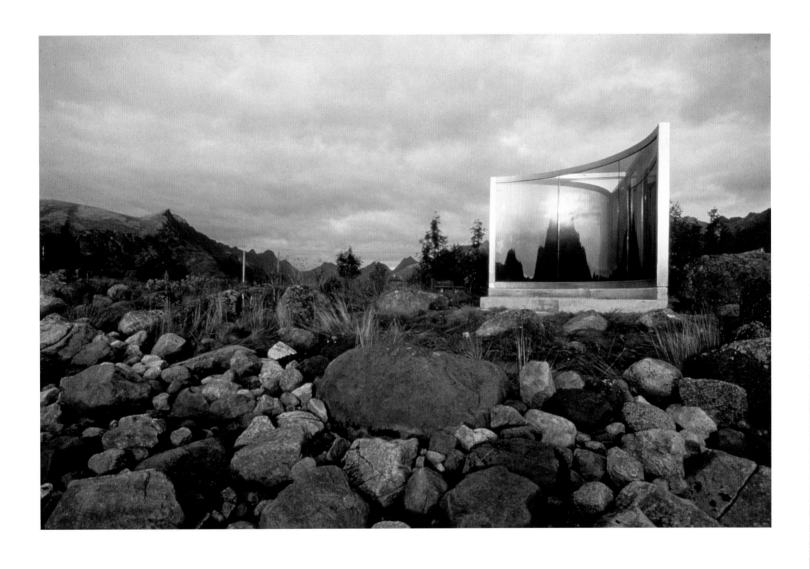

Two-Way Mirror Triangle With One Curved Side (1996);
two-way mirror and stainless steel; 8 1/4 x 9 7/8 feet; collection
Vågan County, Norway; installed in Lofoten Islands, Norway

following spread
New Space for Showing Videos (1995) installed
at Marian Goodman Gallery, New York, 1996

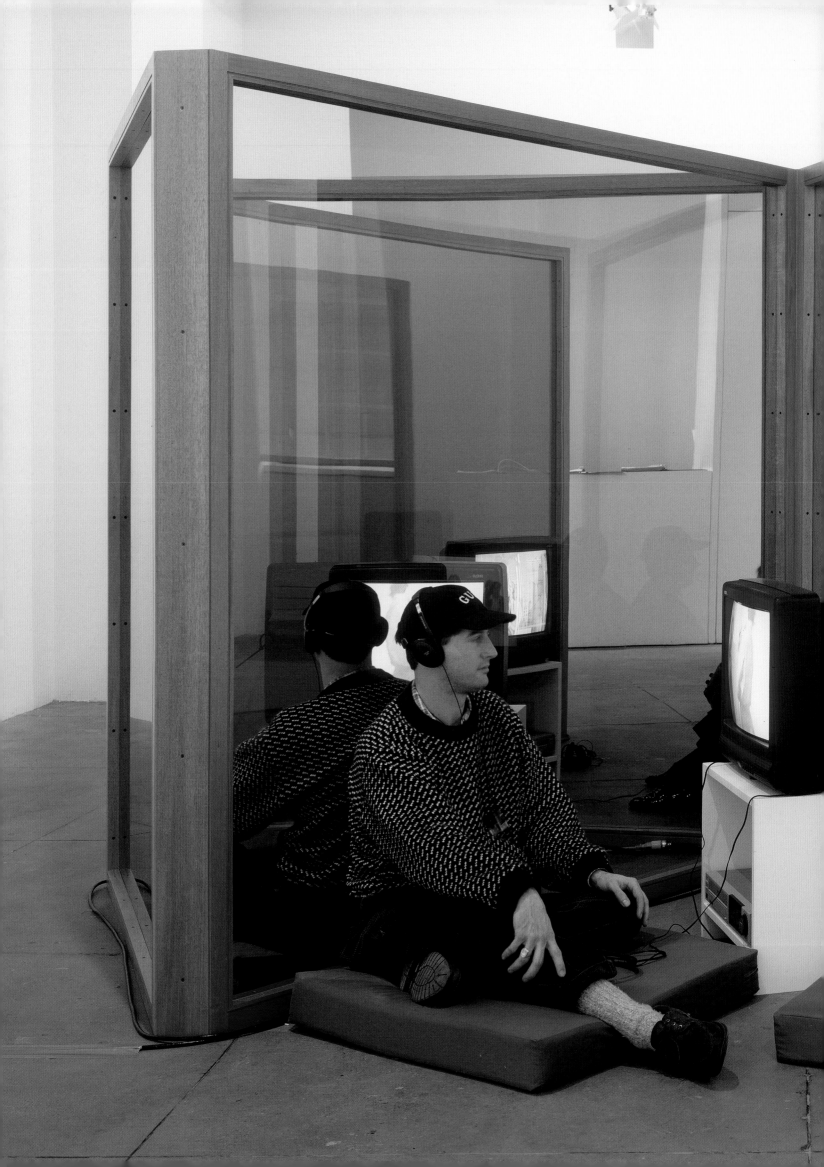

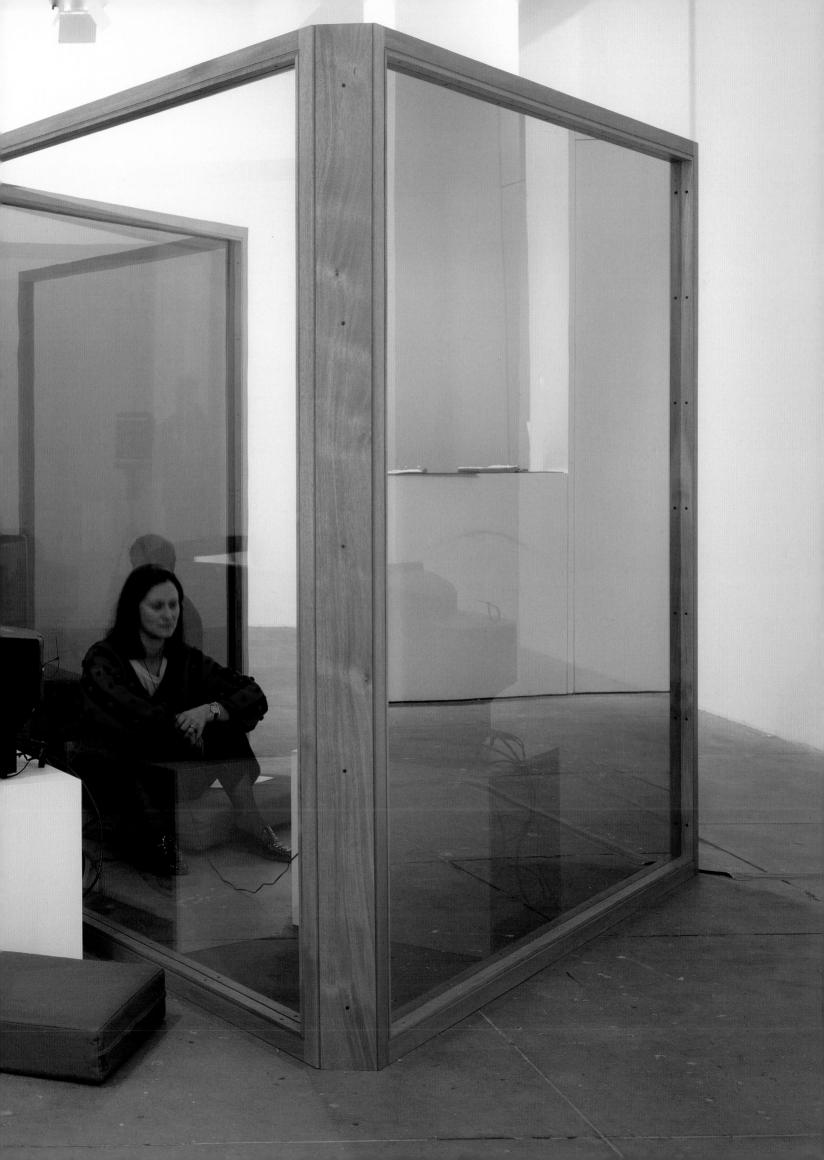

Liza Bruce Boutique Design, 1997

The shop faces an open sky and a park with gardens.

Goods are displayed between the showcase windows and the curved 2-way mirror. Passing shoppers can see images of both the clothes and themselves observing. These are superimposed due to the partial transparency of the 2-way mirror as well as images of people inside on the partition.

From the outside, there is an optical superimposition between the weak mirror reflection of the showcase window's right angle glass corners and the anamorphic distorting perspective of the 2-way mirror.

People entering the shop who decide to walk into the display alcove will see on the 2-way mirror their body enlarged, anamorphically 'fattened'. When they walk to the side of the 2-way mirror in the main area they see on the concave surface an image of themselves 'miraculously' thinner.

As the sunlight continuously changes due to moving clouds, there is also flux between the relative reflectiveness as against the relative transparency of the 2-way mirror's image.

The rubber floor surface, identical to that used in work-out gyms, gives the potential customer a buoyant feeling to her body.

The dressing room's 3 interior walls are mirrorized, while the entrance door side consists of 2 sliding panels of perforated aluminum. As the sliding doors are moved the interior mirrors re-reflect moire patterns from the sliding door. The tiny holes of the perforated aluminum allow the person dressing/undressing to be almost seen nakedly. This effect caused by the small peep-holes, relates to the near transparency of Liza Bruce's designs.

1

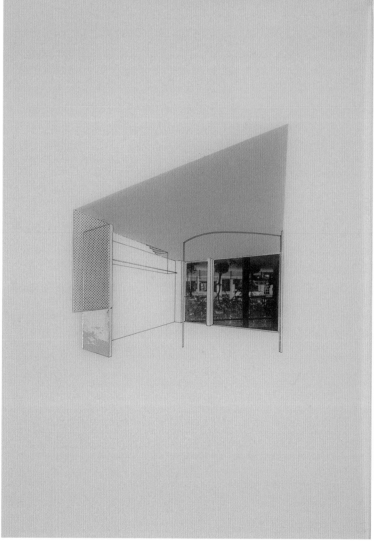

Details from Graham's *Liza Bruce Boutique Design*
(1997, in collaboration with Apolonija Sustersic)

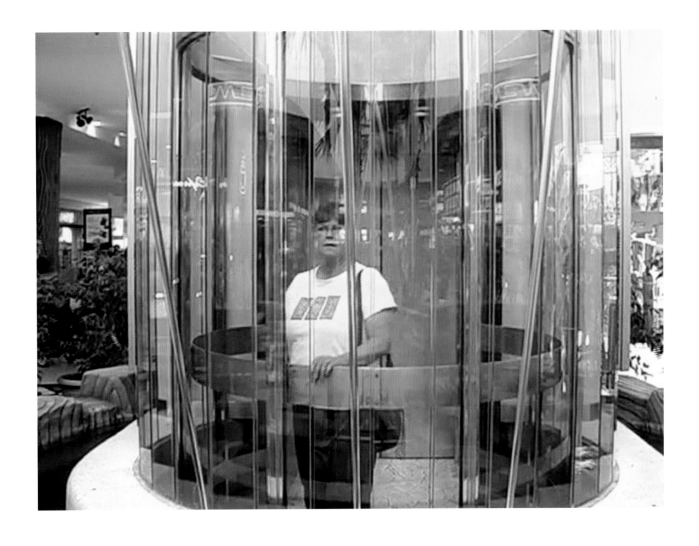

Stills from *Death by Chocolate: West Edmonton Shopping Mall (1986–2005)* (2005)

following spread
Architectural model *Portal* (1997); two–way mirror glass; 29 $^{15}/_{16}$ x 42 $^{1}/_{8}$ x 36 $^{1}/_{4}$ inches; Friedrich Christian Flick Collection; installed in "Dan Graham, New Works/New Age" at Galerie Hauser & Wirth, Zürich, Switzerland, 1997

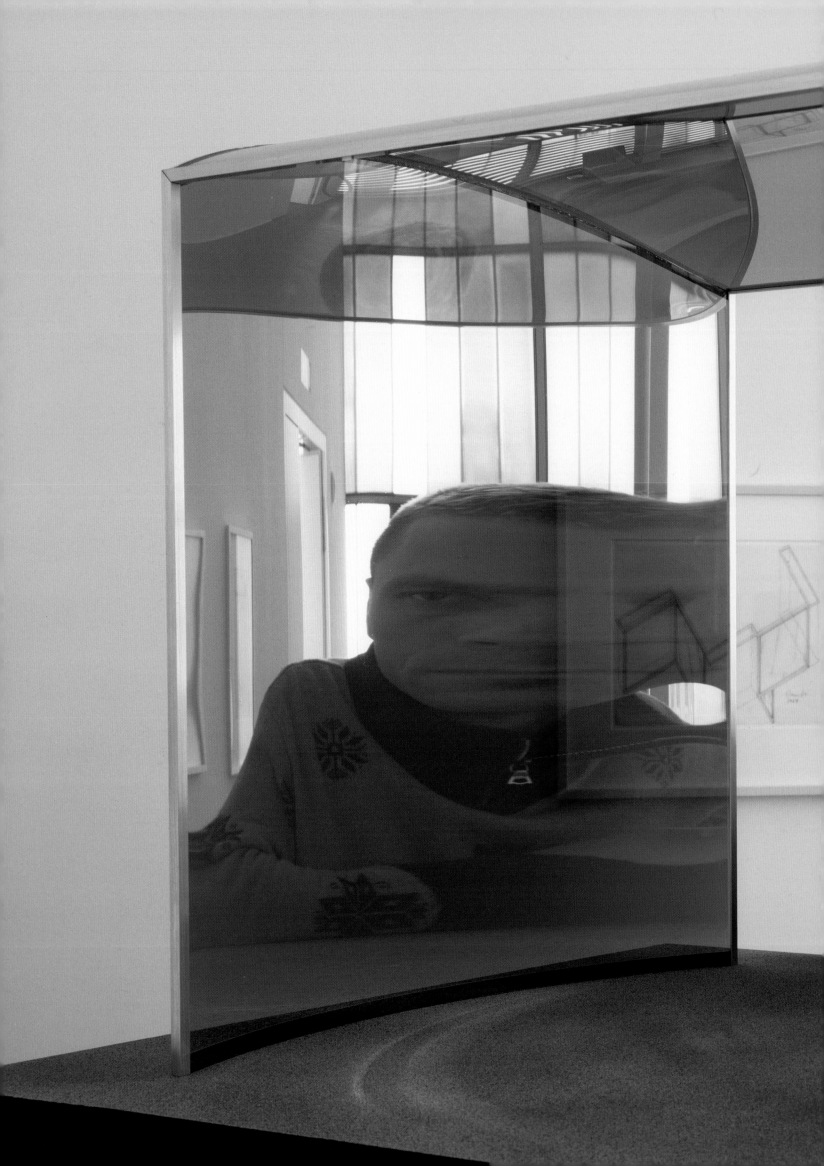

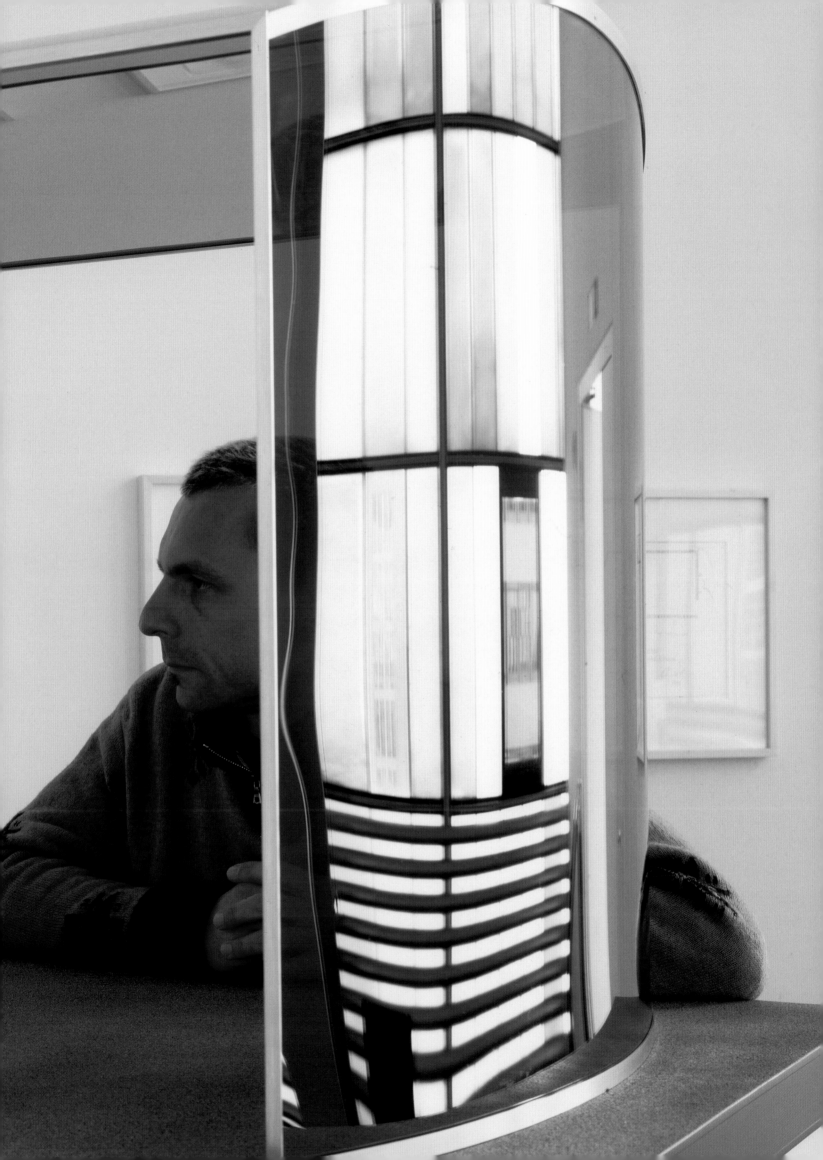

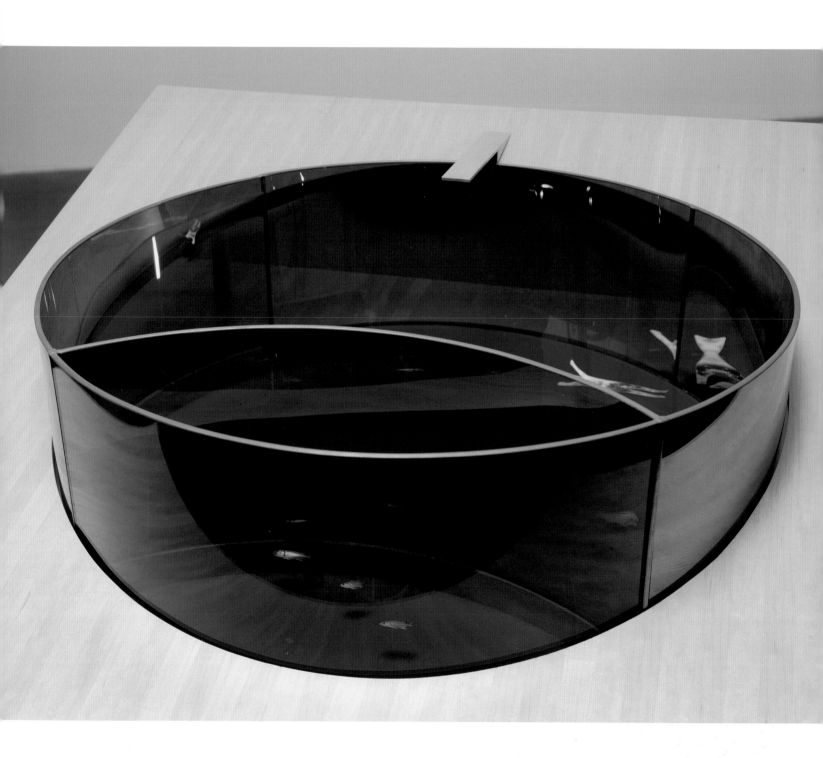

Architectural model *Swimming Pool/Fish Pond* (1997)

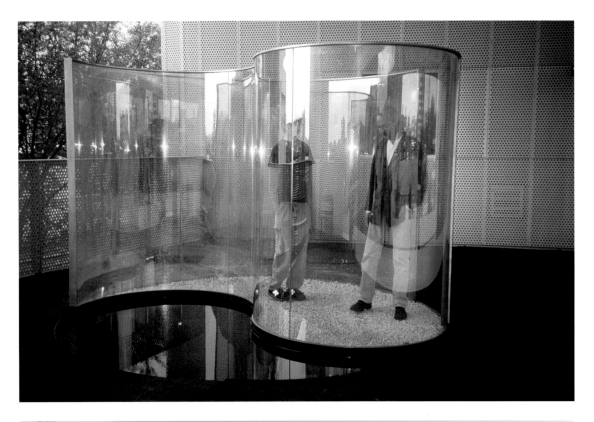

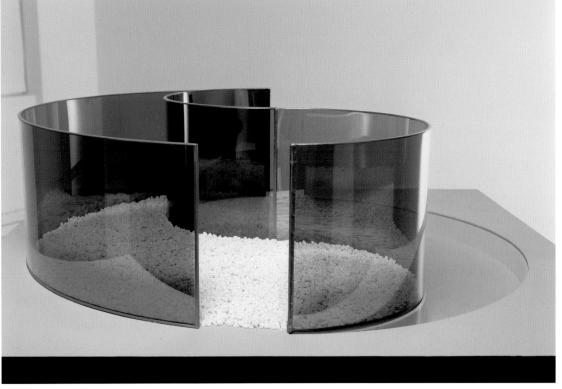

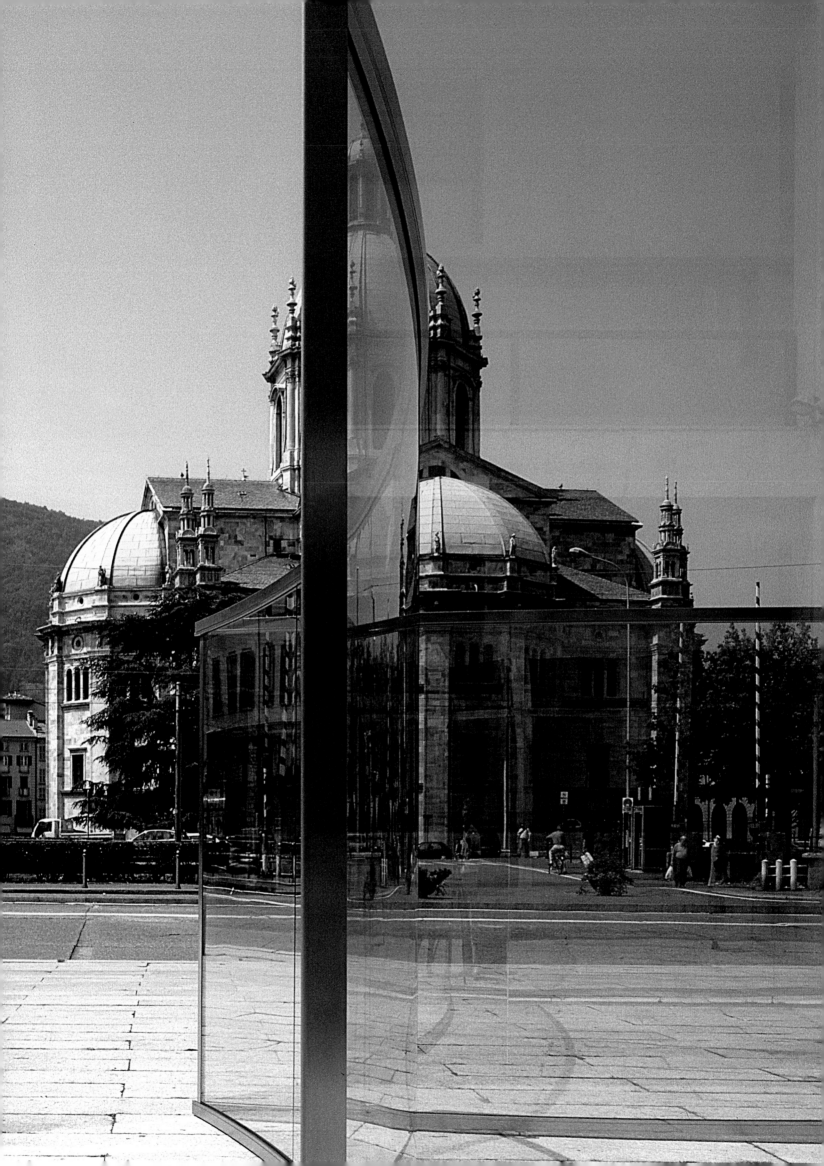

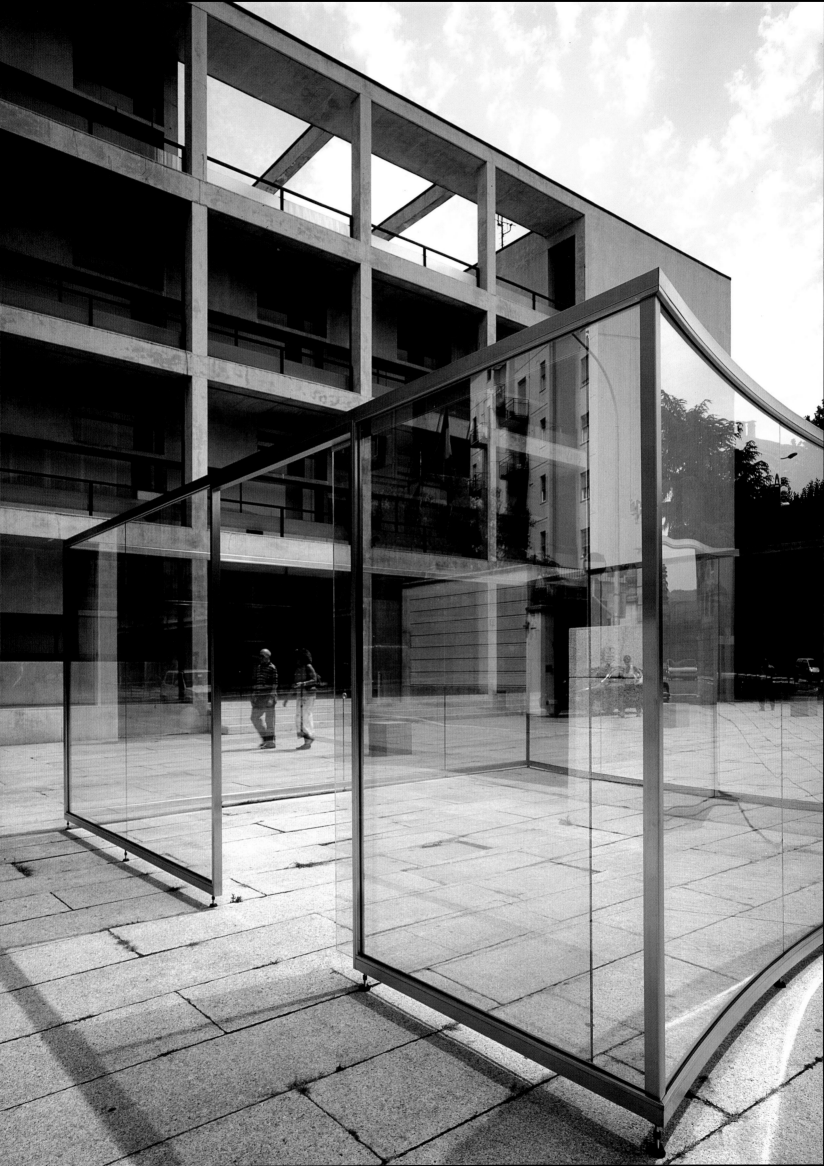

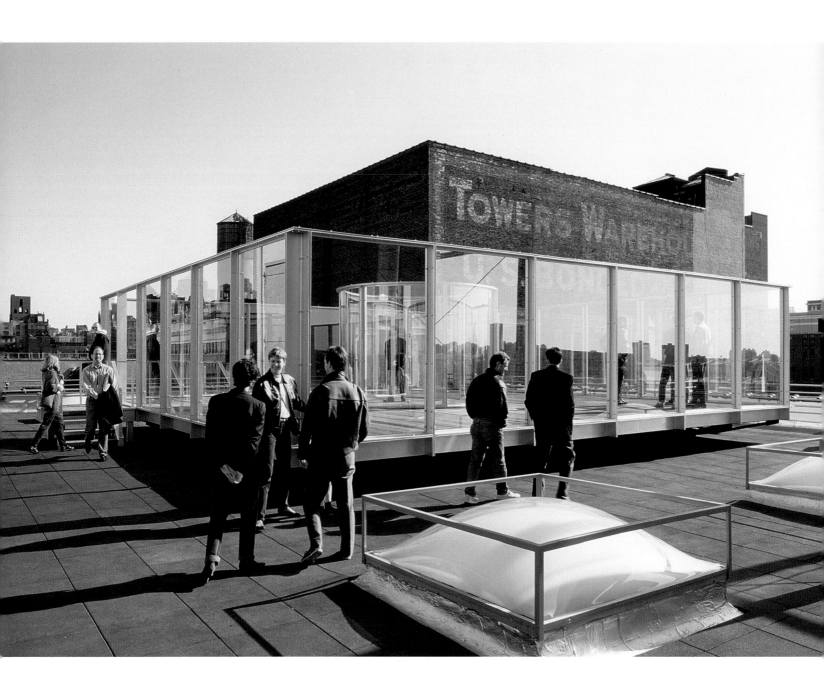

Two-Way Mirror Cylinder Inside Cube and a Video Salon: Rooftop Urban Park Project for Dia Center for the Arts, New York (1981/91); two-way mirror, glass, steel, wood, and rubber; pavilion: 9 x 36 x 36 feet; video salon and café: 10 $^1/_2$ x 12 x 23 feet; collection Dia Center for the Arts, Dia Foundation, New York; installed on rooftop of Dia Center for the Arts, New York, 1991–2004

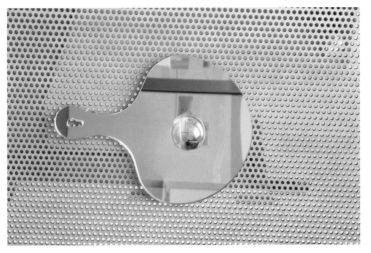

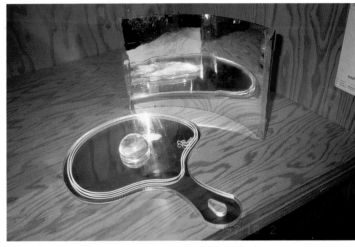

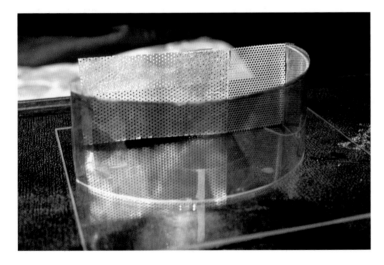

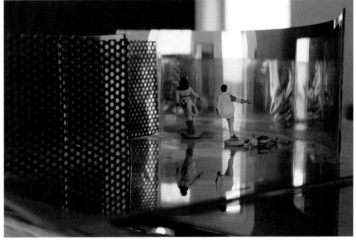

top left
Detail of *Girls' Make-Up Room* (1998–2000),
interior view of hand-held mirror mounted on
sliding entrance door

top right
Girls' Make-Up Mirror (1998–2000): reflective
plastic with fish-eye lens and magnetized
back; edition; 11 $5/8$ x 8 $1/4$ x 1 inches; with
fragment of model

bottom row
Architectural model *Girls' Make-Up Room*
(1997); reflective plastic, perforated metal,
and scotch tape; 2 x 3 $3/4$ x 2 inches; Flick
Collection, St. Gallen, Switzerland

following spread
Girls' Make-Up Room (1998–2000) installed
in "Dan Graham: A Show for All the Children,"
Galerie Hauser & Wirth, Zürich, Switzerland,
2001

left
1920s Amusement Park Carousel, Asbury Park,
N.J. (2006)

right
Entrance, Mafia Mansion, Deal, N.J. (2006)

Writings by
Dan Graham

Garden as Theater as Museum (1989)
Dan Graham

The site was empty.... There was to be an enormous amount of educational gardens, of scientific gardens, research gardens, exotic gardens; there had to be gardens in which the surrounding neighborhood could indulge in some of the most modern media of the twenty–first century.... There was a cybernetic dimension; there were corporate gardens.

—Rem Koolhaas on the Parc de la Villette competition.[1]

The first Italian Renaissance gardens, built astride Roman ruins on hillsides, were sculpture gardens, theaters, archaeological museums, alfresco botanical encyclopedias, educational academies, and amusement parks that drew on special effects to entertain the public. Their meaning was either moral or allegorical, natural or scientific, and political lessons were incorporated into their designs.

As "art forms" they were models of a world intended to be studied. Archaeological excavations, including local statues and sculpture from far away, were exhibited *in situ* when they related in theme or period to a particular garden. Their spaces contained botanical collections, minerals, and other natural curiosities. In Florence's Orti Farnesiani, classical sculpture was displayed in juxtaposition to every plant mentioned in classical literature.

The Renaissance garden symbolized the Edenic, pre–Fall of Christian man and of Arcadian (Roman) time that was associated with earthly paradise, a mythical past, or a future utopian time of eternal pleasure and natural harmony. Through its Arcadian associations with paradise, the garden embodied all that was pleasure and a contrast to man's worldly existence. The garden transported him to another world:

in which everything laughs and is full of love, of joy, and of wonder, and where the flowers and herbs not only delight the corporeal eye of the beholder, but by very subtle means pass into their minds.[2]

The designs of Renaissance gardens were often derived from classical texts. One of the most influential texts was Ovid's *Metamorphoses*. In his poem, Ovid brings together the natural and the artificial in a metamorphic chain in which nature imitates art, and conversely, in which the artificial mimes the natural. The Boboli Gardens in Florence, a triple grotto whose architecture appears to yield to "natural" rock decorating the outer edge of the grotto and descending around its entrance, is a fine example. Its "natural" effect was artifice escalated to almost Disney–like proportions, creating a childish fairyland:

By the time we reach the entrance and see inside, our experience is a transformation of architecture

into its natural materials; or, such is the ambiguity, of an opposite metamorphosis—rock and stone gradually shaping themselves into artifact. Inside this first room, this ambiguous world is heightened by a scenery of man and animals who are either emerging out of, or changing into, stone.[3]

Gardens contained various allegorical memory places. Artificial memory in the Renaissance was an attempt to resurrect what originally was a part of Greek, and later, Roman, rhetoric. In order to memorize long sequences of speech in a culture without readily available written texts, a metaphoric chain of ideas was symbolically associated with specific architectural places. One sign might be imagined to be in the forecourt, the next in the atrium; others were associated with statues. Each symbolic space, in relation to other signs and architectural symbols in the garden, was designed to trigger certain memory responses in the visitors.

So one would not be confused with another, distinct intervals separated each memory space. Imagistically striking loci prevailed in gardens: grottoes, statues, and inscriptions. Each image stimulated a specific idea or theme. The garden as a whole could be viewed as a theater in which one strolled from one stage to another, from scene to scene, and in so doing, reactivated certain memories and allegorical images within the environment (fig. 1).

Guilio Camillo's Teatro del Mundo was the ultimate model for the garden as a memory theater. It attempted to create an association between memory and symbolic images. These images were magic, talismatic representations of a coded system of the world. Camillo's encyclopedic memory machine—no one is clear as to whether it actually existed as a transportable pavilion or an unrealized idea—was intended to exist as an actual miniature theater large enough for one spectator–scholar, who could stand in the central stage area. The spectator was to use the device to learn the structure of the universe from microcosm to macrocosm, as in a modern science museum's representation of subatomic physics or outer space.

Camillo reversed the conventions of spectator to stage; the audience member was to be on the stage, instead of looking at the spectacle on stage. Each tier in the Teatro del

Mundo represents aspects of the "universe expanding from First Causes through the stage of creation." Images of planetary gods were placed on the outside of each tier. Under these images were "boxes containing masses of papers, and on these papers were speeches, based on the works of Cicero, relating to the subjects recalled by the images." Teatro del Mundo's ultimate goal was not to "expose reality, but to reveal a hidden one through a different scheme." This scheme was embedded in the architecture. The structure's ultimate purpose was like a Jesuit exercise: to remake memory. Memory was given the coherence and micro-macrocosmic meaning denied in ordinary life.

A typical Renaissance garden was first viewed and entered from a loggia at the base of a villa. The garden's overall geometric plan was seen as if in a perspective painting or from the back of a theater looking straight at the stage. The apse was like a stage's proscenium overlooking the garden below and prepared the visitor for later closeup views of the garden's statues, flora, vistas, and emblematic narrative flow.

By the period of the Italian Baroque, garden design and theater design were so closely connected that they directly influenced each other. The Baroque garden, treated metaphorically as a vast, natural theater, usually contained one or more areas for theater performances. The theater's architectural boundaries were defined by boxed hedges, grass, stones, statuary, and foundations that also formed the staging and seating areas. The sets of such productions sometimes utilized the garden's actual pathways, radiating in perspective through the garden, or they represented the garden's perspectives as part of the temporary set designs.

THE ENGLISH GARDEN

The English landscape garden of the early eighteenth century contained the Italian tradition of the garden as an outdoor theater of moral allegory. One of William Kent's earliest garden designs, Chiswick, begun in 1731, extended the garden plan into a virtual replica of Andrea Palladio and Vincenzo Scamozzi's Teatro Olimpico, whose five streets disappeared in perspective into an urban plaza. The Teatro Olimpico was the model for Renaissance stage designs that replicated the surrounding cityscape. In Chiswick, instead of urban streets there were grass lanes that terminated in buildings and obelisks,

fig. 1
Johannes Willemsz Blaeu's illustration of Villa d'Este and its gardens at Tivoli, Italy, from *Teatrum Vivitatum* (1663)

emphasizing the unresolved relationship between urban and rural.

The Elysian Fields section of the garden at Stowe, constructed in England between 1720 and 1740, was a liberal Whig allegory against the restored British monarchy. Designed by William Kent and Charles Bridgeman for Lord Cobham, Stowe translated to garden plan an essay by Joseph Addison from *The Tatler*, which presented a "dream" in which the walker experienced the human condition by passing through a garden whose paths provide insight into human and political motivations. Approaching "middle age"

the dreamer walked on a straight road with laurels, behind which were trophies, statues of statesmen, heroes, philosophers, and poets. This path led to a Temple of Virtue, which hid a Temple of Honor behind it. Visible through the arch of the Temple of Honor was a crumbling structure, the Temple of Modern Virtue.

Addison's "dream" was translated into the "constructed" ruin, a Temple of Modern Virtue, built as a ruin seen from the future,[4] yet looking back to the past. It dramatized the corruption of the present, monarchist regime. A headless statue of then Prime Minister

fig. 2

William Kent's *Twickenham, Alexander Pope's Garden*
(1730–48); pen and black and gray ink and brown
wash over graphite on paper; 11 $^7/_{16}$ x 15 $^9/_{16}$ inches;
The British Museum

Robet Walpole stood next to the ruins. Across
the River Styx stood the Temple of British
Worthies, with busts of a Whig Hall of Fame
in semicircular niches around the forum. They
included Francis Bacon, John Milton, William
Shakespeare, Elizabeth I, Inigo Jones, and
Alexander Pope, among others.

THE FRENCH "ENGLISH GARDEN"

The English garden, transplanted to France,
became a "garden of sensibility" in which
an elegiac view of death was represented
by an Arcadian garden. When death was
encountered, it was in a "peaceful setting
fraught with sweet melancholy and nostal-
gia." Various monuments evoked Arcadia as
a pastoral retreat and as a sublime memorial
evoking "those tender feelings of which we
are susceptible when we revive the memory
of a lost friend."[5]

In 1730, Alexander Pope built his English
garden around a memorial shrine to his
mother (fig. 2). Pope's example was extended
by other garden builders, and a cult of burial
memorials to dear or noble friends, especially
to those who had visited the particular garden,
sprung up.

Ermenonville, designed by the marquis
de Girardin, was inspired by Jean-Jacques
Rousseau's writings. The garden translated
philosophic categories into their emotional
evocation in specific picturesque pavilions,
arrangements of the natural landscape, and
various recreations, including bucolic villages
with working farms, peasant villagers, and
meadows. The Temple of Philosophy was
built as a ruin. Left in an unfinished state, it
signified:

> the imperfection of human
> knowledge…. Dedicated to
> Montaigne, the former monument
> is the occasion to evoke the
> Philosophers and their contribution
> to humanity: Newton—light,
> Descartes—the absence of void
> in nature, Voltaire—the ridiculous,
> Montesquieu—justice, Penn—
> humanity, Rousseau—nature.[6]

Rousseau's "cottage" was a hermit-
age. Hermitages in English gardens in France
were somewhere between primitive huts
and pseudo-medieval "ruins" and suppos-
edly constructed for homeless, wandering
monks, philosophers, or the garden's owner,
who might wish to detach himself from the

cares of urban life. Rousseau's dwelling had a view of a lake, and beyond it, of an Arcadian meadow containing a medieval village and tower. It was modeled after descriptions in his own *La Nouvelle Héloïse*. Rousseau died and was buried at Ermenonville, his tomb designed by the painter of archaeological ruins and architect of artificially constructed ruins, Hubert Robert (fig. 3). Rousseau's tomb on the Isle of Poplars, along with the Altar of Reverie, which marked the place where the writer often stopped to rest, evoked an Arcadian, sentimental mood in which the dead thinker's life was remembered.

The natural change of seasons, water, and rocks were used to symbolize feelings of fear, tranquility, sorrow, or the sublime. Rock formations provoked astonishment, vexation, and terror. The forest, by its elevation and expanse, was meant to be considered in heroic terms. Peaceful, solitary, serene, melancholic scenes were designed according to the layout of the trees. Water was sublime; it ran deep.

By the mid-nineteenth century, with Baron Georges Haussmann's plan for Paris's redesign, central parts of the city were transformed into English gardens, traversed by spacious, tree-lined boulevards. The overt rationale for these urban, sylvan spaces was to bring "airy greenery and light into crowded districts."[7] Their unstated purpose was to mask the boulevard's political and military functions.

Boulevards facilitated communication between various city districts and allowed the military easy access to any point in a city. They also countered a rebellious proletarian's tactic of "taking to the streets." Haussmann's reorganization of Paris involved the creation of a politically defensible capital city whose arteries were accessible at all times by troops and made for rapid communication between parts of the city and the central government.

The city's new, open boulevards with civic squares and plazas were also used by rulers from Napoleon onward to turn Paris into an outdoor museum. The city was to become an exhibition space designed for the education of the emerging middle class, a "collection of permanent reminders" of the historical greatness and hegemony of, not only "the French nation, but also of the comparable—though slighter lesser—contribution of mostly subservient Europe."[8] This idea is perhaps the first appearance of a recurrent nineteenth-century theme:

fig. 3
After Gandat, *The Grave of J. J. Rousseau in the Garden at Ermenonville* (1781); etching; 20 3/4 x 15 1/2 inches; The British Museum

the city as a museum…a positive concert of flirtations with the Saracenic remains of Sicily…culture and education…as benevolent course of random but carefully selected information….The city as museum mediated…classical decorum…[with] the…liberal impulse…and free trade.9

THE BIRTH OF THE MODERN MUSEUM

The bourgeois national museum as an educational institution developed simultaneously with the capital city as an outdoor museum. It was meant to foster a new nationalism separate from classical Greece or Rome, or even the Italian Renaissance tradition. "Recognizing French Gothic as one of the most daring conceptions of the human spirit," the national museum was to be an aid "toward happiness in being French." Ideas of didacticism and

moral improvement for a new middle-class notion of public education emerged as a national priority and, as such, helped to justify a "national" collection:

A museum should be instituted according to two points of view, one political, the other concerned with public instruction from the political point of view. It should be established with enough splendor and magnificence to speak to every eye…. From the instructional point of view, it should include everything the arts or sciences could together offer to public education.10

The Abbé Alexandre Lenoir, chief propagandist for the national museum, originally housed his collection in the church of an abandoned convent. This proto–French national

collection, organized between 1796 and 1800, divided French cultural history into epochs, with one hundred years as the basic time unit. Each room or century was given the "character, the exact physiognomy of the century it should represent." Fragments of surviving windows, doors, and other interior décor were added to the surface of the room's walls to give authenticity.

Anthony Vidler, the Anglo–American architectural historian, remarked that "in each of these rooms, despite Lenoir's frequent protestations that everything has been executed according to notes taken from the actual monuments of the time and after the proper authorities," his theatrical virtuosity generally overcame his historical accuracy. As Vidler admitted, "the whole shows the effects that can be produced to decoration with old details skillfully applied."

WINTER GARDEN AND GARDEN CITIES

At the same time as Haussmann was politically rationalizing the street plan of Paris to bring militia as well as hygienic air and greenery into formerly overcrowded, polluted environs, artificial streets, or *passages*, were being built in Paris for shoppers. These glass-roofed shopping arcades were devoted to the display of commodities. They created phantasmagoric "dreamlands" of product display. The mercantile display devices of arcades, new department stores, and trade fairs culminated in the Paris Universal Exposition in 1889. For Walter Benjamin, the German social historian and art and literary critic, these glassed-in settings were a "dream world...in which individual consciousness sinks into ever-deeper sleep...[and] generates hallucinations or dream images."[11] Benjamin saw commodities creating a dream of ever-newness, in which each new product causes the spectator to forget the now devalued, passé commodity, idea, or fashion.

The same artificial "dream" was induced by the winter garden, which allowed exotic and tropical vegetation to be displayed even in the temperate or cold climates of northern, industrial, urban European cities year-round. The winter garden, like the shopping arcade and Sir Joseph Paxton's Crystal Palace at the International Exhibition in London in 1851, were replicas of a world within a world. With the appearance of the winter garden, the meditative private garden was replaced by the public botanical garden-museum and became a place for mass education and entertainment and a temporary refuge from everyday life (fig. 4).

Utopian garden-city settlements were proposed throughout the nineteenth century as a way of employing technology to create a more ideal structure as a socialist, bucolic antidote to the capitalistic city. Such ideal communities were to be located outside a city in self-sufficient garden settings. Instead of individual houses, extended families would share work and child-rearing responsibilities to create an economically and socially efficient "machine for living." The efforts of nineteenth-century reformers influenced the later commercial development of suburban garden towns around 1900.

After the First and Second World Wars, suburban settlements were located on the edge of a city's boundary, adjacent to and resembling those first picturesque park cemeteries whose design had evolved from the elegiac Elysian Fields of the English garden's

fig. 5
Entrance to the Luna Amusement Pavilion at Coney Island Amusement Park, Coney Island, New York, c. 1944

monuments to the dead. Like cemeteries, suburbia's "garden evoked a nostalgic sense of perpetual peace in its well-manicured shrubs and green lawns. Accommodating working-class families in their own suburban homes helped to stabilize and defuse the revolutionary potential of the inner-city working class. With the growth of a more stable, lower middle class, small nuclear family suburbs helped create a new consumer society based on home consumption.

BIRTH OF THE AMUSEMENT PARK

For the working class left in the city, the birth of electric lighting made possible new types of leisure, nighttime consumption. Projected light filled previously dark spaces, providing an illusory world of personal pleasure and "dream." Electric lighting was responsible for both the birth of film and of the amusement park. It was around 1900 that Freud's notion of the "unconscious," the cinema, and Coney Island simultaneously appeared.

Rem Koolhaas, the Dutch architect, discusses the development of Coney Island as an unconscious dreamland in the midst of the waking, rational world of New York City in his book *Delirious New York*. Coney Island's first amusement complex, Luna Park (fig. 5), which opened in 1906, followed nearly the same scenario and dreamlike, science-fiction fantasy of Georges Mélies's film *A Trip to the*

fig. 6
Sleeping Beauty's castle at Disneyland, Anaheim,
California, c. 1960

Moon (1902). A visitor entered the park's lunar landscape in much the same way an astronaut begins a trip to the moon:

The ship is 1,000 feet in the air. A wonderful, wide-eyed panorama of the surrounding sea, Manhattan, and Long Island seems to be receding as the ship mounts upward.... The moon grows larger. Passing over the lunar satellite, the barren and dissolute nature of its surface is seen. The airship gently settles... and the passengers enter the cool caverns of the moon.[12]

Luna Park's neighbor was Dreamland, built around an inlet of the Atlantic Ocean.

Its entrance porches were underneath huge plaster-of-Paris ships under full sail; metaphorically, the surface of the entire park was under water.[13]

Other simulations in Dreamland were the midget city of Lilliputia, in which "the midgets... have their own Parliament, their own beach complete with midget lifeguard and a miniature...Fire Department responding to a false alarm"[14]; a simulated ride in a submarine; an enactment of the fall of Pompeii; an Incubator Building in which premature babies from the area were actually collected and nursed to health in technologically advanced facilities; a ride on Venetian canals; and a set that fabricated a New York City block where each night firemen demonstrated how to fight the flames of a burning building.

THE CITY TO THE SUBURBS

The spread of suburbia after World War II correlated with automobile's alteration of American life. The new, middle-class, suburban family was more transient than ever before, more willing to pack up and move quickly to another location. Corporations spread and decentralized, shifting their staffs from branch to branch throughout the country. This suburban automotive period also saw the rise of drive-in cinemas and shopping malls. It was the use of the automobile for leisure and the decline of the urban cinema that led to the many highway theme parks, of which Disneyland is the best known example (fig. 6).

Like the nineteenth-century trade exposition, the theme park became a spectacle of capitalist ideology. Disneyland's Tomorrowland had, until recently, housed General Electric's New York World Fair Carousel of Progress. This was a film-and-slide dreamland that presented the idea of progress or "better living" through commodity technology.

Visitors sat as if in a slide carousel, moving ahead in time incrementally in a circular progression, in which they experienced "progress" through a series of tableaux of a family of natural-looking robots in a middle-class kitchen. The sequence progressed in twenty-year segments, from the turn of the century onward. Between each section, the audience was encouraged to sing along with the robots: "It's a great big beautiful tomorrow, shining at the end of every day. Man has a dream and the dream can come true."

Each time the audience sang, the carousel magically advanced—the whole theater unit actually moved—twenty years onward, but the same family was in the same setting—almost. The robots were imperceptibly older, and their clothing and the décor had been changed to reflect the styles of the time. However, the most significant changes, which the family was always emphasizing, was the kitchen's electricity-based home technology. History was neutralized by the ever-new, by progress. The circular motion of the carousel expressed endless technological progress, endlessly satisfying human needs.

Louis Marin, French art historian, sees Disneyland as an allegorical narrative in which spectators as "actors" perform the text as entertainment. Disneyland is a cynical inversion of such early American utopias as those of the Shakers, the Mormons, and the Hudderites—as well as European communal

socialist experiments proposed by Louis Fournier and Robert Owen that attempted a reconciliation of Rousseau's return to freedom and innocence of nature with urban technology's promise of liberating man from enslaving work. Disneyland, according to Marin, attempts to resolve central contradictions in the ideological myth of America:

> Disneyland is a...displaced metaphor of the system of representation and values unique to American society. This projection has the function of alienating the visitor by a distorted and fantasmatic representation of daily life, by a fascinating picture of the past and the future, of what is estranged and what is familiar.... In "performing" Disney's utopia, the visitor realizes the models and paradigms of the society in a mythical story by which he imagines his social community has been constructed.[15]

Disneyland as a semantic map consists of a division into three places or concepts:

1. The outer limit defined by the parking lot where the visitor leaves his car. As the car is one of the most powerful markers of his daily life, in leaving it behind and exchanging his behavior for a free field of consumption and play, the visitor enters the imaginary realm of The Magic Kingdom.
2. The intermediate area where the visitor purchases tickets and Disneyland money in order to participate in Disneyland life.
3. The visitor's actual entrance into Disneyland at the embankment of the Santa Fe and Disneyland Railway with its subsequent stations.

The railway leads to the park's central strip, Main Street USA, which separates Frontierland and Adventureland. As the route to Fantasyland, the railroad is the axis. Marin notes that in Adventureland and in Frontierland, Main Street USA represents America itself in present time:

> By selling of up-to-date commodity goods in the setting of a nineteenth-century street, between adult reality and the

childish fantasy, Disney's utopia converts commodities into signification. Reciprocally, what is bought there are signs, but these signs are commodities.... Main Street USA signifies to the visitor that life is an endless exchange and constant consumption.[16]

The cinematic version of American history as mythology is equivalent to the use of Ovid's *Metamorphoses* in the Renaissance. In Disneyland, Marin proposes, man is twice removed from nature:

> All that is living is an artifact. Nature is a simulacrum. Nature is a wild, primitive, savage world, but in this world is only the appearance taken on by the machine in the utopian play. In other words, what is signified by the left part of the map is the assumption that the Machine is the truth, the actuality of the living....In Tomorrowland machines are everywhere: from the moon rocket to the atomic submarine.... [These machines] are scaled-down models of the actual machines. We have false duplicates of living, and concealed mechanistic springs on the left, obvious machines on the right.[17]

On the left of a large, free-standing map are Adventureland and Frontierland. Adventureland with wildlife in exotic countries is viewed during a boat trip down a tropical rain-forest river. It defines America in relation to the savage outside world it has conquered, as opposed to Frontierland, which shows the American conquest of its own savage interior.

Both are imperialist myths. To the right of the map is the future, Tomorrowland, in opposition to the past of Adventureland and Frontierland. In Tomorrowland the universe has been conquered in the future by science and technology. America's ruling 1950s and 60s imperialist mythology, progress, the mythology of the American corporation, prevails.

While the Italian Renaissance Baroque garden was based on a tension between the artificial and the natural, Marin suggests that in Disneyland nature itself is only a representation, the other side of which is a machine.

THE CORPORATE ATRIUM AS MUSEUM AND GARDEN

In its interior atrium, "a rectangular hole inserted in a seventy-story cylindrical tower clad in reflecting glass," Atlanta's Peachtree Center Plaza Hotel (1976) is a typical John Portman building, a tropical resort in the center of the city. From the outside, the tower looks like a rocket in its gantry; it is connected to the building by bridges at each level. The floor of the tower is covered by a reflecting pool, or, as Jonathan Barnett, who collaborated with Portman on a book dealing with Portman's work, has written: a "half-acre lake.... [in which] boat-shaped islands are pushed out between the columns, forming places to have a drink and observe the space and the people."[18]

Portman's hotels link the dreamworld of Luna Park and Disneyland to the recreational Arcadia of the picturesque city park. Landscaping techniques are brought indoors to create the mood of a film set.

The glass-topped Parisian arcades, the world expositions, and the European winter gardens of the nineteenth century were first adapted by the United States at the turn of the century, when they were used in hotels and in commercial office buildings.

The best-known corporate office building with a central glass skylight design was Frank Lloyd Wright's Larkin Building, built in Buffalo in 1904, but now destroyed. Employee and management desks were democratically arranged on balconies, stacked in tiers along the interior walls and in the central court. Each member of the corporate "family" could view each other in and through an open central court. Strong overhead sunlight pored through the central skylight.

During the 1960s, the American city center came to be dominated by high-rise office buildings. But by the early 1970s, following the economic recession after the Vietnam War and the Nixon administration's cutbacks in funding for blighted, older, East Coast cities, the streets surrounding these corporate headquarter towers were threatened by crime. An initial solution was to build medieval fortresslike megastructures enclosed in concrete. Services, retailing of goods, and pedestrian traffic became concentrated in a protected, central court. Following the lead of Portman's hotels and Kevin Roche's Ford Foundation garden atrium design, the substitution of an atrium skylight and "ecological" greenery created an accessible pedestrian corporate office building lobby that was safe.

In the 1970s, the atrium space became a way of competing with and paralleling the suburban shopping mall. As the upper middle class moved back to the city from the suburbs, the atrium was adapted to suburban forms. Real trees and earth were combined with high-tech features and suburban patiolike design. Green-and-white metal openwork chairs and green lettering on shop windows connoted a suburban Arcadia in the midst of a city—an urban fantasy of the picturesque brought into the central city.

New York's Chem Court, a glass-encased structure, alters its appearance with fluctuations in natural light. Inside the court of the bank building, anodized aluminum columns, water-filled canals, a tiered marble fountain, and stone-faced planters comprise a mini-botanical garden. The plants are oversized versions of domestic, suburban house plants, but they are labeled in the style of a botanical garden. Seasonally changing displays are maintained by the staff of New York's Botanical Garden. Labeling creates the civic-minded aspect of an educational garden and gives the impression—only partially accurate—that Chem Court's atrium is an extension of the New York Botanical Garden.

Corporate atriums and lobbies already function as part of the New York museum system. The Whitney Museum has three museum branches in corporate lobbies, while the IBM Corporation lobby contains its own botanical garden-style atrium and, below it, a separate underground museum. Battery Park City, a "public-private" financial center and high-rise, high-income housing development, has created a new riverside park, open to the public, but maintained by private security. It also functions as an outdoor "art museum" in which artists such as Richard Artschwager, Scott Burton, and Siah Armajani have created "public amenities."

The solar-heated, high-tech space capsule, wedded to the nineteenth-century winter garden, defined the look of these mid-1970s corporate garden spaces. They can be considered a political allegory related to the Whig's political allegory in Stowe. The oil shortage and ecological crisis of the mid-1970s undermined the public's perception of the corporation's ideology of "better living through chemistry" and scientific progress. The corporate garden merges the 1960s space machine *2001: A Space Odyssey*, with the ecological,

utopian dream of earth as a "garden," or sub-urban patio garden. Corporations were then able to deny the historical crisis, the ecological movement, and the movement's radical critique of the 1960s energy–wasting high technology.

CITY AS HISTORICAL MUSEUM

While the 1970s saw the birth of the interior, corporate park–atrium, American cities were also creating new outdoor plazas that empha-sized a continuity with the past. As part of the 1976 U.S. Bicentennial celebration, Washing-ton and Philadelphia rebuilt their city centers, emphasizing historical reconstruction.

Washington is a city metaphorically vi-sualized as a park, being partly based on the gardens of Versailles. Within its double network of orthogonal and radial roads of urban forest—nature made into an object of civic use—are fifteen public squares for the fifteen states of the Union.

Venturi, Rauch, and Scott Brown's 1978 plan for a new public square off Pennsylva-nia Avenue—a second, less complex plan was eventually executed (fig. 7)—consisted in part of a two–dimensional map of Pierre Charles L'Enfant's original plan of the City, which was to be inscribed on a marble court, as well as scale models of the White House and Capitol buildings, and a replica of the Mall, which like the original, was to be simply flat glass. The plaza was to be read as a miniature scale model of the city, which, in the context of the actual city surrounding it, would jux-tapose the original, historic, and ideal plan with the city's present reality. The map and the models would have aligned themselves to the local, rectilinear street grid. The idea was to accentuate the smaller scale's relation to the local neighborhood, the historic and tourist aspects of the city, and to restore the central axis of Pennsylvania Avenue.

The original plan was to have had two tall, thin pylons, which would have related to the present day, overblown scale of Washington, a deviation from its original neoclassical plan. Seen from a distance, the pylons would have appeared monumental, "purposefully abstract and simple," like other monuments of Wash-ington, but they also were meant to have been read as simple, linear framing devices.

The pylons, as abstract markers, were to appear to correct present–day Washington—reinstating the grid of the original plan—and then point to the nearby Treasury Building, block-ing the intended clear view along Pennsylvania

fig. 7
Western Plaza designed by Venturi, Rauch, and Scott Brown with landscape architect George Patton, Washington, D.C. (1980)

figs. 8, 9
Architectural model (top) and plan by Office for
Metropolitan Architecture for their proposed layout
of Parc de la Villette (1982)

Avenue from the White House to the Capitol.[19] In a manner similar to William Kent's eighteenth-century plan for Chiswick, in which the *allées* were terminated by smaller-scale versions of famous English architectural monuments, Venturi wanted to terminate his smaller-scale map with the actual monuments of Washington.

However, the plan with the pylons was not accepted. Venturi, Rauch, and Scott Brown's realized plaza is a flat plane, three-and-a-half inches above the existing sidewalk. L'Enfant's plan is inscribed on its marble surface. The grassy mall is represented by real grass. Numerous quotations from important architects, city planners, presidents, and other public figures about Washington, D.C., have been inscribed on it. Streets are represented by black marble against white marble ground. The Basin and Reflecting Pool, between the Jefferson Memorial and the Washington Memorial, is of black marble etched with lines signifying "waves." The waves can be "felt" through people's feet, scaled up to be an abstract reduction of the actual street plan that surrounds it and that it represents. The linear marks are incised into the sign one walks on. One "feels" with one's walking body, as a blind person's hands "read" Braille. Venturi describes the plaza as picturesque.

PARC DE LA VILLETTE

The plan for Paris's Parc de la Villette was conceived by the French Socialist Mitterand government in 1982, with the general intention of decentralizing cultural institutions. Traditionally, these institutions were placed, strategically, in the center of power—and Paris. Placed there, they were designed to uphold the symbolic power and cultural *élan* of France's cultural image.

A good example of this is the Centre Pompidou, conceived by the former Conservative government of Georges Pompidou. The museum was realized by razing a working-class area near the center of Paris. The result was the creation of a fashionable, futuristic, "high-tech" museum that housed modern "cutting-edge" art and design exhibitions.

By contrast, the original site of the Parc de la Villette is located on the northern margins of Paris. The site had contained a science museum with an adjacent mirror-domed Omnimax cinema—*La Géode*—which screened 360 degree-surround films dealing with nature and science themes.

The original idea was to reinvigorate the surrounding somewhat derelict, working-class and industrial slums. Initially, the area was designated for a planned, then cancelled, 1989 world's fair. Then these plans were modified to merge the existing science museum's educational function with a natural park with cultural, educational, and amusement-park-like features. The Parc de la Villette was something of a Socialist antidote to both the Centre Pompidou centralization of culture and to the outlaying suburban, seductive lure of Euro Disney.

The site, bisected by highways and working canals linking Paris to the industrial suburbs, was once the slaughterhouse district. Intended to offset the proliferation of corporate tower-slabs, this new park would also contain a new music center and various sports facilities. The competition for the design of this park was open to the international architectural world and received proposals from both well-established architects and more visionary figures, such as Cedric Price and Rem Koolhaas (figs. 8, 9). The driving intellectual force behind this utopic plan was Françoise Choay, France's leading urban theorist.

The initial competition brief suggested a park that would have:

> Educational facilities, such as a library; spaces for various kinds of exhibits, some permanent, such as: "an astro-numerical garden comprising a radio telescope, a sundial inspired by an Indian example, and an amateur observatory";..."workshops for production and creation," hosting "group music, photo, cinema, video, model-making...microcomputers, gardening." Sport facilities, such as: play areas, "thermal baths"... Social facilities, such as: a diversity of eating places from sophisticated restaurants to...picnic and party areas...A temporary market and permanent shops. Entertainment facilities, such as: outdoor theater and concert areas.[20]

The location of the park is significant. Located at the edge of both the city's fortification walls and its suburbs, Parc de la Villette's site is further emphasized by its visibility from the highway that encircles Paris and creates a second post-World War II boundary.

figs. 10, 11
Plan by Bernard Tschumi Architects (top) for Parc de la Villette, Paris (1982–98), and view of their completed design

fig. 12

Graham's *Octagon for Münster* (1987); two-way mirror, wood, and steel; 7 7/8 x 12 feet diameter; collection Westfälisches Landesmuseum für Kunst und Kulturgeschichte, Münster, Germany; installed in Münster, Germany

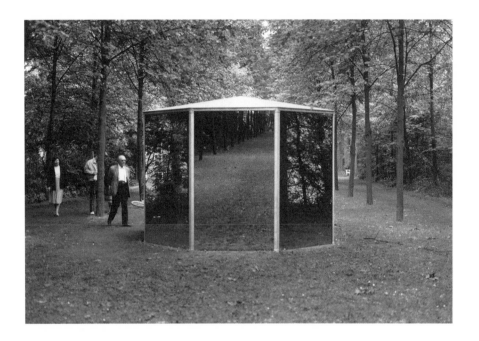

In the 1970s, modernist architecture and urban planning were replaced by an interest in historical restoration and typological models. The eighteenth-century ruling-prince's palace and its surrounding park was the site of Kassel, Germany's late-60s massive survey of modern art, Documenta.

By the early 80s, there was a proliferation of similar, large expositions of contemporary art in palaces and surrounding parks/gardens. Such massive educational attractions would take place during the summer tourist season, and both students and families with children would encamp to enjoy these spectacular art events. They were thematic in nature. Documenta, in typical German pedogological fashion, presented every succeeding version with a new, timely, socially relevant theme.

In 1977, the city of Münster, Germany, staged an extensive survey of modern sculpture in both its contemporary museum and in outdoor settings throughout the city. "Skulptur '77" was co-curated by the architecture historian Klaus Bussmann and the art guru Kasper König. Some early site-specific work was shown by contemporary artists, such as Donald Judd and Claes Oldenburg.

In the summer of 1987, a second exhibition by the same curators, "Skulptur Projekte," featuring new site-specific sculptures opened. Art lovers, many arriving in cars from nearby Holland, experienced the art and aided the local economy.

My project for this show, *Octagon for Münster* (1987, fig. 12), consists of eight two-way mirror side panels topped by a wooden roof sloping at an angle of about fifteen degrees. One of the panels is a sliding door, which allows spectators to enter the interior. A wooden pole in the center of the interior connects roof to floor. The work center of the interior space connects roof to floor. The work was sited in the middle of a tree-lined *allée* in the park surrounding the eighteenth-century palace of the ruling prince. With the exception of this *allée*, the original baroque design for this park had been converted to a picturesque English garden, which was later subdivided into a university botanical garden and a nineteenth-century-style public park. When the park was still classical, various pavilions surrounded the palace at regular intervals. At present only one, now a music kiosk, has survived. My *Octagon for Münster* faced the rear of the palace to the left, equivalent to the

The imposition of a pleasure park at the exact point where the city ends and the suburbs begin parallels the early twentieth-century pattern of situating amusement parks in industrial marshes, undeveloped beach fronts, or "dead" suburban land sites.

The winning scheme for the competition was that of the young Swiss-born architect Bernard Tschumi (figs. 10, 11). For me, Tschumi's plan represented the triumph of Parisian intellectual elitism over the Socialist-inspired desire for a new regionalism and educational populism—a mix of both

"high" and "low" cultural forms. Tschumi's scheme played on traditional French cultural ideas. First, there was reference to the aristocratic era's "follies." Second, he proposed various interdisciplinary collaborations. One pavilion was co-designed by the French philosopher Jacques Derrida, known for his "deconstructive" linguistic approach, and the "deconstructivist" American architect Peter Eisenman. Tschumi's strategy was not unlike a star-studded interdisciplinary academic conference. These "follies" replayed the traditional game of Parisian intellectual salon.

position of the music pavilion relative to the palace but on the right side.

While the octagonal form, its siting in the *allée*, and the use of mirrored surfaces related it to the classical baroque period, the use of wood, the "primitive" wood pole, and compact scale alternatively related the pavilion to the simple "rustic hut" associated with the romantic anti-urban ideology of the post-Enlightenment garden. The music pavilion, which is open on five of its sides, is something like a gazebo. My pavilion has a similar relation to a nineteenth-century gazebo, but contradicted this traditional form. Instead of the sides of my *Octagon* being open like the gazebo so that those inside might have the prospect of the natural setting and be better seen by those outside the pavilion, the use of the two-way mirror turns both inside and outside views into self-reflections.

The two-way mirror glass deliberately alludes to the modern bank and administrative buildings' façades in the surrounding city, while at the same time reflecting the arcadian parkscape.

For the public, from the outside the mirroring surfaces provide photo opportunities for parents with children. From inside it is a kaleidoscopic "fun-house" experience for the kids. The wood pole provides play moments for children rotating around it.

Meanwhile, in France during the 80s, the Socialist government as part of its strategy to decentralize French cultural institutions created a system of country-wide regional art associations, Fonds Régional d'Art Contemporain, based in various smaller cities as well as in old gardens and nature preserves. In summertime, families with children, traveling by auto, come to see art in the countryside, camping out in parks nearby. Art tourism and nature worship commingle.

In Brittany, there are two examples of art centers placed inside old chateaux or within its surrounding landscape garden. I worked on an unrealized project for the Domaine de Kerguéhennec in 1987.

TWO-WAY MIRROR BRIDGE AND TRIANGULAR PAVILION TO EXISTING MILL HOUSE

The Domaine de Kerguéhennec is a sculpture park and nature preserve in Brittany, France. It is based around a central chateau and originally was landscaped with a French formal garden, which was then converted to an English picturesque garden. It was relandscaped early in this century with the planting of many species

figs. 13, 14
Views of Graham's architectural model *Two-Way Mirror Bridge and Triangular Pavilion to Existing Mill House for Domaine de Kerguéhennec* (1987); two-way mirror, steel, aluminum frame, and landscape materials; 4 1/8 x 8 x 1 5/8 feet; courtesy the artist and Marian Goodman Gallery, New York and Paris

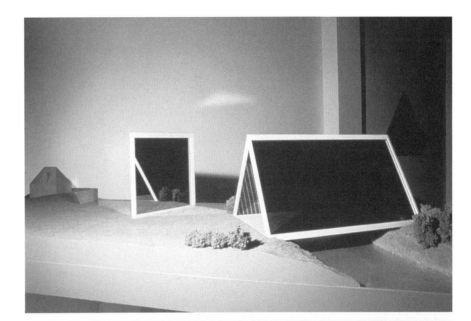

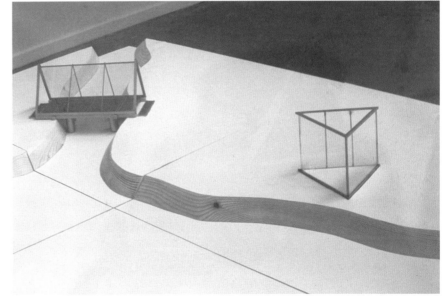

figs. 15, 16
Views of Graham's *Two-Way Mirror Pergola Bridge* (1988–90); two-way mirror, glass, steel, and aluminum; 9 $^7/_8$ x 11 $^1/_8$ x 14 $^1/_8$ feet; collection Fonds Régional d'Art Contemporain des Pays de la Loire, Nantes, France; installation in "Les grâces de la nature," Clisson, France, 1988

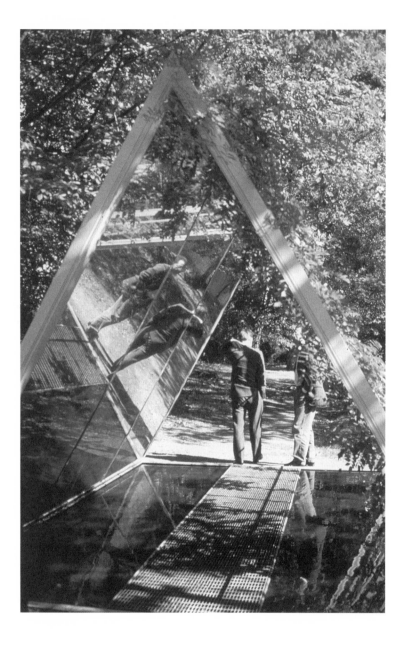

of forest trees and the enlargement of its main lake to become a nature preserve. Remnants of both the French geometrical garden and the English garden remain.

I had proposed for Kerguéhennec that two structures (figs. 13, 14) be built to create a "modern" "allegorical" "narrative" form derived from the reflection of the oversized triangular roof of the early nineteenth-century mill house (a survivor of the earlier English garden design of the park). That reflection on the lake is near an existing "Chinese garden style" wooden bridge traversing a small stream that runs into the lake. The bridge, in my plan, was to be replaced with a two-way-mirror covered bridge whose form was to be an equilateral triangular solid, enterable and useable by the public. The bottom of the triangle—the walkway surface—was to be steel grating with an open square grid, the same surface used for Paris street air vents over sewers and the Metro. Because of its openness, a spectator walking over the bridge could view reflections on the water's surface below; the water would reflect the sky from and through the surfaces of the two-way mirror overhead, as well as views of the spectator's body and the surrounding landscape. The effect would be prismatic (fig. 15).

In the distance from the bridge is the mill house. Toward the mill house, closer to the edge of the lake and about twenty meters from the entrance/exit to the bridge, would be built a second triangular solid pavilion in the form of an equilateral solid triangle. It would be two-way mirror glass on all sides, each side two-and-a-half-meters square. The roof would be clear glass. Its interior could be entered through a sliding door. Under most sun conditions a spectator inside the structure, with the door closed, could not be seen from the outside. It would appear, at first, as closed as the mill house from penetration. The reflection of the mill house would be seen several feet from the mirrored triangular pavilion reflected in the lake.

There is a relation between the pyramidal triangular form of the large roof of the mill house, the two triangles of the covered bridge, and the triangular pavilion. A path alongside the lake would connect the two objects, their optical/geometrical prospect and alignment varying as the spectator traverses this pathway. The intention was to construct a partial allegorical circuit along the lake.

Also in Brittany is Clisson, which is an island "theme-park" built in the eighteenth

century, surrounding a chateau on its garden grounds with replicas of Greek temples based on various Poussin paintings. Clisson was the creation of a French former painter–student of Poussin when both were based in Rome. After the French Revolution, he returned to France where he found some very cheap land and built his park.

My *Two-Way Mirror Pergola Bridge* from 1988–90 consists of a four-meter-long equilateral triangle bridge, one side two-way mirror glass, the opposite side an aluminum lattice planted with climbing vines. The spectator can walk through the triangle over a water canal across an open steel grid.

The reflective mirror glass and the water under the grid reflect on their surfaces the moving sky, water, and people's bodies. The two-way mirror glass's reflectiveness against its transparency continuously alters as the sunlight/cloud cover changes, as do the shadows created by the dappling of sunlight on the surrounding plants. The vines, near the time of sunset and approaching dusk, cast a projection of chiaroscuro-like shadows. The pergola form is a romantic feature in domestic gardens.

The piece is sometimes used for wedding ceremonies (fig. 16).

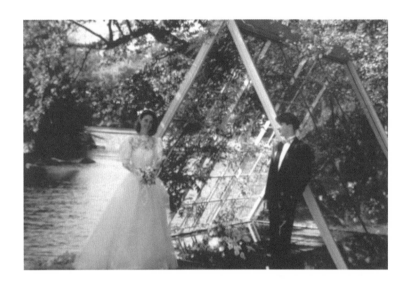

Notes

1. Rem Koolhaas, unpublished remarks from a videotape transcript of Koolhaas's speech at Southern California Institute of Architecture, March 1986.
2. John Raymond, quoted by John Dixon Hunt in *Garden and Grove* (Princeton, New Jersey: Princeton University Press, 1986), 6.
3. Taegio Bartolommeo, *La Villa* (published in Milan in 1559), translated and quoted by Margaretta J. Darnall and Mark S. Weill in "Il Sacro Bosco de Bomarzo," *Journal of Garden History* 1, no. 1 (1984): 8.
4. John Raymond, quoted by Hunt in *Garden and Grove*, 92.
5. Quintilian, "De Institutione Oratoria," quoted by Frances A. Yates in *The Art of Memory* (Penguin, 1966), 37–38.
6. Yates, *The Art of Memory*, 141.
7. John Macky, "Journey Through England, 1724," quoted by Hunt, *Garden and Grove*, 197.
8. Richard A. Etlin, *The Architecture of Death* (Cambridge, Massachusetts: The MIT Press, 1984), 189.
9. Joseph Heeley, quoted by Etlin, *The Architecture of Death*, 176.
10. *Jardins en France, 1760–1820* (Paris: Caisse Nationale des Monuments Historiques et des Sites, 1977), 77.
11. Ibid., 39.
12. Etlin, "Landscapes of Eternity," *Oppositions* 8 (spring 1977): 18.
13. Ibid., 19.
14. Ibid.
15. Louis Marin, *Disneyland: A Degenerate Utopia*, Glyph 1 (Baltimore, Maryland: Johns Hopkins University Press, 1977).
16. Ibid.
17. Ibid.
18. John Portman and Jonathan Barnett, *The Architect as Developer* (New York: McGraw-Hill Book Company, 1976).
19. Robert Venturi, "Learning the Right Lesson from Beaux-Arts," *Architectural Design* 49, no. 1 (1979): 31.
20. Françoise Choay, "Critique," *Princeton Journal of Thematic Studies in Architecture. Landscape* 2 (1985): 212.

Originally published in *Theatergarden Bestiarium: The Garden as Theater as Museum*, exh. cat. (Long Island City, New York: The Institute of Contemporary Art/P.S. 1 Museum; and Cambridge, Massachusetts: The MIT Press, 1990). Updated in 2008.

Signs (1981)
Dan Graham

Artistic representation is proclaimed (and enforced) as "pure" (profound) in the same process in which "propaganda"—previously an open *political rhetoric*—is...transformed into fetishized, irrationalist re-presentation centered...around commodities and fantasy figures.... The transformation of [the] older political discourse of bourgeois democracy of Europe into [the] new advertising discourse of Fascist/Democratic Europe/America...is centered in... Hollywood and Madison Avenue.... "Propaganda" [is placed]...on a more subjectified footing through...cinematic techniques with their links to experimental (and depth/dream) psychology.

—Jeff Wall, *Problems*[1]

A 1978 exhibition by Jenny Holzer at the Franklin Furnace in New York was juxtaposed with the appearance of Holzer's printed statements in variously sized posters on nearby public walls. "Street art" met "gallery art": statements identical (although often in different combinations and typographic sizes) to those on the gallery windows appeared anonymously throughout the neighborhood, where they were placed alongside other posters, graffiti, and other "street work." The exhibition itself was of large posters, each one filling a window that faced the street. Many of the posters survived in fragmented form, in some cases for months after the termination of the Furnace exhibition (figs. 1, 2).

Holzer's work used the common code of vernacular discourse, the written and spoken text, permitting it to be read by both the art public and by the general public. Rather than remaining detached, it engaged with other public language codes. The work, then, referred both to the spectator (who read it), and to *signs*, not necessarily those of art—political messages, miscellaneous posters or advertisements, comments superimposed on these printed messages (including, possibly, those written across the artwork itself), or adjacent, related street works by other artists. Holzer's wall posters remained on the same level as these other kinds of statements, but placed the assumptions of both in a kind of relief. Unlike the false homogeneity (the single, closed idea) of other, nearby wall posters. Holzer's statements, in their exposure of multiple contradictions, opened up a heterogeneous array of viewpoints to those reading other messages in the vicinity.

Some extracts from a Holzer poster:

PEOPLE WHO GO CRAZY ARE TOO SENSITIVE

PEOPLE WON'T BEHAVE IF THEY HAVE NOTHING TO LOSE

PLAYING IT SAFE CAN CAUSE A LOT OF DAMAGE

PRIVATE OWNERSHIP IS AN INVITATION TO DISASTER

ROMANTIC LOVE WAS INVENTED TO MANIPULATE WOMEN

SELFISHNESS IS THE MOST BASIC MOTIVATION

SEPARATISM IS THE WAY TO A NEW BEGINNING

SEX DIFFERENCES ARE HERE TO STAY

STARVATION IS NATURE'S WAY

STUPID PEOPLE SHOULDN'T BREED

TECHNOLOGY WILL MAKE OR BREAK US

THE FAMILY IS LIVING ON BORROWED TIME

THE LAND BELONGS TO NO ONE

TIMIDITY IS LAUGHABLE

TORTURE IS HORRIBLE AND EXCITING

TRADING A LIFE FOR A LIFE IS FAIR ENOUGH

Such statements place in contradiction certain ideological structures that are usually kept apart. They refer to beliefs that for many provide the underlying psychological basis for action. Members of the public reading these statements might at first agree with some, not agree with others—all the while wondering if they are to be taken seriously. They are hilariously funny. But later, in appraising them, the reader gradually becomes aware of contradictions, not only in the internal relationship among the statements on the poster, but also in the relationship of those statements to others in the surrounding environment. For, when the posters appear on public walls, the philosophical assumptions implicit in them pick up the underlying meaning of, or generate their contradictions from, assumptions found in public languages; at the same time, they subvert these assumptions and conventional meanings.

A Holzer poster is composed not of one message but of many diverse and contradictory messages, making a single interpretation by the spectator impossible. Unlike the political messages in the surrounding environment, Holzer's do not aim rhetorically at changing the reader into a believer, whose beliefs then would be merely embodied in the message. Most of the statements quoted (listed) by

Holzer seem ultimately "unviable"; statements a reader might, conceivably, agree with are placed in relation to totally untenable ones.

All statements are made to appear banal (not mystifying) and unsubstantiated. Unlike most "political" art, which a priori begins with a worked-out belief and then employs a methodology to prove it, Holzer's statements deconstruct *all* ideological (political) assumptions.

In 1970, and again in 1973, Daniel Buren placed conventionalized, vertically striped one-color posters on 140 advertising billboards in several stations of the Paris Metro (fig. 3). These posters are documented in the black-and-white photographs of Buren's two-part publication from 1973, *Legend I* and *II*. Each striped "sign" partially obscured a large billboard ad. The location of the works in 1973 was exactly the same as it had been in 1970. The earlier works consisted of blue-and-white striped paper positioned in the upper right part of the board, while those of 1973 were orange-and-white striped, and were positioned in the lower left corner. The only visible change that occurred in the three years between documentations (besides this positioning) was a change in the *types of advertisements*, which differed both in style (cultural signification) and in the types of products advertised. Ostensibly, we see a series of simple photo-documentations, made over three years, with Buren's neutral sign-as-artwork as the apparent raison d'être for the photo-documentation. But we also see startling changes in the cultural signification of the advertising images—changes that otherwise would have gone unnoticed. The architectural backdrops are seen to isolate both the neutral art signs and the advertising signs by framing the juxtaposition of the two. While the art refers only to itself and keeps a static meaning, the ads subtly change meaning when seen in various locations during the same time period, or when seen in the same station in 1970 and then in 1973. Buren uses the particular qualities of the photographic medium to bring out the "content" of the advertising system. Showing the *difference* between the ads of 1970 and the ads of three years later contradicts, or historicizes, the "timeless" quality that the mythology of advertising would like to project. Buren's art recedes, in order to call attention to the function of the ads as mythological sign. While Holzer's use of non-neutral vernacular signage is an implied critique of Buren's anonymous (and elitist)

IS NOT ALWAYS THE KINDEST
NTAL IS A SIGN OF LIFE
YOURSELF MEANS YOU'RE A
EBIRTH IS THE SAME AS ADM
ES YOU DO CRAZY THINGS
CONDUCIVE TO CREATIVITY
FEAR IS CALMING
UABLE BECAUSE IT LETS TH.

YOU HAVE TO MAKE THOUSANDS OF PRECISE AND RAPID MOVEMENTS TO PREPARE A MEAL. CHOPPING, STIRRING AND TURNING PREDOMINATE. AFTERWARDS, YOU STACK AND MAKE CIRCULAR CLEANING AND RINSING MOTIONS. SOME PEOPLE NEVER COOK BECAUSE THEY DON'T LIKE IT. SOME NEVER COOK BECAUSE THEY HAVE NOTHING TO EAT. FOR SOME, COOKING IS A ROUTINE, FOR OTHERS, AN ART.

fig. 4
"Objects and Logotypes: The Relationship between Minimal Art and Corporate Design" installed at The Renaissance Society at the University of Chicago, 1980

fig. 5
Trademark for Herman Miller, Inc., designed by George Nelson & Co. (1947)

art signs, Buren's work does not romantically idealize non–gallery street art—a possible weakness of Holzer's works.

Unlike Pop art, which was made to refer to the media world of signs and current representations, Minimal work was composed in terms of its material support—pointing to the limits of its structure. These limits were the physical art gallery and the system of art–gallery installations. Where Pop art had referred to art images in terms of common societal codes—signs on billboards, in ads, on TV—which were shared by design, "high art" and popular culture alike, Minimal art appeared to aspire to structural self–sufficiency, and thereby to be free of any symbolic content. In an essay accompanying the exhibition "Objects and Logotypes," which he organized in 1980 for the Renaissance Society at the University of Chicago, Buzz Spector suggests a connection between three–dimensional Minimal Art and two–dimensional corporate design of the 1960s in America[2] (fig. 4). Quoting Robert Morris, he sees Minimal art as referring to "manufactured objects" in its repeatability. Spector notes that Donald Judd's wall boxes keep a rigorously regular measure with respect to "voids between elements, proximity to corners or projecting architectural elements, and distance from boxes to floor.... These measures are three–dimensional contextual cues to the identity of the works—spaces characteristically 'Judd.'" These seemingly neutral, three–dimensional Minimal art forms can be related to two–dimensional corporate design. According to Spector, the typical graphic corporate trademark of the 60s was based on "similarly explicit measures between elements, even to the spacing between letters...Control of the space surrounding the logotype [trademark] becomes an active element of the total display." Corporate symbols are used on business cards, in ads, buildings and vehicles to build for the corporation's employees and for the public the corporate "image." A typical example is George Nelson's Herman Miller logo (fig. 5).

Similarly, some of John Knight's artworks have focused on exhibition posters and announcements as preliminary influences on spectators' perceptions of a show; in this sense, the qualities of a gallery's "image" would have as important a background influence on an exhibited work's "meaning" as would the architectural space. These two aspects—three dimensional design and

two-dimensional design—are conflated in Knight's exhibitions at California State College, Humboldt, in 1973 and at Nova Scotia College of Art and Design in Halifax in 1975. Both consisted only of posters which were intended to "give a 'complete' description of the space in the sense of an architectural phenomenon."[3] In a 1978 project *Journal Piece*, Knight sent magazine subscriptions to various residences that he knew of through social or architectural contacts. Here, two-dimensional graphic design became a part of three-dimensional interior design and influential patterns of interior life.

Two-dimensional design can be used to reflect corporate identity, social/political identity, and individual identity. Examples of graphic markers of individual identity (which often serve to correlate that identity to corporate or social/political interests) are personalized T-shirts, personal stationery and business cards, greeting cards, and the like. (T-shirts imprinted with logotypes are a good example of either corporate or social identities being used by *individuals* as a sign of individual identity.) These "personal" items mark an "individual" identity that is socially prescribed by convention and commercial systems of exchange.

Recently, such artists as Louise Lawler, Kim Gordon, Michael Asher, and Vikky Alexander have designed cards, interiors, and matches for individual clients. These "products" are neither part of commercial mass production nor designed for gallery exhibition and sale as art objects. They set up a peculiar and ambivalent relation between artist and client. A designer's professional relation to a client is more like that of a doctor or an interior decorator; the designer's goal is assumed to be that of improving the quality of the client's lifestyle (and, indeed, life) by redesigning an aspect of it. This activity is not, however, free of social convention, as the usual purpose of the improved "personal" design is to enhance the client's social status. Thus the kind of designer-client relationship that is constructed inherently questions values of both "design" and of art receivership, in psychological as well as social/esthetic terms.

Graffiti, too, uses a highly readable variant of the normal decorative-art code. But because the graffiti's author (artist) isn't classified as an artist, graffiti is not (considered to be) art. Graffiti begins as a mark of individual identity, a personal "signature"; when it is placed on public buildings, it modifies their

fig. 6
Frank Stella's *Guadalupe Island, Caracara* (1979); mixed media and metal; 7 7/8 x 10 1/8 x 1 1/2 feet; Tate Gallery, London

socially fixed meanings. Graffiti often seems to the public a negative sign of defacement; but for its writer, it means, in many cases, giving the surface a more meaningful public symbolism. Graffiti is one way subcultures express an alienated oppositional reaction to their environment. Ali, a New York subway graffiti writer, states: "Graffiti takes away the placenta and reminds people how violent the subway is. The real vandalism is what you'd see if you scraped the windows clean."[4]

"High art" has more recently taken its revenge upon graffiti by appropriating it into the system. "Debased" popular art's transformation into fine art is inseparably linked, it turns out, to the evolution of style. The art historian T. J. Clark has pointed out that, in the nineteenth century, "reference to popular art was, in...sublimated form...[a] source of delight to the connoisseur who "'recognized' it and praised the artist's transformation of his souces."[5]

Frank Stella's "Exotic Birds" paintings are prime examples of an artist's skillful elevation of a "debased" popular form—graffiti—into stylistic and formal innovation (fig. 6). But Stella's compositional game is more complex than it first appears, involving a self-conscious process of bringing the effects of fashion to the foreground. Graffiti has become

fashionable. Actually, by mimicking fashion, in the way that Andy Warhol mimics "show business," Stella raises some basic questions.

This work seems deliberately to accelerate the process whereby a popular art, initially perceived as "tasteless" or repulsive, becomes "high style"—initially through irony and later through transformation according to compositional devices (formalism). High art's economic reliance on fashionability, with its plays on good or bad taste, and the reliance of fashion (one which must be disguised) on popular forms, creates an uneasy tension between the formalist concerns of high art and its secret links with the "real" world. In Stella's paintings the uneasy juxtaposition of tasteless but chic imagery is used in the end, and paradoxically, as a device in the service of compositional formalism. Stella's strategy entails a suspended ambiguity. Unlike practitioners of Pop art, he doesn't base his images on duplication of popular imagery, and unlike those of Minimalist formalism, he doesn't adopt a (stylistically) purist stance. Instead, Stella elects to go for the two readings simultaneously.

Stella's strategy owes something to John Chamberlain's work, in particular his "smashed-automobile" sculptures. These sculptures are the end-product of a process in which formerly elegant cars, now turned to junk, are again transformed by the artist into the "elegance" of sculptural high-art objects. The art viewer is aware of the cultural irony here. There is esthetic irony, too, in Chamberlain's questioning of the effect of American mass-consumption on both vernacular taste and high-art esthetics, as well as social irony concerning the economics involved in the ethos of built-in obsolescence of both popular and fine-art objects and styles.

Stefan Eins's experiment at Fashion Moda, an alternative space he opened in New York's South Bronx (a media symbol for urban blight and devastation), involves the relationship between fashion in "high art" and in vernacular urban art produced by untrained, non-white ghetto artists. He had noted that younger "downtown" gallery artists were stylizing their work according to urban decorative codes that ranged from 14th Street tacky glitter to neo-primitive fake African. At the same time, many of these artists professed an interest in making their work political and accessible to the general public. Eins noted also that the "new museums"—alternative spaces—were being funded according to how well they met local community needs. But the community being served, for all of the many alternative spaces, was inevitably that of the SoHo elite. (Earlier, Eins himself had run a storefront space in SoHo.)

Fashion Moda exhibits an equal number of community-based and gallery artists. Since many of the South Bronx artists had been doing only graffiti paintings on subway cars before, this gallery afforded them their first opportunity to confront professional artists and artworks. Both groups exhibiting at Fashion Moda, the locals and the SoHo artists, have influenced each other's work. This tendency was taken a step further when Fashion Moda presented a typically "mixed" show, with work by *three* geographically separate groups of artists indistinguishably hung together in the New Museum. (The museum itself is located in an area in which different cultures meet—on the predominantly Puerto Rican shopping strip of 14th Street, but adjacent to the upper-middle-class academia of NYU/Parsons School of Design and the New School. The three groups shown were SoHo artists, South Bronx artists, and artists from New Orleans and Atlanta (who were not represented by the New York–based, gallery art establishment). Within this exhibition one interesting phenomenon was the proliferation of spray-painted murals which redefined (or re-created) styles as diverse as 40s decorative (derived from Kandinsky), Morris Louis's and Jackson Pollock's materialistic, all-over color painting, and Pop art—styles that are now (or always have been) part of the everyday urban environment.

The street is a contested zone. In American mainstream culture, it is the public interface between individual and corporate commercialism, and the people:

On Main Street, shop-window displays for pedestrians along the sidewalks and exterior signs, perpendicular to the street for motorists, dominate the scene.... It is the highway signs, through their cultural forms or pictorial silhouettes, their particular positions in space, their inflected shapes, and their graphic meanings, that identify and unify the megatexture. They make verbal and symbolic connections through space, communicating a complexity of meanings through

fig. 7
Venturi, Rauch, and Scott Brown's photomontage
proposal for City Edges (1976)

hundreds of associations in a few seconds from far away. Symbol dominates space. Architecture is not enough. Because the spatial relationships are made by symbols more than by forms, architecture defines very little.... The sign is more important than the architecture.... Sometimes the building is the sign.[6]

Robert Venturi uses the symbolism of the commercial sign as ironic reference in his own architecture by placing signs on stop of standard structures. Some of these signs relate to older architectural stereotypes—they play with the idea that the ornamentation of most architecture, from neoclassical to Beaux–Arts, alludes to an earlier architectural style and value system. Two examples are a project for a jazz club in Houston (1976), which is surmounted by a grandiose, three–dimensional, nineteenth-century ship, and the Hartwell Lake Regional Visitors Center (1978), in Hartwell Lake, South Carolina, the rural–cottage–style roof of which is topped by a scaled–down, three-dimensional medieval castle. In both projects, Venturi deliberately separates the publicly symbolic sign from the utilitarian structure. The signs use the same scale and communication codes as billboards do. They reduce three–dimensional reality to Disney (fantasy) scale, and enlarge two–dimensional typographic conventions to oversized publicness.

By incorporating commercial trademarks or symbols into a building's visual code, the architect can comment through the work on the commercial surroundings. Venturi's approach is dualistic; the competition between two different orders—the architectural and the commercial—is reflected in two different viewpoints. From a distance, perhaps viewed from the highway, a work fits into the commercial scale and code, whereas up close, the pedestrian's viewpoint reveals its architectural formalism.

Venturi proposed a series of road signs, called "City Edges," for use during 1976, the Bicentennial year, on the highway approaches to Philadelphia (fig. 7). In concept, they played off the standard modern design and

iconography of existing billboards and road signs. Venturi's signs represented food, buildings, art, and other subjects that typify contemporary or historic Philadelphia. Things to eat—for example, "HOAGIE" or "SOFT PRETZEL"—were depicted in both word and image; they echoed other roadside billboard ads for brand–name food products. These Pop art–like representations of food were contrasted with framed, billboard–scale re-productions of paintings from the Philadelphia Museum of Art. Below each painting were the addresses of the museum and of other art museums in the city. In one "WELCOME" sign, Benjamin Franklin gestured toward the auto rider, while striding atop a handscripted, eighteenth–century–style message that said, "To Penn's Greene Countrie Town." Across the road a commercial sign advertised the "COLONIAL MOTEL" using an identical hand-scripted typeface.

There are two ways in which the Venturi series could be read. First, signs could be read in relation to each other: modern food to famous paintings to colonial, historic buildings—the logic of the series not being manifested until all had been seen. Second, each Venturi "Bicentennial" sign was seen in relation to a comparable, extant commer-cial message—a typical food in relation to an ad for a commercial food, and so on. In one case an advertisement for a contemporary "colonial–style" house was shown in relation to a Bicentennial sign depicting an *actual*, his-torical colonial building.

Venturi's design for a science museum in Charlotte, North Carolina, returns its subject matter to its own geographic location. Just as modern artists such as Flavin or Buren wish to control the entire architectural environment, so architects have moved toward assum-ing total control, in their own right, designing more than the external shells of buildings. Venturi is interested here in representing (redesigning) the museum's conceptual re-lationship in place. In the Science Museum, the geography of the area is presented not only through displays inside the museum, but also outside, through an environment in which both the city and the spectator are located. The more sculptural depiction pro-vided by a geological map of a region is meant to contrast with the conventional maps found in typical museum displays. Venturi also has taken typical museum objects and displays out of the neutral setting of the building's in-terior and has placed them, instead, within the three–dimensional "real" context of its urban surroundings. Thus the city, and the museum as an artifact of urban culture, are contrasted to and placed back within the countryside that surrounds them.

In recent years these and other artists have increasingly blurred the line separat-ing private, "high–art" work from vernacular and corporate–commercial discourse. In all of this work, attention is focused on the sub-texts that underlie the visual rhetoric of both art and public signs.

Notes

1. Jeff Wall, *Problems* (Vancouver: Simon Fraser University, 1979).
2. Buzz Spector, *Objects and Logotypes: Relationships Between Minimalist Art and Corporate Design*, exh. cat. (Chicago: Renaissance Society at the University of Chicago, 1980).
3. John Knight, conversation with the author, 1979.
4. Ali, quoted in Richard Goldstein, "In Praise of Graffiti: The Fire Down Below," *Village Voice*, 24–30 December 1980.
5. T. J. Clark, *Image of the People* (London: Thames and Hudson, 1973).
6. Robert Venturi, Denise Scott Brown, and Steven Izenour, *Learning From Las Vegas* (Cambridge, Massachusetts: The MIT Press, 1972).

Text as first published in *Artforum* 19, no. 8 (April 1981): 38–43.

Transcript of the Second Performance of *Performer/Audience/Mirror* at Institute for Art and Urban Resources/ P.S. 1, New York (December 1977)

Dan Graham

STAGE 1

I'm sort of sliding around in place...umm... wearing a very bright carmine red shirt with one hand completely in the pocket, finger, thumb stuck out, the other thumb in the pocket, hand stuck out, knuckles kind of touching the edge of my pocket as I turn ro-tating on my right leg...uh, more so than the left arm; now it goes back; both, uh...actu-ally the, the right arm is just slightly akimbo, pressed back against the body as I rock back pivoting now and actually balancing on my... left...leg...my left foot, which is on the audi-ence's right side. Hands haven't changed, very subtly the foot is changing, the heel kind of peeps up...creeping up...creeping down as if peeping...peeping, at the audience...but it's not moving very much....The mouth speaks and now the head is rotated slightly toward the audience on the right side; it continues to rotate. The whole torso—actually it's not the head, it's the torso...but the feet are sta-tionary, they haven't moved an inch. Now the head goes up looking at the corner up near the lights toward the window at the back and going a little bit higher, uh...the shoulders haven't moved an inch. Now the head goes up looking a little bit...uh, there's a little bit of movement now as the knees become a tiny bit looser and the body now rocks back and forth in a stable position...feet slightly spread...

fig. 1
Graham performing *Performer/Audience/Mirror* (1977) at Institute for Art and Urban Resources/ P.S. 1, Long Island City, New York, 1977

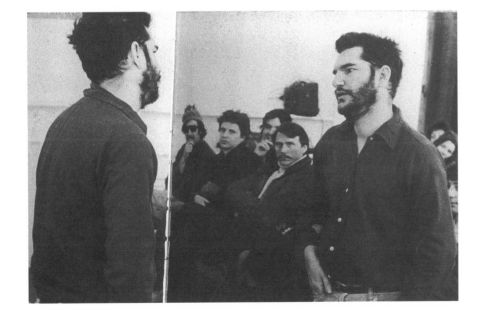

uh...a good center of balance...and perhaps slightly more relaxed. The head, which was looking straight up, now looks down...uh... at a spot on the floor, perhaps, or at the first chair and as this happens the knees now, now the whole bottom part of the body is bending towards the audience's left and almost losing its balance for a second...there was a stutter in the speech as the balance was almost lost, almost regained, but now moving again in that direction almost compulsively...repeating the same pattern as before. The hands haven't changed much, uh...except the knuckles aren't touching. Umm...maybe it's, uh, it's not a fist as much as it was before on the right side and, as this happens, as if to accent that, uh, there's a pivot on the right, uh, the right leg, the leg on the audience's left side, on the heel so it's now at right angles to the other foot, only now the head looks down looking at that formation...and there's a movement, uh, in that direction as if walking in that di-rection to the side of the room, which has commenced...and I'm walking...walking in that direction...to the side of the room off-stage; it stops at the word "stage," hesitates on the toe of the left foot, which is unbal-ancing the body as I can't stand properly, and now starting to walk backwards...with a kind of trembling, a kind of lack of balance and an attitude of, uh, hesitation...and there is a rocking on the knee, the knee on the side closest to the audience...rocking up and down and kind of puffing...maybe an impatience and slight anger...it might stop but it hasn't stopped and now the body rotates, uh, very slowly, deliberately looks at the audience; it's slightly moving now toward the room, though, as if pivoting again on the top of the torso. The feet staying stationary so there's a bisection between those two parts of the body, torso and the top; the head looks up again, staring above the audience...at, uh, a very bright, uh... lighted wall, uh, above, looking, uh, continuing, it's as if once movement begins it's, it's like a tripod, it keeps just going higher and higher, pivoting, panning back, looks down, slight eye contact with the audience for a second, and now the body pivots in the other direction... on the audience's right...the foot on the, uh... inside. Now the foot on the on the audience's right side now is at right angles and the head is looking at the foot but there's no movement this time...a kind of rocking back and forth...uh, the hands haven't moved at all...and, umm... now looking directly at the audience...

STAGE 2

The audience is looking down, particularly the audience in the front row looking down toward my feet...no...not much eye contact...uh, the eye contact, uh, is now more established in the middle than in the front rows and in the back rows the audience is less distracted than it was, umm...a few seconds ago. Umm...there is a kind of eye blink, umm...by a number of people, uh...the eyes make contact, blink, go down, umm...the people seem a little bit, uh... uh, they're a little bit startled, umm...umm... the expression is now that some people are frowning as if disagreeing with that, puckering at the edges, uh, the very edges of, of, the, uh, of the lips. Umm...now...a couple of people move their head or shake their head, uh...which is a head movement instead of an eye movement...and there's a little bit of lip movement. There's been no sound...there's only a tiny snicker in the front row, but no one else; now everyone is snickering, but not the same way; it's kind of an acknowledgment snicker, um...saying you agree with, uh... um...now there's much more blinking and much more coquettish kind of attitude in the blink rather than just a kind of distancing— not trying to look. And people smile a little bit, slightly smirking, slightly smiling, somewhere between the two of these; these, uh, tend to be people in the center, uh, which is where I'm looking...um, uh, not people in the front. Umm...everyone...uh, other people now touching their bodies scratching themselves or moving a little bit in position (I say everybody, I don't mean that, I mean about half of the people in one...tends to be people that I'm looking at that, uh, move this way, other people I'm looking at I catch aren't)...someone's parting their hair; someone looks back... um...now the difference between the people in the back is, is they seem much more stone-faced about the whole thing...they're hiding, they're hiding in the back...they're either very serious or they don't want to be seen. Umm... people in front, um, seem to be staring slightly down not looking up, uh, well, uh, they're, uh, now they're looking up...I guess it's rather hard for them to see me on an eye contact basis. It's the people in the center that, uh, are the focus of my attention. And now it's funny, all the people seem very disparate with what they're doing, not that they're moving much but they're taking separate poses, kind of defining their individual selves as statues posing, uh...now everybody smiles at that; uh, the smiles are not...of a uniform type...uh, people

now are not...no, they're—some people are making eye contact; a lot of people shifted... and there's a kind of laughter...uh, a laughing and looking away, uh...uh...a number of people....

STAGE 3

I'm looking at myself and my face looks almost as red as the shirt I'm wearing. As I look back and I'm scratching at the acned face—as I look at that, the eyes are red too, the rims of the eyes, uh, the face is rather round, umm, the shirt is open in a kind of triangle and my hands are in my pockets, one thumb in the pocket... uh...on one side and the hands in the pocket with the thumb sticking out on the other side. The feet are kind of, one foot is forward in a very angular way from the other, umm...a very dynamic pose although there's no motion... um...involved in it...and now a kind of violent shrug of the shoulder, uh...rather aggressive, and a rocking so that the other hand is akimbo; it goes back and forth; the other hand doesn't move, umm...and then the feet kind of kick each other, kick around the place...a kind of hop, skip, and jump: a semi-dance... it's hard to know what that signifies; it's much more aggressive as I move onto that foot...it is a kind of dance pattern trying to communicate something, and then a shuffle...and...I'm looking down again and, uh, from the side, uh, not much more information uh, about the... except the shoulders seem even more, um, hunched, uh; but as I do that I shake my, umm, arms, somewhat loosening them up, and now they're out of the pocket and I'm making a fist and the fist goes up in a pugilistic, uh, boxing sense and I hit the mirror for a second, look down, look up, uh, the eyes, uh, they look a little bit deadpan, umm, the lip, the lower lip is a little bit loose, it could be a half pout...uh... um...it's tired; it looks tired, somewhat tired... the eyes look somewhat tired, um...I also see wrinkles around the edges, the edges, the corners of the eyes, as I look. But the face is very dead, very deadpan, very straightforward, very unexpressive, except perhaps for the lips as I talk...um...it seems like the upper lip is more aggressive, umm...umm...goes up...and now I'm moving the arms akimbo as if I might communicate something, perhaps contradicting that last message; again, hard to know what that means precisely, uh...I'll try to guess...umm...perhaps it is some kind of disagreement; and now I just spread my legs totally, so that cuts off movement, uh...as the legs are very far apart; it creates a center

of balance; the head is down; I'm not even looking at myself; it goes up as I do, I detect a smile or a semi-smile, just the beginning of one, and, uh...the expression, it's a little more light-hearted, and now [*much laughter in the background*]...and now you can see my teeth...[*more laughter*] and also the smile... and that [*more laughter*] takes away from the redness and, uh, it's a kind of humorous, humorous gesture...

STAGE 4

As I'm looking at the audience back here the audience seems, uh...mildly amused...uh, all the audience...uh...and there they got their heads, uh, hanging, ostensibly just to look at my eyes, which is very hard for them to see—they're actually just seeing my back.... Uh, but they're craning themselves in order to do that so they look a little bit more angular. Umm...it's like, reversed...collectively, they seem much more similar...rather than individual, and they all seem content, umm...they seem fairly, umm...content...and they laugh with a sound for the first time...licking the tops of their lips some of them, well, uh...different people have different ways of expressing this, but the faces are not as symmetrical; it's not a kind of, "I'm O.K." smile, more, uh, relaxed, um, than previously; I also see, um, the eyes are much more alive than they were previously and there's less of them blinking, umm, perhaps because I'm not looking directly at them. Let's move around here...um...now this side of the audience...which is, um, now on my left side, which is the audience's left side, umm...well, a moment ago they were smiling, now they're very serious. Umm...and now there's a half smile that comes up to a full smile in the case of a couple of people... umm...and now I see two people in the third row and then a woman who wouldn't smile if nobody else did—that's where my eyes were directed at the time—which was strange... and everyone else was not...um, people in the back, in the back row, are dead [*much laughter*]; either their head and faces, uh, have, uh, have a beard which hides them or glasses or a kind of professional look, uh; the same could be said of the people standing in that position—of course, when I said that, that was not true, but they all, uh—well, the person with a beard has a camera and is taking pictures; they're all trying to disguise their expressions in various ways...it's very different from the people in the middle who—where I look—who seem much more natural in a funny way. The people in front are just looking up because they're very low, um, kind of like footlights. I'm looking at the other side now; I see peoples' heads quite askew, um, in different ways; I think they're trying to catch my eyes, um... from here it looks like they probably do from where, from where they are and their heads kind of move but they're not looking at me as they move their head. Umm, people are... people...um, on that side they're um, um... How can I do that?...I have to define them as being different from the people on the other side, I guess; I guess I can't, uh, really, at this point, except that they seem to be, uh, able to look at, at my eyes so that they're looking at me from a much more angular view and, um, testing that, uh, situation. Further back, um...............[*laughter*] everybody laughs... umm...and as they laugh...um, they move their heads and it's a much more animated laugh than before.... It's funny, people, a few people have touched their body with their, uh, um, hands, but most people haven't...there's very little body movement; a, uh, a lot of head movement...eye movement, but very little body movement. Uh, a few people are clutching their hands together. In fact, everybody in the first row seems to have that posture. Now the people in the second row, um, seem to be holding, um, their body together; rather than clutching their hands they're clutching their body, uh; a lot of people in the second row are doing that. In the third row, well, it's impossible to see, but I think that it also seems to be true; it seems to be rather uniform, that situation in the piece. Umm...some people in the back row are moving, sort of, sort of shaking their heads, but maybe because I'm not concentrating on them they feel they can do that. Uh...many yawns, uh, about half the yawns in the front row, uh, people in the second row are very amused as as a whole group [*laughter*], uh...on the left side quite amused [*some laughter*].

STAGE 5, STAGE 1 REPEATED

Now as I pick up the stride, and deliberately scuff the floor as I move from one side to the other, my hands are very loose at my sides...I'm twiddling my fingers somewhat, a little bit like a kind of monkey, uh, pose as I walk back, certainly much more relaxed than before as I scratch my head, walking to the side, not even looking at the audience, just making a corridor, uh, walking back across from one side to the other, um...somewhat, uh, very...loose, somewhat, and, uh, somewhat

slower than I normally walk and when I do that I kind of twist on my hips, uh...as if I'm, uh, at a party and I want to dance, um, but I can't really do it [*laughter*], and, uh, now I put my hands out in front and they're almost prayer–like...I guess that's what that represents, umm...gesture bringing the hands up and down, up and down, I'm looking at my hands as I do it and now the hands go down to the side; they're very loose, almost too loose... uh...almost artificial; when they do I kick with my right foot on the audience's left, and now I bring my knee up so I'm balancing on the other foot, which creates a kind of playful, um, pose, perhaps I could fall.... Um...and I look up...I look up for a second for a confirmation from the audience, um, now the foot goes down... um, but it's still a little—...here seems to be a little unsteadiness, um, involved. And now suddenly there's a decisive gesture...the feet are splitting apart and, um, a kind of clutching one ear, the ear on the audience's, uh, right side...umm...and scratching it, taking the wax out of it, looking at my finger [*some laughter*], uh, looking—now I'm looking up at the audience—the audience, um, has made some reaction, uh, I look over the audience, now I look down at my body; it's as if I'm checking out parts of my body, semi–aware of the audience and semi–not aware of the audience. At one point I, um, well, this actually continues because I'm looking at a fingernail on my, uh, left hand—audience's right side—um, seeing that they're dirty, um, quite dirty, um, and while I've done that the finger, the thumb has gone back inside the pocket on the right of my side. Hands now, instead of clutching against the corduroy pants, are actually, the fingers are actually outward as if they were about to take off, and I take it out of the pocket and look at it for a second...now a very decisive move to the side....For the first time that I turn around and make a fist, scratch the ear again and, um, look at the audience, and I look at the audience.

STAGE 6, REPEATING STAGE 2

As the audience, uh, has just completed, uh, very individual gestures, uh, coughing, uh, things that have nothing to do with reflecting what I'm doing, umm...and now they're, umm...um...gradually coming around to look at me. It's funny...now some are very serious...a little sad...and some are very happy...umm, I guess that's the way people are: they're either one way or the other...um...so maybe they're acting more natural and this amuses some people and it doesn't amuse other people. Umm...I'm looking for, um, the hand, things that I noticed before....I'd say that the people in the front row haven't changed at all; they're generally clutching, uh, their hands together, uh, but not their body, and some people in the second row have loosened up their hands and they're not clutching their body; other people are, uh, that's true of the people in the third row, uh, and, uh, and I can see it's probably less true of the people in the fourth row who are more natural with their hands, and now they have a semi–yawn and, umm...um...a loose smile at that; it's a time for some people to yawn and loosen up their heads a little bit at this moment, and look away for the first time; I'm losing some people's attention, umm...which has a little bit to do with physical tiredness; now some people are actually communicating rather than responding, that is, they're moving their face or their lips, uh, as if they're actually looking at me directly to say something individually; um, people are much more individual and it's become a little closer to a dialogue, um, I see more yawns; it's as if it's given people permission to express that, um...um, that feeling that some people must have...um...the people who are standing in the back and probably not seeing the mirror seem, uh, really to be quite serious...um, extremely serious.........Uh, um, the people in front are not looking at me, they're looking at the mirror and probably at themselves or the other bodies [*inaudible*]...uh...more people yawn...someone's parting his hair; other people look away...people express something with an aside...an asymmetrical gesture with the sides of their mouths, which, uh, I take to be, uh, uh...through its lack of symmetry a kind of, um, loss of interest. Now everyone... people are leaving and other people shuffling, uh, shuffling into position...um...

STAGE 7, REPEATING STAGE 3

I looked very strange for a second, lips are together, um, looking down...hands in the pocket...pockets, a kind of exaggeration, seriousness, bewildered humor at the same time...uh...again the stance is half aggressive...with the feet bending, bending with front torso forward in the way the feet are splayed in that kind of asymmetrical fashion as if about to move, when the arms are akimbo but because the head is down, um, and the shoulders somewhat up and I just moved them up again to emphasize that, uh...there's a kind of timidity or fear, and

now they go back and relax and the opposite happens, um, there is a kind of confidence… and, um, semi-grin is more of a [inaudible] and also a little bit of frustration and a little bit of relaxation and now a little bit more serious expression emerges. It's very hard, uh, the changes in expression are so rapid it's hard to even see them, and as I do this I'm again moving—straddling to the side slightly, um, balancing on one foot and raising the other foot up, up to the toe and then rotating. A very stiff, strange kind of gesture, uh…um… sort of more a dance gesture. The hands are different from the last time in that the, um, two hands, both fingers are in the pockets; the two thumbs are out, uh….My body is basically symmetrical, which it hasn't been in a long time. Just as I do that, uh…I kind of make a gesture with one shoulder to make it asymmetrical a little bit…but because the arms are a little akimbo (the entire body spreads out a bit). What this means probably is that, um, uh, the performance has settled into a kind of balance…um…situation. Um…maybe I have a more balanced view of myself. Uh…maybe I don't because I just kicked the cinder block which indicates a very great level, uh…is that humorous or what? [laughter—especially loud from one woman]

STAGE 8, REPEATING STAGE 4

Now the audience is…is, uh, is actually laughing, uh, pretty loudly…uh, horsey laughs, and, as I say that, everyone kind of lets their laughs and their heads go…[inaudible] impersonating their looks as if to de-emphasize the fact that they even did that. Um, of course, some laugh and some don't…they're very aware of me. Their mouths are open; people's mouths are a little bit more open and talking, uh…that means they're probably more, um, relaxed again, uh…it's funny, now people are amused but in a different way, some look at me and some look the other way…that is, they're listening. Uh…as I said that everyone's eye goes back to look at me sometimes very sneakily, which is odd because their bodies are asymmetrical; they may be looking one direction, uh, pointing the body in one direction and looking in the other direction. Um…it's very hard to get people in the very back, uh…they seem to be more attentive than before, um…well…they're more relaxed; they're less serious, but they're also very uninvolved, um…in different ways, either, um, chewing or looking to the side… um…. Again, it's quite hard for me to see this, um…it's more of a guess than anything. Also,

the people in the direct middle, um, it's difficult, um…to see it, but as a group they're quite serious at the moment now; of course, everyone seems a little serious…it's as if I'm about to make a philosophical point, which I'm not… um…they're expecting that and, as I say that, everyone laughs again a very relaxed laugh, um…and, um…people are nervously moving their hands a tiny bit, um…but it's as if there's a kind of semi-communication, where they're smoking, they're, they loosen up their hands a little more than before, and, as I say that, one of the persons in the front row moves his hands together, clutches them, had his hands, uh…normally clutched, unclutched, and then he clutches them again, um…um, more people scratching just as I say that, scratching their face…some people looking away, uh…um…also tension…some blinking… umm…someone deliberately trying to get my attention, um…in a theatrical way, uh…uh… that's like, well…people broadly smiling in the area that they normally have been, which is like the third row…second, third row are the most active ones, um [laughter], and they now look at each other nodding as if they're collectively [laughter] aware of this fact, um [much laughter], as a group [laughter]. Umm…this, by the way, is on the left side…my left side…their left side…our left side…um… now we got some action in the fourth row, too [loud laughter], as well as the third row, for the first time…um…I must say that it's the left side that's the, um, people who seem to like it better…appreciate me more…though I don't see any humor in this piece, um…uh…. These remarks affect more one than the other side…'cause I'm looking in that direction…that may be a constant tendency…uh, seeing what happens on the other side…now the more serious people, uh, it's hard to make judgments but, uh, some of them are the ones that are not—are—they're not really laughing; the others haven't really changed…ummm… too much.

STAGE 9, REPEATING STAGE 1

Well…I'm looking down after looking up for a second and I just moved forward with one foot…. As if scratching in place…uh…the body is kind of rigid, the arms are akimbo as they have been all along, as I move directly in on the audience, um; I'm stopping in front of the audience, and, um, kneeling on a chair for a second, shaking a little bit, going back, um; I'm making a semi-fist; there seems to be a kind of semi-aggressive attitude but I don't

know whether it's more toward myself or toward the audience—it's always aborted. Um...there's, um, a tiny bit of kicking and, um, a sort of semi-kick.... It's funny how the feet are now splayed apart. They're always asymmetrical, as if the audience, as if I deliberately want to unbalance myself; but I don't move; I'm stationary; I don't move in one direction or other, I'm in the center, uh...this is where I tend to station myself during the performance.... Now I'm turning, um, and actually kind of looking at the direction of the audience on, on the audience's left side, and, as I do this...do that, I do something I did last time but different, raising my hands, they're together, they're at right angles to my body and, uh, now the fingers are pointed directly at the audience and, uh, it's as if it's a calisthenic gesture; now I bring the arms apart and down again, uh, and then relax them. What this signifies, um, I don't know. Maybe because it's I'm in school, P.S. 1, that's uh, that's why this is happening.... It's a little bit like, uh...gym class or something...although all these things are aborted and now there's a kind of rocking, uh, on the hip, back and forth in place. The feet again are, uh, akimbo, I guess that's the rather...it's about...it's as if I'm about to move very suddenly but I don't do it. Um...and then they freeze...and there's some bending of the knees, which causes both balance and lack of balance, and now I try to correct the balance... and just, [sound] just snapped my two fingers together [again, the sound of fingers snapping], did that again...rocking back and forth; it's that kind of semi-parting, um, gesture but, um, it doesn't really mean that much. Now I go back a little bit again...backing up a kind of hop, semi-trot...O.K...thanks [applause]... [applause continues loudly].

This text was written at the time of the work's first performance, which took place at De Appel, Amsterdam, June 1977. It was followed by a second performance at P.S. 1, New York, December 1977, and a third at Riverside Studios, London, March 1979. The text was first published in Anton Herbert, ed., *Dan Graham: Théâtre* (Ghent, Belgium: De Appel, 1982), n.p. This version appeared in Graham, *Two-Way Mirror Power: Selected Writings by Dan Graham on His Art*, ed. Alexander Alberro (Cambridge, Massachusetts: The MIT Press, 1999), 125–35.

Art as Design/ Design as Art (1986)

Dan Graham

For the private person, living space becomes, for the first time, antithetical to the place of work. The former is constituted by the interior; the office is its complement. The private person who squares his accounts with reality in his office demands that the interior be maintained in his illusions.

—Walter Benjamin, "Paris, Capital of the Nineteenth Century"

I. OLDENBURG

Claes Oldenburg first exhibited his *Bedroom Ensemble* (fig. 1) at the Sidney Janis Gallery in New York in 1964. Built during an extended stay in Los Angeles, the work was a kitschy modern-home-furnishing suite. As Oldenburg later described it, "The suite consisted of a bed covered by a quilted black vinyl bedspread and white vinyl sheets: A synthetic 'zebra-skin' couch with a fake leopard-skin coat placed on top of it; a bureau with a large metal 'mirror' and imitation marble lampshades. The walls are textile with black embossed patterns decorated with a pseudo Jackson Pollock silk-screened 'painting.'"[1]

The painting reference is deliberately ironic, as Pop art was taking Pollock's random-ized automation of the production of images to the factory, where cheap representa-tional and "modern" abstract images were produced without the "heroic" effort of the Abstract Expressionist. And, unlike Pollock's paintings (despite their relative frame), these factory-produced images affected millions of anonymous consciousnesses as they became part of the modern home.

The viewer was presented with a series of rhomboidal parallelograms, as if in three-quarters profile. The furniture appeared to "project in all directions... [half] three-dimensional realization and... [half] two-dimensional representation..."

Oldenburg wanted to abstract a "manu-factured object...made by conventional industrial procedure."[2] But the manufactured look he achieved is not solely an objective simulacrum; it is anthropomorphized in the same terms used by the industry to manufac-ture the collective subjective "tastes" of the mass-consuming individuals. Don Judd noted how the production of the consumer's sub-jectivity was present in the Oldenburg object itself: "The emotive form [of an Oldenburg] is equated to the man-made object...Nothing made is completely objective...changing—as if melting and sliding in time."[3]

The issue of the art gallery as business office, on the one hand, and on the other hand as a mock-up of the private interior where the art, when purchased, will be located, is also raised by Oldenburg's *Bedroom Ensemble*. The work was specifically designed to foreground the presence of the gallery that contained it as a *modern office space*. The work, Olden-burg noted, "had to have the...presence of the front room of the Sidney Janis Gallery: what was already there...the air conditioner, the blinds that shut out the light, and the myste-rious door marked *private*."[4]

The bizarre arbitrariness of the ensemble as modern bedroom design brings into per-spective the oddness and ambiguity of the modern art gallery interior—half showroom and half business office. The pseudo-Pollock

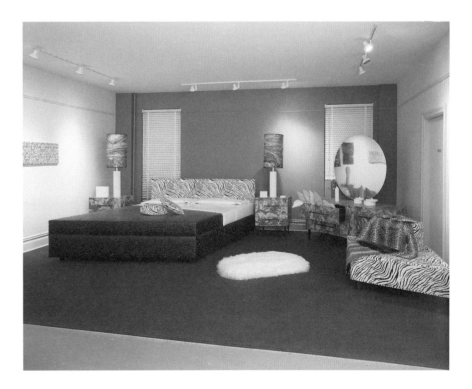

fig. 1
Claes Oldenburg's *Bedroom Ensemble* (1963/95); wood, vinyl, metal, fake fur, muslin, Dacron, polyurethane foam, and lacquer; 10 x 17 x 21 feet; Whitney Museum of American Art, New York; gift of The American Contemporary Art Foundation Inc., Leonard A. Lauder, President

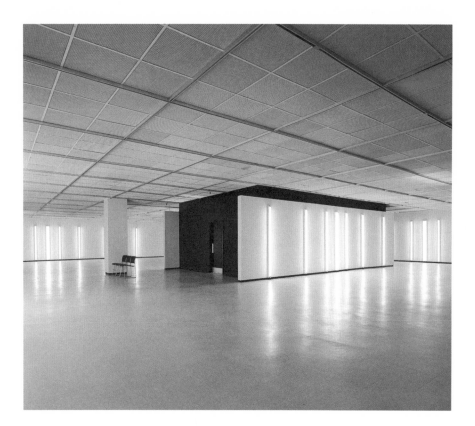

fig. 2
"Dan Flavin: Alternating Pink and Gold" installed at the
Museum of Contemporary Art, Chicago, 1967

painting makes this connection humorously evident—for the same wall might support a *real* Pollock in the gallery's next exhibition.

II. FLAVIN

Oldenburg's (and other Pop artists') reduction of fine art to quasifunctional (or nonfunctional) décor appears also in the early work of Minimal artist Dan Flavin. Flavin wrote in 1966, "I believe that art is shedding its vaunted mystery for a common sense of keenly realized decoration."[5]

While American Pop art of the early to mid-60s referred to the surrounding media world for a framework, Minimal art of the mid- to late 60s would seem to refer to the gallery itself. Both the gallery, as architectural container, and the work seen inside it were meant to be seen as nonillusionistic, neutral, and objectively factual—that is, simply as material. The gallery literally functioned as the art. The lighting—even light fixtures within the architectural setting of the gallery—is normally regarded or considered merely functional or as minor interior decoration. As gallery space is meant to appear neutral, the lighting, which creates this neutrality as much as the white walls, and at the same time is used to highlight and center attention on the artwork on the wall or floor, is kept inconspicuous. While the background in general makes the artwork visible, the lighting *literally* makes the works visible. The lighting system, within which the specific light fixtures of a gallery arrangement function, is both part of the gallery apparatus and part of the larger, existing (nonart) system of electric lighting in general use.

Fluorescent light fixtures are *replaceable* in a number of senses. First, they can be placed in conjunction with other architectural features, other functional fluorescents, or other artworks in any specific room exhibition. Second, they are replaceable separately from their fixtures (in the sense of having a limited existence). Third, upon termination, the components of a particular Flavin exhibition are replaced in another situation, perhaps put to a nonart use as part of a different future.

Flavin's works take on meaning by being placed in relation to other works of art or specific architectural features in an exhibition space (fig. 2). Systematically, Flavin has investigated this gallery architecture by placing his arrangements of fluorescent tubes: (a) on the wall in either vertical, horizontal, or diagonal bands; (b) in the corners of the room; (c) on the floor; (d) relative to exterior

light sources (near windows, open doors); (e) partially visible/partially invisible, behind columns, architectural supports, or in niches; (f) in the hallway before the spectator enters the gallery (thus altering the spectator's perception when he enters the gallery to view the work); or (g) in an antechamber to the gallery/museum itself.

The fluorescent-lighting illumination plays across the surfaces of other paintings or sculptures creating shadows or highlights that disturb their illusionary planes, undercutting (and so revealing) the latent illusionism employed in their construction. Similarly, the space in which the spectator stands is highlighted and dramatized. The effect is both neoconstructivist and neoexpressionist. In one early installation, the use of all green tubes bathed the interior space in a lurid green glow. When the viewer turned to the window to look outside, the sky had an afterimage, garishly colored in the complementary of green, lavender-purple. This effect could be read ironically as reversed illusionism or, literally, as (physical) light, and, hence, the opposite of the illusionary illumination emanating from the other artworks on display in the gallery.

In addition to gallery installations, Flavin has used fluorescent light in several permanent installations for public sites outside of the gallery. For example, Flavin used fluorescent lighting on two adjacent tracks and platforms in Grand Central Station. There the lighting modifies the public space and throws into relief the existing, archaic tungsten illumination on the other tracks.

III. VENTURI AND RAUCH

Venturi and Rauch's use of neon light for design, symbolic meaning, and functional use in the 1968 restoration of Saint Francis de Sales Church in Philadelphia is similar to Flavin's use of fluorescent lighting (fig. 3). The newly introduced liturgical practice of the Catholic church required a freestanding altar to replace the traditional one against the wall. Instead of destroying the old sanctuary, Venturi and Rauch left it as it was and installed an electric cathode light tube (since removed) suspended on a wire, ten feet high, parallel to the ground, and just above the eye level of the seated parishioners. The electric line defined an ellipsoidal semicircle inflected inward, following the perspective of the parishioners' line of sight, as well as the line of the old altar. It ran from just behind the new altar following the curve of the apse behind it, to define a boundary that separated the old rear altar from the new altar whose activities its light functionally illuminated. Here the light tube served only as sign (replacing nothing), a two-dimensional, graphic indicator, drawing a (mental) line through the old altar (thus leaving it in relative darkness) without physically destroying it. It literally illuminated and delineated the new area and so juxtaposed the old and the new, placing them in a historical or archeological relation to each other.

fig. 3
Renovation by Venturi and Rauch of the Church of St. Francis de Sales, Philadelphia (1968, renovations later removed)

figs. 4, 5
figs. 4, 5
Views of "Andy Warhol: Wallpaper and Silver Clouds," installed at Leo Castelli Gallery, New York, 1966

fig. 6
John Chamberlain's *Couch* (1971); urethane foam; 3 1/8 x 6 3/8 x 25 1/2 feet; location unknown

IV. WARHOL

In the spring of 1966, Andy Warhol presented two environments at the Leo Castelli Gallery. One room consisted of wallpapered walls with the repeated motif of a large cow's head in fluorescent pink on a yellow ground. In the other room was a nightclub–like environment of floating, helium–inflated, silver pillowlike forms (figs. 4, 5). Their slickly metallic covers connoted a new–style disco where they might have served as cushions. They had a curious passivity, floating aimlessly, but totally affected by the boundaries of the space and the air currents created by human circulation in the space. Their outer skin was plastic and brittle, but their "cloudlike" shape and behavior was soft and resilient. Because of their occupancy of much of the eye–level space normally the domain of the spectator's gaze, the silver forms produced a subjective sensation of floating "in" the space for the spectator. They had a kinaesthetic and physical body sensation; viewing them was different from taking the merely visual, traditional position of the spectator's ego observing art.

V.

The decorative arts, by historical definition…directed primarily at the upper–middle–class home, expressly protected by the rights of the (private) elitism in liberal, constitutional ideology, could "freely" elaborate (fashionable) themes. But their freedom was constrained, defined and organized not only by the style ("public" regulation) of flow of the social (political) fashionable market itself, but by the (political) struggle within the bourgeois couple which is the engine of fashion.

—Jeff Wall[6]

Furniture is…like sculpture which is always added to the human figure…In a chair there's a kind of tension; the suggestion of the human figure that sets it up.

—Robert Venturi[7]

A chair or couch can be seen as an object identified with the space into which it is placed, or it can be viewed subjectively as the site of an experience with tactile and inter–subjective connotations (two or more people on a couch); people sit on it. An ensemble of

furniture in a room forms a kind of stage set for the conventions of social exchange in groups. In a private setting, it helps to define the experience of "the personal." It also expresses to others the subjective taste or lifestyle of its owner. Domestic furniture creates, in Walter Benjamin's words, a "phantasmagoria of the 'private' interior"—often in juxtaposition to the owner's public image or role.

VI. CHAMBERLAIN

In late 60s, John Chamberlain's work shifted from his earlier sculptures of crushed and discarded automobile bodies to raw foam-rubber sculptures. He began experimenting with forming the foam into "design" chairs or couches. These were impermanent; their new, extruded, immaculately white surfaces would dry up, turn yellow, and eventually crust off. They could either be read as soft sculptures or used as chairs; Chamberlain seemed to be taking a step further Oldenburg's soft, anthropomorphic common household items (represented visually by psychological, anthropomorphic sculptural forms). With Chamberlain's chairs, people could actually sit on the work and experience the effect physiologically within their body, on/as the skin of their body.

These soft sofas were, in a sense, a logical extension of Chamberlain's smashed-automobile sculptures. The earlier sculptures were the end product of a process in which formerly elegant cars, now turned to junk, were again transformed by the artist into the "elegance" of sculptural, high-art objects. The art viewer was aware of the cultural and aesthetic irony in Chamberlain's questioning of the effect of mass consumption on both vernacular taste and high-art aesthetics. There was also a certain social irony concerning the economics involved in the ethos of built-in obsolescence for both popular and fine art objects and styles.

Foam rubber is an artificially produced material with structural characteristics that enable it both to support the human body firmly and to have a soft quality. The couches reflect the topological nature of the human body subjectively experienced, that is, the body's permeability to other bodies. Foam rubber has a humanlike feel. As it is usually used for the underpinning of mattresses and chairs, couches, or beds, it is rarely experienced as a visible surface; rather it is experienced purely as tactile cool/warm by the body surfaces and internal musculature. Chamberlain molded the exposed foam rubber forms into free-form chairs and couches. They referred to modern high-fashion furniture.

In Chamberlain's chairs and couches (fig. 6), the user/spectator does not gaze at an object or representation outside of him- or herself, but sits to experience the softness of the material support as part of his or her body which, in turn, itself changes the sculptural form (as it adapts to their contours and movements). By using it, the buyer or user also helps contribute to its disintegration (aiding the change in the material). Like drug experiences, the spectator experiences him- or herself floating "in" space.

For Chamberlain's retrospective exhibition at the Guggenheim Museum in 1971, a very large, raw foam-rubber couch was placed on the ground-floor lobby. Its scooped-out seats permitted several people or more to rest. Other works of Chamberlain's were exhibited on the Guggenheim's continuously spiraling walls. These walls formed a Möbius strip or helix. When the spectator faced away from the walls and turned toward the empty center of the museum, he faced a void—a vortex of negative space. Frank Lloyd Wright, architect of the Guggenheim, meant for it to be an inversion of the normal Cartesian, gravity-bound, rectilinear cube of the conventional gallery. The building set up a desire to disregard the art on the walls and to look into the vertiginous nullity of the museum's empty center.

The people resting on Chamberlain's lobby couch were subject to the gaze of the spectators above. But when a spectator was actually sitting on the couch, its softness was experienced in terms of their own body warmth in relation to the warmth or coolness of the material and to the position, subtle movements, and warmth/coolness of the other seated bodies on the couch. Again, as in drug experiences, the spectators experience a subjective "melting" and a "floating" of their bodies. For the spectator sitting on the couch, the hardness and "objectivity" and linear time engendered during the walk along the museum's spiral that chronicled the history of Chamberlain's art disappeared; there was a change from object observed or conceptualized as object or design concept into a subjective biophysiological sensation.

As a conceptual comment on the design process in modern functionalist design, Chamberlain takes the logic of functional design one step further in its reduction to structural support as exposed surfaces.

Rather, like Dan Flavin's exposed fluorescent light tubes and fixtures, Chamberlain's couches, in their use of disintegrating foam, strip the functionalist chair of its superficial stylization to expose the material base that the functionalist chair's surface veneer covers. Thus modern design and furniture are reduced to their (industrially produced) *unseen*, *real* material support. The neoclassicism of functional design is disputed by exposing the reality of the actual structure underneath the cushioning that disintegrates. Even functionally designed chairs are designed to wear out, being part of the modern capitalist economy of built-in obsolescence.

In 1981, Chamberlain used the entrance lobby of the "Westkunst" exhibition organized by Kasper König in Cologne for a new work. This was a large, room-filling, raw foam-rubber couch with television monitors at either end. Joining television to the couch resembled the pay-TV sets attached to chairs in waiting rooms of American bus and air terminals. These monitors showed a continuous program of American television commercials. At first glance, the work seemed "all-American"— showing the "good life" of the "American Dream." This initial impression became ironic when the viewer recognized that each of the TV commercials was an unusable outtake from commercials that had been done over and broadcast. Each "blooper" or bad take revealed, unconsciously, the ideological conventions that determine the advertising industry's artificially constructed version of the American consumer's "dream."

VII. VENTURI

Venturi's design for Knoll's New York showroom in 1979 (fig. 7) consisted of a subtle rearrangement of chairs, modified wall and floor covering, and a complex mixture of illumination to set up a deliberate ambiguity between the functions of the contemporary showroom/office space. One enters the Knoll showroom at the first-floor level via an elevator. A stairway leads to an upper floor. On the right, on the first floor, is a small section for textile products; near the elevator entrance to the left center, blocking the immediate view of the showroom beyond, is a three-foot-high stage, which displays classic Knoll chairs. The base of the stage is carpeted in a dark green, this color mirroring the sides of the first floor's wall color. The stage is lighted from overhead by spotlights and from below by fluorescent tubes embedded in the front of the stage. This places a kind of sheen on the objects, at the same time creating for the spectator an "alienation effect." The small stage area works something like a display window, announcing the company's best-known goods. On the right side, the textile division's products are symbolically showcased by a dramatic display that Venturi calls a "cascade of fabric." A multi-colored circular drapery hangs from the second floor to the first floor, falling down through an ellipsoidal cutout. Glamorously spotlit, the effect is like a fountain or an illuminated waterfall. The display is visible equally well from the first and second floors or as one walks up or down the stairway. The "fountain" of drapery contradicts the classicism and "objectivist" ideology of the Knoll modernist-style chairs.

Drapery alludes to the personal and to a sense of domestic comfort. Drapery emerged in the paintings of the sixteenth century, initially as a backdrop to the human figure. Bunched-up cloth was placed behind nude figures in paintings of this time in order to signify the subjects' "spirituality" (they were often religious figures), in opposition to the secular fleshiness of the body. In a distorted, reversed way, this reflected the new role textiles were taking on in the emerging bourgeois society; cloth had become an economic staple, a symbol of new wealth attained through the manufacturing process (equaling as a status symbol the importance attached to gold and fine glass).

A question that might be raised about Venturi's showroom renovation is whether the furniture displayed is to be related directly to the architectural space in which it is placed, or whether it exists historically or semiotically apart from it:

> Modern architecture worked with an idiom of spareness: white walls, great clarity of expression, and spaces that didn't have clutter. In fact, this [the Knoll showroom] is a rather cluttered space and the walls are not white; they are an ambiguous color. So...we are putting these classic objects in a slightly "off" context, but only slightly off. What [this]... represent[s] is putting familiar objects in a slightly unfamiliar setting.[8]

In the Knoll showroom, Venturi uses the color of the wall paint to question the design objects' meaning in relation to the architectural container (in a manner similar to the 1926 demonstration rooms of El Lissitzky).[9] On both floors, the walls are painted in two hues of green; the top is light green, the bottom a dark green. The color changes just above eye level; the two hues are separated by a black line of wainscoting. The black line is continued to mark Venturi's new fluted columns (which cover existing structural columns). The columns start their radical curve about a foot below the ceiling, at the level of wainscoting. The black line on the convex column creates illusionistic tension as to whether it is flat or attached to the three-dimensional column.

The baseboard moldings are a mixture of genuine marble and ordinary black rubber, although their color and hardness are quite similar. The "elegant" marble relates to high-level office suites, while the cheaper rubber appliqué suggests more ordinary office interiors or apartment interiors. Upon closer observation, ironically, the marble reveals itself to be simply "tacked on"—just as much cheap appliqué as the rubber. The use of line and border to define architectural parameters is used by Venturi in order to rethink modernist architectural suppositions. As Venturi has said about his use of both in the Knoll showroom, "The line is a constant; it is a stable element, a contrast to all these changing objects. Borders interest me: the border was defeated by the Modernist aesthetic. [This design] brings back the idea of border."[10]

fig. 8
Remodel by Venturi, Rauch, and Scott Brown of INA
Capital Management Offices, Philadelphia (1977)

fig. 9
John Knight's *Journal Piece* (1976) installed in 74th
American Exhibition, Art Institute of Chicago, 1982

fig. 8
Remodel by Venturi, Rauch, and Scott Brown of INA
Capital Management Offices, Philadelphia (1977)

fig. 9
John Knight's *Journal Piece* (1976) installed in 74th
American Exhibition, Art Institute of Chicago, 1982

The Knoll showroom design can be compared with Venturi's earlier (1977) redesign of Capital Management's Philadelphia office suite (fig. 8). No architectural modifications were involved. Venturi employed three elements, juxtaposing three period styles of furniture: nineteenth-century Chippendale; 30s Art Deco; and conventional, efficient, modern office furniture. The effect seemed comfortable and bourgeois on the surface, but on a deeper level it yielded ambiguous meanings. While it may not be uncommon for two types of furnishings—normal office equipment and a decorative historical overlay, connoting "hominess"—to be present in modern office decor, Venturi's use of *three* irreconcilable levels in this case created a paradox. For instance, which style, the Chippendale or the Deco, truly reflected this cultivated businessman's taste? And, if one or both of these "retro" styles reflected his own taste, which one was to be found in his home? Was one of the two earlier styles, then, the imposition of his decorator and one his own, or were they both artificial interventions?

Whereas two elements—the contemporary and the particular historical period selected—reflect a normal private choice, the housing of more than one historical period of furniture turns the office space into a museum, a museum in which comparisons between periods are inevitably made. Normally, the museum is distinct and not related to office décor and corporate displays of art.[11] In the Capital Management office, more than one period of furnishing was displayed. This suggested that the spectator should look to the container itself as a third historical style— as if it might be a clue to placing the earlier styles in context. This also raised certain museological questions. If the 30s Deco chairs related, as a classical predecessor, to the functional modern décor now in use in the office display spaces, did the presence of the 30s artifacts imply a subtle criticism of the current degeneration of this style into corporate modern?

The office suite and the Knoll showroom are both quasi-museum containers exhibiting artifacts slightly out of their original historical context: "You can put the object in a context which contrasts with its historical context, or in one that is analogous. For instance, if you have a Louis XV chair, you can put it in a Louis XV room and install a whole setup with the eighteenth-century furniture, or you can put it in a white room on a pedestal, four feet up

from the ground, with spotlights on it. What we wanted to do [in the Knoll showroom] was to combine those two approaches."[12] The historical modernism of the Knoll chairs is de-contextualized by the hybrid bourgeois home/office Venturi-designed exhibition space.

VIII. KNIGHT

Artist John Knight's *Journal Piece* (1976) (fig. 9) is concerned with the unsolicited mailing (without prior knowledge by the recipients) of gift subscriptions to popular middle-class magazines to the homes of nearly a hundred people. The work continues through the present period. The people and their homes are known to the artist. There is a deliberate attempt to match, contract, or subtly influence these recipients' lifestyles or domestic habits and tastes through the selection of a particular magazine as a "gift." Some of the periodicals mailed were *Sports Illustrated* (to this writer), *Popular Mechanics*, *Us*, *Arizona Highways*, *New West*, and *Better Homes and Gardens*.

Mid-to-late-60s Conceptual art dealt with design in a number of ways. For instance, On Kawara's mailed postcard series I Got Up, begun in 1968, involved picture postcards with commercially produced views showing where Kawara was staying. Kawara rubber-stamped on each card the exact time when he woke up and mailed a small number of cards to a selected list of people—each received a daily sequence of cards.

In relation to *Journal Piece*, Knight notes that the magazine is a "collected object which becomes quasi-precious for two reasons: first, it is received as an 'artwork' from the artist, and second, 'well-made,' nicely designed magazines become objects which are held onto and collected for a period of time before being disposed of or placed in the storage room. Their covers are made to fit into the décor of a conventional house environment, an environment which a number of these magazines already deal with as content (for instance, *Metropolitan Home* or *Better Homes and Gardens*). It is an artwork that can take up space in the architecture which is not possible for the conventional art work to occupy—the bathroom, the garage, for instance. It uses the interior-design aspects of the architecture which already has a coffee table, magazine rack, or bedside table."[13]

Knight's work, by foregrounding the obtrusiveness of the penetration of the private sphere of home life by the subliminal design package, adopts a distanced, philosophical-ethical view of this phenomenon. This is unlike the currently popular position of Jean Baudrillard, which sees everything as a simulation in which "the slightest details of our behavior are ruled by neutralized, indifferent, equivalent signs...a simulacrum which dominates [everything]."[14]

Magazines are "designed as packages, which, due to their visuals...habitually change a person's life-schedule." "The *Journal Piece*," notes Knight, is itself "as fascist in intention as the periodical is designed, in its 'normal' sense, to be....[Magazines are] objects which are 'prefabricated'" and common parts of the environment in a semiological sense. They are designed in such a way that they can't be thrown away. Instead of being a 'readymade,' the receiver has to deal with its [written/pictorial] content."[15] In a sense, magazines—especially their covers—are subliminally planted in the home (like the pods in Don Siegel's 1956 film *Invasion of the Body Snatchers*), where they implant "new design ideas" that are purchasable in the form of commodities by the millions of magazine readers.

The November 1983 issue of the glossy, coffee-table periodical *The World of Interiors* features a photo-essay titled "Kunsthaus" on a successful German artist's home. The large caption reads: "The interior of Karlheinz Scherer's German home is subjected to the same discipline as his painting, a constant reducing and stripping away, to leave only the bare essentials. Under the circumstances, it is not surprising that *it has itself become a work of art*...The environment he has created inside the old house corresponds with and modifies his paintings." Here a magazine spread, which is meant to convince the readers that in redesigning their own house they can be creating a work of art on a par with a famous German artist, is *also* creating a market for the paintings of Mr. Scherer within beautifully designed homes like his. But it is not only artworks that are contextually validated by being reproduced in glossy magazines within "designed interiors," but architecture itself, which is now designed to be photographed and reproduced in lush, *Architectural Design*-style magazines. Just as the cover and the glossy color pages of slick magazines are meant to be part of and to fit into the interior design/furnishings of their readers, so the architecture—seen first in photo form (two-dimensionalizations of "real" architectonic space)—often plays off its dual

existence as a form to be viewed on site *as well as reproduced in a magazine*. The new architecture, influenced by its potential re-producibility, seems to shift interchangeably between two- and three-dimensionality. Such architecture, in its "cardboard" qualities, foregrounds the idea that any architectonic, three-dimensional form can be (hypothetically) constructed from perspective or that any three-dimensional product can be constructed from an arbitrary logic, such as that used in computer-generated, hyperspace video graphics.

What is radically new in John Knight's *Journal Piece* is its contextualization (only) *within the private, domestic interior of the stereotypical house*, connoting artificial luxury and aesthetic tastefulness.

Notes

1. Claes Oldenburg, "Statement on Bedroom Suite," published by the National Gallery of Canada.
2. Ibid.
3. Don Judd, review, Oldenburg exhibition, *Arts Magazine* (September 1964).
4. Oldenburg, "Statement on *Bedroom Suite*."
5. Dan Flavin, "Some Remarks...Excerpts from a Spleenish Journal," *Artforum* 5, no. 4 (December 1966): 27.
6. Jeff Wall, "problems," unpublished notes, 1983.
7. Robert Venturi, interviewed by Andrew MacNair in "Venturi and the Classic Modern Tradition," *Skyline* 2, no. 8 (March 1980): 4.
8. Ibid.
9. El Lissitzky describes his 1926 International Art Exhibition, Dresden, exhibition room: "I placed thin wood strips (7 cm deep), spaced at intervals of 7 cm, against the wall surface. These slats were painted white on the left side and black on the right side, while the wall itself was painted gray, thus the wall is perceived as white from the left, black from the right, and gray when viewed from the front. Accordingly, and depending on the position of the viewer, the paintings appear against a black, white, or gray background— they have been given a triple life." See Lissitzky, *Russia: An Architecture for World Revolution*, trans. Eric Dluhosch (Cambridge, Massachusetts: The MIT Press, 1970), 150. As the paintings displayed were largely gray, black, and white, Lissitzky here foregrounded the question of the gallery as ultimate picture frame—calling attention to painting *and* exhibition architecture as radical and publicly manipulatable design.
10. Venturi, *Skyline*, 5.
11. Today, corporate offices often employ an art consultant to buy and arrange displays of acquired artwork. And recently, several corporations, such as IBM in its New York headquarters, have incorporated museums open to the public.
12. Venturi, *Skyline*, 4.
13. John Knight, in conversation with the author.
14. Jean Baudrillard, "The Precession of Simulacra," in *Art After Modernism: Rethinking Representation*, ed. Brian Wallis (New York: The New Museum of Contemporary Art; and Boston: David R. Godine, 1984), 275.
15. Knight, in conversation with the author.

First published as "Kunst also Design/Design als Kunst," *Museumjournaal* (Otterloo, The Netherlands), nos. 3–4 (1986), 183–95; and in French as "Design comme art/Art comme design," *Des Arts* (Rennes, France), no. 5 (winter 1986–87). This English version appeared in Graham, *Rock My Religion: Writings and Art Projects, 1965–1990*, ed. Brian Wallis (Cambridge, Massachusetts: The MIT Press, 1993), 208–21.

A Conversation between Dan Graham and Nicolás Guagnini

New York, New York
14 May 2006

Dan Graham: Today is Mother's Day, which is a very sacred day in America. I want to dedicate this talk to Nicolás Guagnini's mother. She's a psychotherapist, and she actually thinks she's got it all figured out psychologically. Nicolás thinks he's got it all figured out artistically. [*Laughs.*]

Nicolás Guagnini: So, before we get into talking about your mother, which is relevant to the issue at hand, I'd like to dedicate this lecture to the mothers at Orchard Gallery. We're ten members of a limited liability corporation, fifty percent of them women; three mothers among them. Moyra [Davey], who edited a mother's reader; Becky [Quaytman]; and, of course, Karin [Schneider], the mother of my boy and my wife and partner. So, I'm very proud that as a gallery that we're able to support both experimental artistic practices and the nuclear family. [*Laughs.*] The nuclear family is a lot better than what we think it is. It is, in fact, a productive unit. So Dan, as I understand, you were part of a nuclear family, and your mother was an assistant to Kurt Lewin.

DG: Correct. She studied under Kurt Lewin, who is a German Jewish psychologist. She actually was his babysitter and student. He did very important work using topological diagrams based on [Albert] Einstein's field theory. His diagrams were a very huge influence on Jacques Lacan I think, who widely read German publications.

NG: The first publication in English was in 1936, *Principles of Topological Psychology*, for those who want to read the book. So, you didn't come to Kurt Lewin through your mother?

DG: No, I actually had the book but I didn't really read it but looked at the drawings. Of course in the 60s, we were all very interested in issues of topology. [Werner] Heisenberg's uncertainty principle was also very important. It had an influence on my *Schema (March 1966)* [1966–67] piece. We didn't know Lygia Clark or [Friederick] Kiesler in the early 60s, who were working with topology. I thought that Buckminster Fuller was kind of an engineer and rather boring. But we had people who were very interested in topology. The Möbius strip was a very important mathematical metaphor and a model for all that art.

NG: Let's then rewind to 1964, you had a gallery, John Daniels Gallery, that was for a year.

DG: Less than a year.

NG: Less than a year. Your mother helped you out, right?

DG: My parents put in a little bit of money, and I had two friends who wanted to have a gallery for

My idea was to go right back and to put things in printed matter into magazines as magazine pages. They would be disposable.

My gallery failed, it was a total failure, we sold nothing. So, I wanted to destroy galleries. That was my idea at the time.

vanity reasons. I didn't have a job. I was actually somebody who was kind of a dropout. I didn't go to art school or college, but I read a lot of magazines like *Esquire*. In *Esquire* you could read that galleries were where it's at. [*Laughs.*] They were fascinating places. What I really wanted to do was to write. And when I had my gallery, the first show I did was actually for Christmas, and we invited everybody who came into the gallery to show, absolutely everybody was in the show. In other words, a Christmas present to all the artists who didn't have galleries. I got very close to Sol LeWitt because his favorite writer was Michel Butor, who wrote *Passing Time*. It was about the city plans of cities like Manchester in England. It also had a huge influence on Aldo Rossi. Sol actually had worked for magazines as a designer. His background was architecture. We started talking and actually everybody we knew, like Donald Judd, wanted to be a writer. [Dan] Flavin wanted to be James Joyce. We were all writing for magazines, so I was interested in this idea of artist/writers. I got into art because in the 60s you could do anything and call it art, and you didn't really have to have critics. There were no critics at all. There were just writers who worked for magazines for money. Judd did reviews for thirty-five dollars. I did a number of group shows at the gallery. One was called "Plastics," in which we had an early Donald Judd. But Flavin had the biggest influence on me. He put a piece on the floor, fluorescent tubes, and somebody had broken it, stepped on it, and it had exploded. He liked that idea. He said, after the show was over, things should go back to the hardware store.

NG: I have here a text of yours, "My Works for Magazine Pages." In one paragraph you basically made the shift from what you interpret to be the step forward that Flavin does after [Marcel] Duchamp and how magazines come into that.

DG: I'm sorry, we hated Duchamp.

NG: It's quite clear here. [*Laughs.*]

DG: Flavin comes directly from Russian Constructivism, from [Vladimir] Tatlin. He tried to combine Tatlin and [Albert] Speer. We loved Speer at that time.

NG: So, I need somebody that actually speaks English, unlike me. John [Miller]? Would you read this little paragraph loudly?

John Miller: This top one?

NG: Yeah.

JM: "Through the actual experience of running a gallery, I learned that if a work of art wasn't written about and reproduced in a magazine, it would have difficulty attaining the status of art. It seemed that in order to be defined as having value, that is, as art, a work had only to be exhibited in a gallery and then to be written about and reproduced as a photograph in an art magazine. Then this record of the no-longer-extant installation, along with more accretions of information after the fact, became the basis for its fame, and to a large extent, its economic value."

NG: Okay, so basically you shift from the experience of having the gallery to the importance of magazines and why you focus on magazines, how the magazines feed into the construction of value.

DG: Not to be academic about it, but I think the mid-60s was magazine culture. I really liked *Esquire*, which had writing and also photographs by famous photographers, often about the suburbs. I had a hero. I'm Jewish, like Nicolás; us Jewish artists loved Roy Lichtenstein. Sol LeWitt loved Lichtenstein. Lichtenstein said he wanted to destroy value by putting junk printed matter onto canvases. It didn't work. They became valuable. My idea was to go right back and to put things in printed matter into magazines as magazine pages. They would be disposable. They would also be both about the magazine system as well as art criticism, at the same time. I wanted to create a kind of Lichtenstein by putting *Side Effects/Common Drugs* [1966] directly into a magazine like *Ladies' Home Journal*. At that time the Rolling Stones were attacked because people said they were drug users. They counterattacked with a song, "Mother's Little Helper." They wanted to show that housewives also used drugs. [*Laughs.*]

NG: The song talks about little yellow pills, like over-the-counter stuff, to my recollection. Before we get into *Side Effects/Common Drugs*, let's talk a little bit about *Figurative*, which is from '65 and is your first magazine piece.

DG: Not published until '68.

NG: Okay, so you actually published the other ones before.

DG: *Homes of America* [1966-67] was probably the first published thing, then *Schema* in *Aspen* magazine just after that. I jokingly called my first piece *Figurative*. I didn't want that to be the real title, I used that as just a handle and it was given to a friend of Robert Smithson, a poetry editor at *Harper's Bazaar*, and he put it in with that title as kind of concrete poetry.

NG: *Harper's Bazaar* published poetry?

DG: Yes.

NG: Okay, that's shocking, another piece of information about the 60s. So that would be within the layout of the magazine, where normally a poem could be?

DG: It was placed in relationship to advertising. I thought magazines were always involved with getting you excited to buy something. So I wanted to contradict that. I wanted to show what happened after you bought something: you got a cash receipt. I just wanted to show the cash receipt, but it wouldn't add up to anything. So I cut out the sum at the end and I wanted just to put it directly in a magazine. In other words, I wanted to put a hole in the system of magazines. Also, this was a time when people were trying to do work that was without metaphor. So, I wanted to do something that was called *Figurative*, but it was only about figures, in other words, numbers, *very* Sol LeWitt. It didn't add up to anything.

NG: So you did mean it to be concrete. Why is that then that you reproduced the cash receipt photographically as opposed to displaying pure information?

DG: That was a mistake. I just wanted to put it in print, but the editor did it that way. The great thing is in this issue of *Harper's Bazaar*, on one side there was a Tampax advertisement, and on the other side was an advertisement with a woman in her bra for Warner's bras and it says that "What nature doesn't Warner's will." [*Laughs.*]

NG: The thing about this piece is that it looks like content, because it does have a title and an author, so it wasn't an ad as you portray it. More like concrete poetry…. Well, good that you mentioned again concrete poetry. It doesn't add up. It doesn't have a top or a bottom. The de-hierarchical possibility of reading from top to bottom, left to right, right to left, etc., is a characteristic of concrete poetry.

DG: To be really honest, I didn't know anything about poetry. I discovered [Stéphane] Mallarmé much later. My real interest was magazine pages themselves. We were all very influenced by Jean-Luc Godard. His early work, films like *Two or Three Things I Know About Her*, were like magazine essays. I think it was a vibrant magazine culture. In fact, later I earned my living writing for rock-and-roll magazines, about rock music.

NG: So, let's go then to *Side Effects/Common Drugs*. You talk about this piece in relation to Lichtenstein and obviously we have the dots…

DG: Well, it was also Larry Poons, remember Op art? You had contrast, you saw dots in front of you. I thought of putting this as a page in a women's magazine based on "Mother's Little Helper." You take one drug as an antidepressant, then it causes anxiety so then you have to take a tranquilizer to combat it, and so on—and you have all these side effects of common drugs adding up. What I was interested in, because I was a structuralist at the time, was the idea of the diagrammatic grid, like in [Claude] Lévi-Strauss, where you have a horizontal and vertical reading. But then it takes place in time, even though it seems instantaneous. When you see it at first, it's like a Larry Poons Op painting. I wanted to make art; there were no canvases, but instead it was in a magazine and disposable. In fact, I never actually published it, so it didn't work out, but it was my homage to Lichtenstein, in many ways. As you know, they also call this Conceptual art. My interest was not in the idea of philosophy, but in the idea of anarchistic humor. I met On Kawara, and I thought his work was about existentialist humor. Stanley Brouwn was also a big influence. My friend Kasper König did a book on Stanley Brouwn. I think Fluxus contains this idea of anarchistic humor. I was also very influenced by rock, by songs like the Kinks' song "Mr. Pleasant," about the suburbs. I wanted a very short form, like a pop song, which you can see and then dispose with. And also, the great thing about magazines is that every issue had a theme, so it related to all the other things in that magazine. And then after the month was over it was thrown away, disposable. My gallery failed, it was a total failure, we sold nothing. So, I wanted to destroy galleries. That was my idea at the time. I'm afraid I had an aggressive and very bitter point of view at that time. [*Laughs.*]

NG: I see that your affiliation with anarchistic humor was coming via Fluxus towards Stanley Brouwn and On Kawara. And I always see that your work has, inevitably, a connection with American popular culture. And whether you think it's academic Marxism or not, there's always a poignant critique of capitalism. You take a pill that forces you to take another pill, to take another pill, to take another pill, and you have a denouncing of the chemical industry right there.

DG: The Rolling Stones had an album called *Sympathy for the Devil*. I was never into devil worship. I didn't go that far. Of course, we hippies—I was a fellow-traveler hippie—didn't like the new Left. We hated the political correctness of the new Left. But we hippies, or semi-hippies, actually, were interested in critiquing the 50s idea of togetherness. I was always against corporations, which I

think most Americans are also; I was not against capitalism. I just didn't like corporate culture. I wanted to poke at it.

...

NG: I think of this as part of a larger project of your lifetime: the reading of your work is primarily the reading you give to the work. You have in that sense generated fully preemptive criticism. But again, in order to create that information, you need to appropriate the aesthetics of that information, so you went and took the pictures for *Homes for America.*

DG: What actually happened with *Homes for America* was that after my gallery went out of business I was evading creditors, so I lived with my parents just outside of the edge of suburbia. And I took a suburban railroad and saw things and images that were a little like Judd. I read Judd's great article about the city plan of Kansas City, which he wrote in *Arts Magazine.* Judd moved from Kansas City to New Jersey. So, I saw actually that Judd was dealing with real things in suburbia. So, where Judd used transparent plastic, I wanted the transparency of the slide itself. I was asked to put them in a show called "Projected Art" at Finch College. They were just shown as slides. Then the assistant editor of *Arts Magazine,* a very brilliant girl who was a filmmaker and at that time was the girlfriend of Mel Bochner, went to see the show and she said, "Dan, why don't you put the photographs in the magazine?" It was a pretty irreputable magazine, even if Judd wrote for them, so I thought it would be more interesting to do an article about the city plan of the suburbs. The photographs came first and illustrated the article in terms of a grid. I had to write the thing very quickly, and they took out most of my layout because they had no space. The title, *Homes for America,* was given by the editor. Unlike what Mr. Benjamin Buchloh says, it's not really about sociology. It's like *Esquire* having a sociologist talk about what was wrong with the suburbs and also have a photographer, like Stephen Shore, taking nice photographs. My idea was to make a fake think piece. It was more trying to do like [Gustave] Flaubert. It was a kind of a poetic pastoral. We were very influenced by the French new novel, and the idea was not to use metaphor. The idea was a kind of phenomenological present time, as if we didn't have any history. Lawrence Weiner still talks about it, but I revolted against that a few years later and got very into historical and just-past time. It was supposed to be a little bit humorous. It's actually very much based on songs like "Nowhere Man" by the Beatles. It was kind of a cliché. I parodied hippies around

the same time in my article "Eisenhower and the Hippies." I didn't believe in anything organic at that moment. In fact, I still don't. What I was really talking about was the look of the suburbs. I talked in the article about how the suburbs began after the war. There were people on the West and East Coasts fabricating ships and airplanes for the war. It was mass production. Then, after the war, they needed a place for people returning to live, so they used mass production to make these housing developments. I liked the fact that they were very temporary and wouldn't last for very long. It's the kind of culture that we still have. And John Chamberlain talked about it a lot. His early work was about the fact that you buy a beautiful automobile and then it's junked very quickly. He did this also with his foam couches. It's just the look of the 60s. Everything was produced synthetically and fell apart instantly and you had to buy something new.

NG: Built-in obsolescence.

DG: Built-in obsolescence, yeah.

NG: What seems to link the narrative breakthrough generated by Flaubert with that period in the 60s is the consciousness of the simultaneous; the intertwining of the so-called real time and psychological time; and the constant shifting of the point of view, where you can't identify the author's voice. There's not an overall point of view of the author.

DG: In other words, it was deadpan flat.

NG: It feels deadpan flat, but at times you're seeing from the subjectivity of a character, at times you're seeing from a so-called objective point of view.

DG: I have to admit something; I never read Flaubert as you did, in depth. But whatever sense that I had of Flaubert was that it was all about stereotypes and clichés. And my great interest was stereotypes and clichés. I don't mean that negatively. I think stereotypes are very important because we live by them, pretty much.

NG: In your statement at the art workers' hearing in 1969, there's a paragraph that always struck me as your piece of writing that brings together the problem of literary analysis with the social reality of art-making. In fact, you don't refer to Flaubert, but you refer instead to the structuralist analysis of Flaubert, a suspicion confirmed now that you confess that you never read it. John, will you please read me this paragraph?

JM: "The writer in the past has been presented with an analogous problem. All magazines, in order

to survive, are forced to present a well-known point of view to identify readers with advertisements, just as in the past, the structure of the book as object functioned to repress the author's private interior perspective or vision of life to the private reader, who has bought the unique illusion as he reads through the narrative—linear, progressive, continuous, from beginning to vanishing end point—his perspective is supposed to be altered by a novel insight into the world; he is changed. In [Karl] Marx, [Emile] Zola, and [Bertolt] Brecht's time, he was hopefully motivated to change affect into effecting changes back in the *outside* world. Magazines—art magazines—continued this fiction of assuming private points of view whose sum they must assume to be the collective view of its readership and advertisers. They depend exclusively for their economic existence on selling ads to galleries for the most part. For what it's worth to readers who will buy it, the critic who must sell it, quality in art is all that counts (time is money which counts, man is the measure of all things). For the writer, and recently, some so-called Conceptual artists, there is a simple solution: buy the ads himself—the cycle thus feeds back on itself; invest in oneself—it's a free society."

NG: This is one of your pieces of prose which Karin [Schneider] and I call quasi-schizophrenic, because you move at a very, very fast pace. You go from literary analysis to the critique of how value is constructed without transition. You identified the representational system of perspective with the idea of the novel moving linearly in time. Then you refer to "so-called" Conceptual art. And hint why is it "so-called." Next, you bring what your simple solution would be, to break down that linear continuity of reproduction of capital through interlocking reading, authorship, and point of view. But you also state that the cycle does feed back on itself. The cycle that feeds back on itself is, again, a topological model. The relationship between symbolic and financial capital through advertisements and content seems to be interpreted here also with a topological metaphor.

DG: My interest was, as a subversive thing, that artists just simply buy advertisements. I had this idea before it became fashionable, using the page of the magazine as a site for art. In terms of Conceptual art, I'm afraid I had a very unfortunate situation in my life. I was stalked by a School of Visual Arts student, Joseph Kosuth. His teacher was Robert Mangold, who actually taught him about my work; Mangold loved my work. He stalked me to On Kawara's place.

Lawrence Weiner, who generally liked my work, was with a gallery, Seth Siegelaub, which was then a painters' gallery with Robert Barry and Douglas Huebler. Seth, I think because of Kosuth and Wiener's interest, invited me to a meeting where we would talk about information as art. I gave them lots of ideas, but I realized Seth wanted to make a movement, and the last thing I wanted was a movement. Art and Language came to see me very early and I was in their first issue. I put them in touch with Sol LeWitt and Lawrence. I was published in their first issue of the magazine, but then Kosuth said, "dammit you should do some paintings and then say you're giving up paintings and you're just going to do advertisements." I thought that was cynical and Machiavellian. So Kosuth was very angry at me, and he hooked up with Art and Language. They did a show at the Gallery of Modern Art in Columbus Circle and he made sure that he covered up the first issue. I always thought these people were really out for themselves. I thought this idea of art as philosophy—sure we all love philosophy, we wanted to make philosophical models—was just academic bullshit. Also, it didn't have much humor. But I have to admit, Lawrence Weiner's first works were both poetry and also art at the same time and I loved—and love—them. They were *absolutely* brilliant. Although they had very little to do with this idea of Conceptual art as philosophy. His work was very much about linguistics, which I liked. So, when I talk about "so-called Conceptual art," I mean that. I thought it was academic gibberish.

...

NG: Let's go back to your magazine pieces. You put an ad looking for a professional medical writer willing to write quick a description covering equally the physiological and psychological response of the human male after sexual interaction. "The description selected would be reproduced as a piece in a national magazine. Writer of piece retains copyright and is free to use description for his own purposes. Contact: Dan Graham, 84 Eldridge Street, New York City, 10002."

DG: Which, by the way, is this neighborhood. [*Laughs.*] I'm from the original Lower East Side when it was Jewish, before it became Chinese.

NG: I must also say, this is published in a page that advertises all kinds of weird funny shit, the "homosexual probe group encounter," "do it in sandals," and other stuff. Which magazine was this?

DG: The magazine was the *New York Review of Sex*. The editor was my old editor at *Arts Magazine,*

I thought that everything in magazines was to get you involved in having a climax. The climax in advertising was to buy something. So I wanted to do something that happened after male ejaculation, which is called "detumescence." Nobody wants to be interested in detumescence.

> I didn't want to be an artist, but John Gibson said I should do art. So, in fact, I got pushed into doing art and selling it.

Sam Edwards, who was interested in poetry and sexual experimentation. He had a magazine called *Second Coming*. [*Laughs.*] He became editor at *Arts Magazine*. He didn't know much about art. He went out of business and then he had this idea of a literary version of *Screw Magazine*, he called it *New York Review of Sex*. He gave me the advertisement free. What I wanted, of course, was something clinical. I wanted a medical writer to write this. This was very much like Judd having things fabricated for him by fabricators. The work was called *Detumescence* [1966].

NG: Well, your statement in the booklet *For Publication* is a bit of a lie because it says, "I bought an ad in *Screw*, mid-'69, I have received no responses." So, you say you bought the ad. But in any case, the ad will fit this kind of page, this context. You didn't go through an editorial selection or anything like that.

DG: That is correct.

NG: You wrote the description yourself?

DG: No, the description was actually written by a medical writer named Roger Sharp and I made a few additions to it. But it's basically from a medical co-writer. The idea was to publish it as a page in a magazine, because again I thought, this was kind of a feminist piece, the penis loses its power. I thought that everything in magazines was to get you involved in having a climax. The climax in advertising was to buy something. So I wanted to do something that happened after male ejaculation, which is called "detumescence." Nobody wants to be interested in detumescence.

NG: So, do me a favor John, read the description. [*Laughs.*]

JM: "Involuntary body contractions ensue, bringing a steep drop in excitation. The most obvious indication of this is the rapid loss of penile erection and the return of the scrotum and testes to an unstimulated state. This action occurs in two stages. The first leaves the penis enlarged while a continued shrinkage takes place concurrently at a slower rate. The body slackens its tension. There is a loosening of physical tautness and a simultaneous sense of release and relaxation. Sensations of orgasm or desire are extinguished, emotions recede, and ego is again bounded. Psychologically there may be feelings of anxiety, relief, pleasurable satiation, disappointment, lassitude, exhaustion, disgust, repulsion, or indifference and occasionally hatred [*laugh*] depending on the partner and the gratification achieved in the orgasm state." [*Laughs.*]

NG: So, two things: your claim that this is an objective physiological description is just phony. This is a psychological description as well and as such an attempt to objectivize the subjective. As a psychological description, it's not strictly Freudian. For instance, "sensations of orgasm or desire are extinguished, emotions recede, and ego is again bounded." The idea that during the orgasm, the ego will be unbound…There will be a dissolution of the ego?

DG: Didn't you read D. H. Lawrence?

NG: I did, but this comes strictly from Wilhelm Reich.

DG: It was before I did Reichian therapy. But, I have to say something, Doctor Wilhelm Reich and I are both Aries. [*Laughs.*] Aries have a strange thing about the ego. We're like small children, we either have no ego or a big ego.

…

NG: The writer must have been keen on Reich, or at least cognizant of his text called "The Function of the Orgasm," which is from the 40s. Did you use Sharp's draft and then departed and wrote your own text?

DG: I was never published. I was a failure as an artist. Joseph Kosuth wrote a letter to my friend Jeff Wall saying, "Dan Graham was a concrete poet who couldn't get published." In fact, I was a failure for many years, an extreme failure. Some things were published, some things were not published. But that's the way it is for writers. But there's normally a thing called a "kill fee." If your article is killed, they give you some money.

NG: So, *Figurative* was published as a photograph by mistake because it was meant to be pure information. The title of *Homes for America* was given by the magazine and the layout was altered beyond distortion. Two other pieces were just not published. In other words, we can claim that despite whatever is in this booklet called *For Publication*, your magazine pieces are at least forty- or fifty-percent fiction.

DG: But the fact is, even the published version of *Homes for America* made its way to Vancouver and two artists, Ian Wallace and Jeff Wall, were very influenced by it. But this is the whole thing about magazines, and the idea is to get as much out as possible. And of course, *Figurative* was published. I think it may have been ignored somewhat, but in fact, I did a lot of other writing, like "Eisenhower and the Hippies," the piece about Dean Martin, and they had huge influences. That was done by only writing. In fact, I really believe

in artists writing. I thought that was very very important. Jeff Wall wrote some brilliant articles about Rodney Graham and Ken Lum. Then he told me, recently, "Dan, the artist should never write about other people or themselves, the job of the artist is to become famous. They should have curators or critics write about them." We now have Mike Kelley. Mike actually wrote brilliantly about his hero, Öyvind Fahlström, and he also wrote against somebody who I thought was very important, Marcel Broodthaers. We have John here. I think the main thing for writing, and Judd did this brilliantly, was to support your fellow artists and to learn about their art.

NG: A lot of your work revolves in or around the idea of time. And in your writing about your magazine pieces you talk about the point of view of the author and the point of view of the magazine. I have a little piece here, this is a text that John wrote for me, for my *Monkeys and Shit*, that mentions you. "In his text *For Publication*, Dan Graham discusses the tautology between art magazines' ads and reviews. Financially, art magazines rely on ads to continue publishing. Conversely art galleries rely on published art reviews to legitimate the artworks they want to sell. Put bluntly, art magazines trade cultural capital for financial capital. Graham accordingly concluded that the published review is more important than the execution itself. He claimed his publication pieces, which went straight into magazines, could dispense with exhibitions per se. That, at least, was his idea in theory. In practice, the material he put into print—number systems and a quasi-medical description of a post-erectile penis—left all but a few insiders completely befuddled. In sum, if these works can be said to have a public, it is a retrospective one. The retrospective nature of this public goes straight to the histories of the legitimization processes. That is, in short, the production of value." So basically, what John here is saying is that, in fact, this art form functions right here today in a retrospective manner. And this is what produces its value.

DG: I'm not as much a strict Marxist as John Miller is. I also think what he's saying makes a lot of sense. But in fact, the work still doesn't have much value. Actually, I sold it to a collector, a radiologist, at a thousand dollars a piece. I got five hundred dollars because it was sold by my then-dealer John Gibson. I didn't want to be an artist, but John Gibson said I should do art. So, in fact, I got pushed into doing art and selling it. [*Laughs.*]

NG: John has a point, once you publish either about somebody else, or if you produce art-magazine pieces that will be revisited, as they're being revisited today, you have generated so-called cultural capital that is always regenerating itself. The capital of the written word and of the published never ends. The prestige keeps on coming and coming. So, it's a funny thing. It's something that wasn't saleable or that you sold for a few hundred dollars, but it will always come back to haunt you and make you culturally indispensable. Any time there's a Sol LeWitt big show or lecture, there's Dan Graham's text about Sol LeWitt; any time there is a discussion of Conceptual art, there is *Homes for America*.

DG: First of all, I have to say that I got out of the field almost immediately. I didn't capitalize on it because I didn't want to be a Conceptual artist. I usually go through things very fast. I like things that are early experiments or models, and what I didn't do was to make a trademark of it.

Interview excerpted from a conversation between Nicolás Guagnini and Dan Graham at the offices of *Scorched Earth* on New York's Lower East Side on 14 May 2006. The full conversation and audience discussion will be published in a forthcoming issue of *Scorched Earth*, a twelve-issue journal devoted to questions of drawing.

Manga Dan Graham Story
by Fumihiro Nonomura
illustrated by Ken Tanimoto

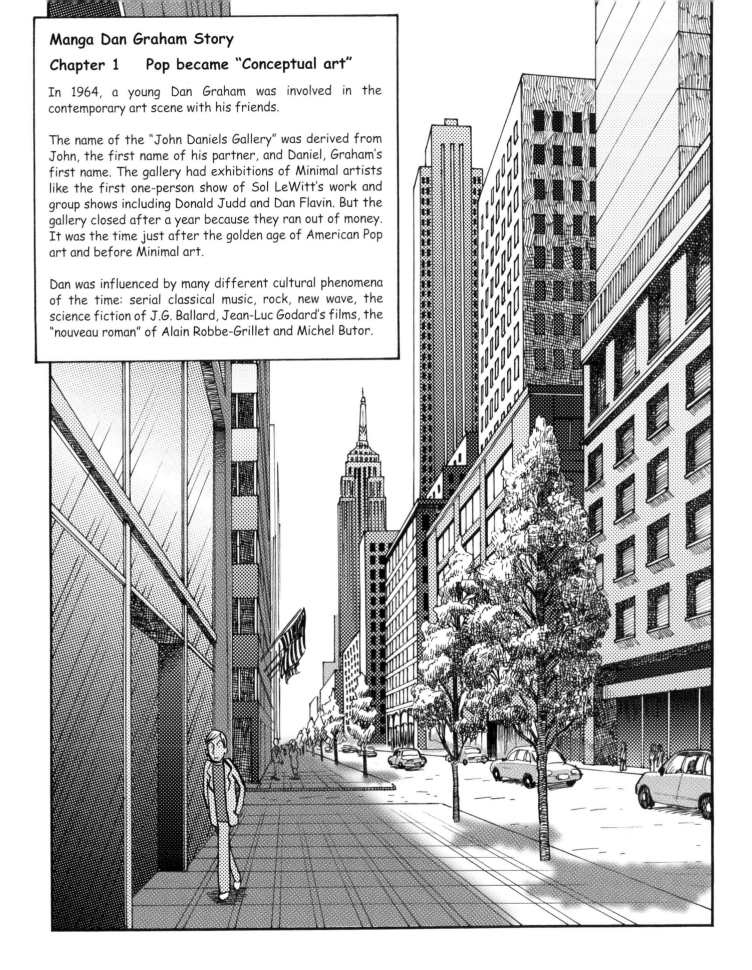

Manga Dan Graham Story

Chapter 1 Pop became "Conceptual art"

In 1964, a young Dan Graham was involved in the contemporary art scene with his friends.

The name of the "John Daniels Gallery" was derived from John, the first name of his partner, and Daniel, Graham's first name. The gallery had exhibitions of Minimal artists like the first one-person show of Sol LeWitt's work and group shows including Donald Judd and Dan Flavin. But the gallery closed after a year because they ran out of money. It was the time just after the golden age of American Pop art and before Minimal art.

Dan was influenced by many different cultural phenomena of the time: serial classical music, rock, new wave, the science fiction of J.G. Ballard, Jean-Luc Godard's films, the "nouveau roman" of Alain Robbe-Grillet and Michel Butor.

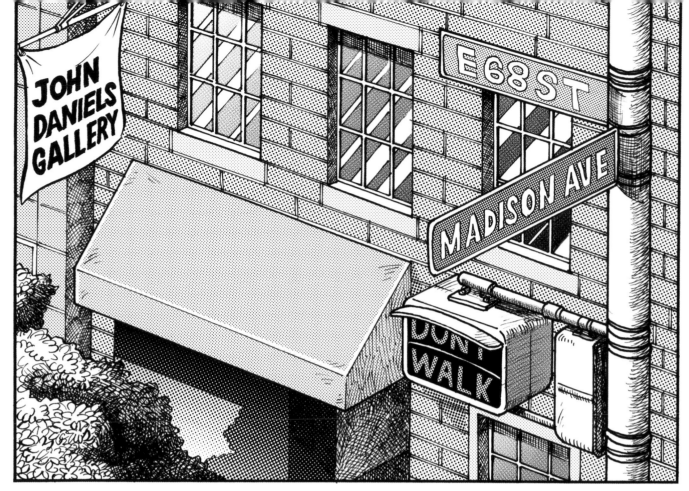

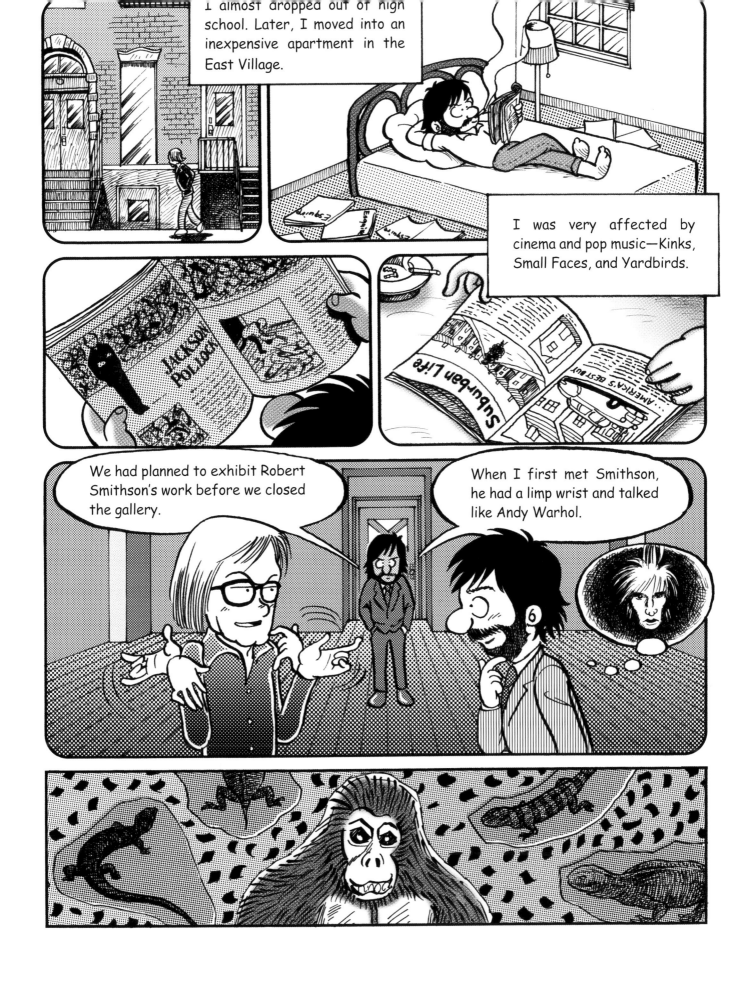

Flavin's pieces undermine the way

the white cube of the gallery supports art works

by replacing the usual neutral lighting

with space-destroying colored lighting.

It didn't upset Flavin. He wanted his work to be disposable.

Don't worry about it.

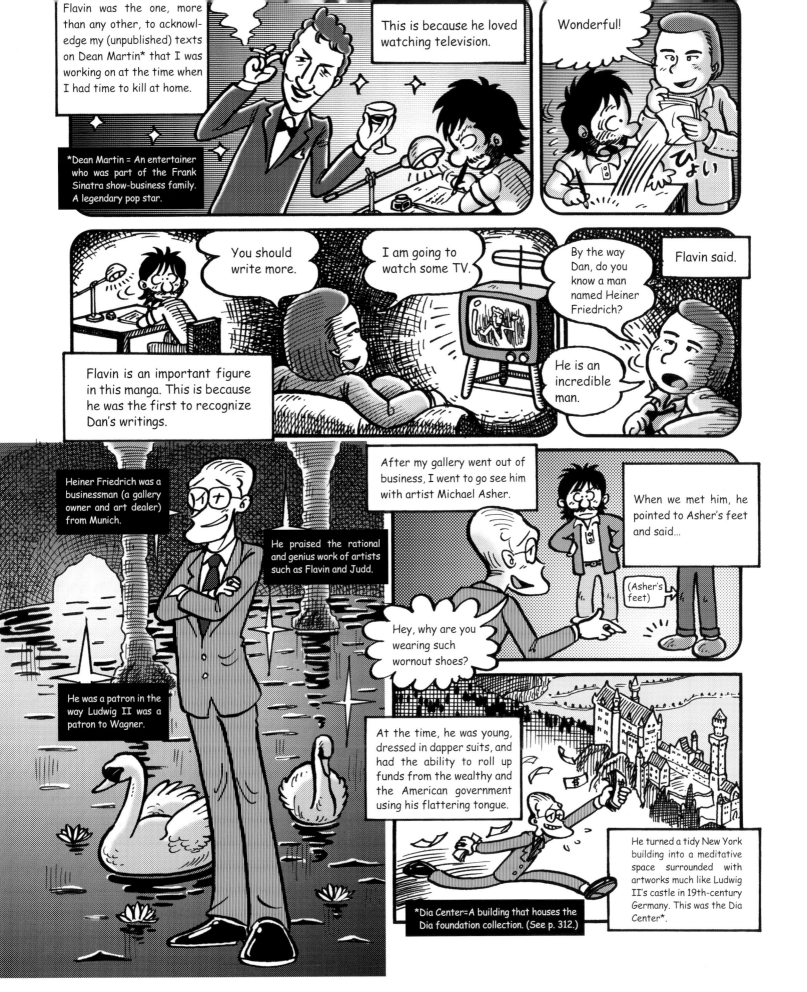

Flavin was the one, more than any other, to acknowledge my (unpublished) texts on Dean Martin* that I was working on at the time when I had time to kill at home.

*Dean Martin = An entertainer who was part of the Frank Sinatra show-business family. A legendary pop star.

This is because he loved watching television.

Wonderful!

You should write more.

I am going to watch some TV.

By the way Dan, do you know a man named Heiner Friedrich?

Flavin said.

He is an incredible man.

Flavin is an important figure in this manga. This is because he was the first to recognize Dan's writings.

Heiner Friedrich was a businessman (a gallery owner and art dealer) from Munich.

He praised the rational and genius work of artists such as Flavin and Judd.

He was a patron in the way Ludwig II was a patron to Wagner.

After my gallery went out of business, I went to go see him with artist Michael Asher.

When we met him, he pointed to Asher's feet and said...

(Asher's feet)

Hey, why are you wearing such wornout shoes?

At the time, he was young, dressed in dapper suits, and had the ability to roll up funds from the wealthy and the American government using his flattering tongue.

*Dia Center=A building that houses the Dia foundation collection. (See p. 312.)

He turned a tidy New York building into a meditative space surrounded with artworks much like Ludwig II's castle in 19th-century Germany. This was the Dia Center*.

At the time, there was a rise in people known as yippies* who were a part of the urban hippie anarchist movement and continued to gather in anti-war demonstrations during the Vietnam War. The leader and radical star of that era's anti-establishment movement, together with promiscuous sex and public drug use, was Abbie Hoffman.

*yippie = Youth International Party + hippie

I'm next!

New York liberals who were young yippie parents would let their kids smoke marijuana while showing them Flavin's light works. This was the era.

Happy.

Psychedelic!

Heiner Friedrich had smoked too much.

You're doing it too?

When the Dia foundation committee was faced with financial difficulties, Heiner Friedrich was fired by the board of directors one day.

Although Friedrich was well off, he still returned to Europe in distress.

Dan Graham's rooftop project* at the Dia Center was undertaken long after he left.

*Rooftop project = A project that used the rooftop of the Dia Center in 1989. (See p. 312.)

Sol LeWitt denied all value of his art in those days. I loved his dry sense of humor.

Sol LeWitt

The exhibition was a success.

The pieces should be used for firewood.

At his studio, Sol told me the first grids were used as playgrounds for his cats.

LeWitt, Dan Flavin and I saw a show at the Museum of Modern Art based on the book "The Russian Experiment in Art, 1863–1922" by Camilla Gray. Tatlin was a huge influence on Flavin's work.

It's time to close the gallery. We have sold nothing and can't pay the rent.

Yes, suburban space.

まんがダン・

Manga Dan Graham Story

Chapter 2 Homes for America

グレアム物語

Illustrated by Ken Tanimoto

Dan, can we display your photograph at our house?

Robert Smithson

Nancy Holt

The photographs are traces or "evidence."

I see two books on the table: "Robert Smithson: Photoworks," a catalogue of the exhibition at Los Angeles County Museum, and "Rock My Religion," by Dan Graham.

He sees the photograph as a result of his para-sociological field work. At Finch College, he presents the work as a slide show.

I would like to display the slides in a reduction of the transparencies of some of Donald Judd's stacking pieces.

LIKE

Female	Male
Skyway Blue	Skyway Blue
Lawn Green	Colonial Red
Nickel	Patio White
Colonial Red	Yellow Chiffon
Yellow Chiffon	Lawn Green
Patio White	Nickel
Moonstone Grey	Fawn

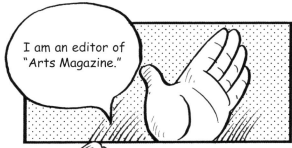

Homes for America

D. GRAHAM

I love magazines because they are like pop songs, easily disposable, dealing with momentary pleasures. They are full of clichés. We all love the cliché. We all like tautologies, things that seem to be dumb and banal but are actually quite intelligent.

Large-scale 'tract' hou
stitute the new city,
where. They are not p
ing communities; they
gional characteristics or
'projects' date from th
when in southern Cali
erative' builders adapt
niques to quickly build
fense workers over-c

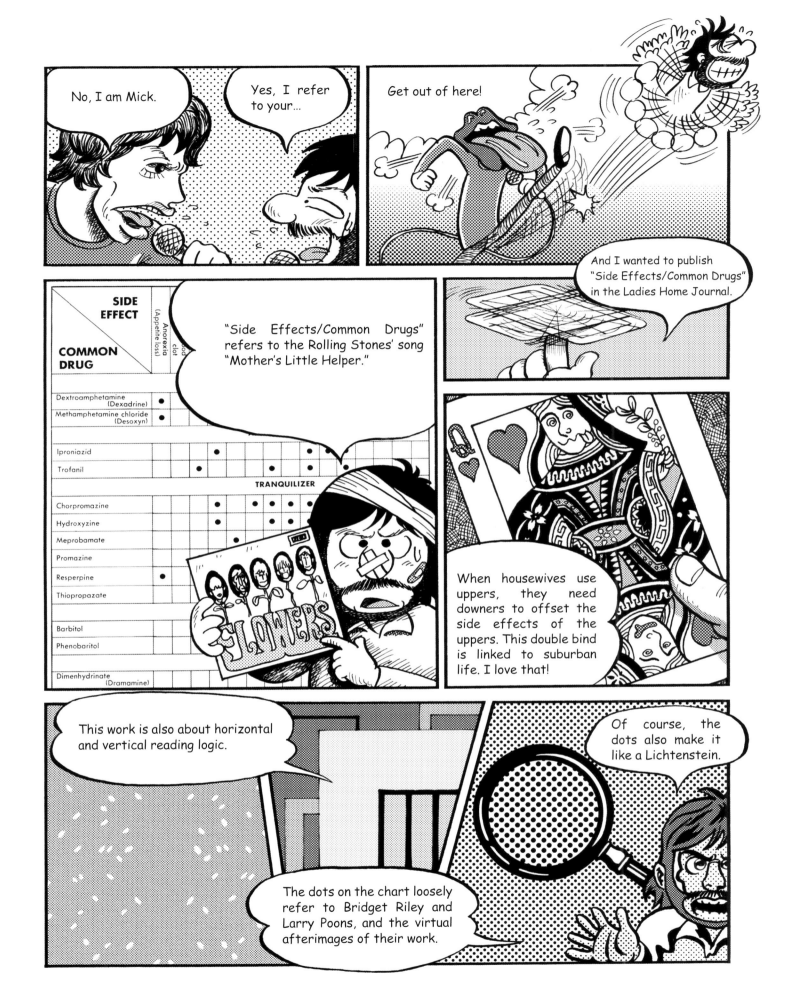

Dan's slide-show lectures led to his interest in motion pictures. But, at the time, it was too expensive to make films. Dan begins teaching at the Nova Scotia College of Art and Design in Canada. He uses the video equipment with excitement.

Canada had lots of money to invite artists to make new conceptual works. Dan visited NSCAD in Halifax, Nova Scotia, every summer to produce film and video works. "Sunrise to Sunset" was a film Dan made using the school's equipment.

Dan noticed Richard Long's landscape piece and Bruce Nauman's collaborations with Anna Halprin.

The choreography was especially important to him—it made clear the engagement of our bodies in the world. All of the artists were reading Merleau-Ponty. Nauman's big hero was the quantum physicist Richard Feynman, who lectured at Berkeley.

In 1964, at the Filmmaker's Co-op in New York, Jonas Mekas introduced Chris Marker's films to America. Warhol, influenced by Mekas, began to make experimental films.

Art in the late 60s meant you could do anything: writing, philosophy, film, video, photography and performance. Carl Andre and Lawrence Weiner were writing poetry.

I am skeptical of models that implicitly recognize the world as it is.

I want to show that our bodies are bound to the world whether we like it or not.

I speak about Bruce Nauman's performances in my article "Subject Matter."

Video is good for describing these principles.

At Nova Scotia College of Art and Design in Halifax, Canada, I speak with Kasper König about inviting a theorist who specializes in art and gender. Kasper is an independent curator and editor of catalogues. I first suggested Shulamith Firestone, a Marxist-oriented feminist who wrote "The Dialectics of Sex."

But I gave up film because I couldn't afford to produce the pieces.

An important aspect of the film is the curved mirror cylinder that I made to film the work.

I also have an interest in gender issues.

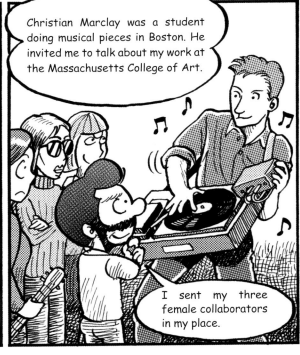

I started to collaborate with three women musicians. They could barely play their instruments. Kim Gordon of Sonic Youth was one of them. I was interested in female bonding in rock groups.

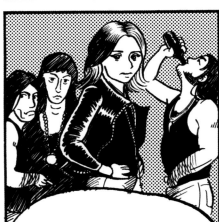

Although some female rockers imitate male rock heroes, others are interested in women's power.

Christian Marclay was a student doing musical pieces in Boston. He invited me to talk about my work at the Massachusetts College of Art.

I sent my three female collaborators in my place.

Chapter 4 To the Pavilion

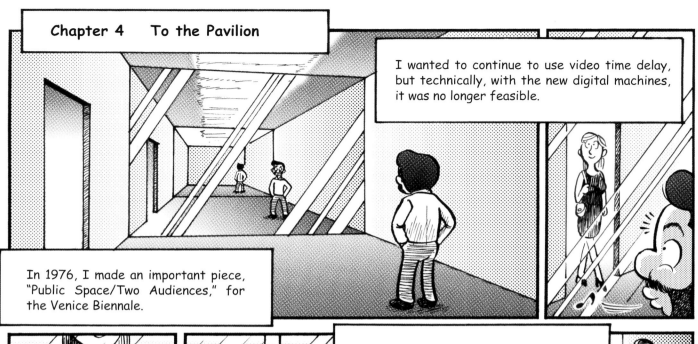

I wanted to continue to use video time delay, but technically, with the new digital machines, it was no longer feasible.

In 1976, I made an important piece, "Public Space/Two Audiences," for the Venice Biennale.

I wanted the audience to be like the commodity inside the showcase window.

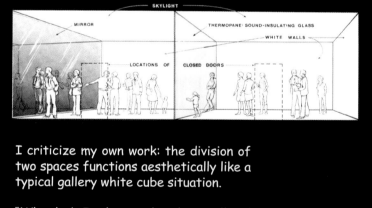

I criticize my own work: the division of two spaces functions aesthetically like a typical gallery white cube situation.

"Why don't I take out the white wall and replace it with a window?

I want to make pieces that are hybrids of architecture and sculpture."

Gordon Matta-Clark and I were influenced by the same architects and architectural theorists.

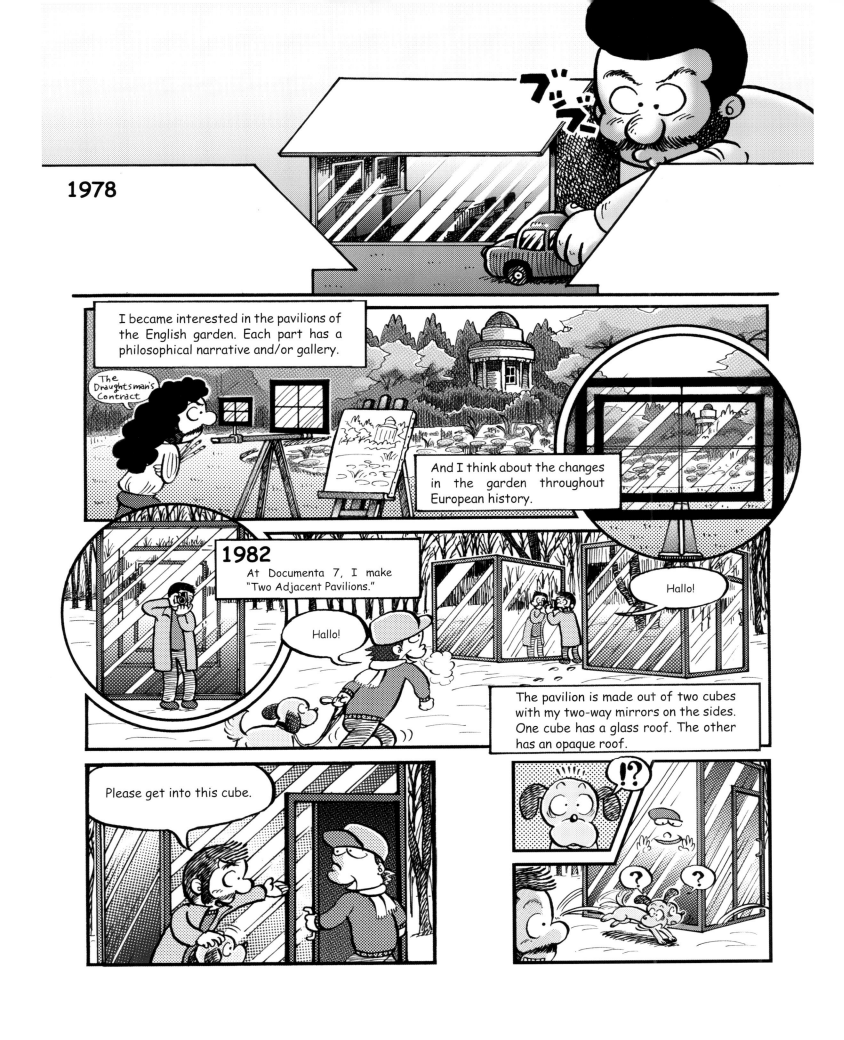

1978

I became interested in the pavilions of the English garden. Each part has a philosophical narrative and/or gallery.

The Draughtsman's Contract

And I think about the changes in the garden throughout European history.

1982
At Documenta 7, I make "Two Adjacent Pavilions."

Hallo!

Hallo!

The pavilion is made out of two cubes with my two-way mirrors on the sides. One cube has a glass roof. The other has an opaque roof.

Please get into this cube.

!?

1987

Klaus Bussmann*, who collaborated with Kasper König at the 2nd Münster Sculpture Project, was a regional architectural scholar.

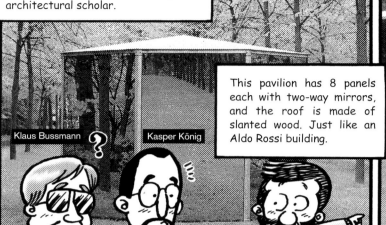

Klaus Bussmann

Kasper König

This pavilion has 8 panels each with two-way mirrors, and the roof is made of slanted wood. Just like an Aldo Rossi building.

ちょっとそこまで散歩しませんか？

どこ連れてくつもりだい？

This work was placed along the intersection of a three-way promenade inside the garden that surrounded the 18th-century king's palace. This garden was originally a baroque-style garden, but besides the three roads, it was remodeled into a picturesque-style English garden, and sectioned off between a university botanical garden and a 19th-century-style park. Gardens were frequently remodeled this way in Europe, in which many stylistic layers from history accumulated.

At the center of the pavilion, there was one wooden column, which sustained the structure. Similar to a "country log cabin" style, it conjures a feeling of romantic nostalgia from a 19th-century alcove, but the form itself is the opposite of traditional 19th-century architecture.

This is the original format for the piece.

This is America!

Well, well, here you go.

これも元ネタ

アルド・ロッシの天がい付ポット

I actually borrowed the residential form of the "octagon house" popular in 19th-century America.

Ghost architecture.

The Dia piece is based on a city plan. Architect Robert Venturi's Franklin Court (Philadelphia) and Sol LeWitt's grid is based on a modern city grid.

The "Pergola/Conservatory," presented the same year, is built with a tall cloister-like form. This is a reproduction of a garden pergola from the Romantic period. The grape tree vine contains a rural arcadia and modern city dialectic. When you look at the sky from here, one can see a pure nature that hasn't been corrupted by contemporary times, and watch the clouds flow between the vines. It's a truly a romantic state.

1987

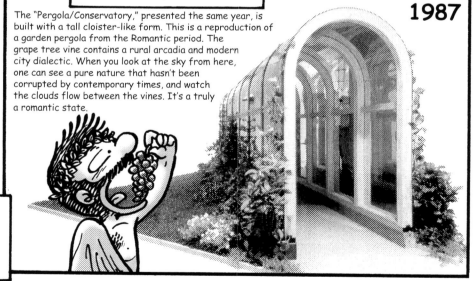

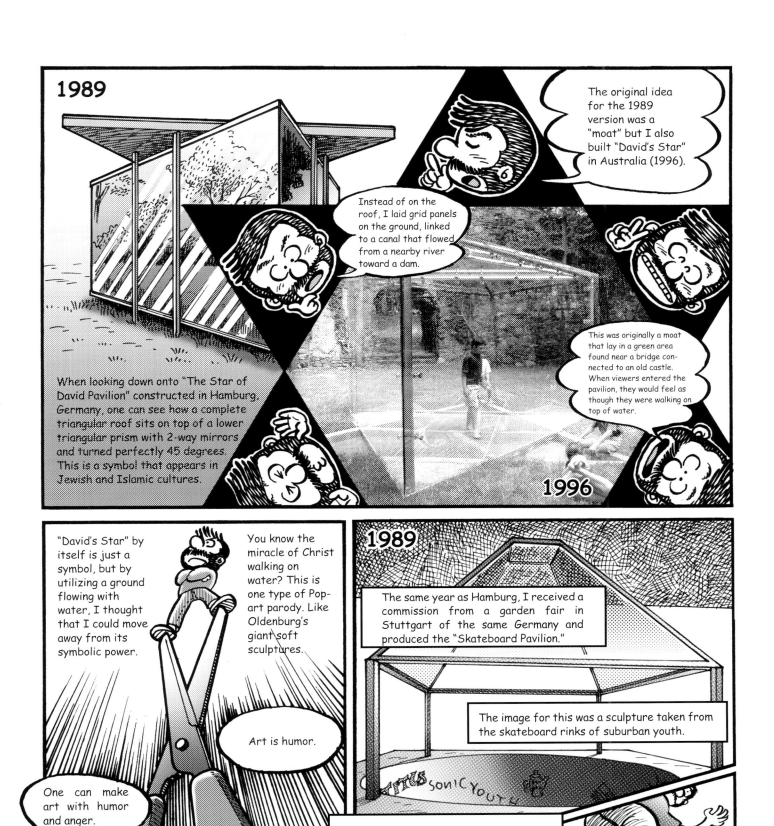

1989

When looking down onto "The Star of David Pavilion" constructed in Hamburg, Germany, one can see how a complete triangular roof sits on top of a lower triangular prism with 2-way mirrors and turned perfectly 45 degrees. This is a symbol that appears in Jewish and Islamic cultures.

Instead of on the roof, I laid grid panels on the ground, linked to a canal that flowed from a nearby river toward a dam.

The original idea for the 1989 version was a "moat" but I also built "David's Star" in Australia (1996).

This was originally a moat that lay in a green area found near a bridge connected to an old castle. When viewers entered the pavilion, they would feel as though they were walking on top of water.

1996

"David's Star" by itself is just a symbol, but by utilizing a ground flowing with water, I thought that I could move away from its symbolic power.

You know the miracle of Christ walking on water? This is one type of Pop-art parody. Like Oldenburg's giant soft sculptures.

Art is humor.

One can make art with humor and anger.

1989

The same year as Hamburg, I received a commission from a garden fair in Stuttgart of the same Germany and produced the "Skateboard Pavilion."

The image for this was a sculpture taken from the skateboard rinks of suburban youth.

When skateboarders jump in the air, they might be able to see a glimpse of themselves in the 2-way mirrors on the pavilion roof.

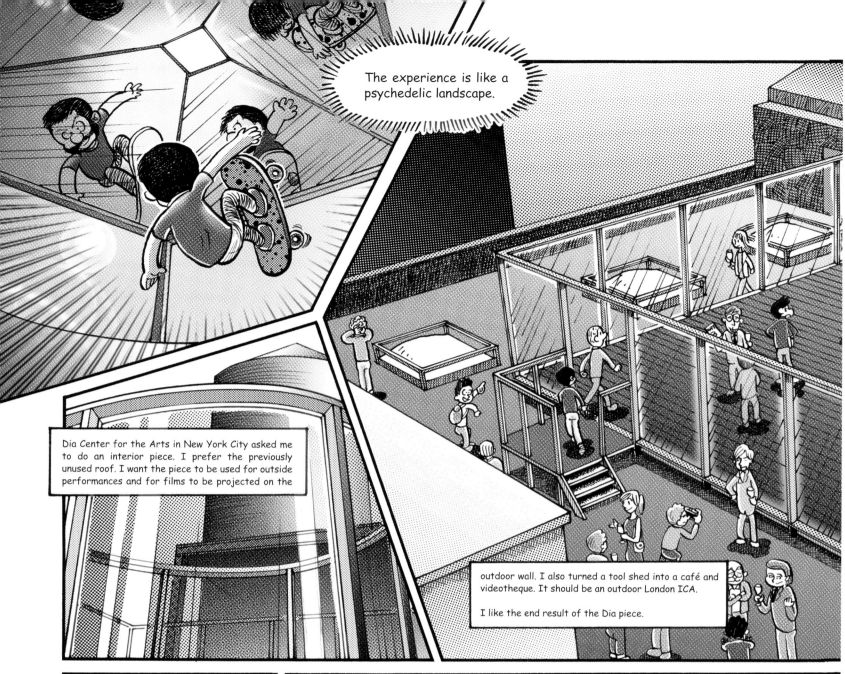

The experience is like a psychedelic landscape.

Dia Center for the Arts in New York City asked me to do an interior piece. I prefer the previously unused roof. I want the piece to be used for outside performances and for films to be projected on the

outdoor wall. I also turned a tool shed into a café and videotheque. It should be an outdoor London ICA.

I like the end result of the Dia piece.

It is good for seeing the city.

I can see from the slum rooftops of downtown to the skyscrapers uptown.

And we can see the clouds changing their faces in the New York sky.

I want to change the function of Dia. After touring the building, I realize that the roof is unused at this time. It has a 360-degree view of the city. I particularly like the fact that one can see the sky there.

So I design a two-way mirror cylinder to be situated in a two-way mirror cube. The cylinder echoes the water tower above.

Dan, the party doesn't come alive until the leading actor is there.

I imagine the legendary alternative spaces, which had many great performances in the 70s,

and also the corporate atriums of buildings in the 80s. I want to combine both, making the audience aware of the just past.

This art is not for the elite. This is a space where all different kinds of people can gather.

A public park where people from all walks of life can converse. A space where both parents and their children can enjoy.

During this time, I traveled to all parts of the world to construct the pavilion. And I felt an impact from the different cultures and different gardens. Of course, I was greatly influenced by Japan.

When I was first invited to Japan, I felt inside the airplane that Japan was the future of America. While America is an embodiment of the future of Europe, Japan was perhaps the future embodiment of America. This is the way I felt.

Japan Foundation was the first to invite me to Japan. At the time, Fumio Nanjo and Nobuo Nakamura were there.

Nobuo Nakamura Fumio Nanjo

To my surprise, there was a tour planned every hour. It took me awhile to realize that this was a form of genuine hospitality towards guests. In any case, it was the first time that I had an hourly schedule.

Miroku Bosatsu

Goju no-tō

KINKAKU-JI TEMPLE

One of the most famous of Japan's sekitei, this garden consists of a 300m² area of sand with 15 rocks arranged to represent islands in the ocean...

A young woman from the Japan Foundation took me on a tour to temples in Kyoto and Nara and around the city of Osaka.

After that, I realized that Japanese tourists who traveled abroad also took different walking tours every hour or 30 minutes. Very hurried people.

I was invited by Kazue Obata to conduct a lecture and a video performance at Plan B in Nakano. Then I had an interview for Brutus magazine.

小幡和恵氏

I couldn't wait to get out of the heat (rush), and escaped to the city in Osaka.

As I was strolling through town, I encountered the popular high school manga "Manga Koshien."

I had a caricature of myself drawn. This was my first encounter with Japanese manga culture.

"Ultra-man '82" A caricature drawn by an actual high-school student. ▶

This was the beginning of this cartoon biography "Manga Dan Graham Story."

I bought up lots of volumes of comics during my travels and read them all. And then, I felt that manga would invade visual culture.

Manga will be the universal language for the youth generation!

HISTOIRE DU CINEMA(S)

LES SIGNES PARMI OU

QUE CHAQUE ŒIL

NEGOCIE POUR LUI MEME

I loved 20th-century culture as much as I loved Ray Davies from the Kinks and Eero Saarinen, the architect.

My teenage memory. Like the sudden variations in children's culture.

My work lies in pulling together our confused and shared condition of the 20th-century into a hybrid form.

My work is a two-way mirror that reflects the 20th-century landscape.

Fin.
おしまい

Manga Dan Graham Story by Fumihiro Nonomura, illustrated by Ken Tanimoto. Originally published in English in ***Dan Graham: Works 1965–2000*** (Düsseldorf, Germany: Richter Verlag, 2001), 375–98. A revised and expanded Japanese version was published in booklet form in 2003.

Checklist of the Exhibition

Figurative, 1965

Magazine layout published in *Harper's Bazaar* (March 1968) and *Scheme for Magazine Page 'Advertisement'*
Two parts: 24 x 24 $^7/_{16}$ and 22 x 15 inches
Collection Herbert, Ghent, Belgium

Figurative, 1965

Published in *Harper's Bazaar* (March 1968): 90
The Museum of Contemporary Art, Los Angeles

Scheme, 1965

Published as *Discrete Scheme Without Memory* in *0–9*, no. 4 (June 1968)
Collection of the artist

Scheme, 1965

Published as *Discrete Scheme Without Memory* in Robert Smithson, "Quasi-Infinities and the Waning of Space," *Arts Magazine* 41, no. 1 (November 1966): 28
The Museum of Contemporary Art, Los Angeles

Scheme, 1965/73

Book of 130 leaves, front and back covers of Mylar, bound with pins
7 $^1/_4$ x 8 $^1/_2$ inches
Designed by Dan Graham and Gerald Ferguson
Published by Gerald Ferguson, Halifax, Nova Scotia
Collection of Gerald Ferguson, Halifax, Nova Scotia

Untitled, 1965* +

Xerox on paper
10 $^1/_2$ x 7 $^3/_4$ inches
The Museum of Contemporary Art, Los Angeles, The Dorothy and Herbert Vogel Collection: Fifty Works for Fifty States, a joint initiative of the Trustees of the Dorothy and Herbert Vogel Collection and the National Gallery of Art, with generous support of the National Endowment for the Arts and the Institute for Museum and Library Services

Detumescence, 1966

Ink on paper and printed matter
28 x 27 inches
Courtesy Marian Goodman Gallery, New York and Paris

Detumescence, 1966

Published in *The New York Review of Sex*, no. 11 (15 August 1969)
Collection of Tom Brinkmann

Homes for America, Early 20th-Century Possessable House to the Quasi–Discrete Cell of '66, 1966–67

Published in *Arts Magazine* 41, no. 3 (December 1966–January 1967): 21–22
The Museum of Contemporary Art, Los Angeles

Homes for America, 1966–67

Printed texts, handwriting, and black-and-white and color photographs for article for *Arts Magazine*
Two panels: 39 $^{15}/_{16}$ x 33 $^1/_4$ inches each
Collection Daled, Brussels, Belgium

Homes for America, 1966–67

Twenty 35mm slides and carousel projector
Dimensions variable
Courtesy of the artist and Marian Goodman Gallery, New York and Paris

March 31, 1966, 1966

Typewriter ink on paper
3 $^1/_8$ x 9 inches
Collection Daled, Brussels, Belgium

March 31, 1966, 1966

Published in *Extensions*, no. 2 (1969): 59
Research Library, The Getty Research Institute, Los Angeles

March 31, 1966, 1966

Published in *Aspen*, no. 8 (fall–winter 1970–71)
The Museum of Contemporary Art, Los Angeles

Pink Kitchen Trays in Discount Store, Bayonne, N.J., 1966

Color photograph
11 x 14 inches
Collection of Jeff Wall

Project for Slide Projector, 1966/2005

Eighty 35mm color slides and carousel projector
Dimensions variable
Courtesy Orchard, New York

Schema (March 1966), 1966–67

Printed matter and handwriting on paper
Fifteen framed parts: 20 $^1/_2$ x 16 $^1/_2$ inches each
Collection Daled, Brussels, Belgium

* Work not included in Whitney presentation
+ Work not included in Walker presentation
° Full program only available in MOCA presentation

Schema (March 1966), 1966–67
Variation published in *Aspen*, nos. 5–6
(fall–winter 1967)
The Museum of Contemporary Art,
Los Angeles

Schema (March 1966), 1966–67
Variation published in *Extensions*, no. 1
(1968): 22–23
Research Library, The Getty Research
Institute, Los Angeles

Schema (March 1966), 1966–67
Variation published in *Art–Language* 1,
no. 1 (May 1969): 14, text 15–16
The Museum of Contemporary Art,
Los Angeles

Schema (March 1966), 1966–67
Variation published in *End Moments*
(1969): 44–46
Collection of Steven Leiber, San Francisco

Schema (March 1966), 1966–67
Variation published in *Konzeption/
Conception* (Leverkusen, Germany:
Städtisches Museum, 1969): n.p.
Research Library, The Getty Research
Institute, Los Angeles

Schema (March 1966), 1966–67
Variation published in *Possibilities of
Poetry*, ed. Richard Kostelanetz (New
York: Dell Publishing Co., 1970), 181–82
The Museum of Contemporary Art,
Los Angeles

Schema (March 1966), 1966–67
Variation published in *Aspen*, no. 8
(fall–winter 1970–71)
The Museum of Contemporary Art,
Los Angeles

Schema (March 1966), 1966–67
Variation published in *Interfunktionen*,
no. 8 (1972): 32
Collection of the artist

Schema (March 1966), 1966–67
Variation published in *Studio International*
183, no. 944 (May 1972): 212–13
The Museum of Contemporary Art,
Los Angeles

Schema (March 1966), 1966–67
Variation published in *Flash Art*, nos.
35–36 (September–October 1972): 8
The Museum of Contemporary Art,
Los Angeles

Schema (March 1966), 1966–67
Variation published in *Selected Works
1965–1972* (London: Lisson Publications;
and Cologne, Germany: König Brothers,
1972)
Collection of Steven Leiber, San Francisco

Schema (March 1966), 1966–67
Variation published in Graham, *For
Publication* (Los Angeles: Otis Art Institute
of Los Angeles County, 1975)
The Museum of Contemporary Art,
Los Angeles

Side Effects/Common Drugs,
1966
Offset lithography on paper
46 x 30 inches
Collection Daled, Brussels, Belgium

One, 1967/91
Silkscreen type in white on a puzzle
of black plastic
3 x 3 1/2 x 1/4 inches
Collection of Rhea Anastas

Proposal for Aspen, 1967–68
Published in Graham, *For Publication*
(Los Angeles: Otis Art Institute of
Los Angeles County, 1975)
The Museum of Contemporary Art,
Los Angeles

Income (Outflow) Piece,
1969–73
Texts and postcard on mount board
24 13/16 x 20 1/4 inches
Courtesy of the artist and Lisson Gallery,
London

Income (Outflow) Piece,
1969–73
Framed black–and–white text poster
37 x 28 3/8 inches
Courtesy of the artist and Lisson Gallery,
London

Lax/Relax, 1969
Framed black–and–white photographs
on mount board
31 3/4 x 40 7/16 inches
Courtesy of the artist and Lisson Gallery,
London

Lax/Relax, 1969/95
Video of performance at Lisson Gallery,
London, July 1995; color and sound
24:00 minutes
Filmed by Rory Logsdail
Courtesy of the artist and Lisson Gallery,
London

Two Correlated Rotations, 1969
Two Super–8mm films transferred to
16mm; black–and–white and silent;
double projection onto two walls at
right angles to each other; and panel of
documentation with two photographs
Approximately 1:00 minute; and
47 x 67 3/8 inches
Tate Collection

Body Press, 1970–72
Two 16mm films; color and silent; double
projection on parallel and opposite walls
8:00 minutes
Courtesy Marian Goodman Gallery,
New York and Paris

*Time Extended Distance
Extended*, 1970
Lithograph
22 1/2 x 22 13/16 inches
Whitney Museum of American Art,
New York, purchase with funds from
the Print Committee

Past Future Split Attention, 1972
Video of performance at Lisson Gallery,
London, March 1972; black–and–white
and sound
17:03 minutes
Courtesy of the artist and Electronic Arts
Intermix (EAI), New York

Past Future Split Attention, 1972
Photograph and text
20 1/4 x 39 3/8 inches
Collection Nicole Verstraeten, Brussels,
Belgium

*Two Consciousness
Projection(s)*, 1972
Black–and–white photograph on
cardboard documenting performance
at Lisson Gallery, London, March 1972
50 x 41 5/16 inches
Collection Herbert, Ghent, Belgium

*Opposing Mirrors and Video
Monitors on Time Delay*,
1974/93
Two mirrors, two cameras, and two
color monitors with time delay
Dimensions variable
San Francisco Museum of Modern Art,
gift of Dare and Themis Michos and
Accessions Committee Fund: gift of
Collectors Forum, Doris and Donald Fisher,
Evelyn and Walter Haas, Jr., Pam and Dick
Kramlich, Leanne B. Roberts, Madeleine H.
Russell, and Helen and Charles Schwab

Nude Two Consciousness Projection(s), 1975
Text and photographs on panel documenting performance at Nova Scotia College of Art and Design, Halifax, Canada, 1975
50 x 41 5/16 inches
Collection Herbert, Ghent, Belgium

Yesterday/Today, 1975
Video camera, sound-recording device, video monitor, and sound-playback device with time delay
Dimensions variable
Collection Van Abbemuseum, Eindhoven, The Netherlands

Production/Reception (Piece for Two Cable TV Channels), 1976
Photographic reproduction and text
Dimensions variable
Courtesy of the artist

Project for Record Cover, Sounds, St. Mark's Place, NY, 1976
Color photograph
13 3/4 x 12 inches
Courtesy Marian Goodman Gallery, New York and Paris

Public Space/Two Audiences, 1976
Two rooms, each with separate entrance, divided by a sound-insulating glass panel; one mirrored wall; muslin; fluorescent lights; and wood
9 3/8 x 24 x 10 1/2 feet
Collection Herbert, Ghent, Belgium

Public Space/Two Audiences, 1976
Drawing on paper with ink, gouache, and collage
21 7/16 x 29 1/2 inches
Collection Herbert, Ghent, Belgium

Video Piece for Showcase Windows in Shopping Arcade, 1976
Photographic documentation
Dimensions variable
Courtesy of the artist

Performer/Audience/Mirror, 1977
Video of performance at Video Free America, San Francisco, with transcript; black-and-white and sound
22:52 minutes
Courtesy of the artist and Electronic Arts Intermix (EAI), New York

Alteration to a Suburban House, 1978/92
Wood, felt, and plexiglas
11 x 43 x 48 inches
Collection Walker Art Center, Minneapolis, Justin Smith Purchase Fund, 1993

Clinic for a Suburban Site, 1978
Painted wood, plexiglas, and plastic
13 5/8 x 41 7/8 x 28 1/4 inches
Courtesy Marian Goodman Gallery, New York and Paris

Pavilion/Sculpture for Argonne, 1978
Wood and plastic
9 1/4 x 18 x 18 inches
Courtesy Marian Goodman Gallery, New York and Paris

Tourist Bus, Portugal/Shopping Center, Palo Alto, CA, 1978/80
Two color photographs
34 1/2 x 25 inches overall
The Museum of Contemporary Art, Los Angeles, purchased with funds provided by the Photography Committee

Video Projection Outside Home, 1978
Painted wood and plastic
9 x 20 x 30 3/8 inches
Courtesy Marian Goodman Gallery, New York and Paris

Dan Graham and Ernst Mitzka
Westkunst (Modern Period): Dan Graham Segment, 1980
Video; color and sound
7:10 minutes
Produced by WDR and Ernst Mitzka; script: Dan Graham; camera: Michael Shamberg; and sound: Glenn Branca
Courtesy of the artist and Electronic Arts Intermix (EAI), New York

Cinema, 1981
Foam core, wood, two-way mylar, plexiglas, and Super-8mm film loop transferred to 16mm film; color and silent
23 5/8 x 22 3/8 x 22 3/8 inches
Centre Pompidou, Paris, Musée national d'art moderne/Centre de création industrielle

Rock My Religion, 1982–84
Video; black-and-white and color and sound
55:27 minutes
Courtesy of the artist and Electronic Arts Intermix (EAI), New York

Minor Threat, 1983
Video; color and sound
38:18 minutes
Courtesy of the artist and Electronic Arts Intermix (EAI), New York

Dan Graham and Glenn Branca
Musical Performance and Stage Set Utilizing Two-Way Mirror and Time Delay, 1983
Video; black-and-white and sound
45:45 minutes
Designer: Dan Graham; music: Glenn Branca; camera/director: Jucith Barry; musicians: Axel Gross, Margaret De Wys, and Glenn Branca
Courtesy of the artist and Electronic Arts Intermix (EAI), New York

Three Linked Cubes/Interior Design for Space Showing Videos, 1986+
Two-way mirror, glass, wood frames, video monitors, and players
Eight panels: 91 1/4 x 61 7/8 x 2 3/4 inches each; four posts: 91.1/4 x 2 2/3 inches each
Whitney Museum of American Art, New York, gift of The Bohen Foundation and purchase, with funds from the Painting and Sculpture Committee

Altered Two-Way Mirror Revolving Door and Chamber (for Loie Fuller), 1987
Two-way mirror, glass, and aluminum
7 3/8 x 9 7/8 x 13 1/8 feet
Collection Le Consortium, Dijon, France

Dan Graham and Robin Hurst
Private "Public" Space: The Corporate Atrium Garden, 1987
Black-and-white and color photographs with printed texts mounted on cardboard
Six framed panels: 40 x 30 inches each
Collection Generali Foundation, Vienna

Dan Graham and Marie-Paule Macdonald
Wild in the Streets: The Sixties, 1987
Nine drawings by Marie-Paule Macdonald for rock opera libretto: mixed media and photo collage on paper
11 x 14 inches each
Collection of Marie-Paule Macdonald, Halifax

Dan Graham and Jeff Wall
Children's Pavilion, 1989
Five drawings and text
11 1/2 x 19 5/8 feet overall
Collection of the artist

Skateboard Pavilion, 1989
Two-way mirror glass, brushed aluminum, wood, and graffiti
37 x 50 x 50 inches
Courtesy Marian Goodman Gallery, New York and Paris

Triangular Solid with Circular Inserts (Variation E), 1989/2007
Two-way mirror, glass, and aluminum
84 x 84 x 84 inches
Charpenel Collection, Guadalajara, Mexico

Heart Pavilion, 1991
Two-way mirror glass and aluminum
94 x 168 x 144 inches
Carnegie Museum of Art, Pittsburgh, A. W. Mellon Acquisition Endowment Fund and Carnegie International Acquisition Fund, 92.5

Star of David, 1991–96
Aluminum, glass, and wood
Model: 26 $^9/_{16}$ x 26 $^9/_{16}$ x 14 $^3/_4$ inches; base: 43 $^5/_{16}$ x 43 $^5/_{16}$ x 2 $^3/_{16}$ inches
Collection Dieter and Gertraud Bogner, Museum Moderner Kunst Stiftung Ludwig Wien, Vienna

Two-Way Mirror Hedge Labyrinth, 1991
Aluminum, glass, chrome, and metal
13 $^3/_4$ x 38 $^9/_{16}$ x 56 $^5/_{16}$ inches
Collection, Archiv Kunst Architektur, Kunsthaus Bregenz, Austria

Double Exposure, 1995*+
Two-way mirror and cibachrome transparency
15 $^5/_{16}$ x 41 x 41 inches
Courtesy Marian Goodman Gallery, New York and Paris

Elliptical Pavilion, 1995*+
Two-way mirror, punched aluminum, and aluminum
22 $^1/_2$ x 30 x 40 inches
Courtesy Marian Goodman Gallery, New York and Paris

New Space for Showing Videos, 1995*
Two-way tempered mirror glass, clear tempered glass, and mahogany
84 x 160 x 213 inches
Collection Walker Art Center, Minneapolis, T. B. Walker Acquisition Fund, 2002

Two-Way Mirror Triangle with One Curved Side, 1996
Two-way mirror and aluminum
23 $^1/_4$ x 35 $^{13}/_{16}$ x 35 $^{13}/_{16}$ inches
Collection Raymond Geerts, Mol, Belgium

Caravans, Berwick-upon-Tweed, 1997
Color photograph
16 $^1/_2$ x 23 $^3/_8$ inches
Courtesy of the artist

Dan Graham in collaboration with Apolonija Sustersic
Liza Bruce Boutique Design, 1997
Drawing and collage on paper and photographs
Six parts: 13 $^3/_8$ x 10 inches each; one part: 10 x 13 $^3/_8$ inches
Courtesy of the artist and Johnen + Schöttle, Cologne/Berlin

Swimming Pool/Fish Pond, 1997
Coated glass, lead foil, wood, acrylic, and sheet aluminum
12 $^1/_2$ x 42 x 42 inches
Courtesy of the artist and Patrick Painter Editions

Girls' Make-Up Room, 1998–2000
Two-way mirror glass, perforated stainless steel, wood stool, and cosmetic articles
67 x 118 inches
Courtesy Hauser & Wirth, Zürich and London

Yin/Yang, 1998
Two-way mirror, acrylic, wood, lead, and water
12 $^1/_2$ x 42 x 42 inches
Courtesy Marian Goodman Gallery, New York and Paris

Coulisse to Ocean/Boardwalk, Belmar, N.J., 2006
Color photograph
9 x 13 $^1/_2$ inches
Courtesy of the artist

Dunkin' Donuts Façade/Interior View, Union City, N.J., 2006
Color photograph
30 x 20 inches
Courtesy of the artist

Entrance, Mafia Mansion, Deal, N.J., 2006
Color photograph
30 x 20 inches
Courtesy of the artist

Exterior of Highway Store, Near Pt. Pleasant, N.J., 2006
Color photograph
15 $^7/_8$ x 11 inches
Courtesy of the artist

Hotel, Belmar, N.J., 2006
Color photograph
15 $^7/_8$ x 11 inches
Courtesy of the artist

Items for Sale Outside Highway Store, Near Pt. Pleasant, N.J., 2006
Color photograph
15 $^7/_8$ x 11 inches
Courtesy of the artist

1920s Amusement Park Carousel, Asbury Park, N.J., 2006
Color photograph
13 $^1/_2$ x 9 inches
Courtesy of the artist

Plastic Pool Outside Highway Store, Near Pt. Pleasant, N.J., 2006
Color photograph
15 $^7/_8$ x 11 inches
Courtesy of the artist

Seaside Houses, Belmar, N.J., 2006
Color photograph
13 $^1/_2$ x 9 inches
Courtesy of the artist

Artists' and Architects' Works That Influenced Me, 2009
Twenty-six 35mm slides, carousel projector, and text panels
Dimensions variable
Courtesy of the artist

Video Documentation for Video-Viewing Environments°

Pavilion/Sculpture for Argonne, 1978–81
Super-8mm film transferred to video; color and silent
00:35 minutes
Courtesy of the artist and Electronic Arts Intermix (EAI), New York

Two Adjacent Pavilions, 1978–82
Documentation excerpted from *Pavilions* (1997; video; color and sound; 26:00 minutes)
2:26 minutes
Courtesy of the artist and Electronic Arts Intermix (EAI), New York

Video Projection Outside Home, 1978–96
Documentation of 1996 temporary installation in Santa Barbara, California, excerpted from *Pavilions* (1997; video; color and sound; 26:00 minutes)
00:50 minutes
Courtesy of the artist and Electronic Arts Intermix (EAI), New York

Sculpture/Pavilion II, 1986
Documentation excerpted from *Pavilions* (1997; video; color and sound; 26:00 minutes)
1:32 minutes
Courtesy of the artist and Electronic Arts Intermix (EAI), New York

Triangle for New Urban Landscape, 1988
Documentation excerpted from *Pavilions* (1997; video; color and sound; 26:00 minutes)
2:28 minutes
Courtesy of the artist and Electronic Arts Intermix (EAI), New York

Star of David Pavilion for Schloss Buchberg, Austria, 1991–96
Documentation excerpted from *Pavilions* (1997; video; color and sound; 26:00 minutes)
2:54 minutes
Courtesy of the artist and Electronic Arts Intermix (EAI), New York

Two–Way Mirror Hedge Labyrinth, 1991
Documentation excerpted from *Six Sculpture/Pavilions for Pleasure* (2000; video; color and sound; 22:09 minutes)
Approximately 2:40 minutes
Courtesy Hauser & Wirth, Zürich and London

Two–Way Mirror Cylinder Inside Cube and a Video Salon, 1992
Video; color and sound
19:32 minutes
Courtesy of the artist and Electronic Arts Intermix (EAI), New York

Heart II, 1993
Documentation excerpted from *Pavilions* (1997; video; color and sound; 26:00 minutes)
2:48 minutes
Courtesy of the artist and Electronic Arts Intermix (EAI), New York

Elliptical Pavilion, 1995
Documentation excerpted from *Six Sculpture/Pavilions for Pleasure* (2000; video; color and sound; 22:09 minutes)
Approximately 5:35 minutes
Courtesy Hauser & Wirth, Zürich and London

Two–Way Mirror Triangle with One Curved Side, 1996
Documentation of Artscape Nordland Project, Norway, excerpted from *Pavilions* (1997; video; color and sound; 26:00 minutes)
1:43 minutes
Courtesy of the artist and Electronic Arts Intermix (EAI), New York

Children's Pavilion/Chambre d'Amis, 1997
Documentation excerpted from *Pavilions* (1997; video; color and sound; 26:00 minutes)
3:17 minutes
Courtesy of the artist and Electronic Arts Intermix (EAI), New York

Funhouse for Münster, 1997
Documentation excerpted from *Pavilions* (1997; video; color and sound; 26:00 minutes)
2:32 minutes
Courtesy of the artist and Electronic Arts Intermix (EAI), New York

Waterloo Sunset at the Hayward Gallery, 2003
Video; color and sound
Approximately 8:06 minutes
Courtesy the Hayward, Southbank Centre, London

Half Square/Half Crazy, 2004
Video; color and sound
Produced by SUPSI Lugano C4; camera and editing: Natalia Fiorini
9:59 minutes
Courtesy of Borgovico33, Como, Italy; and Galleria Massimo Minini, Brescia, Italy

Death by Chocolate: West Edmonton Shopping Mall (1986–2005), 2005
Video; color and sound
8:00 minutes
Courtesy of the artist and Electronic Arts Intermix (EAI), New York

Double Exposure, 2006
Video; color and sound
Text: Dan Graham; voice: João Fernandes; video: Amarante Abramovici, Tiago Afanso, and Rui Coelho; production: Museu de Arte Contemporânea de Serralves
8:36 minutes
Collection Fundação de Serralves—Contemporary Art Museum, Porto

Yin/Yang, 2006
Video; color and sound
4:39 minutes
Courtesy of the artist and Electronic Arts Intermix (EAI), New York

Films installed in single–evening gallery screening at the Whitney Museum of American Art, New York

Binocular Zoom, 1969–70
Two Super–8mm films transferred to 16mm; color and silent; double projection side by side
1:07 minutes
Courtesy Marian Goodman Gallery, New York and Paris

Sunrise to Sunset, 1969
16mm film; color and silent
4:20 minutes
Courtesy Marian Goodman Gallery, New York and Paris

Roll, 1970
Two Super–8mm films transferred to 16mm; color and silent; double projection on parallel and opposite walls
1:00 minute
Courtesy Marian Goodman Gallery, New York and Paris

Helix/Spiral, 1973
Two Super–8mm films transferred to 16mm; color and silent; double projection on parallel and opposite walls
5:26 minutes
Courtesy Marian Goodman Gallery, New York and Paris

DAN GRAHAM

JANUARY 2 - 20

FRANKLIN FURNACE

**BUILDINGS
AND
SIGNS**

**Dan Graham
Lisson Gallery**

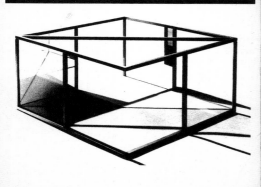

LANGUAGE III

OPENING SATURDAY MAY 24 THROUGH JUNE 18, 1969 DWAN 29 WEST 57 NEW YORK 10019

DAN GRAHAM

7 February 1976

SPERONE WESTWATER FISCHER INC
142 Greene Street New York NY 10012 (212) 431-3685

DAN GRAHAM

mercoledì 24 maggio 1972 ore 20 **Performance**
martedì 30 maggio 1972 ore 20 **Performance**

Toselli via Melzo 34 20129 Milano tel. 2041429

DE VERENIGING
VOOR HET MUSEUM VAN HEDENDAAGSE KUNST TE GENT

DAN GRAHAM

TWO ROOMS REVERSE
VIDEO DELAY

27, 28, 29, 30 MEI 1977

in het Museum van Hedendaagse Kunst, Citadelpark, Gent
op vrijdag 27 mei van 17 tot 20 h en op 28, 29 & 30 mei van 9 tot 12 h en van 14 tot 17 h

dan graham
6 maggio 1976
samangallery
vico parmigiani 1
16123 genova ☎ 585562

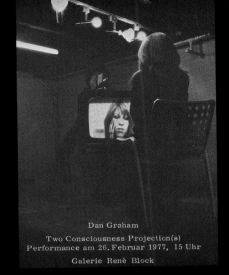

DAN GRAHAM
28. 4 - 10. 5 1976

Performance
le mercredi 28 avril 1976 à 19 heures

Video-tape, films 16 mm. et super 8

SALLE SIMON I. PATINO
centre d'art contemporain - cité universitaire
av. de miremont 26 - genève - Tél. (022) 47 13 98
heures d'ouverture:
15.30 h. - 19.00 h. du mardi au vendredi

PHOTOGRAPHIE EXTRAITE DU FILM HELIX/SPIRAL, DAN GRAHAM

Dan Graham
Two Consciousness Projection(s)
Performance am 26. Februar 1977, 15 Uhr

Galerie Renê Block

Dan Graham

The New York University Art Students' Association presents
an evening of "Performance, Film, Television, & Tape" by
artist Dan Graham on Monday, December 14, at 8:30 p.m. in
the Top of the Park (5th floor) of Loeb Student Center,
566 La Guardia Place. Admission is $2 which includes the
Dan Graham issue of _Performance_. Produced by John Gibson.

PROGRAM

("LIKE") 1969 Tape recorder and pre-recorded tape on con-
tinuous loop (with the help of 36 students, Nova Scotia Col-
lege of Art).
[First played: Loeb Student Center, New York University,
October, 1969.]

LAX/RELAX 1969 Tape recorder, pre-recorded tape and per-
former (with the help of Charolette Townsend).
[First performed: Nova Scotia College of Art, September,
1969.]

TWO CORRELATED ROTATIONS 1969 Two Super-8 films.
[First shown: "Artists & Photographs" exhibition, Multiples,
New York, March, 1970.]

INTERMISSION (20 minutes)

ROLL 1970 Two Super-8 films.
[First shown: University of California, San Diego, May, 1970.]

TV CAMERA/MONITOR PERFORMANCE 1970.
[First performed: Nova Scotia College of Art, October, 1970.]

INTERMISSION (10 minutes)

FROM SUNSET TO SUNRISE (Motion Picture Version) 1970
16 mm color.
[First shown: John Daniels Gallery, New York, January, 1970.]

BINOCULAR ZOOM OF HIGHLIGHT 1969-70 Two Super-8 films.
[First shown: John Daniels Gallery, New York, January, 1970.]

Performance

stichting 'de appel', brouwersgracht 196, amsterdam 1003, tel. 255651

DE APPEL - BROUWERSGRACHT 196, AMSTERDAM

open:
dinsdag tot en met zaterdag, 14-18 u.
tuesday through saturday, 2-6 pm

uitnodiging
invitation

Juni 1977

DAN GRAHAM

8 Juni Woensdagavond 8 uur:
Performances: SEX PROJECTION 1976---
 MIRROR PERFORMER/AUDIENCE DESCRIPTION 1977---

literatuur over Dan Graham:
"Films" Dan Graham, Ecart publications, Geneve 1977
Catalogus Stedelijk van Abbe Museum, Eindhoven Mei 1977
Antje von Graevenitz: "Dingen gebeuren binnen het gezichtsveld" Museum
 Journaal, nr. 2 1977 blz.74-79

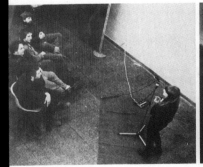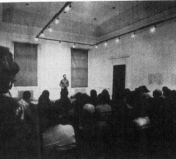

| Nova Scotia College of
Art and Design
6152 Coburg Road
Halifax
Nova Scotia
Canada | **Dan Graham**

October 8-15 1970

March 10-22 1971 | 7 Performances
16 Presentations
Obverse |

Selected Exhibition History
Compiled by Christine Robinson

Selected Solo and Two-Person Exhibitions

1969
John Daniels Gallery, New York

1970
Anna Leonowens Gallery, Nova Scotia College of Art and Design, Halifax, Canada

1972
Galleria Toselli, Milan, Italy

Lisson Gallery, London

"Performance: New Piece," Fourth Floor Gallery, Halifax, Canada

Project, Inc., Cambridge, Massachusetts

Protetch-Rivkin Gallery, Washington, D.C.

1973
Galerie MTL, Brussels

Galerie Rudolf Zwirner, Cologne, Germany

Galleria Schema, Florence, Italy

Gallery A-402, California Institute of the Arts, Valencia

1974
Galerie MTL, Brussels

Galerie 17, Paris

Galleria Marilena Bonomo, Bari, Italy

Lisson Gallery, London

"Performance and Films," Epson School of Art, Surrey, England

Royal College of Art, London

1975
International Cultural Centrum, Antwerp, Belgium

John Gibson Gallery, New York

Lucio Amelio/Modern Art Agency, Naples, Italy

Otis Art Institute Gallery, Los Angeles (with Mowry Baden)

Palais des Beaux-Arts, Brussels

"Video Project," Griffiths Art Center, St. Lawrence University, Canton, New York

1976
Anne Marie Verna Galerie, Zürich, Switzerland

Kunsthalle Basel, Switzerland (with Lawrence Weiner)

New Gallery, Institute of Contemporary Arts, London

Salle Simon I. Patino, Centre d'art contemporain—Cité universitaire, Geneva, Switzerland

Saman Gallery, Genoa, Italy

Sperone Westwater Fischer Inc., New York

1977
Stedelijk Van Abbemuseum, Eindhoven, The Netherlands

"Two Rooms Reverse Video Delay," Museum van Hedendaagse Kunst, Ghent, Belgium

"Video-Architecture Projects, Photographs," Galerie René Block, Berlin

"Video Piece for Two Glass Buildings," Leeds Polytechnic Gallery, England

1978
Museum of Modern Art, Oxford, England

"Video Pieces for Shop Windows in an Arcade," Corps de Garde, Groningen, The Netherlands

1979
"Architectural Models and Photographs," Galleria Paola Betti, Milan, Italy

Franklin Furnace, New York

Galerie Rüdiger Schöttle, Munich, Germany

"Videotapes and Diagrams," Centre for Art Tapes, Halifax, Canada

1980
Central Library, Los Angeles (sponsored by Foundation for Art Resources)

"Gallery Projections, Architectural Proposals, Photographs," Galerie Rüdiger Schöttle, Munich, Germany

The Museum of Modern Art, New York

1981
"Buildings and Signs," The Renaissance Society at the University of Chicago; Museum of Modern Art, Oxford, England; Lisson Gallery, London; and Galerie Liliane et Michel Durand-Dessert, Paris

Institute for Art and Urban Resources/ P.S. 1, Long Island City, New York

"Pavilion/Sculpture," Center for the Arts, Muhlenberg College, Allentown, Pennsylvania

"Two Viewing Rooms," The Museum of Modern Art, New York

1982
Anna Leonowens Gallery, Nova Scotia College of Art and Design, Halifax, Canada

Gewad 23, Ghent, Belgium

Hotel Wolfers, Brussels

Johnson State College, Johnson, Vermont

Plan B, Tokyo

"Rock and Roll & Architecture," Corps de Garde, Groningen, The Netherlands

1983
Amelia A. Wallace Gallery, State University of New York, Old Westbury, New York

David Bellman Gallery, Toronto

"Pavilions," Kunsthalle Bern

Walter Phillips Gallery, The Banff Centre, Canada

1984
Galleria del Cavallino, Venice, Italy

Marianne Deson Gallery, Chicago

"Photos 1965–81," Todd's, New York

1985
Art Gallery of Western Australia, Perth

1986
Cable Gallery, New York

"Dan Graham & Sol LeWitt: Recent Work," Lisson Gallery, London

Galerie Liliane et Michel Durand-Dessert, Paris

Galleria Lia Rumma, Naples

"Interior Design for Space Showing Videotapes," Het Kijkhuis, The Hague, The Netherlands

"Sculpture, Pavilions & Photographs," Galerie Rüdiger Schöttle, Munich, Germany

Storefront for Art and Architecture, New York

"Three Pavilion/Sculptures," Galerie Johnen + Schöttle, Cologne, Germany

1987
Musée d'Art Moderne de la Ville de Paris/ ARC; and Museo Nacional Centro de Arte Reina Sofía, Madrid

Le Consortium, Dijon, France

Marian Goodman Gallery, New York

"Photographs 67–87," Galerie Hufkens–Noirhomme, Brussels

"Video/Cinema," Fruitmarket Gallery, Edinburgh

1988

"Dan Graham, Jeff Wall, Children's Pavilion,"
Musée d'Art Moderne de Saint-Etienne,
France

Kunsthalle zu Kiel, Germany

"Pavillons," Kunstverein München, Munich,
Germany

1989

"Children's Pavilion" (collaboration with
Jeff Wall), Galerie Roger Pailhas, Marseille,
France; Santa Barbara Contemporary
Arts Forum, California; Villa Gillet, Fonds
Régional d'Art Contemporain Rhône-
Alpes, Lyon, France; Marian Goodman
Gallery, New York; and Galerie Chantal
Boulanger, Montréal

1990

"Photographs and Drawings," Gallery
Shimada, Yamaguchi, Japan

"Photographs 1965–1985," Marian
Goodman Gallery, New York

Yamaguchi Prefectural Museum of Art,
Yamaguchi, Japan

"Zeichnungen 1965–69; Fotografien
1966–78," Galerie Bleich-Rossi,
Graz, Austria

1991

Castello di Rivara, Turin, Italy

Galerie Micheline Szwajcer,
Antwerp, Belgium

Margo Leavin Gallery, Los Angeles

"New Work—Roof Project," Dia Center
for the Arts, New York

"Pavilions/Sculptures," Galerie Rüdiger
Schöttle, Munich, Germany

"Pavilion Sculptures & Photographs,"
Fondation pour l'Architecture, Brussels;
Galerie Roger Pailhas, Marseille, France;
and Lisson Gallery, London

"Photographs 1966–1987," Le Case d'Arte,
Milan, Italy

1992

"House and Garden," Marian Goodman
Gallery, New York

"Travaux 1964–1992," Le Nouveau Musée/
Institut d'Art Contemporain, Villeurbanne,
France

"Walker Evans/Dan Graham," Witte de With
Center for Contemporary Art, Rotterdam,
The Netherlands; Musée Cantini, Marseille,
France; Westfälisches Landesmuseum,
Münster, Germany; and Whitney Museum
of American Art, New York

Wiener Secession, Vienna

1993

"Art in Relation to Architecture/
Architecture in Relation to Art," Stedelijk
Van Abbemuseum, Eindhoven, The
Netherlands

"Children's Pavilion: Dan Graham & Jeff
Wall," Museum Boymans Van Beuningen,
Rotterdam, The Netherlands

"House and Garden," Margo Leavin Gallery,
Los Angeles

"Museum for Matta-Clark, For Paris, 1984:
Marie-Paule Macdonald and Dan Graham,"
Ausstellungsraum, Künstlerhaus,
Stuttgart, Germany

"Public/Private," Paley/Levy Galleries,
Moore College of Art and Design,
Philadelphia; MIT List Visual Arts Center,
Massachusetts Institute of Technology,
Cambridge; Art Gallery of Ontario, Toronto;
and Los Angeles Contemporary Exhibitions

1994

"Korrektur: Dan Graham,"
Ausstellungsraum, Künstlerhaus,
Stuttgart, Germany

"Kunst und Architektur/Architektur
und Kunst," Museum Villa Stuck,
Munich, Germany

"New American Film and Video Series,"
Whitney Museum of American Art,
New York

"Selected Photographs, 1965–1991,"
Mai 36 Galerie, Zürich, Switzerland

1995

American Fine Arts Co./Colin de Land Fine
Art, New York (with Mariko Mori)

Kunst-Werke Berlin

"Pavillons 1989–1996," Städtische Galerie
Nordhorn, Germany; and Museum van
Hedendaagse Kunst, Ghent, Belgium

"Video/Architecture/Performance,"
Generali Foundation, Vienna

1996

Galerie Micheline Szwajcer, Antwerp,
Belgium

Galleria Massimo Minini, Brescia. Italy

"Models to Projects, 1989–1997,"
Marian Goodman Gallery, Paris

"Star of David," Schloss Buchberg,
Gars am Kamp, Austria

"The Suburban City," Museum für
Gegenwartskunst, Basel, Switzerland;
and Neue Galerie am Landesmuseum
Joanneum, Graz, Austria

"Videos on Sculpture/Pavilions," Gallery
Shimada, Tokyo

1997

"Architecture 1," Camden Arts Centre,
London

"Architecture 2," The Architectural
Association, London

Centro Galego de Arte Contemporánea,
Santiago de Compostela, Spain; and
Fundació Antoni Tàpies, Barcelona, Spain

Galerie Rüdiger Schöttle, Munich, Germany

Johnen + Schöttle, Cologne, Germany

"New Works/New Age," Hauser & Wirth,
Zürich, Switzerland

1998

"Architectural Proposals Photographs,"
Galerie Rüdiger Schöttle, Munich, Germany

"Empty Shoji Screen Pergola/Two-Way
Mirror Container," Lothbury Gallery,
London

"Unrealized Projects," Galerie Meyer Kainer,
Vienna

1999

"Architekturmodelle," Kunst-Werke Berlin

2000

"Children's Day Care, CD-Rom, Cartoon
and Computer Screen Library Project,"
Marian Goodman Gallery, New York

China Art Objects Galleries, Los Angeles
(with Julie Becker)

2001

Rooftop Urban Park Project, Dia Center for
the Arts and Electronic Arts Intermix, New
York (video program with Dara Birnbaum)

"Sculptures/Pavilions," Lisson Gallery,
London

"A Show for All the Children,"
Hauser & Wirth, Zürich, Switzerland

"Works 1965–2000," Museu de Arte
Contemporânea de Serralves, Porto,
Portugal; ARC/Musée d'Art Moderne de
la Ville de Paris; Kröller-Müller Museum,
Otterlo, The Netherlands; Kiasma—
Museum of Contemporary Art, Helsinki;
and Kunsthalle Düsseldorf, Germany

2002

"Five Films (1969–1973)," Marian
Goodman Gallery, New York

Galerie Christine Mayer, Munich, Germany

Galerie Rüdiger Schöttle, Munich, Germany

Galleria Massimo Minini, Brescia, Italy

Marian Goodman Gallery, Paris

"Target in the Park: Dan Graham, Mark Dion,
Dalziel + Scullion," Madison Square Park,
New York (organized by Public Art Fund)

2003

Contemporary Art Gallery, Vancouver

"Dan Graham by Dan Graham," Chiba City Museum of Art, Japan; and Kitakyushu Municipal Museum of Art, Japan

"Double Exposure," Fundaçao de Serralves, Porto, Portugal

"Waterloo Sunset at the Hayward Gallery," Hayward Gallery, London

2004

"Don't Trust Anyone Over Thirty," Art Basel Miami Beach; Wiener Festwochen, Vienna; Staatsoper Unter den Linden, Berlin; and Walker Art Center, Minneapolis

Galerie Christine Mayer, Munich, Germany

"Half Square/Half Crazy," Casa del Fascio, Piazza del Popolo, Como, Italy

"Performance," Lisson New Space, London

2005

Galerie Micheline Szwajcer, Antwerp, Belgium

2006

Castello di Rivoli, Museo d'Arte Contemporanea, Turin, Italy

"Death by Chocolate: West Edmonton Shopping Mall," Orchard, New York

Johnen Galerie, Berlin

2007

"Dan Graham's New Jersey," Arthur Ross Architecture Gallery, Columbia University, New York

Marian Goodman Gallery, Paris

2008

"Dan Graham and Jeppe Hein: From Seriousness to Silliness," Galerie Johnen + Schöttle, Cologne, Germany; and Galerie Rüdiger Schöttle, Munich, Germany

"More of the Same," Hauser & Wirth, Zürich, Switzerland

"Sagittarian Girls," Francesca Minini, Milan, Italy

Selected Group Exhibitions

1966

"Projected Art," Contemporary Wing, Finch College Museum of Art, New York

"Working Drawings and Other Visible Things on Paper not Necessarily Meant to Be Viewed as Art," Visual Arts Gallery, School of Visual Arts, New York

1967

"Art in Series," Contemporary Wing, Finch College Museum of Art, New York

"Artist–Writers," Fordham University, New York

"Cre-action," Goucher College, Baltimore

"Fifteen Artists Present Their Favorite Book," Lannis Museum of Normal Art, New York

"Focus on Light," New Jersey State Museum, Trenton, New Jersey

"Language to Be Looked At—Words to Be Seen," Dwan Gallery, New York

"Language II," Dwan Gallery, New York

1969

"557,087," Seattle Art Museum

"Konzeption/Conception," Städtisches Museum, Leverkusen, Germany

"Language III," Dwan Gallery, New York

"No. 7," Paula Cooper Gallery, New York

"Time Photography," Visual Arts Gallery, School of Visual Arts, New York

1970

"Art in the Mind," Allen Art Museum, Oberlin College, Oberlin, Ohio

"Information," The Museum of Modern Art, New York

"955,000," Vancouver Art Gallery, Vancouver

"Recorded Activities," Moore College of Art and Design, Philadelphia

1971

"Arte de Sistemas," Museo de Arte Moderno de la Ciudad de Buenos Aires

"Earth, Air, Fire, Water: Elements of Art," Museum of Fine Arts, Boston

"John Gibson at Galerie Daniel Templon," Galerie Daniel Templon, Paris

"Prospect 71," Städtische Kunsthalle, Düsseldorf, Germany

7th Bienniale de Paris, Musée d'Art Moderne de la Ville de Paris

"Sonsbeek '71," Park Sonsbeek, Arnhem, The Netherlands

1972

Anna Leonowens Gallery, Nova Scotia College of Art and Design, Halifax, Canada

"Body," John Gibson and Loeb Student Center, New York University, New York

Documenta 5, Kassel, Germany

1974

"Art Video/Confrontation," Musée d'Art Moderne de la Ville de Paris

"Kunst bleibt Kunst: Project 74," Kunstverein, Cologne, Germany

1975

"Painting, Drawing and Sculpture of the 60s and 70s from the Herbert and Dorothy Vogel Collection," Institute of Contemporary Art, University of Pennsylvania, Philadelphia

"A Space: A Thousand Words," Royal College of Art, London

"Video Art," Institute of Contemporary Art, University of Pennsylvania, Philadelphia; Contemporary Arts Center, Cincinnati; Museum of Contemporary Art, Chicago; and Wadsworth Atheneum, Hartford, Connecticut

1976

"Ambiente Arte," XXXVII Biennale di Venezia, Venice, Italy

1977

"American Art in Belgium," Palais des Beaux–Arts, Brussels

Documenta 6, Kassel, Germany

"In Video," Dalhousie Art Gallery, Halifax, Canada; Art Gallery of Ontario, Toronto; and Winnipeg Art Gallery

"Kunst und Architektur," Galerie Magers, Bonn, Germany

"Opening Exhibition of the Permanent Collection," Musée National d'Art Moderne, Centre Georges Pompidou, Paris

"Time," Philadelphia College of Art

1978

"Drawings and Other Works on Paper," Sperone Westwater Fischer, New York

"Numerals 1924–1977," Leo Castelli Gallery, New York

"Videotapes and Diagrams," Centre for Art Tapes, Halifax, Canada

1979

"Accrochage III: Oeuvres contemporaines des collections nationales," Musée National d'Art Moderne, Centre Georges Pompidou, Paris

"Concept, Narrative, Document," Museum of Contemporary Art, Chicago

"Dan Graham, Louis Lawler, Peter Nadin, Lawrence Weiner," Peter Nadin, New York

"Perceiving Time and Space Through Art," Hartnett Gallery, University of Rochester, New York

73rd American Exhibition, The Art Institute of Chicago

"12 Films, Beeldende Kunstenaars," Stichting de Appel, Amsterdam

1980

"New Work," Hal Bromm Gallery, New York

"Television by Artists," a space in cooperation with The Fine Art Broadcast Service, Toronto

"Video," Institute for Art and Urban Resources/P.S. 1, Long Island City, New York

1981

"Artist as Architect/Architect as Artist," Ohio State University Gallery, Columbus

"Construction in Process," Stpwarzuszemie Tworcow Kultury, Lodz, Poland

"Street Sites 2," Institute of Contemporary Art, University of Pennyslvania, Philadelphia

"Video Classics," Bronx Museum of the Arts, New York

"Westkunst," Museen der Stadt Köln, Cologne, Germany

1982

"Cinema & Video," Galerie Rüdiger Schöttle, Munich, Germany

Documenta 7, Kassel, Germany

"Extended Photography," Wiener Secession, Vienna

"Rock Religion: Architecture by Artists," Institute of Contemporary Arts, London

74th American Exhibition, The Art Institute of Chicago

"60–80: Attitudes/Concepts/Images," Stedelijk Museum, Amsterdam

"Spiegel–Bilder," Kunstverein Hannover, Germany; and Haus am Waldsee, Berlin

Biennale of Sydney, Sound Section, Australia

1983

"A Pierre et Marie 3: Une Exposition en Travaux," Galerie Pierre et Marie, Paris

"Artists Use Photographs," Marianne Deson Gallery, Chicago

"1, 2, 3, etc. Progressions numériques dans l'art contemporain," Musée des Beaux-Arts et d'Archéologie, Besançon, France; and Musée Rolin, Autun, France

"Scenes and Conventions in Architecture by Artists," Institute of Contemporary Arts, London

"Sessanta Opere," Galleria Massimo Minini, Brescia, Italy

1984

"L'Art et le temps," Palais des Beaux-Arts, Brussels

"Flyktpunker/Vanishing Points," Moderna Museet, Stockholm

"Le Livre," Galerie Pierre et Marie, Paris

"Repertoire: Werken uit de collectie Anton Herbert," Stedelijk Van Abbemuseum, Eindhoven, The Netherlands

"Skulptur im 20. Jahrhundert," Merian Park, Basel, Switzerland

1985

"The Art of Memory/The Loss of History," New Museum of Contemporary Art, New York

"Les Immateriaux," Musée National d'Art Moderne, Centre Georges Pompidou, Paris

"Louis XIV Tanzt, Purgatorium, Inferno rette sich wer kann," Galerie der Künstler, Munich, Germany

Nouvelle Biennale de Paris, La Villette, Paris

1986

"Chambre d'Amis," Museum van Hedendaagse Kunst, Ghent, Belgium

"Sonsbeek '86," Park Sonsbeek, Arnhem, The Netherlands

"Le Temps regards sur la quatrième dimension," Le Nouveau Musée/Institut d'Art Contemporain, Villeurbanne, France

"Video," Hallwalls, Buffalo, New York

"Video by Artists," Art Metropole, Toronto

1987

"L'Epoque, la mode, la morale, la passion: Aspects de l'art d'au'jourd'hui 1977–1987," Musée National d'Art Moderne, Centre Georges Pompidou, Paris

"Skulptur Projekte in Münster," Westfälisches Landesmuseum, Münster, Germany

Whitney Biennial, Whitney Museum of American Art, New York

1988

"Accrochage I," Galerie Meert Rihoux, Brussels

"Future of Storefront," Storefront for Art and Architecture, New York

"1967: At the Crossroads," Institute of Contemporary Art, University of Pennsylvania, Philadelphia

"The Viewer as Voyeur," Whitney Museum of American Art, New York

1989

"L'Art conceptuel, une perspective," Musée d'Art Moderne de la Ville de Paris; Fundación Caja de Pensiones, Madrid; Musée d'Art Contemporain, Montréal; and Deichtorhallen, Hamburg, Germany

"Image World: Art and Media Culture," Whitney Museum of American Art, New York

"International Landscape," Galerie Christoph Dürr/Leitung Matthias Buck, Munich, Germany

"Play of the Unsayable: Wittgenstein and the Art of the 20th Century," Wiener Secession, Vienna; and Palais des Beaux-Arts, Brussels

"The Presence of Absence: New Installations," University of Illinois at Chicago; University of Arizona Museum of Art, Tucson; Laumeier Sculpture Park and Garden, St. Louis, Missouri; Albany Institute of History and Art, New York; Oakville Galleries, Gairloch Gardens, Oakville, Canada; University of Kentucky Art Museum, Lexington; Longview Museum and Arts Center, Longview, Texas; Prichard Art Gallery, University of Idaho, Moscow; Museum of Art, The Pennsylvania State University, University Park; University of Iowa Museum of Art, Iowa City; and University of New Mexico Art Museum, Albuquerque

"Some Detached Houses," Contemporary Art Gallery, Vancouver

"Suburban Home Life: Tracking the American Dream," Whitney Museum of American Art at Federal Reserve Plaza, New York, and 1 Champion Plaza, Stamford, Connecticut

"Theatergarden Bestiarium," Institute for Contemporary Art/P.S. 1 Museum, Long Island City, New York; El Casino de la Exposición, Seville, Spain; and Le Confort Moderne, Poitiers, France

1990

"Affinities and Intuitions: The Gerald S. Elliott Collection of Contemporary Art," The Art Institute of Chicago

"L'Art conceptuel/Formes conceptuelles," Galerie 1900–2000 and Galerie de Poche, Paris

"Passages de l'Image," Musée National d'Art Moderne, Centre Georges Pompidou, Paris; Fundació Caixa de Pensions, Barcelona, Spain; Wexner Center for the Arts, Ohio State University, Columbus; and San Francisco Museum of Modern Art

1991

Carnegie International, Carnegie Museum of Art, Pittsburgh

"A Dialogue about Recent American and European Photography," The Museum of Contemporary Art, Los Angeles

"Inscapes," Foundation de Appel, Amsterdam

1992

"Ars Electronica," Linz, Austria

Documenta 9, Kassel, Germany

"Like Nothing Else in Tennessee," Serpentine Gallery, London

1993

"American Art of the Twentieth Century," Martin-Gropius-Bau, Berlin; and Royal Academy of Arts, London

"Die Arena des Privaten," Kunstverein, Munich, Germany

"5th Semaine Internationale de Video," Saint-Gervais, Geneva, Swizerland

"Passageworks," Rooseum Center for Contemporary Art, Malmö, Sweden

1994

"Crash," Thread Waxing Space, New York

"Films on Art," National Gallery of Art, Washington, D.C.

"House Rules," Wexner Center for the Arts, Ohio State University, Columbus

Inaugural exhibition, Musée d'Art Moderne et Contemporain, Geneva, Switzerland

"Pictures of the Real World (In Real Time)," Paula Cooper Gallery, New York

"Radical Scavenger(s), The Conceptual Vernacular in Recent American Art," Museum of Contemporary Art, Chicago

"Toujours Modern," Le Nouveau Musée/ Institut d'Art Contemporain, Villeurbanne, France

1995

"Light Construction," The Museum of Modern Art, New York

Lyon Biennial, France

"Mapping," American Fine Arts Co., New York

"1965–75: Reconsidering the Object of Art," The Museum of Contemporary Art, Los Angeles

"Public Information: Desire, Disaster, Document," San Francisco Museum of Modern Art

1996

"Everything That's Interesting Is New: The Dakis Joannou Collection," Athens School of Fine Arts

"Home Show II," Santa Barbara Contemporary Arts Forum, California

"Project for Survival," National Museum of Modern Art, Kyoto, Japan; and National Museum of Modern Art, Tokyo

1997

Documenta X, Kassel, Germany

Institute for Art and Urban Resources/ P.S. 1, Long Island City, New York

"Künstlerinnen: 50 Positionen zeitgenössischer internationaler Kunst," Kunsthaus Bregenz, Austria

"Rooms with a View: Environments for Video," Solomon R. Guggenheim Museum, New York

"Skulptur Projekte in Münster," Westfälisches Landesmuseum, Münster, Germany

Whitney Biennial, Whitney Museum of American Art, New York

1998

"Berlin/Berlin," Berlin Biennale, Berlin

"I Love New York," Museum Ludwig Köln, Cologne, Germany

"Sharawadgi," Felsenvilla, Baden, Austria

"Weather Everything," Galerie für zeitgenössische Kunst, Leipzig, Germany

1999

"The American Century: Art and Culture (1950–2000)," Whitney Museum of American Art, New York

"Circa 1968," Museu de Serralves, Porto, Portugal

"Seeing Time: Selections from the Pamela and Richard Kramlich Collection of Media Art," San Francisco Museum of Modern Art

"The Self Is Something Else: Art at the End of the 20th Century," Kunstsammlung Nordrhein-Westfalen, Düsseldorf, Germany

2000

"Hex Enduction Hour by the Fall," Team Gallery, New York

"Let's Entertain: Life's Guilty Pleasures," Walker Art Center, Minneapolis; Portland Art Museum, Oregon; Musée National d'Art Moderne, Centre Georges Pompidou, Paris; Kunstmuseum, Wolfsburg, Germany; and Miami Art Museum, Miami

"Many Colored Objects Placed Side by Side to Form a Row of Many Colored Objects: Works from the Collection of Annick and Anton Herbert," Casino Luxembourg— Forum d'Art Contemporain, Luxembourg

"Media City Seoul 2000," International Media Art Bienniale, Seoul

"Postmedia: Conceptual Photography in the Guggenheim Museum Collection," Solomon R. Guggenheim Museum, New York

"La Ville/Le Jardin/Le Mémoire," Académie de France, Villa Medici, Rome

2001

"CTRL [SPACE]," Zentrum für Kunst und Medientechnologie, Karlsruhe, Germany

"Demonstration Room: Ideal House," Apex Art, New York

"Flashing Into the Shadows: The Artist's Film in America, 1966–1978," Whitney Museum of American Art, New York; Cleveland Museum of Art, Ohio; and Centro Cultural de Belém, Lisbon

"Import/Export: The Miami Arts Project 2001," Miami

"Into the Light: The Projected Image in American Art 1964–1977," Whitney Museum of American Art, New York

"Mia san mia," Generali Foundation, Vienna

2002

"Artists Imagine Architecture," Institute of Contemporary Art, Boston

"I promise it's political," Ludwig Museum, Cologne, Germany

"My Head Is on Fire but My Heart Is Full of Love," Charlottenborg Udstillingsbygning, Copenhagen

"Painting on the Move," Kunsthalle Basel, Switzerland

"Passenger: The Viewer as Participant," Astrup Fearnley Museet for Moderne Kunst, Oslo

"Public Affairs," Kunsthaus Zürich, Switzerland

"The Seventies: Art in Question," Musée d'Art Contemporain, Bordeaux, France

"Video Acts: Single-Channel Works from the Collections of Pamela and Richard Kramlich and New Art Trust," Institute of Contemporary Arts, London; and P.S. 1 Contemporary Art Center, New York

2003

"Darrere els fets/Behind the Facts: Interfunktionen 1968–1975," Fundació Joan Miró, Barcelona, Spain; Fundação de Serralves, Porto, Portugal; and Kunsthalle Fridericianum, Kassel, Germany

"Delays and Revolutions," Italian Pavilion, L Biennale di Venezia, Venice, Italy

"Dreams and Conflicts: The Viewer's Dictatorship," L Biennale di Venezia, Venice, Italy

"The Fourth Sex: Adolescent Extremes," Stazione Leopolda (produced by Fondazione Pitti Imagine Discovery), Florence, Italy

"Happiness: A Survival Guide for Art and Life," Mori Art Museum, Tokyo

"The Last Picture Show: Artists Using Photography, 1960–1982," Walker Art Center, Minneapolis; UCLA Hammer Museum, Los Angeles; Museo de Arte Contemporánea de Vigo, Spain; Fotomuseum, Winterthur, Switzerland; and Miami Art Center, Florida

"The Seventh Art: New Dimensions in Cinema," San Francisco Museum of Modern Art

2004

"Art and Utopia: Limited Action," Museu d'Art Contemporani de Barcelona, Spain; and Musée des Beaux-Arts, Nantes, France

"Beyond Geometry: Experiments in Form, 1940s–70s," Los Angeles County Museum of Art, Los Angeles; and Miami Art Museum, Miami

"The Friedrich Christian Flick Collection in the Hamburger Bahnhof," Hamburger Bahnhof, Museum für Gegenwart, Berlin

"Metamorph," 9th International Architecture Exhibition, La Biennale di Venezia, Venice, Italy

"A Minimal Future? Art as Object 1958–1968," The Museum of Contemporary Art, Los Angeles

2005

"Beyond: An Extraordinary Space of Experimentation for Modernization," Second Guangzhou Triennial, Guangdong Museum of Art, Guangzhou, China

"Down the Garden Path: The Artist's Garden After Modernism," Queens Museum of Art, New York

"The Experience of Art," LI Biennale di Venezia, Venice, Italy

"M Stadt—European Cityscapes," Kunsthaus Graz, Austria

"Minimalism and After IV," Daimler Contemporary, Berlin

"Occupying Space: Generali Foundation Collection," Haus der Kunst, Munich, Germany; Witte de With Center for Contemporary Art, TENT., and Nederlands Fotomuseum, Rotterdam, The Netherlands; and Museum of Contemporary Art, Zagreb

"Open Systems: Rethinking Art c. 1970," Tate Modern, London

"Single-Screen Selections of Rare Film and Audio from the Pamela and Richard Kramlich Collection," The Fabric Workshop and Museum, Philadelphia

"Slideshow," Baltimore Museum of Art, Maryland; and Contemporary Arts Center, Cincinnati, Ohio

2006

"Beyond Cinema: The Art of Projection Works from the Friedrich Christian Flick Collection in Hamburger Bahnhof and Loans," Hamburger Bahnhof, Museum für Gegenwart, Berlin

"Collection Sylvio Perlstein: busy going crazy," La Maison Rouge, Paris

"...Concept Has Never Meant Horse," Generali Foundation, Vienna

"The Downtown Show: The New York Art Scene 1974–84," Grey Art Gallery and Fales Library, Special Collections, New York University, New York; Andy Warhol Museum, Pittsburgh; and Austin Museum of Art, Texas

"Draft Deceit," Kunstnernes Hus/Office for Contemporary Art, Oslo

"The Early Show: Video from 1969–79," Bertha and Karl Leubsdorf Art Gallery, Hunter College, New York

"Ideal City—Invisible Cities," Öffentlicher Raum Potsdam, Germany

"Interventions," Thomas Solomon Gallery @ Rental Gallery, Los Angeles

"Intouchable: L'idéal transparence," Centre National d'Art Contemporain, Villa Arson, Nice, France

"Inventur: Werke aus der Sammlung Herbert/Inventory: Works from the Herbert Collection," Museu d'Art Contemporani de Barcelona; and Kunsthaus Graz am Landesmuseum Joanneum, Austria

"Strictement confidentiel: A partir de la collection de Marc et Josée Gensollen," Centre International d'Art et du Paysage, Ile de Vassivière, France

"25 Jahre österreichische Ludwig Stiftung," Museum Moderner Kunst Stiftung Ludwig Wien, Vienna

27th Bienal de São Paulo, Brazil

"Video Times 1965–2005: The New Media Collection of the Centre Pompidou with the Participation of 'La Caixa' Foundation of Contemporary Art Collection," CaixaForum, Barcelona; Taipei Fine Arts Museum; Miami Art Central, Florida; Museum of Contemporary Art, Sydney, Australia; Australian Centre for the Moving Image, Melbourne, Australia; and Museu do Chiado, Lisbon

"Whitney Biennial: Day for Night," Whitney Museum of American Art, New York

2007

"Gartenlust. Der Garten in der Kunst," Atelier Augarten, Vienna

"Kinomuseum," 53. Internationale Kurzfilmtage, Oberhausen, Germany

"KölnSkulptur 4," Skulpturenpark, Cologne, Germany

"MACBA im Frankfurter Kunstverein: Eine Werkauswahl aus der Sammlung des Museu d'Art Contemporani de Barcelona," Frankfurter Kunstverein, Frankurt am Main, Germany

"Mapping the City," Stedelijk Museum, Amsterdam

"Ohne Wenn und Aber: Die Schenkung Bogner," Museum Moderner Kunst Stiftung Ludwig Wien, Vienna

"Sammlung," Generali Foundation, Vienna

"Someone Else's House," 6 Hillsleigh Road, Notting Hill, London

"Sympathy for the Devil: Art and Rock and Roll Since 1967," Museum of Contemporary Art, Chicago

"A Theatre without Theatre," Museu d'Art Contemporani de Barcelona, Spain; and Museu Colecção Berardo, Lisbon

"Zwischen zwei Toden/Between two deaths," ZKM/Zentrum für Kunst und Medientechnologie, Karlsruhe, Germany

2008

"Anniversary Exhibition," Galleri Nicolai Wallner, Copenhagen

"The Art of Participation: 1950 to Now," San Francisco Museum of Modern Art

"Color Chart: Reinventing Color, 1950 to Now," The Museum of Modern Art, New York

"Genau und Anders. Mathematik in der Kunst von Dürer bis Sol LeWitt," Museum Moderner Kunst Stiftung Ludwig Wien, Vienna

"The Impossible Prison" (organized by Nottingham Contemporary), Galleries of Justice, Nottingham, United Kingdom

"Kavalierstart 1978–1982: Aufbruch in die Kunst der 80er," Museum Morsbroich, Leverkusen, Germany

"Revolutions—Forms That Turn," 16th Biennale of Sydney, Australia

"Sonic Youth etc.: Sensational Fix," LiFE, St. Nazaire, France; Museion—Museum für moderne und zeitgenössische Kunst, Bolzano, Italy; Kunsthalle Düsseldorf, Germany; Malmö Konsthall, Sweden; and Centro Huarte de Arte Contemporáneo, Navarra, Spain

"Worlds Away: New Suburban Landscapes," Walker Art Center, Minneapolis; Carnegie Museum of Art, Pittsburgh; and Yale School of Architecture, New Haven, Connecticut

DAN GRAHAM'S

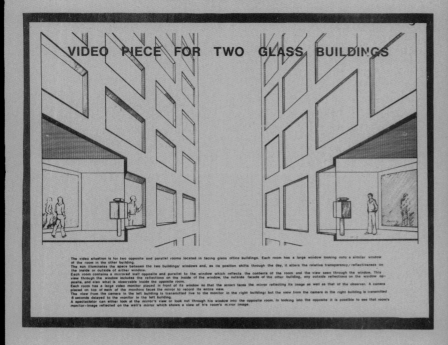

VIDEO PIECE FOR TWO GLASS BUILDINGS

The video situation is for two opposite and parallel rooms located in facing glass office buildings. Each room has a large window looking onto a similar window of the room in the other building.
The sun illuminates the space between the two buildings' windows and, as its position shifts through the day, it alters the relative transparency/reflectiveness on the inside or outside of either windows.
Each room contains a mirrored wall opposite and parallel to the window which reflects the contents of the room and the view seen through the window. This view through the window includes the reflections on the inside of the window, the outside facade of the other building, any outside reflections on the window opposite, and also what is observable inside that opposite room.
Each room has a large video monitor placed in front of its window so that the screen faces the mirror reflecting its image as well as that of the observer. A camera placed on top of each of the monitors faces the mirror to record its entire view.
The view from the camera in the left building is transmitted live to the monitor in the right building; but the view from the camera in the right building is transmitted 8 seconds delayed to the monitor in the left building.
A spectator can either look at the mirror's view or look out through his window into the opposite room. In looking into the opposite it is possible to see that room's monitor-image reflected on the wall's mirror which shows a view of his room's mirror image.

IN ROOM H603 (IN THE ART BUILDING)

AND ROOM F603 (IN THE HOME ECONOMICS AND EDUCATION BUILDING)

OPEN TO THE PUBLIC 10.30 A.M. TO 4.00 P.M.
MONDAY 13, TUESDAY 14, WEDNESDAY 15 JUNE 1977.

DAN GRAHAM: VIDEO PROJECTION OUTSIDE HOME (1978)
VIDEO PROJEKTION VOR EINEM WOHNHAUS (1978)

Ein großer ADVENT Video-Projektionsschirm wird auf dem Rasen vor dem Haus aufgestellt, so daß er auf die Fußgänger des Gehwegs gerichtet ist. Er zeigt das Bild von jedem TV-Programm, das die Familie auf ihrem Fernsehschirm im Haus sieht. Wenn dieses ausgeschaltet ist, bleibt der Video-Projektor ausgeschaltet; wenn die Kanäle gewechselt werden, ist dies auf dem vergrößerten, öffentlichen Bildschirm außerhalb des Hauses zu sehen.

VITO ACCONCI GIOVANNI ANSELMO ELEANOR ANTIN ROBERT ASHLEY DAVID ASKEVOLD JOHN BALDASSARI KARL BEVRIDGE WALLACE BRANNEN GENE DAVIS GRAHAM DUBE GERALD FERGUSON DAN GRAHAM DOUG HEUBLER NELSON HOWE RICK JAMES RICHARDS JARDEN GARRY KENNEDY SHARON KULIK LES LEVINE GARY MARCUSE TOM MARIONI MARIO MERTZ MIKE METZ KARL MILER DONALD MUNROE IAN MURRAY BRUCE NAUMAN ROBIN PECK BILL RUFFER MICHAEL SNOW ALAN SONDHEIM PETR STEMBRA JOAN SWARTZ DOUG WATERMAN LAWRENCE WEINER MARTHA WILSON JON YOUNG LA MONTE YOUNG TIM ZUCK ORGANIZED BY IAN MURRAY ANNA LEONOWENS GALLERY NOVA SCOTIA COLLEGE OF ART AND DESIGN 6152 COBURG ROAD HALIFAX NOVA SCOTIA CANADA AUGUST 18-SEPTEMBER 12 1972 12-5 DAILY 12-10 THURSDAYS

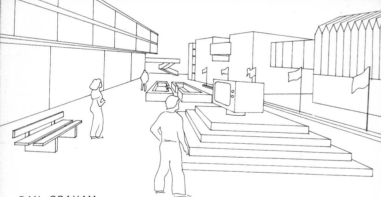

DAN GRAHAM
VIDEOTAPES AND DIAGRAMS APRIL 18 - 28 1979

Centre for Art tapes 1671 Argyle St., Halifax, N.S. B3J 2B5
Opens 8 p.m. Wed. 18 Viewing Monday to Saturday Noon till 5

DAN GRAHAM
LIVE PERFORMANCE
PROTETCH-RIVKIN
8:00 TO 10:00 P.M.
FRIDAY MAY 5TH

DAN GRAHAM

8.2.75 ore 20

Lucio Amelio
Modern Art Agency
58 Piazza dei Martiri
80121 Napoli 081 399023

CONFERENCE

'GARDEN AS EDUCATIONAL PARK'

- FROM ITALIAN RENAISSANCE GARDEN TO LA VILLETTE -

The Work shown in this space is a response to the existing
conditions and/or work previously shown within the space.

Nov. 9—
 30 days work:
 1,450 sq. ft.
 Function by Peter Nadin
 Design by function
 Execution by Peter Nadin , Christopher D'Arcangelo and Nick Lawson
 Materials: Compound, Drywall, Wood, Nails, Paint.

We have joined together to execute functional constructions and to alter or
refurbish existing structures as a means of surviving in a capitalist
economy.

Dec. 12 1978—
 FOLLOWING AND TO BE FOLLOWED.
 A work in situ by DANIEL BUREN
 Opening Tuesday, Dec. 12 7-9 pm.

Feb 1 1979—
 PAINTING FOR ONE PLACE
 SEAN SCULLY

Mar 28 1979—
 JANE REYNOLDS

Apr 19-25 1979
 A PLACE TO STAY / CONCERNING A DUALITY
 OF FUNCTION

APRIL 26, 1979— AROOM
 DEFIN
 EDNOT
 BYITS
 WALLS
 BUTBY
 APUMP PETER FEND

MAY 16, 1979
8PM
 RHYS CHATHAM
 performance with
 GLENN BRANCA
 and NINA CANAL

MAY 30, 1979

DAN GRAHAM LOUISE LAWLER

PETER NADIN LAWRENCE WEINER

This Work may be seen every thurs thru sat 1-6pm at
Peter Nadin, 3n 84 West Broadway, N.Y., N.Y. 10007.

Lundi 21 Mars 1988, 19 h.

SOUS·SOL Ecole supérieure
 d'art visuel
 2, rue Général-Dufour
 1204 GENÈVE
 Tél. 022 / 21 67 06

DAN GRAHAM

1965 SCHEME (1965) 1969 INCOME (OUTGO) PIECE
1966 SCHEMA (MARCH, 1966) 1969 TIME/PLACE EXTENSION
1966 MARCH 31, 1966 1970 TV CAMERA/MONITOR PERFORMANCE
1966 SIDE EFFECT/COMMON DRUGS 1972 PAST FUTURE SPLIT ATTENTION
1966 TWO HOME HOUSE
1966 HOMES FOR AMERICA 1978 ALTERATION OF A SUBURBAN HOUSE

HOTEL WOLFERS
RUE A. RENARD 60
1060 BRUXELLES

DU 16.1.82 AU 6.3.82.- LE SAMEDI DE 14 H. A 17 H. OU SUR RENDEZ-VOUS (TÉL. : 02 / 648.33.82)

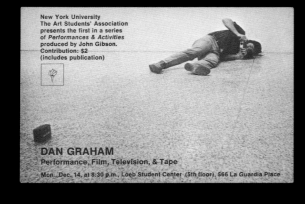

New York University
The Art Students' Association
presents the first in a series
of *Performances & Activities*
produced by John Gibson.
Contribution: $2
(includes publication)

DAN GRAHAM
Performance, Film, Television, & Tape
Mon., Dec. 14, at 8:30 p.m., Loeb Student Center (5th floor), 566 La Guardia Place

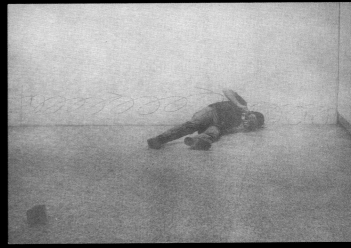

Selected Bibliography

Compiled by Christine Robinson The "Bibliography of Writings, Interviews, and Catalogues" in *Dan Graham: Works 1965–2000* (Düsseldorf, Germany: Richter Verlag, 2001) proved to be an incredibly valuable resource and served as a helpful starting point for this compilation.

Selected Catalogues and Books

1969

Graham, Dan. *End Moments.* New York: Dan Graham, 1969.

1970

Dan Graham: Some Photographic Projects. New York: John Gibson Gallery, 1970.

Dan Graham. New York: John Gibson Gallery, 1970.

Performance 1. New York: John Gibson Gallery, 1970.

Two Parallel Essays/Photographs of Motion/Two Related Projects for Slide Projectors. New York: Multiples Inc., 1970.

1972

Selected Works 1965–1972. London: Lisson Publications; and Cologne, Germany: König Brothers, 1972.

1974

Dan Graham: Textes. Brussels: Galerie 17 and Editions Daled, 1974.

1975

Graham, Dan. *For Publication.* Los Angeles: Otis Art Institute of Los Angeles County, 1975. Reprint, New York: Marian Goodman Gallery, 1991.

1976

Dan Graham. Basel, Switzerland: Kunsthalle Basel, 1976.

Six Films. New York: Artists Space, 1976. Xerox brochure for film program, 2 and 3 January 1976.

1977

Films. Geneva, Switzerland: Éditions Centre d'Art Contemporain and Écart Publications, 1977.

1978

Dan Graham: Articles. Eindhoven, The Netherlands: Stedelijk Van Abbemuseum, 1978.

1979

Buchloh, Benjamin H. D., ed. *Dan Graham: Video–Architecture–Television, Writings on Video and Video Works, 1970–1978.* Halifax, Canada: Nova Scotia College of Art and Design Press; and New York: New York University Press, 1979.

1981

Dan Graham: Theatre. Ghent, Belgium: Anton Herbert, 1981.

Rorimer, Anne, ed. *Dan Graham: Buildings and Signs.* Chicago: The Renaissance Society at the University of Chicago; and Oxford, England: Museum of Modern Art, 1981.

1982

Dan Graham. Brussels: Editions Daled, 1982.

1983

Martin, Jean–Hubert, ed. *Dan Graham: Pavilions.* Bern: Kunsthalle Bern, 1983.

1985

Dan Graham. Perth: The Art Gallery of Western Australia, 1985.

1987

Dan Graham. Paris: Musée d'Art Moderne de la Ville de Paris/ARC, 1987.

Dan Graham. Madrid: Centro de Arte Reina Sofía, Ministerio de Cultura, 1987.

Dan Graham: Art as Design/Design as Art. Edinburgh: Fruitmarket Gallery, 1987.

1988

Bischoff, Ulrich, ed. *Dan Graham: Sculpture–Pavillons.* Kiel, Germany: Kunsthalle zu Kiel, 1988.

Dan Graham: Pavillons. Munich, Germany: Kunstverein München, 1988.

Wall, Jeff. *Kammerspiel de Dan Graham.* Brussels: Editions Daled–Goldschmidt, 1988. Published in English as *Dan Graham's Kammerspiel.* Canada: Art Metropole, 1991.

1989

Dan Graham, Jeff Wall: Children's Pavilion. Lyon, France: Villa Gillet—Fonds Régional d'Art Contemporain Rhône–Alpes, 1989.

Teatrojardin Bestiarium. Seville, Spain: Junta de Andalucia, Consejeria de Cultura, 1989. Published in French as *Bestiarium Jardin–Théâtre.* Poitiers, France: Entrepot—Galerie du Confort Moderne, 1989. Published in English as *Theatergarden Bestiarium: The Garden as Theater as Museum.* Long Island City, New York: The Institute for Contemporary Art/P.S. 1 Museum; and Cambridge, Massachusetts: The MIT Press, 1990.

1990

Dan Graham. Yamaguchi City, Japan: Yamaguchi Prefectural Museum of Art, 1990.

Dan Graham: Drawings, 1965–1969. Graz, Austria: Galerie Bleich–Rossi, 1990.

1991

Dan Graham. Rivara/Turin, Italy: Castello di Rivara, Franz Paludetto, 1991.

1992

Dan Graham: Ma position—Écrits sur mes œuvres. Vol. 1. Villeurbanne, France: Le Nouveau Musée/Institut Les Presses du Réel, 1992. *Dan Graham: Rock My Religion.* Vol. 2. Villeurbanne, France: Le Nouveau Musée/Institut Les Presses du Réel, 1993.

Dan Graham: Triangular Pavilion for Secession Wien. Vienna: Wiener Secession, 1992.

Dan Graham: Two–Way Mirror Cylinder Inside Cube and a Video Salon. New York: Dia Center for the Arts, 1992.

Walker Evans & Dan Graham. Rotterdam, The Netherlands: Witte de With, Center for Contemporary Art; Marseille, France: Musée Cantini de Marseille; Münster, Germany: Westfälisches Landesmuseum; and New York: Whitney Museum of American Art, 1992.

1993

Dan Graham: Kunst und Architektur/Architektur und Kunst. Munich, Germany: Museum Villa Stuck; and Eindhoven, The Netherlands: Van Abbemuseum, 1993.

Dan Graham: Public/Private. Philadelphia: Paley Levy Galleries, Moore College of Art and Design, 1993.

Graham, Dan. *Rock My Religion: Writings and Projects 1965–1990.* Ed. Brian Wallis. Cambridge, Massachusetts: The MIT Press, 1992.

1994

Dan Graham: Ausgewählte Schriften. Ed. Ulrich Wilmes. Stuttgart, Germany: Oktagon Verlag, 1994.

Dan Graham: Nouveau labyrinth pour Nantes. Nantes, France: Ville de Nantes/DGAU, 1994.

Graham, Dan, and Marie-Paule Macdonald. *Wild in the Streets: The Sixties.* Ghent, Belgium: Imschoot Publishers, 1994.

1995

Breitwieser, Sabine, ed. *Dan Graham: Video/Architecture/ Performance.* Vienna: EA Generali Foundation, 1995.

Dan Graham. Paris: Éditions Dis Voir, 1995.

1996

Dan Graham: Models to Projects. New York: Marian Goodman Gallery, 1996.

Metzger, Rainer. *Kunst in der Postmoderne: Dan Graham.* Cologne, Germany: Walther König, 1996.

Vischer, Theodora, ed. *Dan Graham: The Suburban City.* Basel, Switzerland: Museum für Gegenwartskunst, 1996.

Zevi, Adachiara, ed. *Dan Graham: Selected Writings and Interviews on Art Works, 1965–1995.* Rome: I Libri di Zerynthia, 1996.

1997

Dan Graham. Santiago de Compostela, Spain: Xunta de Galicia, Consellería de Cultura e Communicación Social, 1997.

Dan Graham: Architecture. London: Camden Arts Centre and AA Publications, Architectural Association, 1997.

Huber, Hans-Dieter, ed. *Dan Graham: Interviews.* Ostfildern-Ruit, Germany: Cantz, 1997.

Köttering, Martin, and Roland Nachtigäller, eds. *Dan Graham: Two-Way Mirror Pavilions/ Einwegspiegel-Pavillons 1989–1996.* Nordhorn, Germany: Städtische Galerie Nordhorn, 1997.

Moure, Gloria, ed. *Dan Graham.* Santiago de Compostela, Spain: Centro Galego de Arte Contemporánea, 1997; and Barcelona, Spain: Fundació Antoni Tàpies, 1997.

1999

Dan Graham: Rock/music textes. Ed. Vincent Pécoil. Dijon, France: Les Presses du Réel, 1999.

Two-Way Mirror Power: Selected Writings by Dan Graham on His Art. Ed. Alexander Alberro. Cambridge, Massachusetts: The MIT Press; and New York: Marian Goodman Gallery, 1999.

2000

Wachtmeister, Marika, ed. *Dan Graham: Two Different Anamorphic Surfaces.* Laholm, Sweden: The Wanås Foundation, 2000.

2001

Dan Graham. London: Phaidon Press, 2001.

Dan Graham: Works 1965–2000. Düsseldorf, Germany: Richter Verlag, 2001.

2003

Mizunuma, Hirokazu, Makiko Matake, and Shin'ichi Hanada, eds. *Dan Graham by Dan Graham.* Chiba City, Japan: Chiba City Museum of Art; and Kitakyushu, Japan: Kitakyushu Municipal Museum of Art, 2003.

Waterloo Sunset at the Hayward Gallery. London: Hayward Gallery, 2003.

2005

Dan Graham: Half Square/Half Crazy. Milan: Charta, 2005.

Don't Trust Anyone Over Thirty. Vienna: Thyssen-Bornemisza Art Contemporary, 2005.

2008

Stemmrich, Gregor. *Dan Graham.* Cologne, Germany: Dumont, 2008.

Selected Writings and Interviews

1966

"Homes for America: Early 20th-Century Possessable House to the Quasi-Discrete Cell of '66." *Arts Magazine* 41, no. 3 (December 1966–January 1967): 21–22.

1967

"The Artist as Bookmaker [II]: The Book as Object." *Arts Magazine* 41, no. 8 (summer 1967): 23. See expanded version "Information" in *End Moments* (1969), 39–42.

"Carl Andre." *Arts Magazine* 42, no. 3 (December 1967–January 1968): 34–35.

"Dan Flavin." In *Dan Flavin: Pink and Gold*, n.p. Chicago: Museum of Contemporary Art, 1967. Also published as "Flavin's Proposal," *Arts Magazine* 44, no. 4 (February 1970): 44–45.

"Muybridge Moments." *Arts Magazine* 41, no. 4 (February 1967): 23–24. See also "Photographs of Motion" in *End Moments* (1969), 31–38; and "Photographs of Motion" and "Two Related Projects for Slide Projectors" in *Two Parallel Essays/Photographs of Motion/Two Related Projects for Slide Projectors* (1970).

"Models and Monuments." *Arts Magazine* 41, no. 5 (March 1967): 32–35.

"Of Monuments and Dreams." *Art and Artists* 1, no. 12 (March 1967): 62–63.

1968

"Holes and Lights: A Rock Concert Special." *Straight* 1, no. 1 (April 1968): 1–2.

"Oldenburg's Monuments." *Artforum* 6, no. 5 (January 1968): 30–37.

1969

"Art Workers' Coalition Open Hearing Presentation (10 April 1969)." In *An Open Hearing on the Subject: What Should Be the Program of the Art Workers Regarding Museum Reform and to Establish the Program of an Open Art Workers' Coalition*. New York: Art Workers' Coalition, 1969.

"Eisenhower and the Hippies." *0 to 9*, no. 6 (July 1969): 30–37.

"Foams" and "March 31, 1966." In *Extensions*, no. 2 (1969): 34–35, 59.

"Live Kinks." *Fusion* (1969).

"Subject Matter." In *End Moments* (1969), 15–30.

"Synthetic High & Natural Low: Dean Martin on TV." *Fusion* (1969): 12–13. Reprinted as "Dean Martin/ Entertainment as Satire" in *End Moments* (1969), 7–14. Alternate title: "Dean Martin/Entertainment as Theater."

"Two Structures/Sol LeWitt." In *End Moments* (1969), 65–68. Also as "Thoughts on Two Structures" in *Sol LeWitt*, 24–25. The Hague, The Netherlands: Haags Gemeentemuseum, 1970.

1970

"Ecological Rock." In Henry J. Korn and Richard Kostelanetz, eds. *Assembling*, no. 1 (1970). Also as "Country Trip" in *Performance 1* (1970), 32–34.

"Editorial: One Proposal." *Aspen*, no. 8 (fall–winter 1970–71). Earlier version dated 1967–68 published in *For Publication* (1975).

"Eleven Sugar Cubes." *Art in America* 58, no. 3 (May–June 1970): 78–79.

"Late Kinks." *Revista de Letras* (Universidad de Puerto Rico Mayaguez) 2, no. 5 (March 1970): 43–48; and in *Performance 1* (1970), 23–28. See also "Live Kinks."

"Several Works." *Interfunktionen*, no. 5 (November 1970): 153.

1971

"Like." In "Future's Fictions," special issue edited by Richard Kostelanetz. *Panache* (New York) (1971): 68.

Pluchart, François. "Entretien avec Dan Graham." *ArTitudes*, no. 3 (December 1971–January 1972): 22.

"Several Works" and "Performance as Perceptual Process." *Interfunktionen*, no. 7 (1971): 83–89.

"TV Camera/Monitor Performance." *Radical Software* (fall 1971). Reprinted in *TDR* (June 1972).

1972

"Dan Graham, Galleria Toselli, Milano." *King Kong International*, no. 2 (July 1972): 12.

"Eight Pieces by Dan Graham, 1966–72." *Studio International* 183, no. 944 (May 1972): 210–13.

"Film Pieces: Visual Field." *Interfunktionen*, no. 8 (January 1972): 27–33.

"Pieces." *Flash Art*, nos. 35–36 (September–October 1972): 8.

1973

"Le Corps materiel perceptuel." *L'Art vivant*, no. 1 (July 1973).

"Dan Graham, Various Pieces." *Interfunktionen*, no. 9 (1973): 57–64.

Field, Simon. "Dan Graham: An Interview with Simon Field." *Art and Artists* 7, no. 10 (January 1973): 16–21.

Graham, Dan, and Tomasso Trini. "Dan Graham I/Eye." *Domus*, no. 519 (February 1973): 51.

"Intention Intentionality Sequence." *Arts Magazine* 47, no. 6 (April 1973): 64–65.

"Magazine/Ads" and "Income (Outflow Piece) 1969." In *Deurle 11/7/73*. Brussels: MTL, 1973.

"Two Correlated Rotations." In Richard Kostelanetz, ed. *Breakthrough Fictioneers*. Boston: Something Else Press, 1973.

1974

"Das Buch als Objekt/The Book as Object" and "Notes on Income (Outflow Piece)." *Interfunktionen*, no. 11 (1974): 108–19.

"Two Consciousness Projection(s)." *Arts Magazine* 49, no. 4 (December 1974): 63–66.

1975

"Dan Graham: Architecture/Video Projects." *Studio International* 190, no. 977 (September–October 1975): 143–46.

"Income (Outflow) Piece 1969." *Control Magazine*, no. 9 (1975): 5–7.

1976

"Elements of Video/Elements of Architecture." In *Video by Artists*, 193–95. Ed. Peggy Gale. Toronto: Art Metropole, 1976.

"Environment/Time-Delayed Reflections." *Casabella* 411 (March 1976): 29–33.

"Film and Performance/Six Films, 1969–74." *Six Films*. New York: Artists Space, 1976.

"Public Space/Two Audiences." *+ – 0 (Revue d'Art Contemporain)*, no. 14 (September 1976): 6–7. See later version of "Public Space/Two Audiences" in *Buildings and Signs* (1981), 23–24.

1977

"Duchamp/Morris." *Connaissance des Arts*, no. 299 (January 1977): 47–55.

"Three Projects for Architecture and Video/Notes." *Tracks* 3, no. 3 (fall 1977): 52–61.

Von Graevenitz, Antje. "Dingen gebeuren binnen het gezichtsveld/ Things Happen in the Visual Field: A Discussion with Dan Graham." *Museumjournaal* 22, no. 2 (April 1977): 74–79.

1979

"Art in Relation to Architecture/ Architecture in Relation to Art." *Artforum* 17, no. 6 (February 1979): 22–29.

"Essay on Video, Architecture and Television." In *Dan Graham: Video–Architecture–Television* (1979), 62–76.

Graham, Dan, and Dara Birnbaum. "Local Television News Program Analysis for Public Access Cable Television." In *Dan Graham: Video–Architecture–Television* (1979), 58–61.

Graham, Dan, and L. Licitra Ponti. "Dan Graham a Milano: Architectural Models and Photographs." *Domus*, no. 594 (May 1979): 55.

"The Lickerish Quartet." In *12 Films*, 28–32. Ed. Barbara Bloom. Amsterdam: De Appel, 1979.

"Notes on Video Piece for Showcase Windows in a Shopping Arcade." In *Dan Graham: Video–Architecture– Television* (1979), 53–54.

"Notes on Yesterday/Today." In *Dan Graham: Video–Architecture– Television* (1979), 44–46.

"Punk: Political Pop." *Journal: Southern California Art Magazine*, no. 22 (March–April 1979): 27–33; and as "Punk: Politischer Pop/Punk als Propaganda," *Überblick*, no. 3 (March 1979). Reprinted in *Post-Pop Art*, 111–37. Ed. Paul Taylor. Cambridge, Massachusetts: The MIT Press; and Milan, Italy: Flash Art Books, 1989.

"Video Arbeit für Schaufenster," "Schaufenster aus Glas," "The Glass Divider," and "Bild–Fenster Arbeit." *Zweitschrift*, nos. 4–5 (1979): 108–13.

1980

"Dan Graham." *New Art*, nos. 3–4 (fall 1980): 24–33.

"The Destroyed Room of Jeff Wall." *Real Life*, no. 3 (March 1980): 5–6.

"L'Espace de la communication." *Art Actuel Skira Annuel* (1980): 90.

"Larry Wayne Richards' Project for Conceptual Projects." In *Larry Richards, Works 1977–80*, 18–22. Halifax, Canada: Library of Canadian Architecture, Nova Scotia Technical College, 1980.

"Video Piece for Two Glass Office Buildings (1976)." In *En torno al Video*, 212–13. Eds. Eugeni Bonet, Joaquim Dols, Antoni Mercader, and Antoni Muntadas. Barcelona, Spain: Editorial Gustavo Gili, 1980.

"Situation Esthetics: Impermanent Art and the Seventies Audience." *Artforum* 18, no. 5 (January 1980): 24–26.

1981

"Alteration to a Suburban House (1978)." In *Dan Graham: Buildings and Signs* (1981), 35.

"Bow Wow Wow." *Real Life*, no. 6 (summer 1981): 11–13. Reprinted as "McLaren's Children (We're Only in it for Manet)." *ZG*, no. 7 (summer 1982). See later version "Malcolm McLaren and the Making of Annabella." In *Impresario: Malcolm McLaren & The British New Wave*, 60–71. New York: The New Museum of Contemporary Art; and Cambridge, Massachusetts: The MIT Press, 1988. Reprinted in *Plus*, nos. 3–4 (May 1988): 54–56. Unabridged version in *Rock My Religion* (1993): 142–61.

"Cinema." *A.E.I.U.O.* 2, no. 4 (July–December 1981): 38–47; *Buildings and Signs* (1981): 46–51; and as "Bioscoop," *Museumjournaal* 27, nos. 5–6 (1981): 239–43.

"Clinic for a Suburban Site (1978)." In *Dan Graham: Buildings and Signs* (1981), 32–33.

"The End of Liberalism (Part I)." *ZG*, no. 2 (1981): n.p.

"Films/Video/Performances." *Art Present*, no. 9 (summer–fall 1981): 14–19.

"New Wave Rock en Het Feminiene." *Museumjournaal* 26, no. 1 (1981): 16–32. Reprinted as "Semio–Sex: New Wave and the Feminine." *Live*, nos. 6–7 (1982): 12–17; and in *Open Letter*, nos. 5–6 (summer–fall 1982): 79–105.

"Not Post–Modernism: History as Against Historicism, European Archetypal Vernacular in Relation to American Commercial Vernacular, and the City as Opposed to the Individual Building." *Artforum* 20, no. 4 (December 1981): 50–58.

"Pavilion/Sculpture for Argonne." In *Dan Graham: Buildings and Signs* (1981), 27–29.

"Pavilion/Sculpture for Park Setting." In *Performance Text(e)s & Documents*, 199. Ed. Chantal Pontbriand. Montréal: Parachute, 1981.

"Signs." *Artforum* 19, no. 8 (April 1981): 38–43.

"Two Adjacent Pavilions." In *Dan Graham: Buildings and Signs* (1981), 31. See later version in *Dan Graham* (1985), 46–51.

1982

"The End of Liberalism (Part II)." In *The Un/Necessary Image*, 36–41. Ed. Peter D'Agostino and Antoni Muntadas. New York: Tanam Press, 1982.

"My Religion." *Museumjournaal* 27, no. 7 (1982): 324–29; and "Rock Religion." In *Scenes and Conventions in Architecture by Artists*, 80–81. London: Institute of Contemporary Arts, 1983. Later versions: "Rock–Religion" in *Dan Graham: Pavilions* (1983), 12–17; *Just Another Asshole*, no. 6 (1983); and *Video by Artists* 2, 81–111. Ed. Elke Town. Toronto: Art Metropole, 1986.

1983

"Sur Gordon Matta–Clark." *Art Press*, no. 2, special architecture issue (June–August 1983): 13. Later versions "Gordon Matta–Clark's Projects." In *Flyktpunkter/Vanishing Points*, 90–102. Stockholm: Moderna Museet, 1984; *Kunstforum International*, no. 81 (October–November 1985): 114–19; *A Pierre et Marie: Une Exposition en Travaux*, 114–15. Paris: Association pour l'avenir de l'art actuel, 1986; and *Parachute*, no. 43 (June–August 1986): 21–25.

"Theater, Cinema, Power." *Parachute*, no. 31 (June–August 1983): 11–19. See also *Dan Graham: Pavilions* (1983): 19–44.

1984

"On John Knight's Journals Work." *Journal: A Contemporary Art Magazine*, no. 40 (fall 1984): 110–11.

1985

"An American Family." In *TV Guides: A Collection of Thoughts About Television*, 13–14. Ed. Barbara Kruger. New York: Kuklapolitan Press, 1985.

"Darcy Lange: Work and Music." *New Observations*, no. 29 (1985): n.p.

"My Works for Magazine Pages: A History of Conceptual Art." In *Dan Graham* (1985): 8–13.

1986

"Chamberlain's Couches." In *Interior Design for Space Showing Videotapes*, 1–2. The Hague, The Netherlands: Stichting Kijkhuis, 1986.

"Kunst als Design/Design als Kunst." *Museumjournaal*, nos. 3–4 (1986): 183–95. See also "Art comme Design/Design comme Art." *Des Arts*, no. 5 (winter 1986–87): 68–71.

"Pavilion/Sculpture Works." In *Chambres d'Amis* (1986).

"Urban/Suburban Projects." *Zone*, nos. 1–2 (1986): 363–65.

1987

Dercon, Chris. "Interview with Dan Graham (28 November 1984)." In *L'Epoque, la mode, la morale, la passion*, 341. Paris: Centre Georges Pompidou, 1987.

Graham, Dan, and Robin Hurst. "Corporate Arcadias." *Artforum* 26, no. 4 (December 1987): 68–74; and as "Odyssey in Space: Dan Graham and Robin Hurst on the U.S. Corporate Atrium," *Building Design* (21 October 1988): 38–43.

"Legacies of Critical Practice in the 1980s." In *Discussions in Contemporary Culture*, 88–91, 105–18. Ed. Hal Foster. New York: Dia Art Foundation; and Seattle: Bay Press, 1987.

Pelzer, Birgit. "D'après un entretien avec Birgit Pelzer." In *Dan Graham* (Paris, 1987): 33–38.

1988

"Pavilions, Stagesets and Exhibition Designs, 1983–1988." In *Dan Graham: Pavillons* (1988): 36–58.

1989

"Forum—1989." *M/E/A/N/I/N/G*, no. 5 (1989): 9.

"Garden as Theater as Museum." In *Theatergarden Bestiarium: The Garden as Theater as Museum* (1990), 53–64. See also "Garden as Theater as Museum/El jardín como teatro como museo." In *Teatrojardín Bestiarium* (1989), 83–120. "Garden as Theater as Museum/Le Jardin comme théâtre comme musée." In *Bestiarium Jardin–Théâtre* (1989), 53–63.

Graham, Dan, and Jeff Wall. *A Guide to the Children's Pavilion*. Exh. brochure. Santa Barbara, California: Santa Barbara Contemporary Arts Forum, 1989; and "The Children's Pavilion/Der Kinderpavillon." *Parkett*, no. 22 (1989): 66–70. See later version *Children's Pavilion Dan Graham en Jeff Wall*. Exh. brochure. Rotterdam, The Netherlands: Rotterdamse Kunststichting and Museum Boijmans Van Beuningen, 1993.

Tsai, Eugenie. "Interview with Dan Graham." In *Robert Smithson: Drawings from the Estate*, 8–22. Münster, Germany: Westfälisches Landesmuseum für Kunst und Kulturgeschichte, 1989.

1990

Salvioni, Daniela. "Dan Graham: I'll Call Myself a Conceptual Artist, Though I Don't Like Conceptual Art." *Flash Art International* 23, no. 152 (May–June 1990): 142–44.

"Video in Relation to Architecture." In *Illuminating Video: An Essential Guide to Video Art*, 168–88. Ed. Doug Hall and Sally Jo Fifer. New York: Aperture Foundation; and San Francisco: Bay Area Video Coalition, 1990.

1991

"Dan Graham in Conversation with Brian Hatton." In *Talking Art*, 53–65. Ed. Adrian Searle. London: Institute of Contemporary Arts, 1993.

Dercon, Chris. "Dan Graham, I Enjoy that Closeness Where I Take Things That Are Very Close and Just Slightly Overlap Them." *Forum International*, no. 9 (September–October 1991): 73–80.

Hatton, Brian. "Conversation: Dan Graham." *Galeries Magazine*, no. 46 (December 1991–January 1992): 58–61.

"Skateboard Pavilion." In *Jahresring 38: Der öffentliche Blick*, 200. Munich, Germany: Verlag Silke Schreiber, 1991.

"Two-Way Mirror Cylinder Inside Cube and a Video Salon: Rooftop Park for Dia Center for the Arts." In *The End(s) of the Museum*, 126–28. Barcelona: Fundació Antoni Tàpies, 1991.

1992

"Ma Position." In *Dan Graham: Ma Position: Écrits sur mes œuvres* (1992): 10–54.

"Performance: The End of the 60s" (1985). In *Ma Position: Écrits sur mes œuvres* (1992), 114–16.

Thomson, Mark. "Dan Graham: Interview." *Art Monthly*, no. 162 (December 1992–January 1993): 3–7.

1993

Ardenne, Paul. "A Modern Archaeology of Perception." *Art Press*, no. 178 (March 1993): 10–16.

"City as Museum." In *Rock My Religion* (1993): 244–63. Revised text including material from previously published articles "Signs" (1981) and "Not Post-Modernism: History as Against Historicism, European Archetypal Vernacular in Relation to American Commercial Vernacular and City as Opposed to the Individual Building" (1981).

Graham, Dan. "My Works for Magazine Pages." In *Kunst & Museum Journal* 4, no. 6 (1993).

"Video in Relation to Architecture." In *Dan Graham: Public/Private* (1993): 6–17. Compiled from previous articles including "Essay on Video, Architecture and Television" (1979), "Art in Relation to Architecture/Architecture in Relation to Art" (1979), "Signs" (1981), and "An American Family" (1985).

1994

"Arcadia." *Peep*, no. 1 (spring 1994): 10–11.

Metz, Mike. "Dan Graham Interviewed by Mike Metz." *Bomb*, no. 46 (winter 1994): 24–29.

1995

Branca, Glenn. "Glenn Branca and Dan Graham in Conversation." *Be Magazin* (Künstlerhaus Bethanien), no. 3 (summer 1995): 113–17.

Doroshenko, Peter. "Dan Graham." *Journal of Contemporary Art* 7, no. 2 (1995): 12–17.

Schöllhammer, Georg. "Dara Birnbaum und Dan Graham im Gespräch über Familie, Fernsehen, Techno." *Springer* 1, no. 5 (June 1995): 12–16.

1996

Alberro, Alexander. "The Most Recent Past/Interview with Dan Graham and Jacqueline Donachie." *Index*, no. 2 (1996): 40–43, 75–78.

Fricke, Marion, and Roswitha Fricke. "Interview par Marion & Roswitha Fricke." *Art Press*, no. 17 (1996): 55–57.

Gerdes, Ludger. "Dan Graham Interviewed by Ludger Gerdes." In *Dan Graham: Selected Writings and Interviews on Art Works, 1965–1995* (1996): 175–200.

Huber, Hans-Dieter. "Dan Graham Interviewed by Hans-Dieter Huber." In *Dan Graham: Selected Writings and Interviews on Art Works, 1965–1995* (1996): 219–36.

Nonomura, Makoto. "Interview with Dan Graham." *BT (Bijutsu Techo)* (Tokyo) (December 1996): 100–13.

"Short Statement on My Two-Way Mirror Pavilions." In *Dan Graham: Two-Way Mirror Pavilions/Einwegspiegel-Pavillons 1989–1996* (1997): 87.

1997

De Bruyn, Eric. "Interview with Dan Graham." In *Dan Graham* (1997): 195–205.

"The Development of New York from the 1970s to the 90s in Relation to Urban Planning." In *[Realisation]: Kunst in der Leipziger Messe/Art at the Exhibition Centre Leipziger Messe*, 246–49. Cologne, Germany: Oktagon, 1997.

Hatton, Brian. "Feedback: An Exchange of Faxes, Dan Graham and Brian Hatton." *Dan Graham: Architecture* (1997): 7–19.

Köttering, Martin, and Roland Nachtigäller. "Dan Graham im Gespräch." *Neue Bildende Kunst* 7, no. 2 (April–May 1997): 50–58.

Metzger, Rainer. "Dan Graham in Conversation with Rainer Metzger, Vienna, October, 1995." In *Künstlerinnen: 50 Positionen*, 111–15. Bregenz, Austria: Kunsthaus Bregenz, 1997.

Sustersic, Apolonija. "One Morning Talking with Dan Graham." In *Dan Graham* (1997): 31–36.

1998

Bader, Joerg. "Les Kaleidoscopes de Dan Graham/The Architecture of Seeing." *Art Press*, no. 231 (1998): 20–25.

"Der Künstler als Produzent/The Artist as Producer." In *Crossings: Kunst zum Hören und Sehen*, 117–22. Vienna: Kunsthalle Wien; and Ostfildern, Germany: Cantz Verlag, 1998. See also versions in *Two-Way Mirror Power* (1999): 1–9; and *Dan Graham: Rock/music textes* (1999): 131–46.

Müller, Markus, and Ulrike Groos. "Interview with Dan Graham: New York, May 1998." In *Jahresring 45: Make It Funky, Crossover zwischen Musik, Pop, Avantgarde und Kunst*, 139–45. Ed. Markus Müller and Ulrike Groos. Cologne, Germany: Oktagon, 1998.

Ramos, Maria Elena. "Interview with Dan Graham." In *Intervenciones en el espacio*, 145–69. Caracas: Museo de Bellas Artes, 1998.

Skoog, Leif. "Interview with Dan Graham." *Paletten* (Göteborg, Sweden) 59, no. 4 (1998): 16–19.

"Zweiweg-Spiegel-Macht/Two-Way Mirror Power." In *Peripherie ist Überall*, 240–45. Ed. Walther Prigge. Frankfurt am Main, Germany: Campus Verlag, 1998. See also version in *Two-Way Mirror Power* (1999): 174–75.

1999

De Bruyn, Eric. "Conversation avec Dan Graham." In *Dan Graham: Rock/music textes* (1999): 147–57.

2000

Kaijima, Momoyo. "Interview with Dan Graham." *Switch* (June 2000): 108–13.

2003

Graham and Itsuko Hasegawa. "Children Within Public Space." *Dan Graham by Dan Graham* (2003), 244–51.

Iles, Chrissie. "Send in the Clouds." *Frieze*, no. 79 (November–December 2003): 68–74.

Obrist, Hans Ulrich. "Dan Graham." *Interviews*, Volume 1, 327–41. Milan, Italy: Edizioni Charta, 2003.

2004

De Bruyn, Eric. "Sound Is Material." *Grey Room* 1, no. 17 (2004): 108–17.

Griffin, Tim. "In Conversation: Dan Graham & Michael Smith." *Artforum* 62, no. 9 (2004): 184–89.

Zevi, Adachiara. "Half Square/Half Crazy: Interview with Dan Graham." In *Half Square/Half Crazy* (2005), 10–19.

2005

Francis, Mark. "Dan Graham. Mark Francis in Conversation." In *Press PLAY: Contemporary Artists in Conversation*, 243–58. London: Phaidon, 2005.

2006

"Architectural Tourists: Hans Ulrich Obrist and Dan Graham in Conversation." *Contemporary*, no. 87 (2006): 18–21.

Graham, Dan. "Apocalypse Now: Dan Graham on John Martin's 'The Great Day of His Wrath.'" *Tate, Etc.*, no. 8 (autumn 2006).

2008

"'Das große Dilemma der Kunst ist: Sie muß mit Disneyland klarkommen.' Interview Silke Hohmann." *Monopol*, nos. 7–8 (July–August 2008): 84–91.

"Jeppe Hein and Dan Graham: The Mirror Stage." *Art Review*, no. 24 (July–August 2008): 59–63.

Selected Writings about Dan Graham

Alberro, Alexander. "Wild in the Streets." *Frieze* (November–December 1995): 44–47.

———. "Structure as Content: Dan Graham's Schema (March 1966) and the Emergence of Conceptual Art." In *Dan Graham* (1997), 21–30.

Antin, David. "Dan Graham." *Studio International* 180, no. 924 (July 1970): 1.

———. "Review of End Moments." *Avalanche* (fall 1970): 7.

Atkinson, Terry. "Introduction." *Art and Language* 1, no. 1 (1968).

Avgikos, Jan. "Dan Graham: Dia Center for the Arts, New York." *Artforum* 30, no. 4 (December 1991): 101–02.

Baracks, Barbara. "Dan Graham: Sperone Westwater Fischer Gallery." *Artforum* 14, no. 9 (May 1976): 67–68.

Bartolomeo, Massimiliano di. "Dan Graham: Artist, maybe Architect." *Parkett*, no. 68 (September 2003): 114–22.

Battcock, Gregory. "Dan Graham: Photographs." *Minimal Art: A Critical Anthology*, 175–79. New York: Dutton, 1968.

Beveridge, Carl. "Dan Graham's Video-Architecture-Television." *Fuse* (May 1980).

Birnbaum, Daniel. "Dan Graham." *Artforum* 41, no. 4 (December 2002): 118–19.

Bochner, Mel. "Less and Less." *Art and Artists* (December 1966).

———. "The Serial Attitude." *Artforum* 6, no. 4 (December 1967): 28–33.

Brett, Guy. *City Limits* (London) (December 1980).

Buchloh, Benjamin H. D. In Dimitrijevic, *Graham, Kawara, Opalka*. Berlin: DAAD, René Block, 1977.

———. "Moments of History in the Work of Dan Graham." In *Dan Graham Articles* (1978), 73–78.

———. "Michael Asher and the Conclusion of Modernist Sculpture." In *Performance Texts & Documents*, 55–65. Montréal: Parachute, 1981.

———. "Documenta 7: A Dictionary of Received Ideas." *October*, no. 22 (fall 1982): 105–26.

———. "From Gadget Video to Agit Video: Some Notes on Four Recent Video Works." *Art Journal* 45, no. 3 (fall 1985): 217–27.

———. "Conceptual Art 1962–1969: From the Aesthetic of Administration to the Critique of Institutions." *October*, no. 55 (winter 1990): 122–23.

———. "Sculpture Projects in Münster." *Artforum* 36, no. 1 (September 1997): 115–17.

———, Rosalind Krauss, and Thierry de Duve. "Conceptual Art and the Reception of Duchamp." *October*, no. 70 (fall 1984).

Buci-Glucksmann, Christine. "Dan Graham, the Movie Machine Stripped Bare." In *Cinema* (1981).

Cameron, Eric. "Dan Graham: Appearing in Public." *Artforum* 15, no. 3 (November 1976): 66–68.

Camnitzer, Luis. "Dropping Sculpture by the Pound." *Texte zur Kunst* 15, no. 57 (March 2005): 154–61.

Chaimowicz, Marc. "Performance." *Studio International* (January–February 1976).

Charre, Alain. "L'insituable architecture de Dan Graham/Dan Graham's Unplacable Architecture." In *Dan Graham* (1995), 5–26.

Chevrier, Jean–François. "Dual Reading." In *Walker Evans & Dan Graham* (1992), 14–25.

Christov–Bakargiev, Carolyn. "Dan Graham and Jeff Wall." *Flash Art*, no. 147 (summer 1989): 163.

Colomina, Beatriz. "Double Exposure: Alteration to a Suburban House (1978)." In *Dan Graham* (2001).

Corris, Michael. "Conceptual Art: Theory, Myth and Practice." *Contemporary*, no. 66 (2004): 51–52.

Crow, Thomas. "Committed to Memory: Thomas Crow on Benjamin H. D. Buchloh." *Artforum* 39, no. 6 (February 2001): 29–32.

De Bruyn, Eric. "Topological Pathways of Post–Minimalism." *Grey Room*, no. 25 (fall 2006): 32–63.

De Duve, Thierry. "Dan Graham und die Kritik der künstlerischen Autonomie/Dan Graham et la critique de l'autonomie artistique." In *Dan Graham: Pavilions* (1983), 45–73.

Deitcher, David. "Art on the Installation Plan." *Artforum* 30, no. 5 (January 1992): 78–84.

Dercon, Chris. "Dan Graham, I Enjoy that Closeness Where I Take Things that Are Very Close and Just Slightly Overlap Them/Ik geniet van die dichtbijheid waarbij ik twee dingen neem die erg dicht bij elkaar liggen en die ik lichtjes laat overlappen." *Forum International*, no. 9 (September–October 1991): 73–80.

Duguet, Anne–Marie. "Dan Graham ARC." *Parachute* (1987).

Field, Simon. "The Venice Biennale." *Burlington Magazine* (summer 1976).

Fisher, Jean. "Dan Graham: Marian Goodman Gallery." *Artforum* 26, no. 4 (December 1987): 111–12.

Flavin, Dan. "Some Other Comments...More Pages from a Spleenish Journal." *Artforum* 6, no. 4 (December 1967): 20–25.

Fol, Jacques. "Dan Graham: L'artiste à distance." *Des Arts*, no. 2 (1985).

Francis, Mark. "Dan Graham." *Aspects*, no. 5 (winter 1978).

——. "New York, Dia Center for the Arts: Brice Marden, Dan Graham." *Burlington Magazine* 134 (February 1992).

Gale, Peggy. "A Tableau Vivant." *Parachute*, no. 39 (June–August 1985): 33–35.

Gingeras, Alison M. "Dan Graham: Musée d'art moderne de la ville." *Art Press*, no. 271 (September 2001): 64–65.

Glozer, Laszlo. "Kritische Modelle." *Süddeutsche Zeitung*, 21 February 1978.

Godfrey, Mark. "Dimensions variable." *Frieze*, no. 84 (June–August 2004): 116–21.

Goldberg, RoseLee. "A Space, A Thousand Words." *Architectural Design* (May 1975).

Goldenberg, David. "The Cold War and Jeff Wall's 'Dan Graham's: Kammerspiel': A Sketch for a Cultural Practice in a New World Order." *Flexible Response* (1994): 13–31.

Grima, Joseph. "Half Square/Half Crazy—In front of Terragni's Casa del Fascio at Como, Graham Pays a Subtly Ironic Homage to Modernism." *Domus*, no. 873 (2004): 24–32.

Groot, Paul. "Popmuziek als inspiratie voor Beeldende Kunst." *NRC Handelsblad* (July 1980).

Grüterich, Marlis, and Wulf Herzogenrath. "Video." *Magazine Kunst*, no. 4 (1974).

Guagnini, Nicolás, and Karin Schneider. "Quasi Schizophrenia." *Parkett*, no. 68 (September 2003): 98–104.

Halle, Howard. "Pausing to Reflect: D. Graham Doesn't Throw Stones in Glass Houses." *Time Out* (January 1996): 17–24.

Hanada, Shinichi. "Dan Graham and No Wave." In *Dan Graham by Dan Graham* (2003), 54–59.

Hatton, Brian. "Dan Graham: Present Continuous." *Artscribe International*, no. 89 (winter 1991): 64–71.

——. "Victor Burgin/Dan Graham/Rodney Graham/John Hilliard." *Art Monthly*, no. 199 (September 1996): 29–31.

——. "Dan Graham in Relation to Architecture." In *Dan Graham: Works (1965–2000)* (2001), 317–28.

Hettig, Frank–Alexander. "A Minimal Future? Art as Objects 1958–1968" *Kunstforum International* (July–August 2004): 401–04.

Heubach, Friedrich Wolfram. "The Observed Eye, Or Making Seeing Visible (On the Video Works of Dan Graham)." In *Dan Graham* (1997), 191–94.

Hobermann, J. "Sympathy for the Devil." *Village Voice*, 2 June 1987.

Holert, Tom. "Wissenswerte: Dan Graham's 'Rock My Religion' oder Was Künstler interessiert." *Texte zur Kunst*, no. 12 (November 1993): 115–25.

Jones, Bill. "Translucent Trans–migration." *East Village Eye* (March 1985).

Joselit, David. "Object Lessons." *Art in America*, no. 107 (February 1996): 68–71.

Kirshner, Judith Russi. "Non–Uments." *Artforum* 24, no. 2 (October 1985): 102–08.

Kozloff, Max. "Pygmalion Reversed." *Artforum* 14, no. 3 (November 1975): 30–37.

Kuspit, Donald. "Dan Graham: Prometheus Mediabound." *Artforum* 23, no. 9 (May 1985): 75–81.

Lebeer, Imerline. "Le Corps Matériel Perceptuel." *L'Art Vivant*, no. 41 (July 1973).

Lee, Pamela M. "Split Decision." *Artforum* 43, no. 3 (November 2004): 47–48.

LeWitt, Sol. "Paragraphs on Conceptual Art." *Artforum* 5, no. 10 (summer 1967): 79–83.

Lippard, Lucy. *Six Years: The Dematerialization of the Art Object from 1966 to 1972.* New York: Praeger, 1973.

Lyotard, Jean–François. "Les Immatériaux." *Art and Text*, no. 17 (April 1985): 17.

Macdonald, Marie–Paule. "Matérialisations—Production de masse, espace publique et convention architecturale dans l'oeuvre de Dan Graham/Materializations." In *Dan Graham* (1995), 27–72.

——. "Glass Perception." *Parkett*, no. 68 (September 2003): 106–13.

Madoff, Henry. "A 60s Psychedelic Tale of Youth Conquering All (the Revolutionaries Are Puppets." *The New York Times*, 1 December 2004.

Matake, Makiko. "Intersecting Vision, Intersecting Time." In *Dan Graham by Dan Graham* (2003), 42–47.

Mayer, Rosemary. "Dan Graham: Past/Present." *Art in America* 63, no. 6 (November–December 1975): 83–85.

McEvilley, Thomas. "I Think Therefore I Art." *Artforum* 23, no. 10 (summer 1985): 74–84.

Meyer, R. "Dan Graham: Past and Present." *Art in America*, no. 63 (November 1975): 83.

Meyer, Ursula, ed. "Dan Graham." In *Conceptual Art*. New York: Dutton, 1972.

Miller, John. "In the Beginning There Was Formica." *Artscribe International*, no. 62 (March–April 1987): 36–42.

———. "Review." *Artscribe International*, no. 691 (May 1988): 79.

———. "Now Even the Pigs're Groovin'." In *Dan Graham: Works 1965–2000* (2001), 356–74.

Millet, Catherine. "L'Art conceptuel comme semiotique de l'art." *Revue Trimestrielle*, no. 3 (autumn 1970).

Moore, Allan. "Review of 597 Broadway Exhibitions." *Artforum* 43, no. 10 (summer 1975): 67–72.

Morgan, Robert C. "Conceptual Art and the Continuing Quest for a New Social Context." *Journal: Southern California Art Magazine* (June–July 1979): 59.

———. "Transmission Aesthetics: Public Interaction and Private Awareness." *New York Arts Journal*, no. 18 (June 1980).

Moure, Gloria. "Dan Graham, in the Third Discontinuity." In *Dan Graham* (1997), 13–18.

Müller, Markus. "Dan Graham: Collaborations, in Other Words, Not Alone." In *Dan Graham: Works 1965–2000* (2001), 17–48.

Nakamura, Nobouu. In *Thoughts and Words*. Tokyo: Japan Foundation, 1980.

Nemser, Cindy. "Subject–Object: Body Art." *Arts Magazine* 46 (September 1971): 38–42.

Newman, Michael. "Beyond the Lost Object: From Sculpture to Film and Video." *Art Press*, no. 202 (May 1995): 45–50.

Nicholson, Annabel. "Artist as Filmmaker." *Art and Artists* (December 1972).

Nonomura, Fumihiro. "Suburbia's Desire: What the Modern Architecture Was Concealing–Pavilion." In *Dan Graham by Dan Graham* (2003), 66–72.

Owens, Craig. "Bayreuth '82." *Art in America* 70, no. 8 (September 1982): 132–39, 191.

Pacquement, Alfred. "L'Art conceptuel." *Connaissance des Arts*, no. 236 (October 1971): 100–03.

Pagel, David. "Dan Graham: Exploring Vision and Knowledge." *Los Angeles Times*, 13 May 1993.

Payant, René. "Dan Graham: L'Effet Méduse mise en scène." *Art Press*, no. 47 (April 1981): 10–11.

Pelzer, Birgit. "Vision in Process." *October*, no. 10 (fall 1979): 105–19.

———. "Double Intersection: The Optics of Dan Graham." In *Dan Graham* (2001), 36–79.

Phillips, Christopher. "Factual Fictions." *Art in America* (March 2001): 46–51.

Piguet, Philippe. "Dan Graham, Sol LeWitt, Vladimir Skoda." *Flash Art*, no. 134 (May 1987): 112.

Plagens, Peter. "557,687." *Artforum* (November 1969).

———. "Dan Graham and Mowry Baden, Otis Art Institute, Los Angeles." *Artforum* 14, no. 4 (December 1975): 77.

Pohlen, Annelie. "Documenta." *Artforum* 21 (October 1982): 82–84.

Raynor, Vivien. "Art: The Conceptualists." *The New York Times*, 11 July 1985.

Reeve, Charles. "T.V. Eye. Dan Graham's Homes for America." *Parachute*, no. 53 (winter 1988): 19–24.

Rein, Ingrid. "Historischer Abend im Spiegelkabinett: Eine Performance von Dan Graham im Lenbachhaus." *Süddeutsche Zeitung*, 24 February 1980.

Rosenberg Miller, Carmen. "Questionnaire for Mr. Graham." *Parkett*, no. 68 (September 2003): 123–31.

Smith, Roberta. "Was 1967 When Abstraction Met Reality?" *The New York Times*, 29 March 1987.

———. "Review of 'Theatergarden Bestiarium.'" *The New York Times*, 3 February 1989.

Smithson, Robert. "Quasi–Infinities and the Waning of Space." *Arts Magazine* 44, no. 1 (November 1966): 28–31.

———. "A Museum of Language in the Vicinity of Art." *Art International* 12, no. 3 (March 1968): 21–27.

Soutif, Daniel. "Le Point virgule sur le minimal." *Libération*, 13 April 1987.

Stemmrich, Gregor. "Dan Graham's Cinema und die Filmtheone." *Texte zur Kunst* (March 1996): 81–97.

———. "Dan Graham's *Homes for America* (1966): The Artist as Photojournalist and the Discovery of the Suburbs/Dan Grahams *Homes for America* (1966): Der Künstler als Fotojournalist und die Entdeckung der Vororte." *Daidalos* 66 (December 1997): 54–63.

Stimson, Paul. "Book review of 'Video–Architecture–Television: Writings on Video Works.'" *Art in America* (April 1981).

Tarantino, Michael. "La Collection Herbert: La Recherche sans compromis d'Anton et Annick Herbert." *Parachute*, no. 54 (1989): 8–13.

Taubin, Amy. "Dan Graham at the Mudd Club." *SoHo Weekly News* (New York), 14 June 1979.

Town, Elke. "Between Affirmation and Contempt." *C*, no. 5 (1985).

Trainor, James. "Don't Trust Anyone Over Thirty." *Frieze*, no. 89 (March 2005): 78–79.

Van Assche, Christine. "Dan Graham." In *Dan Graham* (1997), 19–20.

Wagner, Anne M. "Being There: Art and the Politics of Place." *Artforum* 63, no. 10 (summer 2005): 264–69.

Wall, Jeff. "Dan Graham's Kammerspiel, Part I." *Real Life*, nos. 14–15 (1985).

———. "Zinnebeeldige Procedures van Vesterving. Dan Grahams Kammerspiel." *Museumjournaal*, no. 5 (1986): 276–84.

———. "Een architectural emblem van varvalste openherd. Dan Grahams Kammerspiel II." *Museumjournaal*, no. 6 (1986): 367–71.

———. "Judd plus Flavin—plus ein Foto." *Kunstforum* (March–April 1999): 231–45.

Wechsler, Max. "Dan Graham, 'Pavilions': Kunsthalle." *Artforum* 22, no. 2 (October 1983): 86–87.

Wood, Paul. "Dan Graham." *Artscribe International*, no. 66 (November–December 1987): 63–65.

Wooster, Ann–Sargent. "P.S. 1/Two Viewing Rooms." *Village Voice* (December 1980).

Zevi, Adachiara. "Dan Graham: Il minimo allo specchio." *L'Architettura: Cronache e Storia*, no. 10 (October 1991): 825–30.

———. "Art as a Social Sign." In *Dan Graham* (1997), 215–20.

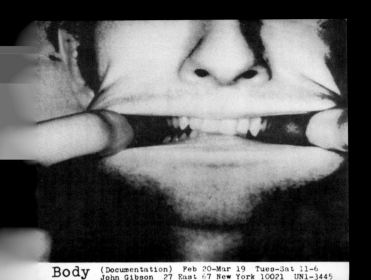

Body (Documentation) Feb 20-Mar 19 Tues-Sat 11-6
John Gibson 27 East 67 New York 10021 UN1-3445

Body

(Performances & Films)
Monday, February 22
Tuesday, February 23
at 7:30 p.m.

Vito Acconci
Dan Graham
Bruce Nauman*
Richard Serra*
Michael Snow

New York University
Eisner & Lubin Auditorium
Loeb Student Center
566 LaGuardia Place
Contribution: $2
*Courtesy Leo Castelli

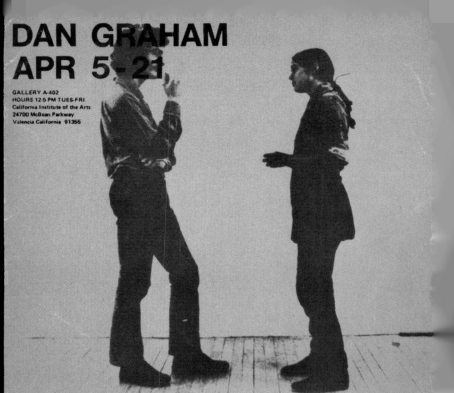

DAN GRAHAM
APR 5-21

GALLERY A-402
HOURS 12-5 PM TUES-FRI
California Institute of the Arts
24700 McBean Parkway
Valencia California 91355

One person predicts continuously the other person's future behavior;
while the oth er person recalls (by memory) his opposite's past be-
havior.

Both are in the present so knowledge of the past is needed to con-
tinuously deduce future behavior (in terms of causal relation). For
one to see the other in terms of present attention there is a mirror-
reflection (of past/future) cross of effect(s). Both's behavior be-
ing reciprocally dependent on the other, each's information of his
moves is seen in part as a reflection of the effect their just past
behavior has had in reversed tense as the other's views of himself.
For the performance to proceed, a simultaneous, but doubled attent-
ion of the first performer's 'self' in relation to the other('s im-
pressions) must be maintained by him. This effects cause and effect
direction. The two's activity is joined by numerous loops of feed-
back ←——→ and feedahead words and behavior.

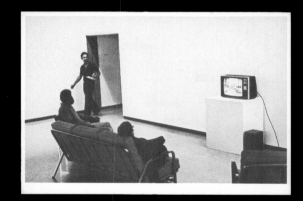

Brian Albert Andrea Fisher
Laurie Simmons John Schlesinger
Wolfgang Staehle Dan Graham

unbesehen: 6 zeitgenössische
amerikanische Künstler arbeiten in
Hamburg mit dem Medium Photographie.
Eine Ausstellung der Arbeitsgemeinschaft
Hamburger Galerien im Rahmen der Woche der
bildenden Kunst, realisiert von der Kuratorin

MARIKO MORI

REUBEN ROOM:
DAN GRAHAM
DAN GRAHAM IS REPRESENTED BY MARIAN GOODMAN GALLERY

MARCH 18 - APRIL 15

AMERICAN FINE ARTS, CO.
COLIN DE LAND FINE ART
22 WOOSTER STREET NYC 10013 (212) 941-0401

RECEPTION SATURDAY MARCH 18, 1995 6PM

Van Abbemuseum
Bilderdijklaan 10
Eindhoven/Nederland

Dan Graham
video-installaties
foto's films
conceptueel werk.
Tijdens de tentoonstelling
zal Dan Graham op een
nader aan te kondigen
tijdstip een performance
geven.
U bent van harte welkom
op de opening op donderdag
26 mei a.s.
20.00 tot 21.30 uur

PUBLIC SPACE / TWO AUDIENCES

THE PIECE IS ONE OF MANY PAVILIONS LOCATED IN AN INTERNATIONAL ART EXHIBIT WITH A LARGE AND ANONYMOUS PUBLIC IN ATTENDANCE.

SPECTATORS CAN ENTER THE WORK THROUGH EITHER OF TWO ENTRANCES. THEY ARE INFORMED BEFORE ENTERING THAT THEY MUST REMAIN INSIDE FOR 30 MINUTES WITH THE DOORS CLOSED.

EACH AUDIENCE SEES THE OTHER AUDIENCE'S VISUAL BEHAVIOR, BUT IS ISOLATED FROM THEIR AURAL BEHAVIOR. EACH AUDIENCE IS MADE MORE AWARE OF ITS OWN VERBAL COMMUNICATIONS. IT IS ASSUMED THAT AFTER A TIME, EACH AUDIENCE WILL DEVELOP A SOCIAL COHESION AND GROUP IDENTITY.

SKYLIGHT
MIRROR
THERMOPANE SOUND-INSULATING GLASS
WHITE WALLS
LOCATIONS OF LOCKED DOORS

DAN GRAHAM

Dan Graham (Urbana, Illinois, 1942) inicia la seva activitat creadora a la segona meitat dels anys seixanta i en podem parlar com un dels cossos de producció més diversificats i, alhora, coherents d'un artista contemporani.

Inscrita la seva obra en els corrents escultòrics «minimal» i en la discussió crítica generada entorn de l'art conceptual, al llarg dels anys, Graham ha fet nombroses aportacions crítiques (textos, articles) i creatives (performances, video, film, fotografia, escultura/ arquitectura)...

Simultàneament a la realització de les primeres obres, Graham es dedica a l'escriptura i a la crítica d'art i de música.

A partir de 1969, Graham realitza les primeres performances, en algunes de les quals hi col·laboren artistes com Vito Acconci, Bruce Nauman, Richard Serra, Dennis Oppenheim, Michel Snow, o Glenn Branca. Així mateix, entre 1969 i 1973 Graham realitza sis pel·lícules.

Gran part de la seva obra, especialment els articles, és fruit d'una recerca acurada sobre fenòmens culturals/socials/humans contemporanis produïts pel desenvolupament de medis de comunicació (TV per cable, circuits tancats, video,...) i, per exemple, l'arquitectura moderna. L'arquitectura és, així mateix, la base de les preocupacions de Graham i és tractada com a objecte de crítica a articles com ara «Art in Relation to Architecture/Architecture in Relation to Arts (Artforum, febrer 1979), o «Not Post-Modernism, European Architectural Vernacular in Relation to American Commercial Vernacular», i «The City as Opposed to the Individual Building» (Artforum, desembre 1981).

Disseny Ignasi Reventós

2 de febrer, 19:30 hores

PRESENTACIÓ I PASSI DELS VIDEOS
ROCK MY RELIGION
60 minuts, 1982-84
i
MINOR THREAT
35 minuts, 1982

3 de febrer, 19:30 hores

CONFERÈNCIA
«PAVELLONS, ESCENARIS, I DISSENY D'EXPOSICIONS»

Els dos actes aniran a càrrec de l'artista
Sala de Conferències * Traducció simultània
Coordinació: BARTOMEU MARI

icn
institut d'estudis nord-americans

DAN GRAHAM

INVITACIÓ

2 i 3 de Febrer de 1989

Via Augusta, 123 Telèfon 209 27 11 08006 Barcelona

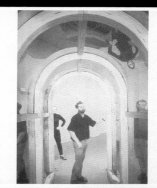

2 HET APOLLOHUIS
TONGELRESESTRAAT 81 EINDHOVEN
5613 DB. HOLLAND
TELEFOON 040-440393 & 040-441966

DAN GRAHAM
PERFORMANCE~LECTURE
ONDERWERP: NEW-WAVE ROCK & FEMINISME

De New Yorkse kunstenaar Dan Graham heeft in zijn talrijke installaties, performances en publicaties altijd een diepgaande interesse aan de dag gelegd voor de rol die communicatie-media en architectuur spelen in de interacties tussen mensen.
Verder is hij een groot kenner van de nieuwe golf van rock 'n roll die recentelijk uit de wereld van de beeldende kunstenaars in New York is voortgekomen. Hij is aanwezig bij alle belangrijke concerten, en vele van de meest vooraanstaande jonge musici behoren tot zijn vriendenkring.
Hij heeft nu een voordracht van anderhalf uur voorbereid, die hij zal presenteren in het Apollohuis te Eindhoven en in het Institute for Contemporary Art in Londen, over het onderwerp "New Wave Rock and Feminism".
In deze voordracht zal hij bespreken hoe de appreciatie van muziek van vrouwelijke bands tot stand komt, en analyseren hoe het publiek zich met vrouwelijke performers vereenzelvigt. Graham's ideeen daarover leunen aan bij de feministische stroming binnen de moderne Franse semiotiek.
De voordracht zal zich niet helemaal in abstracte sferen afspelen, maar uitgebreid ondersteund worden door muziekvoorbeelden en diaprojecties. Daarbij zullen meer en minder bekende vrouwelijke musici de revue passeren, zoals Suzi Quatro, Lydia Lunch, Siouxie and the Banshees, The Slits, The Raincoats, Desperate Bicycles, en Ping Pong. Ook mannelijke groepen die de feministische problematiek binnen hun muziek betrekken (b.v. The Gang Of Four) komen aan de orde.
Na afloop van zijn voordracht zal Dan Graham, indien gewenst, nog ingaan op vragen uit het publiek. Hij zal daarbij een selectie van eigen live-opnames van nieuwe vrouwelijke groepen uit New York (Y Pants, Bush Tetras, Ud, Disband, CKM) paraat hebben.
INLICHTINGEN: PAUL PANHUYSEN EN REMKO SCHA ()

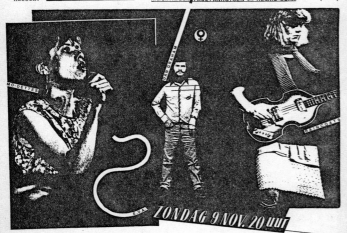

ZONDAG 9 NOV. 20 UUR
1980

DAN GRAHAM
PHOTOGRAPHS FILM VIDEO PERFORMANCE
FEB 25 - MAR 18
LISSON GALLERY
57 LISSON STREET LONDON N W 1

Lenders to the Exhibition

Rhea Anastas
Tom Brinkmann
Carnegie Museum of Art, Pittsburgh
Centre Pompidou, Paris, Musée national d'art moderne/
 Centre de création industrielle
Charpenel Collection, Guadalajara, Mexico
Collection Daled, Brussels, Belgium
Le Consortium, Dijon
Electronic Arts Intermix (EAI), New York
Fundação de Serralves—Contemporary Art Museum, Porto,
 Portugal
Gerald Ferguson, Halifax
Galleria Massimo Minini, Brescia, Italy
Raymond Geerts, Mol, Belgium
Generali Foundation, Vienna
Research Library, The Getty Research Institute, Los Angeles
Dan Graham
Hauser & Wirth, Zürich and London
The Hayward, Southbank Centre, London
Collection Herbert, Ghent, Belgium
Johnen + Schöttle, Cologne/Berlin
Collection, Archiv Kunst Architektur, Kunsthaus Bregenz, Austria
Steven Leiber, San Francisco
Lisson Gallery, London
Marian Goodman Gallery, New York and Paris
Marie-Paule Macdonald, Halifax
The Museum of Contemporary Art, Los Angeles
Collection Dieter and Gertraud Bogner, Museum Moderner Kunst
 Stiftung Ludwig Wien, Vienna
Orchard, New York
Patrick Painter Editions
San Francisco Museum of Modern Art
Tate Collection
Van Abbemuseum, Eindhoven, The Netherlands
Nicole Verstraeten, Brussels, Belgium
Walker Art Center, Minneapolis
Whitney Museum of American Art, New York

DAN GRAHAM

TRAVAUX CONCEPTUELS

MAQUETTES

VIDÉOS

INSTALLATIONS VIDÉO

PAVILLONS

FILMS

Exposition du 4 novembre 1992 au 28 février 1993

DAN GRAHAM

"Videos on Sculpture/Pavilions"

Oct. 8 – Nov. 9, 1996

artist's reception Saturday, Oct. 5 6–8 pm

GALLERY SHIMADA, TOKYO

ダン・グ レ ア ム

"Videos on Sculpture/Pavilions"

1996年10月8日 ー 11月9日

オープニングレセプション 10月5日(土) 6 ー 8pm 作家出席

火～土 11:00 - 18:00 休廊 日・月・祝

〒107 東京都港区南青山2-22-17 川上ビル8F TEL 03-5411-1796 FAX 03-5411-2496
Kawakami Bldg. 8F., 2-22-17 Minamiaoyama, Minato-ku, Tokyo, 107 Japan

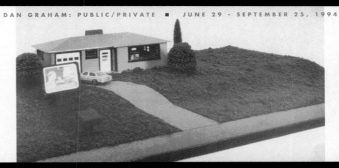

DAN GRAHAM: PUBLIC/PRIVATE ■ JUNE 29 - SEPTEMBER 25, 1994

MUSÉE DES BEAUX-ARTS DE L'ONTARIO

ART GALLERY OF ONTARIO

NEW URBAN LANDSCAPES #5 DAN GRAHAM
a focus on lower manhattan through a series
of documented projects, proposals, and events.

DAN GRAHAM
Photographs 1966 - 1987

Giovedì 7 febbraio 1991

Le Case d'Arte - viale col di lana, 14 20136 milano 02·8370407 / 89400628

GALERIJ
MICHELINE
SZWAJCER

D A N G R A H A M

17 April - 25 May 1991
Private View 16 April 1991, 7 - 10 p.m.

Models, Verlatstraat 14, B-2000 Antwerpen, tel. & fax (03) 237 11 27, open wednesday to saturday 2 - 6 p.m.
Photographs, Museumstraat 15, B-2000 Antwerpen, tel. & fax (03) 237 11 27, open wednesday to saturday 2 - 6 p.m.

Photo Credits

Unless otherwise noted, all images of Dan Graham's work have been provided by the artist. The following list, keyed to page numbers, applies to photographs for which separate or additional credits are due: Courtesy Galleria Massimo Minini, Brescia, Italy, and Borgovico33, Como, Italy, photo: Pino Musi, pp. 2, 6, 230–31; courtesy Marian Goodman Gallery, New York and Paris, pp. 4, 186, 222–23, photo: Jon and Anne Abbott, p. 229 bottom; courtesy Whitney Museum of American Art, New York, © 2009 Bruce Nauman/Artists Rights Society (ARS), New York, photo: Geoffrey Clements, p. 40; photo: Jon Abbott, p. 45 top; courtesy Electronic Arts Intermix (EAI), New York, pp. 62 top, 68 bottom; photo: Peter Kirby, pp. 34, 46–48, 145 bottom, 158, 225; photo: Todd Eberle, pp. 49, 138, 141; courtesy of the artists, p. 50; photo: Roland Fischer, Munich, p. 51; courtesy Beryl Korot, p. 58 top; photo: Richard Landry, p. 58 bottom; courtesy Orchard, New York, pp. 76 top, 77 top; © 2009 Sol LeWitt/Artists Rights Society (ARS), New York, pp. 113, 256 top; courtesy PaceWildenstein, New York, Art © Judd Foundation, Licensed by VAGA, New York, photo: Ellen Page Wilson, p. 115; Art © Estate of Robert Smithson/Licensed by VAGA, New York, p. 118; © Fred W. McDarrah, p. 118; courtesy Walker Art Center, Minneapolis, p. 152 bottom; photo: David Allison, New York, pp. 162–63; photo: Thurston Moore, p. 168; courtesy Herbert Collection, Ghent, photo: Annick Herbert, pp. 184, 192; courtesy Samuel Courtauld Trust, Courtauld Gallery, London, p. 188 bottom; courtesy Dia Art Foundation, p. 232, photo: Dan Graham, p. 190; courtesy The Museum of Modern Art/Licensed by SCALA/Art Resource, New York, © 2009 Artists Rights Society (ARS), New York/VG Bild–Kunst, Bonn, pp. 193, 204 bottom; © 2009 Artists Rights Society (ARS), New York/ADAGP, Paris, p. 198; photo: Anne Rorimer, p. 200; Foto Marburg/Art Resource, New York, p. 204 top; courtesy Diller Scofidio + Renfro, photo: Beat Widmer, p. 206;

courtesy Edgar Allan Poe Museum, Richmond, Virginia, p. 214 left; photo: NASA, p. 215; courtesy the artist, Paul Morris, and David Zwirner, New York, p. 217; courtesy Fundação de Serralves—Contemporary Art Museum, Porto, Portugal, photo: Anabela Rosas Trindade, p. 219 top and bottom right; courtesy Johnen + Schöttle, Cologne/Berlin, p. 224; courtesy Galerie Hauser & Wirth Zürich London, pp. 234–35, photo: A. Berger, p. 236; Biblioteca Estense, Modena, Italy, courtesy Alinari/Art Resource, New York, p. 239; © Trustees of the British Museum, pp. 240–42; courtesy Getty Images, © Time Life Pictures, photo: Marie Hansen/Time Life Pictures, p. 243; © 2009 Getty Images, photo: Keystone/Getty Images, p. 244; courtesy Venturi, Scott Brown and Associates, Philadelphia, pp. 259, 269, photo: Tom Bernard, pp. 247, 273, 274 top; courtesy and © Office for Metropolitan Architecture, p. 248 bottom, photo: Hans Werlemann (Hectic Pictures), p. 248 top; courtesy Bernard Tschumi Architects, p. 249 top, photo: J. M. Monthiers, p. 249 bottom; courtesy and © 2009 Jenny Holzer, member Artists Rights Society (ARS), New York, p. 255 top and middle; courtesy Lisson Gallery, London, © Daniel Buren, p. 255 bottom; courtesy Tate Gallery, London/Art Resource, New York, © 2009 Frank Stella/Artists Rights Society (ARS), New York, p. 257; © 2009 Whitney Museum of American Art, New York, photo: Jerry L. Thompson, p. 267; courtesy Museum of Contemporary Art, Chicago, © 2009 Stephen Flavin/Artists Rights Society (ARS), New York, p. 268; courtesy Leo Castelli Gallery, New York, photo: © 2009 The Andy Warhol Foundation for the Visual Arts/Artists Rights Society (ARS), New York, p. 270 top and middle; and © 2009 John Chamberlain/Artists Rights Society (ARS), New York, p. 270 bottom.

This publication accompanies the exhibition "Dan Graham: Beyond," organized by Bennett Simpson and Chrissie Iles and presented at The Museum of Contemporary Art, Los Angeles, 15 February–25 May 2009; the Whitney Museum of American Art, New York, 25 June–11 October 2009; and the Walker Art Center, Minneapolis, 31 October 2009–31 January 2010.

"Dan Graham: Beyond" is organized by The Museum of Contemporary Art, Los Angeles, in collaboration with the Whitney Museum of American Art, New York.

The exhibition is made possible by generous endowment support from the Sydney Irmas Exhibition Endowment. Major support is provided by Hauser & Wirth Zürich London; Marian Goodman Gallery, New York and Paris; The MOCA Contemporaries; the National Endowment for the Arts; the Graham Foundation for Advanced Studies in the Fine Arts; Mary and Robert Looker; the Pasadena Art Alliance; Betye Monell Burton; Peter Gelles and Eve Steele Gelles; John Morace and Tom Kennedy; Bagley and Virginia Wright; and Marieluise Hessel.

In-kind media support is provided by Ovation TV, the Official Network Partner of MOCA; 89.9 KCRW, the Official Media Sponsor of MOCA; and Los Angeles magazine.

Director of Publications: Lisa Gabrielle Mark
Senior Editor: Jane Hyun
Editor: Elizabeth Hamilton
Publications Assistant: Dawson Weber
Designer: Michael Worthington and Yasmin Khan at Counterspace, Los Angeles
Design Assistant: Cassandra Chae
Color Separators: Echelon, Venice, California
Printer: Shapco, Minneapolis

© 2009 The Museum of Contemporary Art, Los Angeles, and Massachusetts Institute of Technology

MIT Press books may be purchased at special quantity discounts for business or sales promotional use. For information, please email special_sales@mitpress.mit.edu or write to Special Sales Department, The MIT Press, 55 Hayward Street, Cambridge, MA 02142.

ISBN: 978-1-933751-12-2

Library of Congress Cataloging-in-Publication Data

Graham, Dan, 1942–
Dan Graham: beyond / organized by Bennett Simpson and Chrissie Iles; original texts by Rhea Anastas... [et al.]; original interviews with Dan Graham by Kim Gordon and Rodney Graham.
p. cm.
Issued in connection with the exhibition organized by the Museum of Contemporary Art, Los Angeles, in collaboration with the Whitney Museum of American Art, New York.
Includes bibliographical references.
ISBN 978-1-933751-12-2
1. Graham, Dan, 1942—Exhibitions. 2. Graham, Dan, 1942—Interviews. 3. Artists—United States—Interviews. I. Simpson, Bennett. II. Iles, Chrissie. III. Anastas, Rhea. IV. Gordon, Kim, 1953– V. Graham, Rodney, 1949– VI. Museum of Contemporary Art (Los Angeles, Calif.) VII. Whitney Museum of American Art. VIII. Title.
N6537.G674A4 2009
709.2—dc22

2008052314

10 9 8 7 6 5 4 3 2 1

This book was set in Ezzo, designed by Dino dos Santos, and was printed and bound in the United States.

cover
Graham performing Performer/Audience/Mirror (1977) at De Appel Arts Centre, Amsterdam, 1977

page 1
Graham photographing Two Adjacent Pavilions (1978–82); two-way mirror, glass, and steel; two structures: 8 1/4 x 6 1/8 x 6 1/8 feet each; collection Kröller–Müller Museum, Otterlo, The Netherlands; installed in Documenta VII next to the Fulda River, Kassel, Germany, 1982

page 2
Graham with Half Square/Half Crazy (2004); two-way mirror and stainless steel; 7 7/8 x 19 5/8 x 19 5/8 feet; collection Casa del Fascio, Como, Italy; installed in Como, Italy

page 4
Detail of Triangular Solid with Circular Inserts (Variation E) (1989/2007), installed in "30/40," Marian Goodman Gallery, New York, 2007

page 6
Photograph of Graham filming Binocular Zoom (1969–70) bordered by stills from the film

page 7
Graham photographing Half Square/Half Crazy (2004); two-way mirror and stainless steel; 7 7/8 x 19 5/8 x 19 5/8 feet; collection Casa del Fascio, Como, Italy; installed in Como, Italy

page 10
Graham performing Performer/Audience/Mirror (1977) at De Appel Arts Centre, Amsterdam, 1977

page 11
Graham with architectural model Elliptical Pavilion (1995)

page 348
Likes (A Computer-Astrological Dating-Placement Service) (1967–69) reproduced in Graham, For Publication (Los Angeles: Otis Art Institute of Los Angeles County, 1975)

back cover
Detail from Fumihiro Nonomura and Ken Tanimoto's Manga Dan Graham Story (2001)

LIKES A COMPUTER—ASTROLOGICAL DATING—PLA... m 1967-69

LIKE RELATIONS *[select appropriate box(es)]*

DEFINING WHAT YOU ARE LIKE:

Your sun sign is Aries☐ Taurus☐ Gemini☐ Cancer☐ Leo☐ Virgo☐☐
Name sun signs of others you generally like or relate to
Aries☒ Taurus☒ Gemini☐ Cancer☐ Leo☐ Virgo☐☐
Name those colors you generally like or respond to
red-magenta☐ orange-red☐ white☐ black☐ purple☒ gre... ...on-wine☐

Do you like yourself Yes, all the time☐ Yes, most of the time☒ Yes and No☐
What qualities do you like in a date
physical appeal☒ intelligence☐ loving nature☒ compatibility☐ style☒ enthusias... ...lefined☐
How do you generally like to pass the time while on a date
smoking☐ arguing☐ driving☐ listening to rock☐ partying☒ intimately☒ drinking☐ ...☒
Does the time tend to pass quickly or slowly quickly☒ varies☐ neither☐ slowly☐ ...
(if it varies check one of the other boxes to give average experience)

DEFINING WHAT WOULD YOU LIKE YOUR DATE TO BE LIKE:

Looks great☐ nice☐ O.K.☐ doesn't matter much☒
Color white black *what's that?*
Age 15-18☐ 18-21☐ 21-25☐ 25-30☐ 30-35☐ 35-40☐ Over 40☐ *Immaterial*
What qualities you would like your potential date to like in you
physical appeal☒ intelligence☒ loving nature☒ style☒ enthusiasm☐ compatibility☐ interest in he...

DEFINING WHAT RELATIONSHIP YOU WOULD LIKE

I see love as deep emotional feeling☐ sex☐ joy☒ poetry☐ nothing☐ eternity☒ giving☐ relationship... salvation☐
I see in love deep emotional feeling☒ sex☒ joy☒ poetry☐ nothing☐ eternity☒ giving☐ relationship... salvation☐
Do you wish relationship to last beyond initial relaxation Yes☒ No☐ Open☐
Do you wish the time to pass quickly☐ slowly☒ no time in particular☐

EXACT TIME AND PLACE OF BIRTH *Dec. 24, 1942 8:05 P.M. Bronx, N.Y.* DATE THIS PROGRAM WAS FILLED OUT *Oct.*
NAME *Gloria S. Kaplan* ADDRESS *36 Monroe Pl., Bklyn., N.Y. 11201* SEX *Female* AGE *26*

SEND $5— REMITTANCE TO: **LIKES** 501 LEXINGTON AVENUE, NEW YORK, N.Y. 10017

You are guaranteed to receive names of three astrologically matched dates. You also will be getting a new questionaire asking you about how the time passed (and for filling this out a special reduced rate is given for your next matching). So that with the passing time we learn more about astrology as a social science and improve the quality of the system. Then the ad changes in stages in order to better meet the more clearly, defined needs of you, the participators.